A H M A N S O N · M U R P H Y
FINE ARTS IMPRINT

THE AHMANSON FOUNDATION

has endowed this imprint

to honor the memory of

FRANKLIN D. MURPHY

who for half a century

served arts and letters,

beauty and learning,

in equal measure by

shaping with a brilliant

devotion those institutions

upon which they rely.

THE GREAT AMERICAN THING

THE GREAT

Modern Art and National Identity,

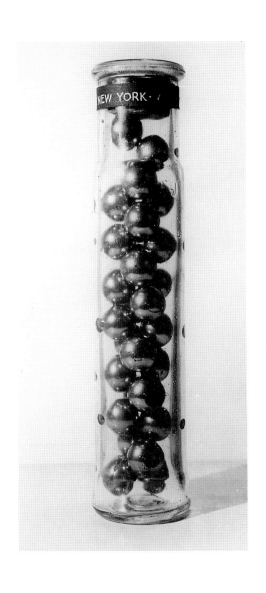

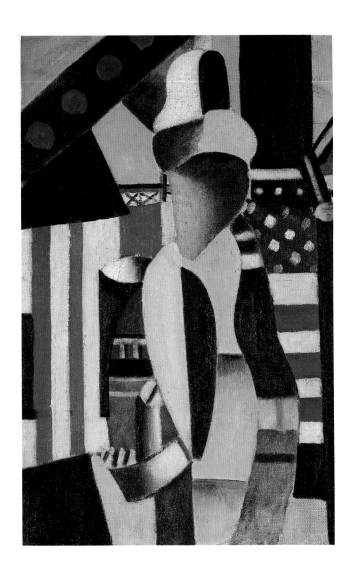

AMERICAN THING

1915–1935

WANDA M. CORN

University of California Press

Berkeley Los Angeles London

University of California Press
Berkeley and Los Angeles, California

University of California Press, Ltd.
London, England

Library of Congress Cataloging-in-Publication Data

Corn, Wanda M.
 The great American thing : modern art and
national identity, 1915–1935 / Wanda M. Corn.
 p. cm.
Includes bibliographical references and index.
ISBN 0-520-21049-2 (alk. paper)
 1. Art, American. 2. Art, Modern—20th century—
United States. 3. National characteristics, American,
in art. I. Title.
N6512.C597 1999
709'.73'09041—dc21
 99-24604
 CIP

Printed and bound in Canada

08 07 06 05 04 03 02 01 00 99

10 9 8 7 6 5 4 3 2 1

The paper used in this publication meets the minimum
requirements of ANSI/NISO Z39.48-1992 (R 1997)
(*Permanence of Paper*).

TITLE-PAGE IMAGES: Man Ray, *Export Commodity* or
New York, 1920. See Figure 64.
Fernand Léger, *Man with Hat*, 1920 (detail). See Figure 110.
Charles Demuth, *Buildings, Lancaster*, 1930 (detail).
See Figure 195.

For Joe

DONORS

The publisher gratefully acknowledges the
generous contribution toward the publication
of this book provided by the Director's Circle of
the Associates of the University of California Press,
whose members are:

Jola and John Anderson

Elaine Mitchell Attias

Jody Upham Billings

Agnes Bourne

Janice and Thomas Boyce

Rena Bransten

June and Earl Cheit

Margit and Lloyd Cotsen

Sonia Evers

Phyllis K. Friedman

Susan and August Frugé

Sheila and David Gardner

Harriett and Richard Gold

Ellina and Orville Golub

Janie and Jeffrey Green

Ann and Bill Harmsen

Florence and Leo Helzel

Mrs. Charles Henri Hine

Beth and Fred Karren

Jeannie and Edmund Kaufman

Nancy and Mead Kibbey

Leslie J. Kitselman

John Lescroart and Lisa Sawyer

Susan and James McClatchy

Ruth and David Mellinkoff

Hannah and Thormund Miller

Mimi and Burnett Miller

Katrina and John Miottel

Elvira Nishkian

Joan Palevsky

Mauree Jane and Mark Perry

Margaret and John Pillsbury

Lisa See and Richard Kendall

Shirley and Ralph Shapiro

Judy and Donald Simon

Sharon and Barclay Simpson

Judith and William Timken

Melinda McCary Wulff

The publisher also gratefully acknowledges the
following organizations for their generous support
of this book: the Ruth Levison Halperin Fund and
the James and Doris McNamara Fund in the
Department of Art and Art History at Stanford
University; the Society for the Preservation of
American Modernists; and the Art Book
Endowment Fund of the Associates of the
University of California Press, which is supported
by a major gift from the Ahmanson Foundation.

CONTENTS

PREFACE

When I was a graduate student in the mid-1960s and shifted my focus from medieval to American art, I quickly learned that the Americanness of American culture was, and had been for almost half a century, a key issue in scholarly and museological circles. Although my generation of scholars would come to dispute its centrality, as a young student I quickly fell under its spell. The books that excited me argued that America had always been different—in geography, natural resources, and political formation and in its intellectual development as an agrarian, middle-class society. Its difference from Europe and other colonial territories could be detected in the artistic and imaginative practices and symbolic structures of the country's earliest writers and artists and then traced through the nineteenth century and into the twentieth. For my literature classes I read Henry Nash Smith's *Virgin Land: The American West as Symbol and Myth* and Leo Marx's *Machine in the Garden: Technology and the Pastoral Ideal in America*. Both brilliantly analyzed the continuity of American pastoral ideals in nineteenth-century works of art and literature. Smith also discerned pastoralism in vernacular publications like pamphlets and dime novels, and Marx found it in the twentieth-century work of Charles Sheeler and F. Scott Fitzgerald. In the history of art, John McCoubrey, in a passionate long essay of 1963, proposed modern alienation as "a native visual tradition."[1] From the earliest days of the Republic to the present day, he argued, American painters have continually expressed their inability to be at home in the country's immense spaces or to command its physical environment. The historical sweep of McCoubrey's thesis was conveyed by the design of the bright red softcover edition that I bought in graduate school: portraits by John Singleton Copley and Thomas Eakins on the back cover and an abstraction by Robert Motherwell on the front. The book's central question was posed in script printed

prominently above the Motherwell painting: "What is distinctively American about American painting?"

A few years later, Barbara Novak addressed the same question in a much longer book, *American Painting of the Nineteenth Century: Realism, Idealism, and the American Experience.* She located an "enduring American vision" in process, opticality, and style. Whereas McCoubrey had argued for an essential American psyche, Novak constructed a linear, hard-edged style as the primary formal characteristic of American art. Finding these features in American artists as early as John Singleton Copley and the early limners and as recent as Charles Sheeler and Sol LeWitt, Novak traced a continuum in the way American artists "saw" and "conceptualized" objects in space. She was concerned, she wrote, less with *what* is American in American art than with *how* it is American.[2] While McCoubrey's book connected abstract expressionism to a three-century-long American paradigm of angst and alienation, Novak gave a national heritage to the conceptual and minimalist artists then emerging in New York.

These studies engaged me in the 1960s for many reasons, not the least of which was their authors' passion as scholars and flair as stylists. These books were, and still are, great reads. It was also deeply satisfying that this literature about American art circumvented the "quality" question. As a new recruit to the field, I knew that many art historians found American art deficient in the innovation and originality they saw in European masters. The Americanness issue enabled scholars to study this material without apology and turned what had been assumed a provincial and marginal body of work into an intellectually exciting field of study; it legitimated American art for the classroom and facilitated serious scholarship in both the academy and the museum. Though such inquiries ultimately exaggerated American achievements, ignored issues of diversity, and assumed American exceptionalism without examining it, they also defined the terms by which today's private and museum collections and wings of American art came into being. Once the bugaboo of provinciality had been suppressed, or redefined as a uniquely indigenous characteristic, scholars and curators could exhibit and study American art on its own terms. Exceptionalism profoundly shaped the study of American art history, giving the field a

parity and intellectual distinction it had previously not had.

So I went through graduate school asking myself questions: What made a colonial portrait look American and not British? How was the spatial construction in a Hudson River School landscape indigenous, and how did it diverge from that found in nineteenth-century European landscapes? What differentiated the pragmatic realism of American cubism from the intellectual abstractions of the French cubists? Why was American abstract expressionism more freely spontaneous than 1950s abstract painting abroad?

Today, we readily detect in these questions the grand narrative of American exceptionalism that guided so much research and writing after World War II. Discredited now for its generalizations and its assumption that every citizen, male or female, black or white, rural or urban, shared a single national experience, exceptionalism has lost its explanatory power. Since the late 1960s and, particularly, the 1970s the idea of a singular national art as a scholarly unit of measure has seemed troubling: it is both grandiose and romantic, sweeping all internal differences (those of class, race, and gender as well as those of historical circumstances) under the rug; it also reinforces the nation-state and its traditional hierarchies of power. Exceptionalist studies today are considered forms of cultural aggression, compelling conformity of behavior and belief and asserting political claims for American national superiority.

One reason I wrote this book was to uncover the roots of this exceptionalist discourse in American arts and letters. At first, I thought to find them in the art and art criticism of the 1930s, when nationalist rhetoric flourished and when artists across the country laid passionate claim to making an American art. But the more I studied the regionalists and other artists working during the Great Depression, the more I realized that they were co-opting vocabulary, strategies, and stated goals that had been articulated ten to fifteen years earlier by modern artists in New York City. The beginnings of the mid-twentieth-century question "What is American in American Art," I concluded, are better located in the practice and theories of the small modernist community gathered around Alfred Stieglitz in New York City and in international circles advocating a new

machine age art. American artists, supported by Europeans such as Marcel Duchamp and Fernand Léger and by writers such as D. H. Lawrence, Van Wyck Brooks, Lewis Mumford, Matthew Josephson, and Paul Rosenfeld, envisioned a new art, distinctively modern and American. Making an identifiably "American" work became an important goal for them.

But whether European or American, they did not know, a priori, what such an art should look like. They knew that it ought not to look European and that it ought to correspond to the peculiarities of American society and culture. But they felt they had on hand no intellectual understanding of, or visual forms for, a modern national identity. These they had to invent—and it is the processes and complexities of their research, with all its accompanying uncertainties and internecine battles, that I picture in the chapters to follow. A few looked for national traditions that might provide contemporary writers and artists with what Brooks called a usable past. Others defined a usable present, finding an American identity in the country's newness and in its lack of any weighty past. Sometimes these artists expressed Americanness concretely: the red, white, and blue of the American flag showed up in works by artists as different as Florine Stettheimer, Arthur Dove, Georgia O'Keeffe, Charles Demuth, Fernand Léger, Albert Gleizes, and Stuart Davis. Sometimes they reworked older tropes, such as the American girl or American amazon. And sometimes they persisted in using the word "American" as a compliment, not a put-down, so that John Marin was as American as American pie, and Georgia O'Keeffe envisioned everyone's chasing "the Great American Thing."[3] Such concerns for a national art and a national style affected what art critics looked for in a painting or sculpture and gave rise to artistic developments—a competitiveness with Paris and an ambition for an American style of art—that would be intensely replayed in Manhattan after World War II. In the interim between the two postwar movements the preoccupation with an American art momentarily left New York for the provinces, where it took hold among the regionalists of the 1930s. During the same period the Americanizing dilemma began to seep into our academies and started to shape the way I would be taught the history of American culture in the 1960s.

Calls for an "American" school of art making were by no means exclusive to early-twentieth-century modernists. The language of nationalism is inseparable from the history of American art. Supporters of the Hudson River School believed that in painting the American landscape they broke away from Europe to work in the native school of art founded by Thomas Cole and Frederick Church. During the Gilded Age academically trained American artists were encouraged to acquire learning and a cosmopolitan outlook in Europe and to return home to establish artistic traditions and monuments equal to the best in Europe.[4] At the end of the nineteenth century Eakins and Homer envisioned themselves as American-style realists; in 1914 Eakins advised students against expatriation. "If America is to produce great painters and if young art students wish to assume a place in the history of the art of their country, their first desire should be to remain in America, to peer deeper into the heart of American life."[5] In the early twentieth century Robert Henri, the leader and teacher of the Ashcan school and an admirer of Eakins, similarly encouraged artists to enter into the spirit of their country and paint the American scene.[6]

In modernism, however, we find a notably different call for a "new American art." Unlike nineteenth-century cultural nationalists, who focused on the content of a native art and the competency and schooling of American artists as compared with their sophisticated European peers, the first generation of modernists struggled to invent what they called Americanness (or, less frequently, Americanism). Discarding older definitions that linked America to nature, wilderness, democracy, and a "new Adam," machine age modernists focused on industrialized America, replacing the iconography of Niagara Falls and the Rocky Mountains with that of skyscrapers, billboards, brand-name products, factories, and plumbing fixtures. They eagerly rendered Americanness in an abstract, formal language drawn from such modern inventions to give their art a distinctive but not necessarily literal American identity. Calling upon symbolist theories of correspondences and equivalences, they researched new materials and new forms of line and color and devised new metaphors to embody their understanding of Americanness. If being American meant things like walking or producing goods and

services at a fast pace, then artists worked to incorporate speed into their formal vocabularies. If ultramodern bathrooms, tabloid newspapers, or many-windowed skyscrapers summed up the country's character, then artists incorporated shiny porcelaneous surfaces and represented glass, large typographic elements, and soaring vertical lines in their paintings, sculptures, and photographs. Even the artists in the Stieglitz circle whose art remained nature-based defined their adoption of abstract forms as a response to the deficiencies and lack of wholesomeness of the American way of life. By creating a "healing" vocabulary of organic lines, sensuous forms, and orbs of light, they aspired to redeem America from its spiritual bankruptcy.

These artists laid the groundwork for the midcentury's obsession with Americanness and an American style. The question of what is American about American art, pursued so vigorously during the cold war and the abstract expressionist years, was, I argue in the Epilogue, the last gasp of an identity discourse that originated after World War I. In establishing the origins of American exceptionalism in the arts, I also push back by a full generation the popular assumption that New York's ascendancy as an international art center began only with the exile of famous European modern artists to New York during World War II. This view originated in the 1950s, when the critic Clement Greenberg, heedless of earlier schools of modernism in New York, gave the New York School of abstract expressionism an exclusively European, not an American, past. Historians of the New York School followed suit. In his 1970 study *The Triumph of American Painting: A History of Abstract Expressionism*, Irving Sandler began, not with Alfred Stieglitz or Marcel Duchamp, but with a discussion of Fernand Léger, Piet Mondrian, Salvador Dalí, Yves Tanguy, and André Masson, all of whom sought refuge in New York during the Second World War. "The awareness of being at the center of the international art scene instilled in American modernists a sense of confidence," Sandler noted. "After the arrival of the Europeans, . . . New Yorkers felt less provincial."[7] With such encouragement they went on to create the New York School of modern art, Sandler concluded, one that rivaled and triumphed over the School of Paris.

With a longer view of modernism, we can see that Sandler's claims neatly replay boasts made by critics and journalists fifty years earlier, when they credited Marcel Duchamp, Albert Gleizes, Francis Picabia, and Edgard Varèse, all wartime refugees in New York, with instilling confidence in American artists and helping them formulate new goals. During World War I not only Americans but also many European artists and intellectuals optimistically proclaimed New York a new world art center, some finding the city far more adventuresome and exciting than Paris; together, they made bold claims for the emergence of a new American art. While it may seem ironic that outsiders played a part in this national movement (it certainly did to me as I encountered the towering presence of so many nonnationals), I now believe we must rewrite the early history of modernism in this country to acknowledge the many foreign voices who aided and encouraged their American colleagues to set new goals for the country's fine arts. European artists courted America during and after World War I and sought working relationships with New York modernists, initiating a series of transatlantic exchanges comparable to those we associate with John Singleton Copley and Benjamin West, who went to London in the eighteenth century to work alongside English artists. The new migration, now from Europe to America, took people by surprise. Artists who grew up at the turn of the century, when intellectuals routinely condemned the United States as boorish, ruthlessly commercial, and inimical to the arts, had to adjust to the European avant-garde's adulation of their country. Suddenly, it seemed, American culture was in the limelight, particularly those features foreign artists found more modern than anything at home. In an age when ocean liners made transatlantic travel more comfortable and accessible, the international set found skyscrapers, jazz, comic books, the Charleston, brand-name products, and Coney Island so exhilarating that they invented a mythos of American-style modernity. This, in turn, encouraged New York modernists to rethink their relationship with home and country. Buttressed by America's postwar political and technological power and prosperity, they pondered their customary reliance on European cultural models and talked of creating a uniquely American modernism. Perhaps, they dared to think, New York City would equal Paris as a leader in the arts. But even as they envisioned greatness close at hand, they continually had to combat their sense

of cultural inferiority to Europe, conditioned by two centuries of assumed provinciality.

American confidence was buoyed by the international attention artists paid to living in a machine age, when innovation and change superseded traditions and the past. From a European perspective, Americans had no past and seemed always to have lived in a machine age, while continentals were technologically *retardataire*, struggling to overcome the weight of history. The futurist, de Stijl, and Bauhaus movements, along with the Purists in Paris, envisioned a utopian new age, often turning to New York, if not as a model to emulate, then as one to improve upon, wanting all the while to marry the new to their own local circumstances. American modernists often helped consolidate these machine age stereotypes by accepting them as their new definition of national identity. Americans were unique, they decided, because they hailed from an industrialized culture without meaningful history or traditions. For some, to lack antiquity seemed a curse; for others, it was a boon, constituting the country's Americanness. In the absence of meaningful traditions, they mused, might they not forge an identity based on modern skyscrapers and machines?

Although some American artists were given to such bold thinking, they rarely succumbed to machine age idealism as completely as Europeans. And with good reason. Given that symbolist theory had led many turn-of-the-century American intellectuals to condemn their country's business ethos, modern artists remained skeptical and uneasy about any impending marriage with industrial culture and its products. They had only to walk the streets of lower Manhattan to see that reality in the most advanced industrial power in the world was less wondrous than the futurist visions of machine age enthusiasts abroad. When Americans painted a skyscraper or factory or created a poem from advertising jingles, they often expressed a felt disjunction between art making and daily material life. That ambivalence shows up in the irreverence and humor of Demuth's art, in the parodic poetry of Malcolm Cowley and e. e. cummings, and in the insistence of many painters that modern New York, beautiful at night, was not so by day. Some artists hedged by dividing their productive energies between art depicting modern things and the art of rural landscapes or still lifes of fruits and flowers. Unlike postwar European

advocates for a new machine age art, whose views today seem utopian, their art idealistic, Americans of similar disposition often equivocated, and their work hovers between ridicule and celebration.

A few other things about this book. I try hard in it to use a commonly understood vocabulary. Long ago my father, who was born and raised on a farm in the heartland and spent much of his working life in a pulpit, taught me to write so that he and my mother could understand me. His teaching remains my credo. I want to be understood, not always an easy position in an era when humanists, content to speak only to themselves or to the fully initiated, often adopt specialized vocabularies. I stand alongside those pragmatists and public scholars who urge a plain style and enjoy the challenge of explaining complex phenomena in accessible language. When I use terms such as "modernism," "avant-garde," and "America," I ask that they be taken in their most commonly used and accepted meanings. I occasionally use "modernism" and "avant-garde" interchangeably, seeking some variety in language. I realize that "avant-garde" is rarely used today except as a period term, but it continues to be serviceable as a shorthand description for early-twentieth-century artists who deliberately set themselves apart from academic and realist models of art making to create the new visual languages of cubism, expressionism, and abstraction. Finding themselves living in unprecedented times—the modern era, they called it—they believed they had to invent language to express the newness of their age.

In the formation of postmodernist thought over the past two decades, "modernism" has been understood as a set of social and artistic inquiries that have come to an end, and most historians now discuss the movement as outsiders to it. In that my artists were active during the first decades of modernism—arguably, the movement began with the late-nineteenth-century postimpressionists and symbolists—I call them early modernists, or sometimes interwar modernists, to distinguish them from artists practicing later in the century. And I occasionally refer to them as the moderns, a term used early in the century (not always kindly) to describe men and women who self-consciously set themselves apart in their dress, manners, and art from the bourgeois

mainstream. The moderns were not bohemians, living in Greenwich Village or Montmartre garrets like members of pre–World War I avant-gardes. Instead, they set themselves apart by their association with one another and by their often distinctive aesthetic garb: Stieglitz wore a black cape, O'Keeffe dressed in black and white, Demuth and Duchamp affected the tradition of the fin-de-siècle dandy. Gerald Murphy became such a modish dresser that he influenced French fashions; Florine Stettheimer's dresses expanded upon designs from art nouveau. These artists were most closely connected to the symbolist, expressionist, cubist, and dadaist movements, all of which developed in Europe before or during the war but had their most enduring impact on American artists after it. I use the term "transatlantic modernism" to signify the remarkable intercultural exchanges between American and European modernists, especially those from Paris, that shape so much modern art during and after the war.

By "America," I mean the United States, and not the North American continent or the Americas. Like "avant-garde," this too is something of a period term, one that virtually everyone used to describe the nation until the 1930s, when the country became better known as the United States.

I also avoid some commonly used terms because they lock us into one story about 1920s arts and letters, making it difficult to tell a different one. Thus I try to avoid the conventional descriptors of style, choosing *not* to categorize artists very often as, say, dadaists, organic abstractionists, or precisionists, or to separate painters from photographers and poets from novelists. In avoiding the various isms and distinctions between media, I hope I can persuade my readers to think differently about works of art, to see them as having meanings beyond the surfaces conjured by the names of styles, and to focus on their interrelatedness. Most specifically, I hope the tilt away from conventional art-historical nomenclature will help demonstrate how the first New York avant-garde organized itself, not around formalist questions of style, as post–World War II critics and historians claimed, but around different interpretations of Americanness.

Similarly, I want to distance myself from the literary concept of a lost generation, the phrase Gertrude Stein is said to have coined to describe Ernest Hemingway and other young American writers in

Paris. Although the literary establishment has long used the term to characterize American writers during the 1920s, it could not be more misleading. For it emphasizes the American artists' alienation from America while implying that Parisians somehow were wholly secure in their own artistic direction and not themselves lost. Americans sought refuge abroad from the stifling puritan mores of the Prohibition years at home, according to this concept, while cosmopolitan and anxiety-free Parisians became their mentors. This often-told tale oversimplifies a complex, more interesting story. Artists from both America and France, I argue, visited each other's countries to escape the provinciality and stagnancy of home. If the Americans were lost, so too were the Parisians who came to the United States in quest of cultural renewal. In general, both wanted something they believed they could not find in their own country: the European, the technologically progressive and go-go spirit of the United States, the American, the intellectual stimulation and deeper artistic traditions of the old country. Indeed, this book demonstrates the almost balletic intercontinental dance of artists' sailing in and out of the ports of Le Havre and New York, heading from one continent to the other, that makes the period so fascinating and distinguishes it from any time before or after. The fixation of an earlier generation of scholars, themselves alienated from corporate America during the cold war, on the "lostness" of artists in the 1920s, seems quaint from the globalist perspective of the 1990s. Thus I concentrate on the bicontinental traffic that recognized contemporary American culture as a new force to be reckoned with in the Western world.[8]

I try to get some purchase on the complexity of this transatlantic dialogue about Americanness by looking closely at only seven works of art, each drawn from a different sphere of artistic activity and each created by an artist of different temperament. The first of these, which I examine in the Introduction, is *Port of New York*, a book published in 1924 by Paul Rosenfeld, a New York intellectual and a highly respected art and music critic. His book, fourteen essays given over to individual artists, was one inspiration for my own organization, and his story, like my own, unfolds through essay-chapters, each with its own organic unity. Furthermore, a central theme of Rosenfeld's epilogue is intercontinental

artistic travel, the ocean liners sailing in and out of New York harbor serving as metaphors for American artists. These metaphors bring me to the larger themes of my book and afford a means of exploring the art made by members of the Stieglitz circle after World War I. Rosenfeld was one of Stieglitz's closest associates and a major spokesman for his group.

My book's six numbered chapters are divided into two parts. Part 1, "The Transatlantics," gives a chapter each to a work by three artists—Marcel Duchamp, Gerald Murphy, and Joseph Stella—that inscribes the dynamism of the New York–Paris axis and the internationalism of the quest for a new American art. These three chapters are very much a metropolitan story, looking at the ways Euro-American art, whether made in Paris or New York, located the meaning of America in the machine age and in the modernity of New York. The three chapters of Part 2, "The Rooted" (a term used often by Rosenfeld and other organicists who talked of the need to resist Paris, stay at home, sink roots, and make art from local materials), discuss one painting each by Charles Demuth, Georgia O'Keeffe, and Charles Sheeler from the later 1920s and early 1930s, when some modernists had moved out of the metropolis. Demuth went home to Lancaster, Pennsylvania; O'Keeffe to northern New Mexico; and Sheeler to small towns within commuting distance of New York City. Their art broadened the debate over what constituted America, adding their own backyards in effect to the transatlantic's modern New York. The chapters devoted to paintings O'Keeffe and Sheeler made in 1931 explore their use of language and imagery that is both modernist and regionalist, urban and rural, presentist and historicizing.

By dividing the book into transatlantics and stay-at-homes, I identify one of the most pronounced tensions American modernists faced during the 1920s: the long-familiar lure of Europe in competition with the newly legitimate course of remaining at home and making New York the center of one's artistic universe. My epilogue points to the ways these tensions and bold claims for a national art persisted in later American art movements.

I have arranged my chapters in a loose chronological order, according to the dates of the seven works of art on which they center. Yet each chapter ranges backward and forward in time and overlaps temporally with others. Some of my artists show up in more than one chapter, others only in one. Many historically important figures do not appear at all; I am not surveying all the territory. It is possible to read my chapters out of sequence, but such a reading would cut against the grain of a book in which I have consciously juxtaposed and organized the chapters to convey the process of inventing a new American art even as I maintain that it was an ongoing affair, with multiple dialogues taking place at any one time. This complexity resists organization, and I hope that the book in fact keeps alive the cacophony of voices and the subtle differences between them.

My organization also demonstrates how seemingly separate cultural spheres are fluid and contingent. The Americanophilia that Duchamp's ready-mades reveal in Chapter 1 continues to raise its hydralike heads in the chapters that follow. This happens, not necessarily because of Duchamp's presence or influence, but because modern artists in different places were participating in many of the same cross-cultural practices, gauging America's national character by comparing it to that of Europe, and vice versa. These practices took many forms and shaped the art produced by both Americans and Europeans, a theme developed throughout the book.

My analyses of the formal structure and thematics of the particular works of art that begin most chapters lead me to formulate questions beyond the work—specific to the culture, the conditions of production, often the work's reception, and, invariably, its creator. The artist who made the work, and something of his or her life and temperament, appear as a conjured presence in every chapter. While there have been powerful arguments in recent years to bury authors and their biographies—what Rosalind Krauss called "art history as a history of the proper name"—I do not want to disregard the human agency represented by authorship, nor do I wish to privilege the story of the artist's life over other explanatory models.[9] Because I seek a highly textured, multilayered interpretation, I make the author just one of the variables I turn to when trying to answer questions posed by a work of art. Artists are creatures of a particular historical moment; of local and broader cultures; of race, gender, class, religion, and profession. Their lives—both their private subjective selves and their self-consciously public selves—are also cultural texts. Their way of dressing, writing

letters, and decorating rooms and their choice of where to live or how to treat someone of the opposite sex are not just individual acts but also cultural ones. The same is true for their shifting identities over the course of a lifetime. Late-twentieth-century artists do not (and cannot) make the same choices modernists made a half century ago. Today, for example, they often choose to teach in the academy, never an option for an early modernist, who seldom worked for a living outside the studio. It seems to me that if the art historian can decode a work of art as a cultural text, she can do the same with the life of the artist; and the results often shed light on each other. The artist's ways of being in the world often help us see something in the art work that we might otherwise miss.

Characteristically, early-twentieth-century modernists were totally absorbed in art issues. Single-mindedly, they dedicated nearly every working hour of their adult lives to inventing and disseminating modern thought in both arts and letters. Though most believed that modern art had an ameliorative social dimension, they were generally not active in politics, reform groups, or clubs. They disdained organizations they had not themselves created. For all their talk about improving national life, they were not reformers who focused on the living conditions of the working class or the immigrant populations. They wanted to reform creativity and the human psyche. They spoke of a tomorrow when their art might have wide circulation and liberate men and women from the dullish conventions of their daily lives.

In that spirit, the moderns eschewed conventional family life. With the exception of Gerald Murphy, none of the artists I study closely here had children. Paul Rosenfeld, Marsden Hartley, Florine Stettheimer, and Charles Demuth neither married nor had long-term partnerships. Several of them were homosexual. Those who did marry established unusual households, with freer routines in unconventional living spaces. Before apartments in high-rise buildings were widely available and popular, O'Keeffe and Stieglitz lived in a spartan apartment on the thirtieth floor of the Shelton Hotel and took their meals elsewhere. Charles Demuth lived with his mother in the eighteenth-century family townhouse in Lancaster, Pennsylvania. Arthur Dove lived for a time on a sailboat. Stella often disap-

peared from New York and no one knew where he was. Hartley was always on the move and never made a permanent home. Even the wealthy Murphys, who put family and friends at the center of their universe, continually broke the rules of genteel behavior to which both had been born. They conducted their life in the 1920s as if they were putting together a stylish work of modern art.

Artists shared each other's company, gathering together in tight clusters in cities like New York and Paris. These clusters met in salons, sometimes in galleries, sometimes in restaurants or studios: they invariably included patrons as well as artists and writers. As Raymond Williams observed, the avant-garde was founded at the time when cities were becoming dynamic and complex metropolises and attracting new populations from near and far. In such large fragmented settings, intellectuals, writers, and artists began to seek out those who thought like them, coming together to "found the only community available to them: a community of the medium; of their practices."[10] What brought them together was less class or ethnicity than their dedication to the practice of new art forms, which was both their religion and their politics. While modernism in New York circles attracted primarily white middle- or upper-class men, in other respects the group was heterogeneous. Most of its members had not been born in New York City: Hartley came from Maine, Dove from upstate New York, Stieglitz from Hoboken, O'Keeffe from Wisconsin, Sheeler from Philadelphia, and Demuth from Lancaster. Some of the writers, like Paul Rosenfeld and Malcolm Cowley, had Ivy League training, as did Gerald Murphy, but artists generally went to art school rather than the university. Dove, who took an undergraduate degree at Cornell, was an exception. Rosenfeld, Stieglitz, Murphy, and Demuth had inherited incomes but others, like Sheeler, worked at jobs for a living; Marsden Hartley sometimes endured near-poverty railing against a society that did not support its artists. Stieglitz and many of the writers in his circle were Jewish-born, though nonpracticing, but most of the artists around him were not. O'Keeffe, whom he married, was a lapsed Catholic. Few modernists participated in any organized religion.

The most notable artist or writer of color attached to the modernist circles of the 1920s that I discuss in the book is the African American writer Jean

Toomer. Although racial discrimination helps explain the exclusion, even more important was the modernists' lack of commitment to any social program that might have encouraged artists of color or invited them to feel welcome in downtown gallery settings. Josephine Baker and black jazz do play a role in my study, but the New Negro movement, known popularly as the Harlem Renaissance, does not. When I began this study, scholarship was beginning to emerge on prominent writers and entertainers of the Harlem Renaissance, but not yet on artists, many of whom were genre painters working in figurative modes that modernists avoided. Aaron Douglas, who fully adopted a modernist style and created his own "spiritualized" or "geometrized" cubism to convey the history and aspirations of the black race, did his most important work in mural commissions of the 1930s, after the terminus of this study. The rise of a regionalist consciousness from the late 1920s through the 1930s, as well as the revival of the mural movement, helped Douglas conceive a style that was not only modern but also epic and narrative, both qualities excised from early modernism but permissible, even desirable, in the 1930s.[11]

If most modernists in downtown Manhattan did little to encourage artists of color in the 1920s (Carl Van Vechten being a notable exception), they did help a few women who sought entry to their world. While no programmatic and institutionalized support existed for women, progressive artists were generally aware that women had not been successful or had lacked equal opportunities in the arts. Here, it seems to me, Progressive Era politics and the suffrage movement exerted pressure on modernist communities to bring an occasional woman into their confines. "Finally," Stieglitz is reported to have said upon seeing O'Keeffe's drawings, "a woman on paper"—as if he had been waiting years for someone of her sex and caliber to appear on his doorstep.[12] His support of O'Keeffe is well documented, as is the emergence of a few other strong and independent women in the modernist movement.

But modernist communities also made special demands on women by assuming that their art should reveal and express femininity. The nineteenth-century ideology of separate spheres that imputed different characters, abilities, and duties to men and women hung on into the early modern period, but

with different emphases. Under the influence of Freud and other psychoanalytic theorists, modern artists constructed psychological differences between male and female sexualities based on their different biologies and what was loosely referred to as masculine and feminine sensibilities. That men thought in phallic, and women in organic terms, and that the sexes were at war became modernist clichés. The dadaists made it part of their program to play on sexual differences, making endless jokes about stiff male body parts and uterine female ones and often crossbreeding them to create hybrid figures that both flaunted and fused maleness and femaleness. Florine Stettheimer created an androgynous body type that she used throughout her work while maintaining, in her own self-presentation, an exaggerated femininity. O'Keeffe first achieved fame because critics believed she successfully painted abstractions no man could imagine or create. At first she had the same gendered expectations of herself, but ultimately she became frustrated that her art was always judged as a woman's expression, whereas men's work could range freely. As a consequence, she made major adjustments in both her practice and her life to destabilize the stereotyping brought to bear on her work.

Similarly, progressive men and women judged homosexual artists by standards different from those for heterosexuals. The chapter on Demuth, an artist known in his lifetime as a homosexual, looks at the subtle and not-so-subtle ways in which homophobia and sexual stereotyping in modernist circles affected his reputation and the interpretation of his art.

My indebtedness to feminist and queer studies will be especially evident in the chapters on Demuth and O'Keeffe, but I owe other debts as well. In writing about artists engaged in rethinking national identity, I am grateful to Ernest Gellner, Eric Hobsbawm, and Benedict Anderson, who have focused our attention on the range of mechanisms societies employ to construct and invent nationhood.[13] "Nationalism is not the awakening of nations to self-consciousness," Gellner has written; "it *invents* nations where they do not exist" (emphasis in original).[14] The insistence that cultures invent and reinvent what is meant by nationhood and that sources such as newspapers, dictionaries, the census, and maps, as Anderson has shown, play roles in this imaginative process has helped me think about how

works of art might also figure in the process. Hobsbawm's studies of the historical circumstances that gave rise to a particular national tradition, be it the rituals of honoring a national flag or celebrating a national holiday or taking on a national dress, as well as the disappearance of other traditions, helped me see that generations often destabilize one set of definitions to install another. Clearly, something of this sort happened in America after 1910, when culture makers revised a national identity based on nature and frontiers to produce one allied to technology and industry. Subsequently, engineers and industrialists generally replaced cowboys and Indians as national folk heroes.

The art historian Angela Miller has recently written of the role works of art played in forming mid-nineteenth-century American identity. In her *Empire of the Eye*, a close study of Hudson River School landscapes, she offers myriad lessons in how paintings enlisted their audiences in larger national agendas, such as imperial conquest and triumph over nature. I found particularly useful her concept "synecdochic nationalism," which exists when an artist conceives a local scene, and the public views it, as symbolically representing a larger whole—when, in Miller's words, "the form was local, but the program was national."[15] Thus an image of wilderness landscape might conjure for the nineteenth-century American not just a particular geography, but also an idealized image of American nationhood and ideological values that bind the work of art to the practice of the state.

In the early twentieth century nationalism also worked synecdochically, but details of modern life replaced landscape forms. The country's Americanness was newly represented by imagery taken from contemporary commerce and the appurtenances of modern existence. Instead of Niagara Falls or a Catskill wilderness, urban imagery, usually of Manhattan—the port of New York, Brooklyn Bridge, the city tabloid, or the porcelain bath fixture—signified the national and implicitly endorsed federal policies to increase American productivity and expand the American marketplace into countries around the world. Synecdochically these images were understood as a new America in the making. The national mind, still constructed as pragmatic and self-reliant, as it had been in the nineteenth century, now re-

sided in a set of symbols that encoded the shift in national agenda from the nineteenth-century conquest of peoples to the twentieth-century conquest of markets.

My work has also been shaped by cultural anthropologists like Clifford Geertz and Mary Douglas and the anthropological turn one finds in New Historicists such as Stephen Greenblatt; social and cultural historians like Carlo Ginzberg, Robert Darnton, and Natalie Davis; and art historians such as Jules Prown and Michael Baxandall. Since I care passionately about the specificity of history, and the plenitude of evidence that historians bring to their tasks, I also feel a kinship with those social art historians who focus on the relationship between works of art and material conditions. The work of Meyer Schapiro, Svetlana Alpers, Carol Duncan, Linda Nochlin, Robert Herbert, T. J. Clark, Thomas Crow, and of their many students, while often more grounded in social change and class formations than my own, has always given me pleasure and has strengthened my commitment to reading works of art as inscriptions of culture and evidence of historical realities.

From Baxandall, whose *Painting and Experience in Fifteenth-Century Italy* remains a model, I have taken the term "the period eye," which I use to describe how modern artists and writers see, think, and act in ways common to their kinship circle and their broader culture, and not unique to them individually.[16] While this may not be as ambitious a definition as Baxandall assigns the term, it is, I think, in the spirit of his inquiry. From Stephen Greenblatt, I have learned the pleasures of making (over)familiar works of art strange again by situating them in a cultural world different from the one we inhabit today and by interrogating elements of them we have taken for granted. From Geertz and his many students and colleagues, I have learned the usefulness of "thick description," which I engage in whenever I tackle an in-depth reading of a work of art. Thick description has revived my flagging faith in the formal reading skills drummed into the art historians of my generation. While social historians of art of the 1970s and 1980s justifiably dethroned art-historical formalism, some of its procedures may now be revived as an evidentiary tool to serve a new cultural art history. Precisely because such reading

skills best represent what art historians bring to the interdisciplinary table, I use them to advantage in this study.

Indeed, in writing this book I have learned that for all my forays into literary and intellectual history, anthropology, popular culture studies, and social history, I am first and foremost a historian of art. I care most for what works of art can tell us about the past. For art *is* history, albeit not transparently. You have to work long and hard to extract the historical stories embedded within a visual text. What I hope I accomplish in this work is ultimately modest: to illuminate how a few works of art, made by a small and rather fragile group of artists, expose the multiple cultures that formed them, which they in turn helped reformulate.

THE GREAT AMERICAN THING

As I was working I thought of the city men

I had been seeing in the East. They talked so

often of writing the Great American Novel—

the Great American Play—the Great

American Poetry. . . . I was quite excited

over our country and I knew that at that

time almost any one of those great minds

would have been living in Europe if it

had been possible for them. They didn't

even want to live in New York—how was the

Great American Thing going to happen?

GEORGIA O'KEEFFE

SPIRITUAL
AMERICA

For the first time, among these modern men and women, I found myself in an America where it was good to be.

Paul Rosenfeld, *Port of New York*, 1924

America without that damned French flavor!

Alfred Stieglitz, 1923

One of the liveliest pictures we have of 1920s America is Frederick Lewis Allen's *Only Yesterday*. Published in 1931, before the severity of the economic depression was well understood, the book caught the tenor of a decade when the country was immersed in its own prosperity and well-being. Although it is unillustrated and flush with statistics and sociological terms, it evokes memorable images of a time when the "business of America was business": Calvin Coolidge, the complacent leader of the country, at the altar of "the great god business"; the advent of the modern salesman; and the new promotional tactics of a rapacious advertisement industry. Writing with panoramic sweep, Allen took note of such things as the disillusionment of the American intellectual but was at his best capturing the zaniness of the decade: the fad for mah-jongg and crossword puzzles; Bruce Barton's promotion of Jesus as a modern businessman; the hero worship of Charles Lindbergh; the debunking historians who turned American heroes into profligate rascals; the crime sprees of Al Capone; and the national advertising campaign against halitosis, a newly invented social disease.[1]

But in chronicling extravagant behavior, Allen did not address the hometown pride and the self-absorption in what it meant to be a "modern American" that had surfaced during World War I and girded the hype of the following decade. He could not see it because he and his culture in 1931 were not only still captive to an Americanizing discourse but also busy reworking it. What began in the 1920s as a booster mentality for things American became, by the mid-1930s, the more virulent and politicized nationalism prompted by the Great Depression. The concern for defining and defending "Americanness"

Fig. 1 (facing). Alfred Stieglitz, *Spiritual America*, 1923. Gelatin silver print, $4\frac{1}{2} \times 3\frac{5}{8}$ in.

that historians find so integral to the 1930s was first formulated, I want to suggest, in the preceding decade, when the standard of living in this country became the highest it had ever been. With a marketplace of newly invented American products not only available at home but also exported abroad, editorials and advertisements generated a new phrase, "the American way of life." Alongside the advertisers and journalists boasting of American cars, canned goods, boxed cereals, and safety razors came a new middle American, George F. Babbitt and his kin, small-town people inordinately proud of their material goods, their solid citizenship, and the clean living of their America. Increasing numbers of service clubs and veterans' groups promoted "100 percent Americanism" for young people in the schools and for members of immigrant groups, and nearly everyone, it seemed, praised the skyscraper as a uniquely American invention that could climb endlessly up through the clouds.[2] Mayors and chamber-of-commerce merchants sought to put their communities on the American map by building skyscrapers and airports, along with department stores, and by electrifying their Main Streets, transforming them into miniature "white ways." Everything was to be up-to-date—and American—in Kansas City.

Because Sinclair Lewis and H. L. Mencken so successfully parodied the boosterism associated with small towns and small minds, historians generally associate it with the American hinterland, especially the Midwest, and not with urban centers. Boosters, it is assumed, were provincial, unpolished, and uncomplicated men and women who blindly believed in American-made products, American politics, and something loosely defined as the American way of life. This book contends, however, that there were also sophisticated America-firsters who lived in big cities and considered themselves the most progressive thinkers and artists of their day. These highbrow men and women, who disdained boosterism and its boorish connotations, were themselves but an urban and urbane version of the same species. Called cultural nationalists by today's scholars, the culture makers of this new breed emerged in full force during World War I, especially in New York. Dedicated to the growth and development of a new American arts and letters, they included Mencken, Herbert Croly, Van Wyck Brooks, Randolph

Bourne, Alfred Stieglitz, Lewis Mumford, Waldo Frank, Paul Rosenfeld, and James Oppenheim. White, well educated, and contentious, these men grew up during the Progressive Era and by the time they were young adults had ideologically committed themselves to the politics of modernism and to a renaissance in the nation's arts and letters. In keeping with such ideals, they carved out a rarefied cultural space in which to work, one from which they self-consciously cast a critical eye upon the dulling habits of ordinary Americans, and upon a country mired in its own materialist success. Their most popular weapon was the pen, which they wielded with ferocity and with faith that words could change the world. Their usual enemies were the political conservatism, materialist drive, and provincial routine of what they configured as a large, undifferentiated American public, of which George F. Babbitt was representative.

Ironically, these cultural nationalists were as concerned as the fictional Babbitt with establishing the superiority and excellence of modern American goods. If Babbitt registered his inordinate national pride by taking satisfaction each morning in his new alarm clock and safety razor, two of the country's latest time-saving inventions, the cultural nationalists registered theirs by celebrating an intellectual renaissance, in which they themselves were participants. They too boasted wildly and immodestly of an incipient national greatness embodied, not in machinery and gadgets, but in arts and letters. If Babbitt spoke for small-town America's nationalist fervor, newly aroused by World War I, the cultural nationalists expressed the same sentiment for New York's intellectual elite.[3]

Paul Rosenfeld, a cosmopolitan man of letters who championed the modern artists and writers of his day, was one such cultural booster. In his book *Port of New York: Essays on Fourteen American Moderns*, published in 1924, Rosenfeld offered his account of the beginnings of an authentic national culture. Speaking as if the country had never had any cultural achievements and using high-minded booster rhetoric, he claimed that the American artists, writers, and musicians of whom he wrote gave him "the happy sense of a new spirit dawning in American life."[4] For the first time ever, he explained, the arts were thriving in a country habitually inhospitable to the life of the mind. Those who

gave him hope were Sherwood Anderson, Carl Sandburg, and William Carlos Williams in literature; Roger Sessions in music; Margaret Naumburg, founder of the Walden School, in education; Randolph Bourne and Van Wyck Brooks in criticism; and Albert Pinkham Ryder, Kenneth Hayes Miller, Arthur Dove, John Marin, Marsden Hartley, Georgia O'Keeffe, and Alfred Stieglitz in the visual arts. Except for Ryder, a member of an earlier generation who had died in 1917, and Bourne, who in 1918 had died tragically young, all these artists were active when Rosenfeld published his book. Most of them were his personal friends and often the beneficiaries of his generosity. Rosenfeld had nursed Bourne, then only thirty-two, during the last days of his final illness and had paid for Sherwood Anderson and his wife, Tennessee, to accompany him on what was their first trip to Europe in 1921. Furthermore, not only did he know all the artists he wrote about, but he was also building a small personal collection of their works.[5]

In an era when people traveled to and from America by ocean liner, and more often than not entered and left the country through New York's harbor, the title of Rosenfeld's book—*Port of New York*—evoked what he and his contemporaries took to be the country's principal gateway. As a place of transition, a tip of land that looked to Europe in one direction and to America in the other, the port took on heightened meanings in the 1920s as artists and writers, photographers and filmmakers endowed it with rich symbolism and poetic meaning. Certainly this was the case with Rosenfeld's book, which constructed the port in ways that were pivotal for his generation. For him it was synecdochically the entire country that stretched out beyond it. It was America, home, motherland, repatriation. So rich is his investment of this place with issues of cultural nationalism that it provides me, some seventy-five years later, with my own gateway text, a literary portal to this art-historical study of progressive artists who lived and worked in New York and Paris during World War I and the 1920s. It is the archway through which we will pass slowly, to identify the key issues and complexities of cultural nationalism that drove so much art making during the period. While in succeeding chapters I focus on paintings and sculpture as texts, Rosenfeld's book, especially its epilogue, serves me here as primer and prologue.

Laden with the tropes and mental habits of early-twentieth-century cultural nationalists, Rosenfeld's text makes transparent issues that are often recalcitrant in works of fine art. Its evangelizing for an American modernism initiates us straightaway into the polemics of cultural nationalism, the issues of identity formation, and the centrality of transatlantic exchange that are the themes of my study. It also allows for a close look at the Stieglitz circle while raising questions that all the artists under study here took to be central: What should be the relationship of modern American artists to their own culture? Should artists ship out for Paris or remain docked in their home port? What resources could American artists draw on to reconnect with their home culture? What were the appropriate themes for American modernists committing themselves to a newly revived national art? If the artists' subjects were somehow to resonate as those of the New, not the Old World, what was American about American culture, anyway? And once this question was answered, how could these American traits lead to the creation of an authentic national art?

One characteristic to note at the outset is *Port of New York*'s partisan stance. While one might assume that a critic as well educated and well traveled as Rosenfeld spoke objectively about New York's cultural landscape, nothing could be further from the case. *Port of New York* has notable breadth in its inclusion of artists, writers, musicians, and critics, but at its heart beats a promotional poetics boosting the accomplishments of a thin cut of New York moderns. Its structure—fourteen essays about fourteen individuals, bracketed by a foreword and an epilogue—belongs to the genre of books about Great Men that the Victorians had made their stock-in-trade. Its basic unit is the testimonial portrait of a creative person and the brilliance, sometimes failures, of his or her contributions to art, literature, criticism, politics, and education. Rosenfeld's use of a photographic or pencil portrait to accompany many of the essays reinforced the sense of heroic individualism. Eight essays open with what the title page calls camera portraits, five of them by Stieglitz. For Bourne, Rosenfeld used an Arthur Dove line drawing done from a death mask, and for Ryder, an Alice Boughton photograph. Paul Strand supplied the photo portrait of Stieglitz.

Another characteristic that should catch our

attention—but may not, given New York's stature on today's cultural maps—is that Rosenfeld made New York and its native culture makers the center of his 1924 inquiry. He put in the center what had routinely been on the edge—New York—and put on the margin the city American intellectuals traditionally honored as home to the arts, Paris.[6] But equally important, he used the transatlantic trade route between America and Europe as a central trope. While he privileged his own country and city, he identified Euro-American cultural exchange as vital to New York's success in becoming an art capital. He rejected expatriation as an option—for Rosenfeld, the transatlantic voyage for Americans must end in New York—but in constructing his book around voyaging, he identifies one of the central cultural dynamics at work during the postwar period. European and American artists were engaged in an economy of exchange that took place, for the first time in history, as much in New York as in the art capitals of Europe.

Rosenfeld's rhetoric is also noteworthy, his mannered symbolist prose style so foreign to us today that he can turn away all but the most patient and forgiving of readers. Indeed, his involuted sentences and his predilection for romantic metaphor made his prose so densely imagistic that even in his own day he was condemned for his excesses. "His huge mud-bed of undisciplined emotionalism, his inflated windbag of premature ejaculations," complained Gorham Munson, "no one, apparently, thinks of dredging or pricking. Blithely complacent, he goes undisturbed."[7]

Here are two brief examples. Rosenfeld describes Stieglitz's photographs of Georgia O'Keeffe as coming "from the deeps of the psyche. They are moments of the race of those which glint ephemerally in some intimate, intense, decisive passage of life, reveal the trend of subterranean streams and are gone again unseen except of the well-attuned spirit." In another passage, photographs by Stieglitz become miraculous revelations. "The noble prints, so clear, precise, charged with unimaginably subtle detail and vibrantly given textures are like the writings of a needle sensitive to the gravity of man, the state of his spirit, the movement of his blood, the faintest tingling of his cortexes, as the seismograph is sensitive to the minutest vibrations of the crust of the earth."[8]

Such heated and attenuated prose reveals Rosen-

feld's aesthetic loyalties; he was both a latter-day symbolist, seeking to create verbal equivalents for the emotions he experienced when viewing works of art, and a postwar Freudian, for whom art was related to the dark recesses of sexuality and repressed drives. His reliance on fifty-year-old symbolist practices deep into the 1920s and 1930s is striking, for his writing seems more comfortable in the company of late-nineteenth-century critics like Walter Pater and Arthur Symons than in that of such postwar peers as Edmund Wilson and T. S. Eliot, with their cool and precise prose. Wilson's and Rosenfeld's writing styles were polar opposites—Wilson practicing what he once described as the new criticism, "spare and terse in style, analytical and logical in treatment," while Rosenfeld evangelized in metaphoric hyperbole. Yet the two men admired each other and were often in one another's company. Wilson could attack Rosenfeld's emotionalized criticism, a style commonly referred to in the period as "impressionistic," but he deeply respected Rosenfeld's broad learning and dedication to the humanities and clearly thought of him as a modern critic of substance. At the time of Rosenfeld's death Wilson compared him to H. L. Mencken and Van Wyck Brooks and wrote that "he has probably done more than any other critic to break down the provincial prejudices and the inhibitions against artistic expression which have hampered Americans." Wilson's admiration for Rosenfeld's cosmopolitanism was deeply shared; in 1946 forty-nine artists and belletrists contributed to a volume of homage and appreciation: *Paul Rosenfeld: Voyager in the Arts*.[9]

The friendship of Rosenfeld and Wilson emblematizes the complexity of human and aesthetic relationships among practitioners and producers of modern arts and letters in New York during the 1920s. All too often this decade is pictured as a streamlined cultural terrain occupied by a new order of critics like T. S. Eliot or Edmund Wilson, and by machine age enthusiasts, Precisionist painters, and Objectivist poets. But it really is a bumpier landscape, peopled equally with powerfully influential artists and writers bred in fin-de-siècle aestheticism whose art resisted change and indulgence in the new. Modernisms, not a monolithic modernism, are what we ought to be talking about. Writers like Rosenfeld who doggedly upheld turn-of-the-century values— especially those constructing art making as a reli-

gious faith dedicated to overthrowing the evils of commerce—overlaid them with presentist concerns about national achievement. This book explores the dialectical tensions between the latter-day symbolists and those who invented the Hemingway sentence and the Precisionist painting, and the ways both groups argued for primacy in creating the first, the only, and the most authentic American art.

Rosenfeld's most powerful literary device was the metaphor. He did not call things by their proper names but evoked them through surrogate imagery, placing a high value on indirection and allusion. Take the title of his book. Why name a study of creative people *Port of New York*? Only in the final essay, "Epilogue: Port of New York," do we come to know why. The port, we learn, is Rosenfeld's code word for America, and ocean liners moving in and out of New York are his metaphors for creative American men and women desperately sorting out their relationship to Europe and to their own country.

Fourteen pages long, the epilogue is a sustained meditation on transatlantic ocean liners, that is, artists and writers, coming into New York harbor and going out again, bound for Europe. It tells a modernist parable of the struggling and progressive American artist who leaves home time and time again for the attractions of Europe but finally comes home to stay and make his peace with his own country. Using the formal pronoun "one" ("one went back over the sea"), Rosenfeld narrates in an archaic voice, describing the odyssey of Every Artist. He tells how in the years before the war one felt unwelcome and unhappy returning home from Europe; the New York port was ugly, and one wanted to ship right back out again.[10] But now, he says, something has changed; the port opens its arms and embraces its artists and poets. One wants to stay and do one's work in America. Yesteryear, alienation and despair; this year, reconciliation and hope.

The parable reveals itself slowly in the epilogue, taking the reader on ocean crossings that are turbulent journeys emotionally. We do not learn until we have voyaged into despair and back out again that reconciliation has been effected. The essay opens brightly enough, but then spirals downward. The narrator, standing at the lower tip of Manhattan, the

Battery most likely, creates a series of images for the transatlantic ocean liners arriving and docking at, and eventually departing from, the piers in the harbor. Since this was an era when a critic like Rosenfeld felt obliged to travel to Europe every few years to stay current with developments in art, and when the means of travel was the behemoth ocean liner celebrated for its sleek, streamlined design, the narrator not only imagines such ships as metaphors for wandering artists but pictures them as beautiful human bodies sensuously riding the waves. The ocean liners are "lean voyagers"; moving "up through the Narrows, they heave their sharp prows." But within sentences Rosenfeld's language changes from sexual pleasure to the unpleasant sensation of captivity. When the ships come into the Manhattan slips, their "flanks are lashed to the town; holds thrown open to the cobbled street." And there they lie like "rows of captives handcuffed to policemen." After days, even weeks, imprisoned in New York harbor, a murky and unpleasant place, the boats "evade" their "stupid" sentinels and return to Europe. They have "fled again through the straits." As they depart, they offer their beautiful backsides to the narrator's lusting gaze. "Beyond where eye can reach iron rumps dwindle down the ocean."[11]

Having established the ocean liners' physical beauty—especially as they head for Europe—and New York's mean ugliness, Rosenfeld employs new dualities, of heaven and hell, sunlight and darkness. The liners "did not come across the Atlantic on a single plane. Somewhere, in the course of their voyage from Europe to New York, they left one plane and descended to another." And when they dropped down, it was as if they fell from "a heaven-near plateau under blue skylands into a dank and shadowy vale." They had left the sunshine of European ports and descended into a cold, dark hell, an uncivilized state, a "chaotic pre-creature darkness." When the liners set themselves on a return course, they reversed the order and, from the darkness of their imprisonment in New York, they ascended into the morning light, like "exiled princes gone to regain their thrones."[12]

This sounds Wagnerian, with its romantic rhetoric of light and dark, good and evil, and a desire to leave the dim netherworld for the warmth, healing, and enlightenment of Valhalla, and it is. But if Rosenfeld's metastructure belongs to a nineteenth-

century aesthetic system, his metaphors are of his own time. Rosenfeld's imagery is domestic and topical, not mythological. He roots his paradigmatic journey in the popular transatlantic passage of his day and makes his image for enlightenment and civilization that of the everyday sun giving life to growing things. He works the sun image particularly hard as his metaphor for a nurturing environment, a trope that recurs in his work and in that of many of the artists he championed. The sun is secular and "natural" but also retains its allegorical signification, having the power to heal and to enlighten. In New York, Rosenfeld explains, the sun shone but gave off no heat; it did not grow things or nurture the city's artists and citizens. "The seed inside did not take root." Even those born and bred in New York were not organically rooted there. Cornfields in Germany or iron balconies in Paris "were more life-giving, more feeding and familiar," than "the corner of New York" that one rounded every day. New York was alien and unfriendly; its crowds, its towers, and its drive to make money, all "snatched the light from each other." So barren was it that one always felt an irrepressible pull back to the ocean liners that sailed upward to the sensuous warmth and light of European shores.[13]

For creative people, this was a terrible dilemma: if America offered them no nourishing light, Europe's "attractive rays," while warm, could not sustain them indefinitely. Europe "had its roots in a past which was not ours, and which we might never adopt." Americans in Europe felt homeless and bereft. "It was beauty in America one wanted, not in France or Switzerland. It was the towers of Manhattan one wanted to see suddenly garlanded with loveliness." What was missing was the "will to take root in New York." But how to sink roots? It could not happen through patriotism, an "insane self-abnegation," or by wearing a "red, white, and blue rosette in the buttonhole." It would take a miracle—and here Rosenfeld evokes both the gods of mythology and the Christian God—perhaps in the form of "a supernatural and winged visitor" who might "fall into the port as a meteorite might fall from the sky."[14]

The epilogue continues, recounting experiences that take the reader from hope to disappointment and back again. There is only frustration, never fulfillment. Every time one came back from Europe,

one prayed that "the arms of the port would open up and receive one, and the sense of home be written large over every crevice and electric sign."[15] But the parental embrace was cold and unsatisfying, and a feeling of restlessness soon returned. It was impossible to create in this land of no heat. And one began the cycle again, dreaming of steamers taking one back to Europe.

Just as the essay seems to be coming to a tragic end, New York blindly shunning her progeny, the pent-up reader is released in a burst of imagery infused with the sacred, the organic, and the sexual. "What seemed a miracle alone could accomplish has taken place." Something mysterious has happened. The sea route between Europe and New York has evened out. "The steamers no longer descend from one plane onto another when they come into New York harbor. The port is not the situation, depressive to every spiritual excellence and every impulse to life, which once it was. Glamour lies upon it still; but not the painful dream light of yesteryear." Daylight has "come upon the port" and there is an "almost beauty that comes to dress the slipshod harbor of New York."[16]

The pace and excitement of Rosenfeld's prose accelerate as he describes his newfound "relationship with this place in which we live." His language again becomes explicitly erotic, his organic images referencing male fluids and coitus. Earlier, he lusted after the rumps of ocean liners. Now the artist consummates sexual union with his home place. The skyscrapers and the artist "have suddenly commenced growing together." Rosenfeld rushes toward climax. "It seems we have taken root. The place has gotten a gravity that holds us. The suction outward has abated." A miracle has happened, for New York is now a center like other great cities, and its port "lies on a single plane with all the world." "In the very middle of the city, we can feel the fluid of life to be present." A new spring has burst forth, "a push and a resilience; and here where Europe meets America we have come to sit at the focal point where two up springing forces balance." The sun, "which once shone brightly on Europe alone," has "moved across the Atlantic," bringing its fertile warmth and life-granting properties to New York.[17]

When did the "new orientation" and warmth begin? asks Rosenfeld. Perhaps it was the war that made Americans reorient themselves. For up to

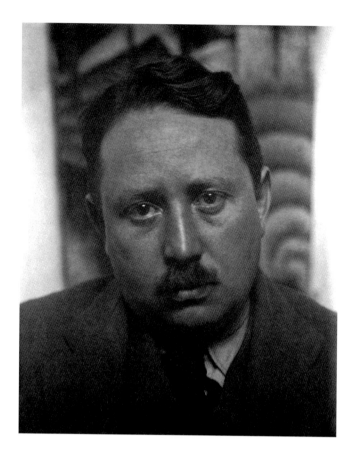

Fig. 2. Alfred Stieglitz, *Paul Rosenfeld*, 1923.
Palladium print, 9¹⁄₁₆ × 7⁹⁄₁₆ in.

then, "we had been sponging on Europe for direction instead of developing our own." When Europe fell apart, "we were thrown back on ourselves" to find a "sustaining faith."[18]

The important thing for Rosenfeld is that some miracle has transpired on the national front; he announces it like a heralding angel delivering news of a blessed birth. "To-day the commencement of a religious sense is here." People are beginning "to come into relationship with one another and with the places in which they dwell." The labors of a few writers and artists—the men and women Rosenfeld honors in his book—have brought this thing to pass. They have reunited with their birthplace. "Through words, lights, colors, the new world has been reached at last. We have to thank a few people—for the gift that is likest the gift of life."[19]

Just who was this evangelist who spoke the language of Bible and libido and put contemporary American art and letters at the center of his faith?

Born in 1890 to a cosmopolitan and financially comfortable German Jewish family, Rosenfeld was a well-read, cultured New Yorker (Fig. 2). His mother had been an accomplished pianist and his father was a dress manufacturer; both saw to it that Rosenfeld and his sister grew up amid books, music, and things of the mind. Though his was not a particularly happy childhood, it bred in him a desire to be artistic and a deep respect for European arts and letters. Like many affluent Americans of cultured European background, Rosenfeld traveled abroad at a young age for education and for visits with family in Germany. After his mother died, when he was ten, he was reared by a grandmother who sent him to Riverview

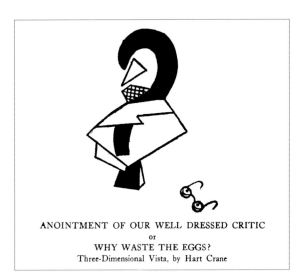

Fig. 3. Hart Crane, *Anointment of Our Well Dressed Critic* From *The Little Review* 9 (winter 1922), p. 23.

Military Academy in Poughkeepsie for his secondary education. From there he went to Yale, graduating in the class of 1912.[20]

At Yale Rosenfeld emerged as a man of letters and a fin-de-siècle aesthete, his correspondence peppered with quotations from Maurice Maeterlinck, Henri Bergson, and Remy de Gourmont as well as from his favorite German writers Heinrich Heine, Friedrich von Schiller, Johann Gottfried von Herder, and Goethe. He became a writer for, and then editor of, the prestigious *Yale Literary Magazine*, publishing essays on James McNeill Whistler and Aubrey Beardsley, among other topics.[21] And in keeping with the values of a latter-day Whistler, he became a dapper dresser, proclaiming in his aesthetic dress his hostility to conformity, to standardization, and to bourgeois values. His stylishness became something of a trademark (Fig. 3). At the Columbia School of Journalism he worked under Talcott Williams and underwent his first newspaper assignment, quickly concluding that his arena was not the journalist's neighborhood beat but the rarefied world of the artist. Like a number of American modernists, he had a family inheritance, giving him the freedom to move into less profitable forms of writing.

Rosenfeld tried his hand at writing novels, but his imagistic style did not lend itself to good storytelling. The only novel to make its way into print was the autobiographical *Boy in the Sun* (1928), whose heated prose details the pain of an intensely confused childhood (there, as in *Port*'s epilogue, the rays of the sun signify health and happiness).[22] More successfully, Rosenfeld forged his literary identity as a cultural critic and essayist, writing about modern literature and the arts for the country's newest and most progressive journals such as the *Seven Arts*, the *New Republic*, the *Dial*, *Vanity Fair*, the *Nation*, and the *New Yorker*. He was particularly effective in promoting and explicating modern music, a field lacking competent critics in this country. Between 1920 and 1927, he edited the "Musical Chronicle," a monthly column for the *Dial*, and from 1916 to 1942 he wrote music criticism for the *New Republic*. These pieces, as well as his writings on art and literature, were regularly collected and reprinted.[23]

Given the Eurocentricity of his education at Yale, and his keenly felt German and Jewish heritage, how did Rosenfeld become the strenuous advocate

for a contemporary national culture that we find in *Port of New York*? Like most intellectuals of his generation, Rosenfeld was groomed to be a Europhile, to assume Germany and France the centers of progressive culture, and to disdain the provinciality and vulgarity of his own country. When he spoke of America as a dank and dark place in *Port of New York*, he was speaking the language of his teachers, recalling the way he had been schooled at Yale to think of his country's cultural inadequacies.

Rosenfeld's experience as a writer and editor for the *Seven Arts*, a journal that appeared in New York during the war, helps to explain his intellectual turn. He was one of its youngest contributors, sometimes writing under the pseudonym Peter Minuit. The magazine lasted only a brief year, from November 1916 to October 1917, failing in part because of its strongly stated pacifism and its urgings of nonintervention in the European war. But its ideological commitments determined Rosenfeld's life's work as a proselytizer for contemporary American arts and letters.

The *Seven Arts* began in a state of euphoria about what it deemed new promise in American art and writing. "It is our faith and the faith of many that we are living in the first days of a renascent period," the first editorial read, "a time which means for America the coming of that national self-consciousness which is the beginning of greatness. . . . Our arts shown [*sic*] signs of this change."[24] Given that the war in Europe had cut the United States off from France and Germany, the future health of the arts depended, the editors maintained, on the New World. Such a position combined a realistic consideration of what would happen if Europe were closed off indefinitely, and art capitals like Paris collapsed, with a self-congratulatory prophecy that if European art centers were in decline, New York was poised to ascend. While the journal's title gave no clue to the editorial decision to boost the American arts, the editors considered other names that reveal their intent: *Roots*, *America Singing*, the *New Pioneer*, *Native Soil*, and the *New World* were among those suggested.[25]

To give intellectual ballast to such bold claims, and to signify transatlantic support for their enterprise, the editors called on a French wartime pacifist, the novelist Romain Rolland. Writing from war-torn Europe where it appeared to him that the arts

might be tragically doomed, incapable of surviving the carnage, he pleaded with Americans to take command of their own cultural destiny. In words that would have sounded startling at the time, given how little attention the French traditionally paid to American art forms and how much Americans presumed the French their cultural superiors, he encouraged Americans to realize that their freedom from strife gave them an extraordinary opportunity to reinvent the arts and take the baton from Paris. It was "America's solemn duty to uphold the wavering torch," he exhorted. "Be free! Do not become slaves to foreign models." Defend the cause of liberty and, most of all, make sure the arts survive. "You are fortunate. Your life is young and abundant. Your land is vast and free for the discovery of your works. You are at the beginning of your journey, at the dawn of your day. There is in you no weariness of the Yesterdays; no clutterings of the Pasts."[26]

Such encouragement from France characterized the wartime Franco-American alliance, which depended on imagery that constructed the relationship between the two countries as one of parent to child. Europe, as Rolland pictured it, was the old, worn-out parent culture, America the enviable young and innocent child that had not yet exercised its muscles in the arts. This new international partnership, complexly configured as familial, fueled the budding nationalism of New York intellectuals and artists like Paul Rosenfeld and deeply influenced creative work done in New York over the next two decades.

Paul Rosenfeld was not the only young cultural nationalist to find his intellectual voice while working on the *Seven Arts*. Waldo Frank, a writer so close to Rosenfeld in age, background, and persuasion that their friendship was fraught with the tensions of rival siblings, had a similar experience.[27] Frank too was an assimilated German Jew, a New Yorker, a graduate of Yale (class of 1911), well traveled and schooled in European (especially French) culture, an aspiring novelist, and an influential critic of American culture. In the postwar decade he published two books that prophesy a regeneration in American intellectual life and form something of a trilogy with Rosenfeld's *Port of New York*: *Our America* (1919) and *The Rediscovery of America* (1929).[28]

Frank, like Rosenfeld, felt he "discovered"

America after his college years. In an autobiographical essay of 1925, "I Discover the New World," Frank sounded the same theme as Rosenfeld in his epilogue to *Port of New York*. In 1913, as Frank tells it, he had his conversion experience while trying to write novels in Paris, a city where writing was "considered a sacrament" and where "life was looked on as a lovely, mysterious adventure." He was happy and content in the company of other American exiles, who all "sneered" and "jeered" whenever the topic of their own "barbaric land" came up. But in listening to such criticism, Frank began to question how his country was ever going to improve if he and other "conveyers of truth, creators of beauty" did not return home to "endow America with what they accused America of lacking." He began to feel like a "parasite" in Europe, "nourished by what other men, through centuries and ages, had created." He came home, where he felt needed, convinced he would find others with whom he could build a new American culture. "I rented a room in Washington Place. I stared at the dirty wall—and wondered what madness had driven me. No matter. I was where I belonged!"[29]

This story of homecoming, of forging a new alliance with one's own country regardless of its barbarity and philistinism, was told and retold by Americans of this generation, becoming a standard modernist narrative in the 1920s and 1930s. From Paul Rosenfeld to Waldo Frank, Malcolm Cowley to Matthew Josephson, Marsden Hartley to Grant Wood, writers and artists constructed the three-part drama found in Rosenfeld's epilogue: first, early indoctrination and enculturation in the superiority of European arts and letters and the provinciality of one's own culture; second, repeated visits to Europe; and finally, the collapse of Euro-idolatry in the realization (sometimes an epiphany) that one's own culture had unrecognized value and needed its writers and artists at home.[30]

European intellectuals were often cast as parental figures and mentors in these tales—as people who, especially in France, encouraged the Americans to break off relations with Europe and tend to their own cultural gardens. Frank specifically addressed his first book, *Our America*, to French intellectuals he had met abroad.[31] It was they, he claimed, whose questions about the New World and envy of its cultural youthfulness had helped him uncover a love

for America he had not known he felt. Citing their questions as a justification for his inquiry, in itself an act of deference to France's presumed cultural superiority, Frank bemoaned what seemed to him his native land's history of cultural failure. But his book was not just a bleak admission of his country's lack of artistic greatness in the past, for he projected a brighter future in which America's arts and letters would be competitive with Europe's.

Like Rosenfeld's *Port of New York*, Frank's *Our America* exposes the pain and dilemma of American intellectuals who suddenly found themselves, late in the second decade of this century, in a love-hate relationship with their national culture. They wished both to expose the inadequacies of their national tradition and to convince themselves that their generation was on the edge of greatness. In these early years, self-depreciation held boosterism in check. Frank's analysis—lengthy, passionate, and rife with the evangelizing rhetoric we find in Rosenfeld—was quasi-historical as he sought to explain to his readers his country's arid literary past and shallow culture. Although he placed some blame on the barren physical environment of the young nation, he mostly faulted two character types that all the cultural nationalists targeted as the origins of the country's problems: emotionally repressed Puritans forbidding exploration of the senses and materialist Pioneers searching for new land and wealth. With this heritage that devalued (and left no time for) leisure, pleasure, or the life of the emotions, Americans, from their earliest days, had led stunted lives and created a civilization of machines and industry, not of great art and literature. The few Americans who had tried to create a lasting culture had mostly tragic personal histories. Many, like Ralph Waldo Emerson, Edgar Allan Poe, Henry James, and Whistler, became escapists; Mark Twain became a "clown," interested only in making money and striving to please. Only Walt Whitman and Abraham Lincoln transcended cultural and environmental determinism to become men of vision, spiritual leaders of their country.

After reciting the country's failures, Frank, again like Rosenfeld in *Port of New York*, sees signs of change that make him optimistic and finds a new spirit in the arts and literature coming out of Chicago (Theodore Dreiser, Carl Sandburg, and Sherwood Anderson), New England (Henry Adams,

Ryder, Robert Frost, and Amy Lowell), and especially New York (Stieglitz, Leo Ornstein, Rosenfeld, Oppenheim, Mencken, and Brooks). Like Rosenfeld, he dated the renaissance to the war years, when America was cut off from Europe, and when, "silent and attentive, we were finding our new voice."[32]

Such hopefulness distinguished Rosenfeld and Frank from the man whose writings about America's national culture had helped to shape their own. Van Wyck Brooks's prewar critiques of America's artistic barrenness were formative texts for the *Seven Arts* editors, of whom Brooks himself was one.[33] A literary critic, older and more academically inclined than either Frank or Rosenfeld, Brooks was the first of this generation of cultural nationalists to identify the elements in the American past that explained why the country had no great artists. Using a rather primitive index to national character, and assuming all Americans to have the same legacy, he blamed the earliest settlers in the New World for their practicality and expediency, traits antithetical to creativity. In a small book called *The Wine of the Puritans*, published in 1908 and subtitled *A Study of Present-Day America*, Brooks blamed the Puritans for both the emotional blockage of American artists and their inability to muse and reflect.[34] It was these first colonists who made reason and industry primary values, leaving no space for the spiritual. "Where a whole race is immersed in mechanics the quality of life and its arts is forgotten, and the national point of view—so far as there can be any—becomes curiously threadbare."[35] Brooks went on to critique expatriates like Whistler and John Singer Sargent, who lived in Europe instead of sinking their roots in native soil. He deemed both men completely out of contact with the realities of their own country. Without *contact*—after the war the word became a rallying cry for the cultural nationalists—there would never be a genuine American art.

In "America's Coming-of-Age," a provocative essay of 1915, Brooks refined his examination of what was wrong with native arts and letters. Our literature, he explained, was either highbrow or lowbrow. It was either abstract and completely remote from the facts of life, as in the works of Jonathan Edwards and the nineteenth-century American romantic writers, or it dealt only with practical matters and common sense, as in the writing of Benjamin Franklin. What was needed, Brooks believed, was a mid-

dle tradition, a fusion of great expressiveness with a rootedness in the facts of everyday American life. To Brooks, only one native artist had ever effected this fusion—Walt Whitman, whose poetry merged the "incompatible extremes of the American temperament," the passion of the artist's mind, and the acceptance of American life in all its facets.[36]

Precisely where Brooks saw the failure of American culture—in the lack of spiritual bonding between artists and their country—Rosenfeld and Frank placed their faith. Belief in the need to become rooted and make contact lay behind Rosenfeld's images of the sun's rays warming New York so that artists were finally feeling native heat. Indeed, a sense of contact and union—sometimes organic, sometimes sexual—was embedded in all of Rosenfeld's nature imagery and rhetoric, as well as in his stylized writing, whose self-conscious ebb and flow emblematized his theoretical commitment to sinking roots into home soil. His prose style was one of continuous flow and movement, an idealized analogue to nature's rhythms.

Frank and Rosenfeld rejected Brooks's cultural determinism and his continual attack on the inhospitable American environment. Brooks, Rosenfeld complained, "wishes to believe that America produces men who, if they had issued into a different world, would have become Swifts and Rabelais but who, since they are born in America . . . fall in comparative failure."[37] Rosenfeld believed that the kind of artist Brooks called for—someone who stayed at home, bled himself organically into the very fibers of American existence, and sang this country's joys and tragedies in transcendent language—could be found. His own generation—with Whitman the only useful predecessor—would turn the situation around. Both Rosenfeld and Frank believed themselves such artists, along with Alfred Stieglitz, Sherwood Anderson, Carl Sandburg, and Robert Frost. The young critics found in Anderson, and especially Stieglitz, true American soldiers fighting the battle against puritanism at home, rather than exiling themselves in Europe. These older artists spoke out against commerce and materialism, and their art, although based on the realities of American life, particularly its natural beauties, was not factual (material) but expressive and visionary (spiritual). Rosenfeld (pseudonymously) wrote his first essay extolling Alfred Stieglitz in the inaugural issue

of the *Seven Arts*, and Frank wrote of Sherwood Anderson.[38]

This bonding in 1916—of Rosenfeld, Stieglitz, Frank, and Anderson—in a new magazine dedicated to promoting modern American art was symptomatic of the new alignments under way during the war. After the war all four men became even more closely associated as a new circle of artists and writers gathered around Alfred Stieglitz. Their common belief in rootedness and contact and in the unclouded vision of themselves as America's first authentic school of artists became the glue that held them together. They took Stieglitz as their spiritual leader and constituted themselves a lay brotherhood that would lead America into its first moments of cultural worth. Cultivating a rhetoric that was both separatist and evangelizing, they pictured themselves as the first artists to feel the warmth of the American sun and Stieglitz as the "supernatural and winged" genius leading them to renewal and greatness.

It was probably Frank who introduced Rosenfeld to Stieglitz sometime in 1914. The two writers were then in their mid-twenties, fledgling critics without public names; Stieglitz was in his fifties, an established artist and the uncompromising, tough-minded director of 291, the New York gallery that championed modern art. He became an important post-Yale mentor to both younger men, in a decidedly paternal relationship, more teacher to student or guru to disciple than man to man.[39] This was particularly true for Rosenfeld, whose friendship with Stieglitz was so intensely filial that it confounded some of his friends. Edmund Wilson could never fathom why a critic of such breadth and cultivation would be so obedient to a single master. Rosenfeld "accepted and revered" Stieglitz as if he were a "prophet," Wilson complained, and would pay no attention to any artist who was not Stieglitz's disciple or who had been "excommunicated." If Stieglitz decided an artist was no good, Rosenfeld, "following the official directive, would condemn him, not merely as an artist but as a reprobate who had somehow committed an unpardonable moral treason."[40]

Rosenfeld's partisanship was undeniable. While relatively catholic in his literary and musical criticism, he rarely wrote about any visual artist other than Alfred Stieglitz and the five artists around him: John Marin, Arthur Dove, Marsden Hartley, Georgia O'Keeffe, and Paul Strand. Five of the essays in *Port of New York* were dedicated to members of this group, and the essay on Stieglitz, at forty-plus pages twice as long as any other, was honored with the penultimate position, immediately preceding the epilogue that declared the arrival of a new age and a new American art. For Rosenfeld, Stieglitz was the captain of the cultural ship bringing the new American art into port, the genius who "set life thrilling and rhythming through the place of New York."[41]

Such extravagant adulation certainly fueled the complex father-son relationship that developed between Rosenfeld and Stieglitz. They spent considerable time together and even uncovered an indirect family relationship.[42] In the summers Rosenfeld visited Stieglitz and O'Keeffe at Lake George; the three of them would work in separate spaces during the day and socialize over meals (Fig. 4). Even in later years, when Stieglitz became so crotchety that he lost many friends, Rosenfeld remained close to him and may have willed himself to join him in death. The two men died within eight days of each other in 1946. Stieglitz, who died first, was eighty-two, Rosenfeld fifty-six.[43]

Rosenfeld's reverence for Stieglitz, however, was embedded not just in psychological need and fulfillment but in shared cultural politics. For the two men were inextricably bound up in an effort to preserve for Stieglitz and his circle the mantle of *true* and *genuine* American artists, those that the *Seven Arts* had predicted were on the horizon, poised to give the country its first native school of artists. Rosenfeld became vocal and vehement about the issue because it was widely contested. Many after the war expected a new American art, if there was to be one, to emanate, not from the Stieglitz circle, but from artists like the dadaists and Precisionists, who engaged directly the forms and manifestations of industrial and technological modernity. For Stieglitz and Rosenfeld this source was ideologically unacceptable; holding firm to an earlier avant-garde code of behavior, they maintained that the artist must stand critically outside industrial culture, which epitomized in their own times the Puritan and Pioneer sensibilities they disdained. Their challenge, tensely configured in their art and writings,

was to devise a way to live alongside machine age artists, with whom they felt an avant-gardist kinship even as they opposed their program, viewing it as too soft and complicitous with American business and capitalism. Their view, always predicated upon an assumption that the modern artist worked in isolation from other social groups, was elitist and exclusionary but also relentlessly critical of the status quo.

As the postwar American economy boomed and machine age enthusiasms accelerated, Rosenfeld, Stieglitz, and their allies stepped up their opposition and met what they rightly interpreted as an ideological assault on their claim to be the country's premier modern artists. Whereas others spoke of factories and jazz, they were more likely to speak of

churches and divinity. While others painted the sky-scraper and the machine, Stieglitz photographed clouds and Rosenfeld spoke of sinking roots and rising suns. As poets began to write taut lyrics drawn from advertisements and proclaim themselves the country's true artists, Stieglitz gathered his group more tightly around him, insisting they remain true to an organic aesthetic. Most important, when others claimed to be creating an authentic American aesthetic, Stieglitz and supporters like Rosenfeld argued that this was their own mission, and theirs alone. They appropriated the word "American" and used it to describe their work—with such frequency that it appeared as if no one else in the cultural realm had rights to it.

It is worth taking some time to understand these

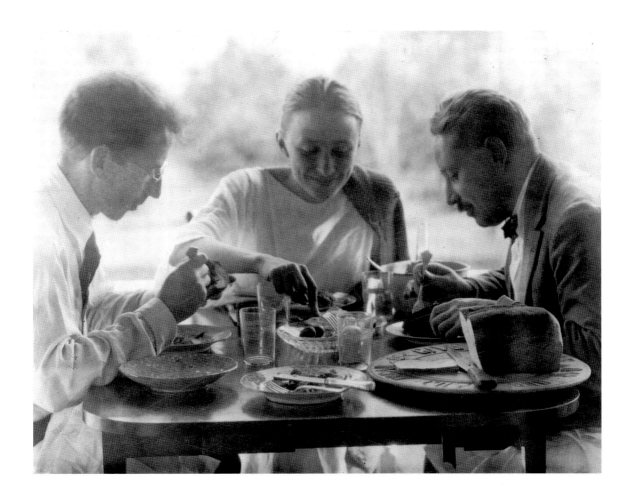

Fig. 4. Alfred Stieglitz, *Georgia O'Keeffe: A Portrait—with Paul Rosenfeld and Charles Duncan*, 1920. Gelatin silver print, 3¼ × 4⁹⁄₁₆ in.

dynamics in New York art politics during and after the war. By revising—or at least giving more detail to—the usual historical accounts of what happened to Stieglitz's theory and practice after the closing of 291 in 1917, we can better situate Rosenfeld's fervent beliefs and proselytizing prose. Historians have a tendency both to describe Stieglitz as a monolithic, unchanging personage in the early modern period and to merge his later-life activities seamlessly with those before the war. But that description oversimplifies dramatic changes, both in the direction of his artistic activism over the years and in his close associates. Though it is common to speak of "the Stieglitz circle" as if it were a steady state organization, it was not. It is more helpful, and more accurate, to speak, not about Stieglitz and his circle but about Stieglitz and his *two* circles, the one that formed before the war and the new one that gathered around him in 1916–17, as 291 closed. Rosenfeld, along with Frank, Anderson, O'Keeffe, and Strand, was central to the *second* Stieglitz circle and its nationalist politics, but *not* the first.[44]

The *first* circle was notably large, eclectic, open-ended, international, and experimental. It was intimately connected to activities at 291, the gallery Stieglitz ran from 1905 to 1917, and to *Camera Work*, the progressive publication he edited from 1902 to 1917. At 291, after an initial few years devoted to art photography, particularly that of the Photo-Secessionists, one could see the work of Parisian modernists such as Rodin, Matisse, Picasso, and Brancusi and American painters and sculptors who worked in styles associated with Continental Cubism and Expressionism: Max Weber, Abraham Walkowitz, Oscar Bluemner, Arthur B. Carles, Stanton Macdonald-Wright, Marius de Zayas, John Marin, Alfred Maurer, Marsden Hartley, and Arthur Dove.[45] The gallery also exhibited African art, Japanese prints, caricatures, and children's drawings, representing the radical new tastes of an international modernist community. *Camera Work* was equally inclusive and global in its coverage, publishing writings by Bergson, George Bernard Shaw, Wassily Kandinsky, and Gertrude Stein alongside New York critics such as Benjamin de Casseres, Sadakichi Hartmann, and Charles Caffin. Its beautifully crafted reproductions constituted an anthology of

pictorialist photography from throughout the Western world, and its articles served as an international forum for the debates on photography as an art; in its later years the journal moved away from photography to issues of abstraction and the aesthetics of modern art.

But during the war years Stieglitz's support shifted irreversibly from the continental modernists, among whom he proudly placed American practitioners, to a few native-born artists cut free from any international context.[46] His new focus was in formation when in 1916 he took O'Keeffe and Strand into his stable and helped to organize the *Forum Exhibition of Modern American Painters*. Using the format of the very successful international Armory Show of 1913, the Forum exhibition was a pointedly national show of 193 paintings by seventeen artists. The object, the catalogue announced, was to showcase native expression, "to turn public attention for the moment from European art and concentrate it on the excellent work being done in America."[47] Though hardly a statement of much force, this was the cultural goal Stieglitz embraced and promoted from this point on.

Closing 291 in June 1917, but remaining active as the director of other galleries for nearly thirty more years, Stieglitz dedicated himself to a narrow slice of local talent and formed a *second* circle of artists and writers around him. This one was tighter and more rationalized. Of the one hundred exhibitions Stieglitz organized in the twenty years after the war, only four included Europeans; almost all the others were dedicated to an inner core of American artists whom Stieglitz once conceptualized as "six + X": Stieglitz himself, Dove, Hartley, Marin, Strand, and O'Keeffe and then a changing member, X, who happened to be of interest at any one time (Fig. 5). (Demuth was often the X artist; Stieglitz, for reasons I will examine later, never supported him with the same enthusiasm he gave the others.) Primarily artists born in the Northeast, they tended to live, with the major exception of Hartley, either in New York or within easy commuting distance. A small group of writers in the circle embraced the same aesthetic and nationalist goals as Stieglitz; they publicized the second circle and interpreted it. "From the first," the art critic Henry McBride shrewdly noted, commenting upon his own sympathetic support for the group, as well as that of others, "the Stieglitz circle

THE
INTIMATE
GALLERY
ROOM 303
ANDERSON GALLERIES BUILDING
489 PARK AVENUE AT FIFTY-NINTH STREET, NEW YORK

announces its Eighth Exhibition—November 9 to December 11, 1927

FORTY NEW WATER-COLORS BY JOHN MARIN

The Intimate Gallery is dedicated primarily to an Idea and is an American Room. It is used more particularly for the intimate study of Seven Americans: John Marin, Georgia O'Keeffe, Arthur G. Dove, Marsden Hartley, Paul Strand, Alfred Stieglitz, and Number Seven (six + **X**).

It is in the Intimate Gallery only that the complete evolution and the more important examples of these American workers can be seen and studied.

The Intimate Gallery is a Direct Point of Contact between Public and Artist. It is the Artist's Room. It is a Room with but One Standard. Alfred Stieglitz has volunteered his services and is its directing Spirit.

The Intimate Gallery is not a Business nor is it a "Social" Function. The Intimate Gallery competes with no one nor with anything.

The Gallery will be open daily, Sundays excepted, from 10 A.M. till 6 P.M. Sundays from 2 till 5 P.M.

Exhibition I —JOHN MARIN, December 7, 1925-January 11, 1926.
Exhibition II —ARTHUR G. DOVE, January 11-February 7.
Exhibition III —GEORGIA O'KEEFFE, February 11-April 3.
Exhibition IV —CHARLES DEMUTH, April 5-May 2.
Exhibition V —JOHN MARIN, November 9, 1926-January 9, 1927.
Exhibition VI —GEORGIA O'KEEFFE, January 11-February 27.
Exhibition VII —GASTON LACHAISE, March 9-April 14.

Hours of Silence: — Mondays, Wednesdays, Fridays, 10-12 A.M.

Fig. 5. Intimate Gallery announcement, 1927.

has known how to attach literature to itself."[48] Rosenfeld was one of the most important of these "attachments," whose number also included Waldo Frank, Sherwood Anderson, Herbert Seligmann, Louis Kalonyme, Jean Toomer, and Dorothy Norman. At its periphery, the second circle counted Hart Crane, William Carlos Williams, Henry McBride, and Lewis Mumford and, in later years, Elizabeth McCausland and Jerome Mellquist.

The second circle, then, was small, closed, white, mostly male, middle- to upper-class, and exclusively East Coast American. And in its configuration, as well as its aesthetic program, it replicated a nineteenth-century social pattern that was particularly adhered to by symbolist artists.[49] Like the group of artists Vincent van Gogh dreamed of form-ing in Provence, or the one that gathered around Stéphane Mallarmé in the 1880s in Paris or around Paul Gauguin in Pont-Aven, or the more formal brotherhoods of the Nabis and the Abbaye de Créteil, the second circle came together as a small fraternity that posited the artist as outside, not inside, his own culture and envisioned art as a rarefied and enlightened activity that would serve as antidote to, and therapy for, a money-driven, bourgeois society. Such groups formed to shelter and shield one another from the pollution of the materialist world, and to bolster one another's faith in art as a form of aesthetic activism. For it was not just art for art's sake that motivated these artist circles, but art to save the world from enslavement to things and emotional starvation. Their art would, if embraced, help

people to transcend the baseness of modern existence and live, if only momentarily, in the wholesomeness of beauty. Given their moralizing and their strong sense of entitlement as spiritual healers, these groups often fashioned themselves as quasi-religious fraternities with their faith rooted idealistically in the healing powers of art; they usually had a paternal leader—a "master"—and "disciples." Arthur Symons recalled the "religious atmosphere" of Mallarmé's Tuesday evenings, when artists and writers gathered around the poet in his apartment; while he discoursed like a "master," those around him took the "attitude of the disciple."[50] Another writer continually referred to Mallarmé as "the Master" and "the high priest of poetry."[51]

Some prewar bohemian circles—la Bande à Picasso, for instance, or the Greenwich Village Ashcan artists—were much looser social structures, more diffuse in their activities and leadership and more anarchic in outlook. They resisted hierarchy, self-promotion, and formal record keeping. And after World War I the more formal artist circles that developed in Europe radically revised the symbolist project. De Stijl, l'Esprit Nouveau, and the Bauhaus communities sometimes adhered to residual features of religious idealism and rhetoric, but their agendas and social organization were notably secular. Conceiving of themselves as artistic reformers, they promoted what seemed to them the peculiar beauties of modern life, its materials, shapes, forms, and radical new functionalism. Accommodating modernity rather than opposing it, they promoted styles and modes of production they believed would help people come into harmonious alignment with the new world of glass, steel, and geometry.

This was not true of the second Stieglitz circle, which adhered to many of the attitudes of fin-de-siècle groups, giving New York modernism in the 1920s and 1930s its peculiar cast. Their art-for-art's-sake program allowed for only the most tentative and unsure adjustments to machine age modernity. Their true calling, rather, was to save the country from its modern evils: emotional repression (Puritanism) and relentless materialism (Pioneerism). Stieglitz, as the circle's "master," set its nationalist goals and arranged for its activities, its promotion, and its self-documentation. (The archives of the second circle are among the most complete of any artistic group in history.) As Stieglitz aged, he increasingly adopted the bodily and verbal posturings of prophets and spiritual leaders. Often inspired by his evangelizing, and always standing to benefit from it, circle members acknowledged his leadership, even as they complained of his paternalism and prophetic airs. They allowed him to promote them as America's finest artists, to articulate their artistic program, and to position the circle, as he always did, as an artistic elect, outside, not inside, the cultural mainstream. Someone like Rosenfeld, comfortable as an acolyte, was Stieglitz's perfect audience, a son who encouraged his father's proselytizing, flattering him through imitation. O'Keeffe, in contrast, gradually found the second circle's insularity damaging to her own need for selfhood. The brotherhood of the second circle, she came to realize, meant just that, a fraternity in which she could only be the exception, the single "woman artist" in an all-male club. She slowly extricated herself from its ranks without, however, really blowing the whistle until after Stieglitz had died, and then not very loud.

By the early 1920s the second circle was firmly in place and its self-promotional tactics in play. In 1922–23 Stieglitz sponsored the publication of a new little magazine, *MSS*, which, during its six-issue life, served as the new group's literary house organ. O'Keeffe designed the cover, and Rosenfeld, Anderson, Frank, Seligmann, Williams, Marin, Stieglitz, and Strand provided much of its text (Fig. 6). In 1924 came *Port of New York*, with its in-depth attention to the group. And in 1925 Stieglitz created a blockbuster exhibition, 159 works, whose message about his newly purified circle no one could misinterpret. He called the exhibition *Seven Americans*. Though he announced it as a celebration of the twentieth anniversary of the opening of 291, he *excluded* everyone he had exhibited in earlier times except for the "seven Americans" he now promoted.[52] It was as if the first circle had been nothing but prologue.

The sixteen-page catalogue opened with a typical postwar statement by Stieglitz, celebrating the artists in his circle for their "Americanness" while castigating the country for not recognizing their native genius.

The work exhibited is now shown for the first time.
Most of it has been produced within the last year.
The pictures are an integral part of their makers.

That I know. Are the pictures or their makers an
 integral
part of the America of to-day?
That I am still endeavoring to know.
Because of that—the inevitability of
this Exhibition—American.[53]

Along with two short essays, by Anderson and Ar-
nold Rönnebeck, and a poem by Dove, the cata-
logue listed exhibitions that had been mounted at
291 before the war, each one now annotated with
congratulatory phrases like "First American Exhibi-
tion," "First Exhibition of Its Kind Anywhere," or
"First One Man Show Anywhere," the last a charac-
terization of a 1911 exhibition of Picasso drawings
and watercolors. This was booster rhetoric of the
first order, and the catalogue used it to make a gene-
alogy, claiming 291, in no uncertain terms, as the
birthplace of modernism in America and the new cir-
cle as its natural heir.

 The catalogue promoted the circle's "firstness"
and Americanness so relentlessly that some critics
were incensed. One of them complained that "Amer-
icanism and emotionalism" were so "self-consciously
and unduly emphasized" that the pictures could not
"speak for themselves." Another felt that the lan-
guage of the catalogue was so bathed in protection-
ist rhetoric that she felt outside "the limited circle of
'knowing ones,'" without "the password." She was
"quite unmoved by its artistic or literary (see cata-
logue) propaganda."[54]

 This was a common complaint. Many people felt
like outsiders to the second Stieglitz circle because
of its exclusive stance and the mystical, vitalist, and
nationalistic rhetoric in which its members inter-
preted themselves and their art. Rosenfeld's lofty
and loamy prose represented the group at its most ex-
treme, but even O'Keeffe, the most down-to-earth
member and the one who liked best to speak bluntly
in the vernacular, could, when she wanted to im-
press someone, turn on what she called the "emo-
tional faucet."[55] In writing to Frank in 1926, she
used his own effusive and circular language.

 You are mixing with that vile hash of so called thinkers
 and workers—working with it—playing with it—being
 of it—and consciously trying to come out whole—
 Sometimes you seem to get out almost all of you but
 your feet I don't see anyone else getting so far out—

Fig. 6. Cover of *MSS [Manuscripts], Number One*,
New York, Feb. 1922. Nameplate by Georgia O'Keeffe.

I rather am inclined to think you will make it some day—and get out and walk around in the sun—unsmeared—You may not know it when it happens—I may not see it You see—you will not know it because you will be thinking of other things—It will happen *to* you—not *for* you—and will happen *for* others if you can keep your direction clear.[56]

It was this kind of foggy talk that made Van Wyck Brooks keep a respectful distance from the group after the war. Stieglitz, Brooks wrote in his memoir, became a "mystagogue" whom one wished neither to join nor to annoy. "If you could not be his disciple and would not be his enemy, you had to maintain in his presence a certain aloofness."[57]

The second circle's Bergsonian defense of nature and vitalism as art's proper domain was also deemed remote and cultist. When Anderson wrote glowingly of the artists in the *Seven Americans* exhibition as "conscious of clouds, horses, fields, winds, and water," he was voicing what he responded to in their work (organic life being his subject too) and what others found anachronistic and retrograde.[58] But for many critics, the second-circle artists had their heads in the ether, ignoring the realities of the modern age. Blind men, Duchamp called them.

This critique in the 1920s was aimed particularly at Stieglitz, who was making his *Songs of the Sky* series, hundreds of abstract photographs of clouds vigorously opposing what young dadaists and Precisionists were arguing American art should be all about (Fig. 7). Twenty-eight of them hung in the exhibition. Thus Rönnebeck, a European artist in sympathy with the new generation, when asked by Stieglitz for a contribution to the *Seven Americans* catalogue, took on the task but confessed to difficulty in locating the Americanness of the circle's work. Even though the exhibition included photographs of New York and machines by Strand, collages by Dove, and the first of Demuth's poster portraits, the work Stieglitz made and encouraged did not match Rönnebeck's idea of America. As a European, his America was one of "Skyscrapers, Jack Dempsey, Five and Ten Cent Stores, Buffalo Bill, baseball, Henry Ford, and . . . Wall Street." Wanting clearly to oblige Stieglitz and defend the exhibition's Americanness, he awkwardly praised the works' pioneering spirit. The exhibition was not work that had been "Americanized" but art that demonstrated the

risk-taking exploratory spirit of America, he wrote, as if taking a line from Rosenfeld, "animated and dictated by the ever flowing sources of life itself."[59]

Rönnebeck's Fords and Woolworths made up the America the second circle wanted to save from itself. Members of the circle were particularly skeptical of, sometimes downright hostile to, the growing enthusiasm for new technologies and popular art forms associated with "the modern," such as film, ragtime, and jazz, or for urban phenomena such as rush-hour crowds, billboards, store window displays, and factories. None of them ever tried to paint or photograph Coney Island. And they pointedly ignored Broadway's Great White Way (with the exception of Marin), which for so many modernists was the big American subject. In the 1920s Stieglitz, in particular, took an aggressively antimodern and antibusiness stance, railing against the "system" and against captains of industry—the Rockefellers, the Fords, and George Eastman—and wanting nothing to do with newfangled cars, Victrolas, films, airplanes, gadgetry. "As long as there are dividends & the 'help' is happy owning Fords & Victrolas & Radios & can go to movies of which Eastman has the film monopoly why the Hell should any one care about the quality of a postal?" he wrote to Sherwood Anderson, angry about the poor quality of Eastman's new postal card paper.[60] Rosenfeld, whose taste was so highbrow that he felt compromised even talking about popular culture, became particularly upset by young composers like Darius Milhaud who were incorporating jazz rhythms into their art and "mistaking" American popular culture for some kind of new primitive art. "These fantasies are supplying a number of embryonic artists with cheap formulae, keeping them from working from their sensibilities," he warned.[61] Rosenfeld, Wilson reported, "loathed jazz" and would never consent to the new vogue for American writers like Ring Lardner and Mark Twain who spoke in the vernacular. When Wilson gave Rosenfeld "*Huckleberry Finn* as a Christmas present, he refused to open it, having heard that Henry James once said of Mark Twain that he wrote for immature minds."[62]

So critical were Stieglitz and Rosenfeld of everyday America that they could be characterized, to

Fig. 7 (facing). Alfred Stieglitz, *Equivalent, Mountains and Sky, Lake George*, 1924. Gelatin silver print, 9 5/16 × 7 1/2 in.

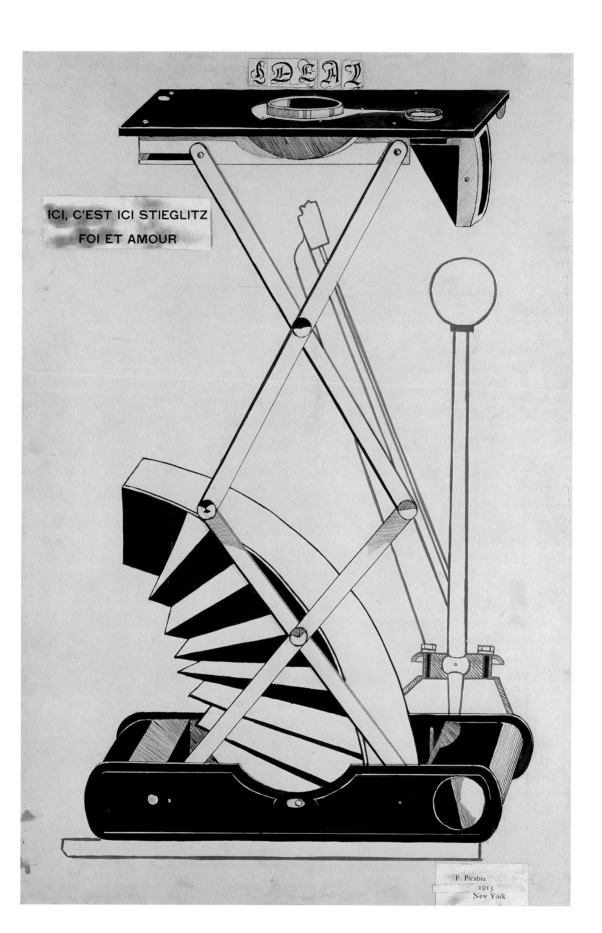

ICI, C'EST ICI STIEGLITZ
FOI ET AMOUR

borrow Raymond Williams's phrase, as "modernists against modernity."[63] Or at least modernists against much of modernity. Circle members self-consciously worked in abstract styles identified as radically modern—and would, on occasion, render a bridge, skyscraper, or machine part as a beautiful form, but outside of their own fairly privileged patterns of living, they expressed minimal interest in quotidian life and no confidence whatsoever in the enthusiasms of the general American populace. In this respect they carried on the aristocratic anti-modernism of earlier American intellectuals like Henry James and Henry Adams, whose despair, however, they transformed into a more hopeful agenda of national renewal.[64] They did not retreat into solitary pursuits or into organized religion or depart for Europe like an earlier generation; they had absorbed too much of the Progressive Era's belief in change. For Stieglitz, and those he affected with his enthusiasms, the visual arts were capable of fostering a revolutionary new consciousness, but people would have to come and open themselves to art, not the other way around. His version of modernism retained features of nineteenth-century aristocratic traditions in that it valued art, as Williams put it, "as a sacred realm above money and commerce" and maintained older upper-class attitudes toward "the ignorant populace."[65] Within the larger field of competing modernisms, the Stieglitz circle, one might say, situated itself as a modernist aristocracy in New York. Members maintained a polite distance from other modernist expressions and styles (dadaism, Purism, and Precisionism, in particular) and disdained other artists' tastes for the popular and the everyday (jazz, newspapers, cars). Unlike other avant-garde groups that shocked the bourgeoisie or mocked its tastes and habits, they felt superior and genteelly ignored it.

By 1915 artists like Marius de Zayas and Francis Picabia had taken to teasing Stieglitz about being stuck in his ways. In Picabia's 1915 symbolic portrait of Stieglitz, the younger artist adopted the drafting style of the mechanical engineer and modern-day advertiser, a terse graphic style that stood for all that Stieglitz hated (Fig. 8).[66] It was inorganic and had no flow. He then concocted a hybrid machine—a camera with automobile gearshifts—and filled this American "thing" with ironic commentary that acknowledged Stieglitz's idealism while making light of it. That it was pointed commentary comes through in the little text, "Ici, c'est ici Stieglitz Foi et Amour," that announces the portrait subject with dramatic flourish and brandishes his ideals, faith and love, the very words having a quaint romantic ring to them. Representing Stieglitz as a driving and seeing machine, a visionary, Picabia also represented him as aging and exhausted, the phallic bellows of the Kodak camera having lost its erection. The lens (eye) of the camera is focused, not down upon the real world, but heavenward, at old-fashioned idealism, the word IDEAL written in the upper stratosphere in antiquated Germanic script. (Rosenfeld, for one, not attuned to dadaist capers, caught none of this satire and read the portrait's sassy text as a compliment to his mentor. "Faith and love, love for art, faith in its divine power to reveal life, to spur action, to excite the creative impulse, those are the dominant characteristics of Alfred Stieglitz.")[67]

In picturing Stieglitz as part car, Picabia also mocked his elder, especially since this camera-car is going nowhere, its gear shift in neutral and the brake firmly engaged. Furthermore, Picabia had a passion for cars, and Stieglitz would have nothing to do with them in these years, especially the plain and inexpensive Model T, emblematic for him of the country's rapacious commercialism and ugliness. "Every time I see a Ford car something in me revolts," wrote Stieglitz. "I hate the sight of one because of its absolute lack of any kind of quality feeling. . . . They are just *ugly* things in line & texture—in every sense of sensibility in spite of the virtue of so called usefulness."[68] He and his friends also grasped that cars signified a new mass culture in formation, one in which the old distinctions between rich and poor, educated and uneducated, artist and philistine would become blurred. Their snobbery and artistic elitism were transparent: "The lower classes as they used to be called, are now the disgusting well-to-do thanks to Mr. Ford," Hartley wrote Stieglitz from Gloucester. "The washerwomen gather their washing in Fords here. Servants have Fords and won't take a job where there is no garage for their machines."[69] Cars, furthermore, belonged to the mechanical, practical world, not that

Fig. 8 (facing). Francis Picabia, *Ici, c'est ici Stieglitz*, 1915. Pen, red and black ink on paper, 29 7/8 × 20 in.

of transcendent nature. Marin, in a free-verse manifesto about living in a product-smitten culture, borrowed the jerky, mechanical rhythms and line breaks of the Futurists, making fun of them and other artists who were in love with cars. Using a vocabulary self-consciously centered on nonorganic words like "things" and "products," he pictured the automobile as "a man fashioned thing" and compared it to "nature products" like human beings and their "art products." The car had none of nature's "generating power" or "spirit." It "won't go," he wrote, formulating, as it were, a second-circle response to Picabia's mechanical portrait of Stieglitz.[70] The tone was bantering, but underneath it lay a more consequential dispute about the new technologies of the machine age. The artist's relationship to modern "things" was heatedly debated in the postwar years; the crux of the argument was always who spoke as authentic American artists.

The circle engaged in some of its most formulaic diatribes against "soulless" Manhattan, a city modernists like Picabia found rapturous and exhilarating. Every year as Stieglitz departed for Lake George or contemplated his return to New York City in the fall, his letters would take obligatory swipes at the city. He and O'Keeffe lived "in the center of the maddest city that ever happened—mad—soulless—cruelly heartless."[71] Neither he nor O'Keeffe had "any desire to see the sky scraping."[72] He found it too much the same old thing. "Concerts and Theatres and parties and discussions—hustlings and fatigue—smells and crampedness."[73] O'Keeffe was terse but equally judgmental. The city for her was "mad" or a "nightmare." At the end of one summer she complained that there were only a few more days "to make you feel you are living before you leave for the city."[74] Other members of the circle eagerly shared their discontent, their negative comments on the city sometimes being as routine in their letters as those on the weather. Each wrote the other what the other wanted to hear, reinforcing their close fraternity and dedication to a common litany. "New York," wrote Strand to Stieglitz from Colorado, is "a distant and disagreeable ant heap—everybody crawling over each other." It disturbed him to find Manhattan in other parts of the country, its "deadness and cheapness, standardized mediocrity—in towns and towns trying to be cities."[75]

Their hate affair with New York was often tem-

pered by the aesthetic pleasure members could take in the form of an actual skyscraper or the Brooklyn Bridge arching over the East River. But this never changed their low opinion of street life. If Frank could be ecstatic about the city's "slashing steel and stone" structures in one phrase, he would despair of driven New Yorkers and their rapacious commercialism in the next. "New York is a resplendent city," he wrote in *Our America*:

> Its high white towers are arrows of will: its streets are the plowings of passionate desire. A lofty, arrogant, lustful city, beaten through by an iron rhythm. But the men and women who have made this city and whose place it is, are lowly, are driven, are drab. Their feet shuffle, their voices are shrill, their eyes do not shine. They are different indeed from their superb creation. Life that should electrify their bodies, quicken them with high movement and high desire is gone from them. And if you seek that life, look to slashing steel and stone that stands above them, look to the fierce heat of their material affairs. America is the extroverted land. New York, its climax.[76]

By the mid-1920s, when advocacy for machine age New York was at its highest pitch, these conflicting sentiments became more apparent as Frank and his colleagues struggled to keep their aesthetic loyalties on the highest ground possible. Their dilemma was how to be modern and antimodern simultaneously or, to formulate it another way, how to be cultural leaders of machine age America without succumbing to its perceived evils. It was increasingly difficult to just turn away and refuse to "see" what others were pitching as American innovations. Frank wrote a number of essays trying to find an acceptable position for the second circle vis-à-vis the machine, the commercial, and the popular, one that allowed for American "vulgarity," the word used throughout this period to describe mechanical and vernacular culture, without celebrating it.[77] "We are perhaps the only nationally vulgar people. And therein dwells not alone our predicament but our hope." Considering in some detail all the new enthusiasms—jazz, baseball games, electric lights, skyscrapers, tabloids, and advertising—Frank skillfully managed to acknowledge them as defining elements of American culture while nonetheless judging them vacuous and impoverished. The electric light

on Broadway "is bright, dazzlingly," but "it distracts the eye from the beholding of sources. It is a light that blinds. Any artist will assure you that the electric light is false—in the sense that it deforms." For Frank, driven by his anticapitalist politics, the dazzle of Broadway lights, while superficially beautiful, was in the end a cover-up for America's tragedy. It was the very opposite of Rosenfeld's warm and nurturing sun. Sounding momentarily like a critic of the Frankfurt school articulating the false seductions of urban spectacle, he concluded that "the comedy of commerce is a comedy of display."[78]

As Frank formulated a dialectic on the machine age that both admitted the appeal of brash jazz and Broadway lights and responded critically to their allure, most of the second-circle artists also went through a few years of trying to accommodate new forms of city life in their work while holding its perceived vulgarity in check. Paul Strand, in particular, photographed New York regularly, always balancing it as a subject with his renderings from nature. His most obvious machine age works were the very formal abstractions he began to make in 1922 of his Akeley motion picture camera, a machine he carefully lit and composed as sensuous tactile surfaces and breathing metallic forms. Between 1924 and 1926 and occasionally thereafter, Arthur Dove broke stride with his landscape abstractions to make paintings based on jazz and assemblages using detritus as well as newfangled products from the five-and-ten, itself a new emporium of mass-produced goods (Fig. 9). In 1925 Marin, who for years had pictured the soaring skyscrapers of New York as a site of energy and ecstasy, began to add billboard signage, electric lights, and cars to his paintings of Manhattan, suggesting, however timidly, that he was attuned to the urban phenomena celebrated in the machine age as the new stuff of poetry (Fig. 10).[79] O'Keeffe, the youngest in the circle and the member most pressured by the men in it to be a painter of nature, a theme they assumed appropriately female, bucked that pressure and moved her painting into the contemporary discourse on urban spectacle. By 1926 she was worrying, Stieglitz reported, that her "painting had nothing to do with today," a concern that led her, between 1925 and 1930, when she and her husband lived high up in the Shelton Hotel, a skyscraper, to paint a series of some twenty New York urbanscapes, while continuing her landscapes

Fig. 9. Arthur Dove, *Miss Woolworth*, 1925. Artificial flowers, stockings, mask, earrings, cork and felt insoles, purse, garden gloves, watch, ring, brooch, and bead necklace.

Fig. 10. John Marin, *Broadway Night*, 1929.
Watercolor on paper, 21⅜ × 26⅝ in.

and flower paintings in the summer.[80] When the Great Depression began to rob modern Manhattan of its artistic allure, and chastened machine age advocates grew silent, O'Keeffe found a new subject in the Southwest and discarded the city as a subject as resolutely as she had adopted it in the first place.[81]

But she was momentarily swept up in skyscraper mania, going so far as to write to Frank in 1927 that she wanted her next exhibition "to be so magnificently vulgar that all the people who have liked what I have been doing would stop speaking to me."[82] That year she painted *Radiator Building—Night, New York*, the most "vulgar" painting she ever ventured in that it included a sign bleating out the name of Alfred Stieglitz (Fig. 11). In this electrified advertisement she exercised humor and a bit of dadaist wordplay, both rarities in her work. The actual sign advertised the magazine "Scientific American,"

blinking its title off and on against the Manhattan skies; Stieglitz, the advocate of a spiritual America, opposed the very concept of a scientific America with his every fiber.[83] Like Frank, O'Keeffe did not engage in machine age arguments for long, but she did feel momentarily compelled to try them out.

By 1929 even Stieglitz showed signs of capitulating to machine age enthusiasms, albeit with all the caveats of an antivulgarian. Partially under pressure from O'Keeffe, who had learned to resist her husband's joyless position against the modern—not just by painting the city but in 1929 by going to New Mexico, buying herself a Ford, and learning how to drive—Stieglitz too began to drive, took a plane ride to New York, bought a Victrola, tried his hand

Fig. 11 (facing). Georgia O'Keeffe, *Radiator Building—Night, New York,* 1927. Oil on canvas.

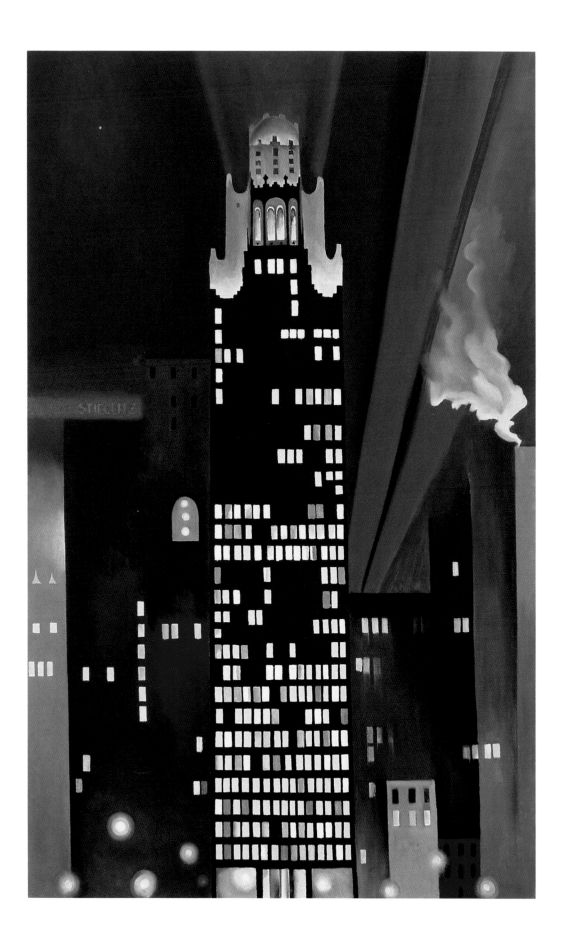

at miniature golf, and took to photographing the New York skyscraper.[84] He had photographed skyscrapers before the war, often, as in *The City of Ambition* (Fig. 12), as much to protest the business ethos and the "madness" of the city as to celebrate its vaunted skyline. In these early city renderings he included some sense of the streets and waterways. In returning to the subject in the late 1920s, he made a series of urbanscapes in which city life was cropped out, and solitary "slashing steel and stone" structures were given center stage (Fig. 13). Using high-contrast gelatin paper, Stieglitz rendered these buildings as dark and sober, but at the same time sublimely majestic, mountains of steel, unsullied by the noisy riffraff in the streets below. Mumford described these images aptly as "cold exhalations of a depopulated world."[85]

The change in Stieglitz's city photographs suggests more generally what happened when the second-circle artists turned to the new, the modern, and the urban as subjects for their postwar work: they focused on the beauty they could find in such material, cutting away or distancing themselves from its vulgarity and crassness. Like Frank, they acknowledged the presence of a technological America but refused to submit to its base materialism. Their critique was embedded in their signature styles, which were fundamentally organicized vocabularies of growth, rapture, and ecstasy that dematerialized and abstracted their subjects. In taking on new, "vulgar," subjects, they vitalized their material, giving it a passion and an excitement that purists of machine age ideologies would not condone. Just as Rosenfeld's quest for the warming rays of the sun and his search for a life force in a city of towers rendered New York's port a spiritual destination, not a place of busy traffic and commercial enterprise, second-circle paintings and photographs of New York made "soulless" Manhattan a transcendent experience.[86] What originated as mysterious rays of nature's light in O'Keeffe's early landscape paintings became mysterious rays of light coming from streetlights and skyscraper crowns. Orbs of moonlight over Lake George were now orbs of streetlights and sunspots on the Shelton. In Dove's abstract paintings based on popular music by Irving Berlin,

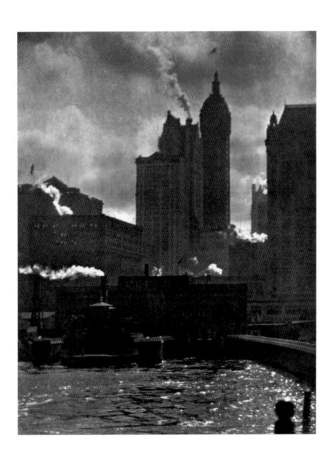

Fig. 12. Alfred Stieglitz, *The City of Ambition*, 1910. Photogravure on Japanese tissue, 13 3/8 × 10 1/4 in.

Fig. 13 (facing). Alfred Stieglitz, *From the Shelton*, 1933/35. Gelatin silver print, 9 11/16 × 7 1/2 in.

Louis Armstrong, and George Gershwin, serpentine lines flow sensuously and fluidly, giving little sense of the tough and street-savvy reputation this music had earned at the time (Fig. 14).[87] Given his usual organic aesthetic, these were, for him, raucous paintings. But compared with other cubist abstractions about jazz, those of Stuart Davis, for instance, they have a kind of light and improvisational poetry to them. Similarly, Dove's assemblages, made from "vulgar" advertisements and new products purchased from drugstores and five-and-tens, showcase his allegiance to careful formal arrangements and to speaking metaphorically. So "gentle" are some of them in their construction, as one of his biographers put it, that they read as "small, lyric poems."[88] Even such a wonderfully witty work as *Miss Woolworth*, a female shopper made up of a mask, stockings, work gloves, purse, wristwatch, artificial flower, and jewelry and encased in a frame of fringe, locates its critique in a composition that mocks female consumption while being ultrasensitive to texture, color, symmetry, and figuration (see Fig. 9). Dove responded to the vulgarity of America's new products by making them aesthetically alive. Marin's city panoramas also throb and heave with life, as if they were plant forms that had just burst through the last inch of topsoil (see Fig. 10). And sometimes he pictured the sun as if it had called the skyscrapers into being, its rays warming and nurturing the forms below.

This practice of animizing the modern material world was one of the most distinctive features of the second circle, a shared rhetoric tied to their idealistic belief in art, both for the maker and the

Fig. 14. Arthur Dove, *George Gershwin—Rhapsody in Blue, Part 1*, 1927. Oil and metallic paint with clock spring on aluminum support, 11¾ × 9¾ in.

audience, as an inward and upward journey out of the prosaic and ordinary. Transcendent modernism, some have called it.[89] It was a vitalist rhetoric, one that pumped life and flow into their cultural production. Even their letter-writing style conformed to this aesthetic. Taking their lead from Stieglitz, who shunned the period mark, they used dashes or squiggles to keep thoughts fluid and in play. Sometimes they wrote down the page in short phrases (rather than straight across) to animate the surface of the paper. And like Rosenfeld, they tended to metaphor, circling around their subjects, hinting rather than declaring, never bringing matters to closure, as if this would be death itself. They also shared a vocabulary that was routine for them, though difficult for others. Some of their key words, often rendered in capital letters (a habit Picabia spoofed), included "Earth," "Sun," "Sky," "Soil," "Spirit," "Seer," "Prophet," and "American."

Of these code words, the circle's three favorite were "American," "soil," and "spirit." "American" they used so often, and so boastfully, and so cryptically that it became cant. Stieglitz, for example, would write that O'Keeffe's color was "rooted in America" and that "she and Marin are supremely American."[90] When he showed O'Keeffe's work in 1923 at the Anderson Galleries, the brochure announced:

ALFRED STIEGLITZ

PRESENTS

ONE HUNDRED PICTURES

OILS, WATERCOLORS;

PASTELS, DRAWINGS

BY

GEORGIA O'KEEFFE

AMERICAN

In 1925 he titled his large exhibition *Seven Americans*. Charles Demuth, in sending Stieglitz a new painting, described it in second-circle-speak as "almost American."[91] One cannot, O'Keeffe wrote, "be an American by going about saying that one is an American. It is necessary to feel America, live America, love America, and then work."[92]

The examples are endless, the adjective flowing from second-circle pens in the 1920s as if self-

evident. In an age of streamlined advertising, "American" was taken as the second circle's brand name. It was a tag used so regularly in their brochures and in the titles of their books that it seeped into wider circulation, appearing in newspaper reviews, articles, and museum catalogues about the Stieglitz artists for many years to come. Though the term "American" was rarely defined or investigated, it was routinely ascribed to the second circle's art. (In the 1930s artists from elsewhere, particularly the Midwest, had to work hard to wrest the term from its association with New York modernism.) Though today the word's promotionalism seems transparent, and the desire to hoard it exclusionary, the second circle's members at the time rejected being categorized as flag-waving patriots. They used the word, they said, to signal, not their patriotism, but their dedication to a homegrown modern art. "That something which we call America," wrote Paul Strand, "lies not so much in political institutions as in its rocks and skies and seas."[93] "American" in their lexicon meant, among other things, a sense of place (we examine this meaning in Chapter 5) and the best modern art produced in New York by artists who had detached themselves from Europe.

Invariably, however, they mixed the national with the religious, shoring up their identity as a chosen people and portending the terrible uses to which mystico-cryptic nationalism would be put in the years to come. Though many of the leading male figures of the second circle were Jewish, they drew not just from the Hebrew Bible but from a generalized Judeo-Christian vocabulary to evoke their mission as that of a brotherhood or religious community. Waldo Frank began his letters to Stieglitz, commonly described as priest, prophet, and seer, with "Dear Master" or "Cher Maître." For Rosenfeld in *Port of New York*, Stieglitz was like Jesus when speaking to his "disciples" in the gallery, and Frank likened him to "God moving a finger over His own Body."[94] Stieglitz's galleries were referred to as the "house of God," "holy places," churches, and sanctuaries. In one announcement for the Intimate Gallery, Stieglitz wrote of himself as its "directing Spirit" and called attention to the gallery's "Hours of Silence," where one could engage in "the intimate study of Seven Americans" (see Fig. 5).[95]

Stieglitz often performed as if he were a holy man. Besides issuing dogma about art, he would tell

visitors to his gallery parables about his struggle to advance the cause of American art. If he were about to eat a loaf of bread, one story began, and "he saw one hundred hungry faces at the door, he would probably refrain from eating and invite all the hundred in." But then, instead of cutting the bread into "a hundred tiny pieces," as a philanthropist would do, he "would give the loaf to three of the hundred." These three in turn, having been satisfactorily fed at the gallery, would go out and bring in others so that eventually there would be thirty-three or thirty-four "leaders" who understood and would all "be feeling and acting in unison." His moral: Feed the few—the artists in his circle—and they in turn would convert the many to beauty and modern art.[96]

Another story he is reported to have told was of "two doors over one of which was written, 'This way to see God!' and over the other, 'This way to hear a lecture about God!' The crowd was going in at the second door. Stieglitz was beyond the other."[97]

"Spirit," a word central to symbolist practice, served multiple purposes: it was at once religious and secular, a word that encoded the second circle's philosophical opposition to the material and the concrete and their belief in art as a higher reality. So when they spoke of "the spirit of place," the "spirit of 291," or "the spirit of one another's art," they intended both religious auras and intangible essences. They commonly used the word "spiritual" to mean the capacity of art to make a bankrupt culture emotionally whole and healthy; their art would "spiritualize" puritan America. For Rosenfeld, 291 offered "perpetual affirmation of a faith that there existed, somewhere, here in very New York, a spiritual America."[98]

So strong was the second circle's talk of a "spiritual America" that Stieglitz used the phrase as a title for one of his photographs, an image of the hindquarters of a gelded workhorse (see Fig. 1). That the horse was both castrated and harnessed gave Stieglitz a striking metaphor for all that was wrong with America. The wild and passionate horse had long been a familiar trope in art, the unfettered animal representing freedom and man's deepest drives and emotional life. But Stieglitz's horse, neutered and strapped in leather, inverted the iconography, presenting a repressed and passionless being that no longer runs free.[99] In a rare instance of irony ("humor and the role of seer do not go together,"

Thomas Hart Benton said of Stieglitz) he titled the work *Spiritual America* to point up what the country was not.[100] The gelded horse pictured a puritan, *spiritless* America, a country unsexed by the work ethic, without soul or passion.[101] Rarely was Stieglitz so explicit and didactic.

Along with talk of "America" and "spirit" was that of "soil." Circle members continually layered and interspersed organic metaphors with their nationalist and religious ones. They wrote of being "rooted," of being "of the soil," of "ploughing our own fields," of being "in the earth" and of "growing" and "maturing." "It seems we have taken root," Rosenfeld declared in *Port of New York*.[102] In America, said Anderson, "there is soil for the raising of a crop . . . if the stones can be taken away."[103] Stieglitz wrote with pleasure of turning down an offer to sell his group's work in Europe. "I told him the Soil was here—the planting was here—the growing where the planting—in the Soil right here."[104] Rosenfeld characterized Marin as an artist "fast in American life like a tough and vigorous apple tree lodged and rooted in good ground," and Anderson described Stieglitz as a "city plowman."[105]

These rhetorical habits found their structural coordinate in the circle members' chosen way of life. So dedicated were second-circle members to nature as an antidote to the enervating city that all of them made rural living an essential part of their postwar lives. If, like O'Keeffe, Stieglitz, Marin, and Strand, they spent the winters in and around Manhattan, they went to the country as soon as the weather got warmer. Stieglitz and O'Keeffe tried to spend at least five months of every year at Lake George, where Rosenfeld often stayed with them for several weeks at a time. Dove, the least urban of them all, had farmed in Westport, Connecticut, and in 1920 began to live on a boat or near the water. Like a nomad, Sherwood Anderson wandered America's hinterland, often on extended camping trips. And other writers took up residence on the Connecticut shoreline, Westport becoming for a time something of an artists' and writers' colony. Rosenfeld was one of the first to live there after the war. His residency in Westport, overlapping with that of Dove, prompted Strand to write: "From all I hear, Westport has become the more or less center of 'Our America.'"[106] Van Wyck Brooks, who also lived in Westport, recalled how hard they all worked at being country

folk: "No word was more constantly on their lips unless it was the native 'soil' or 'earth,' and this obsession lay deep in the minds of urban cosmopolitans whom one saw toiling now with spade and pick."[107]

Along with their strong attachment to the countryside went a new attitude toward Europe. With the exception of Hartley, who in this climate was routinely criticized by his colleagues for living abroad and not sinking roots at home, everyone in the second Stieglitz circle had stopped traveling to Europe by the early 1920s. Demuth took his last trip abroad in 1921, while Dove, Marin, and Stieglitz, who had been abroad several times before the war, never went back. In 1950 Strand returned to France for the first time in nearly forty years. When Rosenfeld took the Andersons to Europe in 1921, they were moved by the monuments but reported their happiness in coming home. "We did not want to spend our lives living in the past," wrote Anderson. "We were going with that America of which we both . . . felt ourselves very much a part."[108] So affected was O'Keeffe by this new isolationism that she never went abroad until after World War II, when she was in her mid-sixties and widowed. Rosenfeld, Stieglitz, and those in the postwar period who measured authentic Americanness by an artist's distance from Europe deeply appreciated her ostensible rootedness, as did others in a climate that popularized declarations that one was "100 percent American." "O'Keeffe is America's. Its own exclusive product," a critic wrote in 1927. "It is refreshing to realize that she has never been to Europe. More refreshing still that she has no ambition to go there."[109] Similarly, Marin, for Paul Strand, was "a kind of spiritual 100 percenter, devoid of sentimentality. When he says that an American tree is different absolutely from a European tree . . . , he means that it is the former and the difference in which he is concentratedly interested."[110]

In a decade when the expatriation of American writers and artists was much discussed, and when transatlantic travel became chic in literary and artistic communities, to promote a proud stay-at-home attitude both opposed fashion and confirmed second-circle politics. Not to travel far, and to cultivate an intimate acquaintance with your particular American place and garden, argued for an art drawn from the local and particular. This was an old argument—it had been used by the Transcenden-

talists as well as the local colorists—but Stieglitz never professed much interest in such "national" antecedents or traditions. Quite the contrary. He rarely called upon past authorities, presenting himself, rather, as a prophet for the future, dedicated to the "fight" at home.[111] Europe was past its climax, Rosenfeld and Frank liked to say, replaying images of European exhaustion and their own country's youthfulness that continentals had first begun to articulate during the war years.

This was a group whose every action, including their everyday practices and the use of code words to communicate with one another, carved out a powerful position in the cultural politics of New York after the war. In all the art capitals of Europe, there was not another modernist group quite like them. With their deep commitment to an art of revelation that relied heavily on natural forms and on earlier symbolist theory, they differed ideologically from groups like the dadaists, the surrealists, l'Esprit Nouveau, the Bauhaus, or de Stijl. Their insistence on spirituality and refined aesthetic pleasures set them at loggerheads with those who praised skyscrapers and jazz as America's greatest achievements. In their desire to take root they warred with those whose America was so provincial that at the least opportunity they shipped out for Europe.

From today's vantage point their hyperbolic promotions and mystifying rhetoric look like a formula for disaster in postwar New York. But by any objective standards, Stieglitz and his artists were successful. Their dedication to one another—really quite extraordinary given the volatile personalities involved—in a tightly drawn circle with its own followers and believers kept them in the public eye. They even fared decently during the lean years of the depression, when it was hard for any artist to make a living from art. Collectivity worked in this instance, guided always by Stieglitz's dogmatic and high-toned moral position against the forces of industry and commerce, and his insistence on the authority vested in the artist to work in an autonomous space and to bring beauty into an inherently ugly world. In a decade of mass culture and new consumer products, when young modern artists were characterized as "playing" at dadaist art making or colluding with the captains of industry in celebrating the machine age, the Stieglitzian high road had considerable appeal for artists and patrons alike.[112] In 1920s New

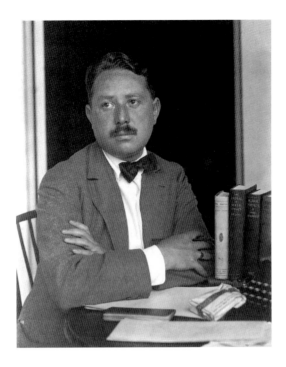

York, in the name of a new American art, it was possible to position oneself, albeit precariously, on the borderline between the modern and antimodern.

When Stieglitz set up his view camera on the porch of his Lake George home and composed a portrait of Rosenfeld, he called upon iconography in circulation since the romantic era, representing him as a contemplative poet at his writing table (Fig. 15). Rosenfeld's lips are slightly parted; his "limpid brown eyes," as Edmund Wilson described them, look abstractly, even sadly, into the distance.[113] He is in the sweet pain of thought, perhaps on the verge of a revelation. Neither the photographer nor the viewer occupies his mental space. His arms are crossed in concentration, allowing the fingers of both hands to rest delicately on the sleeves of his jacket, like young shoots of a plant. Rosenfeld is all softness and delicacy—signs of the aesthete—his body contrasted with the hardness and sharp edges of the writerly attributes on the table: papers, a notebook, the corner of a typewriter, and a crumpled package of cigarettes. At his elbow, four books signify his intellectual alliances: Waldo Frank's *Our America*, Van Wyck Brooks's *Ordeal of Mark Twain*, his own *Musical Portraits*, and Carl Sandburg's *Smoke and Steel*.

Stieglitz made this formal portrait as part of a series devoted to members of the second circle, many of them taken explicitly for Rosenfeld's *Port of New York*. He made others of Frank, Anderson, and the artists in his stable (Figs. 16–21; see also Fig. 2). Taken together, they call the roll of those in whom Stieglitz and Rosenfeld put their faith as the leaders of a new American art. Each is a carefully posed and staged work, often with explicit attributes. Many stand against a work of art hanging in the gallery, sometimes the work of a different member of the circle, making the photograph a double portrait. When Paul Strand in turn photographed Stieglitz in 1922, he used the same format (Fig. 22). The most unusual of the group, Waldo Frank seated in the same chair and on the same Lake George porch as Rosenfeld, is also the most recondite (Fig. 23). Hat pulled low on his head, he holds a few pieces of manuscript and three partially eaten apples in his lap; two more apple cores lie at his feet. The apple, as Sarah Greenough nicely explained, is not a food fetish but, like the Port of New York, stood for America; it was

Fig. 15 (top). Alfred Stieglitz, *Paul Rosenfeld*, 1920. Gelatin silver print, 9 3/16 × 7 5/16 in.

Fig. 16 (bottom). Alfred Stieglitz, *Sherwood Anderson*, 1923. Palladium print, 9 5/8 × 7 5/8 in.

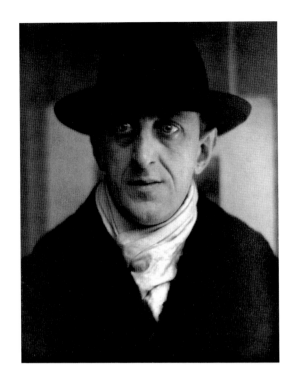

Fig. 17 (above). Alfred Stieglitz, *John Marin*, 1922.
Palladium print, 9 3/8 × 7 5/8 in.

Fig. 18 (top right). Alfred Stieglitz, *Marsden Hartley*,
1915. Gelatin silver print, 9 5/8 × 7 5/8 in.

Fig. 19 (bottom right). Alfred Stieglitz, *Arthur G. Dove*,
1911–12. Platinum print, 9 3/8 × 7 1/2 in.

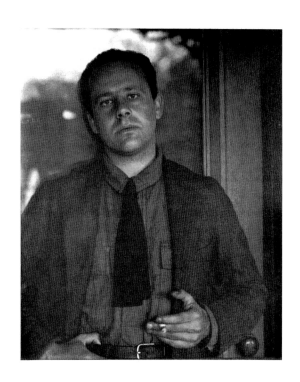

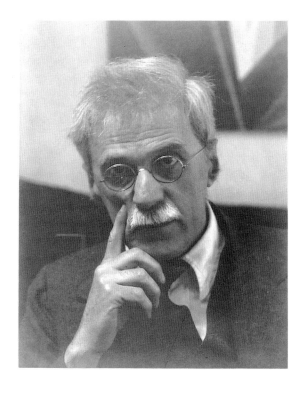

Fig. 20 (above). Alfred Stieglitz, *Paul Strand*, 1919.
Palladium print, 9⅝ × 7⅝ in.

Fig. 21 (top right). Alfred Stieglitz, *Georgia O'Keeffe:
A Portrait—Head,* 1918. Palladium print,
9⁹⁄₁₆ × 7¹¹⁄₁₆ in.

Fig. 22 (bottom right). Paul Strand, *Alfred Stieglitz*,
1922. Platinum print, 9⅝ × 7⅝ in.

Fig. 23 (facing). Alfred Stieglitz, *Waldo Frank*, 1922.
Palladium print, 9⅝ × 7½ in.

adopted by this group as the national fruit and a product of native soil.[114]

This brings me to one last way of thinking about *Port of New York*, this time as a work of literary portraiture comparable to Stieglitz's photographic portraiture. In organizing his book around fourteen essays dedicated to fourteen specific individuals, Rosenfeld was using a portrait format. His essays mix biography and impassioned criticism, each one conjuring up a serious, hard-working, oftentimes heroic individual struggling to make significant art for modern times. What Rosenfeld's essays have in common with Stieglitz's portrait series is that they single out and pay homage to the members of the second circle and its allies. And in that they concentrate on a small number of individuals, they helped to formulate a public profile for the second circle, giving it a firm identity. These portraits performed, then, not just as works of art or criticism, but as public relations tools. They were tributes, proclaiming the American genius they found in one another and in the circle as a whole.

Paying tribute to one another constituted one of the second circle's most successful strategies of aesthetic boosterism. Sometimes these testimonials were works of art: Dove's abstract portrait of Stieglitz; Demuth's portrait posters of Dove, Marin, and O'Keeffe; or Stieglitz's extended photographic essay of O'Keeffe. And sometimes they turned up as dedications to one another of books, poems, and works of art. Hartley and Anderson both dedicated books to Stieglitz, and Rosenfeld dedicated one to Sherwood Anderson and another to Herbert Seligmann.[115] Tributes also took the form of essays written by one circle member about another for magazines or for Stieglitz's exhibition brochures.[116] By the early 1930s Stieglitz, moreover, was encouraging scholarly but highly promotional studies about the art of the second circle, especially those written by its own younger literary members, such as Dorothy Norman, Herbert Seligmann, Elisabeth McCausland, and Jerome Mellquist.[117] As Henry McBride observed, this was "a little group of American painters [and writers, he might have added] who admire each other very much and never hesitate to say so."[118] Though they disdained public relations as a profession, they were its masterly practitioners.

The most hagiographic of second-circle books was *America and Alfred Stieglitz,* published in 1934

on the occasion of Stieglitz's seventieth birthday. Its subtitle? *A Collective Portrait.* Rosenfeld, along with Frank, Norman, Mumford, and Harold Rugg, orchestrated and edited this volume of twenty-five tributes to Stieglitz, most of them from intimates but some from sympathetic outsiders such as Gertrude Stein and Dorothy Brett. With its photographs by Stieglitz, its installation shots from his three galleries, and its reproductions of works by artists he had supported, as well as scholarly appendices giving chronologies and bibliographies, this book was the natural heir to *Port of New York* and the *Seven Americans* catalogue published some ten years earlier. Shot through with "soil and spirit" rhetoric, the foreword proclaimed this "a communal work, a work organic with its subject," describing the "spirit of a man." The volume opened with two passages from Scripture, one from Isaiah and another from John, construing Stieglitz and his contributions in messianic terms. The passage from John used the organic imagery so embedded in the group's artistic litany. "Verily, verily, I say unto you, except a corn of wheat fall into the ground and die, it abideth alone; but if it die, it bringeth forth much fruit." In the introduction (signed by the editors but probably written by Frank) Stieglitz was pictured as "Man . . . in American terms and on American soil" (ellipsis in original).[119] With every page of tribute, a composite portrait emerges of Stieglitz as a larger-than-life being, at once resistance fighter, guru, heroic sufferer, organizer, and brilliant photographer, a man who has seen the light and brought its warming rays to America.

Given that a similar "collective portrait" was produced for Rosenfeld after he died, and that another consisting of some ninety tributes to Stieglitz was published upon his death, one must ask what made it permissible and desirable for this group to portray one another so publicly and so immodestly.[120] Why was the ethos of self-promotion inseparable from their aesthetic productions?

Many would lay the full burden on Stieglitz and the megalomania that drove him to zealotry and the exploitation of those around him. Like many American leaders, especially those in the military and in politics, he was a man of enormous self-confidence and ego who needed constant attention and evidence of his followers' servitude. Others would defend Stieglitz in his own terms: the forces of

commerce and philistinism were so monumental that he had to shout to be heard.

Biography alone, however, cannot explain the hyperbole and promotional tactics, which infused the entire circle's commerce with the world—even that of men like Paul Rosenfeld who were, by all accounts, generous and lovable. We need to look beyond individuals to the cultural systems that were in play, especially the intemperate sloganeering of the 1920s and the development of modern advertising and public relations. Excess, exaggeration, hype, and bombast were not just tolerated but embedded in the very fiber of this prosperous and rapacious decade. We simply are not accustomed to thinking of New York cultural figures in the same league with advertisers ruthlessly developing new techniques to sell products in a global market and newspapermen inventing six-inch-high sensationalist headlines for the new tabloids. And we do not readily compare them to evangelists such as Aimee Semple McPherson, whose evangelical charisma elicited devoted followings, or to figures like Charles Lindbergh, whom the media so aggrandized that he lost all human dimension. Stieglitz and Rosenfeld belong in this cultural company.[121] For they too were shameless campaigners for their brand-name product: highbrow modern art of a particular aesthetic. Though they prided themselves on their superior talents and on their detachment from marketplace vulgarities, they used many of the aggressive and hard-nosed techniques of the commercial world as it moved from the soft techniques of selling to the more calculated ones of marketing.[122] They were public relations men who promoted Stieglitz as their spiritual head, touted the aesthetic life as one of healthy wholeness, proclaimed their art a new and modern product, and boasted of their own greatness, insisting that they—not others—be recognized as the nation's first important artists. They were America's modern greats.

This study returns often to claims for genuine Americanness. For the second circle often raised their voices against other artists making similar boasts during the 1920s and into the 1930s, when not just the second circle, whose members increasingly found themselves pushed to the margins of the art world, but other artists as well tried to manipulate national identity as a base for a successful art. The circle's desire to find a worthwhile America amorphously tied to the land, to the soil, and to

depth of feeling for a particular place was sharply contested, as was their devotion to vitalist and organicist forms. While Stieglitz insisted that the true American artist must speak an idealist language, critiquing American materialism and technology with every organic flourish, others proudly invented a streamlined rhetoric that they deemed the more authentic national style.

Among those who joined these debates were people Stieglitz and Rosenfeld considered friends. The second circle was not closed to exchanges with others. Stieglitz might throw Edward Steichen and Charles Sheeler out of his friendship circle, but he kept Picabia and Duchamp in it, though their concepts of American art were at odds with his. He could even be on good cussing terms with Thomas Hart Benton, someone whose art he deplored but with whom he enjoyed arm wrestling in correspondence. As Benton put it, they wrote as "one brother to another in the stew."[123] The stew was their common dedication to a new American art, which could at times override their considerable differences. Progressive American artists knew that they were a small and vulnerable group; they recognized that too much factionalism would put all their efforts at risk in an economy that found all that they did marginal.

But such blurrings and collusions should not stop us from trying to grapple with the overall campaign for a new American art, with its deep fissures and tensions, especially between those in the second circle and other artists, both European and American, who challenged the symbolist aesthetics and antimaterialist rhetoric that Stieglitz and Rosenfeld held dear. The stronger the challenge, the more Stieglitz intensified his campaign to win for his group the title of First Genuine American Artists in history. He stayed as long as he did on the New York art stage—through World War II—because no other group could call into service his full panoply of resources: financial support, publications, house critics, and most of all his galleries that regularly garnered publicity for second-circle artists. In 1925, after the *Seven Americans* exhibition, friends raised enough money to rent a room in the Anderson Galleries so that Stieglitz could open the Intimate Gallery, which he characterized in the circle's tongue as "an American Room," devoid of commercialism. When the Anderson building was sold in 1929, friends

No formal press views
No cocktail parties
No special invitations
No advertising
No institution
No isms
No theories
No game being played
Nothing asked of anyone who comes
No anything on the walls except what *you see* there

The doors of *An American Place* are ever open to all

Please do not take away.

AN AMERICAN PLACE
509 MADISON AVE., N. Y. C.

Fig. 24. An American Place announcement, with Stieglitz's handwriting, 1930s.

again helped Stieglitz open a space, a two-room gallery, where he continued to show those artists still loyal to him. The first public institution dedicated to modern art had just opened—New York's Museum of Modern Art—and was immersed in its own success, each exhibition accompanied with fanfare, parties, and media publicity; Stieglitz established his last gallery with an eye on this new competitor. Given the new museum's strongly stated commitment to the international art scene Stieglitz had once supported but then abandoned, he called his new gallery—how could he not?—An American Place. And he issued a final manifesto, available as a handout in the gallery, that reiterated his Olympian and purist views and his opposition to the vulgar behavior of the new kid on the block (Fig. 24). *No* formal press views, *No* cocktail parties, *No* advertising, *No* institution, and so forth. In the winter months Stieglitz was always to be found at An American Place, a fighter till the end, providing the dried-out glue that held the last members of the circle together.

The gallery closed soon after his death in 1946 at age eighty-two, but the circle lived on in texts written by its members and in one set of influential acts of philanthropy. In distributing Stieglitz's estate,

O'Keeffe gave more than fifty thousand letters and all of Stieglitz's papers and catalogues to the Beinecke Library at Yale University so that his history and that of those around him could be studied and perpetuated. A few years earlier she had given the bulk of his collection to a few public institutions. Though she might well have sold the collection, or broken it into single-artist groups or into thematic selections or chronological surveys, she did what seemed "natural"; she divided the collection into a few representative samplings of the artists Stieglitz had supported, thereby perpetuating, by deed of gift, the configuration of a preeminent American modernist "circle." Her carefully considered gifts to public collections in New York and Chicago, as well as Philadelphia and Washington, D.C., ensured that the art of the second Stieglitz circle would hang together posthumously as it had in the artists' lifetimes. O'Keeffe fulfilled Stieglitz's vision and, in a manner of speaking, put Rosenfeld's *Port of New York* on American museum walls. Hers was the final "collective portrait," this time of the circle itself, drawn in the body of the bequests themselves. She made sure Rosenfeld's ship was dry-docked in home territory for time immemorial.[124]

PART ONE

THE

TRANSATLANTICS

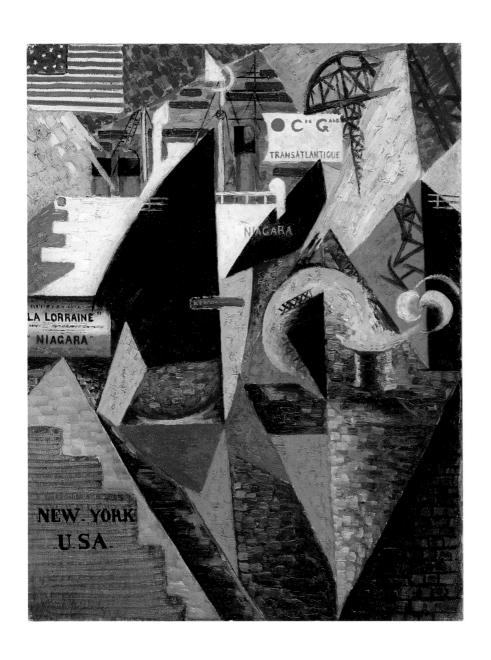

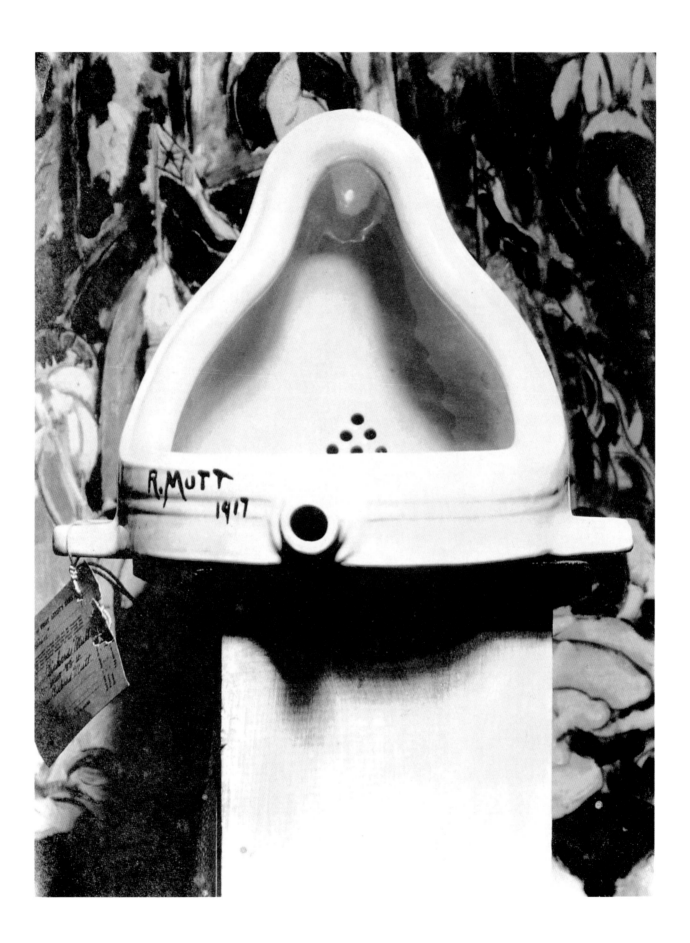

AMÉRICANISME

If only America would realize that the art of
Europe is finished—dead—and that America
is the country of the art of the future.

Marcel Duchamp, *New York Tribune*,
September 12, 1915

For the first time Europe seeks America in matters
of art. For the first time European artists journey
to our shores to find that vital force necessary
to a living and forward-pushing art.

New York Tribune, October 24, 1915

Even as the second circle formed, Alfred Stieglitz's claim to have fathered an authentic modern American art was profoundly challenged—by a brand-new porcelain urinal. In 1917, when Marcel Duchamp submitted *Fountain* for installation at the exhibition of the Society of Independent Artists, he threw down the glove to any New York modernist who envisioned a spiritualized American art of light, landscape, and inner feelings (Fig. 25).[1]

It was impossible at the time to realize the full weight of Duchamp's critique, so playful and spontaneous was his act. Stieglitz could have easily read in *Fountain* views compatible with his own, seeing it as a great spoof of puritan and materialist America, not unlike *Spiritual America*, the photograph he would make a few years later.[2] Furthermore, Stieglitz had a healthy respect for the French moderns visiting New York during the war and wanted to support their work. So when *Fountain* was thrown out of the exhibition, Stieglitz, whom Beatrice Wood remembered as "greatly amused" by the piece, agreed to photograph it "because he felt it was important to fight bigotry in America."[3] Like Duchamp, he was disgusted with the narrow-mindedness of the directors of the Society of Independent Artists who had censored the piece and kept it from being publicly exhibited.

The original *Fountain* disappeared early on, though Duchamp replicated the work several times in his career, using slightly different and later designs of urinals. So we look to the photograph, cropped in three different ways, that Stieglitz made when Duchamp and Beatrice Wood brought *Fountain* to have its portrait taken (Figs. 25, 26; see Fig. 58). This is an elegant photograph, much more

Previous page: Félix Delmarle, *The Port*, 1914 (see Fig. 71).

Fig. 25 (facing). Marcel Duchamp, *Fountain,* 1917.
Original work lost. Photograph by Alfred Stieglitz.
Gelatin silver print, $9\frac{1}{4} \times 7$ in.

Fig. 26 (top). Marcel Duchamp, *Fountain*, 1917.
Photograph by Alfred Stieglitz, from *The Blind Man*,
No. 2 (May 1917).

Fig. 27 (bottom). Photographer unknown,
Duchamp's apartment/studio at 33 West 67th
Street, 1917–18, with *Fountain* suspended.
Gelatin silver print, 2¾ × 1⅞ in.

formal and detailed than two other extant snapshots that show the piece suspended from the door jamb of Duchamp's New York studio (Fig. 27). Stieglitz, composing his picture much like an artist's portrait, placed the urinal on a white pedestal and photographed it head-on against a Marsden Hartley painting hanging in his gallery; he foregrounded the signature and put the entry tag hanging off the urinal's right "arm" in shadow, tell-tale evidence of the indecency of the act that threw the piece out of a nonjuried exhibition. While there is no evidence that Duchamp took part in the making of the photograph, one which clearly follows Stieglitz's own compositional habits, we do know that he was well enough satisfied with the results to publish it in the second issue of the *Blind Man*, a little magazine Duchamp and his friends edited (Fig. 26).[4]

What do we see? An object whose identity is not at all obvious at first glance, certainly not to female viewers, for whom this piece of equipment is hardly a matter of everyday life. Indeed, the fame of *Fountain* has given women intimate knowledge of urinals, acquainting us with an artifact that is as foreign to our sex as a speculum is to men.[5] But even for men Duchamp's urinal, neither on a wall nor in a lavatory setting, was strange and unfamiliar. Out of context and mounted alone on a pedestal, it was presented much like quilts, weather vanes, and altarpieces in museums, stripped of its functionalism, its surfaces and thingness emphasized. But the urinal here is made even stranger because it is wrong side up. What usually extends into space here sits upright. Furthermore, the vessel is boldly signed and dated in hand-printed letters and black ink, as on a traditional work of art.

The photograph accentuates the contours of the urinal, giving it a biomorphic gestalt, compact, monolithic, easy to remember. For someone of my generation, it brings to mind the shape of Al Capp's shmoos or hooded figures such as the one in the Adams Memorial by Augustus Saint-Gaudens. Another compelling note in the composition is the black hole that aims itself at you like the barrel of a gun, the eye of a camera, or the penis of a man—or, if viewed through a male gaze, the vagina of a woman. This is, of course, the piece that connects the urinal to plumbing and delivers water to flush out the bowl, but it is so foreshortened and flattened in the photograph that it reads like an abstract form, a black

Fig. 28. Installation of the First Exhibition of the Society
of Independent Artists. Photograph by Pach Brothers.

circle. The perfect roundness of its calligraphy
contrasts dramatically with the rough hand that has
signed the piece and calls attention to the six repeats
of itself in the drain holes of the bowl just above to
the right. It is as if the big round hole parented six
baby holes.

It is important to remember that Duchamp cre-
ated *Fountain* for the most radically conceived art ex-
hibition of its day, the first of the Society of Indepen-
dent Artists, and for the most sophisticated group of
contemporary artists the country could muster in
1917. This audience included the directors of the so-
ciety and enlightened artists and patrons like Kather-
ine Dreier, William Glackens, George Bellows, and
Rockwell Kent, who positioned themselves—just as
Duchamp did—as progressive and modern and as

opposed to academic art and genteel culture. Du-
champ, himself a director of the society, as was his
good friend Walter Arensberg, had helped his Ameri-
can colleagues plan the exhibition, using the ground
rules of French avant-garde exhibitions, which were
structured to eliminate censorship. "No jury, no
prizes" was the exhibition's central principle. Any
artist, regardless of accomplishment, who paid the
six-dollar fee and sent no more than two works
would be shown. The call for entries brought submis-
sions from over twelve hundred artists from thirty-
eight states for a total of some 2,125 works of art
(Fig. 28). Insisting that the two-mile-long installa-
tion at the Grand Central Galleries be completely
"democratic"—a word with special resonance dur-
ing a war Americans entered to "fight for democ-

racy"—Duchamp suggested that a letter of the alphabet be drawn at random from a hat to determine the sequencing of works.[6] *R* was picked, and artists whose last names began with that letter were the first to be seen in the exhibition hall, with the rest of the alphabet following in order, *S* to *Z* and *A* to *Q*.

The rest of the story is well known. Having had a large hand in setting the exhibition guidelines, Duchamp submitted the urinal with *Fountain* as its title and the fictional Richard Mutt from Philadelphia as the purported artist. Only a few people knew that the work was Duchamp's. *Fountain*'s arrival caused immediate controversy among the society's directors, most of them artists. Many were not prepared to stand by their own open-admissions bylaws if that meant accepting what they told the press was "a very useful object in its place, but its place is not an art exhibition." And, their press release added, "It is, by no definition, a work of art."[7] According to other reported reactions the urinal was indecent and vulgar. And since the piece claimed implicitly that making and crafting a work of art had no value, some directors were deeply concerned at being taken in by a jokester and made to look foolish.[8] The mass-produced urinal mocked the profession, making American artists more insecure than they already were. For both realists and fledgling cubists, *Fountain* raised a troubling question: Why make art at all—at least, art with the paintbrush or chisel?

Just before the exhibition opened to the public, a majority of the directors rejected the entry. Duchamp, on hearing the news, resigned as a director —not because the rejected work was his but because the exhibition's first principle was to be democratic and open to all. His defense of that principle was just one of many lessons he squeezed out of the *Fountain* affair and delivered to his American colleagues. Although he modeled his behavior on that of Parisian artists who for decades had provoked the bourgeoisie, in this case his audience consisted of his peers—the country's most progressive artists. In 1917 no other public had an opportunity to see the work.

Duchamp's submission of such a difficult and iconoclastic piece has never ceased to elicit responses from scholars and critics. Indeed, it has been the fountainhead of over a half century of criticizing and theorizing, with interpretive commentary ranging from considerations of *Fountain*'s dadaist humor and subversion to praise of its brilliance as a pioneering work of conceptual art. But no one, surprisingly, has looked very hard at the didacticism embedded in the submission of the work, a layer of communication so neatly wrapped up in wit and intellectual skepticism that it easily eludes us. Duchamp's iconoclasm in making *Fountain*, I want to suggest, was not just that of a jester and conceptualist, but also that of a teacher. If we set aside momentarily the canonical readings of *Fountain* to ferret out its hortatory motives, we discover that Duchamp in 1917 was as interested as Stieglitz in the possibility of a newly independent, non-Europeanized, American art. *Fountain* was a Duchampian lesson to the American art world in what such an art might look like. The means Duchamp used differed from those of Stieglitz—Duchamp was a non-national provocateur, Stieglitz a native-born evangelist—but his ends were similar.

The desire to teach shows itself transparently in the first issue of the *Blind Man*, an eight-page publication prepared by Duchamp and his friend Henri-Pierre Roché, a French diplomat and art world habitué who, like Duchamp, spent part of the war years in New York. The two Parisians met in New York and became close friends. Along with Beatrice Wood, a young American who loved them both, as they did her, they prepared the *Blind Man* to sell for a dime at the Society of Independents' exhibition. This was the only art commentary available at this circus of art other than the two official checklists one could buy, one with and one without photographs. That the two visiting Frenchmen even went to the trouble of addressing an American audience about modern art says something about their commitment to influencing the New York art community. But when one reads their commentary— exhorting, assaulting, brash, moralizing—it also becomes clear that they felt entitled to educate the American public, especially those who exerted power and leadership in the visual arts. Following in a long tradition of foreign visitors, they took it as a given that their French birth made them superior to Americans in art making, enabling them to recognize, more clearly than the locals themselves, America's potential in the fine arts. Their playful commentary in the *Blind Man* was laced with cultural arrogance. They delivered their message with parental authority, directly and dictatorially. Stop being so Victorian; stop being so provincial; stop resisting

"advanced art." Support your modern artists. Paris had learned to appreciate modern art and it was time New York did too.

The cover of the *Blind Man* depicted a cartoon—not a work of art—that the two Frenchmen had solicited from a local cartoonist, Alfred Frueh (Fig. 29). (I have more to say later in this chapter about how fashionable American cartoons were becoming in French avant-garde circles and, to a lesser degree, in New York. Frueh's caricatures were shown at 291 in 1913.) Here the blind man of the magazine's title, a bourgeois in a suit, starched collar, and derby hat, raises his sightless eyes and brushy mustache to the sky, using a cane to probe for impediments and a dog to guide his steps.[9] He has just passed by—without seeing—a modern painting of a nude woman in a landscape who stares him down with a cubist eye and gives him a vulgar gesture for having snubbed her. Beneath the cartoon was the first directive addressed to American artists, telling them to act now. "The second number of The Blind Man will appear as soon as YOU have sent sufficient material for it." Such demands continued inside the magazine in the main text, written and signed by Roché. In its twenty-three pronouncements we recognize the assertive and browbeating style fairly typical of European modernist tracts. But this one, we must remember, was written by an *Ausländer*, addressing artist colleagues in the country he presently inhabited. To show familiarity with the country's revolutionary past, and the customary French admiration of it, the first sentence of the editorial strikes a resoundingly Fourth of July note: "The Blind Man celebrates today the birth of the Independence of Art in America." Statements then follow bullying New Yorkers into adopting a taste for, and faith in, modern art. For example:

New York will catch the Indeps' fever. It will rush to see what its children are painting, to scold them, laugh at them—and laud them.

For the average New Yorker art is only a thing of the past. The indeps insist that art is a thing of today.

Is New York afraid? Does New York not dare to take responsibilities in Art? Where art is concerned is New York satisfied to be like a provincial town?

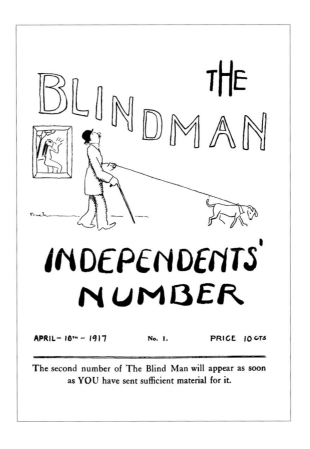

Fig. 29. Cover of *The Blind Man*, No. 1 (Apr. 10, 1917).

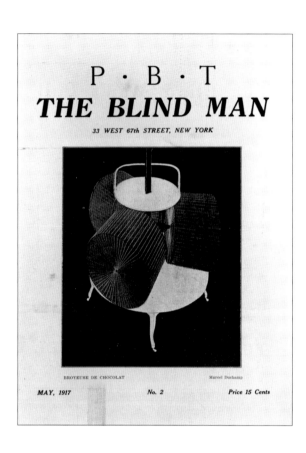

P·B·T
THE BLIND MAN
33 WEST 67th STREET, NEW YORK

BROYEUSE DE CHOCOLAT Marcel Duchamp

MAY, 1917 No. 2 Price 15 Cents

Fig. 30. Cover of *The Blind Man*, No. 2 (May 1917).

Never say of a man: "He is not sincere." Nobody knows if he is or not. And nobody is absolutely sincere or absolutely insincere. Rather say: "I do not understand him." The Blind Man takes it for granted that all are sincere.

While such prose conforms to the modernist practice of chiding and critiquing the bourgeoisie, in this case it is abundantly clear that Duchamp and Roché generally addressed American artists, whom they viewed as out-of-date and uninformed. The blind man with his head in the clouds was not just the generalized bourgeois, but also the symbolist artist, realist artist, academic artist, landscape artist, and impressionist artist, all of whom, in the eyes of these Frenchmen, worked in the shadow of old Parisian formulas and refused to bring their heads down and see the modern culture that they lived in. (Given the man's brushy mustache, could the cartoon, one wonders, possibly be a sly reference to Stieglitz, his head, like Picabia's camera lens, looking upward into the ethereal realm of the Ideal?) In a self-fulfilling prophecy, one scripted by the cartoon, America's most progressive artists proved themselves blind, sitting in judgment of *Fountain* and ejecting it from the exhibition.

In response, Duchamp and Roché, with the aid of Wood, thumbed their own noses and rushed to put out a second issue of the *Blind Man* that even more zealously told the artists who had kept *Fountain* from exhibition how Victorian, blind, and provincial they were. On the cover they put *The Chocolate Grinder*, an earlier painting by Duchamp—one that might under the circumstances be read as three steamrollers, metaphors for the directors' actions as well as another example of *authentic* modern art (Fig. 30)—while inside appeared a full-page photograph of *Fountain* with an unsigned editorial and several statements defending it (see Fig. 26).

Defenders came forward, in the *Blind Man* and elsewhere, to explain why *Fountain* was a work of art. Duchamp and his close friends, particularly Beatrice Wood, Louise Norton, and Charles Demuth—along with Walter Arensberg and Guillaume Apollinaire—all offered early explanations. These, carefully catalogued by William Camfield and separated out from later explanations and interpretations of *Fountain*, offered four lines of defense. First, *Fountain* represented everyday American street

culture. ("It is a fixture that you see every day in plumbers' show windows.") Second, it is a work of art because an artist chose it, placed it in a gallery, and as a result made us see it differently. ("He took an ordinary article of life, placed it so that its useful significance disappeared under the new title and point of view—created a new thought for that object.") Third, *Fountain* is an appropriate work of art in a country whose greatest art forms are, not painting and sculpture, music and literature, but "plumbing and bridges." ("The only works of art America has given are her plumbing and her bridges.") And finally—Duchamp's American friends agreed—*Fountain* was beautiful in its chaste surfaces and sculptural form, reminding several commentators of a traditional Madonna or Buddha. ("Buddha of the Bathroom" was the title of one apologia.)[10]

Of these explanations, the second has received a half century of scholarly attention. I want to consider here the other three, which have only recently been taken seriously. I am convinced that Duchamp was seeking to teach the locals in 1917 a lesson or two, not just about modern art, but also about their national culture. Like a modern-day Frances Trollope or Alexis de Tocqueville, he reflected upon America as an outsider, finding it a strange country whose peculiarities differed from those of his own. From his perspective as a young French avant-gardist, America appeared an ultramodern country of advanced consumerism, technology, and industrially designed goods—and, one might add, popular culture. At bottom his choice of a urinal was a brilliant act of cross-cultural investigation, that of a French visitor researching American-style modernity. Indeed, *Fountain* may be the most Eurocentric reading of the New World since sixteenth-century Europeans represented it as a Garden of Eden peopled by idealized natives of great athletic prowess and handsome physique.

To understand *Fountain* in this way means that we must first appreciate what it meant when Duchamp and other French modernists chose to live in New York during the war. They each had their reasons; Duchamp wanted, as he put it, to leave the stuffy and overwrought "artistic life" in which he had been engaged and to get out of a country overtaken by wartime sentiments.[11] But in settling on New York as a place of exile, he signaled cultural shifts as significant to history in their way as the deci-

sion of Rosenfeld, Stieglitz, and other members of the second circle not to travel to Paris any longer. When New York mattered so much to members of the Parisian avant-garde, Duchamp among them, that they would get on a boat and make the transatlantic journey, new Euro-American relations were under way and a milestone in modern cultural history was being installed. In the past, European cultural figures had, on rare occasions, traveled in America to see wilderness sites, but they had never rooted themselves and entered actively into the local art scene, as Duchamp did. Indeed, throughout the nineteenth century and into the early twentieth, with the exception of an occasional European visitor of the artistic stature of Degas (who passed through New York en route to New Orleans, where he had family) and the visits of a few academicians, the flow of *artist* traffic between New York and Paris was remarkably one way: the American artist went abroad to see collections and learn from European masters while the Parisian artist rarely left the Continent except to cross the Channel.

Duchamp and other progressive French artists initiated a new migratory pattern. At the very moment when their country first looked at America as a military ally and a source of economic support, progressive Parisians were looking to New York as a cultural haven. Their transatlantic journeys signaled a subtle shift in cultural alignments and marked the advent of New York's slow transformation from provincial town to international art center.

Relieved from military service for health reasons, and self-identified as an antiwar pacifist, Duchamp came to Manhattan in 1915, the same year as the painter Albert Gleizes; his wife, Juliette Roche; and the diplomat and writer Henri-Pierre Roché. They were joined by Francis and Gabrielle Picabia, who had already made a highly publicized visit to New York in 1913 to see the Armory Show; the composer Edgard Varèse; the poet Henri-Martin Barzun; and the artists Yvonne and Jean Crotti. Ranging in age on their arrival from twenty-seven (Duchamp) to thirty-four (Gleizes) and thirty-six (Picabia), these artists formed a fairly cohesive wartime French colony in Manhattan. Most of them had known each other in Paris and quickly renewed acquaintance in the New World. In New York the Hotel Brevoort, a

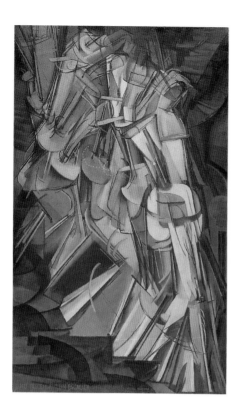

Fig. 31 (top). Marcel Duchamp, *Nude Descending a Staircase, No. 2*, 1912. Oil on canvas, 58 × 35 in.

Fig. 32 (bottom). *Marcel Duchamp, Francis Picabia, and Beatrice Wood at Coney Island*, June 21, 1917. Gelatin silver print, 4½ × 3¼ in.

French hotel in Greenwich Village with an excellent restaurant, became their highly publicized meeting place. Leo Stein wrote to Gertrude from New York in February 1916 that it seemed like old times. "Pascin, Picabia, Nadelman, Duchamp, Gleizes—everybody who isn't in the trenches" was in New York.[12]

For some of the artists—Duchamp, Picabia, and Gleizes in particular—travel to New York took them to a country where their art was already known. Their paintings, especially Duchamp's *Nude Descending a Staircase, No. 2*, had been among the most celebrated and commented upon in the Armory Show of 1913 (Fig. 31). Each of them had sold work out of the exhibition, and they knew some of the Americans who had organized it. Duchamp, met at the boat by Walter Pach, was soon being helped in countless ways by his new friends Walter and Louise Arensberg.

This group of exiles shared a remarkable desire—indeed, determination—to infiltrate the local art scene and establish a transatlantic outpost of modernism in New York. Though some, like Duchamp and Picabia, could speak barely a word of English, they socialized regularly with the New York avant-garde in the salons of the day, especially that of the Arensbergs and the Stettheimer sisters; they showed their work in New York galleries (Picabia, for instance, had two exhibitions at 291); and they participated in group exhibitions. Both Duchamp and Roché were instrumental in organizing the Society of Independent Artists along the lines of the French Société des Artistes Indépendants, a similar group in Paris. During the 1917 exhibition, Duchamp and Picabia arranged for the notoriously iconoclastic Arthur Craven, active in the Parisian avant-garde, to come to New York and lecture on the independent artists in France and America. In that Craven came to the event drunk and had to be restrained and removed because he began to disrobe, the lecture became a transatlantic dadaist event. Soon thereafter, Duchamp took an active role in helping Katherine Dreier form a major modern art collection and establish the Société Anonyme, which sponsored events to exhibit and explain modernism to New York audiences.[13] Roché helped American patrons purchase works by Parisian modernists, becoming for a time an agent in Paris for John Quinn, one of the country's most important private collectors of modern art.

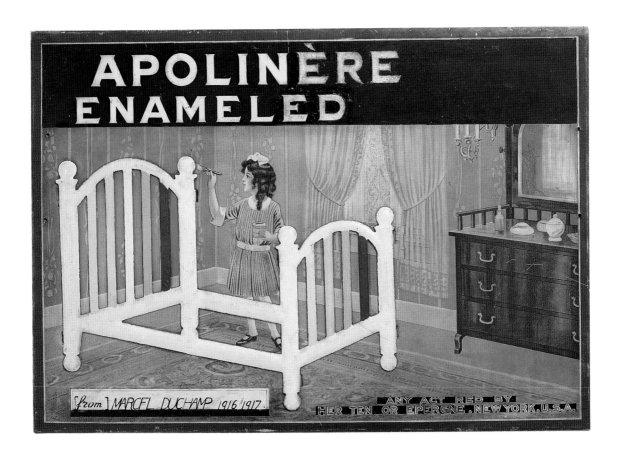

Fig. 33. Marcel Duchamp, *Apolinère Enameled*,
1916–17. Graphite on cardboard and painted tin,
$9\,^{5}\!/_{8} \times 13\,^{3}\!/_{8}$ in.

The exiles' involvement with little magazines best indicates their desire to affect the local art scene and to consolidate Franco-American alliances through a modernist enterprise that structurally bound artists, writers, and patrons to one another. Picabia worked with Marius de Zayas, Stieglitz, and other American colleagues on the little magazine *291* (some parts in French, others in English) and then started his own European offshoot of it called *391*, while Duchamp and Roché, along with Wood, created the *Blind Man*—in English so their New York colleagues could read it (Fig. 32). Yet another literary flourish by the exiles, however, the single issue of *Rongwrong* that Duchamp and Roché published, was half in French and half in English, its bilingual format expressing the new axis developing between Paris and New York.

The French also stayed in close contact with friends back on the Continent, sending them reports and mementos of their American travels. And when they returned to Paris, they corresponded with their New York friends. Albert and Juliette Gleizes sent jazz records to Jean Cocteau, while Roché, at Amédée Ozenfant's request, sought out photographs of American factories and grain elevators for publication and circulation abroad.[14] Picabia, when he got back from his first trip in 1913, began titling some of his works of art in English (for example, *Catch As Catch Can*), though he never learned the language. And with his wife, he unsuccessfully pursued plans to set up a 291-style gallery in Paris. Duchamp, while in New York, took an American tin sign advertising paints, dedicated it to Apollinaire, and called it *Apolinère Enameled* (Fig. 33). He altered the type on the sign so it had a mélange of French and English words. In Paris,

Apollinaire, in an essay about French superiority in poetry, declared that he felt sure a new American art was being born, midwifed into the world by Picabia, Duchamp, and Gleizes. These "French missionaries," he wrote in 1917, "in recognition of Edgar Poe and Walt Whitman . . . have during the war been importing the seeds of a new production. What this will be like we cannot yet foresee; but it doubtless will not be inferior to the work of those two great pioneers of poetry."[15]

That Apollinaire would call his friends abroad "missionaries" is symptomatic of the attitudinal asymmetry members of the French avant-garde demonstrated in New York. When they expressed their opinions about art to New Yorkers, they spoke as colonizers to the colonized or as missionaries instructing an underdeveloped art community. They assumed national superiority when it came to art production. When they spoke of American plumbing and technology, however, they changed their rhetoric to confess their country's industrial inferiority. In their collective mind Americans were *retardataire* as artists but highly original and inventive as plumbers and engineers. With the exception of Whitman and Poe, the only American artists widely admired abroad, who was there? Such reasoning led to some complicated cultural interactions, with the French idealizing Americans for their mechanical genius on the one hand and casting summary judgment on their presumed limitations as painters and sculptors on the other.

The problem, the French repeatedly told American reporters, was that American artists were too much influenced by Europe and had no independent point of view. Gleizes felt that American art "adapts itself to every variation of art development abroad. It reflects every tendency, every school, every distinction."[16] Marcel Duchamp repeatedly told his American colleagues to forget Europe and attend to their own circumstances. "If only America would realize that the art of Europe is finished—dead—and that America is the country of the art of the future."[17] Picabia had said much the same thing two years earlier. "France is almost outplayed. It is in America that I believe that the theories of The New Art will hold most tenaciously."[18]

That New Yorkers accepted these statements as compliments and as genuine offers of help rather than as arrogant and snobbish judgments on their

inadequacies testifies to the charming ways of these Frenchmen as well as to American artists' own deep sense of inferiority and provinciality at the time. Such judgments also reflect the French modernists' fear that Paris would not survive as an art center after the war and their hopes that if it collapsed, New York would be ready to replace it.[19] For their part, Americans, including Stieglitz and his artists, were flattered, if not flabbergasted, to find French cultural figures whose work they had seen in the Armory Show caring so much about their affairs.[20] Paris had for so long been America's teacher in cultural matters that New Yorkers found it newsworthy that "distinguished" French artists were coming to their provincial city for the first time and telling them they were the artists of the future. "When the foremost Cubist painter of France . . . [and his wife] come to New York on their honeymoon," one newspaper reported about the arrival of the Gleizes, "New York preens a bit over the compliment."[21] Another critic manifested pride more baldly. "For the first time," she wrote, "Europe seeks America in matters of art. For the first time European artists journey to our shores to find that vital force necessary to a living and forward-pushing art." "New York is now, for the time being at least," wrote another critic, "the art capital of the world."[22]

What was the "vital force" they were seeking? In a word, it was New York's urban modernity. When the French came, they knew precisely what they wanted to experience, for their own culture had begun to be mesmerized by America and had concocted a crude touristic map of things to do in the New World that rarely extended beyond the Hudson River and never went back into the eighteenth or nineteenth century. As Louis Aragon, the French surrealist writer, put it in 1924: America was "the country of skyscrapers and cowboys, railroad accidents and cocktail shakers," and the French invented it about "ten years ago."[23]

His boast seems more or less accurate. For in 1913, when the French avant-garde began to arrive, they had eyes only for the most contemporary features of New York City: the skyscrapers, the bridges, the busy harbor, the subways, jazz halls, Coney Island, Broadway, and hardware emporiums. From their perspective, these sites were the *real* America. Arriving for his first stay in 1913, Picabia proclaimed New York the city of the future, gushing like a lover

about "your stupendous skyscrapers, your mammoth buildings and marvelous subways." New York was a "cubist, the futurist city. It expresses in its architecture, its life, its spirit, the modern thought." No past held back the American. "You have passed through all the old schools and are futurist in work and deed and thought."[24] When Duchamp came two years later, he wondered where in Europe one could find anything "more beautiful" than the American skyscraper, which, he was disappointed to find, was used only for business offices and not for apartments and artists' studios. Speaking directly to those who lionized Paris for its fine arts and good taste, he called the French capital "a bore" because "everything is perfectly blended and in perfect harmony." In New York he was struck by the energy: "One realizes that here is a people yearning, searching, trying to find something."[25]

Duchamp's touristic embrace of modern New York deeply impressed his American interviewers. He "had insatiable curiosity about everything in New York, from Coney Island to the Metropolitan Museum," one of them wrote. Another found him "keenly interested in all New York from the latest musical comedy to Coney Island."[26] When Albert and Juliette Gleizes first arrived, Duchamp gave them what was fast becoming the transatlantic modernists' standard tour of the city. In the first few days he took them to visit a businessman who had an office on the forty-fifth floor of a skyscraper from which one could see the dizzying spectacle of the city below. They took ferryboat rides to see the skyscraper city in profile from the water; they visited Greenwich Village, Washington Square, and Chinatown; and, to top it all off, he "seduced them with the joys of the drugstore and its soda fountain, an institution unknown to the French."[27]

French exiles circa 1915, then, came to New York because they wanted to convert the necessity of wartime displacement into an opportunity for intellectual growth. Rather than go to Zurich, Switzerland, or Barcelona, Spain, where other artists exiled, they made the more arduous trip overseas to a culture few of their countrymen knew firsthand, but one that had come to loom large in their cultural enthusiasms. They traveled across the Atlantic much as their nineteenth-century predecessors had gone to North Africa—to experience a place of exotic otherness (and in America, newness) that had been

compellingly mythologized in their home country. Like Romain Rolland, who urged the *Seven Arts* crowd to relish their freshness and youth and take the torch from an exhausted Europe, these artists pictured themselves being renewed in a young and innocent country not weighed down by its history or exhausted by the current war. They brought with them that old European idea that America was young, unfettered by a historical past. "America," Goethe had written years earlier, "you're better off than are our own old nations because you are untroubled by 'vain and useless memories' conjured up by 'ruined castles' and 'rock formations.'"[28]

By the end of the nineteenth century, as artists began to envision the modern epoch as a profound rupture from the past, and themselves as citizens of a new era, cultural youthfulness took on new currency. It seemed desirable rather than disadvantageous. In writing about his trip to America in 1894, Siegfried Bing spoke the views of many Europeans when he compared his country's absorption in the past with American future-mindedness. "For the American, however, *yesterday* no longer counts while *today* exists merely as preparation for *tomorrow*."[29]

For French visitors, America's foreignness—summed up in the stereotype of a people who lived thoroughly in the present—took on exaggerated proportions during the war years and the decade that followed. Americans seemed a new kind of primitive, unsullied and uncomplicated by a long past. What was America, after all, but a young and uncultured place where the natives acted instinctively, out of innocence? The French promoted an equally oversimplified view of their own continent as weighed down by history and tradition and, by extension, by too much worldly sophistication. Taking refuge in simple binaries, Europeans commonly judged the two cultures against each other, so that America's wild and primitive modernity served as a rhetorical foil to Europe's tradition-bound character. The New World had all the headstrong energies of youth, Europe the mellowness of age. Europe was tied to the past; America was unfettered. Europe was the seat of humanism, America of efficiency and industry. Europeans sauntered; Americans rushed. Europe had great artists, America great engineers. Europe had palaces and cathedrals; America had skyscrapers.

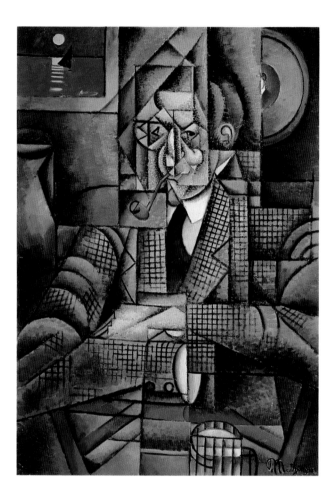

Fig. 34. Jean Metzinger, *Portrait of an American Smoking*, 1912. Oil on canvas, 36½ × 26 in.

When an American journalist asked Albert Gleizes for his views on America, he registered his impressions within this comparative discourse. He was used to the "maze of little streets in Paris where life goes with starts and stops," and he found the crowds and heights in Manhattan awesome, even crushing. Paris was slow, New York fast. The bridges and skyscrapers he found comparable to the great architectural monuments of Europe, but without their age or history. "They are creations in iron and stone which equal the most admired old world creations. And the great bridges here—they are as admirable as the most celebrated cathedrals."[30]

This fascination with comparing modern America with old Europe became so pronounced on the Continent that it was soon given a name: *américanisme* in French; *Amerikanismus* in Germany; *americanismo* in Italy. And the Anglo-American nations increasingly used the words "Americanization" and "Americanized," which, invented in the mid nineteenth century, came into much more frequent use after World War I. Not everyone, of course, was positive about this love of things American. European businessmen seeking to increase efficiency and the speed of production by adopting American-style factories and Frederick Winslow Taylor's management theories encountered significant animosity and resistance. Too much Americanization threatened national and personal identity, and critics found efficiency systems abhorrent. But in avant-garde circles abroad, where it was fashionable to be modern, to use American slang, and to wear American clothes—Jean Metzinger's cubist portrait of an American makes much of the sitter's aggressively checked jacket (Fig. 34)—*américanisme* was generally genial and enthusiastic and rarely attended by significant controversy. Only when Wall Street crashed in 1929 did the romance begin to sour.

The mythology of America was at first promoted among artists on the basis of secondhand accounts rather than personal experience. But once artists actually visited this strange, faraway land, their reports authenticated the myths and helped to fuel Americanomania both at home and abroad. Upon arrival, they were quick to comment on the features of Manhattan they had come especially to see. When Picabia disembarked in New York in 1913 and told the press that the city was a "cubist, the futurist city," he was not being particularly original but rather

repeating shorthand descriptions of America that were circulating among his Parisian friends, though most New Yorkers had not heard them yet.[31] So too Duchamp, when he gave his first newspaper interview, praised not only the New York skyscraper but also the "wonderful intelligence" and "wonderful beauty of line" of the American woman. Sounding very learned on the subject, he declared she was "the only one [in the world] that always knows what she wants, and therefore always gets it." She would help the world "equalize the sexes," and the battle between the sexes would be over. "Visiting Us, Marcel Duchamp, the Cubist Painter, Declares That America Is the Country of the Art of the Future—the American Woman the Most Intelligent of Her Sex" ran the subtitle for the interview (Fig. 35).[32]

Coming from a twenty-seven-year-old artist who had been in the country only a few weeks, these were not highly tested observations. Nor were they particularly surprising for a Frenchman fresh from Paris. If one looks deep into the various male subcultures that shaped Duchamp, one finds that his descriptions of *la femme américaine* were carried wholesale from the opinions of Joris-Karl Huys-

mans, Alfred Jarry, and French writers who had visited New York. Just as in *japanisme* and Orientalism, the foreign woman as a fantasy object of male desire was central to *américanisme*. The American woman was as exotic and seductive to the French male of the time as the odalisque had been to an earlier generation.

Picabia, Duchamp, and other French avant-gardists, I am suggesting, were culturally preconditioned to see only a schematic and thinly constructed America. They came prepared to indulge in New York City's modernity—and to be blind to, and uninterested in, other parts of the vast American continent. Their America was a European schema for the New World, a land of skyscrapers, plumbing, mass culture, industry, efficiency, and American girls. This picture, selective and skewed, told more about what the French found strange and exotic than about the way most Americans lived. It recognized only those elements of life in America that were *different* from those of Europe and exaggerated their character and incidence. This America contained skyscraper cities and rush-hour crowds but no small towns or rural life. It had plumbers,

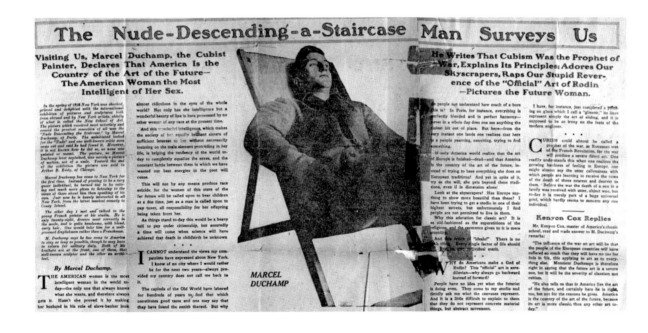

Fig. 35. "The Nude-Descending-a-Staircase Man Surveys Us," *New York Tribune*, Sept. 12, 1915.

engineers, and bankers, but no artists, craftsmen, cooks, or gardeners. There were rich businessmen, American girls, and southern blacks, but no families or old people. There were jazz and Negro spirituals but no symphonies or fine arts. There were no brownstones or parks, monuments or single-family homes. Indeed, if we rely on their reports alone, there was no building under twenty stories high or anything of historical significance before the present century.

The European fascination would, in time, boost the confidence of those American artists who were beginning to articulate a desire to produce an indigenous modern art and would help them to reconstitute their own cultural identity. Ironically, Duchamp and his fellow countrymen served as wet nurses to a handful of American artists who needed, as they had for decades, to be taught by the French first, before they could confidently create a program that called for a break from Paris and a revitalized national art.

Understanding the transatlantic fantasies the French avant-garde brought with them to New York helps us decode the art they made about America, an art so thoroughly informed by early manifestations of continental *américanisme* that it frequently outstripped the capacity of the local audience to follow what was being said. With good reason, Americans found it difficult to formulate their country in the reductive stereotypes that Europeans relished, for their sense of national self was far more ambivalent and complex than the one projected upon them.

One of the easiest ways to grasp something of the European's reading of the New World is to survey what is included in and what is absent from travel accounts. Nineteenth-century travelers had felt obliged to visit and comment on America's great natural wonders—Niagara Falls, the Hudson River, the American West with its indigenous peoples—and older historic cities like Philadelphia and Cincinnati. They liked to report on social settings that they felt demonstrated the workings of American-style democracy and what they perceived as the country's general classlessness and lack of an aristocracy. But by the turn of the century, continental travel writers began to be preoccupied with industrial America and were spending most of their time in New York,

Chicago, Detroit, and Pittsburgh and, if they were French, writing books with titles such as *Outre-mer, La Nouvelle Jouvence, Au pays du dollar, Au pays de l'énergie, L'Amérique moderne,* and *Le Voyage dans l'optimiste Amérique.*[33] While they were reluctant to give up cowboys and Indians as part of their America—Buffalo Bill shows toured European cities until 1907—they found it increasingly difficult to fit them into their schema of youth, newness, money, and industry.[34] Gleizes, Duchamp reported, naively thought he would find cowboys on Broadway![35]

These travel accounts drew vivid pictures of the new phenomena in modern America and paid little, if any, attention to the country's most common or Europeanized elements. They focused on the densities of city life, especially New York, and struggled to find metaphors that would speak to armchair travelers of new wonders abroad: the strangeness of skyscrapers, the dramatic sweep of the Brooklyn Bridge, the tempo of the rush-hour crowd, and the spectacle of electric signs on Broadway at night. By World War I, Thomas Edison, Wilbur Wright, and Henry Ford—and Frederick Winslow Taylor soon thereafter—were the most celebrated Americans in Europe, so that Europeans wanted to visit factories, to see assembly lines in operation, and to witness those manufacturing processes responsible for streamlined American industrial products.

Travelers never failed to be impressed by the conveniences and luxury of everyday American living, pointing to widespread central heating and electricity as evidence that functionalism and comfort were American priorities. They always had something to say about American plumbing, especially the bathroom with hot and cold running water that here, unlike Europe, was a common feature of both private homes and hotel rooms. Accustomed to cast-iron bath tubs and older plumbing systems where toilets were occasionally little more than a drain in the floor, early-twentieth-century Europeans could not help commenting on the high grade of ordinary American plumbing. "Good-by to frequent and well-appointed bath-rooms, glory of the plumber's art!" wrote an English visitor as he left to return to Europe. "I am going to a land where every man's house is his prison—a land of open fires and chilly rooms and frozen water-pipes, of washing-stands and slop-pails, and one bath per household at the

most."[36] A few years later the French intellectual Georges Duhamel, in his damning book on American life, decried "that fabulous bathroom which the economists and the sociologists vie in praising. It is the noblest victory of American pride."[37]

Just as they slighted the country's Beaux-Arts architecture but glamorized the skyscraper, they ignored American haute cuisine but lavished attention on more common fare—pancakes, citrus fruits, and sweet potatoes and, after the war, ice-cream sodas and American mixed drinks. (Duchamp took to drinking cocktails and hard liquor only after arriving in New York.)[38] And they took little notice of museums or concert halls, dismissing our high culture as a pale imitation of their own, but were fascinated by vaudeville, jazz, popular dances, comic books, movies, boxing, football, and baseball, forms for which Europe had few equivalents. Whether or not visitors liked America's sports and popular arts, they found them exotic and described them in great detail, often as if they were tribal rituals practiced by a strange barbarian race.

Indeed, nowhere was the primitivism of American culture more frequently evoked than in French travelers' descriptions of American sports. Jules Huret's *L'Amérique moderne* of 1911, one of the most reasoned and complete travel accounts of the period, devotes an entire chapter to a football match between Harvard and Yale. Like a careful anthropologist, Huret gives a deep description of the strange equipment the players wore, the "brutalities" of the plays, and the savage cries of the spectators: "Kill him" and "Break his neck."[39] Similarly, he underscored what he considered the violence and brutality of the rides at Coney Island, another obligatory stop on the Frenchman's tour of New York. Comparing it to an amusement park in Paris, Huret found its gigantism, its extraordinary rides, its electric lights, and its cheek-by-jowl crowds "ten times" those of the Paris park.[40] The rides, he said, were "a thousand American inventions for breaking one's neck," and the ones that attracted people were "les plus violents et les plus bruyants." The more *sauvage* the ride, the more likely Americans were to return for a repeat, their frenzy carrying Huret along with them. At Coney Island, he claimed, he lost his *différence* and joined the delirium. "Je fais comme tout le monde."[41]

Huret also chronicled continental travelers' fasci-

nation with two exotic modern types that were often stereotyped: the American black and the American woman.[42] In France, as in other European countries, there was little exposure to black ethnic life in any concentration, and given the widespread currency of cultural primitivism, visitors were taken by the visibility of black communities in American cities and in the southern countryside. Indeed, they often visited the South specifically to witness African American life. As one might expect, their accounts were racially reductive and romantic, picturing blacks as a tribal people tragically cut off from their African origins. What travelers most admired was their music and dancing, which they deemed authentic and original. Huret, for instance, described the cakewalk, a popular black dance that had been imported to France at the turn of the century, and pondered the instinct blacks seemed to have for music and rhythm. While he conveyed the racist prejudices of his day in wondering whether blacks were equal to whites and could be educated, he researched their lives with unusual intensity and sensitivity. Unlike other travelers, who would describe the black in picturesque terms, happy in his poverty, white teeth gleaming as he grinned, Huret devoted four chapters to discussing the character of the American Negro and trying to understand his economic place in post–Civil War America. In his travels, he visited a sugar cane plantation, a Negro village, and Tuskegee Institute, and he attended a black funeral and church service.[43]

Similarly, he tried to figure out *la jeune fille américaine,* whose notable independence and seemingly powerful position in male-female relationships fascinated the French. Beginning in the nineteenth century, the American woman had gained a reputation in France, solidified by the early twentieth century, for being extraordinary and unusual. Seeing her in action was a primary tourist attraction. French travel writers, invariably male, said little about the American man, but when they did, they pictured him as a hard-driven businessman, a wealthy tycoon, and a clumsy, ineffectual lover. Women in America were thought to dominate their men. In the art of seduction, as well as painting, French male commentators clearly assumed themselves superior to their American counterparts. This assumption gave them cause to elaborate endlessly on the American woman, often devoting a section of their

books to comparing her with their own women. If the travelers stereotyped French women as elegant, sensuously thin, private, and socially conservative, they found American females independent, ambitious, athletically robust, and fascinatingly unpredictable. Most accounts were simultaneously delighted and appalled by the American woman's muscular physique and her assumed independence of traditional family and social obligations. Frequently stereotyping her as an amazon, they wrote about her unconstrained life as a working girl, her pursuit of sports and outdoor activities, and her power in the home as the chief consumer and decision maker. Sometimes she took on characteristics of the femme fatale, and at others she was clearly drawn as the New Woman liberated from Victorian conventions. (The Dutch artist Paul Citroen represented her walking alone and self-confident against a collage of city buildings [Fig. 36].) Sexual curiosity, if not downright lust or castration anxiety, often pervades these accounts as male travelers ponder

her fitness and body type and her refusal to surrender to male authority. Huret, characteristically thorough, used a visit to Smith College and female gymnastic classes in Boston to analyze how American girls were produced. He outlined their program of study, particularly their courses in the sciences and physical education and their pursuit of games like hockey and basketball; he included in his book, along with his photographs of New York skyscrapers, Coney Island, football games, poor blacks in the South, and chorus girls, several illustrations of American college girls exercising (Fig. 37).[44]

This is the same intelligent and strong-willed American girl that Duchamp came prepared to meet and appraise in New York, just as he came prepared to revel in American skyscrapers, plumbing, and comic books. Although he could have received his schooling in *américanisme* from any number of sources, it probably came primarily from avant-garde writers and artists, who since the days of the symbolists had woven their own pictures of a brave

Fig. 36. Paul Citroen, *The American Girl*, 1919.
Photomontage, 11^{11}/16 × 11^{5}/16 in.

Fig. 37. "Ecole Normale de Gymnastique de Boston."
From Jules Huret, *L'Amérique Moderne* (Paris, 1911).

and seductive new world across the sea. Few of them, unlike the travel writers, ever crossed the Atlantic, but they had engaged in mythmaking ever since the symbolist and fin-de-siècle poets and writers named Walt Whitman the quintessential American artist, a grand innocent whose free verse and open-road style could have developed only in a youthful, less hidebound country.[45] Among their mythic figures was the American girl, with her "supple figure, sinewy legs, muscles of steel, arms of iron." That is Huysmans's description, in *A Rebours* (1884), of the body of Miss Urania, an American acrobat, a figure so "strapping" and of such "brute strength" that the story's emaciated Des Esseintes lusts after her but cannot imagine how she could find his small ravaged body attractive. He dreams of her transformed into a man and himself into a woman, fantasizing that with this sexual reversal, she might conceivably desire him. When he abandons fantasy and summons up the energy to proposition her, and she accepts, his disappointment is pro-

found. All that muscular flesh turns out to be under the control of American puritanism! "She was positively puritanical in bed and treated Des Esseintes to none of those rough, athletic caresses he had at once desired and dreaded." Disgusted by her "icy caresses and prudish passivity," he trades her in for a skinny little French prostitute; in vivid contrast to the American girl, she "reeked of skillfully contrived scents, heady and unhealthy perfumes, and she burned like the crater of a volcano."[46]

In another rendition—Alfred Jarry's *Le Surmâle* (1902)—the American woman has none of the athletic prowess of Miss Urania and is sexually very active; indeed her mindless sexual activity—she goes at it like a machine—defines her Americanness. Ellen is a siren figure, rich, unmarried, "a little slip" of a person, who is just one of the American character types who dominate Jarry's surreal story about a bicycling race. The story, set in the future, in 1920s France, revolves around a widowed American chemist who has invented Perpetual Motion Food

(the product is always referred to in English in the French text); his daughter, Ellen, whose sexual prowess puts her into perpetual motion; Arthur Gough, a "millionaire engineer, electrical expert, and manufacturer of automobiles and aircraft"; and André Marcueil, a philosophically inclined Frenchman who is hosting the Americans. In the tale, a bicycle team trains on Perpetual Motion Food and successfully wins a race against a locomotive; machines and bodies, mechanical and sexual actions become analogized and intertwined. The mechanical inventions of the two Americans eventually run amok—they create a perpetual sexual machine hooked up to the inexhaustible Monsieur Marcueil—and destroy the Frenchman and his château. The Americans survive and unfeelingly—mechanically—go about their business. In a story whose metaphors Picabia and Duchamp would turn into dadaist pictures, Jarry caricatures American science and mechanical wizardry, conflating the American woman with American machinery and the human sex act with the repetitive motion of modern mechanisms.[47]

This trope of the physically powerful American girl was one of the stereotypes Duchamp brought with him from Paris to New York. He also came with Jarry's and Apollinaire's passion for American popular culture. Jarry was one of the first to praise P. T. Barnum's circus for its American gigantism and diversity of acts.[48] Apollinaire, following in Jarry's footsteps, had an even grander appetite for the new and the exotic, writing, among other things, about Native American art, the poetry of Walt Whitman, and what he knew from afar of the American popular arts. Under his editorship the little magazine *Les Soirées de Paris* published articles explaining to the Parisian avant-garde the charm and vigor of American baseball, boxing, and dime novels about Nick Carter.[49] In 1913, when Apollinaire published a fictional account of Whitman's funeral as an orgiastic three-ring circus accompanied by ragtime music, with mistresses, pederasts, and illegitimate children, the story became something of a scandal in literary circles.[50]

By 1913 Duchamp and other members of the Parisian avant-garde were also privy to their friends' firsthand accounts of New York. Two contacts were particularly important. Arthur Craven, who before the war wrote poetry and essays and produced the iconoclastic little magazine *Maintenant*, had visited

America in 1903 when he was sixteen and came again in 1917, when Duchamp and Picabia arranged for him to lecture in New York. Born Fabian Avenarius Lloyd of English parents in Switzerland, Craven was an irrepressible rebel and poseur who bragged of being Oscar Wilde's nephew. He changed his name to make it sound more Anglo and modern and became a boxer, identifying the sport with the roughness and swagger of American men. As early as 1909, while living in Paris, he penned "To Be or Not to Be . . . American," his satirical guide to American masculinist traits he saw replacing those of the French and English dandy. To be American was to chew gum, spit, swear, wear suits two sizes too large, be clean shaven, wear a bowler hat at an angle, always appear busy, and hang out at bars drinking nothing but "American drinks."[51] Craven also wrote one of the first French avant-garde representations of New York as a city of rapacious modernity: the land of skyscrapers ("palaces"), electricity ("globes"), technology ("telephones"), and engineering ("elevators"). In streamlined Dadaist rhetoric he sexualized the imagery:

New York! New York! I should like to inhabit you!
I see there science married to industry,
In an audacious modernity,
And in the Palaces,
Globes,
Dazzling to the retina
By their ultra-violet rays;
The American telephone,
And the softness
Of elevators. . . .[52]

A second prewar traveler to the States was the poet and novelist Blaise Cendrars, whose enthusiasm in his firsthand reports of New York most certainly infected his friends. Born to a Swiss father and a Scottish mother, Cendrars restlessly traveled all over the world throughout his life, making his first trip to America in 1911, when he was in his mid-twenties. This trip generated his first significant poem, "Les Pâques à New York," which, for all its fin-de-siècle despair and symbolist structure, pioneered in depicting New York as a futuristic city of skyscrapers, bridges, and subways and Americans as "sweat-stained with the fever of gold." After his initial trip Cendrars became a close associate of

Duchamp, Picabia, Apollinaire, and Fernand Léger, bringing to his friendships an irresistible appetite for the most modern of inventions. He may well have been instrumental in persuading Picabia to go to "futuristic" America in 1913. Once Picabia returned from his trip, he too became a carrier of Americanophilia, spreading the word that New York had to be experienced to be believed. Picabia, *La Vie Parisienne* reported, is "enchanted with the land of dollars."[53]

While *américanisme* was finding a place in many European artists' studios before the war, no group was more receptive than the so-called Puteaux group of writers and poets. Flourishing as a loose association from 1910 to 1914 and meeting informally in each other's studios, often in Puteaux, a suburb of Paris, this circle included Duchamp and his two artist brothers (Raymond Duchamp-Villon and Jacques Villon), Picabia, Gleizes, Jean Metzinger, Roger de La Fresnaye, Léger, and sometimes Robert Delaunay, as well as the writers Apollinaire, Cendrars, and Henri-Martin Barzun. Most of them were wedded to a cubist aesthetic but rejected the cubism of Picasso and Georges Braque as too hermetic in style and too narrow and inconsequential in subject matter. From the perspective of the Puteaux cubists, Picasso and Braque ignored the substance of the modern world—its machines, spectacles, quotidian street life, and workers—and especially the qualities peculiar to modernity: speed, dynamism, and rupture.

While more philosophical and less militant than the Italian futurists, the Puteaux circle shared their "modernolatry," as one historian called it, and were as committed as their southern counterparts to inventing a modern art that spoke to the irrevocable changes brought about by the car, train, and plane as well as the new city and factory.[54] They were drawn to the cubist aesthetic because it conveyed multiple sensations and collapsed time and space in ways that resembled the effect of modern transportation on human perceptions. More debatably, cubism seemed to them analogous to the fourth dimension. And they found it versatile: cubism could convey change, contrasts, and action and bring together past and present, memory and sight. It was fluid and unstable, just like modern consciousness.

They not only debated cubism as a new style but argued whether modernity demanded a new subject matter or brand-new materials for art. Delaunay's cubist subjects—the Eiffel Tower, the Ferris wheel, biplanes, billboards, football players, and even the sign for New York–Paris transatlantic travel—catalogued the features the Puteaux circle configured as the new epoch (Fig. 38). Others—most notably Léger—argued that expressing the "sensations" of the new age was more important than depicting its actual technologies and machinery. Thus Léger, who like Apollinaire was one of the earliest and most buoyant enthusiasts of airplanes, billboards, and industry (especially its smoke), talked incessantly about these phenomena but did not index them visually in his paintings as Delaunay did. Modernity, he argued, was conveyed in stylistic invention, not in art that illustrated contemporary life. Artists should delight in the new contrasts of their age, the "yellow or red poster, shouting in a timid landscape," but abstract from such sensations a principle, not necessarily a subject matter.[55] Contrasting and dissonant forms, colors, and plastic values in a painting, he argued, make it modern; they capture the newness of its age. "You can advantageously substitute the most banal, worn-out subject, like a nude in a studio and a thousand others, for locomotives and other modern engines that are difficult to pose in one's studio. All that is method; the only interesting thing is how it is used."[56] So when he and his colleague Duchamp investigated movement and dynamism, they would paint the most traditional of French subjects, the figure, more often than the cars, airplanes, and bicycles that had brought into being new concepts of time and space. Duchamp's *Nude Descending a Staircase* (see Fig. 31) and Léger's many prewar figural studies show the traditional studio nude in movement, describing modern-day action and dynamism as much through the drive of their line and the clash of forms as through the subject itself.

For all their advocacy of the new and modern, the Puteaux artists, with the notable exception of Delaunay, created little new iconography before World War I. Some even worried whether contemporary art could ever be as exciting as the technology of modern life itself. Apollinaire, who constantly urged his colleagues to more invention, captured the essence of such concerns when he wrote in 1912 that the "masterpieces of the modern style" were "machines, automobiles, bicycles, and airplanes,"

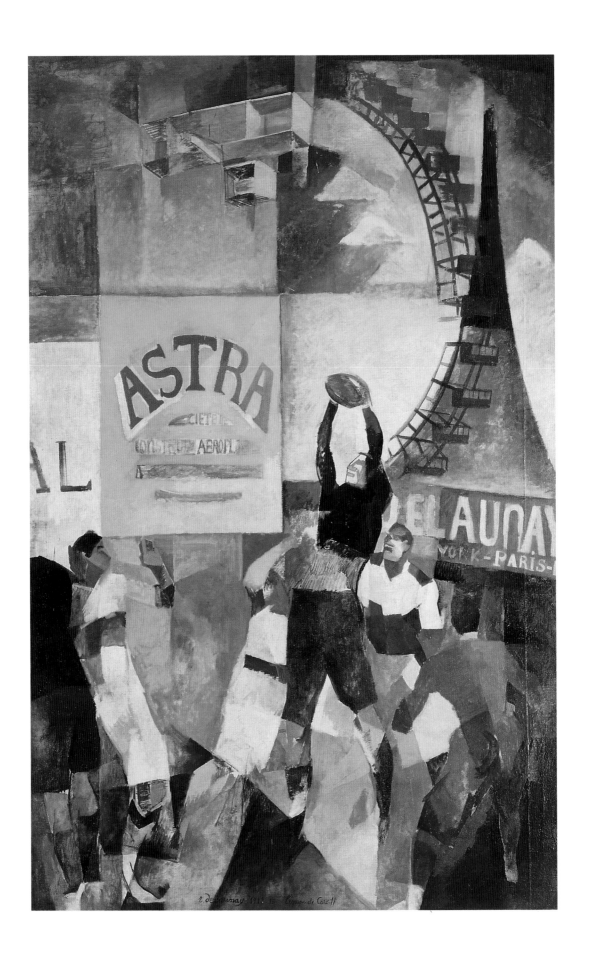

made, like the Eiffel Tower of 1889, "of cast iron, steel, sheet metal."[57] Duchamp voiced the same sentiment when touring the 1912 Salon de la Locomotion Aérienne in Paris with Brancusi and Léger: "Painting is finished! Who can do anything better than this propeller? Can you?"[58] Although the Puteaux circle thus kept alive Baudelaire's injunction of 1846 that as "all peoples have had their own form of beauty, so we have ours," they were continually experimenting in the prewar years to figure out what this art should look like.[59]

Conscious of such a mandate—to invent a new art equal to the age's new technological beauties—the first French modernists to travel to New York came as researchers into the modern, genuinely confused about both the relation of style to subject matter in the new poetics and the materials appropriate for a new art. When they discovered a modernity in America that was so much more pronounced than the Eiffel Tower, bicycles, and trains of contemporary Paris, the experience utterly transformed the way they made art. Remarkably, the French artist found himself beholden to the New World for inspiration and insight not to be gained at home. It was the beginning of a new kind of transatlantic exchange.

Picabia, not Duchamp, was the first member of the Puteaux group to create a distinct body of work inspired by what he found on foreign shores. Before he landed in New York in 1913, Picabia had not made urbanscapes in any number; in 1912 he had painted one quite ordinary cubist street scene of Paris (Fig. 39). But once in Manhattan, he set about making a series of abstractions based on street energy, jazz, and the city skyline, inventing what was for him a new type of city painting—the *New York Tribune* characterized it as "post-cubist." In these works cubist forms crowded together with light barely seeping in around the edges. Some forms were blocky and vertical, recalling skyscrapers, while others were rounded, inspired by the surging motion of the crowds and by the steam clouds that rose from smokestacks and ventilators (Figs. 40, 41).[60] Describing this new work to newspaper reporters, he used the symbolist language of correspondences, emphasizing that these were not

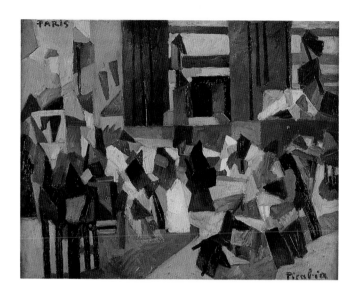

Fig. 39. Francis Picabia, *Paris*, ca. 1912. Oil on canvas, 28¾ × 36¼ in.

Fig. 38 (facing). Robert Delaunay, *The Cardiff Team*, 1912–13. Oil on canvas, 128⅜ × 81⅞ in.

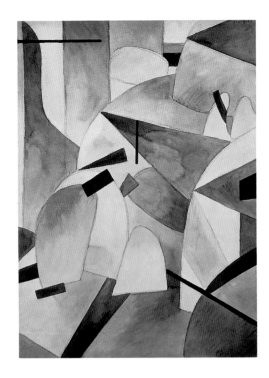

illustrations but pure paintings. He did not, he explained excitedly, paint the city literally but registered his sensations by finding abstract equivalents for New York's "stupendous skyscrapers" and "breathless haste." His watercolors captured the essence of Manhattan's "spirit of modernity."[61] He even insinuated that his technique in them—quick and improvisational—was analogous to the energetic pace of the city. Not surprisingly, Stieglitz, whose aesthetic was also based on a theory of equivalents and who championed Kandinsky over the cubists, was so taken with these abstractions and with Picabia's enthusiasm for New York that he exhibited the works at 291.

Two years later the much more cautious and intellectual Gleizes also found himself transformed by New York to the extent that he set about creating a new body of work. Coming to America in 1915, when the Puteaux artists were making tentative steps to identify subject matter signifying modernity, Gleizes gravitated immediately to Manhattan's most modern monuments and painted some of the most exuberant and unrestrained paintings of his career. Like Picabia, he had not previously been much of a city painter. His almost overnight conversion from a rather mannered French landscape and cubist figure painter to a celebrant of New York's black jazzmen, skyscrapers, Brooklyn Bridge, Broadway signs, and the rush and energy of crowds demonstrates Manhattan's powerful effect on a foreigner, especially one under the spell of *américanisme*. Comparing his orderly and sedate *Bridges of Paris* (Fig. 42) with his riotous paintings of Brooklyn Bridge and Broadway (Figs. 43, 44), their forms jagged and lively, dramatizes how French visitors could be bedazzled, if only temporarily, by the new sensations of their host city. Gleizes and his wife, Juliette, ultimately lost their appetite for the novelty of New York, despaired of its lack of humanity, and returned to Europe.[62]

When Picabia made a second visit to New York, in 1915, he was still committed to an American-

Fig. 40 (top). Francis Picabia, *Entrance to New York*, 1913. Watercolor over pencil, 29 3/4 × 21 3/4 in.

Fig. 41 (bottom). Francis Picabia, *Negro Song*, 1913. Watercolor on paper, 26 × 22 in.

Fig. 42 (facing, top). Albert Gleizes, *Bridges of Paris*, 1912. Oil on canvas, 23 3/8 × 28 1/2 in.

Fig. 43 (facing, bottom left). Albert Gleizes, *On Brooklyn Bridge*, 1917. Oil on canvas, 63 3/4 × 51 in.

Fig. 44 (facing, bottom right). Albert Gleizes, *Chal Post*, 1915. Oil and gouache on board, 40 1/8 × 30 1/8 in.

inspired art but was no longer interested in New York's fabled energy or in cubism or abstraction. He turned now to another component of the American mythos, the country's reputed superiority in machinery and obsession with material goods. Basing his new work mostly on local American newspaper and magazine advertisements, especially those with drawings of specific products, he began a series of what he called object portraits. We looked at his object portrait of Stieglitz in the Introduction (see Fig. 8). These imaginative compilations of parts from Kodak cameras, American flashlights, Victrolas, and For Ever spark plugs—all new products— were drawn in a deliberately mechanomorphic style akin to that of engineering blueprints and architectural renderings. Picabia simplified and regularized his drawings—making his objects look as precise and as "engineered" as possible—and loaded each of them with associations and signifiers. He named each one, either for an American friend of his or for someone whose attributes he imagined were those of the object.[63] In this turn from city abstractions to mechanical drawings, Picabia reinforced his countrymen's obsession with the American woman, picturing her coyly as nude and sexually charged (and, conversely, depicting Stieglitz as the sexually impotent American male). He made one object portrait of Agnes Ernst Meyer as a very phallic spark plug dancing on two balletic legs, either end ready to be plugged in. Calling it *Portrait d'une jeune fille américaine dans l'état de nudité*, he made her body thick and robust—that of an American amazon— and labeled her bust "For-Ever," a spark plug brand name as well as a word associated with sentimental love and affection (Figs. 45, 46). Two years later Picabia drew an *Américaine* as a lightbulb, ready to screw in, with the English words "flirt" and "divorce" reflected in its glass, as if on a window pane (Fig. 47). Like the spark plug, the bulb is shapely, embodying the French view of American women as athletic and muscular, while "flirt" and "divorce" reference her sexuality and her independence from the conventions surrounding marriage. The allusions to electricity in both portraits comment specifically on the French avant-garde's mythology of the American female's sexual prowess as well as their adulation of Thomas Edison.

Radical in the extreme, these object portraits

signaled Picabia's rejection of the art of painting for the "art" of the engineer and adman, a change in direction the artist credited to his experiences in New York. "Almost immediately upon coming to America," he told a reporter in 1915, "it flashed on me that the genius of the modern world is machinery, and that through machinery art ought to find a most vivid expression. I have been profoundly impressed by the vast mechanical development in America. The machine has become more than a mere adjunct of human life. It is really a part of human life—perhaps the very soul."[64]

Only a European, I suggest, could possibly have seen the United States so reductively and unidimensionally in 1915. Picabia had the psychological and cultural advantages of the foreign traveler, who could choose what to see in the new culture, having no lifelong history or memory of living there to impede his vision. His socialization in Paris helped him to view Manhattan in raw, unnuanced terms as the ultramodern metropolis of the Western world and the American woman as a machine for robust sex. As a Parisian who delighted in outrageous behavior, he basked happily in New York's reception of him as a heavyweight in the French avant-garde and felt confidently entitled to demonstrate to his new American friends the uniqueness of their culture and to help them determine how the art of their country and their century ought to be constructed.

Duchamp's effort to invent an Americanized art was far more subtle and philosophical. When he put *Fountain* on view in 1917 at the exhibition of the Society of Independent Artists, he was making some of the same comments as Picabia, but in a work so layered and complicated that its saturation in *américanisme* was barely transparent. It was an object that both encapsulated a French avant-gardist reading of American culture and solidified a direction Duchamp had begun to take in Paris toward a new art that involved mind and concept as well as the manufactured goods and materials of twentieth-century life. New York in 1917 was an extraordinarily fertile city for Duchamp, influencing him as Paris had long influenced American artists.

Duchamp had stopped painting in oils when he first came to New York and had been experimenting with alternatives. Since 1912, the year he had voiced

PORTRAIT
D'UNE JEUNE FILLE AMERICAINE
DANS L' ÉTAT DE NUDITÉ

FOR-EVER

F. Picabia
5 Juillet 1915
New York

GASOLINE

Squir
of ga
cylind
Prim
and
hums

These
ous
Ford
big
po
ple

guarantee
ommended
Ford deal

RED HE

$1.25 each
supply
stores, or

Emil Gross
Bush Terminal
Brooklyn.

Makers of
Mot

$1 25

AMÉRICAINE

Fig. 45 (top left). Francis Picabia, *Portrait d'une jeune fille américaine dans l'état de nudité*, 1915. From *291*, Nos. 5–6 (July–Aug. 1915).

Fig. 46 (top right). Advertisement for the Red Head Priming Plug. From *The Motor* (Dec. 1914).

Fig. 47 (bottom right). Francis Picabia, *Américaine*, cover for *391* (July 1917).

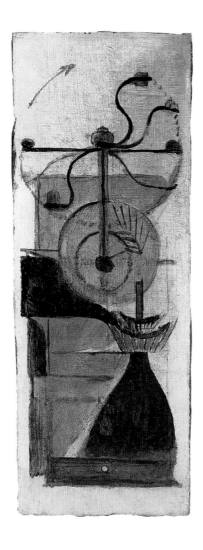

Fig. 48 (top). Marcel Duchamp, *Moulin à café* (*Coffee Mill*), 1911. Oil on board, 28¾ × 13 in.

Fig. 49 (bottom). Coffee mill that belonged to Mary Reynolds.

his doubts about the relevance of oil painting and marble sculpture to an age of airplanes, he had rejected the cubist aesthetic and the sensuous touch of the brush on canvas to work with subjects, materials, and household objects that he identified as closely allied to the modernity of the machine-made world. He had made pieces on glass, using lead wire and metal—materials he associated with industry rather than the fine arts—and had begun to invent freely styled mechanical imagery, drawn in a dry manner that, like Picabia's object portraits, appropriated something from the drawings of the engineer and industrial designer, professional types who seemed more aesthetically integral to modernity than fine artists.[65]

His first machine drawing, a small cubistic work painted in 1911 as a decoration for a brother's kitchen, was based on the shapes and circular hand movements of the *moulin à café* commonly found in French kitchens (Figs. 48, 49). He then went on to make studies and two finished paintings based on a large and clunky chocolate grinder that he had seen in the window of a *chocolaterie* in Rouen (Figs. 50, 51). There was nothing particularly attractive about this *broyeuse de chocolat*—it was hardly Henry Adams's dynamo—but its mechanical action must have appealed to Duchamp; he could watch its two rollers crushing into powder the cocoa beans that had already been coarsely ground. What is so interesting, given how much of a "realist" and vulgarian Duchamp would become in New York, is the element of fantasy and French tradition here. In his hands an untasteful, heavyset European design became a twentieth-century streamlined fantasy machine of three perfectly drawn cylinders balanced on spindly but balletic Louis Quinze legs. He was pleased with the results, which he felt released him from his earlier allegiance to cubism. "Through the introduction of straight perspective and a very geometrical design of a definite grinding machine like this one, I felt definitely out of the Cubist straight jacket."[66] These were the experiments that led him in 1915 to begin the *Large Glass*, which he completed in New York.

From 1913 to 1915 he began another investigation, taking three ordinary objects and casually installing them in his studio for his own pleasure and that of friends. These objects, which as yet had no names, became in retrospect prototypes of *Fountain*

and other readymades Duchamp put on public exhibition once he arrived in New York. All three of them, though radically formulated as works of art—like the coffee and chocolate grinders that inspired his paintings—look quaintly belle époque and European in contrast to the objects Duchamp would gravitate toward in New York's hardware and plumbing shops. His first *objet*, a bicycle wheel, though intimately associated on the Continent with modernity and movement, dated to the earlier pre-automobile era (Fig. 52). (And the stool the wheel was mounted on? Was it not a typical artifact of the traditional French kitchen?) His second, a cheap chromo print of a landscape that he signed and titled, was old-fashioned, Victorian, and sentimentalizing. And the galvanized iron rack for drying wine bottles that Duchamp purchased and displayed in his studio had more in common with the Eiffel Tower of 1889 than with the latest American industrial manufactures of 1914, the year he selected it (Fig. 53).

Duchamp's new machine-mindedness and his use of metal and glass as new art materials—along with his openness to bicycle wheels, coffee grinders, and a chocolate grinder as inspiration—help to explain both his (and Picabia's) desire to experience skyscraper America firsthand, and his quick gravitation toward American products and manufactures once he arrived. What he saw in New York—in shop windows, hardware stores, business offices, and American bathrooms—confirmed the suspicions he had entertained in France: his age belonged more to the engineer, the industrial designer, and the consumer than to the poet and the artist. A notion tentatively held in France became conviction in New York: the most singular quality of his age was not motion, simultaneity, and dynamism, as his Puteaux circle of friends had once proposed, but the total transformation of culture by technology and industry. In such a world, Duchamp mused, artists could do no better than to make their art mirror, in the most literal sense possible, the strange new artifacts of their time. This gave such play to his mind that he began to select objects that embodied both his bemusement and conviction about the unrelenting and unmediated modernity and "Americanness" of the consumer goods he found all around him in Manhattan. It was in New York that he became comfortable and sure enough about found objects to name them, talk about them, and exhibit them in art galleries.[67]

Fig. 50 (top). A chocolate grinder.

Fig. 51 (bottom). Marcel Duchamp, *Chocolate Grinder, No. 2*, 1914. Oil, thread, and pencil on canvas, 25½ × 21¼ in.

Fig. 52 (above). Marcel Duchamp, *Bicycle Wheel*, 1951
(third version, after lost original of 1913).
Metal wheel mounted on painted wood stool,
$50\frac{1}{2} \times 25\frac{1}{2} \times 16\frac{5}{8}$ in.

Fig. 53 (right). Marcel Duchamp, *Bottlerack*, ca. 1936
(after lost original of 1914). Photograph by Man Ray.

As the critic Michel Butor was the first to suggest, when Duchamp chose a urinal, a snow shovel, and a typewriter cover as objets d'art, he selected products as intimately associated with American manufacture as the coffee grinder and drying rack for wine bottles were with French production.[68] (Thirty years ago, in a reverse cross-cultural act, I brought home a wooden coffee grinder with a rich patina that I had bought in a Parisian flea market as a souvenir of old Europe.) Duchamp's American products had no patina or history of use; they were brand-new, each industrially designed and extremely modern in the eyes of a Frenchman unaccustomed to living, as Americans did, with a plethora of manufactured goods. Well before coming, Duchamp had been culturally primed to admire the luxury of the American bathroom and its glistening white appliances, but it was the spectacle of plumbers' showrooms in New York—such as Mott's on lower Fifth Avenue—that inspired his *Fountain* for the Independents' exhibition (Fig. 54). And it is easy to imagine how futuristic a snow shovel of wood and galvanized iron hanging or stacked in multiples in a hardware store—the store itself a marvel to a foreigner—might appear to a Frenchman accustomed to streets swept of snow by brooms of straw or twigs whose design had changed little since the Middle Ages (Fig. 55). "He and Crotti had never seen a snow shovel before," a Duchamp biographer confirms; "they did not make such things in France. Duchamp remembered very clearly how pleased and proud Crotti had looked as he carried their purchase, slung like a rifle on his shoulder, the few blocks to their shared studio in the Lincoln Arcade, where Duchamp, after painting on the title [*In Advance of the Broken Arm*] and signing it '[from] Marcel Duchamp 1915' (to show that it was not 'by' but a selection 'from' the artist), tied a wire to the handle and hung it from the ceiling."[69]

Similarly, the American typewriter for Duchamp's generation epitomized the revolution in modern communications, much as photocopying machines and computers have done for our own. Americans were famous the world over for their efficient and utilitarian office equipment; and typewriters in the war years, especially Underwoods and Remingtons, were on their way to becoming stock modern items that the avant-garde admired. Erik Satie included typewriter bells and key clickings in his

Fig. 54 (top). J. L. Mott Iron Works, showroom, New York, 1914.

Fig. 55 (bottom). Marcel Duchamp, *In Advance of the Broken Arm*, 1915. Wood and galvanized iron snow shovel, height 48 in.

score for the ballet *Parade* (1917), along with the sounds of telegraphs, sirens, airplanes, and revolvers. As a dadaist event in Berlin, George Grosz helped to orchestrate a "race" between six typewriters and six sewing machines, while back in Paris Duchamp's friend Cendrars, in his essay "Profond aujourd'hui," included the typewriter along with the microscope, coal mines, locomotive, billboard, streetcar, cigars, alarm clocks, tall buildings, and black music in a poetic evocation of things that had transformed human existence.[70]

Duchamp learned how to type and acquired his first typewriter in America.[71] His choice of the boxy black rubber typewriter cover for his art *objet* — and not the more heavyset equipment—was compatible with his interest in synthetic materials and his new inclination toward streamlined rather than clunky goods (Fig. 56). Shiny, slick, and pliable, the cover was decidedly modern in material and design, even a bit surreal, and most certainly luxurious to eyes singling out what made American products so distinctive. Duchamp found American rubber goods so seductive that he made another piece from colored bathing caps, which he cut up, glued together, and stretched from corners of his studio, as he put it in a letter, like "a sort of multicolored cobweb."[72] In calling the first piece *Traveler's Folding Item* and the second *Sculpture for Traveling*, he brilliantly signaled their novelty as sculpture—both pieces were pliable and portable—as well as his own awareness of being an émigré, a traveler, in New York. His titles were those of an exceedingly self-conscious artist in exile.

It was in New York that Duchamp came up with the name "readymade" and formally launched as art what had previously been more research than product.[73] He appropriated from the industrial vernacular a modern term that signaled, in its very construction, the obsolescence of art making that depended on a skilled hand. "Ready-made" meant prefabricated, not customized. At the time, the term described off-the-rack clothes and, more generally, any mass-produced goods.[74] But it also signified middle- and lower-class taste and the new mass consumption that was displacing the custom trades. It was the perfect choice for an artist who detested tastefulness and questioned every inherited boundary of art making, especially those hierarchical categories

that declared what was and was not art—or what was and was not beautiful.

Although he began to study the language upon arrival, Duchamp spoke very little English when he came to this country, using French with friends and generally assigning French titles to his pieces. In naming his objects readymades, then, he was clearly electing a word foreign to him and enjoying the transatlantic wordplay that such an act inscribed, aligning his new body of work with advanced American modes of manufacture rather than anything French. (The nearest equivalent in French for ready-made, *tout fait*, like the coffee grinder, was too continental, without the American concision Duchamp now favored.) He was also participating in the early stages of a broader linguistic practice that the French indulge in to this day: co-opting English words to describe modern inventions that are specifically American (sometimes British) rather than inventing French ones. Thus *"le base-ball," "le charleston," "le cake-walk," "le cow-boy," "le cock-tail," "le drugstore,"* and *"le jazz"* maintain the objects' foreignness to French culture while simultaneously adopting them into the French language. Through such practice English words became French slang, a way of owning and disowning the invention at the same time. Beginning early in the century, French artists and writers used a liberal sprinkling of English words in their collages, their poetry, and their prose, showing off their hipness to American culture and in the process creating a new hybrid Franco-American art language. Duchamp and Picabia used French and English interchangeably in their dadaist word-objects, often consciously using both languages in the same work of art. In New York, Duchamp called the group he and Katherine Dreier established the Société Anonyme (S.A. in French is equivalent to Inc. in English). Back home in Paris under the spell of *américanisme*, Picasso, who knew no English and, though he always spoke of going to America, never went, called Braque *"mon cher Wilbur"* and—using cowboy talk—*"notre pard."*[75]

When Duchamp invented his pseudonym Richard Mutt, he did so not only as a word-conscious foreigner but also as a participant in this new system of transatlantic linguistics. It is now well known that the name began as a play on Mott Works, the

plumbing manufacturer from which the artist proba-
bly bought the urinal.[76] He then changed Mott to
Mutt to take on the identity of one of the most popu-
lar American comic strip characters of the day.
"Mott was too close," he said, so "I altered it to
Mutt, after the daily strip cartoon, 'Mutt and Jeff'
which appeared at the time, and with which every-
one was familiar." He took the first name Richard,
he continued, because it was French slang for "fat
cat" or "moneybags."[77] The result, Richard Mutt,
was a witty amalgam of two character types that fas-
cinated the French intelligentsia: the American ty-
coon—a rich old moneybags—and the comic strip
character, in this case a beanpole of a fellow who ran
around with a funny little fat man (Fig. 57).

Though many years later Duchamp said that he
had chosen the name casually, that he "wanted any
old name," one cannot take him literally.[78] Although
"Richard" was a French in-joke, "Mutt" was too rich
in associations for the 1917 audience of *Fountain* to
be "any old name." In America today, the effect of
adopting Mutt would be like that of taking the name
Doonesbury. Given that Apollinaire and others in
France had identified comics, along with detective
stories, as quintessential forms of American popular
culture, freer and less hidebound than anything
French, and given that the cover for the *Blind Man*
had been commissioned from an American cartoon-
ist, Duchamp's choice has, in retrospect, a certain in-
evitability. For Katherine Dreier, who did not know
her friend Duchamp was the true artist of *Fountain*
and who voted to reject it for the Independents' exhi-
bition, the name was the most clear-cut reason to
dismiss the piece: "In my judgment Richard Mutt
caused the greatest confusion by signing a name
which is known to the whole newspaper world as a
popular joker. 'Mutt and Jeff' are too famous not to
make people suspect, if their name is used, that the
matter may be a joke."[79] Dreier, like most New York-
ers, was not yet in tune with those in the European
avant-garde who held that the comics were better
literature than anything put out by the literary
establishment.

Naming his urinal *Fountain*, a word with the
same meaning in French and English, was another
transatlantic act embodying the discourse between
old Europe and new America that shaped thinking
and commentary at the time. The title not only

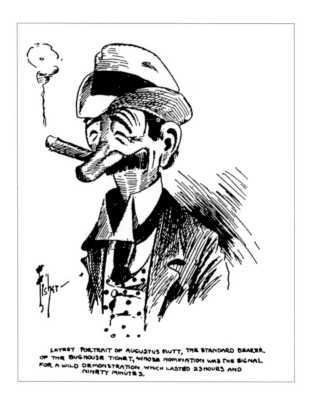

Fig. 56 (top). Marcel Duchamp, *Traveler's Folding
Item*, 1964 (after lost 1916 original). Black plastic,
9¹⁄₁₆ × 16 × 11½ in.

Fig. 57 (bottom). Bud (H. C.) Fisher, *Portrait of
Augustus Mutt*.

underscored, comedically and poignantly, what the urinal most certainly was *not*, but also dramatized the profound differences between the Old and New Worlds. Like a fountain a urinal was sculptural and played water over its surfaces. But it was also a commercial, mass-produced artifact that in its proper place—the men's room—was a private affair between a man and his business. It was *not* what fountains had been for centuries: graceful adornments in gardens, on street corners, and in plazas. In France, antique fountains are *public* monuments, dotting every village and city square and adding old-world charm to their settings. Given European admiration of American plumbing, a New York urinal epitomized the New World as much as fountains did the Old. The same linguistic logic was often applied to skyscrapers, which commentators on both sides of the Atlantic regularly referred to as palaces and cathedrals, thereby underscoring their weightiness as architectural monuments but also their shocking differences from European structures. Such a figurative reference registered not only cultural irony but also the awareness, sometimes bitter, sometimes joyous, that yesterday's forms of architecture, along with the power of royalty and religion, were being displaced. Today's forms were dictated by the new powers of commerce and manufacture. Progress ensured that what was American today would probably be European tomorrow.

That Duchamp chose a urinal, and not, say, a sink, toilet, or tub, also bespoke a French perspective, and a very male one at that. Given the centrality in Parisian male culture of the pissoir, a long communal trough, the urinal possessed an almost talismanic force for a Frenchman musing about the differences between new- and old-world cultures. Louis Lozowick reported that the French could never fathom how American men survived without public toilets. What did an American do, he was asked in Paris in the 1920s, when the call of nature came and "there are not street pissoirs to relieve yourself?"[80] Duchamp, who once referred to *Fountain* as a *pissotière*, vernacular for pissoir, in some sense answered his countrymen's query, demonstrating that there were pissoirs in America, but *quelle différence!*[81] Here such fixtures were made, not of dark and dank cast iron, but of shiny, white porcelain, their design so modern, so abstract, that one of them could be put on its back to conjure up

sly figural connotations or, alternatively, to force the spectator's gaze to pee, metaphorically, into the bowl.

This brings me to two final comments on Duchamp's *Fountain*, both linked to the artist's sensitivity to the non-Europeanness of New York (or its Americanness) and his desire to help Americans launch their own national art. First, Duchamp parodically acted out in his readymades the rituals of the modern American consumer. We might say that Duchamp was the last great French flaneur, the late-nineteenth-century man-about-town, his "looking" transmuted into twentieth-century "consuming." Duchamp walked the streets of New York and took in the spectacle, like Baudelaire and the impressionists in Paris, but he also consumed New York's modernity, both figuratively and literally, making selective purchases, distilling modern-day life in America into visual bites. His *Fountain* was, as the explanation went in the *Blind Man*, "a fixture that you see every day in plumbers' show windows."

By installing these objects in his studio, where he sometimes hung them from the ceiling, or in galleries, where they might lean up against a wall or be put on a pedestal, he mimicked the display techniques he found everywhere in his host city, but especially along Fifth Avenue, where he purchased the urinal, and in hardware stores, where he bought his shovel. While plenitude and abundance often governed window and store displays at the time, billboard and magazine advertisements featured a single example of a product, often in large scale, abstracted from use and surrounded by empty space. By putting isolated objects on display and making no reference to the work they did, Duchamp created a kinship between his readymades and those in advertising and display, of which he was such a student.[82]

Second, if *Fountain* conveyed a sense of wonder at the design of modern products in this country, and the way they were displayed and marketed, it also aimed a French barb at puritanical American culture. *Fountain* was a bawdy and erotic work of art, a Frenchman's jab at repressed America, especially male America. Although the artist argued that he chose his readymades indifferent to their aesthetic properties, evidence clearly shows that Duchamp was not random in his choices; he was always guided by the *américanisme* that shaped his first

years in New York.[83] As a visitor Duchamp did not employ chance and pick from anything and everything in New York. Every shop window was not equal, nor were all objects: some expressed a foreigner's engagement with American culture better than others. While there were always alternatives, when Duchamp chose a urinal, a typewriter cover, and a snow shovel, each object neatly encapsulated a French intellectual's critique of America. His was not only the eye of the flâneur but that of the cross-cultural commentator, choosing his objects for their capacity to inspire bicontinental debate and dialogue. What may have been a quick decision, as buying the urinal seems to have been, was nonetheless deeply shaped by his being a foreigner with a strong predisposition to define the essence of American culture as not just materialist and commercial but sexually puritanical and overconcerned with hygiene.

As a commentator he gravitated toward consumer objects like the urinal and the typewriter cover that could reference human, and especially female, bodies. Bodies, particularly nude or sexualized ones, had no part in American art making at the time, an absence Duchamp was quick to point out. When he came to New York, he was already at work on his *Large Glass,* where he had plotted elaborate allusions to copulation and masturbation, and to male and female sexual parts, allegorizing the whole as a mechanical bride (that is, an American girl) and her bachelors. And in his bottle rack readymade he had chosen a tower of spiky (male) forms that fit into the (female) mouths of wine bottles. In New York his work, like that of Picabia, was often aggressively erotic, underlining the suppression of sexuality he found abroad. Picabia drew attention to his eroticism by referring in the titles of his works to "the American girl"; Duchamp, always the less obvious of the two, made more underhanded references to her.

Duchamp's Underwood typewriter cover is a case in point. Typewriters in 1916 were construed and advertised as a woman's tool, their arrival in the office having played a revolutionary role in feminizing clerical work in the late nineteenth and early twentieth centuries. By 1920 women held ninety percent of all typing and stenography jobs in this country.[84] The typewriter was a woman's stock-in-trade, as closely identified with women as the refrigerator and, eventually, the telephone. When Duchamp, then, took the rubber cover of a typewriter—it was soft and pliable but held its shape—and put it on display, perhaps over a wooden rod, "high enough to induce the onlooker to bend and see what is hidden by the cover," he was treating his object in a way consonant with contemporary gender roles and his own fascination with American culture, especially its "new woman."[85] Composed to look like a woman's skirt, with a phallic wooden rod holding it up, and called *Traveler's Folding Item,* suggesting sex, or masturbatory pleasures, on the road or away from home, the piece is replete with wordplay. The brand name Underwood on the typewriter cover not only directed viewers to look under but also playfully described the wooden rod they would see there even as it countered that description, for the cover was positioned over wood, not under it. The word also played on *underwear,* which the piece, once viewers investigate, clearly does not have. And then there is the possible reference to being under an actual American girl, Beatrice Wood, one of Duchamp's best female friends in America, with whom both he and Roché had an affair.[86] Duchamp could not have had nearly as much male fun with a Remington cover.

Even the rubber material of the typewriter cover had sexual, sensual connotations for Duchamp. When Duchamp and Jean Crotti were interviewed together in 1916, they started the discussion by reporting how beautiful they found the American woman and how pathetically ineffectual the American man in satisfying her. "More and more beautiful American girls should come to Europe where we know how to appreciate them," Crotti was quoted as saying before he segued seamlessly into a comment on the sensuous beauty of "a pair of large muddy goulashes [*sic*]" in the studio he shared with Duchamp, telling the reporter that as a modern artist, rather than as a man, he was turned on by modern goods, not women. Pointing to both the rubber boots and the shovel in the room, he declared these "much more interesting and decorative than a pretty woman," thereby collapsing the readymade, rubber as a material, and pretty American women into one seductive package that typified his, Duchamp's, and Picabia's pursuits in New York.[87]

Duchamp's friends, we remember, remarked on *Fountain*'s form as Buddha- and Madonna-like. Louise Norton's article in the *Blind Man* on *Fountain* was entitled "Buddha of the Bathroom," and Beatrice Wood noted in her memoir that the piece was

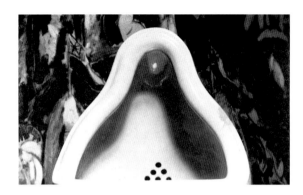

Fig. 58. Alfred Stieglitz, *Fountain*, 1917 (cropped version). Gelatin silver print, 4¼ × 7 in.

renamed "Madonna of the Bathroom."[88] As some scholars remind us, these were not Duchamp's words but those of others who were responding to the anthropomorphic suggestiveness in Stieglitz's *Fountain* photograph. Such responses offer evidence of the rich cross-cultural dialogue that Duchamp's piece set in motion. These analogies to Buddha and the Madonna not only became popular in Duchamp's New York circle but also circulated transatlantically, within his French one. Carl Van Vechten certified in writing to Gertrude Stein that "the photographs make it look like anything from a Madonna to a Buddha." Apollinaire, writing for *Mercure de France* in Paris, said of *Fountain* that Duchamp "ennobled" his subject "by transforming a hygienic object of masculine toilet into a Buddha."[89]

None of this talk in print, interestingly enough, touched on the piece's pronounced sexuality as presented in Stieglitz's photograph. Surely Duchamp's defenders did not miss the obvious, but they did suppress it, their silence attributable to gentility and deep-seated taboos that Duchamp understood better than most. Americans, even progressive ones, did not talk about things sexual in public. But sexuality was a regular part of the Frenchman Duchamp's vocabulary, and he often used his art as a forum for coded discussions about nudity, genitalia, and sexual performance. Indeed it might even be argued that it was in New York, where sexual taboos were so much in evidence, that Duchamp began to overstate sexuality as a theme in his art. The male-femaleness of *Fountain* would soon find its way into his cross-sexualizing of the Mona Lisa by adding a mustache and goatee to her face and then his own cross-dressing to take on the female persona of Rrose Sélavy. Herein was a continual set of lessons he was delivering to his staid American public; sex and art were not mutually exclusive.

In taking *Fountain* to Stieglitz for a photograph, Duchamp offered his American colleague an interesting challenge: how casually or pointedly should the piece be photographed? Stieglitz rose to the occasion, offering a brilliant interpretation. He comfortably photographed the urinal as Duchamp himself might have most enjoyed it, as a sexualized body, and at the same time, he carefully arranged the lighting so that the urinal could also be read as an American symbolist might prefer to see it, as a meditative hooded figure. In one print Stieglitz completely

cropped off the "arms" and "genitalia" to make the urinal reference a cloaked figure (Fig. 58). (This, we might say, was the second-circle rendition, or, as the irreverent in me would have it, the version that most resembles, not the Virgin Mary, but Gertrude Stein.) But the photograph Duchamp published represented the entire fixture on a pedestal, positioned so that it might easily be read as a squat figure, hooded or otherwise, with vestigial arms and prominent genitalia. The suggestion of hermaphroditism in the center pipe opening, simultaneously phallic and vaginal, offered a set of associations made all the more hilarious when the piece was then constructed by Duchamp's friends as a Madonna or Buddha.

In photographing *Fountain*, Stieglitz also emphasized the work's modern sculptural qualities: smooth, undecorated surfaces, clean outlines, minimal detail. He photographed it ceremoniously just as he often posed artists, straight on and against a painting on a wall, in this case one by Marsden Hartley called *The Warriors*, another work of transatlantic exchange; its subject was German soldiers, painted by an American modernist working in Berlin (Fig. 59). In the painting's center, there was a shape very much like the outline of the urinal. Describing it as a work of modern abstract art was another way Duchamp's apologists could talk about the object without directly confronting its sexual nature. Louise Norton thought *Fountain* "pleasant" in its "chaste simplicity of line and color!"[90] And Walter Arensberg defended it as "a lovely form . . . freed from its functional purpose."[91]

What no one seemed to have said at that time,

Fig. 59. Marsden Hartley, *The Warriors*, 1913.
Oil on canvas, $47^{3}/_{4} \times 47^{1}/_{2}$ in.

Fig. 60. Constantin Brancusi, *Princess X*, 1915–16. Polished bronze on limestone block, 22⅝ × 9 × 16¼ in.

though observers have remarked upon it recently, was how much Duchamp's readymade looked like the very abstracted, stylized, and sexualized sculptures of Brancusi. Brancusi and Duchamp were friends, and it seems impossible to imagine that Duchamp did not have works such as Brancusi's *Princess X*—or at least the sculptor's aesthetic—in the back of his mind when he chose the urinal (Fig. 60). *Princess X* was in the 1917 Independents' exhibition and should have incited some response. But its phallus and balls were politely passed over in the press except by one reviewer, clearly upset, who wrote that "phallic symbolism under the guise of portraiture should not be permitted in any public exhibition hall, jury or no jury. . . . America likes and demands clean art."[92] Had *Fountain* and *Princess X* been placed next to each other, Duchamp's urinal would have looked like a Brancusi take-off: both of them highly abstracted and rounded figures with pronounced genitalia.[93]

This is to suggest, not that Duchamp consciously parodied Brancusi so much as that he mused upon the extraordinarily thin line that separated good modern European sculpture from good American industrial design. We know that he brought such concerns with him from Paris, where he had questioned the tyranny of aesthetic hierarchies that so resolutely separated the useful arts from the fine arts, particularly in a technological age when he and some of his friends found cars and airplanes just as beautiful as anything made by an artist. When in 1913 he had first mounted a bicycle wheel so that it could be rotated, he was thinking about the wheel's artistic properties (geometry, symmetry, a line drawing in space) and, at the same time, about speed and dynamism as properties art would have to incorporate if it were to be truly of the modern world. He may even have been thinking about La Grande Roule, the gigantic Ferris wheel that, operating in Paris since the 1900 exposition, was one of the city's great modern structures. One scholar made the nice suggestion that Duchamp may have thought of his bicycle wheel as a domestically scaled Ferris wheel, and his bottle rack as a mimic of the Eiffel Tower, the first structure in Paris to be popularly understood as architecture of the modern age.[94]

In *Fountain* Duchamp extended this inquiry, pondering the formal sculptural qualities inherent in

American modern design and deliberately folding the fine into the industrial arts while refusing to judge one more valid than the other. If we recall the heavy lines and awkward complexity of the chocolate mixer Duchamp had once admired, it is clear that in choosing the urinal, as well as the shovel and the typewriter cover, Duchamp now gravitated toward manufactured objects embodying a particular aesthetic: starkly abstract design, monochromatic and elegantly sculptural in form. (This is the aesthetic he initiated in the *Chocolate Grinder* when he was inventing a fantasy machine.) Most of his American readymades are so simple that their shapes are easy to recall. One was a tin chimney ventilator that is now lost but fits this same description. He titled it in English, *Pulled at Four Pins*, a literal translation of "tiré à quatre épingles," which in French means "impeccably groomed" or, we might say, given how much Victorian embellishment and complexity of form were still a dominant taste, streamlined and modern.[95]

A few years later, in 1921, Duchamp's "Archie Pen Co." advertisement for an Archipenko exhibition at the Société Anonyme gallery in New York made fine-edged humor out of his American investigations into the elastic line between twentieth-century fine and industrial arts.[96] In it he merged an Archipenko figural sculpture with the design of a modern fountain pen, much as he might have analogized the Eiffel Tower and a bottle rack or a Brancusi and a urinal (Fig. 61). The accompanying copy parodied the celebration and hype of modern fountain pen advertisements: "Write us if you are unable to secure genuine Archie Pens at your favorite stationer" and "It does away with blotter [*sic*]." The image Duchamp concocted of an Archipenko-style pen poised elegantly upright on its metal nib was also a common advertising image (see Fig. 107).[97] Duchamp continued in these years to ask where artfulness lay in the modern world and how a self-respecting artist should practice his trade in an industrial age.

In questioning such hierarchies and registering skepticism about the continued necessity for the "fine" arts, Duchamp helped to initiate a much wider anti-Victorian campaign in avant-garde circles, both French and American, to see beauty and vitality in what Stieglitz and others with educated tastes customarily dismissed as vulgar. Part of his

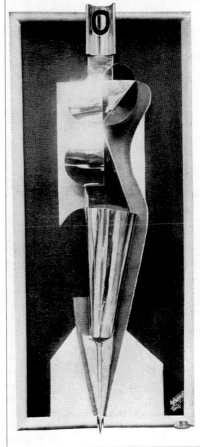

Fig. 61. Marcel Duchamp, "Archie Pen Co." advertisement, 1921. From *The Arts* (Feb.–Mar. 1921).

program was to call taste into question and deconstruct its power and control over the art world. (A French word for one of Duchamp's first readymades, the bottle rack, is *égouttoir*, which can also mean "something without taste.")[98] In New York, Duchamp took tremendous pleasure in jostling common assumptions about tastefulness. He told McBride, we remember, knowing full well how much Americans admired everything haute about Paris, that he loved New York because it was messy and not, like the French capital, a boring city of good taste. And one night when dining out with the Arensbergs, he added his signature to an old-school academic mural on the wall of a New York restaurant, transforming it, as he said later, into "a readymade which had everything except taste."[99]

Such were the difficult lessons Duchamp inflicted upon his New York audiences, his attacks being as much anti-aesthetic as antibourgeois. Among other targets, he aimed his barbs at the fin-de-siècle "tastefulness" of the symbolists, who had elevated art to the empyrean and condemned contemporary American life as hollow and vulgar. When he chose a urinal, an advertisement, or a cheap chromolithograph, he was quietly subverting the tyranny of those symbolist aesthetes—Stieglitz among them—who continually armed themselves against incursions from the common world. Although Duchamp was not above certain aesthete practices—fashioning himself as a dandy, for example—he used his art, especially his readymades, to challenge those who believed that art could be separated from, or elevated beyond, the realities of everyday life.[100] In the readymades, he was the ultimate down-to-earth realist, choosing artifacts he deemed uniquely modern in design and function.

In New York, Duchamp's sense of those realities was so deeply conditioned by European *américanisme* that he was way out in front of his audience. With some scattered exceptions, progressive American artists had not yet endorsed comics, plumbing, and bridges as their national art forms, and if they had, their endorsement was accompanied by embarrassment for what such judgments said about the fine arts in their country.[101] There was no local artist who would unconditionally declare, as Duchamp did when he arrived, that Manhattan was "a work of art, a complete work of art."[102] While New York had artists who had begun to see something American in

skyscrapers—Stieglitz a decade earlier had called the Flatiron Building "a new America in the making"—it was another thing to propose, as Duchamp did, signing the Woolworth Building and transforming it into a readymade even before the construction crews had finished it.[103] Furthermore, New York locals could easily take for granted things that Europeans found extraordinary. This was certainly the case with the American bathroom, which attracted far less attention at home than abroad, where an artist like Diego Rivera delivered "orations on the beauty of American plumbing" and where D. H. Lawrence, in his *Studies in Classic American Literature*, reduced the United States to two pursuits, "some insisting on the plumbing, and some on saving the world: these being the two great American specialties."[104] When Duchamp and his fellow conspirators wrote that *Fountain* was an appropriate American work of art because "the only works of art America has given are her plumbing and her bridges," they were not being entirely flip but were stating a position many Europeans endorsed. In their eyes, the United States was not an old country of traditional culture but a young nation of industry and engineering.

In proposing a new American art consonant with this view, Duchamp threw current artistic practices in New York into relief. But because his proposal was cloaked in iconoclastic humor, Stieglitz and his artists, like so many others, missed most of Duchamp's sermon and caught only the joke. From all the evidence, Stieglitz admired Duchamp's intelligence and provocations. "Wait until Duchamp sees them," he said upon seeing Dove's first assemblages, seeing a kinship between the readymades and Dove's short-lived use of commercial goods in his collages (see Fig. 9).[105] But Stieglitz was not prepared to see in Duchamp, a foreigner and temporary resident, a serious contender in the quest for a new American art. The second circle would flirt with, but never capitulate to, any proposal suggesting that in the country's industrial makeup, its commercial life and popular culture, lay untapped artistic materials, as well as an inchoate modernist iconography, style, beauty, and humor.

A few in the American art community, however, did understand Duchamp's deeper exhortations, and

more would hear his message in the decade to come. Frank Crowninshield, the editor of *Vanity Fair*, supported Duchamp and thanked him and his coeditors, in a letter to the *Blind Man*, for "fostering an encouragement of a truly native art. An art which will be at once the result of a highly vitalized age, of a restless artistic spirit, and of a sudden realization,—on the part of our artists—of America's high destiny in the future of the world." Crowninshield's optimism sounded much like the faith resounding at the same moment through the pages of the *Seven Arts*, that the great age of American art and letters was just around the corner. But that art could not have been more different from what the *Seven Arts* crowd was advocating. Crowninshield talked, not of spirit and soil, but of machines and popular culture. Duchamp was helping Americans learn how to make an art "which shall truly represent our age, even if the age is one of telephones, submarines, aeroplanes, cabarets, cocktails, taxicabs, divorce courts, wars, tangos, dollar signs." Predicting great things to come, he prophesied that someday people would look back and say, "Yes, they had an art, back in New York, in the days following the Great War . . . [one] that mirrored accurately their time, with all of its complexities, graces, horrors, pleasures, agonies, uncertainties and blessings."[106]

Duchamp had a few other American allies. Beginning soon after 1910, there were signs of a New York variant of European *américanisme*, but one that had none of the purity of stereotypes and fewer of the comparisons of Old World to New World that dominated a Paris that was feeling its age. By the time Duchamp came to the United States, Charles Demuth and Marsden Hartley had become advocates of the American circus and vaudeville, Stuart Davis was ferreting out jazz spots, and John Marin, Max Weber, and Joseph Stella were painting cubist urbanscapes of Manhattan, with skyscrapers, bridges, and crowds. By early 1915 Morton Schamberg, having painted his first mechanical object, was ripe for close friendships with Duchamp and Picabia, who would reinforce his fascination with machinery and his desire to develop a new mechanical style of art.[107] In *God*, made out of a miter box and plumbing trap, Schamberg, working with the New York artist Baroness Elsa von Freytag-Loringhoven, echoed Duchamp's view of America as the country where the art of plumbing was more advanced than the

art of painting or sculpture, though their piece was relatively chaste and sexless, appropriately puritan, when put up against *Fountain*'s sexual blatancy (Fig. 62). Duchamp liked the piece so much that many years later he installed it among his own readymades in the Arensberg collection at the Philadelphia Museum of Art.

Another young artist who adopted Duchamp as mentor and completely capitulated to the French preoccupation with sexually charged machines was Man Ray. In the spirit of Duchamp's readymades and Picabia's mechanomorphic drawings, Man Ray photographed a phallic eggbeater and titled the print *Man* and made another of two metal reflectors (breasts) and six clothespins clipped to glass entitled *Woman*. In 1917 and again in 1920 he also made sculptures—Duchamp would have called them assisted readymades—entitled *New York* (Figs. 63, 64). The first was a cluster of wooden bars looking abstractly like skyscrapers held together tightly by a metal C-clamp, and the second, a tall cylindrical glass jar stuffed, not with olives, but with ball bearings. This was the New York mythology, a densely packed skyscraper city, made of steel and glass, represented in a vocabulary of phallic and ovular forms under compression. In the 1920s Man Ray, following in Duchamp's footsteps, made art about the New York–Paris axis. In 1919, before leaving Paris to go back to New York, Duchamp had a vial of Paris air sealed by a pharmacist. He gave it to the Arensbergs as a transatlantic present and as a readymade to add to their collection (Fig. 65). In a similar spirit Man Ray created a collage, using a photograph he had made of burned safety matches and debris, titled *New York*, and a second photograph of a section of a map of Paris. Between New York and Paris he put the printed words *Trans Atlantique*. In the background checkerboard pattern, Man Ray paid homage to Duchamp's love of chess and used the game as a metaphor for the maneuvers and comings and goings of artists between New York and Paris (Fig. 66).

Later chapters return to some of these Americans. But one of them, Robert Coady, promoted skyscraper America so passionately during the war and thought so much like Duchamp and his colleagues that he must be considered here. A New Yorker, Coady evolved his own version of *américanisme*, more fervid, romantic, and nationalistic than that of

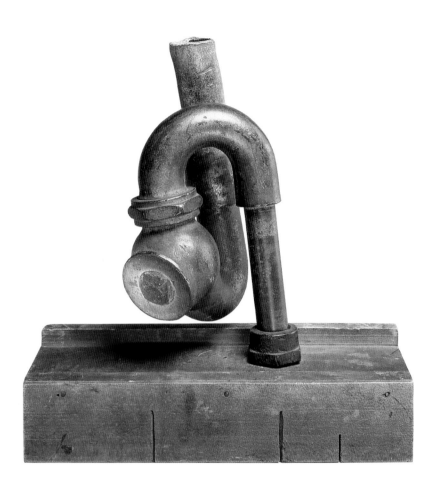

Fig. 62 (above). Baroness Elsa von Freytag-Loringhoven and Morton Schamberg, *God,* ca. 1918. Miter-box and cast-iron plumbing trap, height 10½ in.

Fig. 63 (facing, left). Man Ray, *New York 17,* 1966. Original work lost. Chrome-plated bronze and brass and painted brass vise, $17\frac{3}{8} \times 9\frac{1}{4} \times 9\frac{1}{4}$ in.

Fig. 64 (facing, right). Man Ray, *Export Commodity* or *New York,* 1920. Metal bearings and glass jar, height 11 in.

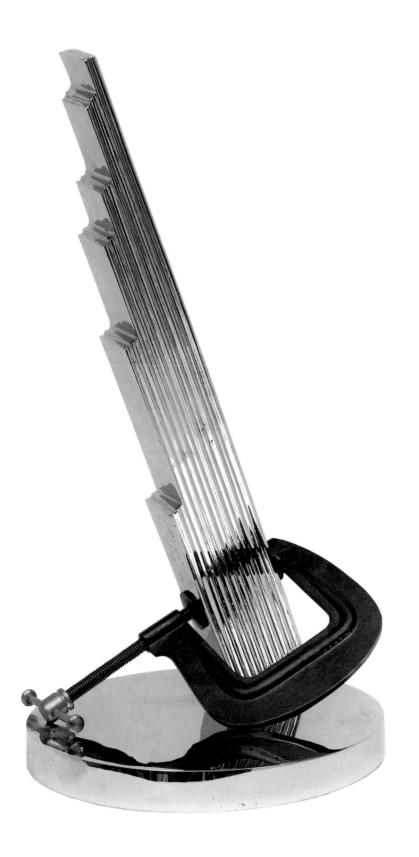
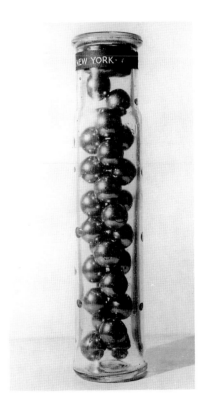

Fig. 65 (left). Marcel Duchamp, *Air de Paris*
(50 cc of Paris Air), 1919. Glass, height 5¼ in.

Fig. 66 (right). Man Ray, *Trans Atlantique*, 1921.
Collage. Photograph by Guerin.

the French. Running through the pages of his short-lived little magazine the *Soil*, Coady's message was clear: America had a great and genuine culture, but it was not to be found in the museums or, as yet, in modern American art. The real American culture, Coady asserted, was "outside of our art world," in American film, comics, and dime novels; in minstrelsy, vaudeville, jazz, and ragtime; in skyscrapers, bridges, railroad stations; in posters and electric signs.[108]

The *Soil* was published for five issues in 1916–17, when the French art colony was active in New York. Although the masthead listed Enrique Cross as literary, and Coady as artistic, editor, Coady was the magazine's guiding spirit.[109] Described as a "pugnacious red-headed Irishman" and a "driving, enthusiastic, fast-talking fellow, on fire with his ideas," Coady taunted and bullied the modernist establishment while pointing the direction he believed American artists would have to move if there was ever to be a native school of art.[110] Although he had none of the savoir faire of Duchamp and Roché, the French exiles adopted him as a kindred spirit. (Léger, we will see in the chapter that follows, made a similar Franco-American alliance with Gerald Murphy.) Duchamp referred to him as "our friend Coady," and Roché advised readers in the first issue of the *Blind Man* to read Coady's magazine to understand the artistic revolution under way: "Every American who wishes to be aware of America should read 'The Soil.'"[111]

Duchamp and Roché appropriated Coady more as an American primitive than as an equal, much as they had Louis Eilshemius, an unsophisticated painter whose canvases of nudes were so crude as to be elevated in their estimation. Similarly, Coady's style of writing was crude in being meandering, eclectic, and highly personal. Sometimes Whitmanesque and incantatory, at others browbeating and arrogant, Coady offered lists, asides, and a dizzying array of articles, photographs, and poetry. But two major theoretical assumptions lay behind his seemingly random parade of information and pictures: first, that any genuine art was spontaneous and expressive, free of reliance on other art forms or on academic formulas, and second, that America had no modern art because its modernists were still too beholden to European isms.

Coady's faith in the untutored eye and in free expression accounts for the wide range of illustrations in the *Soil*, which included Archaic Greek sculpture, African pieces, Chaldean figures, Egyptian paintings, Van Gogh, and Henri Rousseau as well as skyscrapers, prizefighters, rodeo riders, and entertainers. In Coady's canon these were all instances in which art had developed instinctively from healthy contact with "the soil." His insistence on spontaneity and freshness also underlay his merciless mocking of the avant-garde. Though he ran an art gallery in New York, selling work by such French modernists as Juan Gris, Picasso, and Léger, he accused most contemporary modern artists, American and European, of producing work as academic and anemic as the representational art they had once revolted against. "Our 'new men,'" he wrote, "are the 'ismists' who are more interested in theories than art. None of this is American; none of it has come from the soil." What's the difference, he fumed, between the wire portrait sculpture of Jean Crotti, a supposedly "big artist," and that of a "little artist" such as a plumber?[112]

Against the bankruptcy of modern art, Coady held up a vision of American culture that Duchamp applauded. The true American artists of the moment were not those in the galleries and museums but those of the street. In the first issue of the *Soil*, Coady hymned a Whitmanesque list of the country's achievements:

> The Panama Canal, the Sky-scraper and Colonial Architecture. The East River, the Battery and the "Fish Theatre." The Tug Boat and the Steam-shovel. The Steam Lighter. The Steel Plants, the Washing Plants and the Electrical Shops. The Bridges, the Docks, the Cutouts, the Viaducts. . . . Indian Beadwork, Sculptures, Decorations, Music and Dances. . . . Bert Williams, Rag-time, the Buck and Wing and the Clog. . . . The Minstrels. The Cigar-store Indians. The Hatters, the Shoe-makers, the Haberdashers and Clothiers. . . . Coney Island, the Shooting Galleries, Steeplechase Park, the Beaches. . . . the Sporting Pages, Krazy Kat, Tom Powers. Old John Brown. Nick Carter, Deadwood Dick, Old King Brady, Team Teaser, Walt Whitman and Poe. William Dean Howells, Artemus Ward and Gertrude Stein.[113]

Coady went on like this for almost two pages, setting forth a manifesto for the magazine, which

Fig. 67. ''Which is the Monument?''
Two-page spread from *The Soil* (Jan. 1917).

over time would include articles on the American language, American machines, and the Woolworth Building; on the art of dressmaking, the rodeo, and the stampede; and on boxing, clowns, and the movies. He serialized a dime novel about Nick Carter and interspersed photographs of popular entertainers (the comedian Bert Williams and the circus clown Toto) and sports figures (the prizefighter Jack Johnson and the swimmer Annette Kellerman) among the reproductions of primitive and European art. In one two-page photographic spread he compared a typical nineteenth-century public sculpture, the Maine Monument in Central Park, to the Chambersburg double-frame steam hammer (Fig. 67). He asked rhetorically, "Which is the Monument?" in much the same spirit as Duchamp when he compared the modern urinal to a fountain.

Coady's magazine reinforced and elaborated many of the lessons vested in Duchamp's *Fountain*. Both men had lost faith in contemporary art; both believed there might be some redemption in the popular arts and machine culture; both were passionate about New York because the city had a liveliness and modernity found nowhere else. And both liked to mock and sermonize in the same breath. On the surface, they were dadaist iconoclasts. But underneath such witty and irreverent play they were polemicists, arguing for the worth of popular and machine-made American culture, which, they believed, the fine artist first had to recognize and then strive to equal in strength and vitality. As Coady said: "We ought to be the richest race in all history, with the accumulated art of the past, the present of Europe and our own life teeming with future possibilities already begun. With art in abundance and our arteries young, why should we nibble on a dead end of Europe?"[114]

Duchamp never put his views in such bald, nation-alistic terms; he proselytized as a transatlantic mod-ernist, not as an American patriot. And he always kept a certain distance between himself and Ameri-can culture, maintaining the stance of a bemused foreign observer. Coady, in contrast, an American who viewed himself as both a political and a cultural reformer, was much more the cultural nationalist. He dwelled on the evils of European artistic domina-tion and urged Americans to listen to their own voices. Whereas Duchamp's style was witty, cool, and ironic, Coady's was zealous, hotheaded, and ide-alistic. He often used the effusive organic rhetoric so favored by the second Stieglitz circle and the *Seven Arts* group in encouraging an art to grow from Amer-ican soil.

How curious, then, that two such different men, one a foreigner and the other a native, one an intel-lectual, the other a political activist, should come together over the issue of American culture, envi-sioning a bold new national art distilled from the beauty and meaning found in machines, gadgets, and New York streets. But that they did manifests a Franco-American alliance and a romance with America not that different from the one developing on the battlefields abroad. As the French became aware of their antiquated weaponry and embraced American technology to win the war, and were charmed by the youth and innocence of the Ameri-can doughboy, they looked across the seas with a new admiration and envy. They recognized in their American ally the advantages of what they took to be freedom from tradition and a rich stock of both material goods and technological skills. And some, as we have seen, even predicted that the war would usher in a permanent shift of cultural energy from France to America.

Others hoped the Franco-American alliance en-gendered by the war would continue into the fu-ture. "America, let our generation be the piers of a bridge," wrote a young French poet, Mireille Havet, in 1917. "I salute you, well-populated cities of America, / And my heart goes to you / Leaping with hope."[115] Her words, quoted in Pierre de Lanux's book *Young France and New America* (1917), sup-ported Lanux's plea to maintain the alliance brought about by the war. The two countries had much to give one another, Lanux argued. The Americans had their vigor and enterprising spirit and the French,

their great artistic traditions and experience in world leadership. Lanux, a French diplomat and writer sent to the United States to persuade Ameri-cans to enter the war, looked ahead to reconstruc-tion and his country's need for American money, technology, and architecture. He addressed his book to Americans, gently flattering them with re-minders of how highly the French regarded Ameri-can democracy and how much the French literary community respected the works of James Fenimore Cooper, Poe, and, most especially, Whitman. Amer-ica, he asserted, with the assurance of a Frenchman accustomed to wielding political power, was now a country "designated for a certain form of world-leadership," making it a true partner to France.[116] The conditions of life in the two countries were closer than "at any period of history, especially with respect to moral, cultural and political conditions."[117]

Duchamp's recognition of American distinc-tiveness, then, fit into a specific political context. France reached out to America during and after the war for its technological know-how and its advanced engineering skills. Duchamp's irony, on the one hand, reflects the attitude of a proud but belea-guered country at war, forced to admit the strength, if not the superiority, of a country it had customarily regarded as a small player in world culture and po-litics; Coady's evangelism for American culture, on the other hand, grew out of not only American wartime nationalism but also the brash confidence building in a country, abandoned by many of its intellectuals, that was nonetheless emerging on the world stage.

It took a while for Duchamp's and Coady's Franco-American alliance to have its full effect. The seeds they planted matured only in the mid-1920s, when artists on both sides of the Atlantic indulged in an international *américanisme* that was even more intense and influential, and less colored by dadaist irony, than what had appeared during the war. While it was certainly never Duchamp's intention to participate in the creation of a new stylishness, it would be his fate to help usher in machine age en-thusiasms that became fashionable after the war. In the 1920s, when Edward Weston would photograph a toilet, comparing its "swelling, sweeping, forward movement" to the Victory of Samothrace, and Mars-den Hartley would praise plumbers as "creators of

aesthetic delights," Duchamp's irreverent sermon was being transformed into a doctrine of formal beauty (Fig. 68).[118] Similarly, in Europe, where outposts of cultural *américanisme* began to crop up after the war around avant-garde activity, the young idolized American women, skyscrapers, jazz, and pop culture even more energetically and cultishly than had Duchamp, Gleizes, and Picabia. Their reading of American comic books and their fascination with Whitman, Henry Ford, Thomas Edison, and Charlie Chaplin would not be lost on the American expatriates in Paris, who found themselves in the curious position of having gone abroad to study great

European literature and art only to discover that the French were engaged in a serious romance with America. One of these expatriates was Gerald Murphy, who went abroad for study and fell under the influence of French *américanisme;* his thorough identification with the American mystique in France prompted his success as an American-style painter. The paradox of Duchamp's career is that as a Frenchman in New York he found better ways than in Paris to make his art consonant with contemporary culture. The paradox of Murphy's career is that he left America to escape his culture but in France was pressed to reinhabit it.

Fig. 68 (facing). Edward Weston, *Excusado*, 1925. Gelatin silver print, 9 1/2 × 7 1/2 in.

AN AMERICAN
IN PARIS

The future of the western world lay with America. Everyone knew that. In Europe they knew it better than they did in America.

Sherwood Anderson, *A Story Teller's Story*, 1924

We had come three thousand miles in search of Europe and had found America, in a vision half-remembered, half-falsified and romanced.

Malcolm Cowley, *Exile's Return*, 1934

After the war there was the Americanization of France. . . .

Gertrude Stein, *Paris France*, 1940

If Duchamp was the Frenchman in New York, Gerald Murphy was the American in Paris. Both belonged to a new genus born during World War I: *le type transatlantique.* Made up of writers and artists who crisscrossed the Atlantic and worked both in Europe—usually Paris—and in New York, the *transatlantiques* were drawn from many Western nationalities, but in the visual arts they were most often French and American and occasionally English, German, Hungarian, Russian, Italian, or Dutch. Among the American artist *transatlantiques* were Gerald Murphy, Marsden Hartley, Alexander Calder, Man Ray, and Stuart Davis; among the Europeans were Marcel Duchamp, Francis Picabia, Albert Gleizes, Jean Crotti, Bernard Boutet de Monvel, and Fortunato Depero. Louis Lozowick and Joseph Stella, one Russian, the other Italian, both immigrated to the United States as teenagers but traveled abroad throughout the 1920s. Their bicontinental lives and mixed citizenship epitomize *le type transatlantique.*

The hallmarks of *transatlantiques* were different from those of the expatriates—James McNeill Whistler, Henry James, Gertrude Stein, Ezra Pound, Florine Stettheimer, and George Grosz—who abandoned their home culture to live in another, never intending to return to their native land. Expats maintained permanent homes abroad and more or less assimilated to their adopted countries. They often expressed deep alienation from their country of birth. *Transatlantiques*, in contrast, were migrant artists, moving back and forth across the Atlantic, carrying the ideas and values of one culture into the heart of another. Even when they stayed abroad for a number of years, they continued to fashion themselves as non-nationals; they did not renounce their birthplace and assumed they might someday go home

Fig. 69 (facing). Gerald Murphy, *Razor*, 1924. Oil on canvas, 32⅝ × 36½ in.

4. THE GENTLE SEX AND THE MACHINE AGE—THE PRESENT DAY

Fig. 70. John Held, *The Gentle Sex and the Machine Age—The Present Day*. From *Liberty* magazine, Sept. 12, 1931.

again.[1] Often, as in the cases of Duchamp and Murphy, they enjoyed being foreigners abroad and, rather than assimilate or disguise their foreign identity, they used their otherness to charm the locals. As Murphy put it: "Although it took place in France, it was all somehow an American experience. We were none of us, professional expatriates, and Paris and the French seemed to relish this." For Stuart Davis, in Paris "there was no feeling of being isolated from America."[2]

Occasionally, a *transatlantique* evolved into an expatriate. After many trips back and forth, Duchamp made America his permanent home in 1942 and became a citizen. His friend Edgard Varèse, the composer, made a permanent Franco-American alliance by marrying Louise Norton, an American writer in early modernist circles, and lived the remainder of his years in the United States. Both Lozowick and Stella were naturalized. Most American *transatlantiques* eventually came back to the States.

Not surprisingly, when bicontinental activities were at their height, so too was the flow of imagery that represented the cultural primacy of transatlantic travel. Some of it has already been highlighted: Rosenfeld's richly worked metaphor of entering the New York port, for example, or Duchamp's gift of a vial of Paris air to the Arensbergs (see Fig. 65). To these we should add the popular images of John Held, one of the great American illustrators of the day, who made ocean crossings, along with flappers and speakeasies, a favored subject (Fig. 70). And paintings such as Robert Delaunay's *Cardiff Team* (see Fig. 38), Félix Delmarle's *Port* (Fig. 71), or Paul Colin's *Jazz Band* (Fig. 72), and by 1931 a series of three paintings by Stuart Davis in which words and motifs of the two cities that made up the New York–Paris axis appear side by side (see Fig. 311). With his finger firmly on the period pulse, George Gershwin wrote his great symphonic poem *An American in Paris* (1928).

Whether they made art as Frenchmen in New York or as Americans in Paris, artists built upon a fundamental assumption that dominated the Western world at the time: national differences mattered, and their preservation was at stake. American culture during and after the Great War was always central to the inquiry. As European statesmen struggled to set postwar agendas that promoted modernization without imperiling national traditions, they

Fig. 71 (left). Félix Delmarle, *The Port*, 1914.
Oil on canvas, 25½ × 19¾ in.

Fig. 72 (below). Paul Colin, *Jazz Band*
(from *Le Tumulte Noir*), 1927.
Lithograph with pochoir coloring
on paper, 18 × 25 in.

Fig. 73 (top). Gerald Murphy on front porch of the Steele Camp in Saranac, 1934 or 1935.

Fig. 74 (bottom). Man Ray, *Portrait of Sara Murphy and Her Children*, summer 1926.

weighed pros and cons in comparing the traditional cultures of Europe with the new one of America. Such comparisons helped define the United States as separate from Europe, giving it an identity that was no longer one of child to European parent—the image that had prevailed for centuries—but one of national equals. In the arts this dynamic played itself out in curious ways. Such an intellectual climate sharpened Duchamp's identity as a cosmopolitan Parisian in New York and inspired his art of brilliant, assured, and authoritative cross-cultural commentary. He was stimulated by the foreignness of his environment, where his local American colleagues took him and his art far more seriously than his French countrymen. In Paris, Gerald Murphy discovered that America was in fashion and performed his nativeness on the French stage of both art and life. His was a total performance in ways Duchamp's was not. But like Duchamp's art, Murphy's attracted far more attention abroad than it did in his home country.

Murphy arrived in Paris in 1921 with his wife, Sara, and their three young children (Figs. 73, 74). The event was not singular, for a large population of Americans lived in Paris at the time; an estimated thirty-two thousand by 1924, with another twelve thousand coming as tourists that year in one month of the summer alone.[3] Often pictured as a member of America's lost generation—a label that could not be more ill-fitting—Murphy is best known for his friendships with writers, particularly Ernest Hemingway, F. Scott Fitzgerald, and John Dos Passos. Like Fitzgerald and Dos Passos, Murphy had been educated in Ivy League schools, having graduated from Yale in 1912, a class ahead of Waldo Frank and in the same class as Paul Rosenfeld and Cole Porter. But unlike them, he was very well off. Sara Murphy had already received a substantial inheritance from her father, Frank B. Wiborg, a Cincinnati ink manufacturer, and Gerald had income from his family's business, the Mark Cross leather-goods store on Fifth Avenue in New York. In their early thirties, the Murphys were also a bit older than their writer friends, and decidedly more stylish and cosmopolitan. Sara Murphy had spent much of her youth in Europe and was fluent in French, German, and Italian. Gerald had been schooled in literature and the arts and had the inclinations of an aesthete. Never happy working for his father at Mark Cross, he stud-

ied for two years at the Harvard School of Land-scape Architecture after wartime service with the U.S. Signal Corps. The trip abroad in 1921 was ostensibly to study landscape design and gardens.

The journey was also driven by the Murphys' desire to be independent of two demanding families. Going first to England, they stayed but a short time and crossed the Channel to try out the allures of France, finding themselves so content that they stayed for eleven years. They took an apartment on the Left Bank in Paris and, a few years later, bought and renovated a villa and landscaped seven acres of land in Cap d'Antibes. Though they came back to the States for visits, only in 1932 did they return for good, their lives irreversibly darkened by family tragedy and economic reversals. Like so many family businesses, Mark Cross was hard hit by the depression. Murphy's father had died, and it fell to Gerald to keep the business alive. One of his sons, Patrick,

became ill with tuberculosis in 1929 and died eight years later; the other son, Baoth, thought healthy, also contracted a fatal disease and died in 1935. The two deaths, coming within two years of each other, were almost more than the family could bear.

Before such tragedy, the Murphys in France fashioned a charmed family life, which Calvin Tomkins evoked in his classic little book *Living Well Is the Best Revenge.* Thanks to this pioneering essay, originally a *New Yorker* magazine profile, the Murphys' parties—in their ultramodern apartment in Paris, at their villa in Cap d'Antibes, on the beach, and on their yacht—have become part of our storehouse of romantic lore about Americans abroad during the Jazz Age (Fig. 75).[4] Every event they planned was marked by creativity and by Gerald's fanatical attention to organization and detail. Their late-night party on a rented barge in the Seine, with toys as table decorations and "toute Paris" aboard celebrating

Fig. 75. A Murphy picnic at the Plage de la Garoupe, Cap d'Antibes. Picasso and his mother, Señora Ruiz (in black), in the center.

the opening of Stravinsky's *Les Noces,* would by it-self have put them in the annals of their time. Dos Passos, who "had little taste for the large scale en-tertaining the Murphys went in for," had to admit that he regretted missing that party. "Nobody," he said, "organized more amusing affairs" than the Murphys.[5]

The couple, incurably social, also had a great gift for identifying and gathering around themselves creative people, bringing together Europeans and Americans much as Walter and Louise Arensberg and the Stettheimer sisters were doing in New York. The Murphys' American circle included Heming-way and his wives, Dos Passos, F. Scott and Zelda Fitzgerald, Cole Porter, Philip and Ellen Barry, Ar-chibald and Ada MacLeish, Donald Ogden Stewart, Robert Benchley, Alexander Woollcott, Gilbert Seldes, and Dorothy Parker. Unlike many Ameri-cans, they also had close friendships with Euro-peans, particularly Léger and Picasso, and they mixed their American and European contacts, at one time or another entertaining Stravinsky, Sergey Diaghilev, Darius Milhaud, Blaise Cendrars, Jean Cocteau, Erik Satie, Tristan Tzara, and Le Corbu-sier. To take the family photographs in 1926 they en-gaged Man Ray. Like them, he was a young Ameri-can *transatlantique* building a career in Paris on the new Franco-American alliances.

The strange thing is that during those years abroad Gerald briefly became a very fine painter. Although he had no formal art training beyond the drafting courses he had taken at Harvard, he fell in love with modern painting when he encountered it in Paris. He particularly admired the cubist paint-ings of Picasso, Fernand Léger, Georges Braque, and Juan Gris and the Fauvist color of Henri Ma-tisse. "My reaction to the color and form was im-mediate," Murphy recalled. "To me there was something in these paintings that was instantly sym-pathetic and comprehensible."[6] He engaged Natha-lie Goncharova, a Russian émigrée artist living in Paris, to tutor him and Sara in the fundamentals of modern painting. Although Sara did not continue, within a year Murphy was submitting pristine, im-maculately painted canvases of machines to avant-garde exhibitions in Paris. He exhibited regularly at the Salon des Indépendants and may have had a one-person exhibition at the Georges Bernheim Gallery in 1929.[7]

Murphy was not prolific and did not paint for long—no more than seven or eight years. He loved it, he said, but it was not an easy craft for him. Each painting was meticulously worked and completed "with great difficulty."[8] Furthermore, given his deep devotion to family and social life, and the inclination to perfectionism that drove everything he did, he never worked full-time in his studio. And he never again took up the brush after the sudden disruption of family life with Patrick's contraction of tuberculo-sis in 1929, followed three years later by the family's return to the States. Eight works by his hand sur-vive, out of a total of some sixteen paintings that are known from photographs and exhibition reviews.[9]

Tiny his oeuvre may have been, but what he cre-ated was remarkably fine. And it is surprising, not only that he attracted a fair amount of comment, but also that the French praised him for having an inde-pendent, original voice. For them he represented something truly American. The two opinions that meant the most to him were those of Léger and Pi-casso. Murphy reported with great satisfaction that Picasso found his painting *Razor* (see Fig. 69) "sim-ple, direct"—it seemed to him "Amurikin—cer-tainly not European."[10] And Léger found Murphy's work so special that he singled him out from all the other American expatriates painting and exhibiting abroad and proclaimed him the "only *American* painter in Paris."[11] Léger, Dos Passos remembered, would praise one of Murphy's paintings by calling it "très américain."[12]

A younger French artist, Jacques Mauny, went even further and credited Murphy with inventing—in Paris—a new American aesthetic. We do not know when the two men met, but Mauny admired the American so much that he made a portrait of him and showed it in the 1924 Salon d'Automne (Fig. 76).[13] The following year Mauny traveled to the United States and painted canvases of New York that index the French version of Manhattan: sky-scrapers, billboards, tabloids, baseball players, ice cream, and wealthy socialites (Fig. 77). He also came to know the works of other American painters, particularly Charles Sheeler and Preston Dickinson. They had, he felt, something strikingly in common with the way Murphy was painting in France. Well before historians began linking these artists and call-ing them Precisionists, Mauny wrote of them as pio-neering a uniquely American style. He introduced

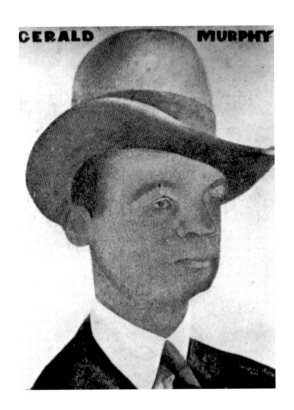

Fig. 76 (left). Jacques Mauny, *Gerald Murphy*, 1924.

Fig. 77 (below). Jacques Mauny, *New York*, 1925.
Oil on canvas, 17 × 21⅜ in.

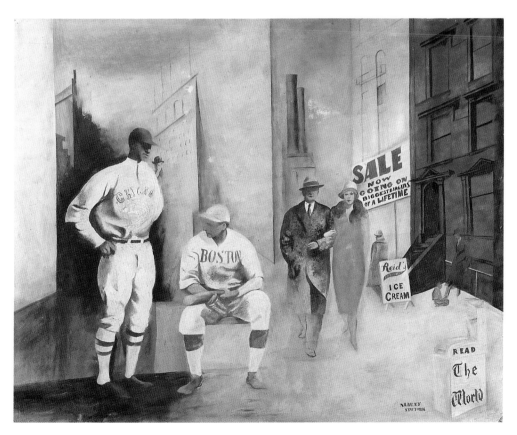

Fig. 78. Jacques Mauny, page from "New York, 1926," in *L'Art Vivant* 2, no. 26 (Jan. 15, 1926), p. 58.

his ideas in a 1926 article in *L'Art Vivant*, illustrating the paintings of Murphy, Sheeler, and Dickinson alongside photographs of New York skyscrapers and Wall Street (Fig. 78). Struggling to put this new style into words, Mauny suggested that the three artists worked in a manner as distinctive as the look of the New York skyline. He praised Murphy for his neatness of surface, his precision, and his modern subjects—machines, watches, steamships, tabloid newspapers—qualities he felt made the paintings especially American. "In the history of the beginnings of the American aesthetic, Gerald Murphy holds an alluring place . . . [His art] explains the new American taste; like a stroll on Park Avenue, it shows us the instruments of prosaic life executed to perfection. His pleasing taste for the mechanical is captivating."[14]

The French artists' insistence on Murphy's Americanness is even more startling when one looks for similar praise and commentary from Murphy's American friends abroad, who might well have taken pleasure in his success as a painter, especially given how difficult it was for a foreigner to earn a Parisian reputation. But no American critic other than the reporters for the Paris edition of the *New York Herald* said much of Murphy's work.[15] And even more significant, none of Murphy's literary friends wrote or commented appreciatively on it. Though Murphy encouraged their careers, often by reading their work in draft and by giving them financial and emotional support, there is little evidence that they took corresponding interest in his art. They seem to have thought of him, rather, as a Sunday painter and an amateur. When Fitzgerald used Murphy as one of his models for Dick Diver in *Tender Is the Night*, he created a character who was elegant, rich, and dandified and arranged unforgettable parties. But he was not depicted as an artist. And Hemingway surprised and hurt everyone when he wrote nastily in *A Moveable Feast* about the oozing charm of the Murphys, calling them, not by their names, but simply "the rich." He charged "the rich" with hobnobbing only with people who had reputations—like himself and Picasso—and said nothing about Murphy as a painter.[16] Even as late as 1966, when Archibald MacLeish, one of Murphy's dearest friends, wrote of Americans working in Paris in the 1920s, all his examples were literary; he made no mention of Murphy.[17] Only Dos Passos in his memoirs

allowed a little space for Murphy as an artist, but guardedly. "There was a cool originality about his thinking that had nothing to do with the wealthy amateur," he wrote, as if to defend Murphy against those who found him a dilettante. In another passage, speaking of the Murphys' success with the French, he clearly felt Gerald had won it through style, not substance. "Americans were rather in style in Europe in the twenties," Dos Passos wrote. "Dollars, skyscrapers, jazz, everything transatlantic had a romantic air. Gerald's painting when it was shown in Paris seemed the epitome of the transatlantic chic."[18]

Probing what Dos Passos meant by "transatlantic chic" can help us understand Murphy's paintings and their appeal to major figures in the French avant-garde, an appeal they shared with the work of no other living American artist, writers included. (One thinks of his countryman Patrick Henry Bruce, so much more the experienced painter in

Paris, who suffered from lack of interest in his cubist abstractions.) Murphy built his success as a painter —and as a popular host—I want to argue, on the ability to meet French expectations of how a modern American was supposed to paint and act. He acted out American stereotypes Europeans cherished. Indeed, the best way to understand Murphy in Paris is to use the same lens we focused on Duchamp in New York. For Murphy's work, like Duchamp's, was shaped by an intense pan-European *américanisme*, especially in avant-garde circles.

In both his art and his life, Murphy became more markedly and joyously American abroad than he would ever have been at home. In Antibes, he and Sara promoted their Americanness by calling their home Villa America and orchestrated visitors' stays there around American themes (see Fig. 99). A sign, a stylized American flag painted on canvas by

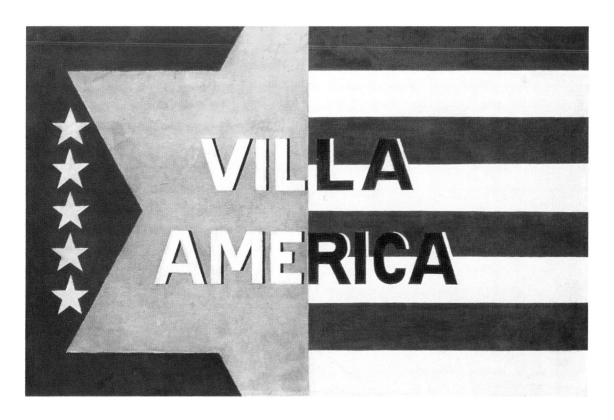

Fig. 79. Gerald Murphy, *Villa America*, 1924.
Oil and gold leaf on canvas, 14$\frac{1}{2}$ × 21 $\frac{1}{2}$ in.

Gerald, announced to arriving guests the driveway of their home and indicated that the Murphys were a family of five "stars" (Fig. 79).[19] The red, white, and blue—the colors of both French and American flags—conveyed the family's bicontinentalism. If it was summertime, one was apt to be served tomatoes and corn or, at breakfast, waffles cooked in the waffle iron sent specially from the States. At the dinner hour Murphy went through an elaborate ritual of making American-style cocktails and took great pains to have just the right proportions of ingredients. He mixed drinks, Philip Barry said, "like a priest preparing mass."[20] For entertainment, there were the latest recordings of American jazz and Broadway musicals, and the children might dance the Charleston. Or Gerald and Sara would sing Negro spirituals and American folk music. In later years, there was sailing on their boat, *Weatherbird*, named after a Louis Armstrong song, with its flag designed to look like a big eye. When the flag flapped in the wind, the eye seemed to wink at you.

The way they lived gives the lie to what is generally said about postwar American literati abroad—that they were the disillusioned young, alienated, lost, and embarrassed about their home culture. "What we lived," Murphy said, trying to revise the stereotype of him and his friends as a "lost generation," was not a simulation of European lifestyles, "but a contemporary American version. We were in close touch with the U.S.A. at all times." And the French, he added, made you "feel proud of being an American. When Lindbergh made his flight, all our French friends at Antibes sent us sheaves of flowers with red-white-and-blue ribbons."[21] Man Ray, too, spoke of an exchange economy. The French "crave America. So we are making a fair exchange, for I love the mellowness and finish of things here."[22]

This reciprocity characterizes *le type transatlantique*. Murphy and Man Ray interacted with the French just as Duchamp did with Americans. But they had no desire to assimilate. They preserved their foreignness, and each of them delighted in being an authority on his own culture and a student of the other. Duchamp instructed New York artists about their country as a Frenchman superior in the arts. And Murphy acted out his Americanness in Paris for a public enthralled by the mythically futuristic and youthful culture across the Atlantic. He was the real thing: a wealthy *Américain*, physically

fit and dapper, with a pronounced taste for the new and modern. And Sara was *la femme américaine*: fashionable, independent, radiating health and intelligence.

Because Murphy was the genuine article, Rolf de Maré, the director of the Ballets Suédois, an avant-garde dance company working in Paris, asked him in 1923 to write the scenario and design the costumes and backdrop for a ballet that was to be authentically American in style and story line (see Fig. 84). Such a commission testified to the confidence Parisian avant-gardists had in Murphy as an artist and to the appetite for American material that spread throughout Europe after the war. It also pointed to the success of *Parade*, an earlier "Americanized" modern ballet that had been created by a remarkable team of Frenchmen.[23] In 1917, when Duchamp was off in New York acting out his *américanisme* in *Fountain*, Cocteau, Satie, Léonide Massine, and Picasso were at home creating the ballet *Parade* out of theirs.

Parade—with a scenario written by Cocteau, an early devotee of American jazz and cinema, and sets and costumes designed by Picasso, whose Americana passions included Buffalo Bill, Abraham Lincoln, and the Katzenjammer Kids comics—opened with two ten-foot-tall male barkers haranguing the audience to come see a sideshow.[24] One of them was French, the other American (Figs. 80, 81). As usual, it was old-world culture pitched against new-world rawness. The cubistically costumed French manager was elegant and urbane; he had a mustache and wore a top hat, white dress shirt and black tails; in his right hand he carried an enormous pipe and in the other a walking stick. Down his back, as if he were a walking collage, he wore a placard of green trees, suggesting the Parisian boulevards where the sideshow was taking place. The American manager, in comparison, looked distinctly unkempt. Giving him as many American references as his costume could possibly bear, Picasso put a Lincolnesque stovepipe hat on his head, cowboy chaps on his legs, a megaphone in one hand, and the cowcatcher of a train on his torso. Skyscrapers with little windows and the flags of transatlantic ocean liners stagger down his back. Later in the ballet, a "Little American Girl" appears, costumed to resemble Mary Pickford and Pearl White in one of their film performances (Fig. 82).[25] In a "Steamboat Ragtime" the

Fig. 80 (top left). Pablo Picasso, costume for French Manager from *Parade*, 1917.

Fig. 81 (bottom left). Pablo Picasso, costume for American Manager from *Parade*, 1917.

Fig. 82 (above). Marie Chabelska as the Little American Girl in *Parade*, 1917.

Fig. 83. Gerald Murphy, program design for *Within the Quota*, 1923. Watercolor, gouache, and collage on paper, 10¾ × 8³⁄₁₆ in.

girl dance-pantomimed activities that for Europeans stereotyped the American girl, who they thought was "more interested in her health than in her beauty." She acts out "riding a horse, catching a train, cranking up and driving a Model T Ford, pedaling a bicycle, swimming, driving away a robber at gun point, playing cowboys and Indians, snapping the shutter of her new Kodak, doing a 'Charlie Chaplin,' getting sea-sick aboard a transatlantic luxury liner, almost drowning, and finally relaxing at the seashore."[26] The original plans included a manager in blackface, eventually eliminated, whose character type was based on American cakewalk dancers and minstrels Cocteau and Picasso saw in Paris.[27]

Satie's score for the ballet originally included modern-day sounds—"sirens, typewriters, trains, aeroplanes, dynamos, gun shots, lottery wheel, and klaxon."[28] Although most of these mechanical and industrial noises did not make it into the inaugural production—some were revived later—they added yet another American association, as did the passage Satie cribbed from Irving Berlin's ragtime composition "That Mysterious Rag" as accompaniment for the American girl.[29]

In appropriating American sounds, Satie used a strategy that European composers were increasingly adopting as a way of modernizing their music. In 1910 Claude Debussy wrote the popular "Golliwogg's Cakewalk," one of three cakewalks he composed for piano. And others—Milhaud, Stravinsky, Maurice Ravel, and Arthur Honegger—all self-consciously borrowed sounds and rhythms from American ragtime and jazz to enliven their symphonic work. When asked by the Ballets Suédois to write an American ballet, Murphy wanted an authentic American composer, not a European, and the score was commissioned from his good friend Cole Porter, who was then at the start of his career. Together, they created an eighteen-minute ballet, the symphonic music patching in references to jazz, New York taxi horns, and a Salvation Army chorale.

Murphy's scenario for the ballet was one more reiteration of the transatlantic theme, this time indulging in *américanisme*. Called *Within the Quota*, a reference to contemporary debates and legislation enacted in Congress to limit immigration to the United States, the ballet was organized around the adventures of a young Swedish man ("The Immigrant") who has just arrived in New York. Murphy's

Fig. 84. Gerald Murphy, painted backdrop and costumes
for *Within the Quota* (shown in performance), 1923.

program design represents the immigrant, a role
played by Jean Börlin, against a photographic col-
lage of Manhattan skyscrapers, ocean liners, and
scenes from the elevated railway; the Mark Cross
sign on the side of a building and a Budweiser bill-
board can be made out between his legs (Fig. 83).
Wearing his immigration tag, the visitor, dressed in
old-world striped stockings and a Scandinavian-
style suit detailed in leather, with his belongings
rolled in colorful cloth and packed in a stenciled va-
lise, looks wide-eyed and unworldly, an innocent
abroad. As his story unfolds, audiences were offered
a series of adventures that played out every Ameri-
can stereotype in the European lexicon: the Million-
airess, the Colored Gentleman, the Jazzbaby, the
Cowboy, the American Sweetheart, the Sheriff,
and so forth. The ballet even included a Puritan,
designed as a nineteenth-century man in black top
hat and frock coat. This is how one commentator
described the immigrant's story:

A millionairess, bedecked with immense strings of
pearls, ensnares him; but a reformer frightens her
away. Then a Colored Gentleman appears and does a
vaudeville dance. He is driven away by a "dry agent"
who immediately thereupon takes a nip from his
private flask and disappears, to the immigrant's
increasing astonishment. The Jazz Baby, who dances
a shimmy in an enticing manner, is also quickly torn
from him. A magnificent cowboy and a sheriff appear,
bringing in the element of Western melodrama. At last
the European is greeted and kissed by "America's
Sweetheart"; and while this scene is being immor-
talized by a movie camera, the dancing of the couples
present sweeps all troubles away.[30]

Typical of Murphy's ability to seize on precisely
the features that fascinated Europeans about Ameri-
can culture was his stage set, an elegant and witty
blowup of a tabloid's front page (Fig. 84). The news-
paper as an everyday object had achieved a certain

status as a design element in French entertainment and was used in music halls for costumes and stage designs. By the time Murphy invented his backdrop, moreover, cubist collages regularly included fragments from newspapers.[31] But Murphy did not cut and paste bits of newspaper as the cubists did. Avoiding that aestheticizing process, he instead presented the banner headlines and front-page stories of an invented newspaper, very obviously an American tabloid and not *Le Journal*, which the French artists used. In that it was gigantic in scale and its headlines were outrageous, it said in effect to his French audience, "This is the way we do things over there." Its hyperbole and sensationalist stories offered a massive spoof of *américanisme*, of transatlantic fantasies about American culture, and even, one might say, of cubism, whose intricacies Murphy never tried to adopt. The backdrop, Murphy said to an interviewer, was inspired by but was "not Cubism."[32]

In burlesque fashion, Murphy's backdrop outtabloided the tabloids. Indeed, he told the press, surely tongue in cheek, that he had studied 250 newspapers to squeeze out from them the "quintessence of Americanism."[33] He included stories about airplanes ("Mammoth Plane"), prohibition ("Rum Raid"), crime ("Gem Robbers"), and wealth ("Unknown Banker," "Shoe-Magnate," and the "Auto King"). In addition, he spoke to the new Franco-American alliances and to America's new power and influence abroad. The largest headline, announcing, "Unknown Banker Buys Atlantic," could be read as a parody of American wealth and the American millionaire's crude habit of buying castles and chapels abroad, usually to reconstruct them at home, and as an ironic comment on America's new power relationship to Europe. America "owned" the Atlantic in a way no country had ever owned it before.

One of the most telling of Murphy's concoctions was the photograph to the left of the main headline, measuring the length of France's longest ocean liner—the *Paris*—against the height of America's most famous skyscraper, the Woolworth Building. Both structures, celebrated in their day, had recently been featured in Parisian exhibitions. A scale model of the *Paris* had been installed in the Decorative Arts section of the 1921 Salon d'Automne, and one of the Woolworth Building was included in a display sent abroad by the American Institute of Architects.[34] Measuring the bigness of modern buildings and engineering feats by depicting them in scale against other world monuments was a common pictorial convention in the early twentieth century, when gigantism was so widely admired and boosterism a common language. No major skyscraper went up or ocean liner was launched without comparisons of its size to that of such old-world monuments as the pyramids, cathedrals, or the Eiffel Tower. While artists themselves never made these comparative charts, they did seize upon them as one of their era's indices of modernity; Le Corbusier reproduced one in the pages of *L'Esprit Nouveau* and again in his book *Vers une architecture* (*Towards a New Architecture*) (Fig. 85). Murphy may also have been inspired by a recent spoof in the fashionable magazine called *Life* (not to be confused with the picture magazine of the following decade), which created a mock financial page with a "bigness chart" that included the California Redwood, the Leaning Tower of Pisa, an ear of Kansas corn, and a stack of *Saturday Evening Post*s (Fig. 86).

Murphy's caption for his photograph, "The Queen of the Seas versus the Cathedral of Commerce," used metaphoric images typical of the day. And in that he compared a French ocean liner with an American skyscraper, the statement encoded what Murphy intuited as the new postwar competitive relationship between France and America. Not only did his image underline the French romance with skyscrapers and modern forms of transport, and the decade's general obsession with technological achievement, but it also pictured France's recognition of, and striving for technological parity with, the United States—and, at the same time, America's reciprocal desire for favorable comparisons with Europe.

In sum, the backdrop, in its blunt and nonapologetic replication of a 100-percent-American artifact, created by an American for a Parisian audience, spoke to the artist's extreme comfort in fashioning himself abroad as a national being.[35] That Murphy would create a full-blown ballet based entirely on American themes for a non-English-speaking audience suggests the great vogue Americans enjoyed in 1920s Paris and the confidence they could develop in such a reinforcing environment. No American would have had the temerity to speak so assuredly in his native tongue a decade earlier.

The ballet also inscribed the status American culture had achieved in postwar Paris. What in earlier years had been a scattered enthusiasm for America, much of it located in elite literary and artistic communities, became more popular and widespread during the French reconstruction period. All sectors of public and cultural life confronted both the allure and the threat of Americanization. Politicians, in their call to rebuild France, and industrialists, seeking to remain competitive, visited the United States to study its factory systems and debated whether to adopt Frederick Winslow Taylor's ideas about assembly-line efficiency.[36] City planners argued about the appropriateness of the skyscraper to French urbanism, and advertisers talked about the "poster crisis" as American storytelling advertisements seemed to sell products more successfully than European advertisements that adhered to traditions of graphic design.[37] The French population embraced American film, jazz, chewing gum, and dance styles in greater and greater numbers. One observer claimed in 1922 that almost everyone in France had "just discovered America." The industrialists had discovered "Business, Dollars, Trusts, Taylorization, Standardization"; the poets had discovered "skyscrapers, 5th Avenue, Chicago, New York, and Cinematography"; and the musicians had discovered "South-American tunes, Barman, Policeman, Tango, jazz-band, etc. . . . etc."[38]

The "discovery" of America was intimately connected to much broader political and economic developments. During postwar reconstruction many official policies in France urged a national agenda of revitalization through modernization. For many that meant a delicate balancing act, embracing the new while trying to preserve national traditions and the best of the old; others less concerned with balance chose modernity, American style. Artists too made such choices. Many in the French avant-garde spoke of the "new spirit," but their meaning differed from that of Rosenfeld, who was using the same term in postwar New York. For him, it denoted the arrival of a brand-new nationally based art that was spiritual in content. For the French, it was also a nationalist term but one that encoded a concern with the survival of their own art traditions, now threatened by shifts in global power. In Paris the "new spirit" meant modernizing to stay nationally competitive; in the arts this was often understood as grafting

Fig. 85 (top). "The Cunarder 'Aquitania,' which carries 3,600 persons, compared with various buildings." From Le Corbusier, *Towards a New Architecture* (1927), p. 92.

Fig. 86 (bottom). *Life*—Sunday Edition, financial page parody, Sept. 7, 1922.

elements of American-style modernity onto French traditions and self-images. Apollinaire was among the first to try to define this double agenda in his 1916 essay "The New Spirit and the Poets." He called on French poets to "preserve the classical heritage of solid good sense" and the "moral responsibility that tends toward austere expression" and at the same time to recognize fully the modern and scientific world in which they lived.[39] Speaking simultaneously of a machine aesthetic, which soon became the touchstone for the "new spirit" movement, Apollinaire predicted that "poets [would] want eventually to machine-ize poetry just as the world has been machine-ized."[40] This subtle alignment—the preservation of France's great classical heritage through modernization—gave rise to a decade of debate and theorizing by French "new spirit" artists Murphy knew and admired: Léger, Le Corbusier, Amédée Ozenfant, and others.[41]

Artists, then, like Cocteau, Le Corbusier, and Léger—all serious students of American culture—studied or mimicked America for their own national purposes. They did not wish to be American, but they looked to America to teach them how to be modern. They wanted to be the new French, who would maintain Paris as an art capital and affirm the superiority of French cultural traditions. To be a jazz buff, like Cocteau, Picabia, and Milhaud, and to search out nightclubs that played American music, sometimes taking a turn as drummer, was to be part of a reconstructed, reborn France. When Milhaud went to New York in 1922 to experience the city firsthand, particularly Harlem and its jazz musicians, he did so to write a new French music, incorporating modern rhythms and syncopation into his ballets and symphonies. The circle around the Surrealist poet Philippe Soupault, motivated by a similar impulse to salvage French modernism, collected

Fig. 87. The Jockey Club on boulevard du Montparnasse, Paris.

American jazz records and Negro spirituals and avidly consumed American popular culture, particularly comic books, detective novels, and the cinema. Soupault, some of whose poems in French had American titles ("Ragtime," "Westwego," "Say It with Music"), also wrote about American cinema. Before the end of the decade he published an important essay analyzing "the American influence in France," in which he said what few French poets were willing to articulate so concisely: the Americans "make us stop and think, and realize that we are no longer the center of the world."[42]

There were many faddish sides to *américanisme*. Soupault, for example, self-consciously affected what he thought of as the "American tempo," which meant being always in a hurry and living at a fast pace.[43] And when he presented the work of Man Ray to the Parisian public at his bookstore and gallery, Librairie Six, he concocted a dadaist persona for him, introducing him as an American millionaire who was a coal merchant and the chairman of a chewing-gum trust. The model Kiki, an habitué of surrealist circles in Paris, dressed as an American tourist and sang jazz songs at the Jockey in Montparnasse, an American-style nightclub decorated with large murals of cowboys and Indians (Fig. 87). She aspired to become an American movie star. Jules Pascin, a Bulgarian who made his home in Paris, recognized the trendiness of the New World by becoming an American citizen in 1920. In Paris his ever-shifting entourage included a number of young Americans, both whites and blacks. At Picabia's fashionable opening in 1920 at Jacques Povolosky's gallery, La Cible, a band of "Peaux-Rouges" ("redskins") were in attendance, and Jean Cocteau, Georges Auric, and Francis Poulenc provided American jazz tunes such as "New York Foxtrott" and "Tango du Boeuf sur le Toit."[44] Another French artist became so pro-American that "for his breakfast each morning [he] drank a bottle of Coca-Cola instead of a cup of *café au lait* which he despised as being old-fashioned and chauvinist."[45] Other French literati went to the Dôme, one of the most popular Montparnasse cafés, to have Quaker oats for breakfast (Fig. 88).[46]

Such obsessions in Paris surprised many American visitors, particularly those who had come to submerge themselves in European culture and to experience the great Continental traditions in literature

Fig. 88. Gino Severini, *Nature Morte: Quaker Oats*, 1917. Oil on canvas, 24⅜ × 20 in.

and art. Nothing had prepared them for European artists who wanted to shed their civilized ways for the supposed freedom, innocence, and faster tempo of the New World. Furthermore, the French image of Americans countered their own less assured self-image. At home, they had never experienced the European's mythic version of their country, a schematic and uncomplicated ultramodern America. After his trip abroad in 1921 Edmund Wilson worried that the French now viewed "good" writing as old-fashioned and were giving up their own nineteenth-century heritage for the supposed vigor and barbarity of modern America. He warned them against such foolishness.[47] He, for one, did not accept their skyscraper mystique.

To accept the myth, with all its romantic embellishments, was like putting on a new suit and trying out an identity someone else had made for you. For Murphy, the process was reflexive; he naturally absorbed the particulars of the romance and became one with it, reinforcing it in the eyes of his French friends and ballet audiences. But for other Americans the process of self-discovery, exploration, and repatriation was more difficult and took time. They struggled to decide how European *américanisme* should affect their art. So momentous were its effects on the work of literary people in particular that in their memoirs they wrote frequently about the culture shock they suffered in Europe, a shock to their habitual sense of their own culture's impoverishment. They did not easily accept the glamorous picture of a complex life that they knew had its dark side. But once they indulged in the romance, it buoyed their spirits and increased their determination to create an American-style art. It was in Europe, they remembered, that the art world had promoted them from provincials to special people. Americans were, as Dos Passos wrote, "in style."

The sense of national identity of young writers such as Matthew Josephson, Malcolm Cowley, and William Carlos Williams, and even of a middle-aged Gertrude Stein, was reinvigorated abroad, for it was in Paris that they realized, as Cowley put it, that the United States was "just as God-damned good as Europe."[48] The heat of *américanisme* fired up these writers to construct an art based on newly identified national themes and characteristics. In Europe,

Cowley recalled, it was so much easier to love home. "We saw the America they wished us to see and admired it through their distant eyes."[49]

Europe was pivotal to the release of Cowley and his generation from the "burden of inferiority" they felt as Americans woefully deficient in culture. In *Exile's Return* Cowley chronicled the experience he and others had when they went abroad after the war to drink at the fountain of European high culture only to find that abroad "intellectuals of their own middle class were more defeated and demoralized than those at home." Such a revelation led Cowley to conclude that he had been wrong in idolizing France, that all Western nations were equally well endowed, and each had a national character.

> Having registered this impression, the exiles were ready to find that their own nation had every attribute they had been taught to admire in those of Europe. It had developed its national types—who could fail to recognize an American in a crowd?—it possessed a folklore, and traditions, and the songs that embodied them; it had even produced new forms of art which the Europeans were glad to borrow. . . . Standing as it were on the Tour Eiffel, they looked southwestward across the wheat field of Beauce and the rain-drenched little hills of Brittany, until somewhere in the mist they saw the country of their childhood, which should henceforth be the country of their art.[50]

Cowley's friend Matthew Josephson rendered the epiphany in more specific detail. When he went to France in 1921 to study Flaubert, Mallarmé, and the symbolists, he was shocked, he said, to discover that the French literati found these figures outdated and were "passionately concerned with the civilization of the U.S.A. and stood in a fair way to being *Americanized!*" With his French friends, most of whom ran in dadaist and surrealist circles, he pored over American comic books ("pure American Dada humor"), films, advertisements, and Nick Carter stories. "Without any premeditation," he wrote, he found himself "acting as a sort of 'carrier' of American influences to France." Like Murphy, Josephson was both affected by French *américanisme* and instrumental in fueling it. When he and his wife went to Zelli's, an all-night jazz spot, they were the center of attention, "dancing the new fox trots in an unaffected American style."[51]

Americans abroad, sought after for their "unaffected style," found themselves aborigines of a newly mythologized culture. They were perceived, in one memorable phrase, as "skyscraper primitives."[52] In 1924 William Carlos Williams could not understand why Valéry Larbaud, a noted French *literatus* and translator of Whitman, would want to speak with him, a poet from the provinces. "He is a student, I am a block, I thought. I could see it at once; he knows far more of what is written of my world than I." But then it dawned on Williams that Larbaud, like an anthropologist looking for authentic specimens, had sought him out as research material. Larbaud looked to Williams as Whitman's successor, and as a Whitman type: innocent, raw, unshaped. "He is a student while I am—the brutal thing itself."[53]

Even Gertrude Stein, who had been in Paris since 1903, wrote near the end of her life that she began to feel what she called "this native land business" during the war. When you are "all alone and completely cut off from knowing about your country well then there it is, your native land is your native land."[54] In the decade after the Great War, when *américanisme* was at its height, she began to dwell on what it meant to be American, what made Americans different from Europeans, and what it meant when America was your "country" and Paris your "hometown." In an intellectual milieu that now relished the contrast and cross-fertilization between Americans and Europeans, Stein became captivated by her own expatriation and described herself as someone who chose to live in Paris but was a child of the country "who is the mother of the twentieth century."[55] Trying to make sense of her life now that everyone wanted to go to America, she concluded that it was only by virtue of working outside her country that she could ever have understood her Americanness. She lived in France because the French let her be an American. "Their life belongs to them so your life can belong to you."[56] Her fascination with national differences led to *Geography and Plays* (1922), her book that included pieces on France, England, the Americans, and the Italians and an essay titled "The Psychology of Nations or What Are You Looking At"; a few years later, she wrote her essay "The Difference between the Inhabitants of France and the Inhabitants of the United States of America" (1928). In these same years she

even entertained the thought of working with Virgil Thomson on an opera about George Washington or Abraham Lincoln.[57]

By the early 1930s Stein went so far as to attribute her preoccupation with tense and time in her writing to her Americanness. Whereas earlier she had described her stylistic concern with time as a cubist innovation and a valid modernist practice, she now began to think of it as an American concern, natural to a people restless and on the go who were masters of time management. Americans, she said in *américanisme* rhetoric, always know "just how many seconds minutes or hours it is going to take to do a whole thing." All Americans are "continuously moving." "Think of anything," she wrote, "of cowboys, of movies, of detective stories, of anybody who goes anywhere or stays at home and is an American and you will realize that it is something strictly American to conceive a space that is filled with moving and my first real effort to expressing this thing which is an American thing began in writing *The Making of Americans*."[58]

The artist Louis Lozowick, a Russian who had immigrated to America in 1906 at the age of fourteen, also testified vividly, in both his autobiography and his paintings, to the pervasive curiosity in Europe about the New World. "Everything American was popular," he told an interviewer.[59] And everywhere he traveled in postwar Europe—Paris, Berlin, and Moscow—people wanted to hear about his American life. The locals peppered him with questions. In Moscow they asked about American machines and wanted to hear about Henry Ford and Thomas Edison. Theater students wanted to know not only about theater in the United States but about the Ford factory in Detroit and the steel mills of Pittsburgh.[60] In Paris, besides the usual questions about American architecture and industry, he was asked whether American drugstores served meals and what American males did without pissoirs and whether it was true that American society frowned on men's having mistresses.[61] The French believed Americans were all rich, he wrote, and "would have been happy to exchange *La Ville Lumière* for the land of opportunity, where they were sure fortune awaited any one of capability."[62]

It was as a *transatlantique* that Lozowick, in the early 1920s, settled in Berlin, where the outbreak of *Amerikanismus* was as serious as that of

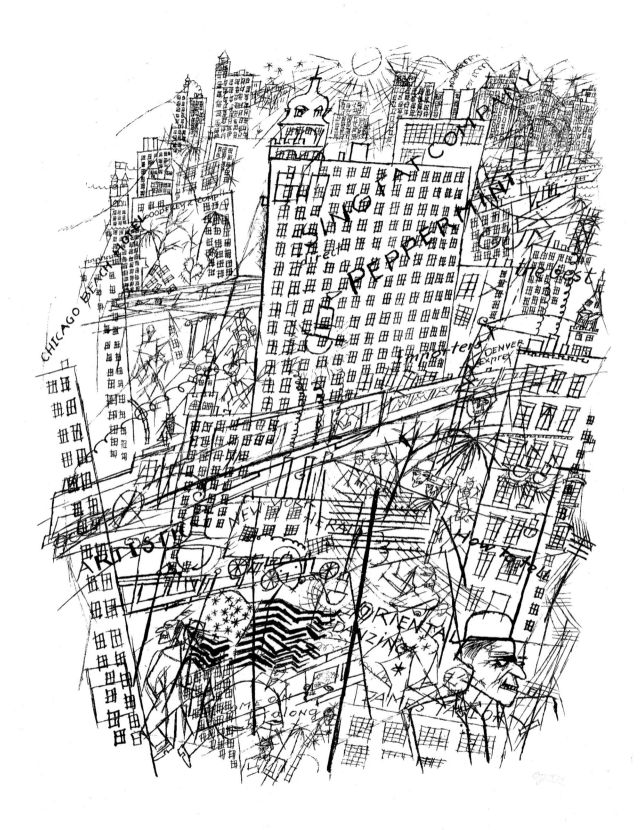

américanisme in Paris. Grosz was one of the trail-
blazers when in 1916 he anglicized his name Georg
to George and his friend Helmut Herzfeld took the
name John Heartfield. Soon Bertold Brecht (origi-
nally Berthold) became known as Bert, and Walter
Mehring called himself Walt Merin, both freely ap-
propriating American slang and slogans and writing
of boxers, gangsters, bilious millionaires, and Salva-
tion Army do-gooders. Grosz was at the center of
these Weimar passions, initiating his peers into
American-style slang and suits. He liked to smoke
a pipe and walk the streets like an American tour-
ist, without a hat. He collected American records,
danced to ragtime, drank American cocktails, and
frequented American films.[63] In his studio, among
photographs and letters about America, he dis-
played his own painting of the port of Manhattan—
an imaginary view that he discussed in detail "as if
he had been there himself"—and autographed (all
in his own hand) photographs of prominent men,
Thomas Edison and Henry Ford foremost among
them (Fig. 89). On Henry Ford's photograph he
wrote: "To George Grosz the artist from his admirer
Henry Ford."[64]

He also collected mementos of the Wild West and
in his studio installed an Indian tepee, where he and
his friends sat on stools and smoked Indian pipes.
Grosz, like so many of his generation, had been
raised on the novels of James Fenimore Cooper and
the immensely popular Wild West stories of the Ger-
man writer Karl May. In other European avant-
garde circles the Indian and Wild West gave way to
the millionaire and New York, but not in Germany,
where, as in a lost painting by Grosz, one encoun-
tered the incongruous mixture of a cowboy, tepees,
African American dancers, and New York skyscrap-
ers (Fig. 90)! Though Berliners—especially Brecht
—were often very critical of America, their flat and
typecast readings of new-world culture were no less
skewed or romantic than those of the Parisians.[65]

In Europe, knowledge of America came via mov-
ies, photographs, firsthand reports, and contact,
whenever possible, with real live Americans. If
those Americans happened to be artists, they often
went native in the presence of such enthusiasm.
Hartley had been in Berlin before the war and,

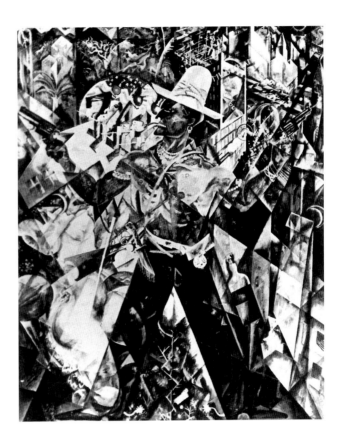

Fig. 90. George Grosz, *The Adventurer*, 1916.

Fig. 89 (facing). George Grosz, *Memory of New York*,
1915–16. Lithograph on Japan paper, 19½ × 15⅜ in.

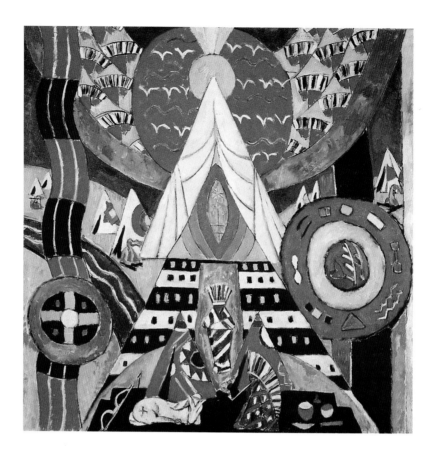

Fig. 91. Marsden Hartley, *Indian Composition*,
ca. 1914–15. Oil on canvas, 47 3/16 × 47 in.

given the milieu, felt the urge to paint a series of paintings he called *Amerika*, based on Indian motifs and the American West, a subject he knew no more intimately than the Germans (Fig. 91). After visiting the American Southwest, he returned to Berlin in 1923 and now painted pictures of the American desert for German audiences. Lozowick, for his part, seized on the Berliners' fascination with American skyscrapers and factories and initiated a series of cubist paintings based on "typical American industrial and mechanical subjects," rendered in an "American style." He devoted a canvas each to "the skyscrapers of New York, the grain elevators of Minneapolis, the steel mills of Pittsburgh, the oil wells of Oklahoma, the copper mines of Butte, [and] the lumber yards of Seattle," a virtual catalogue of those architectural and industrial forms Europeans exalted as typically American (Fig. 92).[66] To his delight—but no surprise given that some characterized Berlin in the 1920s as a suburb of New York and one tourist from New York thought it completely Americanized, given its "traffic signals, American cars, Lucky Strikes, Lux and Woolworth stores" —Germans enjoyed these paintings, and Lozowick tasted his first success.[67] When this art was exhibited in Berlin in 1923 and then in Paris in 1928, he found that critics "stressed its Americanism."[68]

In Paris the Chicago-born sculptor John Storrs also took advantage of his newly acquired authority as an American and developed an art of skyscrapers, though there were none to be seen where he was.

Fig. 92 (facing). Louis Lozowick, *New York*, ca. 1925–26. Oil on canvas, 30 3/16 × 22 3/16 in.

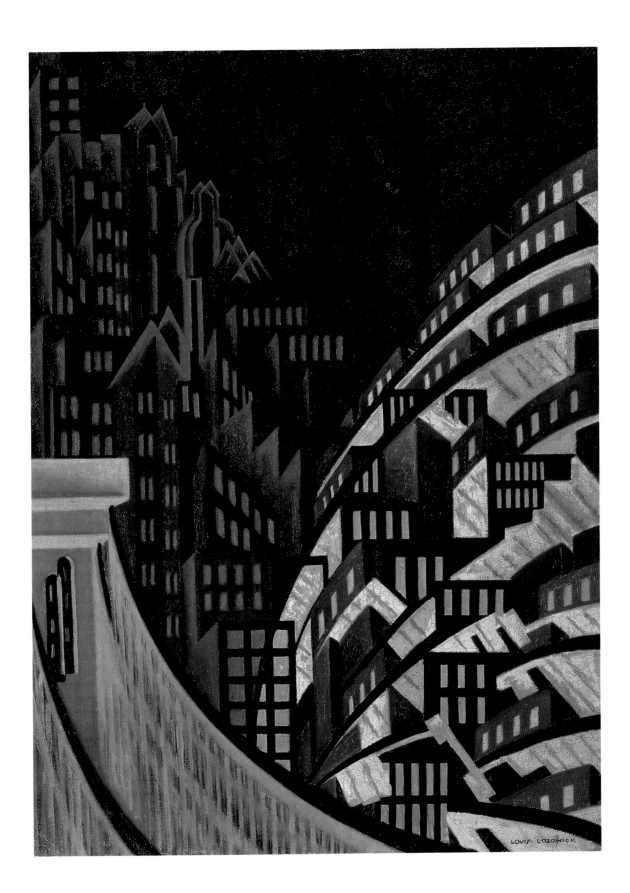

Fig. 93. John Storrs, *Forms in Space*, ca. 1924. Aluminum, brass, copper, and wood on black marble base, 28½ × 5⅝ × 5⁵⁄₁₆ in.

Drawing on his earlier experience in New York and Chicago, he invented a totemic form of sculpture that evoked both single skyscrapers and clusters of them, a kind of compressed Wall Street or Chicago Loop (Fig. 93). As one of the few American sculptors abroad, Storrs was the beneficiary of a commission from France's Aero Club for a monumental sculpture commemorating Wilbur Wright's early flights, and he hoped to do something similar for Walt Whitman, who by the 1920s had achieved cult status in Europe. Writing to Whitman's American biographer, Storrs described the achievements of his country and its poet in the same schematic terms Duchamp had used: "Aside from a few of our designers of bridges, grain elevators, steel mill etc. Walt Whitman stands practically alone as one who has discovered a national soul and has given it expression in a form . . . that can be called art."[69]

The pro-American atmosphere in Paris that led composers like Ravel, Debussy, Satie, Stravinsky, Milhaud, and Honegger to incorporate American sounds into their compositions also nurtured American musicians, making them sympathetic to indigenous materials. One of the most important among them, Aaron Copland, came home in 1924 prepared to use ragtime and jazz rhythms because Europeans had taught him how.[70] The most radical and notorious American composer of the day, however, was George Antheil, a *transatlantique* whose program in 1920s Paris was to create a distinctive new-world sound for audiences hungry for music of the skyscraper age. It was his work, along with that of the French, that inspired Cole Porter to compose a rambunctious score, with American sounds and noises, for Murphy's ballet. Antheil's symphonic music was "mechanistic," to use one of his favorite words; discordant; and often so cacophonous and barbaric that at least one of his concerts ended in a riot. Entitling his compositions *The Airplane Sonata*, *A Jazz Symphony*, *Ballet Mécanique*, and *Transatlantic*, Antheil became famous and infamous for his elaborate performances and his wild and feverish combination of sounds (Fig. 94). Using player pianos, xylophones, wind machines, sirens, airplane propellers, and doorbells, and often including passages from well-known

Fig. 94 (facing). Will B. Johnstone, *El Rivetor.* Cartoon review of Antheil's *Ballet Mécanique* performance in Carnegie Hall. From *The World* (New York), Apr. 12, 1927.

EL RIVETOR

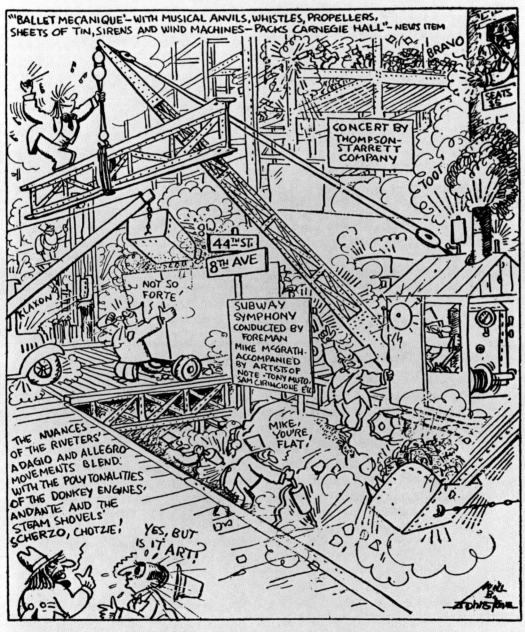

Fig. 95 (top). Josephine Baker wearing the banana skirt, ca. 1927.

Fig. 96 (bottom). Portrait of Josephine Baker by Hoyningen-Huene.

American popular songs, Antheil's music was hailed as giving "musical expression" to the American skyscraper. In so doing, "for the first time, he has broken with European traditions and created an American national music."[71] Ezra Pound, one of Antheil's earliest supporters, called the composer's aesthetic as ultramodern as America itself: "an aesthetic of machinery, of porcelain baths, of cubic rooms painted with Ripolin, hospital wards with patent dustproof corners and ventilating appliances."[72] Pound's references were to *Transatlantic*, Antheil's opera that included a moving elevator and a revolving door, the arrival of an ocean liner, and, in the final act, a woman in a bathtub singing and talking on the phone!

Antheil was one of those in the 1920s whose work was so tightly integrated into the mythology of *américanisme*, both as subject and as agent, that he was more celebrated in Paris than he could ever have been in New York. This was often the case, especially among entertainers, who enjoyed popularity and audiences in Europe that they did not know at home. American chorus lines, sometimes black, sometimes white, hailed as mechanistic and machine age, and always called, in English, "girl" shows, were extremely popular, especially in Germany. Jazz musicians found a warm welcome almost everywhere they went; that they were often African Americans reinforced Europeans' fluid picture of America as a place of exotic otherness, where skyscraper primitives lived with tribal primitives—this cohabitation itself seemed modern—unfettered, uncivilized, freed from convention. No one exemplified this coalescence of modernolatry and primitivizing better than the dancer Josephine Baker, who was probably the most recognized American living in Paris in the mid-1920s. She was a meta-American in that her performances combined American Charleston and jazz rhythms with the tribal beats of Africa and plantation life. Onstage she often dressed as a jungle creature—one famous costume consisted of a low-slung belt of dangling bananas—while offstage she fashioned herself as an ultramodern, with streamlined dress, slicked-down hair, and makeup applied so perfectly that it looked as if it had been applied by machine (Figs. 95, 96). She appeared as modern as a skyscraper. Baker played back to her audience their fantasies of her race as primitive and tribal, on the one hand, and as the genius inventors of modern American dancing and jazz, on the other.

Of all the *transatlantiques* in Paris who profited by the mythos of America, no one enjoyed greater popular success than Baker. Even her theme song encapsulated the transatlantic romance: "J'ai deux amours," I have two loves, my country and Paris.[73]

Gerald Murphy's fan club was considerably smaller and more elite than Baker's, but his success abroad was based on the same cultural dynamic. If Baker played to French expectations of an American Jazzbaby, and Antheil to those of the Skyscraper Primitive, then Murphy acted out the wealthy American Male.

Part of Murphy's seeming Americanness, like Baker's, was his pronounced modernity, a stylishness the French admired and identified with an America of skyscrapers, suspension bridges, and porcelain bathrooms. Murphy's habits of dress were those of a walking machine age abstraction. He was a dandy, but a dandy of the *moderne*, not the *fin de siècle*. Acutely sensitive to contour, he chose clothing with strong accents of solid color and pronounced geometrical patterns. He refused to put anything in his pockets that would break the line of his suit and tied his belongings in a square of striking fabric that he carried Japanese style, in his hands (Fig. 97). Or he put them in a leather envelope, like the ones French couriers used to carry banknotes from the Bourse. He often sported a cane. From the French sailor, he took the striped jersey and pioneered a new look for the Mediterranean: solid-colored shorts or long pants with a sailor's jersey and, on his head, the perfect circle of a white French worker's hat. Sara too was innovative in her dress, charming Picasso, among others, by wearing a long string of pearls with her bathing outfits, sometimes draping them down her bare back (Fig. 98).[74]

The Murphys were also among the first to adopt a machine age aesthetic in decorating their homes, going to great lengths to modernize their prewar villa on the Riviera near Antibes. They spent two years turning a very ordinary and old-fashioned house into an art moderne showpiece. They replaced the peaked chalet roof with a flat sundeck—one of the first on the Riviera—added windows and black tile floors, and whitewashed the interior to harmonize with stainless-steel furniture upholstered in white.[75] They also created an outdoor terrace, which guests

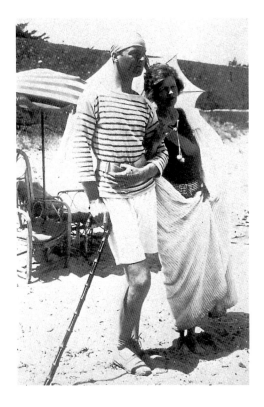

Fig. 97 (top). Gerald Murphy.

Fig. 98 (bottom). Gerald and Sara Murphy, Cap d'Antibes, 1923.

Fig. 99. Villa America as viewed
from the terrace.

found a sensation of nouveau design (Fig. 99). Tiled in white and gray checkered flagstones, it was like an outdoor living room, with iron tables secured from a local restaurant supplier.[76] Murphy had the café furniture painted with silver radiator paint. Le Corbusier, for one, was impressed by the results. Campaigning at the time against revival styles and advocating the unadorned wall and flat roof, he found Murphy's whitewashed walls an excellent backdrop for party goers' colors and silhouettes. "Mr. M. has moved into a house of whitewash," Le Corbusier reported. "When he gives a party, the evening clothes and dinner jackets create a most attractive spectacle."[77]

The Murphys' apartments in Paris were no less sensational. Ellen Barry, a friend, vividly recalled her surprise when she stepped into the one on the quai des Grands-Augustins because she had never seen anything so "modern." Although the apartment was in an old building, Gerald and Sara had completely obscured its antiquity by painting the walls stark white and the parquet floors black. At the windows there were deep red brocade drapes, while the furniture was covered in a shiny black fabric usually used for the linings of men's suits. This was Sara's

creation. Gerald's contribution was the pièce de résistance: a newly chromed ball bearing, a foot and a half in diameter, that Murphy had mounted on a black pedestal and made into a revolving sculpture that sat on the black ebony piano.[78]

In the 1920s this particular bearing, a Swedish ball manufactured by the S.K.F. industries, was hailed by a number of artists as one of the epoch's great mechanical beauties. Blaise Cendrars, the poet, named "the S.K.F. ball bearing," along with advertising, the internal combustion motor, and "the cut of a great tailor," one of the "seven marvels of the modern world."[79] And both Murphy and Léger included ball bearings as a still-life element in paintings (Fig. 100).[80] But Murphy may have been the only artist to install one as a decoration in his home. This was symptomatic of his modus operandi. He transformed current tastes in the studio world of French artists like Léger and Le Corbusier into dress and interior decoration. He made chic what Léger talked about in his lectures and what the magazine L'Esprit Nouveau promoted in art. The "new spirit" Léger and others called for in a revitalized French postwar art strove for a clean, geometric, machine-tooled modernity, replacing the messy and

dynamic definitions of modern life that artists had worked with before the war.[81] Murphy, picking up ideas he said "were in the air," entered into current avant-garde enthusiasms totally unencumbered by the French artists' classical traditions and theoretical complexities, and he demonstrated the "new spirit" aesthetic in its bluntest, most elegant form.[82]

In the 1920s anything in the shape of a wheel, for instance, excited the "new spirit" artists, who found this primary form in the classical column and the coliseum and in the modern watch face, electrical fan, and bicycle or automotive wheel. There was beauty and satisfaction in the "plastic values" of a simple circle, Léger would tell his students, as he pointed out the pleasing perfection of the modern man's straw hat, the watch face, and the bread roll. And then he gave advice, probably drawing on Murphy's example. "Put a sphere or a ball—never mind what material it is made of—in your apartment. It is never unpleasant and always will fit in wherever it may be. It is the beautiful object with no other purpose than what it is."[83] For one of Murphy's parties, Léger hung bicycle wheels on the walls as decorations.[84]

Léger's bicycle wheels and Murphy's ball bearing—ersatz readymades—tell us volumes about how little Duchampian ideas took hold in Paris or, to the contrary, how much they took hold, but only in stylish forms. Duchamp, we remember, hated the tastefulness of Paris. Unlike his *Fountain*, which was bawdy and gritty as an artifact, Murphy's ball was all style and surface, in harmony with its ultra-modern surroundings. In the hands of artists after the war, readymades became debased, or, to put it as an oxymoron, fashionable and tasteful. This talent for fashion, said a jaundiced Hemingway late in life, was what made the Murphys successful. They sniffed out and reinforced who and what was à la mode by giving their high-fashion parties. The Murphys "never wasted their time nor their charm on something that was not sure."[85]

Hemingway was mean-spirited but not entirely wrong. Murphy's intuitive sense of rightness about style and his ability to orchestrate a machine age persona in tune with French expectations were what earned him his reputation as *the* American painter in Paris. Murphy wore his Americanness like fashionable garb. He made himself as streamlined and

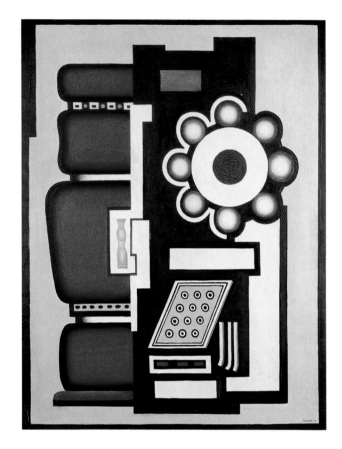

Fig. 100. Fernand Léger, *Ball Bearing*, 1926. Oil on canvas, 57½ × 44⅞ in.

Fig. 101. Gerald Murphy, *Watch*, 1925. Oil on canvas,
78$\frac{1}{2}$ × 78$\frac{7}{8}$ in.

ultramodern as the mythic country from which he hailed. While some of his younger American friends resented his gift for stylishness, his money, and his identification with the beau monde, the French loved it.

With one or two exceptions, Murphy painted things closely associated in the French mind with American inventiveness and with transatlantic modernism. If not specifically American inventions, the objects in his works were nevertheless tagged as typical of an American way of life. Murphy's three earliest paintings, all now lost, were two close-up views of machinery and *Boat Deck*, a painting of an ocean liner that, like other contemporary representations of such ships, embodied the primacy of transatlantic exchange and travel during the period. Other works depicted the mechanical innards of a watch (Fig. 101), the instruments in a scientific

laboratory, and ball bearings (the last two paintings are lost). In one still life he depicted popular American products of the 1920s, the Gillette safety razor and the Parker fountain pen (see Fig. 69), and in another the elegantly orchestrated accoutrements of the American cocktail tray: the moderne shaker, the corkscrew, the lemon, the Manhattan glass and cherry, and accompanying cigars. *Library* included a globe (another sphere) prominently displaying North and South America. In *Portrait* he blew up an eye, footprints, a pair of lips, and fingerprints to the scale of billboard imagery. In two works—*Dove* and *Wasp and Pear*—the subject matter is of a different poetic order, being of nature rather than of manufacture.

What Murphy did not paint was as important as what he did paint. He never painted the human figure, the French landscape, or the café still life so favored by the cubist and "new spirit" painters whom he admired. Unlike many American artists

abroad, he took lessons from the French moderns but then went his independent way. He admired French painters, he said late in life, but had "no desire to paint like Matisse, Picasso, or Léger, or the others."[86]

Like George Antheil and Josephine Baker, Murphy was an original in Paris. In an installation photograph showing his painting *Boat Deck* the work is so large, stark, and forceful that it makes the paintings by Murphy's peers look fussy and overworked (Fig. 102). An eighteen-foot-high still life of ocean-liner ventilators and funnels, *Boat Deck* dominated the American submissions to the 1924 Salon des Indépendants at the Grand Palais. With its minimal frame (the newspaper reported it was made of steel casing); its large, readable forms; its flatly painted surface; and its elementary color scheme (gray, white, black, and red, the artist recalled), the painting looked like a gigantic poster or billboard next to the intricately broken cubist surfaces of the easel paintings to either side.[87] And with its rapierlike contours and smooth surfaces, it appeared printed rather than painted, and shaped by precision tools rather than a paintbrush. In the eyes of the Parisian critics, it was "an enormous machine" and "an immense billboard."[88] Indeed, *Boat Deck* was so schematic that the president of the Indépendants, Paul Signac, dismissing it as an "architectural drawing" out of scale with the other works, wanted to hang it in the hallway.[89] When Murphy refused, Signac temporarily tendered his resignation in protest. A day later, he reconsidered his action while Murphy complained to the press: "If they think my picture is too big, I think the other pictures are too small. After all it is the Grand Palais."[90]

The same brazen independence from the prevailing styles of French cubism made Murphy's *Razor* stand out from its French neighbors in the exhibition *L'Art d'aujourd'hui* in 1925 (Fig. 103). *Razor's* plainness contrasted dramatically with the pictorial intricacies and intellectual savvy of the cubist and Purist canvases by Delaunay, Le Corbusier, and Patrick Henry Bruce that hung nearby. It was not a huge painting like *Boat Deck*; its dimensions matched those of the work hanging next to it. But the scale of the still-life objects *within* the painting was enormous: a nearly three-foot-long fountain pen; a two-foot-long safety razor, and an equally overscale box of safety matches (see Fig. 69).

Fig. 102 (top). Gerald Murphy's *Boat Deck*, 1923, hanging in the 1924 Salon des Indépendents at the Grand Palais. Location of original work unknown.

Fig. 103 (bottom). Gerald Murphy's *Razor* hanging in the *Art d'aujourd'hui* exhibition, Dec. 1925.

Murphy's family, we recall, owned a fashionable retail business; his father had transformed Mark Cross from an ordinary to a high-end leather-goods store. The store was one of Murphy's earliest classrooms, shaping his taste for well-made goods and teaching him to recognize style, quality, and the little details that distinguish one product line from another—the fire engine red of the Parker pen, the diamond-patterned stippling on the stem of the Gillette razor, or the eyelike design of the Three Stars safety matches box cover. In many ways, Murphy had the skills of a product designer; whether setting a table or arranging personal belongings on his bureau top, both of which he was known for, he was concerned with presentation and packaging. After graduating from Yale, he had been involved in product design, working on the patent for a Mark Cross safety razor before Gillette captured the market.[91]

The three objects in *Razor* were as immediately recognizable to Murphy's audience of 1925 as Andy Warhol's Campbell's soup cans were to a later generation. But whereas Campbell's soup cans had been in the American home for many decades before Warhol painted them, Murphy's objects were among the startling new consumer products that flourished in the postwar period, offering time-saving convenience in streamlined, industrial-looking packages. Many of these products were closely identified with an American style of living associated with speed, efficiency, hygiene, comfort, and luxury goods. All that America has to offer, said one skeptical European in 1928, coming up with yet another formula for American inventiveness, is "a new organization [Taylorism] and the best razors."[92] The products Murphy chose were also associated with a consumer stylishness that swept across Europe and the United States in the postwar period. The fountain pen, safety razor, and safety match were modern goods doing age-old jobs, and to use them, rather than their clumsy and old-fashioned predecessors, carried heavy signification. Like bobbed hair and chemises, or alarm clocks and toasters, these goods marked their users as progressive and "modern," as people eager to live fully in their own time.

In avant-garde circles such products were widely admired for their clean and functional designs; they belonged to "our epoch" and represented the "new spirit," as the rhetoric had it. Ozenfant and Le Corbusier, whose magazine *L'Esprit Nouveau* defined a new postwar cubist style called Purism, were convinced that there was a modern style—not many styles, as Le Corbusier liked to point out, but a single, unitary aesthetic that was unique and peculiar to the time. It could be found in those corners of daily life where the engineer and the designer, rather than respond to the canons of official taste, built to accommodate function. The style that resulted was, the argument went, true and natural, characterized by simplicity, classical geometry, and universally pleasing proportions. For Le Corbusier the new aesthetic could already be witnessed in the era's cropped haircuts and "its costume, its fountain pen, its ever sharp pencil, its typewriter, its telephone, its admirable office furniture, its plate-glass, and its 'Innovation' trunks, the safety razor and the briar pipe, the bowler hat and the limousine, the steamship and the airplane."[93] It could be found in the flat-roofed boxiness of the American industrial plant and the purely functional shafts of the American grain elevator. But it was not yet, as it ought to be—and this he sought to rectify—in the mainstream of official art and architecture, which were captive to revival styles.

The proposal to locate the age's beauty in the stripped-down designs of new commodities—which artists like Apollinaire and Cendrars were among the first to make seriously, and Duchamp and the dadaists halfway in jest—became a credo in the 1920s. In 1921, we remember, Duchamp in New York irreverently morphed an Archipenko sculpture into a fountain pen (see Fig. 61) while his Parisian friend Léger very seriously began to include pipes and bowler hats in his paintings. Typewriters, skyscrapers, rubber tires, cars, and airplanes appeared in works by artists as different from one another as Rodchenko in Russia and Sheeler in New York. In New York, Arthur Dove made an assemblage, *Pen and Razor Blade,* while in Paris Soupault marveled at his hands as he watched himself writing a poem by candlelight "avec un stylographe Watermann [*sic*]."[94]

Advocacy of contemporary products and their pleasures went deep into the culture. Admen had never before enjoyed such partnerships. Even the *New York Times* ran an article praising the fine line and color of modern "everyday tools" and their ability to make people feel good. "The safety razor makes its appeal on esthetic grounds. The

enormously useful fountain-pen until recently was content to be merely useful, in its sober case of black rubber. It now charms with all the colors of the rainbow. . . . The famous American bathroom is evolving from a miracle of sanitation into a triumph of form and tint." Recognizing the heresy of locating beauty in things rather than in art, the writer ventured that living with well-designed household objects was life enhancing. "We are at liberty to hold that a man cannot go on, morning after morning, shaving with an art-razor and bathing in a Roman bath-tub without ultimately enriching his soul."[95]

Murphy, too, professed to love these objects for their modern beauty and clearly picked out subjects for his paintings that (like the ball bearing for his living room) he felt exemplified the best in contemporary design. The razor and the fountain pen were objects, he once said, that had "weight and construction," even though they were "no bigger than a man's hand."[96] He also gravitated toward specific brand-name products. Indeed, *Razor* is built upon one of the most consequential commercial innovations of the postwar period: that of differentiating similar products from one another by distinctive styling. This included streamlining and stylizing an artifact, adding color to products that for decades had been black or white, and creating a distinctive, brand-specific logo. Such detailing helped in marketing and, as a corollary, kept the consumer hungry for ever more up-to-date models. Matchboxes, as well as matchbook covers, for instance, became highly designed (vintage examples are collected today for that reason). Because they were colorful and relatively new on the market, they attracted artists as one more quintessentially modern artifact. Duchamp inverted a "naughty" matchbook cover of two dogs sniffing each other to use as the cover image of *Rongwrong* (Fig. 104), and cubists used the matchbook as a new kind of commercial graphic in their collages. Murphy's matchbox was clearly tasteful, his choice dictated by his love of clean geometric forms (Fig. 105). With its bold oval and three stars, all of which Murphy simplified, giving each star a slightly different pattern and eliminating the words identifying the parent company as Swedish, Three Stars matches had a "new spirit" logo.[97]

The fountain pen, with its gold clip and cap band, was unmistakably the fashionable and popular Duofold model from the Parker Pen Company. Its most

Fig. 104 (top). *Rongwrong*, Aug. 1917.

Fig. 105 (bottom). Matchbox cover, Three Stars safety matches.

Fig. 106 (top). Advertisement for Gillette safety razors in China, 1924.

Fig. 107 (bottom). Advertisement for Parker Duofold pens, 1926.

distinctive feature was its strong color. Like other manufacturers, Parker discovered that color would sell pens to people who previously had lived in a black-and-white world. In the early 1920s the company issued the Duofold, an oversize pen (holding more ink than conventional sizes) with a vivid orange-red barrel; advertisements claimed it "rivals the beauty of the Scarlet Tanager" and is as "beautiful as Chinese Lacquer."[98] At seven dollars—a good day's pay for an American factory worker—"The Big Red" cost at least twice as much as other pens, but it was so stylish and functional and was marketed so effectively as the pen of "America's 'go-getters'" that it "vaulted Parker Pen," as one historian put it, "into a place of international renown."[99] (Today, vintage Duofolds are valuable collector's items, and the Parker Pen Company has reissued "The Big Red" in both expensive and cheap, mass-market replicas.)

Of the three products in the painting, the razor was the one the French would have found most identifiably and familiarly American. King Gillette had been manufacturing razors and disposable blades since the beginning of the century—the patent was granted in 1901—and through an aggressive marketing and distribution policy had managed by the 1920s to outstrip his competitors in the industry and dominate the international market (Fig. 106). Gillette stores and billboards had cropped up all over the world, as had advertisements vaunting the throwaway blade and the speed with which one could shave and the feel of the sleek instrument in the hand. Razors as well as fountain pens were packaged lavishly, like precious jewelry, in velvet-lined boxes.

Ever alert to the tactics and images of the commercial world, Murphy clearly knew this product and its promotional literature. Mimicking the standard Gillette advertisements, he drew the big razor in his painting on the diagonal, so that one could see its full length and hallmark features: the toothed head, the blade with rounded edges, and the knurls on the stem and turn knob at the end of the handle. The exaggerated size of the razor, its two-foot-long "heroic scale," was a familiar advertising gambit: representations of huge razors appeared not just on billboards but in magazine advertisements, where it was common to find gigantic fountain pens lording it over skyscrapers and monstrous razors looming over the face being shaved (Fig. 107).

Indeed, what is most startling about *Razor* is its

Fig. 108. Georges Braque, *Still Life on a Table: "Gillette,"* 1914. Charcoal, pasted paper, and gouache, 18⅞ × 24⅜ in.

blatant appropriation of the American advertiser's visual vocabulary. To any sensitive observer in 1925—French or American—*Razor* looked like an advertisement, particularly the American type that the French advertising trade lambasted for its dumb realism and lack of tasteful graphics. The artfulness of the belle époque poster still commanded respect in Paris and the hard-sell techniques of American ads challenged its supremacy. To be more accurate, Murphy's painting looked as if it had been painted by an artist who had married the braggadocio of the American billboard and magazine promotion to the most elementary of cubist structures. He depicted the razor cubistically, Murphy said, "mechanically, in profile and section, from three points of view at once."[100]

Murphy ran in art circles where the newspaper advertisement and billboard had been identified as signifiers of the modern age. Earlier, Picasso and

Braque had put clippings from newspaper ads into their collages, including, in Braque's case, one for a safety razor in a 1914 still life (Fig. 108). And the ever-prescient Apollinaire had used quotations from ads in his poems while formulating a premise—advertising is the "poetry of our epoch"—that was iconoclastic before the war but a machine age adage after it. When Cendrars wrote his essay "Advertising = Poetry," claiming that ads were "the most beautiful expression of our epoch, the greatest novelty of the day, an Art," and when articles appeared in the transatlantic magazine *Broom* calling for an art based on advertising jingles and in *L'Art Vivant*, for one based on the grand scale and color of billboards, the artist's appropriation of the commercial world, already acknowledged as feasible, became programmatic. Machine age artists from both sides of the Atlantic colluded with the captains of the advertising industry as never before.

Fig. 109. Billboards for Bébé Cadum in Paris, ca. 1925.

Léger, vocal about the beauty of billboards, surely took Murphy to one of his favorite urban sites, the Place Clichy, where huge billboards, often of repeated images, overlooked the intersection. (The ads for Cadum soap, carrying the gigantic cherubic face of Bébé Cadum, were favorites [Fig. 109].) He and Murphy liked to take walks together around Paris in search of such exciting visual events, going to Léger's "favorite haunts," as Murphy called them: the bistros, *bal musettes, foires, fêtes,* traveling circuses, railroad cars, stock farms, the Place Clichy, and delicatessens or grocery stores, with their dazzling window displays.[101] John Dos Passos reported that on these walks the two flaneurs excited one another or, as he put it, "set each other off." To tour with these two men, Dos Passos wrote, was to see the world anew, listening to Léger, with his "visual fury," and to Murphy, whose perceptions "were rational, discriminating, with a tendency to a mathematical elegance." The two artists "picked out winches, the flukes of an anchor, coils of rope, the red funnel of a towboat, half a woman's face seen behind geraniums through the casement window of the cabin of a barge. 'Regardez-moi ça.' The banks of the Seine never looked banal again."[102]

Léger called these visual events "spectacles," the French word for parade, pageant, or theater piece, one that today, since the publication of Guy Debord's *Society of the Spectacle,* has become a theoretical term for the commodity and image displays, controlled by forces of production and power, that dominate late-twentieth-century life.[103] Léger used the term in the 1920s without critical edge; although he often applied it to the very same displays that theorists today decode for their falsity and manipulative power, the word for him connoted authentically pleasing formal qualities and abstraction. Léger urged his students to envision themselves as players in a grand festival of modern life, in which they were the audience and the world a set of visual presentations. For him, wherever there was detectable pattern, geometry, and blocks of color—in shop window displays, in advertisements, in interior decoration—there was spectacle. The more unexpected it was, and the more inadvertent on the part of the maker, the more exciting he found it. There was spectacle, Léger declared, in coming upon a young mechanic with red hair, blue coat, and orange pants, "spattered with Prussian blue" paint.[104] In the same essay, he taught his students that "the most beautiful spectacles in the world" were the machines in the Aviation Show and Automobile Show in Paris.[105] When he came to New York, the sensory impact of the buildings, crowds, and lights made it "the most

colossal spectacle in the world."[106] When Murphy
talked about how "real objects which I admired had
become for me abstractions," he was articulating
Léger's theory of spectacle.[107]

One of the ways in which Léger and Murphy en-
gaged with one another as artistic colleagues was
through their common indulgence in modern specta-
cles. This helps to explain their relationship, which
some perceived as that of an odd couple. Léger
was the big, earthy Frenchman who championed
working-class life and railed against "tastefulness,"
Murphy, the rich, elegant American whose natty
tastes ran to white suits and beautiful cravats.[108]
Léger was the established painter, and influential
teacher, Murphy, a Johnny-come-lately to the art
world. Léger painted sophisticated and learned com-
positions while Murphy looked primitive, or "naïf,"
as William Rubin has said, when put up against the
French moderns.[109] Moreover, Rubin continued,
Murphy regarded Léger as one of the great painters
of the day; he thought him "an apostle, a mentor, a
teacher."[110]

But clearly this was a relationship that was more
than that of teacher to student. Its complicated dy-
namics add another layer to our understanding of
the larger Franco-American cultural alliance that
developed during and after the war.

What could Murphy offer Léger in the way of ex-
change? He was a potential patron, of course, and
did help in a number of ways, particularly in the
1930s when he made it possible for Léger to visit
New York for the first time. But in the 1920s, when
the two men saw much of each other in France,
Murphy also tutored his French friend in American
ways. As a student of modernity Léger, like so many
in the French avant-garde, was deeply captivated by
what made Americans tick. Before he turned away
from painting the mechanical in the late 1920s, he
was an enthusiast of Taylorism and Fordism. In
1920 he had even painted a portrait of a fashionably
dressed American man on city streets, with a red,
white, and blue flag behind him. (Though Léger had
not yet met Murphy, and the man is anonymous, the
model, in his dress, especially the bowler hat, bears
an uncanny resemblance to Murphy [Fig. 110].)
If Léger taught Murphy picture making, Murphy
gave Léger firsthand acquaintance with an Ameri-
can modern. Or to put it another way, Murphy con-
firmed for Léger (and for Picasso) that Americans

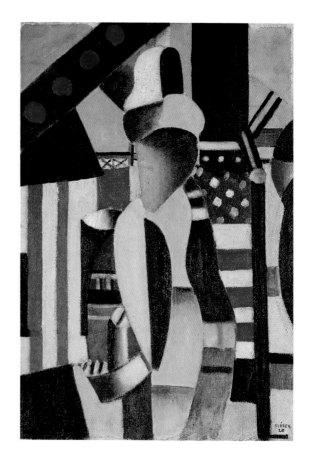

Fig. 110. Fernand Léger, *Man with Hat*, 1920.
Oil on canvas, 21¾ × 15 in.

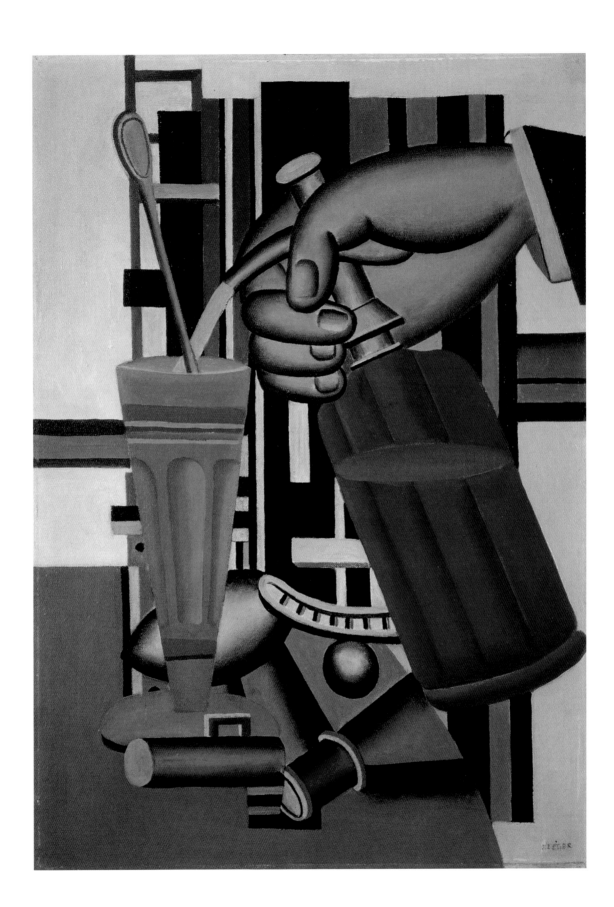

had different, non-European, ways of acting in
the world. Murphy fit so many of the stereotypes:
he was rich, youthful, and independent, witty and
pragmatic. And his paintings seemed proof that
Americans were the world's preeminent admen
and engineers.

One way to substantiate this claim is to look at the
two men's different approaches to a similar painting
problem. If we compare *Razor* with Léger's *Siphon*,
made in the same year as *Razor* and based on a spe-
cific magazine advertisement, it is the painting by
Léger, the great promoter of modern advertising,
that much more consciously reworks and extin-
guishes the commercial element—in this case a
Campari ad (Figs. 111, 112).[111] All that remains of
the original ad that inspired *Le Siphon* are the gen-
eral lines of the composition: a waiter's hand coming
in from the right and filling a glass from a syphon.
The everydayness of the glass, fluted and without
its Campari trademark, disguises the commercial
source for the painting; it seems yet one more
variation on the cubist café still life.

Furthermore, whereas in the ad the hand, bottle,
and glass are rendered as separate and individual en-
tities, in the painting they are knit into a complex cu-
bist structure. As he typically did at this time, Léger
composed the canvas of two structural layers, one
literal (the rounded still-life elements in the fore-
ground) and one abstract (the flat rectilinear planes
of color in the background). In this structure he fol-
lowed his "law of contrasts" and pursued his fond-
ness for a vivid pictorial clash between volumes and
planes, here the contrast between the rounded still-
life elements and the flat "wall" and moldings be-
hind them. But the dynamic of the picture also
depends on the cubist interplay between the two
strata. The layers are not totally separate. The table
edges, the rim of the glass, and the spoon all touch
and intersect the grid work behind them. Parts of
the foreground function as background, and details
from behind push through to the front plane. The
cuff of the waiter's sleeve can be read as both fore-
ground and background, while the band across the
glass is simultaneously a decoration on the glass,
the surface of the liquid in the glass, and the wall
molding behind.

Fig. 112. Campari advertisement, 1924.

Fig. 111 (facing). Fernand Léger, *Le Siphon*, 1924.
Oil on canvas, 25⅝ × 18⅛ in.

The architecture of Murphy's picture, also based on the adman's language, is very different. He composed *Razor* using the same two layers as Léger—a still life in the foreground against abstract blocks of color—but he barely knit the two layers together. The blocks of background color maintain their subsidiary role as backdrop for the objects. Although in one or two passages in Murphy's painting elements in the background push through to the foreground, the cubist push-and-pull is elementary. In Murphy's painting the cubist structure of the picture never violates or interferes with the integrity of the objects. (This led one French critic to call them "cocktail canvases . . . better suited to posters than to easel paintings.")[112]

What distinguishes *Razor* from *Le Siphon*, then, was Murphy's insistence on retaining the specificity of his three still-life elements and their brand-name features. Like an advertiser, Murphy let the products speak. Léger, by contrast, divested his objects of their particularity and their lowbrow advertising origins by privileging pictorial structure over the objects' material being. He abstracted and departicularized what he took from the streets, while Murphy spoke bluntly in the adman's vernacular. Léger subsumed and cubistically aestheticized his popular sources, while Murphy paraded them as well-designed, distinctive modern-day objects. If Léger's style is high modernist cubism, we can call Murphy's low billboard.

This bluntness, materiality, and uncomplicated cubism surely underscored Murphy's Americanness for Léger, Picasso, and others. Like Ben Franklin when he appeared at the French court or Benjamin West, who made modern-day history paintings, Murphy spoke in plain speech. And like Franklin, he appeared witty and wise in his vernacularisms; that wit must have delighted an artist like Picasso, who was himself a master of the double entendre. In crossing the pen and the razor in front of the safety match box, Murphy skillfully refashioned the familiar skull-and-crossbones motif. The skull in this case is the white oval of the matchbox cover staring out at us like a single unblinking eye. That cover, with its prominent words and bright colors, also reads like a billboard hanging over the point where the two implements cross. And the whole painting can be construed as a coat of arms, a heraldic emblem, or a military decoration—flat, decorative, and formal: three

stars pinned above crossed swords. The irony here, applied with an exceedingly light touch, comes in reading the painting as a gigantic emblem—a billboard—for the new age of consumer spectacles. Murphy, in effect, painted a picture that served as a better advertisement for France's "new spirit" than any work by the French themselves. As Romy Golan rightly pointed out, the pages of *L'Esprit Nouveau* were filled with modern-day products and ads, but when it came to making a Purist still life, its guiding spirits, Léger and especially Le Corbusier, and Ozenfant maintained a tastefully French hierarchy between high and low, and made their paintings, not from razors and typewriters, but from bottles, glasses, and vases.[113]

For Murphy, a painter outside of French traditions and an arch-consumer of stylish goods, it seemed natural to render objects like those in *Razor* in a large-scaled *nature morte*. Commercial goods identified him as an American, not a French, painter. In his notebook, he characterized an idea for an unrealized still-life as an exploration of "Man's good-natured tussle with the giant material world; or man's unconscious slavery to his material possessions."[114] His work tended toward the good-natured tussle. In taking on the material world, Murphy was not inclined toward the bleaker, and more layered, criticism of consumer society that one finds in the 1920s novels of his friends Dos Passos and Fitzgerald. For them the modern world had its mean side, especially in urban America, where they found a society hell-bent on material progress but also haunted by death and destruction. It was certainly Murphy's lack of a deeper critique, and his indulgence in the French public's Americanophilia, that kept his American writer friends from taking his art as seriously as they did their own. But in the meantime, his levity—and his lack of complexity— were precisely what endeared him to Léger and Picasso. He painted with a humor and an innocence that the French wanted their American counterparts to possess. Indeed, to Léger and Picasso, Murphy must have looked like a machine age Henri Rousseau—or a modern-day Edward Hicks, one of whose *Peaceable Kingdom* paintings Léger saw on a visit to New York and declared the greatest painting in America (see Fig. 305).[115] Because he was without solid foundation in the French traditions of *la belle peinture* and because he painted with such

gaiety and forthrightness, he would have seemed to the French avant-garde admirably fresh and unconventional, qualities they also adored in Walt Whitman and Charlie Chaplin.

But we should not quickly conclude that Murphy was, in fact, an "innocent" painter or that his lack of training accounts for his independent approach. For all his admiration of the Frenchman, Murphy seems to have understood the differences between himself and Léger and even, one could say, caught Léger in one of his own unresolved dilemmas. For while Léger was certainly articulate about street spectacles, especially those found in modern cities, and liked to argue that there was no artistic hierarchy of beauty in the streets and beauty in modern works of art, he was by no means willing to give up the art of painting just because street life was so good. Indeed

he continually reserved for himself and his fellow artists the superior talent to mediate, manipulate, clean up, rigorously compose, and abstract from modern-day spectacles, presenting forms in what he called "an intensive organized state."[116] His solution was to urge artists to create modern works of art that could adequately compete with and surpass in beauty the superb work of contemporary artisans and engineers and the spectacles of contemporary life.[117]

Léger's enthusiasm for the streets and modern emporiums of Paris, therefore, did not lead him to paint actual sites in his city; *La Ville* of 1919 abstracts the characteristics of a modern metropolis— derricks, tall buildings, and billboards—but not those of any one particular city (Fig. 113). When he came to America as Murphy's guest in 1931, Léger

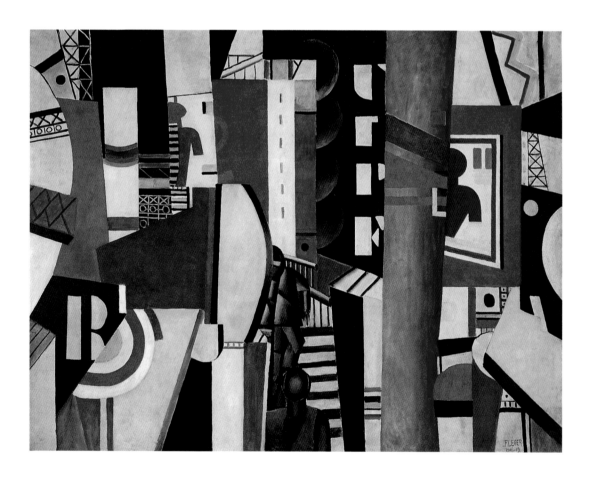

Fig. 113. Fernand Léger, *La Ville* (*The City*), 1919. Oil on canvas, 91 × 117½ in.

tellingly refused to paint any aspect of New York. He enumerated the city's spectacles in print—its newness, its architecture, its cinemas, its staircases, its traffic, "the whole dizzying show which extends to both nausea and Beauty." He took it all in, he said, "this overloaded spectacle, all that unrestrained vitality, the violence that is there, even in mistakes. It's very young."[118] But he could not imagine making art about it. "It is madness to think of employing such a subject artistically."[119]

So while Léger may have helped lead Murphy to some of his imagery—ocean liners, machinery, billboards—the American artist showed Léger how it was possible to paint such spectacles with a literalness and matter-of-factness that erased some of the hierarchy between street and art gallery that Léger spoke to but did not practice in his own work. From Léger's position, Murphy's "billboard cubism"—so primer-like and elementary in form— must have seemed appropriate and natural for an American who hailed from the country of plumbing and ads and provincial artists but unimaginable for a Frenchman whose heritage, thought to be deeply imperiled after the war, was embued with centuries of classicism and fine arts traditions. The Léger Murphy came to know so well in the 1920s, then, was as French to Murphy as Murphy was American to him. They built their relationship as two cultural nationalists, each admiring what the other had to offer. Léger championed modern life and loved its spectacle but tightly guarded the great French traditions of *la belle peinture* and the revered status of the artist in French culture. Murphy, meanwhile, could offer Léger something the Frenchman could advocate but not be himself: a man totally in and of the contemporary world. Seen in this context, Léger was the old-world humanist, Murphy the new-world primitive. Their friendship played out one of the central dynamics of the transatlantic Franco-American discourse of the 1920s.

It is usually said that Murphy ceased painting in 1929 because one of his sons fell ill with tuberculosis and because he had to return home to take over Mark Cross, the family business, during the depression. He left many of his works rolled up in France and never resumed painting again.

But it was the larger dynamics of history, not just personal affairs, that brought closure to Murphy's brief career as a painter. For Murphy's art depended on a leisurely life in prosperous times and on a French milieu that valued transatlantic exchange. With the coming of the depression in America, with its effects felt throughout the Western world, and the rise of fascism in Europe, the ambience that had made Murphy into a painter vanished. Dreams of a future machine age dimmed, and the idealization of modernity collapsed. Like many in the roaring 1920s, he was such a man of his times, and such a perfectionist, that he could not imagine how to go forward as an artist in these new conditions.

Even had he stayed in France, he would have found it difficult to maintain his artistic momentum and glamour. By the late 1920s *américanisme* had become the focus of intellectual debate in France and a topic of considerable concern throughout Europe. Was it simply a veneer or was it a more serious transformation of French life? Who will be the master, Europe or America? was the question for Lucien Romier, an editor of *Le Figaro*, whose book by this title was first published in France but quickly translated and published in an American edition.[120] One of the most comprehensive attempts to answer the question was undertaken by *Transition*, an American little magazine edited and printed in Paris. In 1928 Eugène Jolas, the magazine's editor, surveyed twenty-four prominent European writers, asking each of them to assess the impact of America on Europe and pronounce themselves either "for or against those influences."[121] Although their opinions on Americanization varied—whether it was a beneficial therapy, a destruction of traditional values, or a superficial fashion—they tended to agree that the winds coming across the Atlantic were like a "force of nature," impossible to contain, and, in at least one Spenglerian view, as inevitable as the fall of one nation and the rise of another.[122] "It is the American rhythm that carries the planet today," one of those interviewed wrote. "It is irresistible, whether you regret it or not."[123] Of what did it consist? The writers restated the myth: America was the land of dollars, machines, and mass culture, a utilitarian and pragmatic culture; its gifts to France were the razor, jazz, film, new dances, advertising, the Pullman car, and standardization.

Whatever their stance, they agreed that Americanization meant the importation of a new and different

style of life, in sharp contrast with that of Europe. At every turn, they invoked the familiar comparison: "Old Europe, Young America."[124] Europe had cherished traditions, humanistic values, and elegance, but "America had taught us to love whatever is young, and new."[125] America was "savage" and "barbarian" and had a "freshness" of mind;[126] Americans had "vitality"; they were "fresh and appealing," "simple and childlike." The European, said one, "particularly the old, worn, effete Latin should take a bath of youth, of health and animal joy by flinging himself into the superficial and receptive activity of the United States."[127]

Such comments came on the eve of the American depression and represent the beginnings of an intellectual backlash against the forces of American industry and culture that had been so attractive to many artists and intellectuals ten years earlier. In the past, wrote Paul Morand, "I wished Paris looked like New York." But this was no longer true, he said in his book *New York* (1930), where he decried America's mechanized metropolis, claiming that "the genius of Paris is precisely that of a meticulous peasant," trading in his veneration for the machine for that of the folk.[128] (His new enthusiasm was widely representative of what would become a new site of nationalism.) For the playwright Luigi Pirandello in 1929 the damage wrought by *américanisme* on Parisian life was "as strident and jarring as the make-up on the face of an aging *femme du monde*," a quotation so memorable that it was used by one of Europe's most prominent intellectuals of the Left, the Italian Antonio Gramsci, in his famous essay "Americanismo e Fordismo."[129] Gramsci was an important part of the new intellectual drive to dispute the claims for the revolutionary character of Taylor's and Ford's systems of production. From the poet Georges Duhamel, a friend of Léger's and of other French artists, came *America the Menace: Scenes from the Life of the Future*, a devastating firsthand account of America as "a devouring civilization" where even the fruit and eggs "seemed to taste of machinery." By 1931 Duhamel's book had gone into 243 editions, and *américanisme* had generated so

much heated discussion that it became the focus of a French doctoral dissertation.[130]

American *transatlantiques* also registered the changes in climate. In 1928, in an "Open Letter to Ezra Pound and the other 'Exiles,'" Matthew Josephson, who earlier had discovered his Americanness in Paris, called on his fellow countrymen to come home. "Return!" he urged, and make the artistic renaissance happen. "A period of mind will leaven this society which has known only material preoccupations. The dispersed and scattered beauty of automobiles and spotless kitchens and geometrical office buildings will have been organized and given direction through our understanding of the ensemble. A spiritual equilibrium will have been reached, in which we shall have been factors."[131] Josephson was still in the grips of machine age idealism, but this was soon to ebb as the American economy worsened and artists rethought their priorities. When in 1932 Man Ray sold both his fancy car and his professional movie camera, saying in his memoirs that he felt driven to get "rid of the things that had taken up too much of my time and energy especially mechanical things," it was an act of renunciation that could serve as an epitaph for a brief but momentous transatlantic adventure.[132]

Murphy's success, more than that of other artists, depended on his immediate environment. He had no style or subjects that were not intimately part of the decade in which they had been formed, the foreign country in which he had learned to paint, and the style in which he and his family had lived abroad. He could not replicate in New York the conditions he had enjoyed as an American in Paris. When the climate changed radically, and the 1930s took style out of fashion and destroyed faith in America as the country of industrial progress, something in him died as well. In what seems an authentically American act, he shifted back to business in the 1930s as quickly as he had become a painter in the 1920s. Though he might have continued as a weekend artist, he found the two professions irreconcilable. When he had to sell razors and pens for a living, the romance of *américanisme* was over.

AN ITALIAN IN
NEW YORK

Not one in a hundred of its citizens has ever seen New York. . . . Even our painter people are a little bewildered by its "bigness." They do scraps of color, odd bits along the Harlem, a city square or street; but with a few exceptions, they have not risen to the vast new city.

John Van Dyke, *The New New York*, 1909

It is an immense kaleidoscope—everything is hyperbolic, cyclopic, fantastic. From the domes of your temples dedicated to commerce one is treated to a new view, a prospect stretching out into the infinite. The searchlights that plow your leaden sky in the evening awaken and stimulate the imagination to the most daring flights. And the multicolored lights of the billboards create at night a new hymn of praise.

Joseph Stella, "New York"

Who is Joseph Stella? Is he an American? An Italian? Who is he? And how comes it that he of all painters should be constantly interpreting New York?" In these questions Katherine Dreier, in 1923, formulated the paradoxes of the postwar *transatlantique*.[1] A bicontinental Murphy in France made paintings about America for European audiences; an Italian immigrant to America, Joseph Stella, made art about New York for New Yorkers. Stella's large iconic paintings of modern Manhattan are powerful reminders of the admiration, shock, and confusion Europeans, coming from older and more traditional cultures, experienced in skyscraper New York. Stella's paintings are the most visionary and vertiginous that anyone—Americans or Europeans—painted of Manhattan in the 1920s.

These works and Stella's formation as an artist offer further testimony to the power of *américanisme*—or in his case *americanismo*—to shape cultural production in the early modern period and generate a new transatlantic consciousness.

Italian born and raised—the fourth of five sons born to a lawyer and his wife—Joseph Stella immigrated in 1896 at the age of eighteen.[2] His trip was sponsored by his older brother, who had become a doctor in New York and a leader in the Italian-American community. Young Stella entered the bustling metropolis through Ellis Island. Although this boy from the provinces, who had lived since birth in Muro Lucano, a small mountain village near Naples, took Manhattan as his home, his culture shock never abated. His deep sense of displacement supercharged his canvases of New York, like high-octane fuel.

Stella first took up medical and pharmacological

Fig. 114 (facing). Joseph Stella, *The Voice of the City of New York Interpreted: The Skyscrapers*, 1920–22. Oil and tempera on canvas, 99 3/4 × 54 in.

studies. But it quickly became clear that his interests were in art, and he transferred from medical school to the Art Students League and later the New York School of Art, where he studied under William Merritt Chase. After a few years of living on the Lower East Side of New York, drawing and painting immigrant and working-class figures in a documentary style (Fig. 115), Stella returned to Europe in 1909. His New York brother supported him while he worked in Venice, Florence, Rome, and finally Paris, a three-year stay that convinced him to leave his realist style for that of his aesthetically radical countrymen, the Italian futurists. In contact with all the latest developments in art, he was especially attracted to these artists at the very moment they were making their first major appearance in Italy and in Paris. Back in New York in time to experience the 1913 Armory Show, he quickly committed himself to futurist aesthetics with his *Battle of Lights, Coney Island, Mardi Gras*, painted that year (see Fig. 157). He was thirty-six years old, and this was his first grand painting of New York.

From then until his death in 1946, Stella made New York both the main subject of his painting and his more or less permanent residence, becoming an American citizen in 1923. But he led a restless, peripatetic life and crossed the Atlantic many times. He returned to Italy in 1922 and again in 1926, when he stayed for eight years, with only a brief return to New York in 1928. He took up residence in New York again in 1934, traveling to Barbados in 1937 and making a final trip to Italy and France in 1938.

Stella's migration back and forth across the Atlantic was reflected in his inability to sustain identification with any one artist group, in either Europe or America. Compared with other figures we have looked at, he was a loner. Though his closest association in the early years was with Duchamp, Man Ray, and others in the Arensberg circle and the Société Anonyme, his friendships lacked staying power, so much so that biographers do not have the usual letters, diaries, and photographs that help to tie down details of an artist's life. Even his marriage—and another serious alliance with a woman late in his life—are clouded in mystery. His erratic production, moreover, which defies scholars' attempts to push it into rational sequences, reflects his failure to make a home or find a community for himself. Unified neither by style nor by content, Stella's drawings

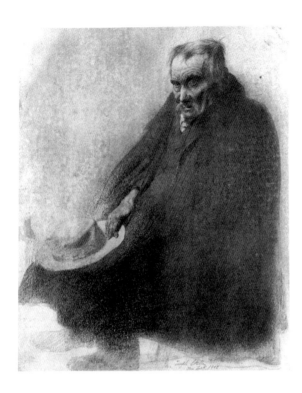

Fig. 115. Joseph Stella, *Portrait of Old Man*, 1908. Graphite and color pencil on paper, 11¾ × 9¼ in.

and paintings were sometimes cubo-futurist scenes of New York but more often, in later years, neoclassical renderings of human figures and fantastic nature themes. He could present himself as an art-for-art's-sake abstractionist as well as a champion of the working class. He painted in oils but was equally proficient in the more arcane crafts of silverpoint, collage, and painting on glass. "The result is a nightmare for the art historian," wrote a sympathetic scholar, who found Stella "an enigma compounded of widely conflicting elements."[3] An Italian newspaperman who interviewed Stella in the early 1930s summarized his transatlantic condition well: "Two-sided, alienated, he views the greatness of America with the eyes of a European, and the gentleness of the Neapolitan sea with the eyes of a stranger. It is here we find the secret of Stella's art. . . . Two homelands crowd his creative thought."[4]

Two homelands: is this not another way to describe the *transatlantique*? For Stella, being a *transatlantique* meant living in a continual state of alienation, which he sometimes tried to overcome by painting epic canvases of modern Manhattan. The city became his "big" theme, in the same way that it had once been Whitman's in poems Stella greatly admired. He never tried to paint other urban spaces he lived in—Paris or Rome—but from 1913 to 1941 he painted eight major works of modern-day Manhattan, giving his life's work its center and its only continuity. Of these, his paintings of Coney Island and Brooklyn Bridge are the best known, but *The Voice of the City of New York Interpreted*, a five-panel painting, is his most ambitious and audacious (see Fig. 118).[5] Measuring nearly twenty-two and a half feet long and almost eight and a half feet at its highest, *The Voice of the City* is the biggest, most complex oil painting of New York created during the period following World War I.[6] At a time when virtually all modernists tried their hand at representing the city, Stella's painting is the summa, with no equals save in poetry (Hart Crane's *The Bridge* of 1930) and in film (Charles Sheeler's and Paul Strand's *Manhatta* of 1921).[7]

All of Stella's Manhattan works "inhabit New York," to use once again Arthur Craven's nice phrase, in a highly concentrated way—but none more than *The Voice of the City*, which is the most obsessively possessive of them all. The painting is so panoramic in its sweep and so intensely hyperbolic

in its forms that one feels the artist's drive and ambition to master or conquer his subject as part of its content. The artist's *desire* to inhabit—ultimately, I think, unfulfilled—is part of what gives the painting its manic energy, an emotional tenor few works of the period came close to duplicating. Stella's imagined city is "science married to industry, in an audacious modernity," to recall Craven again, but so visionary and extraterrestrial that it reminds us of popular prophetic literature. Stella's city embodies New York in 1920 but also projects New York in 2000, imaging a futurology and utopianism popular in the movies, science-fiction writing, architectural design, and urban planning of the period.

By looking closely at *The Voice of the City*, I want to reflect on how it articulates "the greatness of America with the eyes of a European." This is the same lens I used in my exegesis of Duchamp's *Fountain*, though here it reveals a different variant of the European transplant in New York. Duchamp accommodated and reveled in his adopted country and turned his observations as a foreigner into cool and dispassionate play; he lived on both sides of the Atlantic as a cosmopolitan citizen of the world. Stella, in contrast, was a small-town Italian and remained so much a displaced person that he was never happy in either Italy or America.[8] His only home, rhetorically speaking, was permanent transit. Though he took citizenship, he never self-identified as an American, nor was he comfortably Italian-American, unlike his professionally successful New York brother. Such a hyphenated identity required more assimilation and forgetting than Stella allowed himself. In New York, the image he projected to most people was that of a heavy-set Italian displaced in America. He retained a thick southern Italian accent, and he wore a rope "peasant" belt and old-fashioned suits. When he posed for Man Ray, he added a hat, a guitar, and a beer, so that he looked decidedly old-world and nonmodern (Fig. 116). His preferred language was always Italian, in which he would pour out his ideas about life and art in highly emotional writings. Using an imagistic language, he addressed Manhattan as a city not his own, using the second-person pronoun "you." "From the domes of your temples," he wrote of skyscrapers, and "the search-lights that plow your leaden sky," he said of the city's beacon lights; when he wrote of Italy, he spoke of "my birthplace," "my native land," or "my land of

ancestors."[9] He also evoked metaphoric family relationships, longing for a unity with place like that of a child with a parent or a man with his lover. "I thank the Lord for having had the good fortune to be born in a mountain village," he wrote, characterizing his hometown of Muro Lucano as his "mother earth," his "father's house the sole link with the past."[10] He often spoke of himself as "an exile" from his native land and as a man stuck with a wife he could not shake: "New York is my wife—I always come back to her."[11] For Stella, who often expressed his sexual identity as that of a Don Juan, New York was gendered female—wife, mistress, muse, femme fatale, domineering mother.

Stella continually imagined New York as his elusive prey and himself as unrequited suitor, a set of images grounded in fin-de-siècle male anxieties.[12] That he painted the city so often, and in such exaggeratedly modern terms, expressed his continual cultural unease as a male immigrant in a city he seemed to love to hate. Alienation, displacement, and unrequited desire for union with place were, in Stella's case, powerful motivators. But so too were the demands of *américanisme*, which channeled artists into amorous adulation of the modern and the contemporary, leaving no room for family roots, for traditions, for relationships with the past or with individuals. Stella was driven to embrace New York and to inhabit it by the complicated dynamics of martyrdom—yes—but also by the competition in transatlantic circles after World War I to be modern America's greatest interpreter.

Fig. 116. Man Ray, *Portrait of Joseph Stella*, ca. 1920. Vintage silver print, 9⅝ × 6⅝ in.

The Voice of the City is the most ambitious painting of Stella's career, and one of the most virtuoso works of the early modern period. Created in the early 1920s, the painting has a fervor and an intensity that is both dazzling and dizzying. Scholars often find Stella's more atmospheric *Brooklyn Bridge* (ca. 1919) his chef d'oeuvre (Fig. 117), but that judgment represents something of yesterday's tastes. *The Voice of the City* assaults the eyes and pounds the senses in an exciting way familiar to the generations coming of age in a world of marijuana, psychedelic graphics, rock music, op art, art deco revival, and Red Grooms's *Ruckus Manhattan* (see Fig. 316).

Fig. 117 (facing). Joseph Stella, *Brooklyn Bridge*, ca. 1919. Oil on canvas, 84 × 76 in.

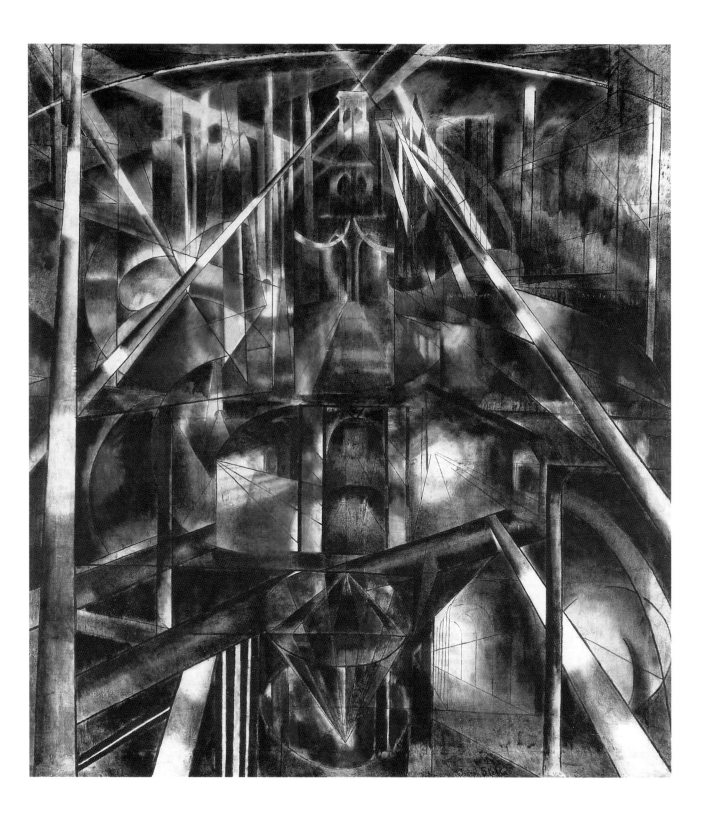

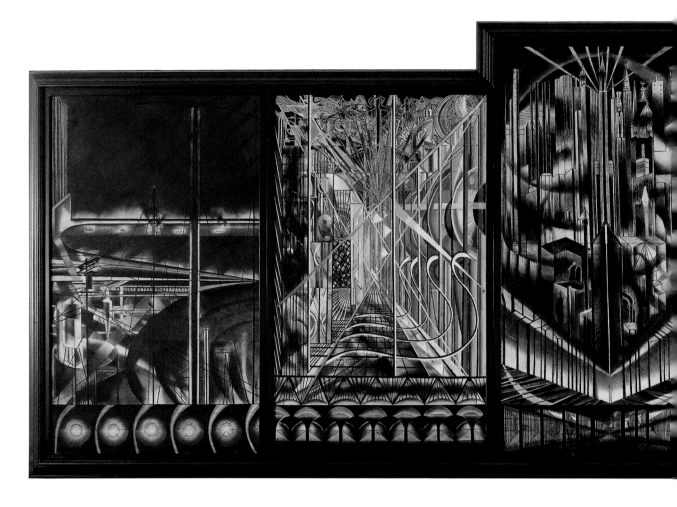

Fig. 118. Joseph Stella, *The Voice of the City of New York Interpreted*, 1920–22.
Oil and tempera on canvas, 88½ (center panel 99¾) × 270 in. unframed.

When installed as the artist intended—his early study describes it as five panels hung flush with one another—*The Voice of the City* extends for ten paces and hangs higher than one is tall (Figs. 118, 119). Scale was part of its message. Its magnitude resembled both that of the great Renaissance altarpieces Stella recalled from Italy and that of long literary masterpieces such as Whitman's *Leaves of Grass* or Dante's *Divine Comedy* that he greatly admired. Its size also translated New York's urban gigantism literally. Just as Gerald Murphy's eighteen-foot-high painting *Boat Deck* towered over viewers like the behemoth new ocean liners, Stella's big work mimed the colossal scale of Manhattan's skyscrapers and bridges.

Size also determined that viewers would have to spend time experiencing the painting. No one can take in this work without expending significant time, either by turning her head back and forth or, better yet, walking the mural from one end to the other. To "see" this painting, in other words, our eyes and our bodies need to travel across it, visiting each of the five panels in turn. (As armchair viewers looking at small reproductions you must try to imagine the painting's physicality.)

In doing this, we discover that Stella is leading us, physically and literally, on a tour of Manhattan's modern novelties. As we move across the five canvases, we take the foreign visitor's tour of New York, like the one Duchamp gave the Gleizes when they first arrived in New York—modern sites seen from waterways, from Broadway, and from high in

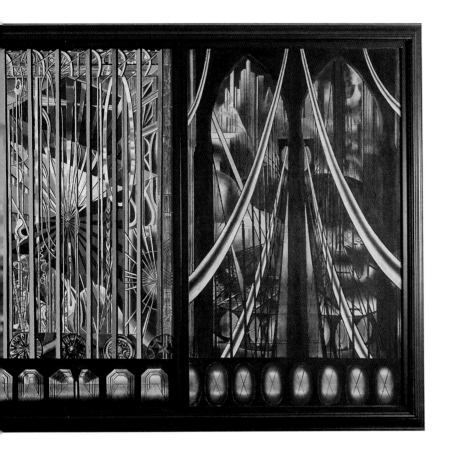

skyscrapers. Three panels are about entering the city, coming into it from outside. (Entrances, of course, are also sites of departure, embodying Stella's ambivalent relationship to New York.) If we begin at the right, we enter Manhattan via Brooklyn Bridge (Stella lived in Brooklyn for a number of years); if from the left, we come through the Port of New York and Battery Park. If from the middle, we encounter a Manhattan skyline as if from the Staten Island ferry or from an arriving or departing ocean liner.

The painting also charts Manhattan's peculiar geography as a narrow overbuilt island. The three middle panels are the land mass, with the Hudson River to the left and the East River to the right. At the bottom of the painting, in the frieze running across all

Fig. 119. Joseph Stella, *Study for New York Interpreted*, ca. 1920. Watercolor and gouache, $10\frac{1}{2} \times 19\frac{5}{8}$ in.

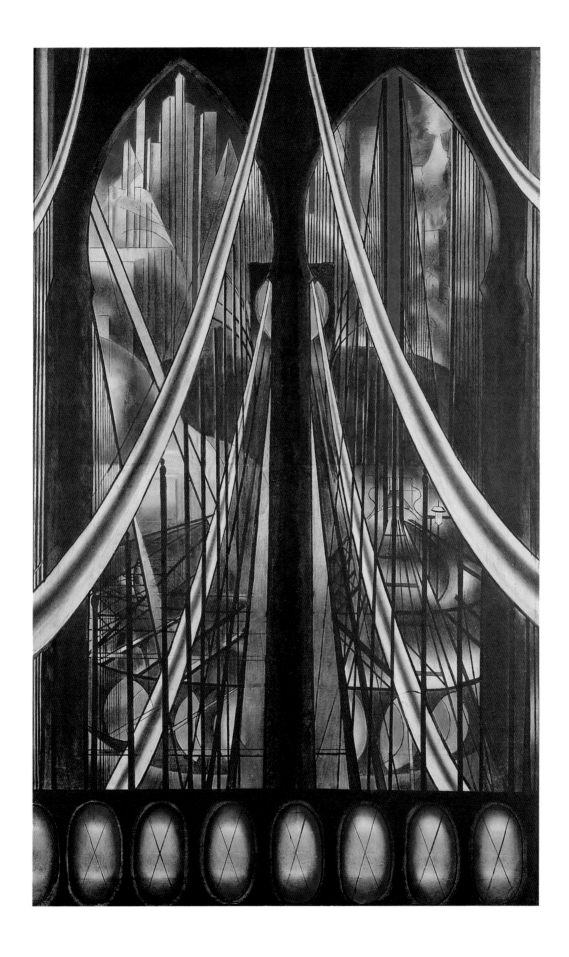

Fig. 121. Joel Greenberg, *Brooklyn Bridge*, 1982.
Gelatin silver print, 20 × 24 in.

five panels, we tour underground, through the is-
land city's tunnels, subways, and theater interiors.

Stella's painting, then, is a topographical mapping
of five modern sites—and a sixth in that the entire
work pictures Manhattan under nighttime condi-
tions: the harbor and the Battery, Times Square, sky-
scrapers, Brooklyn Bridge, the New York subway,
and New York at night. These were all major tourist
attractions in the 1920s, and Stella's original titles
named places and used language that could be
found in the guidebooks of the period. He called
the panels, from left to right, *The Battery*, *The
Great White Way Leaving the Subway*, *The Prow*
(that is, the Flatiron Building), *Broadway*, and
Brooklyn Bridge. For the sake of simplicity and prac-
ticality, subsequent commentators have changed or
shortened these titles to *The Port*, *White Way I* and

Fig. 120 (facing). Joseph Stella, *The Voice of the City
of New York Interpreted: The Bridge*, 1920–22.
Oil and tempera on canvas, 88½ × 54 in.

II, *The Skyscrapers*, and *The Bridge*, stripping from
the titles the idea embedded in the originals of a
spectator touring and experiencing a series of well-
known New York novelties.[13]

Though Stella was culturally hostage to the Euro-
pean's highly reductive schema of New York, he had
what most European visitors did not: an intimacy
with each of his sites. Details in the paintings make
it clear that he knew the places he painted very well.
Unlike Léger, who in *La Ville* evoked all modern cit-
ies (see Fig. 113), Stella was meticulous in giving
each of his panels the specifics of place. His painting
could only be New York. Many of the skyscrapers in
the middle panel are identifiable, and in *The Bridge*
the ample references to the neo-Gothic arches, sus-
pension lines, and distinctive cables of Brooklyn
Bridge tell viewers that it could be no other (Figs.
120, 121). The skyscrapers pictured through the ca-
bles make it clear that we are headed toward Man-
hattan, and the plunging perspective lines position
us as spectators on the pedestrian walkway in the

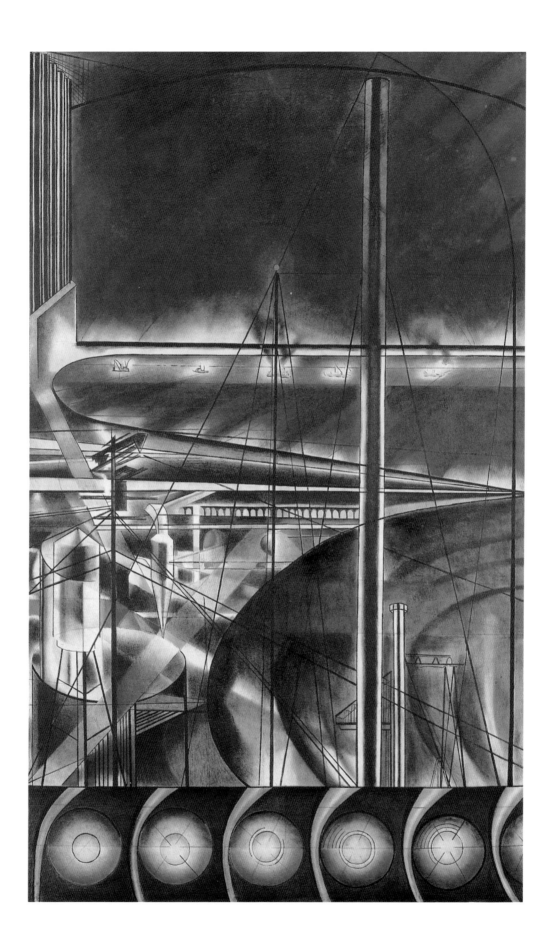

center of the bridge, with roads on either side for vehicular traffic. Underneath the roadbeds are the rounded entrances of the tunnels that in that era carried trains back and forth from Brooklyn to Manhattan.

In viewing *The Port*, Stella's contemporaries surely would have recognized material gathered from Battery Park, South Ferry, and the harbor area at the foot of the island (Fig. 122).[14] This is the only canvas of the five that offers an aerial view—we are on the island's tip, looking down on the landscape and out over the port to the sea—replicating the experience of those who looked down from the tall public buildings surrounding the park. Richard Rummel's view of lower Manhattan, published by Moses King in 1915, helps to identify details in the painting (Fig. 123). The long enclosed piers,

simulating those of Manhattan's harbor, stretch like fingers out into the river and embrace small boats— a dredging boat, a tug, and a sailing vessel. Masts of large ships are in the foreground. Onshore there are signs of industry: a water tower, a ventilator, and a telegraph pole. The tall shaft that dominates the painting is most likely that of a 161-foot flagstaff, once the mast of the Herreshof sloop *Constitution* that sought unsuccessfully to win the America's Cup in 1899 and 1901. The original wooden mast, struck by lightning, was replaced by one of steel that was to fly one of the largest American flags ever flown.[15] The mast is easily sighted in the middle of Rummel's view of the park. The chimney to the right of the mast in Stella's painting was most likely the one that protruded from Castle Garden, a famous historic building at the Battery that had once been an entertainment hall and, from 1855 to 1895, had served as the immigration headquarters for the port. In Stella's day, it had been transformed into a popular aquarium.

Fig. 122 (facing). Joseph Stella, *The Voice of the City of New York Interpreted: The Port*, 1920–22. Oil and tempera on canvas, 88½ × 54 in.

Fig. 123. *Skyscrapers of Lower Manhattan*. From Moses King, *King's Views of New York*, 1915.

Castle Garden was also famous as the site of Samuel F. B. Morse's first demonstrations of electricity that led him to invent the telegraph. If the artist intended the slender telegraph pole next to the water tower at the left to refer to Morse, it would be a rare and uncharacteristic allusion to New York's past history. More likely the pole is there because for Stella it represented the modern communications system that made it possible to send ship-to-shore messages. A monument in Battery Park honored wireless operators who had died at sea, and there were several telegraph offices in the vicinity.[16] The tiny row of rounded lights in the middle of the painting, which could be those of one of the big steamship buildings on the piers at the mouth of the Hudson, simultaneously represent a train on the elevated track that ran across the northern and eastern edges of the Battery to its terminus at South Ferry. Some of the small boats deep in the distance suggest the ferry boats that left the southern part of the island for Staten Island, Bedloe's Island (now Liberty Island), and Brooklyn. And the space-age skyscraper at the upper left was most probably based on the famous Whitehall Building (1903) and its annex (1911), the first tall buildings one came upon at the mouth of the Hudson.[17]

We have seen how powerful the port was becoming as an artistic metaphor when Stella chose it as one of his mural's key sites. Whitman, one of the artist's heroes, had been among the first to establish its poetic potential, but early-twentieth-century writers and artists, European and American, seized on New York's bustling harbor and the port as inseparably intertwined, emblematic not only of the city but of the nation as a whole. For Stella, Battery Park had special significance as the first bit of land an immigrant stepped upon in the New World. It was also a place where people went for leisure to see the coming and going of the great transatlantic ocean liners that docked alongside piers at the mouth of the Hudson River. (By 1900, the demands of the big steamships for wide and deep landings had made the Hudson the main New York port rather than the East River, which had served clipper ships in earlier times.) When one looked beyond the port from the sea wall at Battery Park, with one's back to the city, the water road ahead led to Europe. When one faced the city, those with poetry in their souls easily imagined they were standing at the gateway of the entire city, indeed of the whole American continent. An epiphanic experience like this, Stella recalled, inspired *The Voice of the City*. He told how on a nighttime visit to the Battery, he looked at the city and realized that he stood at the tip of a gigantic organism. "All of a sudden flashed in front of me the skyscrapers, the port, the bridge, with the tubes and subways."[18]

In describing *The Port*, Katherine Dreier, probably using Stella's words, interpreted it as a refuge from the gigantic city's clamor and the place where New York's greatest streets end. "You have reached the harbor—you are standing where all the arteries of the great giant meet—and a quiet sea and sky overwhelm you—you have left the noise and glare of Broadway—you have left the prow of the boat—the ruthlessness which cut through you—all the hardness and brilliancy fade away in the stillness of night."[19] This passage, rife with touring language ("you have reached the harbor . . . you have left the noise"), its imagery confounding arrival and departure ("you have reached," "you have left") reveals how fundamental walking was for Stella. Other rhetoric registers his sensitivity to the sensory experiences of New York in the early century, particularly the bodily demands made by electric lights, congestion, and noise in public spaces. To compare the "quiet" and "stillness" of the harbor with the "noise and glare" of Broadway was to identify *The Port* as a "soft" nocturne, with its pools of light and fuzzy reflections in water, and *White Way I* and *II* as the "hard" nocturnes where artificial lights obliterate the night.

Stella, who called these two panels his "Hymn to Electric Lights," based them on familiar sights in the theater district of Broadway (Fig. 124).[20] In *White Way I* the black grid at the bottom left of the painting represents subway steps leading the viewer from darkness into the burst of artificial lights along Broadway at Times Square (Fig. 125). The big X formed by crossing diagonals in the lower third of the painting suggests the famous crossing of two major city streets, Seventh Avenue and Broadway, that created a large open area anchored architecturally by the Times Building on Forty-second Street, constructed in 1905. (This building gave the crossroads its name, even though there was no square at Times Square [Fig. 126]). The pendant panel, *White Way II*, has similar coloration and riotously evokes the

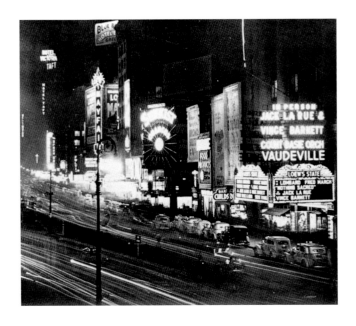

Fig. 124 (above). *Broadway/The Great White Way*, 1920s.

Fig. 125 (right). Joseph Stella, *The Voice of the City of New York Interpreted: The White Way I*, 1920–22. Oil and tempera on canvas, $88\frac{1}{2} \times 54$ in.

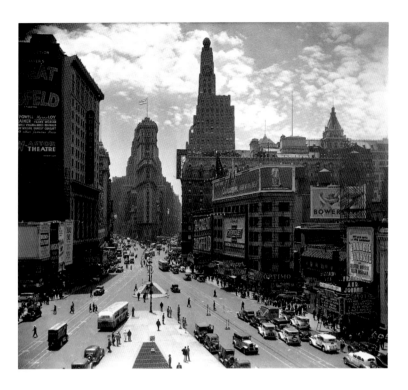

Fig. 126. William T. Roege, Times Square—view of
Broadway crossing Seventh Avenue looking south
from 47th Street, 1936.

nighttime lights on Broadway both inside and out-
side the theaters (Fig. 127).

Initially, Stella designed both panels more liter-
ally as tall buildings densely ornamented with adver-
tising signs and theater marquees, but they evolved
into tour-de-force abstractions sprinkled with realist
details such as the little stick figure from Broadway's
well-known Wrigley chewing gum electric sign that
appears at the top of *White Way I*, just right of cen-
ter, and in the lower left of a documentary photo-
graph (Fig. 128). In *White Way II* there are boldface
letters like those on marquees; some letters are re-
versed as if seen reflected in windows, and others
are strung on the vertical as on theater facades.
There are also recognizable architectural motifs and
little bars of music in the second panel and clear ren-
derings in both panels of the crisp beacon lights that
played every night on Broadway. The colors in both
panels recall the bright multicolored lights of the-
ater facades and lobbies, which at the time often fea-

tured exhibitions of arc lights slowly changing from
one set of colors to another. They also reference the
sumptuous stage sets of the day; in *White Way I*, the
bars that march back from the right edge resemble
the wings of a stage while the bottom edge of both
panels simulates the effect of footlights. Both panels
incorporate the sun ray, stylized whiplash lines, zig-
zag patterns, and repeating chevrons and lotus blos-
soms that were soon to become hallmarks of the art
deco style popularly used in theater designs.

Like bookends, the Broadway panels enclose Stel-
la's imaginary aggregate of skyscrapers (see Fig.
114). This central panel, which commentators often
compare to Valhalla or a holy city on a hill, is also
Stella's hillside village in Italy transformed into a my-
thologized megalopolis, a futuristic city built by
superbeings on a foundation of V-shaped arms of
blazing light. All is steel and stone; nothing natural
or organic raises its head: no trees, moonlight, or
twinkling stars. There is plenty of light, but all of it,

Fig. 127 (above). Joseph Stella, *The Voice of the City of New York Interpreted: The White Way II*, 1920–22. Oil and tempera on canvas, 88½ × 54 in.

Fig. 128 (right). Wrigley's chewing gum sign.

as on Broadway, is generated by electricity. Search-lights shoot out from the highest skyscraper and from ground level, and waves of reflected light encircle the city like gigantic balloons. One strip of bright light in the middle of the picture is the edge of the Flatiron Building (see Fig. 138), which forms the base of the skyscraper mountain and accounts for Stella's original title for the panel, *The Prow*. Like an ocean liner bearing down at sea, the Flatiron simultaneously pulls away from the city and provides its optical foundation. It is yet another metaphor for arriving and departing, the same trope Rosenfeld used in the epilogue of *The Port of New York*, encapsulating the creative individual's vexed relationship with America. For Rosenfeld, the metaphor represented the American's dilemma, to ship out for Europe or to stay at home. For Stella, it embodied the state of homelessness.

Stella's divided mind also expressed itself in the overall emotional pitch of the painting, especially the three middle panels. He gives us, not a leisurely walking tour across the city's face, but a hallucinatory "trip" that takes us deep into darkness and out again into brilliant light. That darkness is literal, not just figurative, black being the color that unites the five canvases.

The Voice of the City is one of the largest urban nocturnes ever made. Although art historians use the term "nocturne" for paintings of night, it more accurately means capturing the effects of light in the darkness of night. James McNeill Whistler made nocturnes of cities one of his specialties in the late nineteenth century, poeticizing the visual effects of gaslights and the sparkle of fireworks seen through a scrim of darkened sky (Fig. 129). Others in his wake, the American Tonalists, for example, featured the soft light of stars and moon in their nocturnes and then went on to represent the first electric lights in the city as equally soft and luminous (see Figs. 143, 144).[21] It was as if nature had put the lampposts in the cityscape. Early on, Stella had painted this kind of naturalized Whistlerian nocturne, but in *The Voice of the City* his vision of night hardened and became thoroughly electric; he virtually catalogued the new lights of the modern metropolis: lights outlining bridges; the lit crowns of skyscrapers and the beacon lights atop them; headlights and streetlights; and, most prominent, the searing colored lights in theater districts. These artificial lights account for the work's two basic color chords: the blues, purples, and blacks suffused with patches of soft silvery light in the first, third, and fifth panels, and the searing oranges, reds, yellows, and whites of Broadway lights in panels two and four. The first chord is a more familiar one, reminiscent of Whistler's nocturnal palette of silvers and grays but with just enough exaggeration in the tonal changes to be ghostly and spectral, hinting at the supernatural and at hellish nightmares. The second chord, with origins in futurist canvases, presents city lights so blinding that they obliterate conventional or normative night and give us an alien world.

In combination the two chords confer a coloristic unity on the painting, an A–B–A–B–A symmetry that is also symphonic, recalling the musical analogies Stella himself liked to make when he talked about the work. He once called *The Voice of the City* "five movements of a big symphony."[22] But Stella's "symphony," unlike the lyrical musical abstractions with musical titles painted by Whistler, Wassily Kandinsky, Georgia O'Keeffe, or Arthur Dove, is cacophonous. The abrupt shifts from silvery blacks to hothouse chromatics and back again add to the painting's general delirium and dissonance.

Not only do we move fast from one color zone to another, but our eyes zip in and out of pictorial space at a frenzied pace. Our vantage point is always changing without warning, and there are no secure resting places. The wide panorama of *The Port* closes to the middle distance in *The Skyscrapers* and zooms to the unnaturally close-up view of *The Bridge*. In between, we plunge like modern-day Alices into kaleidoscopic confusion. In *White Way I* we are pulled in by a Renaissance perspectival grid; in *White Way II* our eye is halted by hard-edged bars stretching from top to bottom like a prison door, enforcing our separation from the geometric fireworks beyond.[23] These repeating lines, not only vertical but diagonal, help to keep us in a constant state of sensory overload. In the two end panels the construct of lines is relatively open and relaxed, and the "beat" is slow, but in the three central panels lines multiply and the tempo accelerates so that we give way emotionally and embrace the vertiginous.

Fig. 129 (facing). James Abbott McNeill Whistler, *Nocturne in Blue and Green*, 1871. Oil on wood, 19¾ × 23¼ in.

Fig. 130 (top). *Sectional view showing how New York uses both elevated, surface, and tunnel roads in providing for its ever-growing traffic.* Published in *Scientific American* series 2, 99 (1908), p. 405.

Fig. 131 (bottom). *Future New York.* From Moses King, *King's Views of New York, 1915.*

Or we turn away. The experience is like a roller-coaster ride, for some more exhausting than exhilarating.

There are two final observations to make about Stella's *Voice of the City.* The first pertains to its structure as a map. We have already looked at the panels as a horizontal touring map, but it is also a vertical one that references the period's fondness for cross-sectional and axonometric maps of cities. Used by early-twentieth-century city planners and futurologists, these popular illustrations demonstrated and glamorized the complexities and efficiencies of modern cities by picturing city streets or large city buildings like hotels in cutaway views, both below and above grade (Fig. 130). City planners commonly slipped cross sections into promotional or visionary statements about the grand cities of the future whose infrastructure would be underground, with skyscrapers and aerial walkways above (Fig. 131). They promoted modernity as a good thing, as a way of living better in densely constructed urban settings.

While Stella's painting situates itself in this modish and prophetic pictorial language, it simultaneously resurrects an old traditional form, that of the five-panel polyptych, familiar to Stella from Italian Renaissance altarpieces (Fig. 132). Stella adopted the altarpiece format almost exactly: large painted scenes on top with predella images along the bottom of each panel. He made the flanking panels equal in size and the central panel a foot higher than the others, just as in altarpieces, where the most important scene, a Crucifixion or a Madonna and Child, is in the center. By hanging the panels flush with one another, Stella made them appear hinged, as in a Renaissance church setting.

Putting such a self-consciously chosen European ecclesiastical form together with an American secular and futuristic city map was just one more way in which Stella deeply inscribed in his painting his conflicted identity as a *transatlantique*. The forms are fused but not reconciled, the suspension of old and new in the work of art indexing the gulf between them. We remember that Duchamp's naming a urinal *Fountain* operated in a similar way, narrating the vast, irreconcilable distance between the past and the present. The commentary might be humorous and philosophical, as in Duchamp's case, or confused and anguished, as in Stella's. Stella saturated

Fig. 132. Simone Martini, *The Altar of S. Caterina*,
ca. 1319–20. Tempera on panel, 76¾ × 133⅝ in.

his painting with Roman Catholic church and liturgical references, signifying not only the European past but his own youth, his region, his Italy, his home country. The Gothic arches of *The Bridge* are obviously cathedral-like, and the brilliancy of the color chords in the *White Way* panels reminds us of stained glass. In the three darker panels, the silvery edges and suffused splashes of light recall earlier traditions of painting halos and spiritual light, while the beacon lights atop skyscraper shafts in the central painting form a diadem, commonly associated with holy Christian figures. Even the repetition of verticals in the painting, and the stretching of arm-like forms toward the heavens, suggest a divine presence somewhere in the upper reaches beyond the painting. And if the top of the painting suggests a Catholic view of heaven, the bottom suggests hell. The murky darkness, the underground tunnels, and the painting's insistent demands upon our senses convey visceral pain and agony, recalling the Catholic church's long-standing power to evoke the fear of hell. Not surprisingly, Stella was a student of Dante, whose *Inferno* as well as *Paradiso* is here evoked.

This, then, is Stella's New York: a visitor's touring map of a city bounded by waterways. A journey of continual arrivals and implied departures. A visionary city of man-made artifacts and special effects.

A city without people and without a past. A visceral city, a delirious spectacle, an electric nocturne. A Christian shrine.

How did Stella come to invent such an awesome place?

When Stella stepped off the *Kaiser Wilhelm der Grosse* on March 1, 1896, he surely felt as if he had traveled to outer space, so different was New York City from the small medieval village he had lived in all his life. The year after he arrived, the American metropolis was symbolically born when Manhattan was consolidated with four neighboring boroughs to become Greater New York, with a population of about three and a half million people. By 1905 the census was just under four million, making New York the second largest city in the world.[24] Other changes too were revolutionizing the look and feel of New York City. Stella was there as skyscrapers began to overshadow churches and city parks; when cars replaced horse-drawn buggies, and motor buses and taximeter motor cabs took over the work of horse stages; when electric lights supplanted gas lamps in city streets; and when electrical engineers transformed public spaces like Coney Island and Broadway into unprecedented revelries of light.

He also belonged to the first generation that could take a bridge to Manhattan rather than a ferry and could travel the city by elevated railway and subway. As he said later in life, he had earned the right to paint *The Voice of the City.* "I had witnessed the growth and expansion of New York . . . and therefore I was feeling entitled to interpret the titanic efforts, the conquests already obtained by the imperial city in order to become what now She is, the center of the world."[25]

One can imagine the impression Brooklyn Bridge might make on a European immigrant who had never seen a modern suspension bridge, not to mention a skyscraper or a train that went underground. When Stella arrived, the bridge was the country's most modern achievement, famous the world over for the daredevil engineering that had thrown a seamless structure across the East River.[26] When it opened in 1883, the first bridge to connect the island of Manhattan with one of the boroughs, observers marveled at its great span and a width whose five transport bays accommodated a great and diverse traffic: at the outer edges, roadways for carriages; next, a public cable train in each direction, with railheads and sheds; and, straight down the middle of the bridge, a promenade for foot traffic. Walking was (and still is) the most spectacular way to cross the bridge. The graciously proportioned promenade, elevated eighteen feet above vehicular and train traffic, offers magnificent views of the southern end of Manhattan, always enframed by the bridge's architecture: the soaring cables that John Roebling invented to hold the bridge in place, the suspension wires strung like harp strings, and the Gothic arches of the towers (Fig. 133). Benches and street lamps transform the walkway into a unique urban park, encouraging pedestrians to tarry and soak up the vistas and dramatic sweep of the bridge. At night the bridge puts "on her diamonds"—Sadakichi Hartmann's description of the lights in 1903—"glinting like a fairy tiara above the waters of the East River."[27] The Baedeker guide warned that "no visitor to New York should miss" that view.[28]

Stella moved to Brooklyn in 1916 and began

Fig. 133. Photographer unknown,
Bridge Promenade, ca. 1891.

Fig. 134. Hugh Ferriss, *Glass*, 1926. Drawing.

regularly to cross the bridge. He knew intimately the exhilaration of the nocturnal walk from Brooklyn to Manhattan and made it his signature theme. He first essayed the subject in his *Brooklyn Bridge* of about 1919 (see Fig. 117) before making it the subject of an end panel of *The Voice of the City*, mapping out the view from the bridge through the thick iron cables that boldly reflect night light (see Fig. 120). He even tucked in one of the bridge's oft-photographed lampposts under the cable on the right. The skyscrapers seen through the suspension lines, he exaggerated. Lower Manhattan, though famous for its skyscraper skyline, did not yet resemble the cluster of slim, soaring shafts Stella constructed, a passage so visionary that it links him to utopian city draftsmen and designers like Antonio Sant'Elia

in Italy and Hugh Ferriss in New York (Fig. 134).[29] Only the pyramidal crown of one skyscraper in the cluster of buildings to the left echoes the tops of actual skyscrapers of the time, the Woolworth and Equitable Buildings in lower Manhattan.

In the *Skyscrapers* panel of *The Voice of the City* Stella showed off his knowledge of the tall buildings constructed during his first two decades in New York when each one's distinctive profile and crown became a new form of advertising for a company rich and successful enough to erect a building in its own name.[30] The pioneer skyscrapers were big news items in New York early in the century, the tallest and most distinctly designed of them reported not only locally but also abroad. Their construction was photographed step-by-step and their silhouettes,

Fig. 135. *Woolworth Building*. From Moses King, *King's Views of New York, 1915.*

especially the distinctive ones, etched into common consciousness even before they were completed. (The same thing had happened with Brooklyn Bridge, whose neo-Gothic towers were popularly known and illustrated years before the bridge opened.) In an age that generally conceived of a skyscraper as a fat block-size, multistoried building, structures that broke with the formula caught the public's eye. The usual variation was to crown the building with a tower, a campanile, that was specially lit at night (as in O'Keeffe's painting, *Radiator Building* [see Fig. 11]). These sculpted towers on early skyscrapers constituted a kind of logo, a corporate identity, and sometimes a nickname. The Woolworth Building, with its distinctive neo-Gothic wedding cake tower, was known as the Cathedral of Commerce (Fig. 135).

Stella attenuated and glamorized such skyscraper towers, arranging a bouquet of distinctive tops along the upper edge of the *Skyscrapers* panel. Though they were not in any accurate order, viewers still could enjoy the shock of recognition: the Woolworth Building (1913) at the very top and in the middle of the panel, above the Flatiron Building, and, left of it, the flagpole-topped mansard roof of the Singer Tower (1908). To the right of the Woolworth is the Metropolitan Life Insurance Company Building, known as the Metropolitan Tower (Fig. 136). The pyramidal crown with the rooster astride a globe was the newest skyscraper of note in Manhattan, the Heckscher Building of 1921 (Fig. 137). As the first stepped-back, or ziggurat, skyscraper erected after the passage of the city's 1916 zoning resolution, the Heckscher attracted a great deal of press, which Stella would have seen.[31]

The easiest skyscraper to identify is the Flatiron Building, its front edge eerily lit in a shaft of light that moves upward into the lighted edges of the Woolworth and downward into the underground (Fig. 138). One of the most distinctive tall buildings of its era, built in 1902–3 on Madison Square by the architect D. H. Burnham, the Flatiron, with its single-shaft design, became a forerunner of the form-follows-function skyscrapers that would crop up all over Manhattan after World War II. Form, in this case, also followed property lines. The site for the building was awkward—a triangular wedge at the crossing of Broadway and Fifth Avenue at Twenty-third Street—but the architect's solution

Fig. 136 (top left). Metropolitan Life Insurance Company Building, New York. Detroit Publishing Company.

Fig. 137 (bottom left). View of Heckscher Building from East 57th Street (Warren & Wetmore, Architects). From *Architectural Forum* 35 (Oct. 1921), p. 121.

Fig. 138 (above). Flatiron Building, Broadway and Fifth Avenue, New York. Detroit Publishing Company.

was brilliant: forgo the addition of a tower to a fat body and make the entire building a three-sided tower. The thinning of the building at one end lightened the structure despite its sheathing of heavy masonry and made it seem headed uptown. To its first audiences, it was a surprising change, and its overall shape—rather than its tower and crown—became its trademark. What began as the Fuller Building became known in the streets as the Flatiron by analogy to the flatirons used to press clothes.

People also saw the building, in one journalist's words, as "an ocean steamer with all Broadway in tow," a vivid image frequently requoted.[32] Sadakichi Hartmann thought it resembled "more than anything else the prow of a giant man-of-war." He, too, felt the building in movement. "We would not be astonished in the least, if the whole triangular block would suddenly begin to move northward through the crowd of pedestrians and traffic of our two leading thoroughfares, which would break like the waves of the ocean on the huge prow-like angle." The building was at first hard to appreciate, he felt, expressing the view of many, but twenty years hence, he predicted, it would be seen as a "thing of beauty."[33]

By 1920, when Stella was conceiving *The Voice of the City*, the building had indeed become beautiful in many New Yorkers' minds, and both the ship and the flatiron metaphors had evolved as standard images in the artist's and writer's poetics. This evolution helps explain why Stella originally called this panel *The Prow*, using nautical imagery not just for the Flatiron Building but for the cluster of skyscrapers as a whole. He envisioned the entire mountain of skyscrapers as an urban ship, the Flatiron its prow, propelled into space, with the other buildings in tow. Another visionary European, Antonio Gaudi, came up with a similar figuration in 1908 when he drew plans for an American hotel in the shape of a multiskyscraper hull, its highest point as tall as the Empire State Building, which was constructed some two decades later (Fig. 139).[34] At its base were Flatiron-like structures attached like boosters to a rocket ship. That both Stella and Gaudi imaged New York as extraplanetary, not of this earth but of another place and time, points to their utopianism and to the European mythos of futuristic New York.

In picturing the skyscrapers wrapped in lights,

Stella spoke to one of the most profound changes he and his generation had experienced firsthand in city life: the "unnatural" illumination of New York City every night, especially in commercial districts like Times Square (see Fig. 124). Such extravaganzas of artificial light began to appear in Western cities at the end of the nineteenth century, when city officials and businessmen recognized that electricity offered a new form of mass communication, a way of "dazzling the multitudes," as someone at the time put it, of drawing attention to a particular site or product.[35] Originally electric lighting had functioned to illuminate interiors and streets more safely and cheaply and with less dirt and labor than oil or gas. But once seized on as a marketing tool, electricity became the means to new kinds of urban promotion. City officials outlined important buildings, bridges, and monuments in strings of light while commercial advertisers experimented first with lighted signs, then with floodlights and powerful searchlights that cast messages on buildings and even on clouds in the skies.

Every Western city had electrical spectacles of one form or another in the early twentieth century. They belong to the history of urban modernization, civic boosterism, and early advertising. In London, Queen Victoria's diamond jubilee in 1897 included complex electrical decorations, while in Paris the Eiffel Tower was used for decades as the site of electrical advertising. But it was commonly acknowledged that American cities were the most extravagantly lit. After 1910 cities developed "White Ways" in downtowns across the country, imitating New York, whose light shows were known the world over for their vastness and originality. The eighty-two arc lamps that lit up Brooklyn Bridge, the five thousand lamps that outlined the turrets and porches of Madison Square Garden, the illumination of thousands of skyscraper windows at night, and the million lights that Luna Park boasted at Coney Island—all these transformed New York's nights into an electric phantasmagoria. By 1913 even a poet like Ezra Pound, whose disagreements with his country would keep him abroad for much of his life, could find the spectacle wondrous. "Squares after squares of flame, set and cut into the ether. Here is our poetry, for we have pulled down the stars to our will."[36]

When a subway stop at Broadway and Forty-second Street opened in 1904, the theater and

Fig. 139. Antonio Gaudi, design for *The American Hotel*, 1908. Drawing by Juan Matanala.

entertainment district began to evolve into a light show all its own. Outdoor lighted advertising signs supplemented floodlights, searchlights, and the outlining of buildings in such riotous profusion that the Fifth Avenue Association became nervous about spillover and banned all "projecting and illuminated signs" on its elegant street.[37] The association was not against what happened on Broadway as long as it stayed on "The Great White Way," or, as someone put it, the "white light district."[38] One specialty of Broadway was the big vertical sign, sometimes moving or flashing, sometimes even making noises and "talking." William Leach, a historian of this new commercial environment, described the Wrigley spearmint gum sign at the "heart of the Square," a detail of which Stella incorporated at the very tip of

his painting (see Figs. 125, 128): "Eighty feet high and two feet long, it contained 17,500 lamps and showed a little animated group of electrified 'brownies' standing next to the words 'Wrigley Spearmint Gum,' 'jabbing' the night, in off-and-on flashes of light, with their little spears." The Wrigley advertisement, which the company claimed was the biggest electric sign "in the world," was white, like most Times Square lighted signs in the first years.[39] But after the invention of neon light by a Frenchman in 1915, signage went to blue, green, red, and yellow, with white fading from view, and Times Square became known for its vast spectacle of colored lights. Stella's Broadway panels, although titled *The White Way*, register in brilliant colors the new Rainbow Way then in the making.

To urbanites accustomed to dispersed lights, as people were early in the century, the concentration of so much artificial light in a few city blocks often came as a bodily shock. People felt overpowered by a visual spectacle of such magnitude and many reported being viscerally excited or undone by the new experience. And the assault was not just visual but also aural and tactile. In places like Broadway—wherever people stood in lines and gathered on the streets amid the din of vehicular traffic—noise reached new levels. As skyscrapers made it possible to concentrate thousands of workers in one building, and as clusters of skyscrapers emerged, New Yorkers noticed not only new street noises but a new kind of street energy. Traffic choked the streets as never before. People commuted across the new bridges and on rapid transit systems at the beginning and end of each day. Writers strove to describe what it felt like to be a part of this new crush of always moving humanity. For one visitor it was all very fatiguing, this "atmosphere of frightful hurry and restless bustle everywhere."[40] To a local it was "the mad throb of life, the trip-hammer pulse beat which is New York's and New York's alone."[41] A new term—"rush hour"—suggested the urban blur of traffic and pedestrians.[42]

When Stella conceived his gigantic altarpiece, the city's frenetic pace and its electric light shows were drawing visitors to New York. Guidebooks directed them to places like Wall Street, Broadway, and selected subway stops to experience the heartbeat of Manhattan crowds. Well before 1920 these same books were prescribing good places to view New York lights at night—Brooklyn Bridge, Chinatown, Coney Island, and finally Broadway, one of the last major additions to the nocturnal repertoire. The nighttime touring Stella's painting encouraged was an invention of his age; earlier commentary had either ignored it or had focused on vice and crime in city streets after dark.[43]

This new touring paradigm, which spectacularized New York City's modernity by night as well as by day and excised the city's history to focus on its futurity, engaged not only artists but also illustrators, photographers, filmmakers, travel writers, guidebook compilers, postcard manufacturers, novelists, and poets from both sides of the Atlantic. Beginning at the turn of the century, these professionals all began to see themselves as part of a new

metropolitan environment, unlike any ever created—or experienced—before. They perceived, dimly at first but eventually categorically, that the city they lived in was no longer defined by its Dutch origins, its Gilded Age mansions and posh avenues, its shoeshine boys and its ragpickers, but by phenomena so new that they did not yet have names. Slowly but effectively they created a rhetoric of newness that revisualized and reordered the old New York into the shape of the *new* New York. Indeed, from 1890 to 1920, interrelated industries, creating and capitalizing on a new visual and verbal order, arose to profit from the city's strange newness. There was the commercial industry, associated with the birth of modern New York as a tourist mecca, with its agreed-upon modern marvels. And there was the cultural industry of artists and writers, engaged side by side in an unstated but deeply felt competition to create the great New York opus, whether in painting, photography, filmmaking, music, or literature. Modernists understood that whoever successfully got New York down would have created, in the process, the great American work.

Chronologically, Stella came near the end of the period when the *new* New York was forming. When he painted *The Voice of the City,* he did so in ways that by 1920 had come to seem right and natural. His was a "consensual image," to use Neil Harris's words, an image that intensified and purified thirty years of iconographical and stylistic experimentation in representing the newness of the modern metropolis.[44] His is the summa of images precisely because he so skillfully condensed what artists and writers before him had been constructing as the *new* New York.

Cities are by definition chaotic and eclectic aggregations of things and sensations. When artists picture them, they have to choose what to paint or photograph. They actively select what to put a frame around and what to crop out of the composition. As Anselm Strauss, a social psychologist of cities, has observed: "The streets, the people, the buildings, and the changing scenes do not come already labeled. They require explanation and interpretation." When artists represent a city, they are making order out of what is decidedly disorderly. They manage the city by creating a rhetoric, to continue Strauss's analysis,

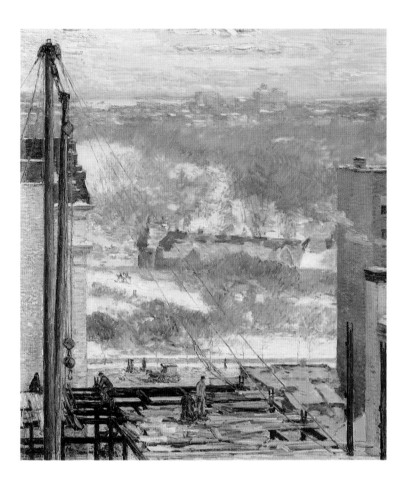

Fig. 140. Childe Hassam, *The Hovel and the Skyscraper*,
1904. Oil on canvas, 34¾ × 31 in.

a visual language that is "indispensable for organizing the inevitably ambiguous mass of impressions and experiences to which every inhabitant is exposed, and which he must collate and assess. . . . To be comfortable in the city—in the widest sense of these words—requires the formulation of one's relations with it, however unsystematically and crudely."[45]

In this country the artists of the impressionist, Tonalist, and Ashcan schools at the turn of the century were among the first to formulate a relationship with modern New York. Working in codes of late-nineteenth-century international realism, they were also deeply tied to the aesthetic standards of the picturesque, an older system of framing that helped to determine what the first artists of the *new* New York

dared to "see." The rules of the picturesque defined the artist's goal as "beauty," not so much of subject matter as of aesthetic principle. The artist of the picturesque found beauty in contrasts, in variety and irregularity of forms, in the exotic, and in naturalizing the man-made world.[46]

Often, then, the first artists of modern New York, working a generation before Stella, composed their pictures around contrasts, particularly of the old city compared with the new one emerging: Childe Hassam, for example, painted a low-lying hovel from the vantage of a skyscraper going up (Fig. 140), and Alfred Stieglitz photographed old and new New York as a row of highly textured brownstones with the sleek steel skeleton of a skyscraper towering over them (Fig. 141). These artists also rendered the

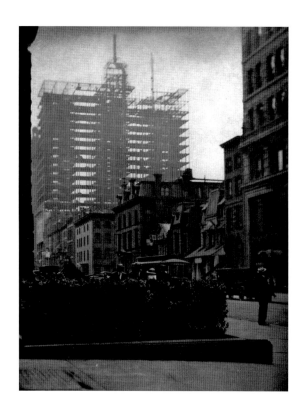

Fig. 141 (left). Alfred Stieglitz, *Old and New New York*, 1910. Photogravure on Japanese tissue mounted on paperboard, 13⅛ × 10⅛ in.

Fig. 142 (below). F. Hopkinson Smith, *Skyline View*, ca. 1912. From *Charcoals of New and Old New York*, by F. Hopkinson Smith (New York, 1912).

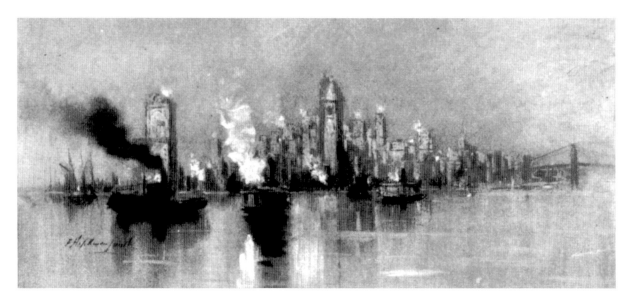

city's modern features as exotic and spectacular. The bustling markets on New York's Lower East Side were made to look like those of the Middle East; and the elevated railway or Brooklyn Bridge at night was presented like a piece of expensive jewelry. Artists frequently pictured the New York skyline as if it were Venice or Baghdad (Fig. 142). In his picture essay "Contrasts," Alvin Langdon Coburn compared his photographs of different cities, New York included, all photographed from the water, as if cities were at their most beautiful when poised on liquid bases.[47]

Wordsmiths worked along similar picturesque lines as they initiated a verbal rhetoric for the newness of the city. Calling upon the exotic, they designated skyscrapers America's pyramids, campaniles, castles, cathedrals, or Towers of Babel. O. Henry tagged his city "Bagdad-on-the-Subway," and explored by night and day its "palaces, bazaars, Khans, and byways."[48] Like Coburn in his photographs, other writers compared New York's skyscraper skyline seen from the sea to that of Venice or Constantinople or "San Gimignano of the Beautiful Towers in Tuscany."[49] Ezra Pound compared New York from the water to Cadiz, a seaport in Spain, and to Venice.[50] Others conjured up Babylon.

Such analogies were ultimately shaped by gentility, by a desire to keep distance between artist and subject, and by an obvious wariness or skepticism about modernity. They came from a generation of city dwellers who had grown up in the waning years of the Gilded Age, when the wonders of the world were assumed to be anywhere but at home and when stays abroad and grand tours were an obligatory part of one's education. By comparing New York's wonders to famous vistas and monuments abroad, writers employed a grand tour rhetoric that was commonly understood by members of their own class, declaring their well-traveled sophistication while also trying to make Manhattan's modern marvels familiar and comfortable. By seeing the new in the context of the old, they were coming to terms, and helping others do the same, with a radically changing environment.[51] Though they had no way of knowing it at the time, they were pioneering a Manhattan poetics by granting the raw newness of New York a beauty equivalent to that of old-world cities whose patina and age were commonly celebrated. Their efforts were also beginning to boost New York

from the provincial capital it had been for decades into the ranks of a world-class city.

The picturesque artist also helped city dwellers accommodate themselves to the new city by presenting it according to familiar landscape conventions. The idea of a new kind of "landscape"—not yet its own subject as "cityscape"—dominated New York representation in and around 1900. Photographers and painters grounded in late-nineteenth-century aesthetics believed the city beautiful only when they softened and naturalized it. They pictured skyscrapers as towering mountains (the Singer Building was called the Singerhorn) and streets between tall buildings as ravines running through them. In their early photographs of the Flatiron Building, Stieglitz and Steichen framed it in trees and shrouded the composition in the soft light of a snowstorm or evening light (Fig. 143). For others of this generation— Joseph Pennell, Theodore Earl Butler, Birge Harrison, and Alvin Coburn—the city was most attractive when pictured in strong and marked weather conditions: sparkling sunlight, mist, snowstorms, rain, dusk, or nightfall (Fig. 144).

Early-twentieth-century writers also used a grammar of landscape to make Manhattan's strange newness hospitable. They referred to skyscrapers as "stony cliffs" occupied by "cliff dwellers," and the streets running between them were "canyons." The light of street lamps was described as "the moony sheen of the electrics." The lighted windows in skyscrapers were "glowworms" and "squares of flame set and cut into the ether."[52] The elevated railroad was an "octopus" or "snake," Brooklyn Bridge a "spider web," the subways "rabbit burrows," and the lights of Broadway "fallen stars." At night, ferry boats went back and forth like "huge fireflies."[53] New York was at its most attractive when nature worked its magic and "everything looks a little out of focus and uncertain in dimensions."[54] Henry James, Manhattan's most outspoken critic, credited light with the power to make ugly New York buildings beautiful. The city, he conceded, "in certain lights [was] almost charming," for then "an element of mystery and wonder entered into the impression."[55]

Despite the contradictions inherent in such accommodations, a standardized iconography of a *new* New York was in the making, one that put the accent on skyscrapers, traffic, and bridges rather than parks, people, and homes. Equally important,

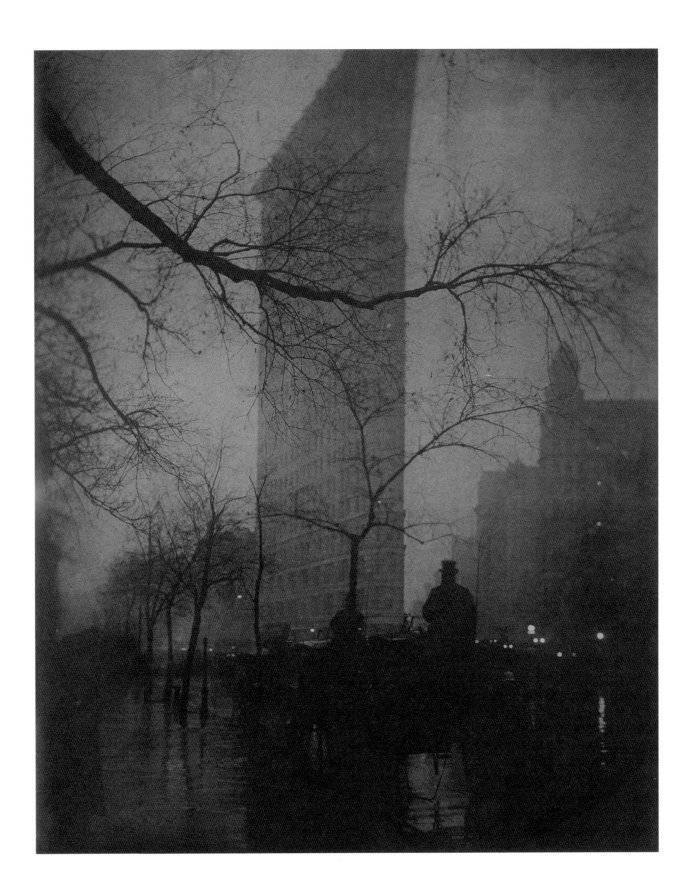

artists were evolving a new position vis-à-vis the sub-
ject. Photographers and painters were conceptualiz-
ing the city as a string or series of distinctive sites
and novelties, as if New York was an ongoing variety
show with many diverse acts. Indeed, their produc-
tions were symbiotic with the vaudeville and variety
shows that were the most popular theatrical forms
of the day and were deeply inflected by picturesque
aesthetics. As in popular theater, New York became
a series of spectacles, and artists referred to them-
selves as "spectators" and "observers." They as-
sumed an earthbound and concrete position as art-
ists but also a touristic moving one, usually that of a
pedestrian going up and down in buildings, crossing
bridges, looking out windows, and riding the ele-
vated. They presented the city as eyewitnesses to its
beauties, and as if it were theater and they (and we
as viewers) were audience. Such a point of view, that
of an "outsider" trying to gain a sense of ease in an
unfamiliar place, would become part of Stella's self-
conception too, but he would recalibrate it. He too
would tour the city, but as a bodily participant in the
experience, not a distanced viewer.

But before his conception was possible, the phe-
nomena and sensations peculiar to the modern city
had to be framed and separated out from those of
the city of old. The peculiar characteristics of Man-
hattan as *modern* metropolis had to be invented
from the visual possibilities that a city offers. In a
classic passage from *A Hazard of New Fortunes*
(1889), William Dean Howells singled out the multi-
plicity of sights and the rapidity with which they oc-
cur as two of the characteristics that made a city. A
man and woman wind their way through the city at
night on the elevated, and as they look out the win-
dow, the narrator describes what they see:

It was better than the theater, of which it reminded
him, to see those people through their windows: A
family party of workfolk at a late tea, some of the men
in their shirt-sleeves; a woman sewing by a lamp; a
mother laying her child in its cradle; a man with his
head fallen on his hands upon a table; a girl and her
lover leaning over the windowsill together. What sug-
gestion! What drama! What infinite interest! At the

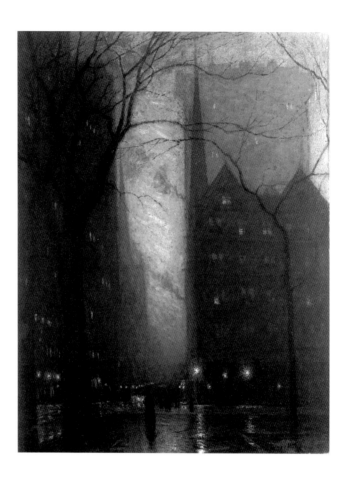

Fig. 144. Birge Harrison, *Fifth Avenue at Twilight*,
ca. 1910. Oil on canvas, 30 × 23 in.

Fig. 143 (facing). Edward J. Steichen, *The Flatiron—Evening*,
1909 print from a 1904 negative. Greenish-blue pigment gum-
bichromate over gelatin silver print, 18 $^{13}/_{16}$ × 15 $^{1}/_{8}$ in.

Forty-second Street station they stopped a minute on the bridge that crosses the track to the branch road for the Central Depot, and looked up and down the long stretch of the elevated. . . . The track that found and lost itself a thousand times in the flare and tremor of the innumerable lights; . . . the architectural shapes of houses and churches and towers, rescued by the obscurity from all that was ignoble in them. . . . They often talked afterward of the superb spectacle which in a city full of painters nightly works its unrecorded miracles.[56]

Howells's New York was a nonstop stream of picturesque sights and sensory thrills, stylistically delivered in rapid succession, as if the quickened pace itself was exclusively New York's. For the next twenty-five years, this tour of endless city sights in rapid succession became the artist's and writer's paradigm.[57] Even Stieglitz, who might later rail against New York, in 1893 conceived of capturing the city in one hundred views. Although he never completed this series, he did publish a group of photographs called *Picturesque Bits of New York and Other Studies.*

Two decades after Howells, John Van Dyke wrote *The New New York*, a nonfictional book intended to sell New Yorkers on the exciting modernity of their city. It is by no means the only book of its type, but a very fine example in that it brought the voices of a major critic and artist together. An urbane art critic, Van Dyke had spent many years abroad, as had his collaborator, the printmaker and draftsman Joseph Pennell, who created one hundred and twenty-four drawings for the book. Their purpose was to identify the hallmarks of New York and to rebut those like Henry James whose pessimistic picture of Manhattan in *The American Scene* upset the city's advocates.

Van Dyke structured his book like a tour, navigating his readers on foot from site to site. The first chapter, not surprisingly, is "The Approach from the Sea"—about the port and the skyline—and the last looks at traffic and rapid transit systems. The twenty-four chapters in between include "Downtown," "Skyscrapers," "Fifth Avenue at Four" (on the rush hour), "New York by Night," "The Bridges," "Docks and Ships," and "Breathing Spaces" (on parks). For over four hundred pages

Van Dyke tells the story of New York's growth as a new financial center, repeatedly pointing out the variety, the vitality, the ebb and flow, the contrasts, the spectacle, and the beauty of the city's infrastructure and street life. "Always contrasts, contrasts, contrasts," Van Dyke exclaimed, reinforcing his picturesque program for making sense of city sights. "In New York they never seem to cease and determine."[58] His enthusiasm is relentless, a tour-de-force promotion of the city's vitality by the rules of the picturesque. What others find inharmonious, he finds fascinating in its variety. When people criticize skyscrapers, he invites them to think about what ingenious structures they are for a city packed into a small island and urges readers to view them in different seasons, under different kinds of light. For every point Van Dyke makes in his text, there is a Pennell drawing to make the same one visually. Pennell's frontispiece was the Singer Building, hovering over older and smaller walk-ups. Captioned "The Old and the New," it announced one of the major themes of the book.

The picturesque, then, for both writers and visual artists, was an aesthetic of accommodation, presenting what was strange—and to many, supremely ugly —in palatable form. By constructing the new out of contrast, variety, and the exotic, this first generation of artists forged a relationship with the changing city that gave them a sense of control and mastery, however illusory. By forcing the newness of the city into standards of beauty that had been around since the late eighteenth century, they domesticated what was wild and novel and made aesthetic order from a city of chaotic modernity. Such representations, as William Taylor has pointed out, in turn helped New Yorkers adjust to the new conditions. Visual images taught people how to orient themselves to the changing city and to manage their restless and disorganized environment.[59]

The classic trademark images of Manhattan— which street vendors hawk today—took root during this period. The Flatiron became an ocean liner, photographed, painted, and picture-postcarded from one angle and one angle alone, that of its prow bearing down upon us. (How many of us would recognize it today from any other viewpoint?) Wall Street buildings dwarfing Trinity Church became a signature for New York, as did the Gothic towers

Fig. 145. Winsor McCay, *Dreams of the Rarebit Fiend*, 1905.

and harp strings of Brooklyn Bridge seen from the pedestrian walkway. And Manhattan as a toothy silhouette of skyscrapers, viewed from the water or from neighboring boroughs, took hold the world over as a standard, concise rendering of New York's identity. It began to appear in photographs and drawings in the 1890s, the decade in which the word "skyline" was invented.[60] By 1908 Moses King had made skyline views of the city a regular feature of *King's Views of New York*, initiated in 1896 (see Fig. 123). In the same moment, writers searched obsessively for metaphors to describe the uncanniness of Manhattan first seen from the harbor. In 1906 H. G. Wells found the "tall, irregular crenellations" that he saw as his ship came in through the Narrows "the strangest crown that ever a city wore."[61] For Henry

James it was a "loose nosegay of architectural flowers" and, when seen from Jersey City, a "pin-cushion in profile."[62]

Popular culture, too, helped invent the *new* New York. Postcard and stereograph makers, magazine illustrators, and cartoonists all found the city a marketable subject. Sometimes the vocabulary was one of old and new, sometimes isolated portraits of the new monuments, sometimes picturesque skylines or walks over the Brooklyn Bridge. In the case of Winsor McCay's 1905 comic strip *Dreams of the Rarebit Fiend*, the Fiend dreams of himself as a supertourist who knows his way about town, a bully, and a braggart (Fig. 145). Wading into the "village" of New York, he leans on the Flatiron, lounges on the cables of the Brooklyn Bridge, stomps on Wall Street, and

digs up a little of the new subway to take home as a souvenir. His macho fantasy is to control and conquer the height, the monumental scale, and the pace of New York by belittling and overpowering it. It doesn't work; the Fiend ends up in jail.

The next generation, to which Stella belonged, was formed by these pioneer images, which established a basic grammar, a pioneer semiotics, for New York's peculiar modernity. This generation was particularly indebted to three grand conceptual definitions of New York that the picturesque artists constructed visually. For convenience, I call these the Cyclopean City, the City Electric, and the City Delirious. The impressionists, Tonalists, and pictorialist photographers invented the first two tropes, and the Ashcan school artists, particularly John Sloan and George Bellows, the third.

The Cyclopean City of unprecedented scale was the first and most popular of the three conceptual definitions. In the early century people referred to the city as a "giant," its buildings as the work of a "Cyclops" and their windows as "Argus" eyes. Stella used this rhetoric in his writings of the 1920s. But how to convey visually that the city seemed not to have been made by people, but by giants? One response, that of the comic strip we just looked at, injected humor into the awesomeness of New York by reducing skyscrapers to the scale of playthings. The usual and most elementary response from graphic artists, however, was to exaggerate the height of buildings relative to the smallness of pedestrians. In the hundreds of drawings and etchings of New York that Joseph Pennell made between 1904 and 1924, structures tower over people, genially but decisively (Fig. 146).[63] If looked at hurriedly, these works seem to be all buildings, no New Yorkers. The buildings have distinct outlines, and famous ones can be recognized; the people, in contrast, are anonymous little marks and scratches at the bottom of the page. These are among the earliest American images of the anonymity of a crowd, of living in a city where the word "colossal" took on new meaning.

Pennell, in seeking a way to picture a skyscraper city, began to invent an urban opticality. He and others consciously changed pictorial conventions by readjusting the proportions of people and buildings that painters had used earlier, visualizing the new

Fig. 146. Joseph Pennell, *Canyon, No. 1,* 1904. Etching, 10 5/8 × 5 3/8 in.

Fig. 147. Childe Hassam, *Washington Arch, Spring*, 1890.
Oil on canvas, 27⅛ × 22½ in.

city as a place where buildings defined boundaries and made people feel small and insignificant. To give a concrete example, when Childe Hassam, in 1890, painted Stanford White's new arch in Washington Square, he included a fashionable woman pedestrian walking toward us on Fifth Avenue, her height about one-third that of the monument behind her (Fig. 147).[64] As a result, she and the other figures in the painting, including the sanitation worker (these workers were called the White Wings because of their distinctive modern uniforms, whose whiteness signified healthfulness), were highly individuated. Most of Hassam's city paintings in the 1890s follow this formula. As Hassam became the painter of skyscraper New York, however, he, like Pennell, reduced the size of his pedestrians and scaled up his

buildings so that they went right to or out of the frame. Buildings like mountain cliffs define space and diminish the tiny pedestrians who cluster together and move forward in congealed dark masses in the street below. The cleavage between the buildings is steep and deep, with only a sliver of sky, picturesquely jagged. In Hassam's *Lower Manhattan (View down Broad Street)* (1907) separate and definable individuals have completely dissolved into anonymous masses at the bottom of a canyon formed by herculean buildings (Fig. 148).

Artists like Pennell and Hassam, joined by other pre–World War I artists like Birge Harrison, Theodore Butler, Guy Wiggens, and Ernest Lawson and photographers like Stieglitz and Coburn, as well as numerous illustrators and picture popularizers,

Fig. 149. Alfred Stieglitz, *Icy Night*, 1898.
Carbon print, 10¼ × 13½ in.

created the first visualizations of New York as the
Cyclopean City.

In their views of the City Electric, the second
Manhattan trope, artists trained in the picturesque
tried to capture the "moony sheen" of street lamps,
the necklace of lights across Brooklyn Bridge, the
thousands of "eyes" in skyscrapers, the moving light
chains of the elevated, car and buggy headlights,
and an occasional lighted store window. Notably
missing—they would come only later—were elec-
tric advertisements. Because commercial signs, for
a variety of reasons, did not conform easily to the
rules of the picturesque, this generation of artists
avoided putting them in their paintings and photo-
graphs or, if they did include them, tucked them
into compositions, as Joseph Pennell and John Sloan
occasionally did, as small elements giving variety

Fig. 148 (facing). Childe Hassam, *Lower Manhattan
(View down Broad Street)*, 1907. Oil on canvas,
30¼ × 16 in.

and picturesqueness to New York's streets. Only
after World War I did signs become a subject all
their own.

But with or without electric signs, painters like
Pennell, Birge Harrison, Everett Shinn, Theodore
Butler, John Sloan, and George Luks and photogra-
phers such as Coburn, Stieglitz, Steichen, Karl
Struss, and Jessie Tarbox Beals, along with trade
publications like *Harper's* and *King's Views*, in-
vented the New York electric nocturnes (Fig. 149;
see Figs. 143, 144).[65] Their work was often in the
soft Whistlerian mode, but with a difference. Whis-
tler painted any kind of light that beamed softly, and
randomly, through the murkiness: candles, gas
lamps, moonlight, fireworks, and electrics. Indeed,
it is often difficult to know exactly what source of
light he was painting. The artists of the *new* New
York, in contrast, clearly registered that their lights
were modern, electric, and standardized. They de-
lineated the march of lampposts down an avenue or
across a bridge and showed how electricity defined

Fig. 150. John Sloan, *The City from Greenwich Village*,
1922. Oil on canvas, 26 × 33¾ in.

specific city spaces with intense brilliance. Their light was "harder" than Whistlerian light, and its source in new technologies was well defined.

In some hands, especially those of the pictorialists and the Stieglitz second circle, nocturnes becalmed the city, subduing and eliminating its chaos. These artists, including writers like Henry James, found the city wondrous and sublime at night, harsh and assaulting by day. Stieglitz made a number of New York nocturnes, and when O'Keeffe turned to city paintings in the late 1920s, she created a kind of ecstatic nighttime spectacle where lights dance and twinkle on the painting's surface. When members of the Ashcan school did night paintings, their purpose was different. John Sloan, who employed the form most often, used it to catalogue the picturesque

variety of city lights that turned urban night into an electric day: the lights of the elevated trains, lighted storefronts, street lamps, apartment windows, even on rare occasion an electric sign. Of all the early city nocturnists, he was the most sensitive to the extreme artificiality and unnaturalness of electric light. His sensibility was close to Stella's in this regard, and in 1922, at the same moment that *The Voice of the City* was under way, he created a painting—*The City from Greenwich Village*—that provides a telling comparison of their respective positions (Fig. 150). While Stella relays the psychic and visceral effects of electricity on Broadway, Sloan is an outside observer, positioning himself, and us, to look uptown at the White Way from a downtown Greenwich Village window high up in an apartment

Fig. 151. John Sloan, *Fifth Avenue, New York*, 1909.
Oil on canvas, 32 × 26 in.

building. From that vantage he describes the City Electric as a spectacle in the far distance. He does not immerse himself in it, but documents it as a strange apparition on the horizon, placing his own body (and ours) in alignment with the old, more human-scaled, traditionally lit parts of the city.

John Sloan and his friends were also the artists who most forcefully defined the City Delirious, the third Manhattan trope that emerged during this formative period. Their paintings were among the first images to pictorialize the density of noise, cacophony, and congestion that everyone had begun to talk about as distinctive to New York. First, they identified those locales in the city where people came together in crowds: entrances to the elevated stations, Coney Island beaches, streets at rush hour, markets

on the Lower East Side, and nightspots like vaudeville theaters, the circus, and boxing rings (Fig. 151). They then depicted those spots jammed full of as many different types of people and traffic as their canvases made pictorially possible, using the brush to render this traffic in flux. Rough strokes, quick touches, swirling impasto, and sketchiness of contour became painterly equivalents to the zest, restlessness, and crush of New York's streets.

George Bellows's grand panorama *New York* (1911) is a wonderful example of the City Delirious (Fig. 152). The painting, loosely based on buildings and activities around Madison Square, an area of New York that had become a hub for department store shopping, shows an unusually frenzied and crowded scene. "The street from gutter to gutter is

just as full of vehicles as the sidewalks are of moving people," John Van Dyke wrote of the square. "Policemen mounted or standing, are in the center of crowded cross-streets to hold up the line of carriages for a moment and allow a stream of foot passengers to pass over. . . . The cabs pay little attention to foot passengers, and the automobiles pay still less."[66] To picture its chaos, Bellows loaded the foreground with people, carriages, and streetcars and showed the park under snow as a sliver of middle ground. In the background, he built an embankment of varied city buildings, signs, and an elevated train crossing a canyon between buildings. With detail piled upon detail, color upon color, Bellows's painting is an exaggerated visual catalogue of street activities, buildings, and signage, rendered with a superactive brush that churns up the surface and forces the viewer's eyes to be constantly on the

move. Like the traffic itself, individual brushstrokes move at rough crosscurrents, colliding, like the people's bodies in the crowds. While Bellows offers a more innocent and joyous account of city crowd scenes than contemporaneous futurists and German expressionists, his project was also a different one: he was not painting modern life in the abstract but trying to configure the specific sensations engendered by the *new* New York's complex and diverse street life.

Stella built upon canvases like this one that gave voice to a chaotic, demanding, restless, and hard-to-contain city. The City Delirious helped shape his concept of New York as spectacle but also as bodily stress, tactile, auditory, and visual. He inherited, moreover, the raw artistic drive that Bellows and others exhibited in their search for a new language appropriate to their city, whose novelty and glamour

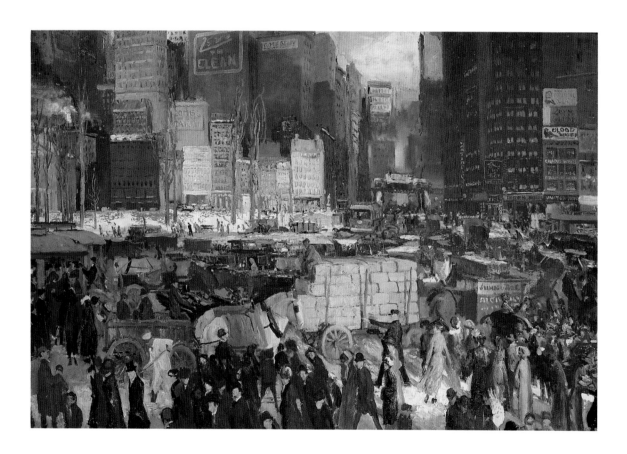

Fig. 152. George Bellows, *New York*, 1911.
Oil on canvas, 42 × 60 in.

were increasingly cast as a national achievement. When Stieglitz made his claim that the Flatiron Building was "the new America that was still in the making" and decreed that it was to America "what the Parthenon was to Greece," he was speaking the language of progressive artists and intellectuals.[67] "In this tall, eccentric tower," another artist wrote of the same building, "we have begun to feel our way toward national buildings—buildings that suit our needs, our comfort, our landscape, without regard to any other nation or civilization."[68] For Claude Bragdon, an architectural critic of fin-de-siècle tastes and Stieglitz's friend, "the skyscraper alone is truly indigenous to the American soil." All other public building types are "uninspired adaptations of stale European originals, but the skyscraper is *a natural growth*, and a symbol of the American spirit" (italics in original).[69] Others offered encomiums to Brooklyn Bridge as a native achievement, "as graceful and lean and characteristically American in its line as our cup defenders, and as overwhelmingly powerful and fearless as Niagara Falls."[70] The city's street life, its incessant noise, ceaseless activity, bodily assault, and psychic demands also began to be interpreted as elements of a peculiar American dynamic. As early as 1903 Sadakichi Hartmann was trying out the idea that New York's greatness was its "exuberant, violent strength" and that there was "an infinitude of art and beauty in all this mad, useless Materiality."[71]

Although this fusion of modernity and nationalism, with New York as the focal point, was only a germ of an idea in the early 1900s, it increasingly drove artists to paint the new Manhattan and forgo, bit by bit, anything of the old. Beginning on the eve of World War I and continuing through the 1920s, the next generation of modern artists ignored the old city altogether. Armed with the lessons of cubism and futurism, they did not so much create a new iconography as refine the one invented by the generation of 1890–1910. They kept alive the tropes of the Cyclopean City, the City Electric, and the City Delirious, but they dropped motifs that artists had included for contrast, variety, irregularity, and exoticism. Except for a few residual steam clouds (denoting industry as much as suggesting atmosphere) and an occasional glimpse of sky, these artists hardened and denatured the city. They eliminated soft and organic lines, building their canvases now with

cubes, right angles, and facets. The skyscrapers in their works rarely cohered into the canyons or pincushion skylines of earlier New York views but were fragmented into gigantic piles of steel and stone. What is perhaps most significant for these cubo-futurist artists, New York was not just the city observed but also the city experienced. They discarded the first generation's distanced pedestrian viewpoint as too static, too stationary, and too much tied to a single vantage point, usually that of the street. The essence of New York could not be captured as a series of "stills" taken from an earthbound perspective; it had to be rendered as a totality of sights and visceral sensations. For them, the new city demanded an approach and style as disjunctive and shrill as the urban environment itself. It was as a player in this revised cultural project that Stella found his place.

Scholars rightly credit John Marin with painting the first cubo-futurist canvases of New York's skyscrapers and bridges. Yet for all his advanced European vocabulary—broken contours, cubist space, and slashing line—his cityscapes from 1910 to 1920 were still deeply tied to the rules of the picturesque (Fig. 153). He positioned himself at a stationary point in picturing a New York street, skyscraper, or skyline; he worked in small scale; and he put high value on atmosphere, contrast, and variety. Using a brushstroke in his watercolors that reminded many of the technique used in Chinese paintings, he exoticized New York in ways that were at once modern and familiar.[72]

Only with the more orthodox cubo-futurist paintings of New York that Max Weber produced between 1911 and 1915, and the buoyantly abstract New York works that Francis Picabia and Albert Gleizes painted about the same time, did a completely new kind of city painting get under way. Using the tools of Continental modernism, these artists compressed skyscrapers, bridges, and the energy of lights, crowds, and traffic into single canvases. They generally focused on an established theme—Broadway at night, the Brooklyn Bridge, or skyscrapers downtown—but now used the power of jagged lines and independent color blocks to convey New York's energy and soaring architecture in abstract terms. Weber, who had learned cubism in Paris, turned the

Fig. 153. John Marin, *Movement, Fifth Avenue*, 1912.
Watercolor, 17 × 13¾ in.

Cyclopean City into a maelstrom of skyscrapers with Brooklyn Bridge as a canopy in *New York 1913* (Fig. 154); in *New York at Night* (1915) the City Electric became a tall vertical nocturne of cut-glass glitter (Fig. 155); and in *Rush Hour, New York* (1915) the City Delirious is revisited with skyscrapers above and fast moving traffic below (Fig. 156). These paintings viscerally evoke the bodily sensations of Manhattan life in their swirling forms, hard edges, and unrelenting activity of surface.

Stella made his debut at picturing urban dizziness and cacophony in *Battle of Lights, Coney Island, Mardi Gras* (1913–14), one of the most visually demanding New York paintings any artist ever conceived (Fig. 157). It is an electric nocturne, so brightly colored that nighttime is nearly eclipsed.

Stella drew the details from visits to Luna Park, the largest of the amusement parks on Coney Island, which boasted such features as an electric tower two hundred feet high; an electric fountain; a City of Delhi with elephants, zebras, and camels; centrifugal swings; a trip to the moon on Luna III; and a submarine journey through tropical and Arctic seas.[73] Every night at Luna Park a quarter of a million

Fig. 154 (facing, top left). Max Weber, *New York 1913*. Oil on canvas, 40 × 32 in.

Fig. 155 (facing, right). Max Weber, *New York at Night*, 1915. Oil on canvas, 33⅞ × 20¹⁄₁₆ in.

Fig. 156 (facing, bottom left). Max Weber, *Rush Hour, New York*, 1915. Oil on canvas, 36¼ × 30¼ in.

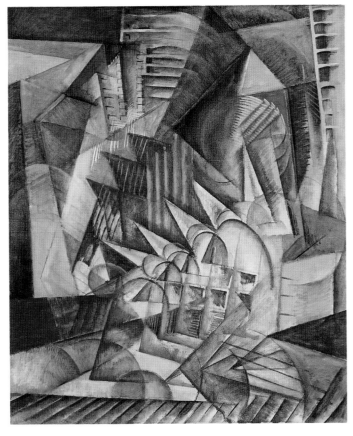

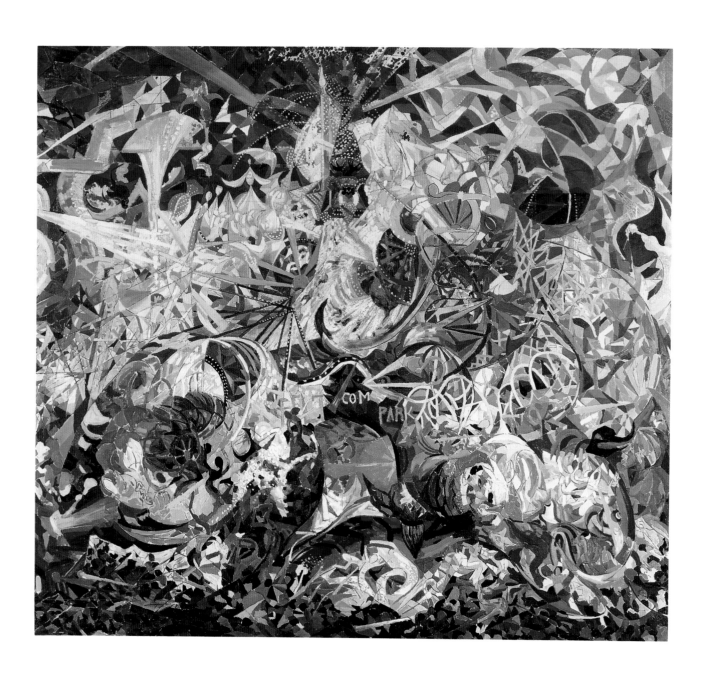

electric lights cast their glow over elbow-pushing crowds and free-for-all revelry, which Stella configured through tiny prismatic forms, as if each were a moving person or a different streak of light. Like bugs drawn to light, the crowds surge from darkness below toward the electrically charged dance of spotlights, decorative lights, and amusement rides above.

This was a painting deeply shaped by the transatlantic mentality. In it Stella applied his Italian countrymen's most radical modernist style to a quintessentially American subject, Coney Island, an obligatory stop on the itinerary of European tourists in New York. This picture fused the artist's recent exposure to futurist paintings and theory with a City Delirious site. Stella had seen the first major futurist exhibition in Paris when he was there in 1912 and had met members of the group, becoming friendly with Gino Severini, in particular.[74] Given that he was a compatriot, Stella could speak with the futurists and read their manifestos in his native tongue. And he obviously did, for his own way of writing about New York is swollen with futurist hyperbole, violence, and aggressiveness. His contact with the futurists also radically changed his ideas about cities, particularly New York. Before he encountered their work, Stella's city pieces had been studies of workers and immigrants along with an occasional landscape of workers' quarters or a factory skyline (see Fig. 115). But after contact with futurism, he eliminated these figures, which the avant-garde deemed sentimental and old-fashioned. The futurists professed interest in workers, but as faceless revolutionaries, not as individuals studied for their character.

The futurists' city was an ultramodern contemporary city, sometimes envisioned as a place like Manhattan, which they knew only from afar, and through its mythos. They found European cities hopelessly weighed down by old buildings and technologies. Presenting themselves as radical reformers, they lambasted the classical architecture, stifling museums, and bourgeois culture of Italian urban centers and celebrated what they projected as the metropolis of tomorrow, incipient, they believed, in the crush and energy of urban crowds; the new engineered environment of modern-day bridges,

railroads, factories, and transportation systems; and in the powerfully searing optics of electric lights. It was to these three features—crowds, technology, and electric lights—that Marinetti sang in the last of his eleven declarations in the 1909 Futurist Manifesto:

> We will sing of great crowds excited by work, by pleasure, and by riot; we will sing of the multicolored, polyphonic tides of revolution in the modern capitals; we will sing of the vibrant nightly fervor of arsenals and shipyards blazing with violent electric moons; greedy rail clouds by the crooked lines of their smoke; bridges that stride the rivers like giant gymnasts, flashing in the sun with a glitter of knives; adventurous steamers that sniff the horizon; deep-chested locomotives whose wheels paw the tracks like the hooves of enormous steel horses bridled by tubing; and the sleek flight of planes whose propellers chatter in the wind like banners and seem to cheer like an enthusiastic crowd.[75]

So comfortably did Marinetti's visionary ideas of a "futurist" city fit the way the *new* New York was emerging in popular and artistic imagination that Stella, an Italian living in Manhattan, became a natural conduit by which futurist theory crossed the Atlantic. Marinetti himself never came to Manhattan, and like so many European avant-gardists, he knew of the skyscraper city only through its mythology. But Stella lived in Manhattan and knew firsthand that all was not paradise under the "reign of holy Electric Light," in a place where the "Murder of Moonshine" that Marinetti called for had been successfully committed.[76] As a consequence, Stella's works engaged futurist theory while disputing its aggressive utopianism. Because he painted as an expatriate, as well as from lived experience, his urban vision inscribed psychic ambivalence that had no place in Marinetti's futurist program. Stella's city paintings were nightmarish in ways Italian futurist canvases of Milan and Rome generally were not. In 1909, when Giacomo Balla painted a futurist hymn to the new electric light, he depicted its energy in a still life of a single streetlight cutting through the darkness (Fig. 158). This was one of the first street lamps in Rome, the artist later recalled, and it was a daring project for him to take on because people thought the subject so inartistic.[77] By New York standards in 1909, however, the idea of a *single*

Fig. 157 (facing). Joseph Stella, *Battle of Lights, Coney Island, Mardi Gras*, 1913–14. Oil on canvas, 76 × 85 in.

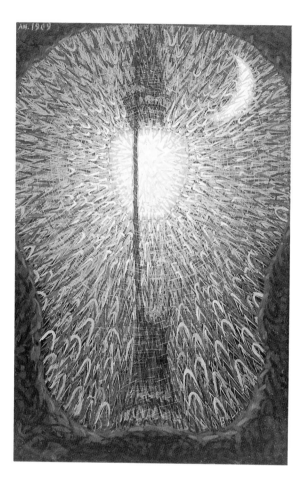

Fig. 158. Giacomo Balla, *Street Light*, 1909.
Oil on canvas, 68¾ × 45¼ in.

streetlight was utterly quaint and precious; artists had been painting and photographing such lights singly and in rows for over a decade. And Stella surely meant to say so to his Italian brethren when he set out to paint his *Battle of Lights* four years later. Abundant in small details and bewildering in its directional signals, *Battle of Lights* is precisely what its title denotes, a scene of combat where we as spectators are optically assaulted. Compared with Balla's streetlight, Stella's Coney Island is a confounding place. Stella's reign of electric light was disorienting, obsessive, even a bit mad—not the urban nirvana his Italian countrymen conjured up.

Even as Stella joined his countrymen in their idolatry of the "divinity" of technology—we have looked at his references to Christian imagery in *Voice of the City* (see Fig. 118), he seems to have felt like Paul Strand, who found it hard to be "particularly sympathetic to the somewhat hysterical attitude of the Futurists toward the machine" when the machine was "with us and upon us with a vengeance."[78] Stella painted as an Italian in New York, not one dreaming about the city from several thousand miles away. Ezra Pound registered yet another corrective to Marinetti's idealistic reforms as seen from an American perspective. When Marinetti called for the destruction of Venice as a way to start all over again and modernize, Pound wrote: "When Mr. Marinetti and his friends shall have succeeded in destroying that ancient city, we will rebuild Venice on the Jersey mud flats and use the same for a tea-shop." Next to the New York skyline, Pound wrote, "Venice seems like a tawdry scene in a play house."[79]

Stella was also responding to another cultural pressure that surfaced in modernist circles around the time of World War I: the desire to visualize or capture the essence of the modern city in one grand and definitive picture, poem, novel, or film. As a city like New York, Paris, or Berlin began to metamorphose into a metropolis, and sociologists such as Georg Simmel and Max Weber began to write about the city's unique physical and psychological spaces, artists, too, began to conceptualize cities as biological wholes, each with a definable personality and character traits.[80] They began to think of individual cities having a "spirit" or "soul" that could be captured in a painting (or used to promote an aviator and his airplane, as in the *Spirit of St. Louis*). The

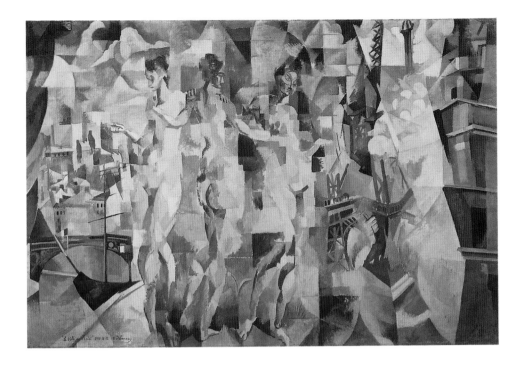

Fig. 159. Robert Delaunay, *The City of Paris*, 1910–12.
Oil on canvas, 105 1/8 × 159 7/8 in.

word "spirit" in this context meant something like "personality." The idea that cities had a "spirit" resembled the new convention of portraiture that modernists invented, exemplified in Demuth's portrait posters (discussed in Chapter 4), which represent people through indirect references and attributes. Similarly, the new city portraits were not descriptive cityscapes but shorthand schemata that claimed to encapsulate the "essence" or the "voice" of a city.[81]

From 1910 to 1930 a number of these city portraits appeared—usually large-scale and very ambitious—that are European kin to Stella's *Voice of the City*. *The City of Paris*, by Robert Delaunay, shown at the 1912 Salon des Indépendants, where Stella most likely saw it, was one of the first (Fig. 159).[82] A sizable canvas, about fifteen feet long, it pictured a set of key monuments that emblematically represent Paris. The old Paris is to the left, in the low-lying city and bridges over the Seine. And the modern is to the right, in the Eiffel Tower and tall apartment house. (The prewar French modernists also constructed cities through contrasts of old and new.)

The two ages are linked by the three graces, an image Delaunay took verbatim from a postcard he owned of a Roman painting in Pompeii. Their presence gendered the city female, but not as Stella gendered New York. His New York was a femme fatale, seducing and smothering, while the languid and sensuous bodies of the goddesses in Delaunay's Paris signified a city of great physical beauty and a history that stretched back to the Roman Empire. Though Delaunay was a great celebrant of modern Paris, he put modernity on the margins in his city portrait and antiquity in the center—an organization that says much about the French desire to honor the past even when celebrating the modern.

Delaunay, in representing his city as one organism made up of different symbolic scenes—right, left, and middle—with leaps of geography and history between them, experimented with a format that would soon become requisite to these new city portraits. Parts collaged one upon the other signified a more inclusive whole, a city's "spirit," not its documentary physicality. In Germany, in depictions

Fig. 160. Otto Dix, *Großstadt (Triptychon)*
(*Big City [Triptych]*), 1927–28. Mixed media
on wood, 71 1/4 × 156 3/4 in.

of a city like Berlin, these parts often represented class difference and exploitation, while in France and America they were more often passages of characteristic urbanscape like those of Delaunay and Stella. When Otto Dix fashioned his *Großstadt* (1927–28) as a triptych, each panel represented a different aspect of Berlin nightlife, each a pointed critique of the decadent rich compared with the suffering poor (Fig. 160). Similarly, when his colleague Fritz Lang made the film *Metropolis* (1926), evoking a mythic modern city loosely based on European stereotypes of New York, his concern was to describe the harsh workings of class in the modern cityscape, not the city's poetic personality.[83]

Art filmmakers like Lang were closest to Stella in sentiment, particularly those who invented the "city symphony." City symphonies were silent documentaries that had no plot in the conventional sense or any specific characters. Their narration, rather, consisted of different views of city life that dramatically

cut from one to the next, the choppiness from part to part inherent in their "cubist" or modern style. These films were usually built around a typical day in a given city from sunup to sundown. Diverse views of the city slowly waking were followed by those of busy streets, shops, and factories during the workday and, finally, city activities at night. Highly poeticized, with occasional small passages of humor and others of machine age abstractions, these films projected cities as if they were grand personalities, each one an organic whole with its own rhythms, its own monuments, and its own activities. By one scholar's calculations, about twenty city symphonies were created between 1921 and 1929, including *Manhatta* by Paul Strand and Charles Sheeler (1921), *Paris qui dort* by René Clair (1923), *Twenty-Four Dollar Island* (1924) by Robert Flaherty, *Berlin: Symphony of a City* (1927) by Walther Ruttmann, and *City Symphony* (1929) by Herman G. Weinberg.[84]

Stella's *Voice of the City* was in process when the first of these films, Paul Strand's and Charles Sheeler's *Manhatta*, opened on July 24, 1921; it ran for a week at the Rialto Theatre on Broadway.[85] Originally entitled *New York the Magnificent*, the film was seven minutes long and played as one small part of a variety program that included an organ overture and postlude, a ballet, a vocal performance, and a full-length feature film. An orchestra accompanied *Manhatta* with popular music about New York, including "Sidewalks of New York." The audience, one critic wrote, was on the verge of bursting into song.[86]

Manhatta and Stella's painting, remarkably symbiotic, were seemingly born of the same discursive impulse: to define New York City through its modernity (rather than its history or its human diversity), and to do so grandly, in a sweeping work of distinct parts that gave the illusion of comprehensiveness. Like Stella's painting, *Manhatta* was made up of

"movements" that seem at first to have little organic relationship, their disjunctive leaps a cubist equivalent to chaotic urban experience. Yet both works were rigorously ordered, Stella's by geographic mapping, and Strand's and Sheeler's by the daily clock. Both were efforts to get beyond a simple series of snapshot views of the city and possess it holistically. The ambition was to define the city's essence, not just to skim its surfaces.

Manhatta consists of twelve sections loosely organized around the hours and activities of a working day, opening at daybreak and closing at sundown. These twelve sections, in turn, are grouped into four parts, or "movements." Quotations from Whitman's "Crossing Brooklyn Ferry" (1856) and his "Mannahatta" (1860) announce each section of the film. Like Stella's painting, the film is bracketed by water and by the imagery of arriving and departing. The opening movement pictures commuters arriving in the city and the business district with cinematic

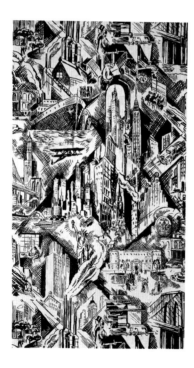

Fig. 161 (top). Paul T. Frankl, Combination Desk and Bookcase, ca. 1927. California redwood trimmed with black lacquer, 86½ × 64½ × 33½ in.

Fig. 162 (bottom). Ruth Reeves, Fabric, "Manhattan" pattern, 1930. Block-printed cotton, 80¼ × 35⅛ in.

views of the Cyclopean City from the East River: the skyline, ferry hangers, and Brooklyn Bridge. The two middle movements explore the City Delirious at work, with crowd scenes, views of the towering Woolworth Building, people scurrying antlike in the streets (with an occasional dark look at the graveyard of Trinity Church), and scenes of industry, especially railroads and steamships. The fourth movement is the end of day, when commuters are again on the move. The final shots are of the island city seen from the water at sundown, and the setting sun—we are the commuters going home on the ferry—bringing a "typical" day in Manhattan to a nocturnal close.

The electric signs and billboards of the White Way were notably missing from *Manhatta*, too vulgar, one presumes, given that both Strand and Sheeler at this time were associated with the second Stieglitz circle and its anti-billboard views. Among the film's many residual references to the picturesque are its atmospheric steam clouds, which erupt every so often; contrasts between old and new; and nature as an active player, in long shots of sky and of sunset. But in other ways Manhattan is as narrowly construed in the film as in *The Voice of the City*, both rigorously suppressing old New York to concentrate on its newness and modernity. One scholar has determined that Strand and Sheeler shot all their footage within a five-block radius in lower Manhattan, exactly the skyscrapered territory of the port and Brooklyn Bridge panels.[87]

While there is no evidence that *Manhatta* had any direct impact on Stella's thinking, or even that the artists exchanged ideas, the shared ambition and *mentalité* are important.[88] By 1920 the *new* New York of skyscrapers, bridges, and bustling crowds had come to be a *big* subject for artists on both sides of the Atlantic, so intimately tied had it become to their self-conception as moderns. No other city in the world attracted such attention. London and Rome had long since lost their magnetism, and Paris, the city whose modernization had been a central theme for late-nineteenth-century writers and artists, had lost its primary place in artists' imaginations. Only Berlin, a city perceived, like New York, as extreme in its modernity, had something of the same appeal.[89]

Who would create the definitive picture? Or, to use the title of this book, who would successfully

capture the Great American Thing? Max Weber, Abraham Walkowitz, John Marin, Margaret Bourke-White, Berenice Abbott, Walker Evans, Louis Lozowick, George Ault, Stefan Hirsch, Strand, Sheeler, Stieglitz, Steichen, and O'Keeffe all took New York's modern persona as their subject for a period of time. While John Storrs was inventing taut abstract sculptures based on skyscrapers pressing against one another, Paul T. Frankl created furniture and Lillian Holm and Ruth Reeves did textile patterns based on the city's skyscrapers (Figs. 161, 162). In 1925, when John Wanamaker opened a new store with an exhibition called *The Titan City: New York*, he included a sixty-foot-high mural, by Willy Pogany, detailing the skyscrapers at the end of the island.[90] Writers too caught the fever as they raced to write the definitive novel or poem about New York. William Carlos Williams, in "Perpetuum Mobile: The City," shaped a poem so that it gave visual form to its content, a skyscraper towering in the clouds.

In 1925 Dos Passos published his *Manhattan Transfer*, a searing novel of life in a business-dominated skyscraper city, followed by Janet Flanner's *Cubical City* (1926) and Samuel Spewack's *Skyscraper Murder* (1926). Hart Crane's poem *White Buildings* was finished in 1925, *The Bridge* in 1930. And in a memorable photograph of about 1932, seven architects pose in skyscraper costumes for a Beaux Arts ball (Fig. 163).

The European love affair with New York also accelerated as artists of the stature of Vladimir Mayakovsky, the Russian futurist writer, made a celebrated 1925 visit to the city and distinguished writers, like Paul Morand, wrote books about New York's modernity. The Parisian edition of Morand's book included lithographs of New York by the Dutch artist Adriaan Lubbers, a *transatlantique* who lived in New York from 1916 to 1919 and again from 1926 to 1928. Lubbers, a friend of Piet Mondrian's, may by example have helped Mondrian decide

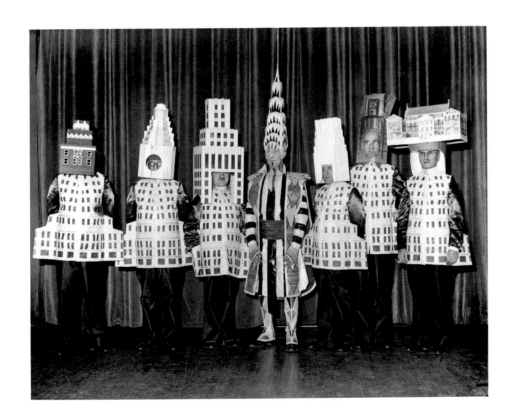

Fig. 163. Architects in costume for Beaux Arts Ball, ca. 1932.

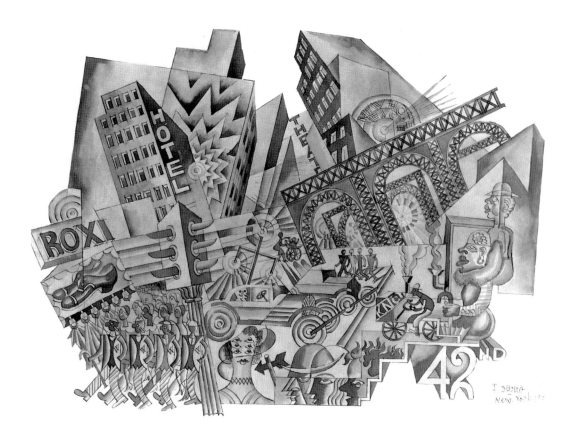

Fig. 164. Fortunato Depero, *Broadway—Crowd—Roxi Theatre* [*sic*], 1930. Ink and diluted ink on paper, 17⅝ × 23⅞ in.

to live in exile in New York during World War II.[91] Maurice Denis, the aging French symbolist painter, visited New York in September 1927 and painted the requisite views of New York's skyline, harbor, and individual skyscrapers. And some artists, following now in the transatlantic pattern set down by Duchamp and Picabia, stayed for a time. In 1928 Fortunato Depero came for two years; he created an entire repertoire of prints, paintings, and graphics about Manhattan and kept in close touch with his fellow Italian futurists back home (Fig. 164). Bernard Boutet de Monvel, a French portraitist, was so enamored of modern Manhattan that beginning in 1926 he spent six months of each year in New York, where he would paint Precisionist canvases of New York's skyscraper cliffs and canyons (Fig. 165). And Le Corbusier had also begun to show interest in New York's

skyscrapers, though he would not see Manhattan until 1935, when he made the visit that inspired his critical manifesto about high-rise cities, *When the Buildings Were White*. In a classic act of transatlantic exchange, *Vanity Fair* bought and published work in the 1920s by the Belgian-born printmaker Frans Masereel, a great admirer of Whitman who lived in France, where he made woodblocks of modern city scenes, often of the Cyclopean City, which he had never visited but could imagine through its mythos (Fig. 166).[92]

Transatlantic exchanges also continued to flow from New York to Paris and back again. Duchamp arranged for a Parisian showing of *Manhatta* at a dadaist event in 1922, and Diaghilev commissioned John Alden Carpenter, an American composer, to create a New York ballet for his Ballets Russes. Its title was

to be "Le Chant des Gratte-Ciels," or "The Song of the Skyscrapers." Carpenter, who had already enjoyed success with a ballet about Krazy Kat that was based on the American cartoon popular among *transatlantiques*, was a friend of Gerald Murphy's. Murphy probably helped him make contact with Diaghilev. No one seems to know precisely why Diaghilev's support for the project dried up, but it did, and in 1926 the ballet premiered, not in Monte Carlo, but in New York's Metropolitan Opera House, now titled *Skyscrapers: A Ballet of Modern American Life*. It enjoyed a two-year run but was always controversial, partially because it had a social message at odds with the buoyant *américanisme* that so many Europeans and Americans embraced. Using a range of percussion instruments to simulate the discordant sounds of New York's streets and telling stories about industrial laborers against the backdrop of an oppressive skyscraper skeleton, the ballet focused, as one critic put it, on "the corrosion that lurks indeed beneath our too proud skyscrapers."[93] Given such social content, it appealed to the Germans, who gave the ballet its premiere in Europe, at the National Theater in Munich. (A few years later Hitler banned Carpenter's music because of its jazz and vernacular sounds.) The French public never did see the ballet, but they heard the music on symphonic programs and loved its loud vulgarity, jazz motifs, and machine sounds. In that music they heard the lighthearted, jazz era New York story the ballet itself did not tell.[94]

Such New York–mania solidified the city's image as gigantic, delirious, and electric; the city acquired an identity so crisp, clean, and schematic that it too seemed formed by machine. It is the "consensual" New York that continued to be replicated in works by artists as varied as Stuart Davis, Mark Tobey, Piet Mondrian, Franz Kline, and Red Grooms (Fig. 167) and often is used as a backdrop in movies by Woody Allen. When in 1978 Rem Koolhaas, the irrepressible Dutch architect, published his *Delirious New York: A Retroactive Manifesto for Manhattan*, with fantastic drawings by Madelon Vriesendorp, it was as if the 1920s had been but yesterday (see Fig. 320). His (and hers) is a post-modern fever—he calls it Manhattanism—as he self-consciously positions himself in the genealogy of the *transatlantiques*, wanting to be their heir and keep their *américanisme* alive.[95]

Fig. 165 (top). Bernard Boutet de Monvel, *New York,* 1926. Oil on canvas, 33 × 21 in.

Fig. 166 (bottom). Frans Masereel, *An Imaginary Portrait of New York*. From *Vanity Fair* (Feb. 1923), p. 37.

Fig. 167. Red Grooms, *The Builder*, ca. 1962.
Ink on paper, 11 × 8⅛ in.

There is one final point to consider about Stella's great opus. He conceptualized his picture at a time when only the thinnest and most permeable of lines had come to separate New York as city from America as country. For visitors and artists alike, particularly those from abroad, the city's identity coincided with a national one. At the height of modernolatry, before the Great Depression burned the dew off the blossom, intellectuals took the voice of the city as the soul of America. Typically transatlantics like Duchamp and Stella were Manhattan-centric and traveled little beyond the Hudson. For if you had lived in New York, you had seen America. Likewise, if you painted or wrote about the modernity of Manhattan, you were creating a work about America. When Stella exhibited a painting in 1919 of a large gas tank, he called it *American Landscape*. Ten years later he used the same name for a painting of Brooklyn Bridge and skyscrapers (Fig. 168). This was characteristic thinking in the 1920s; a New York bridge or skyscraper stood for the American continent. Here is Stella on Brooklyn Bridge:

> Seen for the first time, as a weird metallic Apparition under a metallic sky, out of proportion with the winged lightness of its arch, traced for the conjunction of WORLDS, supported by the massive dark towers dominating the surrounding tumult of the surging skyscrapers with their gothic majesty sealed in the purity of their arches, the cables, like divine messages from above, transmitted to the vibrating coils, cutting and dividing into innumerable musical spaces the nude immensity of the sky, it impressed me as the shrine containing all the efforts of the new civilization of AMERICA.[96]

Even Americans who had lived and traveled in their country would conflate New York and America—or at the very least aggrandize Manhattan into a monumental gateway city to the nation. They demonstrated their own Eurocentricity and transatlantic vision by assuming the country *began* in New York and *flowed* West. (As a relocated New Englander living in California, I have become alert to this prejudice.) In Hart Crane's long and difficult poem *The Bridge*, written between 1924 and 1929, New York City serves as

Fig. 168 (facing). Joseph Stella, *American Landscape*, 1929. Oil on canvas, 79⅛ × 39⁵⁄₁₆ in.

a cosmic bridge that starts and ends a mythic journey across the country. The poet's odyssey ultimately takes him to the prairies, to the Mississippi, to the Midwest, and to the South and, through these places, deep into the country's myths and legends, its past and present greatness and failures. But it begins and ends, significantly, in Manhattan, with the towers and cables of Brooklyn Bridge as an overarching metaphysical gateway to the country as a whole.

> Through the bound cable strands, the arching path
> Upward, veering with light, the flight of strings,—
> Taut miles of shuttling moonlight syncopate
> The whispered rush, telepathy of wires.
> Up the index of night, granite and steel—
> Transparent meshes—fleckless the gleaming staves—
> Sibylline voices flicker, waveringly stream
> As though a god were issue of the strings. . . .

The scale of Crane's poem, like that of Stella's *Voice of the City*, is epic, the poem's visionary passages about Brooklyn Bridge, skyscrapers, electric lights, and street energy seemingly describing Stella's *Voice of the City*. So close are the correspondences that scholars have tried hard to find evidence that Crane was inspired by Stella's work.[97] But there is no need to search for direct influences or empirical data to explain the interfaces between the poem and the painting any more than we should struggle to find concrete linkages between Stella's painting and Strand's and Sheeler's *Manhatta*. These productions were all driven by the same *new* New York discourse, with its highly circumscribed litany of New York sights, sites, and sensations, and its certainty that the modernity of New York was of interest to the entire Western world. Caught up in the mystique of living in a new age, all these artists were also caught up in the dream that the newly formed New York metropolis would give rise to a newly Americanized modern art. They took New York as their subject so that its greatness could be theirs.

THE

ROOTED

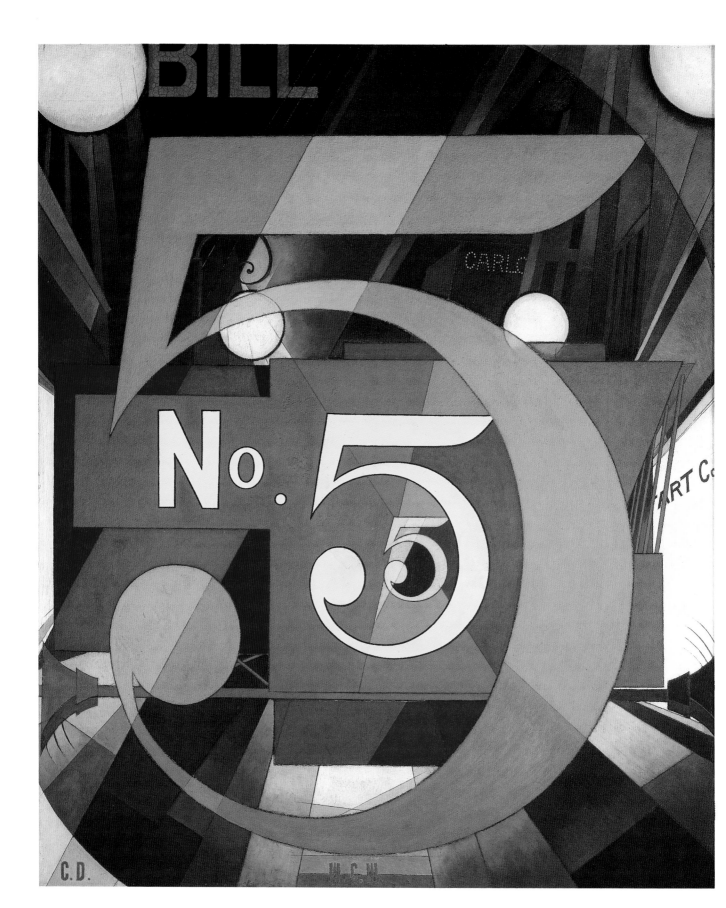

AND THE HOME
OF THE BRAVE

take it from me kiddo

believe me

my country, 'tis of you, land of the Cluett

Shirt Boston Garter and Spearmint

Girl with the Wrigley Eyes (of you

land of the Arrow Ide

and Earl &

Wilson

Collars) of you i

sing

> e. e. cummings, "Poem, or Beauty Hurts
> Mr. Vinal," 1926

But I love Broadway and . . . vulgarity, and gin.
In fact I love my country.

> Charles Demuth, "You Must Come Over," ca. 1921

The internationalism of *américanisme* helps to explain why the paintings Charles Demuth made in Pennsylvania have so much in common with those Gerald Murphy made in Paris.[1] Working on opposite sides of the Atlantic, the two artists had no knowledge of each other. Murphy maintained he did not know any "U.S. painters working in the modern manner."[2] Demuth, whose last trip to Paris was in 1921, before Murphy began to exhibit, never made mention of Murphy. Yet their paintings of the mid to late 1920s today appear so similar that curators place them side by side in exhibitions of Precisionism or machine age art.[3] Because they both used commercial typography in their paintings, drew their subjects from advertising and industry, and worked in Precisionist styles rooted in synthetic cubism, they have repeatedly been depicted as kindred spirits and granted authority as 1920s pioneers of American pop art.

Their similarities give us one more way of indexing the transatlantic character of American modernism after World War I. With the free flow of artists, little magazines, and tourists back and forth across the Atlantic, and the intense focus on modernity American style, artists in Parisian and New York circles could reach similar conclusions on how a new American art ought to look. Indeed, the familial closeness of Murphy's and Demuth's work demonstrates the powerful effect of the postwar mythos about modern America in both Europe and America itself—not only on transatlantics like Joseph Stella and Gerald Murphy, who moved back and forth between continents, but also on American modernists

Previous page: Charles Sheeler, *American Interior*, 1934 (see Fig. 284).

Fig. 169 (facing). Charles Demuth, *The Figure 5 in Gold*, 1928. Oil on composition board, 36 × 29 3/4 in.

who stayed at home, working in and around New York.

But when looked at closely, Demuth's paintings, just like Stella's, emit a tension and complexity we do not find in Murphy's urbane work. Both painters engaged in wit and humor, but in Demuth these characteristics are tinged with irony and inaccessibility; in Murphy they are much less so. And that, we should try to understand. In some ways their differences measure how romantic and fashionably stereotyped America was in Paris and how vexed this enthusiasm became when played out in New York, where artists had to weigh the romance against the reality. In other ways it indexes Demuth's personal circumstances. If Stella was torn between two countries, at home in neither, Demuth was torn between a public and a private self, a public self as an American avant-gardist, a private self as a homosexual artist in a heterosexual art world that from the beginning of his career typecast his work as that of a "delicate." To a degree barely understood to date, Demuth's homosexuality, along with his illness as a diabetic, determined the relationships he would have with other artists and critics as well as the way he would paint. He was one of the most brilliant artists at work during the period; the miracle is that he made so many wonderful works of art with the number of "handicaps" his diabetic body and his sexually prejudiced society imposed on him.

In looking at Demuth in this chapter, and at Georgia O'Keeffe and Charles Sheeler in the next two, we consider American artists who, for a variety of reasons, did not travel abroad in the 1920s and 1930s. They chose to work out of a particular locale in this country. Using one of their own favorite words, I call these artists the rooted to distinguish them from the migratory artists I have considered in the three preceding chapters.

Of the three "rooted" artists, Demuth came closest to being a *transatlantique*. He was a Francophile who had lived in Paris and exhibited there at least once when his work, like Murphy's, was praised by a French critic for its typical Americanness and its "vulgar and unsophisticated charm."[4] Had he not had diabetes—it was diagnosed in 1920—he might well have decided to live in Paris as Murphy did. While he expressed longing to live abroad or visit there more often, he never made the move, traveling for the fourth and last time to France in 1921.

From then until his death at fifty-one, in 1935, he worked out of his family's eighteenth-century townhouse on East King Street in Lancaster, Pennsylvania, where there was little to distract him. He lived with his mother, who cared for him, and exhibited his work in New York, where he had lived earlier—at the Charles Daniel Gallery from 1914 to 1923 and then, from 1925 on, at Alfred Stieglitz's Intimate Gallery and An American Place.

Even when home was Lancaster, Demuth made it a point to keep up with his many friends in New York. "Deem" to his friends, he loved theater as much as art and when vacationing in Provincetown during the war years, began his friendship with Eugene O'Neill. Of those in the second Stieglitz circle, he was closest to O'Keeffe; Marsden Hartley, with whom he may early on have had a brief affair, wrote a memorial to him at his death. William Carlos Williams, the poet, and Henry McBride, the art critic, were very special to him. He was also in close contact with both European and American carriers of *américanisme*, especially through the early twenties. He knew well the Stettheimer sisters, Florine, Carrie, and Ettie, whose parties would bring together the transatlantics, especially Marcel Duchamp, Francis Picabia, and Albert and Juliette Gleizes when they were in New York. Demuth was particularly fond of Duchamp, who encouraged him—as Fernand Léger and Picasso did Murphy—to think of himself as an "American," not just a modern painter. Demuth and Duchamp did the nightspots of New York together and in 1921 made plans to call on Gertrude Stein in Paris; Demuth was one of her admirers (see Fig. 197).[5] Like Murphy, Demuth also had casual contact with figures like Darius Milhaud, Jean Cocteau, and Erik Satie, who were fascinated by Americans and their culture.[6]

Not only does Demuth's art resemble Murphy's, but his persona did as well. Both men fashioned themselves as elegant dandies on the one hand and indulgent consumers of the vulgar and low on the other (Fig. 170). Both were debonair and cosmopolitan—the sort of man featured in *Vanity Fair*—and each prided himself on superior tastefulness, as any reader of their letters will remark. Demuth wrote on soft-colored pastel papers—he liked to "write notes in green ink on pink paper," one friend recalled. Murphy wrote with black crayon on thick-textured rice paper.[7] Both attracted attention for their

fastidious dress. While Murphy dressed as an ultra-modern—white suits and bowler hats—Demuth adopted the tweeds and cane of the 1890s English dandy. Like Aubrey Beardsley, Demuth wore his hair parted down the middle and as his trademark used a walking stick. It was not just for style; Demuth needed it because a childhood injury had left one of his legs shorter than the other. But he used it so elegantly that people rarely noticed his lameness and assumed that he merely affected the cane.[8] In Florine Stettheimer's portrait of Stieglitz surrounded by artists or their attributes, Demuth is figured entering the gallery from the lower left as a hand in a leather glove, a cane, and a leather shoe (Fig. 171).

The two artists took their aesthetic attire into the streets to celebrate the beauty and liveliness of vaudeville, factories, billboards, and hardware stores. But this slumming in natty dress was part of a system of antibourgeois acts in the 1920s. To be an aesthete in dress and carriage—setting oneself off from ordinary and conventional dress—and simultaneously to revel in the low and vulgar arts of the "people" was to perform acts that underlined the stuffy narrowness of bourgeois values and tastes. It was a mix of attributes—one finds it in Duchamp and Florine Stettheimer, among others—that became something of a period style after World War I, replacing the bohemian antidress and casual manners of an earlier moment. Postwar boom and prosperity were writ into the new stylishness, for it took money as well as taste to pull it off with Demuth's and Murphy's aplomb.[9]

Demuth's circle of acquaintances steeped in *américanisme* helped him move toward a mature style that drew from advertising and from industry. Like Murphy, he adapted a late cubist style to the aesthetic of the billboard and the factory. But his "billboard cubism" played differently from Murphy's in Paris. Murphy's paintings, while not taken seriously by his friends in the American expatriate writing community, were lauded by his European friends for their Americanized style and subjects. Demuth's carefully composed paintings of factories, smokestacks, and billboards, in contrast, were met with considerable coolness by an audience made up primarily of his fellow New York modernists. Nowhere was this response more apparent than in the second Stieglitz circle, where Demuth was given

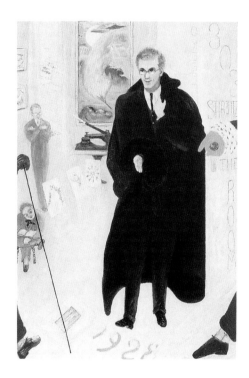

Fig. 170 (top). Photographer unknown, *Charles Demuth*, ca. 1920. From *Look Magazine*, Mar. 28, 1950, p. 52.

Fig. 171 (bottom). Florine Stettheimer, *Portrait of Alfred Stieglitz*, 1928. Oil on canvas, 38 × 25½ in.

Fig. 172. Charles Demuth, *Eggplant and Green Pepper*, 1925. Watercolor and graphite on paper, 18 × 11⅞ in.

affiliate-status, never full membership. Though Demuth and Stieglitz had met by 1914, Stieglitz never showed the artist's work at his gallery 291; in those years Demuth exhibited his watercolors and drawings at the Charles Daniel Gallery, which also supported avant-garde work. Only in 1925 did Stieglitz present Demuth, including him in his *Seven Americans* exhibition; he was X in Stieglitz's formulation of the circle in the exhibition catalogue as "six + X." Thereafter, Stieglitz showed Demuth's work in three one-person exhibitions (1926, 1929, and 1931) and in another after his death (1938). The two men had considerable correspondence, as Stieglitz did with everyone in the circle.[10] In their written exchanges there was always an uneasy dynamic, Demuth seeking confirmation from the older Stieglitz, who acted the part of an encouraging but withholding parent. As I read the letters, Demuth was always X in Stieglitz's mind, the extra member who was more ornament to the second circle than organic to it. X suggests that Demuth was unacknowledged, canceled out. Edmund Wilson, for one, confirmed my suspicions when he wrote in later years that Stieglitz had played too large a part in forming his impressions of Demuth. Stieglitz "played Demuth down," Wilson recalled, and "unduly inflated" the reputation of John Marin.[11] Duchamp concurred: Demuth was "never launched, like some other painters," he said tactfully.[12]

Some of Stieglitz's coolness can be attributed to Demuth's painting "vulgar" subjects that ran entirely against the grain of the rarefied second-circle program. Demuth composed "grotesque and monstrous forms," as Paul Rosenfeld put it in a review, "painted signs, ventilators, fire-escapes, directive arrows, machine-made numerals."[13] Given the circle's faith in an art of soul and spirit, Demuth was a vulgar materialist rather than a transcendent one. Indeed, had Demuth been only an oil painter of industrial scenes and not also a fairly prolific and virtuoso watercolorist of flower and fruit still lifes, it would be hard to imagine Stieglitz caring for his art at all (Fig. 172). For in Stieglitz's mind the watercolors of fruits and vegetables were what aligned Demuth's work most closely to that of O'Keeffe, Arthur Dove, and Marin—these were the works by Demuth that he tried, often successfully, to sell.

Stieglitz's critique of Demuth, however, went

beyond subject matter. He and others in the second circle shared a party line that found Demuth too much the "aesthete," a criticism that asserted the group's masculinist politics in the coded language widely used at the time to identify homosexuals who were flamboyantly mannered. The circle's repeated use of anti-aesthete rhetoric not only served to keep Demuth on the margins of the circle but also damned his art with faint praise, making it clear today why he never earned full membership.[14] Demuth's art, as well as his person, was deemed too pretty, delicate, and feminine. Rosenfeld spoke to the "gemminess" of his oil paintings and his "fastidious, impeccable" surfaces.[15] He found an "almost female refinement" in Demuth's watercolors.[16] Paul Strand criticized Demuth's "delicate niceness," while in the same essay praising the "virility" in Marin's work.[17] "Pretty, pretty, pretty," Strand wrote Stieglitz another time upon seeing Demuth's work.[18] O'Keeffe, more guardedly, found it dispassionate and cool. Seeing it in an exhibition at the Intimate Gallery, she said it was very fine, but she began "to feel that I want to know that the center of the earth is burning—melting hot."[19] Even Hartley, one of Demuth's closest friends who after his death recalled him as "a gay playmate," publicly criticized his paintings for their "perhaps too concrete insistence upon the elements of refinement and grace." He related the art to Demuth's decadence. Remembering him as a Huysmanian character, he wrote that "Charles had a flair for the frivolities, but they had to be of elegant tone, a little precious in their import, swift in their results."[20]

This coming from another homosexual suggests the wider politics that had homosexual men joining straight males in lobbying against effeminacy as a style. As George Chauncey has pointed out, there was public and private resentment and fear of "excessively" effeminate homosexuals—those called fairies, faggots, swishes, or "extreme homosexuals" in the postwar period, just as there was a campaign to revitalize art and cleanse it of the *fin-de-siècle* blurring of sexual lines between men and women.[21] Hartley, in his final "tribute" to Demuth, expressed something of his ongoing war with his own homosexuality while restating the second circle's views on Demuth's work, perhaps even seeking Stieglitz's approval. "If many of his pictures were frail in substance they were true in import, essentially decorative, fastidious in line, harmonious, possibly to excess."[22]

In one instance, Hartley and Demuth were joined in their homosexuality. In his play *Strange Interlude* Eugene O'Neill created an exceedingly dandified gay man whom he called Charles Marsden, taking both Demuth's and Hartley's first names. Marsden is one of the play's central characters, and his dialogue and psychological reactions are predicated upon the audience's recognizing that he is homosexual, of an effeminate type. Called Charlie throughout the play, the character clearly matched Demuth in dress and body type, not Hartley. In his first entrance, O'Neill describes his looks and charm in such complete detail that anyone who knew Demuth would have recognized the paired identity. In every subsequent appearance his clothing is described as carefully considered, immaculate, dark, and English made: "He is a tall thin man of thirty-five, meticulously well-dressed in tweeds of distinctly English tailoring. . . . There is an indefinable feminine quality about him, but it is nothing apparent in either appearance or act. His manner is cool and poised. . . . He has long fragile hands, and the stoop to his shoulders of a man weak muscularly, who has never liked athletics and has always been regarded as of delicate constitution."[23] Charlie lives with his mother, as Demuth did, and when she dies during the course of the play, he grieves excessively. At the end of the play, as a much older and grayed man, he agrees to marry Nina Leeds, the lead character, whose many tortured love affairs Charlie has always helped her surmount. Nina gets a man who has always been paternally kind to her but will not trouble her sexually; and Charlie, who feels desperately alone, gets a female companion to take the place of his mother and sister, who have both died during the play.

Demuth continued to be represented as effeminate and delicate long after his death. When Jerome Mellquist published *The Emergence of an American Art* in 1942, a book so thoroughly conforming to Stieglitz's views that the master himself might have dictated it, the five pages devoted to Demuth compliment as well as typecast him as a defective man. Introducing the artist as "one of the 'delicates' of American art," Mellquist went on to talk first about Demuth's body as "delicate" and frail from illness.

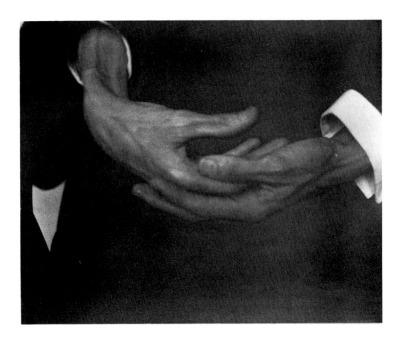

Fig. 173. Alfred Stieglitz, *Charles Demuth's Hands*, 1923.
Platinum or palladium print, 7⅝ × 9½ in.

And then, as if it followed that one's body type determines one's painting style, Mellquist spoke of how much "delicacy prevailed" in all of Demuth's art. "His art, fragile as it is, and special though it may be, was a victory over the circumstances which hedged him in. He triumphed by elegance."[24] In 1950 Andrew C. Richie, the curator for the artist's retrospective exhibition at the Museum of Modern Art, drafted a press release for a Demuth exhibition at the Downtown Gallery, using the same coded language. Demuth was "an esthete," a man of "exquisite tastes" and "delicacy of perception," who painted with "elegant affection."[25]

On one level this vocabulary of elegance, frailty, and fastidiousness described Demuth's sick body and dandified affectations. His art was an "equivalent" of his body type and dress style. On another, it clearly separated out Demuth from the other artists in the circle, especially Dove and Marin, whose masculinity was never questioned. Dove, for Mellquist, was "the celebrator of the soil" and Marin "the master of equilibrium."[26] In Demuth's case, second-circle critics withheld their highest encomiums and used rhetoric that maintained different spheres for

males and females, the virile and the weak. They allied dandified homosexuals with the weak. Although they liked Demuth's art well enough to include him in their discussions, they placed him differently from other men in the circle, giving him a space not far from the one they gave O'Keeffe, a decentered position that maintained and asserted sexual differences. The feminine, whether in men or women, was a separate sphere in second-circle dynamics.

This feminizing of Demuth shows itself most vividly in the photograph that Stieglitz took of Demuth's hands—long, effeminate, sinuous, decorative (Fig. 173). At the time, Demuth's hands were also very thin because the artist's doctors had put him on an extreme diet.[27] Stieglitz did not make similar body photographs of Marin or Dove, Rosenfeld or Waldo Frank, but he did of O'Keeffe, whose hands, breasts, and torso he cropped from her whole person just as he isolated Demuth's hands (see Chapter 5). As O'Keeffe in these photographs of the early 1920s was the complete woman, Demuth was the feminized male. While it is not clear to me exactly when this attribute of isolated or exaggerated hands as a sign for homosexuality first circulated in art and

literature, its frequent use to identify homosexual male artists, especially dandified ones, suggests that by at least 1915 it had become an agreed-upon iconography in modernist circles. Stieglitz certainly did not make it up; he followed suit.[28] Preston Dickinson, a homosexual himself, in drawing Demuth well before his diabetes surfaced, posed him so that his hands were large and prominent, with absurdly long fingers (Fig. 174); a caricature of Hartley does the same with his hands (Fig. 175). Man Ray also photographed Demuth's hands (Fig. 176) as well as those of Jean Cocteau, a French homosexual whose fingers were repeatedly highlighted and dramatized. Hartley found Demuth's hands not only sensitive but patrician, "the fingers long and slender."[29] Stettheimer gave the bisexual writer Carl Van Vechten exaggeratedly long fingers and crossed hands in her painted portrait of him (Fig. 177)—that she did the same in her portrait of Duchamp, a consummate lover of women, shows how intertwined the vocabulary of the homosexual dandy was with that of the heterosexual one (Fig. 178). Duchamp's hands are not as grotesquely attenuated as Van Vechten's, and his legs are loosely rather than tightly crossed—but there is a kinship between his svelte body and that of his female alter ego, Rrose Sélavy, whose heart-shaped form rides the disk that he manipulates.

In modernist literature too, long-fingered hands signify homosexuality. Charles Marsden's hands, we remember, were long and fragile. In Sherwood Anderson's story "Hands," the protagonist has "nervous expressive fingers, flashing in and out of the light." The author never uses the word homosexual to describe Wing Biddlebaum, letting his hands and excessive love of literature serve as the signifiers. Biddlebaum is a sensitive soul, a poet type, whom no one in Winesburg, Ohio, really knows. He is a mysterious villager who is always hiding his hands in his pockets. By the end of the tale we learn that he had once been a schoolteacher in Philadelphia, accused there by a "half-witted boy" of having molested him and other students. Run out of town, he had to take another name and live as an isolate. His hands are his demons, and when he forgets one night and uses them to caress a young man, he panics and runs home, remembering the saloonkeeper's taunt: "Keep your hands to yourself."[30]

These are complex representations that at once crudely stereotype homosexuals and give them an

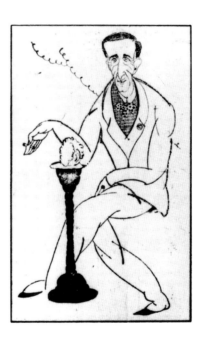

Fig. 174 (top). Preston Dickinson, *Café Scene* (Portrait of Charles Demuth), ca. 1912–14. Charcoal and black chalk on tan wove paper, 18 × 13¾ in.

Fig. 175 (bottom). Djuna Barnes, *Marsden Hartley*, center section from *Three American Literary Expatriates in Paris (Mina Loy, Marsden Hartley, and Gertrude Stein)*. Cartoon drawing from the *New York Tribune*, Nov. 4, 1923.

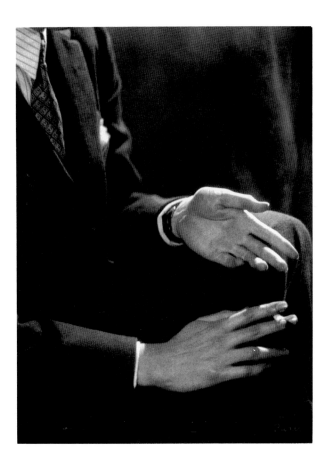

Fig. 176. Man Ray, *Demuth's Hands*.
Gelatin silver print, 9⅛ × 6¾ in.

identity, personalizing their sexual preference. And the artist did not resist. Demuth must have agreed to have his hands photographed—just as O'Keeffe agreed to having her breasts and torso abstracted. Perhaps because of such typecasting, or because he had internalized the art world's positioning of him, Demuth was more comfortable with the women in the circle than with the men. When he made a portrait of Dove, he dedicated it, not to him, but to Helen Torr, Dove's lover. "For Helen with love from Demuth," he wrote on the back (see Fig. 207).[31] He wrote essays about O'Keeffe and about Stettheimer when few other artists did, and when he died, he had named O'Keeffe in his will—not Stieglitz—the beneficiary of all his oil paintings.

But even O'Keeffe, who once told me she liked Demuth best of all the artists around Stieglitz, judged harshly the "vulgarity" of his oils. Explaining why Demuth had sold so few of them in his lifetime, she said that people were interested in him as a "flower painter," not as a painter of industrial scenes or as a poster portraitist—painter of a series of portraits based on a billboard aesthetic.[32] And though she made gifts of some of his oil paintings to major museums, she gave four of what I deem his most daring and experimental paintings—all portrait posters—along with Stieglitz's papers, to the Beinecke Rare Book and Manuscript Library at Yale University. Her second-circle blinders did not let her see the art in them, and she gave them to the library as documents and memorabilia instead of placing them in museums where they more properly belong. Mellquist, always a good guide to second-circle thinking, found these portraits strange, "unlike anything of the kind in America." He noted that "these polished, stylized tributes of Demuth still seem to puzzle some of our critics," himself included.[33] In the 1950 retrospective of Demuth's work at the Museum of Modern Art, the portrait posters were barely mentioned in the catalogue, and only the ones of William Carlos Williams and Eugene O'Neill (see Figs. 169, 198) were exhibited.[34]

It is these portrait posters, as Demuth called them, that are stylistically akin to Murphy's billboard cubist work in Paris and throw into relief Demuth's independent angle of vision in the Stieglitz circle after World War I. And as I suggest at the end of the chapter, they highlight the artist's deep-seated desire for inclusion in the second circle and

for reciprocal love and affection. Yet as much as De-
muth wanted to earn Stieglitz's approval, he could
never subscribe fully to the master's soil-and-spirit
program for a new American art. Like Duchamp,
Robert Coady, and others, Demuth found his Amer-
ica in the grit and rawness of popular street culture
that the Stieglitz circle thought crass and vulgar.
He expressed his differences in many ways, but
none more determined than his portraits cele-
brating the very artists of the circle he wanted to
join while refusing to conform to their expectations,
sexual as well as artistic. Demuth's portraits poi-
gnantly encode his separateness. By making beau-
tiful what these artists generally found repulsive,
Demuth conducted his own private campaign for
acceptance of who he was.

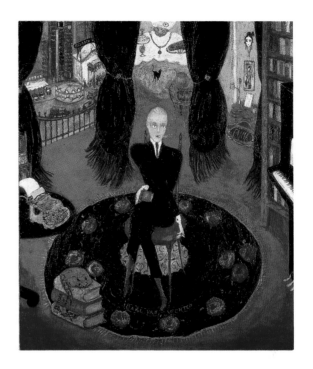

The Figure 5 in Gold, thirty-six inches high and
thirty inches wide, hangs today, thanks to a gift by
O'Keeffe, in the permanent collection of the Metro-
politan Museum of Art (see Fig. 169). This is one of
the portrait posters she admired enough to place in
a museum. The viewer who knows nothing about
this painting and looks at it first from across the
room sees a single number—not a handwritten num-
ber, but the kind of five that appears on commercial
signs. The number is big, gilded, and unmistakable.
At closer range, however, smaller details appear
that signal a city street scene at night, a nocturne of
high-rise buildings, lighted signs, streetlights, and a
background palette of grays, blacks, and whites.

Although it is widely known today that this city
nocturne is a portrait of, and pays homage to, the
poet William Carlos Williams, it takes special learn-
ing to read this cubist street scene as a portrait. Its
intimate set of references, known only to those privy
to details of Williams's life and poetry, is part of my
considerations. Much of this painting's intelligence
hides itself from all but the initiated. Demuth's por-
trait posters generally take work to decipher; some
of them completely resist the process.

In the eyes of many during the period, Williams
was to poetry what Stieglitz was to the visual arts,
a major activist for an indigenous art (Fig. 179).
Williams made his living as a family doctor, but his
true vocation was that of a modern poet. He and
Demuth had long been good friends, having first
met as students in Philadelphia over "a dish of

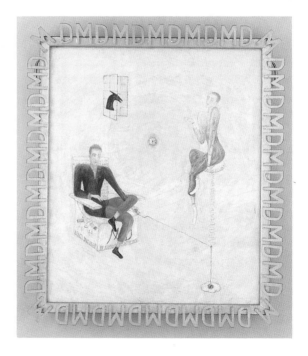

Fig. 177 (top). Florine Stettheimer, *Carl Van Vechten,*
1922. Oil on canvas, 30 × 22 in.

Fig. 178 (bottom). Florine Stettheimer, *Portrait of
Duchamp,* 1923. Oil on canvas, 30 × 26 in.

prunes" at Mrs. Chain's boardinghouse.[35] Their friendship deepened over the years as each became convinced that the American avant-garde had to de-Europeanize its aesthetic by taking its material from the local and everyday. It was their shared artistic interests that sustained their close relationship. Medicine also brought them together. In the early 1920s when Demuth's diabetes was diagnosed and treated (he nearly died before becoming one of the first patients to experiment with insulin), Williams visited at his bedside and took an active interest in his well-being.[36]

The two men's sense of shared mission and fondness came out in their frequent tributes to each other. Demuth wrote a dedication on his painting *Machinery* to Williams, and three years later, in 1923, Williams dedicated his new book, *Spring and All*, to Demuth. In two instances Williams wrote poems about specific paintings by Demuth.[37] And then in 1928 came the greatest tribute of all, Demuth's *Figure 5 in Gold*, a painting replete with sweet and loving tributes to their friendship.

Demuth called this work a portrait poster or, alternatively, a poster.[38] The word "poster" was commonly used in the 1920s to describe an advertising sign or billboard. Demuth, like Duchamp when he named his objects "readymades," called his paintings "posters" to link them with everyday street culture and give them low-life connotations. He called them "portraits" in conformity with the new genre of nonmimetic portrayals that had developed in literary and artistic modernism before 1920. Rather than depict the features of its subject, this new portraiture deployed objects, words, or letters in a pictorial arrangement that did not describe but indirectly symbolized or referenced the subject. Gertrude Stein, among others, had helped establish the new genre by publishing what she called word-portraits, abstract verbal tributes to her friends in avant-garde circles. Simultaneously, Marius de Zayas was publishing and exhibiting his abstract caricatures, and Picabia his machine portraits, all of which established something of a fashion for a new kind of oblique, coded, and intensely modern form of

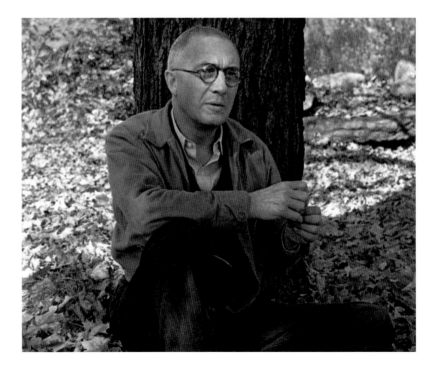

Fig. 179. Charles Sheeler, *William Carlos Williams*, 1938. Photograph, 7 × 8½ in.

portraiture (see Figs. 8, 45). Dove made portrait-assemblages, and O'Keeffe and Stieglitz tried their hand at very abstract ones, based on nature but titled as a portrait of a friend or of each other.[39]

In art history the form is known as symbolic portraiture, a somewhat awkward term for portraits that are rarely symbolic in a traditional way. Symbols are surrogate images for qualities or abstract thoughts that people in a common culture understand and agree upon. During the Renaissance, a lily symbolized purity and virginity, and a dog symbolized faithfulness. But in this twentieth-century portrait system, a lily has no fixed meanings, taking on different meanings that depend on context. A lily may allude to purity, theatricality, or nature. Or if the portrait is of Oscar Wilde or another homosexual—as in Demuth's poster of Bert Savoy, a famous female impersonator who acted in New York vaudeville—it becomes a trope of femininity and homosexuality (see Fig. 203). Two pieces of fruit huddled together might refer to human intimacy or marriage—or a camera with distended bellows to Stieglitz, the phallic king of photographers (see Figs. 206, 8). "Referential portraiture," my own term for this genre, allows for multiple and often free-floating meanings, which interpreters privy to the sitter's character and to the workings of the avant-garde and other subcultures, such as that of the homosexual community, may be able to read. Since the references are often very private, or intentionally elusive, they can escape detection and decoding.

Between 1923 and 1929 Demuth completed at least eight referential portraits of this new type—of William Carlos Williams, Gertrude Stein, Eugene O'Neill, Charles Duncan, Bert Savoy, Georgia O'Keeffe, Arthur Dove, and John Marin (see Figs. 169, 197, 198, 201, 203, 204, 207, and 208)—and gave thought to at least three others, representing Hartley (see Fig. 202), Wallace Stevens, and Duchamp.[40] Had his health been better, and had the series been received more enthusiastically, he would probably have finished more of them. None sold in his lifetime. Significantly, he never designed, or spoke of any intentions to paint, one of Stieglitz, or Rosenfeld, or Strand, his harshest critics.

Whatever their exact number, these portraits possessed Demuth for at least five years and constitute a thematic series. While he continued to create fruit and flower watercolors during this period, he dedicated precious little time to any other major oil paintings, save for *My Egypt* (see Fig. 192). The portrait posters, in other words, were a major undertaking, one that Demuth took seriously, dedicating to it a large period of time during the decade of his greatest productivity. Like the ambition that drove Joseph Stella to put two or three years of work into *The Voice of the City* and Rosenfeld to put together the set of portraits in *Port of New York*, Demuth felt the drive to make a lasting serial work, one that demonstrated his affection for his fellow artists and proclaimed America's greatness in the arts. This is boosterism of the first order, but one marked by uncommon intimacy. Only those portraits by women, Gertrude Stein's word-portraits and Stettheimer's paintings of friends and family, are as personal as Demuth's, focusing as they do on friendships and interpersonal relationships.

What is not always appreciated now, and certainly was not then, is the rigorous thought that went into each of these compositions, not to mention their bold and experimental form. Demuth painted each of them on board, rather than canvas, rendering them more like billboards. And while he used oil paints for his William Carlos Williams poster, he worked with poster paints on others. There is nothing spontaneous or whimsical about the works in this series. On the contrary, they are highly planned paintings, every detail in them designed to convey meaning—often veiled meanings so particular that we cannot decipher them with any certainty. A few are hermetically coded, an abstruseness, unusual in referential portraiture, that ultimately makes Demuth's portraits more private and autobiographical than most.

This is less the case with the Williams portrait than with others, however, because it has been known from the beginning that Demuth based it on a short Objectivist poem Williams published in *Sour Grapes* (1921). Called "The Great Figure," the poem is minimal and not difficult to grasp. It narrates, in a clipped list of words and short phrases, an intense sensory experience Williams had one "hot July day" while walking to Hartley's New York studio on West Fifteenth Street. As he tells us in his autobiography, he suddenly heard "a great clatter of bells and the roar of a fire engine passing the end of the street down Ninth Avenue." He turned to look behind him "just in time to see a golden figure 5 on

a red background flash by. The impression was so sudden and forceful that I took a piece of paper out of my pocket and wrote a short poem about it."[41] In its final edited state the poem reads:

> Among the rain
> and lights
> I saw the figure 5
> in gold
> on a red
> firetruck
> moving
> tense
> unheeded
> to gong clangs
> siren howls
> and wheels rumbling
> through the dark city.[42]

Written during a period when Williams was trying to rid his poetry of symbolic imagery and overly metaphoric language, the poem is spare, only one sentence long, and delivered on the vertical, evoking a tall city building. Each line, one to five words long, describes with precision and concreteness a single thing, sensation, or sound that speeds by the reader just as the fire engine sped past the poet. Though the poem is short, it gives us a good deal of specific information: we know that the event happened when it was raining and the street lights were on; that the poet saw a gold figure five on a red fire truck that was moving fast, "unheeded" by others, its gong clanging, siren howling, and wheels rumbling—all in a city at night.

Demuth is remarkably attentive to the raw data of Williams's poem. Working in a cubo-futurist style that typically assigns more than one meaning to a formal element, the painter found a way to convey every line of Williams's spare but rich sentence. The mise-en-scène of the painting, like that of the poem, is a city street; tall buildings rise up on each side of the canvas. It is nighttime: the skies are black, the windows dark, and the streetlights illuminated. The black rays that cascade from the top of the painting into the street below tell us it is raining. Three of them, those that cut past the second L in the word BILL, are thin yellow incisions in the surface paint, suggesting raindrops reflecting the city's lights. In the lower third of the painting, white and gray wedges seen against

Fig. 180. Street lamp, New York, 1938.

Fig. 181. Stutz hose wagon, 1924.

adjacent blocks of black refer to the wet and pud-
dled street pavement reflecting the night lights.
The light comes specifically from two sources: the
lighted windows of ground-floor shops right and
left, and the streetlights represented by the four
white globes, their design based on that of lamps
found in Manhattan in the 1920s (Fig. 180). Speak-
ing in cubist double entendre, the globes are also,
as one scholar has rightly observed, the round
and very prominent headlights of a 1920s fire
engine.[43]

The red engine itself is highly abstracted in the
painting and described in cubist forms. But it is not
entirely fanciful. We can identify in it features of
the 1920s fire truck (Fig. 181). The engine's ladder,
which traditionally hangs along the side of the ve-
hicle, can be deciphered in the dramatically fore-
shortened set of slanted verticals on the right side
of the truck. And Demuth creatively synopsized
the axle and wheels of the truck in a taut red bar
that stretches across the bottom of the picture and
braces against the outside edges.

As in the poem, the fire engine is moving, the
movement conveyed by several visual devices that
make the red abstraction optically recede and then
bounce back to the surface. The diminishing scale
of the repeated fives and the futurist rays, much like
a zoom lens, push and pull our eyes in and out of the
center of the painting. The smallest of the fives is
also the brightest yellow of them all, and it rests
against a wedge of bright pink. The combination
makes for a hot spot of color that seems to pulsate
and vibrate, a point of visual energy at the heart
of the engine. Another kind of movement can be
read in the little flourishes that come off the wheel
drums, cartoon language for circular rotation. Synes-
thetically, these lines also convey the noise of the
"wheels rumbling," "gong clangs," and "siren howls"
of Williams's poem. Indeed, the conical forms at the
end of the "axle" refer not just to wheels, but also to
the shape of fire engine gongs and sirens. There is
synesthetic sound too, in the elegant tails of the
fives, which hang in the air like grace notes on a
musical scale.

In sum, Demuth's painting gives us the same tex-
tual ingredients as Williams's poem and interprets
the same heightened sensory experience, that of
seeing, for one split second, a gold five pop off the
side of a speeding fire engine and hang suspended
against the nighttime sky.

Fig. 182. Berenice Abbott, *Zito's Bakery*, 1937.
Gelatin silver print.

In some elements, however, Demuth's painting significantly departs from Williams's poem. Both men were concerned with modern form, and the poem is machine age clean in its forms, its streamlined verticality having something in it of the skyscraper and of vertical signage, both of which Williams evoked in other poems (see p. 212).[44] The visual field of *The Figure 5 in Gold*, however, is more energetic and unstable than the taut, ruler-sharp picture drawn by the poem. What is compact and compressed in Williams's poem is more theatrical and explosive in Demuth's work. While Williams's poem, one can say, is cubist in its irregular line breaks, and in the way that each line adds yet another piece of information about the key event, Demuth's aesthetic is more futurist, his compositional lines and echoing fives forcing the eye to move rapidly in and out of the painting. But perhaps the most notable difference between the poem and the painting is the prominent role Demuth assigned to language. While the poem never takes us on side trips, the painting teases us away from the main event with partial words, letters, and numbers that beg to be read and deciphered. Furthermore, all of these numbers and words are in typefaces common to public and commercial signage. In three instances, the words are represented as city signs: a billboard or sky sign, a theater marquee, and signage on a shop window.

Let us look first at the number five identifying the fire engine, the subject of Williams's poem. In the poem the five is mentioned just once, as the object

of the sentence "I saw the figure 5 in gold," and it is referred to obliquely in the poem's title, "The Great Figure." In the painting the figure five appears, not once, but four times, changing in scale each time. The fourth and largest five is nearly out of sight, being larger than the picture frame. We see only a fraction of its body in the upper right corner, and we glimpse its tail at the bottom of the lighted window in the lower left.

We also recognize that this number is very close in graphic style to those used on commercial signage, as well as on fire trucks (Fig. 182). While such numbers had the precision of stencils, they were commonly done freehand early in the century by professional sign painters. Demuth's fives were a refined variant of commercial script in that he rendered the body of his number bulbous and sensuous and gave the corners the precision of pinpoints. While commercial in character, Demuth's fives were elegantly designed.

The other words in the painting are in sans serif type, the new, blocky machine age typeface pioneered by the designers at the Bauhaus who revolutionized typographical design in the 1920s. For the audience of Demuth's day, sans serif letters like those used for "Bill" in the upper left—uniformly wide letters flattened at the bottom—would have signified contemporaneity, for this was the most up-to-date style of graphic design. And to put "Bill" high against the night sky, so high that the frame cuts across the word, was to put the artist's name in a new and popular form of billboard, a "sky sign" on the top of a building (Fig. 183). The word itself, "bill," was Williams's nickname but also a wonderful pun, the word being a synonym for *poster* (as in "Post No Bills"). Demuth put Williams's Spanish middle name— Carlos—in tiny theater lights, making the poet into a Broadway star. This was the name Demuth liked to call Williams—he was the only one who did so—its foreign roll off the tongue in keeping with his other dandified gestures.[45] That both names are so prominent—and so personal—undermines the surface coolness of the painting and to the knowing viewer conveys an intimacy, real or desired, that is always very close to the surface of Demuth's posters.

Demuth's other tender tribute to Williams is in the signage on the lighted window of the shop in the lower right: "Art Co." During the postwar period, as

Fig. 183. Filling station, New York, 1923.

corporate business practices accelerated, abbreviations such as Inc. and Co. increasingly dominated everyday culture and were the butt of humor in avant-garde circles, especially those of a dadaist bent. These words were new and alien—like porcelain urinals—and, like the urinal, modern in the extreme. So they lent themselves to parody. Artists used such business-speak to proclaim themselves completely of their times and, simultaneously, to distance themselves from the corporate mentality. Marcel Duchamp used Société Anonyme (the French term for "corporation") as a name for the group of artists that gathered around Katherine Dreier, and dadaists in France made bad puns with business slogans: for example, "Subscribe to Dada: The Only Loan That Brings No Return."[46] Demuth's "Art Co." cloaked his affection for Williams in an impersonal public language. He and Williams were an Art Company of two, but they were also both a part of a bigger "company," one made up of all their artist friends who joined in the effort to create a new American art.

There is yet another linguistic turn in Demuth's painting—the inclusion of a fragment of a letter before the word "art." Given the cross bar, this would seem to be the letter *T*, which would turn "Art Co."

into "Tart Co." Like his friends Duchamp and Picabia, Demuth could be a sexual punster; "Tart Co." could allude to the prostitutes who frequented New York's streets, particularly Broadway, to which this picture makes so many references.[47] (*F* is another possibility but not Demuth's style of humor.)

Even the artist's signature appears in the language of commercial signs. Using sans serif letters that appear mechanically printed rather than hand done, Demuth put his own initials, C.D., in the lower left. In the center, under the fives, are those of the poet, W.C.W., acknowledging Williams as the writer of the poem, as the initials in the corner commemorate the artist as the maker of the picture.

The ultimate form of signage in *The Figure 5 in Gold*, however, is the whole painting read as a poster or billboard advertisement for William Carlos Williams, the Great Figure of American Poetry. The designs of street advertisements were becoming increasingly modern and abstract in the 1920s, and the distance between the aesthetics of Demuth's work and that of posters hanging in the New York subway was a narrow one (Fig. 184). Street bills were flatter in design, without Demuth's cubist stylizations, and less coded with multiple meanings,

Fig. 184. Subway station, New York, 1925.

but like the painting, they adhered to the principles
espoused by postwar commercial designers: to be
"clean as a hound's tooth, simple as a kindergarten
exercise, insistent for attention, legible in the high-
est degree."[48] With its two-foot-tall five and its
clean-as-a-hound's-tooth design, it would have ap-
peared unmistakably posterlike to its contemporary
viewers, even if Demuth had not called his work a
poster. While scholars commonly refer to Demuth's
style of painting as futurist or cubist-realist, this and
the other poster portraits were painted in what I
have been calling billboard cubism, a style that in
this case brings together cubo-futurist composi-
tional devices and the bluntness, scale, modern ty-
pography, and legibility of 1920s posters and bill-
boards. Billboard cubism self-consciously fused the
high principles of modernism with the lowbrow prac-
tices of street signage.

 Demuth was hardly alone in his appropriations.
As we have seen in reading Murphy's paintings,
European modernist circles showed keen interest
in billboard aesthetics. In Paris, where Murphy de-
veloped his taste for the "artfulness" of ads and bill-
boards, artists like Léger, Robert Delaunay, Picabia,
and Duchamp, to name only the most obvious, and
writers such as Guillaume Apollinaire, Blaise Cen-
drars, and Philippe Soupault developed an affection-
ate and indulgent attitude toward advertising as a
language uniquely of their times. But there was an
important difference between the billboard dis-
course as it developed in Parisian and New York
avant-garde circles. French avant-gardists generally
considered billboards just one element of modern
life, one part of a much larger canon of newness that
set off the twentieth century from previous eras. In
his painting *Cardiff Team*, Delaunay put billboards
alongside the Eiffel Tower, the biplane, the giant
Ferris wheel on the Champ-de-Mars, and a rugby
game, all of them collectively signifying the new age
(see Fig. 38). Similarly, Léger peppered *La Ville*
with numbers, letters, and stylized figures drawn
from public advertising; his billboard references in
this work share space with derricks, subway stair-
cases, and a density of buildings that define the
modern metropolis (see Fig. 113).[49]

 For the New York avant-garde, billboards also sig-
nified the modern—American-style modern. Since
it was generally acknowledged that Americans were
more practiced, successful, and entrepreneurial in

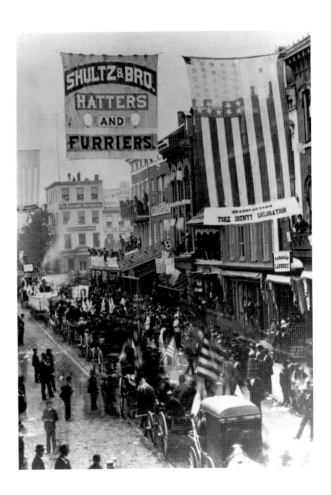

Fig. 185. Penn Square and North Queen Street,
Lancaster, Pennsylvania. Parade in 1880 for the
Garfield-Arthur ticket.

their advertising techniques than Europeans, artists could envision the billboard as a native language, the peculiar dialect, one might say, of the intensely consumer-oriented world in which they lived. They could argue that the language of signs—numbers, slogans, hype, easy legibility—was the mother tongue of the business-minded, word-oriented, hard-selling culture that was Calvin Coolidge's America. For a short while in the 1920s, not only Demuth but a much wider circle of American avantgarde writers and artists became students of, and apologists for, the billboard and advertising arts, seeing in them, as in the skyscraper, jazz, and Broadway lights, a national expression.

Fig. 186 (top). Alice Austen, *Ragpickers and Handcarts, West Twenty-third Street and Third Avenue*, ca. 1896.

Fig. 187 (bottom). Billboards on Market Street, San Francisco, 1924.

Born in 1883, Demuth, like Duchamp, Murphy, and Stella, came of age with the modern billboard and electric sign. As he and his generation grew up, their cities left the horse-and-buggy age for that of the automobile; and signs and billboards not only spread through cities but also moved out into the countryside.[50] By the 1920s outdoor advertising was one of America's boom industries, taking on its modern configuration and securing a place in the American landscape and daily experience that we take for granted today.[51]

By no means, however, was advertising signage a new phenomenon. Early in the nineteenth century, cities like New York and Lancaster, Pennsylvania, developed a tradition of painting signs on buildings to hawk wares, trades, and business concerns (Fig. 185). By Demuth's time painted signs had been augmented by bills, or posters, those large paper advertisements made up of calligraphic flourishes and riotous colors that were glued by billposters to the sides of buildings and to empty walls (Fig. 186). Commonly these posters would be displayed "salon style," stacked one above the other, occasionally in multiples—three of the same poster in a row—for an eye-catching effect.

When Demuth was in his mid-twenties, however, store signage and the turn-of-the-century poster began to look old-fashioned and messy as advertisers developed simpler and more emphatic designs and began to think big, creating huge signs that could be attached to the sides or tops of buildings and alongside roadways on commercially manufactured billboards. These new forms of signage seemed formal

Fig. 188. Howard Thain, *The Great White Way—*
Times Square, New York, ca. 1925. Oil on canvas,
30 × 36 in.

and permanent in comparison with earlier posters, which had been slapped up on a preexisting wall (Fig. 187). The billboard was almost a piece of architecture, typically a separate structure, with its own frame and lighting system. The signs that went onto billboards were also larger, stylized, and eye-catching. Given the postwar fashion for modern design emphasizing clarity, simplicity, and quick-hitting messages, the new billboard advertisements were more or less reduced to three essential ingredients: a brand name, a distinctive logo or product design, and a short and snappy slogan (such as "They Satisfy," "Keep That Schoolgirl Complexion," "After Every Meal"), all rendered large and legible. While the turn-of-the-century poster had been pitched to the strolling pedestrian, who could take the time to stop and read its detailed message, the modern billboard was intended for the citizen at the wheel,

accustomed to taking in information, like the headlines on tabloids, quickly and at a distance.

Along with the billboard came the proliferation of electric signs, especially those of the Great White Way. Demuth knew well the competitive spirit among artists and writers trying to capture Broadway and talked of trying to paint a great New York picture. Though he never credited *The Figure 5 in Gold* with achieving this goal, it is really the closest he ever came.[52] For it is something of a Broadway picture, comparable in its details of streetlights, signs, and coloration to Howard Thain's much more realist Times Square painting of the same moment (Fig. 188). But unlike Thain, Demuth joined Murphy and Stella in not wanting to record an American scene so much as to invent a visual poetics based on the language of billboards and electric signs. In this, he was also in company with John Dos Passos, who

experimented with a new prose style, appropriating the form (not just the content) of advertising rhetoric as well as that of radio, films, and tabloid newspapers.[53] The vernacularity and silly jingles of specific American ads also showed up in poems by e. e. cummings (see, for example, the epigraph to this chapter) and a host of other American poets of the day. Williams too experimented with putting slogans and graphics from ads into his poetry, and in a poem like "The Attic Which Is Desire" used something of the clean and clipped language of the adman's sloganeering. The poem describes the vertical sign advertising soda, "ringed with / running lights" and, in the typography of the printed poem, surrounded by asterisks:[54]

```
        °   °   °
      °   S   °
      °   O   °
      °   D   °
      °   A   °
        °   °   °
```

But probably the best-known instance of billboard rhetoric in 1920s literature was the haunting roadside sign for the eye doctor T. J. Eckleburg in F. Scott Fitzgerald's *The Great Gatsby* (1925). Stark and emphatic, as roadside advertisements had become by the 1920s—no more than a pair of gigantic blue eyes looking through yellow eyeglasses and the name Doctor T. J. Eckleburg—Fitzgerald's fading billboard plays a pivotal role in this famous story of postwar wealth and ennui. Placed in a bleak and tawdry landscape, where death and tragedy eventually occur, the unblinking yard-high retinas became Fitzgerald's emblematic portrait of a modern god and of America. They stare but never respond.

Unlike Demuth's vibrant signage, Fitzgerald's billboard is peeling and ugly. Demuth explored the language of signs for its potential poetry, while Fitzgerald used the billboard as sorrowful commentary on the culture that put it there. Yet in both texts there are underlying tensions: Demuth's playfulness with words mocks his own seriousness in trying to create a billboard aesthetic, while Fitzgerald's huge roadside eyes mesmerize as well as repel us. Most avant-garde appropriations of commercial signs in the 1920s similarly encoded a love-hate relationship between the artist and the newly commercialized American landscape, an unresolvable tension in appropriating—and making art from—the crass new

business environment. For even though postwar writers and artists were convinced that there was a usable American language in billboards and advertisements, they were anxious and uncertain, sometimes downright confused, about what it said of postwar American life. If the language of advertising constituted their country's new vernacular, what did this imply about the state of American culture? It was the question that all their work posed. Did billboards signify T. S. Eliot's cultural wasteland of hollow materialism, or were they inventions of an enterprising and ultramodern culture where youth and genius flourished?

For many commentators in the early twentieth century, including artists in the Stieglitz circles, billboards were unquestionably the enemy of art. A 1901 allegorical cartoon entitled "The Progress of Art" stated the case succinctly: billboards, skyscrapers, and moneymaking obstructed the course of the artist, pictured as a female allegorical figure trying to pick her way from skyscraper to skyscraper with the artist's maulstick as her cane (Fig. 189). At about the same time, the New York critic Sadakichi Hartmann, who always voiced pungent views on aesthetic matters, looked out over the East River at twilight and thrilled to the twinkle of city lights that were beginning to come on, only to be offended on discovering an electrified brand name. Just as "you feel that the City of The Sea has put on her diamonds—then you notice the words 'Uneeda Cracker.'"[55] Later, articles in art magazines—"The Bill Board Menace" or "The Billboard Blight in Our Country"—repeatedly condemned outdoor signs for their "loud color, their ugly vulgarity."[56] From the perspective of artists wedded to symbolist aesthetics, there was an inexorable logic: one could not expect to educate people in the appreciation of finer things when their everyday environment was so ugly, commercial, and base. It was a logic, we have seen, that Stieglitz and those in his postwar circle—Paul Rosenfeld and Waldo Frank, included—heartily endorsed. The only major work with a sign in it by a second-circle artist was O'Keeffe's *Radiator Building*, which assumes the viewer will see her irony in putting Stieglitz's name in neon lights (see Fig. 11).

Demuth was, without question, the New York artist who most aggressively pursued a billboard aesthetic, bringing a perspective into the second circle

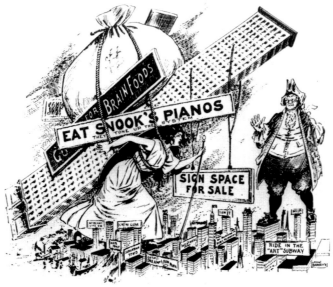

THE PROGRESS OF ART.

Fig. 189. Leon Barritt, *The Progress of Art*, ca. 1900.
Newspaper cartoon.

that was close to heretical. For in these works he embraced the view that, for better or worse, commerce was America's native language—and aligned himself with Duchamp and Picabia, who found the true America in billboards and neon. He brought into the Stieglitz circle a much broader machine age advocacy than any of the others espoused, one to be found in a variety of sources, but none more fervent than the little magazine *Broom* (1921–24). A close look at *Broom* brings into focus the argument for the creation of an American aesthetic based on commercial culture.

Until 1923 *Broom* was edited and published by Americans living in Europe: first by Harold A. Loeb and Alfred Kreymborg, and then by Matthew Josephson, who published its last five issues in New York. It was a transatlantic publication, helping to cement the Paris–New York modernist axis that formed during the war and drove so much art production in the years that followed. The first issues were, as Harold Loeb recalled, not very original, simply "an eclectic collection much like that of the

other little reviews."[57] Like other little magazines, *Broom* had been established to support avant-garde literature and art, both American and European.

In the *Broom* issue of May 1922 Loeb published "Foreign Influence," a catalytic article documenting the impact the French love of things American was having on American literary expatriates and their sense of national identity. Two things struck him: first, that Americans were displaying a new fastidiousness about form and about finding the mot juste and, second—this flabbergasted him—that the expatriate was beginning to reevaluate the "crudeness and strain of his own country." The stimulus for this rethinking came from the European avant-garde's mania for things American. The European was interested, Loeb explained, not in literary America, but in "that other America of the skyscrapers, of the movies, of the streets." Loeb explained that writers like Jean Cocteau and Blaise Cendrars had no patience with Americans who praised French culture while demeaning their own as crude and graceless. It was precisely that new-world crudity and gracelessness the French loved![58]

By now this pattern is familiar to us: the postwar

American abroad astonished that the very culture he was fleeing was all the rage in Europe. And the discovery led to a new editorial slant for *Broom*: boosterism for vulgar America and an out-and-out assault on those intellectuals who disdained it. In a second essay, "The Mysticism of Money," Loeb lashed out at writers such as Van Wyck Brooks, Waldo Frank, and Paul Rosenfeld who "hammer the country for its emptiness of beauty" and encourage "the imitation of European art." Every nation, Loeb explained, trying his best to sound scientific, had three phases to its artistic development: the archaic or creative period, when forms are invented in response to the dominant religion; the classic period, when forms are perfected; and the decadent period, when traditional forms are exhausted. The art of Europe, Loeb claimed, was in the third period of decline. American culture, on the other hand, was in the archaic period, that moment when anonymous workmen, responding to the country's "religion" of capitalism and the "Mysticism of Money," were inventing great machines, skyscrapers, bridges, factories, jazz, movies, bathrooms, advertising, and a new English language. These forms, Loeb declared, were America's archaic art of great genius.[59]

If this sounds somewhat familiar, it is because Loeb had discovered the New York little magazine *Soil* of 1916–17, which Duchamp and his French friends liked so much because it called for a brand-new vernacular American art. In 1916 New York's artistic community had regarded the *Soil's* editor, Robert Coady, as a fiery evangelist and anarchic dadaist.[60] But in 1922 Loeb treated Coady as a brilliant thinker and turned the *Soil's* message into a more rational argument countering intellectuals like Brooks and Frank, or the critics around Harold Stearns, who peddled malaise and pessimism about the state of American civilization. Loeb wrote as a genuine mainline modernist critic, defining the appeal of American popular and commercial culture for a transatlantic readership—not just for American avant-garde interests but also for European enthusiasts of new-world culture. While *Broom* continued to publish modern works of art and literature, its new emphasis became American popular and commercial culture.

The two most vocal enthusiasts were Matthew Josephson and Malcolm Cowley, the magazine's young American editors, both of whom, while living abroad, had experienced a volte-face in their disdain for their native land. Already in rebellion against the moral fervor and symbolist gush of their literary elders, these two young turks were drawn to the upbeat views of machine age America like bees to honey. Both were in close touch with the European avant-garde, particularly the dadaists, and were inclined to high-spirited combat against the establishment. Their revolt took the form of colorful iconoclastic pieces promoting lowbrow American culture and self-consciously tweaking the highbrow tastes of the reigning American literary avant-garde. They argued that if the billboard, the advertisement, and the electric sign were vulgar, such vulgarity had a raw and primitive beauty. Indeed, they went even further: what was most American about American culture was its vulgarity. And until American artists recognized that, and began drawing their inspiration from such street entertainments as jazz, movies, and comic books, the country would not produce a national art.

One of the most controversial of these essays was "The Great American Billposter" (1922), in which Josephson argued, only partly tongue in cheek, that advertising was one of America's greatest indigenous arts, reflecting "the national temperament with great clairvoyance." Ads were the "folklore" of modern times, "the most daring and indigenous literature of the age." They were "far more arresting and provocative than 99 per cent of the stuff that passes for poetry in our specialized magazines." Quoting a line from an anonymous adman, "Meaty Marrowy Oxtail Joints," Josephson claimed to find it more poetic than Keats's line "The beaded bubbles winking at the brim." Applauding the typography and layout of ads, as well as their quick rhythms and precise language, Josephson urged young writers to "become more sensitive to the particular qualities in their material environment."[61]

Josephson's article appeared in the same issue as Cowley's "Valuta," an expatriate's ballad to America, "My land of cowboys of businessmen of peddlers peddling machinery." The poem, incorporating lines from songs and American clichés, was built upon the rhythms of popular music. In March of the following year Cowley liberally sprinkled his "Portrait of Leyendecker," a short satirical takeoff on Sinclair Lewis's George Babbitt, with national brand names and well-known product jingles, some

of them appearing on the page in typographical styles that mimicked advertising's use of different typefaces.[62]

Broom was by no means the only intellectual force in the early 1920s pressing for the "American-ness" and vitality of certain forms of lowbrow life. In a series of articles for *Vanity Fair* and a piece on jazz for the *Dial*, Gilbert Seldes, an established drama critic, began to examine the inventiveness of slapstick comedy films, ragtime, jazz, vaudeville, the circus, comic strips, and popular dancing. In 1923 Seldes became so convinced of his new direction that he left his editorial post at the *Dial*; went to Paris, where he was in touch with French enthusiasm for his subject; and quickly pulled together a book called *The Seven Lively Arts*.[63] The book's title and text proposed that the seven classical arts be replaced by popular ones. In his rambling defense of American popular culture, with many a knock at repressed genteel taste and bogus art (his term for the fine arts), Seldes provided an up-to-date guide to American pop entertainment. He then proposed a companion volume on the "advertising arts"—on billboards, lighted signs, and ads—which he labeled a "fascinating manifestation of American impulses." This volume never got written.[64]

Seldes and the partisans of *Broom* conceived of themselves as brash new voices, subverting both the academy and their elders in modernist circles. If their terms sounded familiar, it was because they continued (though more intensely) the tweaking of American artists that Duchamp and Picabia had initiated nearly a decade earlier, but also because they reinvigorated an older prewar discourse. Josephson argued for the same raw, unschooled beauty in American pop and commercial culture that Picasso and others had once located in an African mask. Picasso never claimed to uncover a national identity by founding an aesthetic based on African art. But the postwar American theorists promoted the new urban vernacular "arts" of advertising and jazz as indigenous American products, in a line of reasoning similar to that once used to defend ethnographic pieces. Josephson laid claim to advertising as an American folk art; his program was to revivify American art by infusing it with energies drawn from the street while attacking those who wanted to keep modern art precious and uncontaminated by contemporary life. He featured himself as a new

vulgarian, located, as Loeb put it in *Broom*, "at the opposite pole to the Sherwood-Anderson, Russian-realism, American soil spirit."[65]

By 1924, then, the rift in the New York avant-garde between what we might call the soil-spirit school and the new vulgarians had become a public one. Both groups espoused a modern art rooted in Americanness and reconciliation with place; but they disagreed on how it was to come about. For Stieglitz, Frank, Rosenfeld, and those in the soil-spirit school, reconciliation was a solemn, meditative process, occurring between artist and place; for the new vulgarians, it was a matter of open, joyous, often witty indulgence in the business-mindedness of postwar American life. For the first group art had an ethical dimension and could heal a country that was drowning in materialism; for the second it was drawn from the culture of materialism and could stylistically internalize the youth and rawness of contemporary America.

For a while in the early to mid 1920s there was open but not always friendly debate between the two camps, each protesting the other's intellectual position and protecting its own claims. We have already seen how Rosenfeld roundly criticized the new vulgarians for their lack of taste and sensibility, and how Frank allowed that the *New York Daily News*, electric lights, jazz, and Gershwin might be American folk art but insisted that they were not related to the forms of high art. For his part, Herbert J. Seligmann, another Stieglitz associate, found Seldes's book repugnant; it made him long "for the air of higher altitudes. And for a prophet of immaculate purity in expression."[66] It is not hard to guess which prophet he had in mind.

Josephson called Seligmann, Stieglitz, and the others the "Uplifters" and, along with Cowley, satirized Van Wyck Brooks in the pages of *Broom* and made hash of Frank's recent books.[67] By 1924 the battle between the two groups was so ferocious that young Edmund Wilson was inspired to pen "An Imaginary Conversation," with Paul Rosenfeld and Matthew Josephson discussing the nature of art. In it Josephson proclaims Rosenfeld an ill-adjusted "romanticist in the wrong century," while Rosenfeld accuses Josephson of playing dadaist games and having a "false idea of what America is actually like." Rosenfeld upholds the "honor of the human spirit" and argues that America starves its artists;

Fig. 190. Charles Demuth, *The Circus,* 1917.
Watercolor and graphite on paper, 8 × 10 ⅝ in.

Josephson counters with a passionate defense of an artistic life led in the here and now, listening to popular voices and experiencing the unrestrained "vertigo of life" in the streets.[68]

"An Imaginary Conversation" is an excellent yardstick for measuring the dynamics and internal tensions of a small group of modernists, all of them at some level wanting to unite in the effort to create a new Americanized art but disagreeing deep down about how to do it.[69] It helps us to understand why artists in the second Stieglitz circle ventured into commercial and popular culture, only to pull back and return to their more nature-based vocabulary in the 1930s, when the depression made artistic accommodation with business suspect; both Cowley and Josephson publicly recanted their earlier youthful efforts to link art and American commerce.[70] It is also by measure of "An Imaginary Conversation" that we need to return to Demuth's posters and his uneasy

position in the second circle. That Demuth managed to infiltrate the Stieglitz circle at all (unlike Charles Sheeler, whom Stieglitz dismissed for being too commercial) attests not only to his interpersonal skills but also to his ability to maneuver artistically and dialectically between the two camps and find a small space in which to work without alienating either of them. Demuth's art, we could say, straddled the two groups and the two generations. He was about fifteen years younger than Stieglitz and fifteen years older than Josephson and Cowley, the young *Broom* iconoclasts. Like Stieglitz, he believed in an art of refinement and beauty and painted watercolors that satisfied Stieglitz's call for works of rarefied sensibility. But like the young turks of *Broom,* and like Duchamp, who early on was a friend and inspiration, Demuth was an ironist and an early pop culturist who spent his entire career trying to figure out how to reconcile his desire to paint beautiful

Fig. 191. Charles Demuth, *At the Golden Swan,* 1919.
The artist and Duchamp are seated at table in lower
left. Watercolor on paper, 8 × 10½ in.

pictures with his need to embrace and be reconciled with the ugliness and vulgarity of the city streets. His story is particularly poignant because its subtext is so deeply colored by his homosexuality. His struggle to accommodate both Stieglitz's spiritual America and Duchamp's materialist America, to paint pictures that were beautiful *and* vulgar, played out in his studio a desire for acceptance, intimacy, community, and even greatness, a combination not to be found in the work of the other American modernists.

In his early years as an artist, Demuth made art about New York City's subcultures of entertainment. He was one of the very first to make drawings and watercolors of the Turkish baths, popular meeting places for homosexual men. And he made many watercolors of vaudeville, circus performances, cabarets, and nightclubs that he liked to frequent, falling in with Coady, Hartley, and Seldes, who were promoting these activities as the best arts America had to offer (Figs. 190, 191).[71] But only in the 1920s, as a more fully articulated theory about the indigenous nature of American popular and commercial culture began to develop, did Demuth consider developing an aesthetic—not just a subject matter—from this material. As European artists and the *Broom* group began to analyze the streamlined functionalist structure of the American advertisement and billboard, as well as that of the American skyscraper, factory, and grain elevator, Demuth took to not only painting smokestacks, ventilators, and billboards in a new series of oil and tempera paintings, but also creating a new formal language drawn from these subjects. He looked to the aesthetics of these reputedly

American-style artifacts to help him invent a comparable one for easel paintings. His art went from small watery watercolor and pencil drawings to oil paint on canvas in a style incorporating features of cubism and futurism as well as the clean Precisionist surfaces critics found so fastidious and elegant. He continued to paint watercolors of fruits and vegetables, but with new grandeur and control.

These new paintings were primarily of sites in Demuth's hometown, Lancaster, or its environs. Here he found urban materials like those being talked about by the avant-garde, especially in European architectural circles, as quintessentially modern and American. This was not the fascination with electric lights and suspension bridges of the *new* New York that we have looked at, but another category of *américanisme*, this one focused on utilitarian structures such as grain elevators and flat-roofed factories. Le Corbusier, Walter Gropius, and Erich Mendelssohn published illustrated essays on these artifacts—like those on the daring engineering and extraordinary height of the skyscraper—that praised their streamlined, no-nonsense undecorated appearance. "America, the Motherland of Industry," Gropius wrote, "possesses some majestic original constructions which far outstrip anything of a similar kind achieved in Germany." American factories "can almost bear comparison with the work of the ancient Egyptians in their overwhelming monumental power. . . . But the impact of these buildings does not depend on sheer material size alone. . . . American builders have retained a natural feeling for large compact forms fresh and intact."[72]

Although Lancaster dated back to the eighteenth century and stood in the middle of an agricultural belt, the city and its environs had long supported heavy industry. Demuth could easily find factory-scapes to paint. He seems never to have made up subjects but instead, like Stella in New York, painted from specific sites. The Lukens Steel Company, some miles east of Lancaster in Coatesville, Pennsylvania, and the inspiration for Demuth's first important industrial paintings, had been operating on its site since 1810. Demuth painted other structures in Lancaster itself: mills, factories, and commercial signage. The John W. Eshelman Feed Company, established in 1881, rebuilt in 1919, and painted by Demuth in 1925 as *My Egypt*, was one of the most modern grain elevators in Lancaster (Figs. 192, 193).[73]

Fig. 192 (top). Charles Demuth, *My Egypt,* 1927. Oil on composition board, 35¾ × 30 in.

Fig. 193 (bottom). John W. Eshelman and Sons grain elevators, ca. 1950.

To see such structures as artful was a stretch for Demuth, and he had to feel his way into making "serious" paintings about something as utilitarian and unartful as a factory. Like Stella, he responded to *américanisme* while wondering if the romance was not overwrought. Demuth was helped, as all the "rooted" artists were, by Williams's argument for an art based on locale. Good art, Williams insisted, could arise from "insignificant place." As Demuth was making the transition from New York to Lancaster, and from watercolors to oils, Williams, along with Robert McAlmon, another friend of Demuth's, was publishing *Contact* (1920–23), urging artists to pay attention to local experience. Contact was what was missing, Williams explained, when artists sat in New York and painted and lived as if they were in Paris. "If Americans are to be blessed with important work, it will be through intelligent, informed contact with the locality which alone can infuse it with reality." Williams's ideas about "contact" between artist and place were confirmatory not only to Demuth but also to members of the second circle; for what Williams called locale, they called soil or place. But for Williams, locale was more than nature; it included buildings, modern-day machinery, factories, backyards, and front lawns. His certitude about the artistic possibilities of provincial materials, and his poetry about ordinary incidents in his own hometown of Rutherford, New Jersey, and the nearby factory town of Paterson, provided Demuth with a model for working out of what he called his château on East King Street in Lancaster.[74]

Another friend who helped was the newspaper critic Henry McBride, who, along with Stieglitz and others, was becoming more and more convinced that an American modern art was on the verge of happening. In 1921 McBride had declared that he liked Paris, but "the time has come when it is no longer necessary for a first-rate American to go there."[75] By 1929 he was convinced that "Paris is no longer the [art] capital. . . . All the intelligence of the world is found in New York; it has become the battleground of modern civilization; all the roads now lead in this direction."[76]

Demuth's worries about making a painting career in the provinces were most poignantly expressed in a series of letters he wrote to Stieglitz from London and Paris in 1921, when he was trying to convince himself that a new American aesthetic was possible.

He was excited to be back in Europe, not having been there since before the war, yet he was also anxious about how American art measured up to what he was seeing abroad. Indeed, what is remarkable about these letters is their documentation of Demuth's shaky confidence as he oscillates between hope and despair—not about European art, but about what might be possible in America. Upon seeing art in London, for example, he found himself wondering, "Will [it] ever happen in the land of the free?—or is it happening?" In the next sentence he asserted what he wanted to believe: America had something different from Europe. "I never knew Europe was so wonderful,—and, never knew really,— not so surely, that New York, if not the country has something not found here. It makes me feel almost like running back and doing something about it." And then, at the end of the letter, he adds a faint note of hope: "It is more difficult in America to work—perhaps that will add a quality."[77]

Two months later Demuth was in Paris, still agonizing, but now in contact with French *américanisme*: "It is very amazing to me, to find this enthusiasm here,—after knowing what we have always felt for the French, not thinking much of our own; and the great French men telling us that we are very good. It seems rather grand." But then he voiced doubts. "It would be so easy to stay" in Paris if he were younger. And then yet another turn. "Sometimes it seems almost impossible to come back— we are so out of it. Then one sees Marcel or Gleize [*sic*] and they will say—'Oh! Paris. New York is the place.—there are the modern ideas—Europe is finished.'" And finally, "How wonderful a time it is. I'm glad, missing the Renaissance,—and I suppose that I did!—that I was not called upon to live at any other time,—aren't you?"[78] Returning home a few weeks later, he wrote Stieglitz to report one last time on his impressions of Paris, the work of Duchamp and Picasso, and his decision to stay put in Lancaster: "What work I do will be done here; terrible as it is to work in this 'our land of the free.'"[79]

Such contradictory sentiments—committing himself to the American scene and mocking it simultaneously—evidence the indecisiveness and ambivalence that marked not only Demuth's thinking in 1921 but also his new work in oils and tempera. These were his first canvases to draw upon a Lancaster landscape that was provincial and uncultured

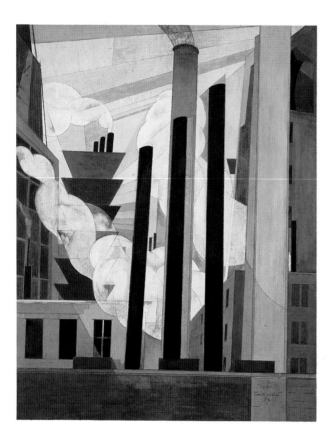

Fig. 194. Charles Demuth, *End of the Parade,
Coatesville, Pa.*, 1920. Tempera and pencil
on composition board, 20 × 15 in.

by European standards—one that he, with his illness, was forced to live in. Like a prisoner, he was learning how to love his jail cell. His nervousness prompted him to give paintings of local churches self-conscious titles—*After Sir Christopher Wren* and *In the Province*—and to call a view from his Lancaster window *From the Garden of the Château*. By bringing forth a smile from his viewers, such titles protected Demuth from those who might have criticized him for taking his hometown too seriously. At the same time, these titles suggest his predicament as a cosmopolitan modernist stuck in a culture that was young and raw. What did he have to paint but humble structures, America's small-town equivalents of the great churches and palaces of Europe?

The same double-edged humor pervades Demuth's first "industrials," as they became known, paintings based on factories, smokestacks, water tanks, ventilators, and grain elevators in Lancaster and its environs. While Demuth was surely aware that many European architects lauded the functionalist beauty of the American factory and the granary, he treated them playfully. Living with them just down the street, Demuth was not fully convinced, as some European enthusiasts claimed, that they were America's majestic pyramids.[80] In *End of the Parade, Coatesville, Pa.* (1920), he rendered the weighty smokestacks of the steel mill as thin black stripes and the blasts of steam as transparent bubbles, and then gave the painting a title suggesting the viewer see it as an image of a parade (Fig. 194). While scholars commonly compare these elements to flags and banners, another possible reference is the steam calliope, which came at the end of parades in Lancaster. The stepped smokestacks resemble the pipes of an organ and the smoke is analogous to the steam puffs that rise from the pipes when they are played.[81] Demuth used a similar nervous humor in *Machinery* (1920), a painting he inscribed to Williams, where he reduced a cyclone separator to a shape reminiscent of a curvaceous teapot. A painting of a round water tower and phallic smokestack, he entitled *Aucassin et Nicolette* (1921), impishly suggesting that "ceci n'est pas une usine" but a medieval fortress, the site of a sexual encounter between two lovers whose story of forbidden love was told in

Fig. 195 (facing). Charles Demuth, *Buildings, Lancaster*,
1930. Oil on composition board, 24 × 20 in.

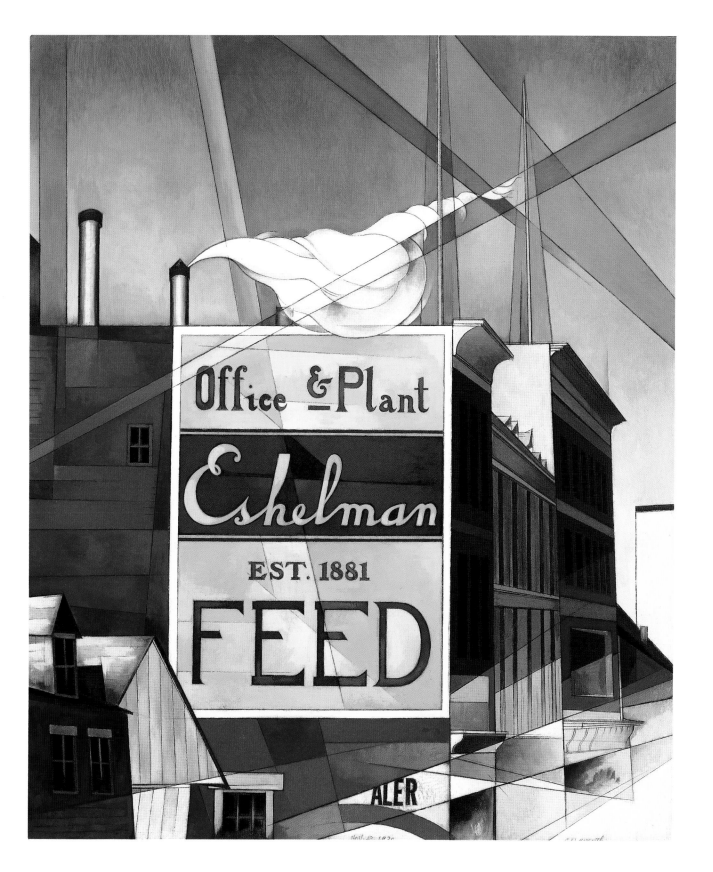

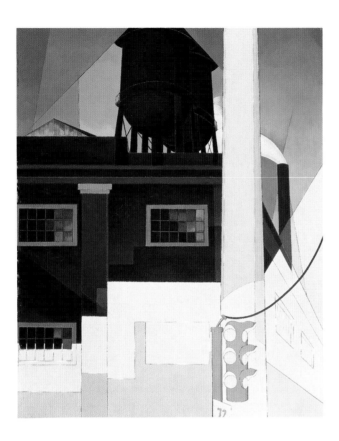

Fig. 196. Charles Demuth, . . . *And the Home of the Brave*, 1931. Oil on composition board, 29 $^{7}/_{16}$ × 23 $^{1}/_{2}$ in.

a well-known thirteenth-century romance. Though forbidden to see one another, the two young lovers, Aucassin and Nicolette, eventually escape their elders and find one another in the shadows of a tower.

Some of these allusions can be traced to dadaist wordplay and Demuth's close friendship with Duchamp. Like Duchamp, Demuth cultivated an ironic stance toward the strange new world he lived in; and like both Picabia and Duchamp, in his early industrial paintings he deflated the potential grandeur of machines by infusing them with erotic suggestiveness. But unlike Duchamp, he neither rejected the art of painting as an obsolete art form nor affected to stand coolly outside culture looking in. No matter how much he cloaked his early work in humor, Demuth clearly wanted to find a way both to marry into his culture and to make an American art that was significant and long-lasting. His was a booster art in ways Duchamp's never could be. Indeed, if we look to the monumental paintings that came in the late 1920s—*My Egypt* of 1927 (see Fig. 192) or *Buildings, Lancaster* a few years later (Fig. 195)—where the commercial structures take on heroic stature and joking is minimized, we realize that dadaist irreverence served as little more than a short-term protective device for Demuth. As he struggled to find an authentic identity as an American painter, humor helped him cover up his lack of confidence as a self-avowed painter of the American industrial scene. It also helped him find a middle road somewhere between the young vulgarians and the slightly older soil-spirit school. For Demuth painted the factory in seemingly elegant fashion, and then, lest he be taken *too* seriously, turned around and critiqued his own subject matter.

By the late 1920s, however, Demuth's paintings of mixed sentiment gave way to industrial scenes of great majesty (Figs. 195, 196). His voice no longer wavered and obfuscated but was confident and assured. He seemed much more comfortable with himself as an artist and began to describe his paintings to Stieglitz as "almost American" and "quite American," using second-circle patterns of speech.[82] In his late industrials he reached an accommodation with the red-brick factories and the belching smokestacks, exulting in the rough and muscular beauty of modern-day Lancaster. Where he once was playfully critical, he was now rhapsodic. His forms were eloquent, the buildings statuesque, and the surfaces of

the paintings, as Rosenfeld commented, as polished and precise as Vermeer's.[83] Titles generally became simple descriptions, as in *Buildings, Lancaster* or *Chimney and Water Tower*.

When, on occasion, Demuth assigned titles in his earlier ironic mode—*My Egypt* or *. . . And the Home of the Brave*—his choices proclaimed something positive, even poignant, about home and place. *My Egypt*, for all the implied humor about living in a backwater, in using the possessive case asserts ownership of place. If in it Demuth also accepts the popular comparison of the American grain elevator to the Egyptian pyramid, he does so from a clear-headed position within the culture rather than one romantically outside. . . . *And the Home of the Brave*—a title readily recognizable as a line from the national anthem—brilliantly encapsulates Demuth's desire to forge a meaningful relationship with his industrialized country. For better or worse, America is "home" and its artists the "brave" ones. The title of the work, painted in 1931, was topical: this was the year Congress voted to designate "The Star Spangled Banner" the country's official anthem.[84] It was also a year, as we will see in the two chapters that follow, when the avant-garde made a particular show of Americanist titles, in response, no doubt, to the growing isolationism and nationalist fervor that were developing nationwide at the time.

The portrait posters, painted between 1923 and 1928, form the bridge between the nervous, dada-flavored architectural paintings of 1920–21 and Demuth's much more assured voice of the late decade. Although it is hard to fathom exactly why, given their lukewarm reception, the posters helped Demuth to be brave and take confidence in his own voice. Stieglitz did little to help him. When Stieglitz showed the first posters in the *Seven Americans* exhibition, he put them in the entrance hall. None ever sold during Demuth's lifetime. And Demuth, internalizing the coolness attending their reception, both deprecated and defended them. "Almost everyone has told me what a mistake I made showing them without explaining that they were made for my own amusement," he wrote to Stieglitz. But then he added: "I'll do three, or more, and show them all next winter. I'll make them look at them until they see that they are, so-called, pictures."[85]

The "them" in this last sentence—vague and unclear—certainly refers as much to Stieglitz and the other men in the circle as to the general public. Demuth wanted to convince his fellow artists that he was a serious picture maker, and he hoped his poster series would be a means of doing so.

Making portraits of and for one another, as we have already seen, was something of an avant-garde industry in the early twentieth century, especially among the artists and writers Demuth most admired: Gertrude Stein and e. e. cummings wrote portraits of their friends in poetry and prose; Paul Rosenfeld had his portrait pantheon in *Port of New York*; Stieglitz made formal portraits of the artists and intellectuals in his circle and created his ongoing photo series of O'Keeffe. Florine Stettheimer painted witty and warm portraits of the avant-garde at leisure. And in time Virgil Thomson, who as a young composer ran in these same circles, began to write musical portraits of his friends.

As a genre, portraiture both flowed from and reinforced group solidarity among those who identified themselves as the country's most progressive artists. Beginning with the witty constructs of Picabia and Marius de Zayas, this modern form of homage helped the American avant-garde to structure their identity, to link themselves to a transatlantic community, and to celebrate—publicly and proudly—their own adherents and achievements. In an age when *Vanity Fair* and other stylish magazines ran caricatures of public figures on their covers, inventing the cult of celebrity that has become so integral to American culture, the avant-garde did something of the same for itself.[86] These portraits, especially the referential ones, also helped to sustain an audience—small as it was—for progressive art. In that referential portraits could be parsed only by viewers skilled in modernist intricacies and referential ploys, they engendered a sense of belonging to an enlightened fraternity. If you could "read" the portraits, you were one of those who "got" modern art.

Certainly, Demuth's portraits functioned then (and now) in this fashion. Each is an intricate puzzle requiring that viewers decipher clues to crack open specific identities. Viewers of the Williams poster must, at the very least, know the poet's name and the poem and be capable of deciphering the cubo-futurist fire engine and street scene before they can enjoy the play of Demuth's mind, the tenderness of

his tribute, the humor embedded in his signs, and his success in capturing the poet's advocacy of an art embedded in local experience. In the poster to Gertrude Stein, the clues remain so obscure that scholars do not agree on their meanings (Fig. 197). Barbara Haskell, arguing that no sure evidence points to Gertrude Stein as the poster's subject, posits it as the theater and Broadway—specifically a play called *Love! Love! Love!* by Evelyn Emig Mellon, published in 1929, that she discovered. She proposes that the numbers one, two, three refer to the number of acts common to plays.[87]

But I see the poster packed with allusions to Stein, many of them recondite. The three "loves" and the numbers one, two, three pay homage to Stein's use of repetition ("rose is a rose is a rose") and the title of one of her first books, *Three Lives* of 1909. Furthermore, as one Stein scholar has deciphered it, *The Making of Americans*, first printed in 1925 by Demuth's close friend Robert McAlmon, is filled with triads and units of three. There are three Hersland children, three Dehning children, three Shilling women, three seamstresses, one of whom had three daughters, and so forth.[88] And throughout the book, there are long passages about love. For example:

> There are many that I know and they know it. They are all of them repeating and I hear it. I love it and I tell it, I love it and now I will write it. This is now the history of the way some of them are it.
>
> I write for myself and strangers. No one who knows

Fig. 197. Charles Demuth, *Love, Love, Love (Homage to Gertrude Stein)*, 1928. Oil on board, 20 × 20 ⅞ in.

me can like it. At least they mostly do not like it that
every one is of a kind of men and women and I see it.
I love it and I write it.

 I want readers so strangers must do it. Mostly no one
knowing me can like it that I love it that everyone is a
kind of men and women, that always I am looking and
comparing and classifying of them. . . .[89]

Stein describes herself here as someone Demuth
would have called a "brave" one, writing for herself
and strangers because none of her friends will "like
it." He could have thrilled to such a passage, given
his lack of success with his portraits and his failure
to sell his art. And "love" would have been a consid-
ered word for him, given how often he expressed
his own deep affection for Stein. He may also have
known that "Lovey" was one of Stein's favorite en-
dearments for Alice B. Toklas, her partner.[90]

The mask, too, signified for Demuth, for Stein
often disguised herself in her writings. She wrote
herself into male roles in her books and, most fa-
mously (though after Demuth made her portrait),
she wrote her autobiography posing as Alice B.
Toklas. The mask—or masking—was a literary
trope and theatrical device widely used in the post-
war era, particularly to express awareness of the psy-
chological theories of Freud and Jung and investiga-
tions into sexual identity. In his plays of the 1920s
Eugene O'Neill capitalized on this new knowledge
about suppressed selves, using masks to represent
the surface or public self while the actor's face un-
der the mask was the private or unconscious one. In
The Great God Brown O'Neill called for actors to
wear masks when they were concealing their identi-
ties, and then to take them off when revealing their
true nature. When Demuth created a portrait of Eu-
gene O'Neill, he hung a red mask over a liquor bot-
tle at a slightly tipsy angle and propped a blue one
up against the bottle, referencing the playwright's in-
novative and modern use of the mask as a stage prop
(Fig. 198). (The bottle refers to the central place of
alcohol in O'Neill's life and art, and in his and De-
muth's early friendship in Provincetown.) To sug-
gest how involuted and indirect Demuth could be,
he called this portrait *Longhi on Broadway*, refer-
ring to Pietro Longhi, the eighteenth-century Vene-
tian painter of masquerades and masked balls.[91]

 Masks were also deployed to talk about sexual dif-
ferences, particularly by lesbians, who used them to

Fig. 198. Charles Demuth, *Longhi on Broadway*, 1928.
Oil on board, 33⅞ × 27 in.

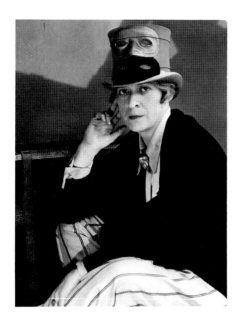

Fig. 199 (top). Berenice Abbott, *Janet Flanner, Paris*, 1927.

Fig. 200 (bottom). Claude Cahun, *Autoportrait (Poupée japonaise debout)*, ca. 1928. Photograph, 4⅛ × 3¼ in.

explore their multiple selves and to signify, for those in the know, their true sexual nature. In Berenice Abbott's portrait of Janet Flanner—both the photographer and the subject were lesbians—Flanner wears two masks on her top hat with her own face peering out from beneath (Fig. 199). And Claude Cahun, née Lucy Schwob, made a series of masked self-portraits in the sexually liberal Paris of the 1920s that poetically express her layered lives as woman, lesbian, surrealist, and photographer (Fig. 200).[92] Surely, the mask in Demuth's portrait of Stein is related to this trope, one that would have had personal resonance for him, given his own sexuality. (Interestingly, Emily Farnham's 1971 dissertation and book on the artist, *Behind the Laughing Mask*, picked up the metaphor as a sly means of alluding to Demuth's homosexuality, a subject she masked in her text and never addressed directly.)

But my larger point is that *Love, Love, Love,* is more reticent and elusive than the Williams poster, as seemed to be the case whenever Demuth made portraits of his homosexual friends. He was more obtuse, finding it harder, given the prejudices of American culture, to invent language that moved easily between public and private realms. A case in point is his poster portrait of Charles Duncan, where interpreters are handicapped by not knowing much about the subject, other than that he was a painter and a friend of Duchamp's, Demuth's, and artists in the Stieglitz circle (Fig. 201; see Fig. 4). For a while he made his living painting billboards, including a seventeen-foot-high Maxwell House Coffee sign on Times Square.[93] Demuth, we know, put Duncan's profile in one of his early watercolors and in 1926, the year after he made the portrait, wrote to Stieglitz: "I saw Duncan this spring in New York and he seemed the maddest of us all—Oh, Lord."[94]

That Demuth had specific allusions in mind, there can be no doubt, but without more information about the sitter and the artist's relationship to him, it is hard to read back into the painting. Duncan's poster appears to represent three works of art or three posters hung on a wall, the middle one with a rainbow form cutting through the composition. Perhaps the poster has something to do with Duncan's signmaking, but this interpretation is not very satisfying; the usual double entendres and shifting signs in the posters are not working. To put it another way,

Fig. 201. Charles Demuth, *Poster Portrait: Duncan*,
1924–25. Oil on wood panel, 24¾ × 28½ in.

the poster refuses public accessibility and remains locked in the private realm.

The unfolding flower in an oval—a rose, it would appear, given the thorns on the stem and the bud at the top—takes on the shape of a mask with the two sprigs of ivy that flare out, like feathers or ribbons, from either side. Given the eroticism of the flower, and its central position, we can assume that this was a tribute from one "masked" person to another. Demuth used similar homoerotic flowers ("fleurs du mal") in portraits of two other homosexuals, Hartley and Bert Savoy and, conversely, did not use them in his portraits of heterosexuals. In his sketch of a poster to Hartley (he never made a finished work) he featured an anthurium plant, known to some as the "little-boy plant," whose phallic yellow spadix wanders languorously out of its waxy red petal into the

open air (Fig. 202). Next to the plant's pot a soft white camellia rests on what appears to be a cross; in taking on the position of a crucified body, the flower may refer to the pain and torture suffered by Hartley, or Demuth, or both in their strained relationships with mainstream culture and with one another.

In the poster Demuth made as an homage to Bert Savoy, three calla lilies and their leaves grow out of a gigantic shell that rides a wave of blue (Fig. 203). In his day, Savoy was a famous female impersonator on the vaudeville stage, where his partner, Jay Brennan, played a straight man. They were a well-known New York couple, both on- and offstage. Demuth, who went to vaudeville weekly as a young man, was a great fan of Savoy, whose portrayals of buxom street harlots were convincing and hilarious. In

Fig. 202. Charles Demuth, *Study for Poster Portrait: Marsden Hartley*, 1923–24. Watercolor and graphite on paper, 10⅛ × 8⅛ in.

1923 Savoy died suddenly, struck by lightning as he walked on a Long Island beach, and Demuth's portrait was a memorial one. The wave refers to the beach where Savoy died; the calla lilies signify funeral blossoms and, covertly, homosexuality.

But without the words and names that animate the other posters, we can only go so far in interpreting the Savoy portrait. Indeed, it seems that whenever Demuth painted poster portraits of homosexual men and women, he became overly secretive. In a society where he could not be open about his sexuality and that of those around him, he could not make these portraits fully reveal themselves to his viewers.

The portrait posters of heterosexual artists like O'Keeffe and Dove, in contrast, like the one of Williams, yield more readily. They depend, as always, on the viewer's knowing details of the sitters' lives and then enjoying the way the artist makes multiple references to those lives, the sitters' art, and, in these two instances, their heterosexuality.[95] Both emphasize organic and natural imagery, just like the works of the artists to whom they pay tribute. Demuth, as in the Stein and Williams portraits, takes pleasure in referencing—mimicking, even—the two artists' stylistic propensities. For O'Keeffe, Demuth created a vertical still life, her own preferred axis and genre, and included a sansevieria plant with leaves that flame upward, as the lines of her paintings so often do (Fig. 204). Demuth found the imagery of "flames" central to O'Keeffe's work. He described her paintings in print as "flowers and flames" or (on another occasion) "a movement of flames." "Flame of the spirit? or Flame of the flesh?" he asked, using Stieglitzian rhetoric.[96]

While flamelike, the sansevieria, or snake plant, as it is sometimes called, is known for its toughness and resilience; it signals O'Keeffe's well-known independent character. (In *Woman with Plants*, Grant Wood used the same plant as an attribute of his mother, a survivor of many hardships.) The Kiefer pear (his pun, not mine) cut in half to the left, and the gourd and apple to the right, are tributes to O'Keeffe's own still lifes of natural elements on flat surfaces, often pieces of fruit—apples, pears, or avocados—huddled together (Fig. 205). Yet the comparison stops here, for Demuth's fruits, unlike O'Keeffe's hardened and sculptural fruits and vegetables, have both a tenderness to them and an

intimacy of scale. As Robin Frank has pointed out, Demuth's fruits are softly curved, nippled, and serpentine, the pears fleshy and full, like the breasts, bared shoulders, and nude torsos in Stieglitz's many photographs of O'Keeffe.[97] The apple and gourd are bodies in themselves, a male form caressing a female one. Such explicit body references remind us once again how Demuth, along with all the other members of the second circle, stereotyped O'Keeffe as soft flesh and rounded body, and as an artist whose femaleness determined the kind of painter she became. That the gourd and the apple just touch, each keeping its individuality, allegorizes O'Keeffe's and Stieglitz's marriage, which by the time this poster was painted may have lost its initial passion, though not its husband-and-wife

interdependencies. (Something very different transpires in the contemporaneous photograph of two squashes by Edward Weston, where the embracing vegetables lose their selfhood and form a sensuous whole [Fig. 206].)

There are other biographical commentaries. The spelling of O'Keeffe's name on the vertical and from bottom to top not only plays with graphics the way a modern advertiser or billboard designer would—this was the heyday of vertical signage—but also, with the sparkles around the double *F* and double *E*, stylizes O'Keeffe's own way of creating forms with halos around them or with radiating energy lines. (Williams's poem "The Attic Which Is Desire" does something similar with a soda sign that blinked off and on outside the poet's window [see p. 212].)

Fig. 203. Charles Demuth, *Calla Lilies (Bert Savoy)*, 1926.
Oil on composition board, 41 × 47¹/₈ in.

Fig. 204 (top). Charles Demuth, *Poster Portrait: O'Keeffe*, 1923–24. Oil on wood panel, 23 × 19 in.

Fig. 205 (middle). Georgia O'Keeffe, *Alligator Pears*, ca. 1923. Oil on board, 9 × 12 in.

Fig. 206 (bottom). Edward Weston, *Squash*, 1936. Photograph, 7⁹⁄₁₆ × 9¹⁄₂ in.

Fig. 207. Charles Demuth, *Poster Portrait: Dove*, 1924.
Oil on wood panel, 22½ × 26½ in.

The formation of the explosive noise (FFEEE!) is also a bit of private humor. Demuth could never remember how many *F*'s and *E*'s were in O'Keeffe's name and usually spelled it wrong in his letters and essays. His variations included O'Kief, O'Keif, O'Kieff, O'Kieffe, and O'Keeffee.[98] (This was not just Demuth's problem. McBride and others in newspaper reviews also got it wrong, as do many contemporary commentators.) By shouting the letters out, and exploding them in our face, he made it clear that he got it right this time—a loving, self-deprecating touch. The sans serif letters in a crosslike form and the spiky crown around the FEE marry religious and billboard rhetoric in a humorous trope, reiterating the claim, made so often in the Coolidge decade, that commerce was the religion of the age.

For the poster of Dove, Demuth created a hori-zontal, undulating landscape composition that included earth, water, and sky, a bunch of grapes, and a pinecone, all obvious references to Dove's paintings of country and seaside (Fig. 207). The grapes and pinecone float above the verdant field of green, and though their mating may seem incongruous, it brings together a rounded female form with a tumescent male one in yet another heterosexual image of caress and coupling. Once again Demuth featured his subject's intimate relationship with a lover. The soft rounded red bow hugging and wrapped around the sickle identifies the artist's love as "Reds," the nickname of Helen Torr, with whom Dove lived and whom he eventually married. The red ribbon tied around a sickle and the sickle itself—both unmistakable symbols of political radicalism in the 1920s— render Dove simultaneously a revolutionary painter

Fig. 208. Charles Demuth, *Poster Portrait: Marin*, 1926.
Oil on wood panel, 33 × 39½ in.

(a reputation he held at the time) and a farmer, a man of the soil.

The name Dove is in white and hangs in the air like a bird—a white dove, as one interpreter saw it—another reference to love, flying over land and sea.[99] The white "Dove" is also the "spirit," the green earth below the "soil," the complementaries so central to second-circle aesthetic theory. The prominence of red, white, and blue in the portrait alludes to Dove as an authentic American painter.

In the poster of Marin, bands of red, white, and blue dominate the most streamlined composition in the series (Fig. 208). The artist's name, the word "play," and a long arrow are layered on the bands and on each other. Two white stars hang in the blue stripe like stars in the sky. The red, white, and blue and the stars unmistakably signal the American flag

and the thick rhetoric of Americanness that Stieglitz and his circle wrapped around themselves like beach towels. It was common for Stieglitz and his in-house writers to boast of Marin as the most American of them all. Marin was, as Rosenfeld put it, "fast in American life like a rough and fibrous apple tree lodged and rooted in good ground."[100] Marin, Strand wrote, "is a kind of spiritual 100 percenter, devoid of sentimentality. When he says an American tree is different absolutely from a European tree . . . he means that it is the former and the difference in which he is concentratedly interested. That kind of American consciousness infuses all his work. . . . Marin is related to the American pioneer."[101]

For the viewer who knows Marin's personal history, the blue, white, and red bands also refer to the French flag and the artist's early years in France,

where he learned his cubism. (Marin's paternal grandfather was French.) And only those viewers familiar with the artist could catch the innuendos of the single word "play," used here as Marin's brand name. The word encapsulated Marin's boyish character, puckish personality, and reputation for an art of youthfulness, spontaneity, and gestural excitement (see Figs. 10, 153). Marin "played" with stroke and color in his watercolors, just as he loved "wordplay" in his letters and his poetry. And the arrow? Certainly, given the way Demuth always found a way to allude to the style of his friends' art works, this was a stylized Marin brushstroke and force line as well as an equivalent of his energy and passion. The arrow was also a graphic used often in advertising and public signage.

Cubism had taught artists how to make abstract forms signify in multiple ways. An arrow that on the surface was a strong abstract graphic form could also, for knowledgeable viewers, summarize the artist's personality as well as his painting style. But in Demuth's case, the ability to invent visual forms whose meanings could slip and slide so brilliantly was also tied to behavioral patterns in the homosexual community, where specific words, colors, and elements of dress that convey nothing unusual to the heterosexual person in the street were loaded with significance for those in gay subcultures. We have been looking at signs whose meanings shift for different audiences. This was one of the ways Demuth injected into modernist poetics the everyday practices of his "other" community. "Most queer men," as George Chauncey repeatedly reminds us, "led a double life."[102] They wore masks for the heterosexual world, where they "passed" as heterosexuals, letting their homosexual identity emerge only among friends. Or they spoke in language that could be taken in several ways, depending upon the receiver.

That double entendres proliferate in Demuth's public paintings—finding covert and overt phalluses in them has long been art-historical practice—was not just a Duchampian antic but the artist's learned way of speaking across communities. In the public language of paint he passed as an artist whose sexuality was not offered as an issue, but in the private language of his many watercolors describing life on the streets, beaches, and baths he placed himself directly and explicitly in a homosexual world of street encounters, same-sex couples, and male

Fig. 209 (top). Charles Demuth, *Four Male Figures*, 1930. Watercolor and graphite on paper, 13 × 8 in.

Fig. 210 (bottom). Charles Demuth, *Distinguished Air*, 1930. Watercolor, 16³/₁₆ × 12⅛ in.

exhibitionism (Fig. 209). He did not put these water-colors into open circulation. Those intended for public consumption, he painted in a much more guarded language, disguising his homosociability in humor, erudition, and slippery referencing—for instance, his watercolor *Distinguished Air*, illustrating a short story of the same name by McAlmon (Fig. 210). The story, published in a tiny edition, was about post–World War I decadence in Berlin and about the life of a homosexual narrator who had a "distinguished air." For general audiences who did not know the story, the watercolor could pass as a genre scene set in a museum or art gallery where dressed-up people admire a piece of modern sculpture. For those who look more closely, it is a hilarious spoof of normative sexual mores. The museum becomes a site for autoeroticism, sexual arousal, and homosexual encounters. The Brancusi sculpture transmutes into a gigantic phallus (see Fig. 60).

Demuth's language breaks down when he cannot find imagery that is both explicit and covert; in his portraits, this seemed to happen whenever his subject was a fellow homosexual. His portraits of Duncan, Stein, and Savoy live on their surface of colors and forms and keep viewers from easily grasping (at least to date) layers of meaning. They have public lives as works of art but do not betray the private lives of their human subjects. They enact the way men and women with sexual preferences different from those condoned by mainstream culture had to live.

There is one final way I want to describe Demuth's posters: as advertisements for a homegrown American art. Taken as a portrait grouping, they boosted what Demuth called (in the store window of *The Figure 5 in Gold*) the Art Co., a transatlantic company made up of artists, writers, and a vaudevillian, drawn from both Paris (Duchamp and Stein) and New York (the others). By crossbreeding cubism and futurism with features drawn from advertising media, and by calling the result posters, Demuth linked his portraits to the aggressive selling techniques of modern marketing and the exaggerations of the modern tabloid. Like Rosenfeld's *Port of New York* and Stieglitz's galleries, they interfaced with the national culture of hyperbole and exaggeration that we looked at in the Introduction. With the ex-

ception of the portrait of Bert Savoy, Demuth's portraits all included words, often large ones in sans serif letters (usually the name of the artist—but in the case of Williams, the number five as well, and in that of Marin, the word "play" in addition to the artist's name). The letters are bold and clear, screaming like those in a tabloid headline or modern billboard. These posters were high-minded advertisements for the business and the celebrities of modern art.

Furthermore, Demuth's rhetorical format—names combined with an oblique image—replicated the underlying structure of postwar advertisements, which often comprise little more than a brand name in big letters, a picture of the product and its distinctive packaging, and then an advertising slogan or jingle. Sometimes, as in a Lucky Strike ad from the period, it included a celebrity with his name in large letters—here, David Warfield, a popular actor—giving his endorsement: "Take care of your voice—smoke Luckies" (Fig. 211). The jingle at the bottom—"It's toasted"—had its own form, one that seemed so peculiarly tied to modern consumer culture that writers from James Joyce to e. e. cummings parodied its stripped-down form, wit, and silliness. They also caught its irony. The jingle never named the product outright but rather described its charms through some clever but indirect phrase: "The pause that refreshes," "Three times a day." In isolation these slogans are pure nonsense; they take on meaning only when the brand name or the picture of the product that is each one's referent accompanies it or when the public remembers the link, having seen or heard the slogan repeatedly in connection with a product. So too with Demuth's portraits, which refer to the artists who are his "sitters" through schematic imagery that does not describe or name them but signifies them through indirect references to their art and personal lives.

What is distinctive about the portrait poster, however—in contrast to the advertisement—is the richness and intimacy of the "jingles" Demuth invented for his friends. Unlike a billboard, designed to speak quickly to homogenized audiences on the move, Demuth's posters refuse the ethos of quick read and fast sell. Involuted and complicated, they take time and effort to parse. Furthermore, they were hand-made and individually tailored, not mass produced, and they hung on the walls of art galleries, not on the streets. Their audience was the very opposite of

a mass public: a small, select group of friends and in-siders. For all that they consciously share with adver-tising, Demuth's portrait posters ultimately borrow from, but refuse to succumb to, the value system of modern-day commerce. At some level, unlike ads, they are intractable, refusing to be fast, easy, and clear. Arthur Danto put it well. The posters, he wrote, hover "somewhere between riddles and allegories"; they are not stable in their meanings and, like good riddles, constantly invite new interpretations.[103]

The tragedy for Demuth was that for decades few took him up on his invitation. Only when artists such as Jasper Johns, Tom Wesselman, Alan D'Arc-angelo, and Robert Indiana came into prominence in the early 1960s did scholars and critics begin to pay serious attention to Demuth's posters, as well as Gerald Murphy's still lifes. Overnight Murphy and Demuth (along with Stuart Davis) became the American parents of pop art (Fig. 212).[104] They be-came proto-pop, pre-pop, and early pop, to use the language of that hour. Overturning the marginal status the Stieglitz circle accorded the portrait post-ers—epitomized in O'Keeffe's consigning four of them to the Beinecke Library along with the Stieg-litz paper archives—they have in recent years been hung in museums as masterpieces of American mod-ern painting.

Robert Indiana helped renew interest in the artist by using Demuth's *Figure 5* as the inspiration for his own series of paintings, paying homage to Demuth as Demuth had once paid it to Williams (Fig. 213). For Indiana, to put himself in a lineage with De-muth was not just to identify the earlier artist as the pop of pop, but to acknowledge the homosexuality they had in common. Very early on, well before it be-came a subject of scholarship, Indiana understood and probed Demuth's layered language: a public voice that was cool and dandified, the private voice underneath, personal and emotive. In *The Demuth American Dream* Indiana combined surface cool-ness with the heat of phrases like "American Dream" and words like "die," "err," "eat," and "hug." As in Demuth's posters, the words were deeply considered. There is the sadness of the Amer-ican government's erring in its aggression in Viet-nam and Cambodia and of people's dying because of it. And then the private language of longing is ex-pressed in words like "eat" and "hug." Most coded is

Fig. 211. Lucky Strike advertisement. From *Life*, Mar. 1, 1928.

Fig. 212. Allan D'Arcangelo, *U.S. Highway 1* [panel 2], 1963.
Acrylic on canvas, 70 × 81 in.

Indiana's linking of his own circumscribed life as a closeted homosexual in pre-Stonewall New York to that of Demuth twenty-five years earlier. In the central bull's-eye, Indiana stencils in AMERICAN DREAM 1928 and 1963, the year of Demuth's *Figure 5* and that of his own work, pointing to the failure of the fabled dream to create a better and fairer world in his lifetime as well as in Demuth's.

Indiana seized upon and reworked one of the traits most peculiar to Demuth's posters: their double- and triple-speak. The portrait posters present themselves as kin to the billboard on the streets but, in contrast to billboards, their surfaces are so cleverly wrought that we never doubt for a moment that we are looking at handcrafted (not machine-made) works of art. In such contradictions, Demuth spoke as one of the *Broom* crowd, exemplifying the pact that the 1920s "vulgarians" made with modern America. Even though they sought peace with signs and billboards and spoke of reconciling themselves

to the world of business and industry, they never suppressed or relinquished their own individuality. To the contrary, they always insisted on their own creativity—playing with, manipulating, and reshaping the vulgarities of their landscape and aestheticizing the street dross around them. As modernists, they did not join Duchamp in his much bolder suppression of self but enjoyed making their manipulations in co-opting their environment obvious and pleasurable to both the mind and the eye. In the final analysis one of the ironies of their work is that the artists' well-being and sense of belonging came less from a marriage with the machine age than from their sense of mission and community with one another. These artists, including Demuth, were sustained more by the ideal that together they might create a great new national art out of the civilization they were born to than by their efforts to be machine age artists. Demuth's portrait posters encapsulate their dream, not its realization; taken collectively, they

Fig. 213. Robert Indiana, *The Demuth American Dream No. 5*, 1963. Oil on canvas, 144 × 144 in.

are about the possibilities of an American Art Co., the collective that was going to give the country its first great school of artists. Each is a valentine, one might say, to a member of the American Dream Team that Demuth hoped would make an authentic national art happen.

"Valentine" is the word I want. For the posters are secret love letters, sent from Lancaster to the artists in New York and to Gertrude Stein in Paris. If we scratch deeper, as I think Indiana did, Demuth's posters collapse the bonding with environment so obvious on the surface into something far more personal and intimate. As we work through the conundrum each poster presents, we feel in touch with Demuth's Duchampian play of mind but in even closer touch with his subjective self. We feel his loneliness and desire for intimacy as he tenderly works in other artists' styles, makes their love lives into metaphors of fruits and vegetables, and exaggerates their names or puts them in lights. To pay such homage,

he had to become momentarily one with Williams, O'Keeffe, or Marin as artists, as names, and as human beings. Even when he did not know a subject well—Dove, for instance, was not a close friend—in painting a portrait homage to him, he engaged this man's life and art forms. The living through others and the longing in Demuth's posters—the desire for a "hug," as in Indiana's homage—separates them from other referential portraiture of the time. Even those that fail to communicate are touching because Demuth's speechlessness seems as much cultural as personal. But the portraits that are legible are tender and personal in ways other referential portraits are not. Forms touch and intertwine. Of all the artists in the American avant-garde, Demuth was the most emotionally introspective and self-investigatory of artists. The posters were his personal contribution to the campaign for a new American art; but they were also entreaties to Stieglitz and his circle for love.

THE GREAT
AMERICAN THING

So as I painted along on my cow's skull on blue I thought to myself, "I'll make it an American painting. They will not think it great with the red stripes down the sides—Red, White and Blue—but they will notice it."

Georgia O'Keeffe, 1976

Charles Demuth's tenuous position within the Stieglitz circle in the 1920s is symptomatic of the strange mixture of Victorian and modern values that Alfred Stieglitz brought to the group's practices. Although he supported radical art forms, practiced free love, and made photographs based on principles of abstraction, he also structured his relationships with others on a decidedly nineteenth-century patriarchal model. In many ways, he could be described as "a Victorian in the modern world," a phrase a member of his generation used to title an autobiography.[1] One of his late-Victorian propensities included a strong demarcation of male and female capabilities and sensibilities. This affected the way he promoted the artists around him and the terms he used to describe the qualities of their art. His advocacy of the male members of his "family," especially John Marin, Arthur Dove, Paul Strand, and Paul Rosenfeld, knew no bounds. He tolerated Marsden Hartley but was much sterner with him, probably because he deemed him wayward, sexually as well as artistically, and could never fully control him. Despite pleas to return home, Hartley continued to live abroad. To Demuth, the sickly and dandified son, Stieglitz was stingy with his affections and offered no secure place. Demuth was X, the poor relation.

And Georgia O'Keeffe—the woman artist in this male circle—how did she fare?[2] Twenty-three years Stieglitz's junior, and his lover for some six years before becoming his wife in 1924, O'Keeffe held a central place in the circle but, from the beginning, a highly gendered one.[3] When they met she was in her late twenties, he in his early fifties. Stieglitz and the other men in the circle were supportive of her art but spoke of it in terms different from those they

Fig. 214 (facing). Georgia O'Keeffe, *Cow's Skull—Red, White and Blue*, 1931. Oil on canvas, 39⅞ × 35⅞ in.

Fig. 215. Alfred Stieglitz, *Georgia O'Keeffe:
A Portrait—Painting and Sculpture*, 1919.
Palladium print, 9 3/16 × 7 5/8 in.

used for each other's work. She was special because she was female and *not* a male artist. From the very beginning, they deeply admired her art but, as with Demuth, felt compelled to explain it as the "equivalent" of her body and her sexuality. As Barbara Buhler Lynes has so carefully demonstrated, her central identity in the 1920s for the men in the circle, and for O'Keeffe's critics in general, was that of a "woman artist" expressing herself.[4] Like Demuth, she could be seen only through the veil of sexuality; the two of them were paired in their otherness—he the effeminate dandy, she the sensuous female. Not surprisingly, each was the other's best friend in the circle.

In an era when few woman artists were professional, and even fewer dared to paint abstractly, O'Keeffe seemed extraordinary. She was an original artist, an unconventional beauty, and a person of nonconforming tastes in dress and behavior. Her independence and her professionalism were those of a "new woman," though in her severe dress—she wore practical shoes, pulled-back hair, and little or no jewelry or makeup—she was at odds with the women of her generation who became flappers. By flapper standards, O'Keeffe was cool, remote, and self-designed. She liked to dress in black and white and in natural fibers, and she radiated a personal autonomy that fascinated artists and critics. Though few felt close to her, she gave depth and dimension to the Stieglitz circle; she was a trophy, a colleague whose singularity validated the circle's progressive nature and broadened its claims to a new American art. To support her professional goals and acclaim her art were progressive acts, just as it was a masculinist one to explain the power of her work as residing wholly in her sexuality.

Stieglitz set the guidelines for interpreting O'Keeffe's art as he did for reading that of Demuth and every other member of his circle. He boosted her as the country's premier female artist and claimed her as America's own. And he was the first to articulate fully the idea that the power of her art came from her female center, from her womb, rather than from a masculine mind. As early as March 1918 he wrote to O'Keeffe, describing her art: "The Great Child pouring out some more of her Woman self on paper—purely—truly—unspoiled."[5] A year later, in his most elaborate essay

on the subject, "Woman in Art," he reiterated the claim that hers was an art of woman's feelings. "Woman feels the World differently than Man feels it. And one of the chief generating forces crystallizing into art is undoubtedly elemental feeling. The Woman receives the World through her Womb. That is the seat of her deepest feeling. Mind comes second."[6] In making a referential portrait of O'Keeffe in 1919, Stieglitz photographed two pieces by her to make them appear in sexual union: on a shelf, a small plaster sculpture she had made in 1916, photographed as if it were the male member penetrating the (female) void of her painting *Music—Pink and Blue No. 1* (Fig. 215).

In focusing his analysis on O'Keeffe's sex, and on the different kind of knowledge that came from a woman's voice, Stieglitz drew on an assumption that was deeply embedded in American culture. Women had been weak as artists, critics said, because they used the formal vocabularies of men instead of speaking from their separate nature. (This was similar to the argument that American artists would never be any good until they got out from under the influence of Europe; both were arguments for an authenticity of voice.) Women "always imitate men, instead of trying to solve problems which have never been touched before," Sadakichi Hartmann wrote in 1901. They should "throw new radiance over art by the psycho-physiological elements of their sex. . . . The woman who can paint men as we have painted women, and paint women as we have painted men, will win for herself the laurel wreath of fame."[7] Stieglitz's promotion of O'Keeffe, predicated on a similar understanding that men and women had not only different biologies but also different psyches and sublimated desires, offered an early-twentieth-century definition of separate spheres for the art of men and women. He celebrated her for breaking the long silence from women artists and for saying things men could not. And he essentialized her both physically and psychologically. In a decade when Freud stimulated widespread psychologizing, it followed that a woman spoke from her womb and a man from his mind or, in popular Freudian terms, his phallus. Men spoke in thrusting forms; women spoke through curves. Men were cerebral; women were emotional. In featuring O'Keeffe as a "woman artist," or "lady," as

McBride liked to call her, critics often adhered to the same gender logic and spoke of Marin and Dove as "male artists."[8]

Both before and during the 1920s, O'Keeffe's colleagues, time and again, constructed her in these gendered terms. When Rosenfeld wrote his first O'Keeffe essay, he found a woman's body expressed at every turn in her paintings. There was "no stroke laid by her brush, whatever it is she may paint, that is not curiously, arrestingly female in quality. Essence of very womanhood permeates her pictures."[9] Strand called her a genius, praising her independence—from men as well as from Europe—and he proclaimed her America's first female artist. O'Keeffe's painting "is not a dilution or imitation of the work of men, nor does it derive from European influences. Here in America this amazing thing has happened. Here it is that the finest and most subtle perceptions of woman have crystallized for the first time in plastic terms."[10] Even Edmund Wilson, one of the more independent voices at the time, followed this line of criticism; he praised O'Keeffe for her "fluidity and vagueness." It was O'Keeffe's "peculiarly feminine intensity that has galvanized all her work . . . in such a different way from the masculine. . . . [W]omen imbue the objects they represent with so immediate a personal emotion that they absorb the subject into themselves. Where the masculine mind may have freer range and the works it produces lead a life of their own, women artists have a way of appearing to wear their most brilliant productions . . . like those other artistic expressions, their clothes."[11] In 1931 Lewis Mumford named O'Keeffe "the poet of womanhood in all its phases: the search for the lover, the reception of the lover, the longing for the child, . . . the sudden effulgence of feeling . . . which comes through sexual fulfilment in love: all these elements are the subjects of her painting." For Mumford, O'Keeffe had invented a new abstract language of womanhood, one that had to do, not with subject matter, but with female feelings and sexuality.[12]

For a number of years, O'Keeffe seems to have worked more or less comfortably in the separate sphere the critics carved out for her; it was a gendered construction that gave her work an interpretive coherence and a well-defined position, even a distinguished one, in the second circle. When she

Fig. 216. Georgia O'Keeffe, *Light Iris*, 1924.
Oil on canvas, 40 × 30 in.

described herself, she often spoke of herself as a "woman" and of others as "men," her gendered rhetoric reinforcing *la différence*. She called the artists around her "the men" (not always with flattery) and the critics "the wise men." In 1923 she thanked Henry McBride for writing first about her of the three women he had critiqued. "I like being first." She didn't mind, she added, if Marin "comes first—because he is a man—its [*sic*] a different class."[13] And in 1930 she explained, "I am trying with all my skill to do painting that is all of a woman, as well as all of me."[14]

Her large flower paintings, begun in 1924, encouraged further the construction of her as a painter working out of female experience (Fig. 216). As a subject, flowers were intimately associated with women and femininity in American culture (and

therefore with homosexuality, as we have seen in the preceding chapter). Joseph Stella reported with some resentment that his teacher let him paint vegetables and dead fish but had a rule against flowers, "for the simple reason [that] flowers were pretty and old maids were in the habit of painting them."[15] Even though O'Keeffe painted her flowers in an unmistakably modern style, her pronounced use of unfolding petals, eroticized stamens, and mysterious centers encouraged viewers to read in these works a language of nature slipping into that of sensuous body parts, especially those of female anatomy and male penetration. Her pictorial rhetoric encouraged critics to see in her work the abstract equivalents to woman's sexual drives and experiences.

The same was true of her modeling for Stieglitz an ongoing portrait, eventually numbering some

330 photographs. In that the portrait was "something like a visual fulfillment of Stieglitz's reading of O'Keeffe's work," as Anne Wagner nicely puts it, it reinforced O'Keeffe's essential womanness whenever parts of it were shown, abetting critics for whom a female voice defined O'Keeffe's strength as an artist.[16] (The series premiered at Stieglitz's exhibition of 1921 at the Anderson Galleries, where almost a third of the 145 photographs on view were of O'Keeffe.) O'Keeffe posed long hours for Stieglitz as he created this composite portrait of her, interpreting her in the early years as a creature of nature, a woman of infinite feeling, and a sensuous woman in love.[17] He often captured her arms, hands, and fingers acting out an "equivalent" of the shapes in her paintings (Fig. 217). Sometimes her arms look like vines or tree branches, or her hands cup her breasts or fruit. While there is much debate about how complicitous O'Keeffe was in the making of the serial portrait, there is no doubt that she was both Stieglitz's muse and his patient, willing model. She took and held some very difficult and uneasy poses. Some of them were so intensely choreographed that it is impossible to imagine Stieglitz's inventing them without her assistance and cooperation; she had to have helped arrange her body to fulfill his reading of womanhood. O'Keeffe's willingness to sit for photographers her entire life and to take dramatic poses suggests she enjoyed something of the process. Stieglitz, of course, like any other photographer for whom she sat, chose what his camera framed and cropped, and which works of art belonged in the series; it was, in the final analysis, the photographer's work of art. But O'Keeffe, like her contemporary Frida Kahlo, was a willing subject.

In the early 1920s O'Keeffe began to resist and even to resent being typecast as the woman modernist, realizing that she was being stereotyped in ways other artists were not.[18] She may also have realized that she was contributing to the overgendering of her work by being a compliant nude model. In the same years, Stieglitz moved from photographing her nude or lightly clad body to picturing her more severely in black-and-white clothing, sometimes wearing a hat or hood (see Fig. 262). As early as the fall of 1922 she complained that Rosenfeld's prose embarrassed her and that critics generally "sound so strange and far removed from what I feel of myself. They make me seem like some strange unearthly

Fig. 217. Alfred Stieglitz, *Georgia O'Keeffe: A Portrait—Head*, 1918. Gelatin silver print, 9$\frac{5}{16}$ × 7$\frac{5}{16}$ in.

sort of a creature floating in the air—breathing in clouds for nourishment—when the truth is that I like beef steak—and like it rare at that."[19] By 1925 she was soliciting critical reviews of her work from women acquaintances, presuming that they would not describe her art as the male critics did and, at the very least, that they would write from a woman's perspective. (Here she made her own gendered assumptions.) To Mabel Dodge Luhan she wrote, "What I want written—I do not know—I have no definite idea of what it should be—but a woman who has lived many things and who sees lines and colors as an expression of living—might say something that a man cant [sic]—I feel there is something unexplored about women that only a woman can explore—men have done all they can do about it."[20] Her efforts were partially successful. In 1926 she did a long interview with Blanche Matthias and got a review in the *Chicago Evening Post* she liked. Matthias complained in the essay that O'Keeffe had been pigeonholed by her critics "of the masculine gender" and needed to be seen afresh. Interestingly, it did not seem to bother O'Keeffe that the review characterized her as "utterly feminine," all woman —"delicate, sensitive, exquisitely beautiful, with the candor of a child in her unafraid eyes"—because her art was not subjected to the intense psychologizing favored by the New York male critics.[21]

The most visible demonstration of O'Keeffe's desire to make changes in her life was her decision in 1925 to take on the New York skyscraper as a painting subject. She called these cityscapes "my New Yorks."[22] Not surprisingly, Stieglitz did not support the idea, it being in his mind a risk for a woman successful as a painter of flowers and an abstractionist. He also thought the subject inappropriate for a woman, given how much the city had become a male subject and how much it was tied to machine age advocacy. In the mid-1920s he was, we remember, completely ambivalent about New York City, seeing it, along with Waldo Frank, as a mean and hostile marketplace, masculine in its aggressive street life and phallic in its skyscraper figurations. Stieglitz's hostility to O'Keeffe's trying her hand at the subject had no effect, except, perhaps, as something to work against.[23] O'Keeffe was feeling so rebellious that she even used the most poisonous word in the Stieglitz lexicon to describe her new aspirations. She wanted to be *vulgar*. To Frank, she wrote

that she wanted to create an exhibition of paintings "so magnificently vulgar that all the people who have liked what I have been doing would stop speaking to me."[24] She wanted, in other words, to break down her audience's expectations of what a woman could and could not do. She pursued the *new* New York for five years, 1925–30, only to drop it as soon as she made what was in hindsight one of the two most influential decisions of her life: to carve out a space in the Southwest she could call her own.[25] (She made the other major decision in 1918, when she left her teaching assignment in Texas to live with Stieglitz in New York.)

After eleven years with Stieglitz, following his routines each year—New York City in the winter and the Stieglitz family compound at Lake George in the summer—she set out in May 1929 for Santa Fe, New Mexico, with her friend Rebecca Strand. They took the train, then a trip of several days, and after a stay in a Santa Fe inn, moved into one of Mabel Dodge's guest houses in Taos for five months. From a variety of sources we know that O'Keeffe sought the solitude and uncongested spaces in which she did her best work, conditions, she chronically complained, unavailable either in Manhattan or at Lake George. She also sought escape from tensions in her relationship with Stieglitz, especially his growing interest in, and dependency on, another woman. Her childhood in the dairy country of Wisconsin and the nearly four years of teaching in Texas, first in Amarillo and then in Canyon, had always been a mental counterpoint to the fixed urban patterns of life with Stieglitz. Having briefly passed through Santa Fe on a trip from Texas to Colorado with her sister Claudia in 1917, she had also heard from friends, like Rebecca and Paul Strand, who had been there earlier, of its attractions and its strong appeal to writers and artists. For several years she had been yearning, as Stieglitz put it in a letter, for the plains and "real Spaces."[26] As soon as she arrived, she was writing of her happiness to friends in the East: "I never feel at home in the East like I do out here. . . . I feel like myself—and I like it."[27]

The trip by train from New York City to Santa Fe, and then by car to a place in northern New Mexico where she would stay for three to six months, became an annual pattern.[28] Sometimes she would spend a few weeks with Stieglitz at Lake George at one or the other end of her trips. In 1940 she

purchased the small house she had been renting summers at a dude ranch called Ghost Ranch, sixty-five miles northwest of Santa Fe. And just before Stieglitz died in 1946, O'Keeffe bought and began to renovate another, much larger, adobe house in the tiny town of Abiquiu, sixteen miles southeast of Ghost Ranch. Beginning in 1949, for the rest of her long life, she lived and painted in these two dwellings, surviving Stieglitz by forty years.[29]

Many art historians stop their accounts of O'Keeffe's innovation in art making in 1929, implicitly recognizing the first trip to New Mexico as a moment when something began to change but underestimating, in my view, its importance.[30] The summer of 1929 in fact marked the closing of her Manhattan years, and her time with Stieglitz, and pointed toward the second half of her life in northern New Mexico that eventually would be hers alone to manage. The trip ultimately changed not only the way she lived but also what she painted and how she was received by the public. It silenced those who claimed that she spoke in a feminine voice, because neither the austerity of her New Mexico paintings nor her behavior in working away from "home" could support such a reading. Though she would never completely shed her mystique as the sensuous woman pouring out her sexuality on paper, New Mexico became the site where she was finally able to complete the reshaping of her public persona. Once the Eternal Feminine, she became the Priestess of the Desert. Her new role was not so much self-imposed as self-fashioned from the symbolist practices of the second circle and from regional precedents.

This chapter describes the moment that this reinvention began and probes O'Keeffe's artistic production during her first three years in New Mexico, the summers of 1929, 1930, and 1931. These summers culminated in O'Keeffe's invention of a new art form, the still life of bleached desert bones, which became her second signature body of work, second to her paintings of blown-up flowers, the hallmark of her Manhattan years and a subject she continued to paint long after. O'Keeffe's development of the bone still life, rich in regional and gender associations (cowboys, saints, Native Americans), deepens not only our understanding of her art but this book's larger narrative about modernists in search of a national art. When O'Keeffe left the architectural

canyons of Manhattan for the God-given deserts of New Mexico and put aside paintings of skyscrapers for those of bones, it was both a private affair and a public announcement that modern America could be found far west of the Hudson, not just on Wall Street, at Lake George, or on the New England coast.

By 1929 changing definitions of what constituted America were developing among painters, especially those known as the Regionalists and American Scene artists. They argued for an expansionist view, wanting art to be made in every region in the country. They vehemently rejected the East Coast's modernist claims to "ownership" of America and its art making. Theirs was a backlash against what they perceived as both Manhattan-centrism and Europhilia in the arts. O'Keeffe's new allegiance to the Southwest, coming from within the ranks of modernism, was symptomatic of corresponding shifts within the avant-garde. While she never broke rank, her bone paintings contested the modernists' focus on Manhattan, made fashionable by the international avant-garde, and the modernolatry that had been dominating artistic debate. Her protest was all the more powerful for her own yielding, a few years earlier, to machine age tropes. Her New Mexico paintings also challenged the "men" in the Stieglitz circle whose worldview had always included the American countryside, but only that within a day's drive of Manhattan. In taking the quest for an indigenous art to a new and distant port of call, one known for its remoteness and antiquity, O'Keeffe began to live and work within the circle and outside it at the same time.

O'Keeffe's well-known *Cow's Skull—Red, White and Blue* of 1931 was not her first bone painting but one of the first in a series that she began in the fall of 1930 and continued to paint throughout 1931 (see Fig. 214).[31] Ironically, given how much she adhered to a philosophy of painting out of an intimate sense of place, she painted this canvas in New York, not in New Mexico. But more on that later. Though Stieglitz exhibited the painting, it did not sell. In 1952 O'Keeffe, signaling how important she felt the work to be, gave it to the Metropolitan Museum, to which she had already donated a sizable collection of work from the second circle. The curators hang it, usually,

Fig. 218. Lee Marmon, *Laguna Eagle Dancers,*
New Mexico, 1975.

not far from another of her gifts: Demuth's *Figure 5 in Gold*.

Though the height of *Cow's Skull—Red, White and Blue* is only four inches greater than its width, the composition, nevertheless, is dramatically vertical. A sun-bleached long-faced cow's skull, partially decayed, appears to hang—or does it float?—right in front of the viewer's face. We look directly at and into the variegated surfaces, eyes, and snout of this animal head. Smooth and chalky white on the crown of the head, its texture as dry as bisque, the skull dissolves into a series of wizened chambers at the snout, their edges brittle and crenulated. The horns are outstretched, suggesting the arms of a body, and a deep crack runs from the middle of the forehead down into the region of the nose. The other elements of the painting are abstract but suggestive: three loosely painted stripes, two red and one black, and behind the stripes, a field of blue tinged by white at the edges and broken by diagonal lines that look like creases or folds.

A mature head, the skull is not a dusty, cracked laboratory specimen. It appears animated, even alive, making mysterious contact with us as if from the grave. In looking at or into it, we experience strange stirrings of life. Like a Sphinx, a medicine man, or a Buddha, it seems to possess secret knowledge, the kind that holy people pass down from generation to generation. It wants to commune.

It is the artist's meticulous orchestration of formal qualities that gives it life. O'Keeffe rendered the skull luminescent, for instance, yet gives no discernible light source. The light could be coming from within or from without—we have no way of knowing—but it is so bright and evenly distributed that it defies natural law; this is the super-natural light beloved by surrealists and by film directors. O'Keeffe also gave the skull special bearing: high and centered on the canvas, its horns symmetrically splayed out almost to the edges, it appears isolated and iconic. The stripes divide the canvas in thirds, reinforcing the skull's heraldic presence. O'Keeffe intensifies our encounter with this skull by giving us the uncommonly close vantage point she had used to such good effect in her paintings of flowers. We could never have such an encounter in real life; a skull brought so close to the face would not stay in optical focus. (You can approximate the experience by looking closely at your own face in a mirror; your eyes cross and your reflection melts into a blur.)

To look at this painting, then, is to have an uncanny experience, one cloaked in naturalness but not, in fact, everyday stuff. We go eyeball-to-eyeball with an animal skull. The skull's gaze returns our own, and we are outdone in the confrontation: we blink; it does not. Furthermore, we have but one pair of eyes, and this skull appears to have two, both equally compelling. The skull stares at us from

above through old and sagging eyes (particularly its right one), and from below through empty eye sockets that are shadowy pockets with animated edges. O'Keeffe has played tricks on us with the cow's anatomy.[32] The beaded "eyes" in the upper skull are not eyes at all but holes (technically, the supraorbital foramen) that channel veins. But O'Keeffe made them look like a second pair of eyes, forcing us to play an old children's game, finding two faces in one. As soon as we have met one set of eyes, the other set beckons, and we change our perceptual field.

In seeing two sets of eyes, we realize that we can read this image as two faces, a smooth porcelain one on top and a craggy, decaying one underneath. Or maybe better, given what we will discover of O'Keeffe's frame of mind, we can imagine that the head wears a mask, as native dancers wear animal and bird masks that cover the tops of their heads and their foreheads, with their own eyes peering out from underneath (Fig. 218). We can then see the outstretched horns as the arms of the dancer. Indeed, once we begin to see the skull as a head wearing a dance mask, it is hard to make the reading go away. The references to a crucified body have a similar effect: the skull's horns splay out like arms nailed to a cross, the upper "eyes" become nipples, and the overall configuration of the head resembles a slumped and lifeless human body. The little creases on either side of the forehead might outline a bowed head. Although O'Keeffe gave the black stripe behind the skull none of the weight or texture of a wooden cross, its form repeats one that had recently appeared in her work. The first summer she was in Taos, O'Keeffe made hypnotic paintings of the large white and black crosses in the northern New Mexico countryside (see Fig. 237).

If an abstracted black stripe turns out to be highly connotative, so do other abstract qualities. The color blue, tinged with white in the background, conjures up the fabled big and open skies of the Southwest, against which wooden crosses are dramatically silhouetted (see Fig. 227). But because the blue field has diagonal creases and the stripes have wavy edges, the background just as easily takes on the character of cloth. A little later on we will see that O'Keeffe was consciously thinking of the American flag and simultaneously working from a Navajo blanket with a plain field and stripes at either end (Fig. 219).

Consider one last detail, the crack that runs down

Fig. 219. Hudson Bay–style Navajo blanket, 1880–90, owned by Georgia O' Keeffe. $97\frac{1}{2} \times 60$ in.

the middle of the cow's skull and the way it recalls the southwestern landscape. It is a natural part of a mature cow's skull, but O'Keeffe darkened and accentuated it so that it takes on a visual life of its own. In the very center of the painting, the crack has flow to it, starting as a trickle at the top and widening at the bottom. O'Keeffe often used a fold in her flower paintings, or a vein or tear in her still lifes of leaves, to divide the composition so that one side of her painting becomes a mirror image of the other (Fig. 220). This crack, we realize, functions in the same way. It helps divide the picture in half and gives the skull a symmetry that enhances its iconic presence. But in alluding to crevices, riverbeds, and arroyos, seen as if from a distance, it embodies O'Keeffe's concept of the "faraway nearby," a wonderful phrase O'Keeffe used as the title for a later skull painting, capturing in it something of her optical system. The cragginess of the crack and its way of dividing the skull in half give it a formal kinship to the many ravines, riverbeds, and dry waterfalls—paths of water flow—that O'Keeffe would feature in her future landscape paintings of the Southwest (Fig. 221). Here she inscribes the local landscape in a finely tuned line.

Many of the shifting references in *Cow's Skull—Red, White and Blue* are intensely regional: the blue skies, low horizons, and dry desert terrain of New Mexico, along with the rituals, religiosity, and artifacts of the local populations, especially the dances of the Pueblo Indians and the crosses of Hispanic Catholics. In 1931 these were new referents for O'Keeffe, unlike any she injected into her first great body of still-life work, her flower paintings. Those evoke human bodies, sinuous landscapes, and exuberant natural phenomena like flames and waterfalls; the interior chambers of one of the flower paintings can transmute before our eyes into folds of flesh or hills and valleys. The flower paintings heave and breathe, inspiring critics to read them as flowing from a woman's womb. In New Mexico, however, O'Keeffe consciously worked to change the paradigm from woman painter to regional painter. She exchanged fleshiness for dryness and hardness; hills and valleys for stony cliffs and deep, dark crevices; fluid forms for strong iconic statements. Most significant, the objects that inspired her to paint—animal bones, crosses, masks, Indian blankets—and the way she configured them were deeply tied

Fig. 220. Georgia O'Keeffe, *Pattern of Leaves*, ca. 1923. Oil on canvas, 22⅛ × 18⅛ in.

to a rich regional culture or, to be more accurate, to the multiple cultures of the Southwest. Indeed, O'Keeffe's bone paintings brilliantly convey, without the obvious romantic or illustrative character of so much southwestern art of that time, what she and other Anglo artists believed to be New Mexico's peculiar "sense of place."

The second Stieglitz circle put the word "place" in the same celestial orbit as "soil" and "spirit." The concept was sacred to them, describing both their philosophy and practice. As philosophy, place connoted commitment to drawing one's art from deep personal experience with an American locale—not from imagination or from literature but from a sustained engagement with some small piece of the planet (usually in rural New England or New York, or in Manhattan and its suburbs). As practice, it meant not traveling here and there looking for picturesque subjects, and certainly not living abroad, but settling in, and having continual and repeated contact with, a particular geographical space, as Demuth did in Lancaster, Pennsylvania; William Carlos Williams in Paterson, New Jersey; Stieglitz and O'Keeffe at Lake George and in Manhattan. One model for sinking roots was John Marin, who for years summered on the Maine coast, where he produced watercolor after watercolor based on encounters with his particular patch of sea, rocks, and trees. In the winter Marin moved back to Cliffside, New Jersey, bonding with Manhattan while painting its towers and bridges. Stieglitz did likewise at his family's summer place at Lake George, where in the 1920s he made his photographs of clouds, trees, and hills. When in the 1930s he took up Manhattan again as a theme, he did not prowl the streets but photographed those views of the city he could see from his apartment and gallery windows, his places. He never traveled for a picture, O'Keeffe said. "His eye was in him, and he used it on anything that was nearby."[33] Stieglitz and others criticized Hartley in the 1920s for wandering here and there and working abroad rather than from sustained contact with an American place.[34] When in 1930 Hartley finally came "home" and began to paint New England, and then the landscape and fisherfolk of Maine, his home state, his critics attributed the new vigor

Fig. 221. Georgia O'Keeffe, *Cliffs Beyond Abiquiu, Dry Waterfall*, 1943. Oil on canvas, 30 × 16 in.

of his work to his reunion with an American place he knew intimately.

Dependent in part on a generalized transcendentalism lifted from Emerson and Whitman, in part on symbolist *correspondances*, this notion of place could take the form of either practical injunction or mystical evocation. It could even provide a name: Stieglitz named his last gallery An American Place, we remember. But no matter how ambiguous, the credo of "place" gave the group a ready defense for the Americanness of their work. An art rooted in a particularized American place was de facto an American art. Furthermore, the ability to penetrate "place" ("penetrate," with all its erotic connotations, is a verb the second circle often used) defined the group's artists professionally and aesthetically. They were society's elite seers who looked deep into places as ordinary Americans did not.

"Place," in other words, connoted more than topography or touristic experience. It meant connecting spiritually and emotionally with a locale. As William Carlos Williams explained it, artists should work out of true "contact" with place, "embracing everything involved, climate, geographic position, relative size, history, other cultures—as well as the character of its sands, flowers, minerals and the condition of knowledge within its borders."[35] Others, like Paul Rosenfeld and Waldo Frank, spoke more mystically about entering into the "spirit of place," engaging with it like D. H. Lawrence, a writer who urged Americans to stay at home and get into their own spaces: "All creative art must rise out of a specific soil and flicker with a spirit of place." Spirit was the mystery of a physical place, its religious aura, its psychological hold on the artist. Though intangible, it could be felt. "Different places on the face of the earth have vital effluence, different vibration, different chemical exhalation, different polarity with different stars."[36] The artist's job was to feel the vibrations of a place and translate them into an art form so that others could feel and receive them.

While O'Keeffe left theorizing to others, there is no doubt that she subscribed to the primacy of place articulated by Williams and Lawrence and judged her own and others' art accordingly. Dove was one of her favorite artists, she said, because "he would get the feel of a particular place so completely that you'd know you'd been there."[37] Just as Lake George and Manhattan were primary places for her,

so was northern New Mexico. When she wrote to a friend about her first bone paintings, she described them as "a new way of trying to define my feeling about that country."[38] In her correspondence about New Mexico, she also reiterated that it took significant time in a new place to get beyond description to something deep and spiritual. Her first bone paintings, she worried, were an "objective kind of work," not yet imbued with spirit or "that memory or dream thing" that really "comes nearer reality."[39] Similarly, when she went for a three-month visit to Hawaii in the late 1930s, she fretted over how to make the "new and different landscape . . . a part of one's world, a part of what one has to speak with." She knew from her twenty-odd years of experience in New York City, Lake George, and New Mexico that "to formulate the new experience into something . . . takes time."[40]

O'Keeffe never made paintings about Hawaii with the layered cultural references of *Cow's Skull*, lending credence to her claim that it took time to sink roots into a place. Perhaps she was not there long enough or was given too little guidance to get below the surface. Or perhaps Hawaii was not imbued with as much "spirit" as Santa Fe and Taos, towns to which considerable lure and lore attached in 1929, when she first arrived. License plates did not yet sport "Land of Enchantment" as the state's slogan— it was first used by the Fred Harvey Company to attract tourists—but the region had already attracted enthusiasts, most of them Anglos from New York, Chicago, and Los Angeles. These visitors, through their anthropology, art, literature, and critical commentary, spun a thick and complex web of local tradition no newcomer could escape.

Visitors came to Santa Fe and Taos in the early twentieth century for a variety reasons, many of them interrelated (and many of them no different from those that draw people there today). City dwellers came to summer at dude ranches and stay in desert inns, attracted by outdoor living and roughing it in the spectacular desert landscape. The combination of desert and mesas, mountains, riverbeds, and arroyos, along with the spectacular clear and changing light and the thunderstorms that clear the air each summer afternoon, give the region its charisma, at least for those who like their landscapes

dry and skies big. In northern New Mexico, the customary flatness of the desert is relieved by the sage that ripples across it, the arroyos that gash the flat earth, and the mushroom mesas that protrude every few miles. And all is not russet sand. Green pines cover the slopes of the Sangre de Cristo and Jemez mountain ranges, and fertile valleys follow the paths of the rivers, especially the Rio Grande, which snakes through the area. If one travels west from Santa Fe, toward Arizona, as O'Keeffe liked to do, one enters a pink and creamy badlands, an almost lunar, even spectral, landscape. O'Keeffe came to love this remote area the most; it was here that she acquired her homes, at Ghost Ranch and in Abiquiu.

O'Keeffe also responded to the promise of good air in New Mexico, for her health in these years was unstable; from her letters we know that she worried about it constantly. Like many others, she attributed her well-being in the Southwest to the high-desert air. For the very ill, especially the tubercular, well-known sanatoriums at an altitude of six to seven thousand feet there offered effective places for healing. Some of the area's important writers, artists, and architects first became acquainted with the region as medical patients.

But for many who came there, particularly those who managed the Fred Harvey Company and the Santa Fe Railroad, the agencies most responsible for publicizing and organizing tourist and commercial trade throughout the area, the air, weather, wide-open spaces, and healthy outdoor living were ancillary to the main feature: two cultures that had sustained strong identities unassimilated to Anglo-American ways (Fig. 222).[41] The Native American and Hispanic populations gave the region a cultural mix and an exoticism that appealed to tastes for the primitive and the antimodern. In New Mexico it was possible to have dramatic cross-cultural encounters no longer available elsewhere in North America. As the anthropologist Sylvia Rodriguez explains, it was not the Indians' and Hispanos' resistance to modernization that made them hold on to their traditions so much as their geographic isolation from economic and educational opportunities. New Mexico was poor, a "refuge region," where ethnic groups lived in enclaves, often segregated from others because they had neither economic parity nor access to wealth, development, and power.[42]

The Pueblo Indians had always based their

Fig. 222. Behn, *Taos Indian Detour—3 days*, 1930.

Fig. 223. Church of San Francisco de Asis,
Ranchos de Taos, 1990.

economy on agriculture and the raising of animals, and they had lived on the same lands for hundreds of years. Having descended from the Anasazi who lived over a thousand years ago, they are some of the oldest inhabitants in the Americas. In the early twentieth century visitors were lured and engaged by their antiquity, which, because it was on American soil, could be packaged and promoted as America's own Greece and Rome; and it was. On their land in Taos, the Indians still maintain one of the largest and oldest multistoried adobe buildings in the world (see Fig. 231). Self-governing and non-nomadic, living on their original village sites, now government reservations, in the upper Rio Grande, these indigenous peoples offered what was often visitors' first knowledge of medicinal, religious, and tribal rituals, and their initiation into native world-views. The pueblo villages opened their feast days and dances to the public, giving locals, tourists, and scholars a sense of encountering the deep past that seemed intimate and authentic.[43]

Visitors were also attracted to the old adobe churches, some in the small Hispanic villages, others on the reservations. The Catholic Spanish presence in New Mexico permeates everyday culture: it is found in the use of adobe brick and wooden beam construction in the churches (Fig. 223); the dusty, unpaved plazas that are in every town center; the cemeteries dense with wooden monuments and artificial flowers; and the crosses, large and small, homemade and commissioned, along the roads. These crosses, O'Keeffe characterized as "a thin dark veil of the Catholic Church spread over the Mexico landscape."[44] The most extreme religious practices, fascinating even to those who grow up in the area, are the activities of the very old Penitente sects, secret male societies that openly flagellate themselves and reenact the Crucifixion at Easter time. The Hispanic presence in New Mexico also offers distinctive forms of art, in weaving, wood-carved furniture, and religious figures. By the end of the nineteenth century rugs were being traded by Hispanic weavers, as well as by Amerindians, and by the 1920s the Catholic tradition of hand-carved religious artifacts such as the santos was attracting collectors and serious study.

The seemingly "authentic" character of this bicultural landscape attracted the Anglo-American residents, a third culture, whose members first arrived in the late 1840s and 1850s as merchants and soldiers and by 1900 included a number of tourists as well as scholars and artists, many of whom came

specifically to study and learn from the two native cultures. By World War I anthropologists and ethnographers had staked out a clear claim to studying the Native Americans in the area, and by 1923 Anglo-American literati had founded the Spanish Colonial Arts Society to preserve the churches and crafts. In the first decade of the century, artist colonies grew, first in Taos and then in Santa Fe, many of their members onetime summer residents who became permanent émigrés.[45] Most of these artists practiced realist styles; Robert Henri and John Sloan spent summers painting the local landscape and genre scenes, while others—Joseph Sharp, Ernest Blumenshein, William Henderson, and Bert Phillips—made their careers as painters of Indians and the local peasantry.

Though many New York modernists shunned such a "foreign" place, a few responded to the southwestern landscape. Some of those who went found enchantment—O'Keeffe was one of them—and some found the enchantment too transparently packaged. The arguments for and against New Mexico as an artist's destination, as they were played out in essays published by the little magazines, were deeply tied to the aesthetic loyalties of their authors. It was a region more seductive for those whose art was inherently a quest for spiritual wholesomeness than for those whose art was directed to machine age modernities.

Indeed, the Southwest, and especially Native American culture, became another divide, like jazz, skyscrapers, or advertising, separating those for whom art spiritually healed the wounds inflicted by modern culture and those for whom it forced an honest confrontation with modern life. This time, however, the arguments were conducted, not across the terrain of contemporary urban culture in Manhattan, but across remote deserts and equally remote ethnic cultures. At stake were not only ideological positions for or against modernity but also the centrality of Manhattan in American artistic culture and the place of American cultures that abided by laws of behavior different from those of fast-paced city dwellers. New Mexico, hundreds of miles from New York, offered any artist who identified the country with engineers and product designers a diametrically opposed set of experiences. The emergence of New Mexico as a site for making modern art raised

new questions about national identity and for some artists turned the quest for an indigenous modernism from the metropolis toward regionalism and alternative community practices.

For many machine age modernists—Duchamp, Demuth, and Stella, as well as Sheeler, whom we look at in the chapter that follows—the Southwest held virtually no appeal; they never went even to visit. But the painter Stuart Davis and the critic Edmund Wilson, both of whom were transatlantic and Manhattan modernists, did travel to New Mexico. Their experiences, so very different from O'Keeffe's, highlight the public debate about the Southwest in high modernist circles. Davis, for instance, went to Santa Fe in 1923 at the urging of his friends John and Dolly Sloan, who had been summer residents for several seasons. He was stymied by the "aura" of the place and its visitor rituals. For four long months he tried to paint the landscape, finally complaining that it simply was too "dominating" and relentless. As a joke he painted a canvas, using gray paints, of the bare electric lightbulb hanging in his room, making light (or taking a dim view) of New Mexico's celebrated luminosity and simultaneously declaring his allegiance to electricity and modern American products (Fig. 224). While this painting forecast his much stronger canvases of Odol bottles and tobacco papers, it also exudes the estrangement he felt in the Southwest, where rusticity, not modernity, and natural light, not brand-name products, were artistically valued. Declaring the Southwest "a place for an ethnologist not an artist," Davis returned to Manhattan.[46]

To the steely eye of Edmund Wilson, who came to New Mexico a few years after Davis, the place was filled with contradictions. In his essays "The Enchanted Forest" and "Indian Corn Dance" he laid out the complexities that an urbanite like himself found there. About the landscape, he was as lyrical as O'Keeffe: "Riding down into one of the high vivid bottoms, soft and greased with green like the palm of the canyon's hand, where the skull of a steer lies white, you gallop through New Mexico sunflowers that, orange and wild, with disheveled petals, are gold-rusting the wide sudden green."[47] The contradictions lay, however, in what people had done to the land. This he documented by pithily describing the types of people he had met—the rancher, the pros-

Fig. 224. Stuart Davis, *Electric Bulb, New Mexico*,
1923. Oil on canvas, 32 × 22 in.

pector, the lumber yard owner, the summer cowboy,
the Hollywood filmmaker, the Ivy League dropout,
the writer, the priest. He spoke to the ways Ameri-
can industry was disturbing traditional patterns of
living on the land but saved his most vicious attack
for Anglos who professed profound connections be-
tween themselves and the local ethnic cultures. In
wickedly funny little profiles of typical Santa Fe and
Taos émigrés and visitors he depicted, not genuine
connections between Anglos and the land, but fools
acting out their western fantasies at dude ranches
and trying to regain their purity of spirit through
contact with the Indians. He spoofed those who af-
fected Indian dress or wore cowboy boots, pistols,
and scarves, or those seeking to join the Penitente
cults "as one of the only really great things left in the
world today." He was especially suspicious of those
Anglos who claimed life-changing experiences
through their contact with dances and ceremonies
at the pueblos. Expressing his own sense of being
an outsider, Wilson coolly marveled at those who
professed to be touched, even redeemed, by native
beliefs. For him, he wrote, Indians were "narrow,
unbusinesslike, incurious, illiterate, unhygienic, un-
scientific," though he seemed to admire their inte-
gration of life, religion, and law. But he felt no sym-
pathy for Anglo cosmopolites who went to pueblo
dances believing "the Indians were in possession of
some sacred key, some integrity, some harmony with
nature, which they, the white Americans, lacked.
And as they watch, they imagine the dancers experi-
encing some profound satisfaction, renewing them-
selves with some draft of the ecstasy of religion or
poetry which they themselves do not know."[48]

Wilson openly challenged the New York modern-
ists, especially those attached to the Stieglitz circle,
for whom New Mexico had become a place of pil-
grimage and inspiration. Marsden Hartley had been
the first initiate. Having painted his *Amerika* series
in Berlin, he had envisioned himself in war paint
long before he had ever met a Native American or
visited a reservation (see Fig. 91). "I find myself
wanting to be an Indian," he had told Stieglitz, writ-
ing from Berlin in 1914, "to paint my face with the
symbols of that race I adore, go to the West and face
the sun forever—that would seem the true expres-
sion of human dignity."[49] In 1918 he went to the
Southwest for real-life experiences (and for cheap
housing and escape from Manhattan).[50] His visit did

not last much longer than a year, but it generated a new series of paintings and four articles passionately extolling the "redman's" dances and feast days.[51]

Hartley's Indianism was a complicated mix of infantilizing, veneration, and activism. He naturally adopted the primitivist stereotypes and rhetoric common in pro-Indian commentary at the time, picturing Indians as a dying race, childlike in their simplicity. At the same time, he defended contemporary Indians against those who characterized them as idle or barbarian and their dances and ritualistic practices against those white authorities who sought to ban them as pagan and uncivilized.[52] His interests went beyond art and artifacts to finding modern-day values in the Pueblo Indians' religion, their attitudes toward the natural world, and their use of their bodies in ritual and dance. In search of authentic experience and his own "Americanness," he began to think of Amerindians as his aesthetic lineage, putting them at the top of the American artist's family tree. They were a "vastly superior" people who, in their simplicity and calm, were "the one American genius we possess." Most important, they were ours. "We have nothing more native at our disposal."[53] He praised the Indians' sense of form and composition, their use of color and rhythm, their athletic bodies, and the aesthetic qualities of their dances. The contemporary artist should pay attention, he urged, especially the "mechanical brained" artist who was tied up with modern industrial culture and insensitive "to the spirit of existence in the things around him."[54]

Hartley was building a bridge to an American past. In 1918–19, when many of his peers, Edmund Wilson included, were bound up in discourses of modernity, Hartley searched out a native genealogy. Like Diego Rivera in Mexico, who was similarly tracing a lineage between modern artists and ancient native cultures, Hartley sought some genealogical connection between modernists like himself and Native Americans, and between Manhattan and another part of the country. While Rivera would make a lifelong commitment to promoting such cultural unities, inventing a powerful iconography to bring native and modern cultures into a utopian continuum, Hartley, ever the restless intellect, soon lost his sense of excitement about, and connection with, indigenous culture.

But other artists after him venerated the religios-

ity and spiritual ancestry offered by Native American culture: Rosenfeld, Frank, D. H. Lawrence, Hart Crane, O'Keeffe, Marin, and Strand, among others. When Rosenfeld wrote about witnessing a corn dance on his visit to Santa Fe in 1926, he, like Hartley, felt a kinship between the "ancient" dancers and "modern" men. At the opening of his essay, he momentarily sounded like his friend Edmund Wilson, describing the poverty in Indian communities and the "comic-opera" represented by the "poor audience of neurotic whites and half-poets, anthropologists and curiosity seekers" who went to dances. He then led his reader through a dance, questioning its meaning for urban moderns. How could such a ritual, ancient and soil bound, he wondered, have anything to offer a contemporary nation caught up in industry, skyscrapers, and individualism? But then, as doubt faded into admiration, he located something powerfully American and mystical in the dance. It was profound for him, like "the forces that shaped the earth." In a final paragraph of epiphany, Rosenfeld pictured the dance as uniting modern American industrial man with his spiritual forefathers and inspiring the creation of a new American art. The dance was "not so much the expression of a pueblo affirming tribal unity and dancing for corn as a kiss: the spirit of a country calling through a vanishing old lover to another perhaps just awakening to her beauty."[55]

One of Rosenfeld's intellectual mentors here was certainly D. H. Lawrence, whose writings on America's "oldest" race had tremendous authority at the time, especially for those in the second Stieglitz circle. Lawrence, a passionate and eloquent Indianist, was yet one more European intellectual telling Americans how to think; the promise of a new national arts and letters was in their hands, if only they would cease their adulation of Europe. "To your tents, O America. Listen to your own, don't listen to Europe," he told his readers.[56] Like so many other *transatlantiques*, Lawrence was a cultural nationalist on behalf of a country he barely knew. He saw America's promise in resisting both Europe and the technological and industrial forces that gripped the American land. Deeply antimachine and anticity, an advocate of passionate, eroticized connections between artists and their material, he was one of the very few contemporary European writers Stieglitz urged everyone to read.[57] Lawrence offered Euro-

pean authority to the second circle in the same way that Duchamp served the American machine age-ists. And because his America was not Manhattan but New Mexico, the Southwest, and Mexico, his writings were among those cultural directives that engaged O'Keeffe's interest in the region. "America must turn again to catch the spirit of her own dark, aboriginal continent," he wrote, even before he had firsthand experience of indigenous cultures.[58]

It is symbolically apt that when Lawrence came to this country for the first time, he came into the port of San Francisco, *not* the port of New York, and went straight to Taos. He came in the fall of 1922 at the invitation of Mabel Dodge Luhan, who hoped he would be the start of a writers' and artists' colony in Taos. Luhan worked throughout the 1920s to ful-fill her vision—she even gave property to Lawrence and his wife Frieda in hopes they would stay—but the colony never developed a steady membership. Lawrence spent parts of three years in the South-west and in Mexico.[59] By the time O'Keeffe arrived, he was back in Europe, dying of tuberculosis.

The memory of his magnetic presence lived on at Mabel Dodge Luhan's home for years, and his writ-ings about the "spirit" of this desert landscape and its peoples became a serviceable template for the many modernist artists and writers she helped en-tice to the area. Lawrence, in his prose about New Mexico—sensuous, mystical, revelatory—gave it a cosmology especially appealing to those artists who felt magic and appeal in the Southwest. Not every visiting Anglo found his instruction useful—Ed-mund Wilson thought it hokum—but Lawrence pro-vided, for artists like O'Keeffe, a powerful model in constructing the spirituality of the Southwest out of its land, light, air, and distinctive local populations, especially the Native Americans. O'Keeffe gave per-mission for one of her cross paintings to be used as an illustration for Lawrence's last article about New Mexico, published posthumously in 1931.[60]

Lawrence's succinct essay encapsulates the poetic element that modernists like O'Keeffe used to struc-ture a relationship to New Mexico. Beginning with a description of New Mexico's tawdry Hollywood side—the sombreros and kerchiefs on the tour-ists and pseudo-cowboys—Lawrence's essay aims squarely at both believers like O'Keeffe and skeptics like Wilson. The Anglo costumes and affectations,

Lawrence argued, were only the tinsel-town sur-face. "But break through the shiny sterilized wrap-ping, and actually *touch* the country, and you will never be the same again." Two Lawrencian epipha-nies follow, one based on the "greatness of beauty" of the land and weather, the other, on making con-tact with the Indian—not "the Red Indian as he reveals himself in contact with white civilization," where he can be "thoroughly objectionable," but the essential native person when he shows himself older than the Greeks, the Hindus, and the Egyptians. In his dances and in his races one finds "the oldest re-ligion, a cosmic religion the same for all systems." If modern man could rid himself of his materialist drives and return to this holistic, unmediated con-tact with the cosmos, intimate with earth and sky, then healing could begin. "The sky-scraper will scat-ter on the winds like thistledown, and the genuine America, the America of New Mexico, will start on its course again."[61]

O'Keeffe too described feeling in touch with something profound, something religious, and some-thing ancient and American in Taos. It made her want to work, she said. But like everyone who vis-ited Taos, O'Keeffe had to go through the rituals of first-time visitorship before she could penetrate the "spirit" of this heavily endowed place. It would take time, but eventually she would help invest the re-gion with a character and mystique surpassing the legacy D. H. Lawrence had given the place by the time she arrived.

O'Keeffe got her first lessons in experiencing New Mexico from the same teacher as Lawrence: Mabel Dodge Luhan, who had come to Santa Fe in 1917 and proceeded to carve out a cultural space in Taos specifically for modernists (Fig. 225). She was an in-trepid woman, wealthy and energetic, determined to create a satellite modernist culture twenty-five hun-dred miles from Manhattan. She inevitably reminds historians of Gertrude Stein, who had created a simi-lar community at 27 rue de Fleurus in Paris before the war. A more restless and unpolished intellect than Stein, Luhan was experienced in putting to-gether intellectual communities. She had enter-tained writers and theater personalities at her villa in Florence (1905–12) and conducted a salon in

New York (1913–15) before traveling to Santa Fe. She came to New Mexico at the urging of Maurice Sterne, a painter to whom she was then tenuously married. Finding Santa Fe too populated, Luhan took herself to Taos, a remote village with a large Indian population, reached only after a day of rough driving. She bought a handsome property with a house and outbuildings on the edge of the desert and began to remodel and enlarge the structures in expectation of attracting artists and writers (Fig. 226). She surrounded "the big house," as it was called, with ample guest quarters, so visitors had comfortable places to stay and to work.[62]

Besides being a hostess, Luhan engaged actively in a number of progressive social and artistic causes. Her patronage of modern art and letters was linked to her own desire to lead an unrepressed, sexually open communal life. An advocate of free love—and of sunbathing in the nude—she lived more informally and more out-of-doors in Taos than she had in the East. And she conceived of an artist colony that would take full advantage of the natural setting and the nearby Taos pueblo, with its Indian dances and ceremonies. For Luhan, as for Lawrence, New Mexico was a place of spiritual regeneration, a place to be in touch with nature, to shed all restraints, to lead an open life of the senses. She wrote often about New Mexico, publishing essays and, eventually, a number of books based on her own life and observations. Though many of her visitors eventually found her passions, unpredictability, and lack of focus hard to take, her enthusiasm for New Mexico lured many to Taos who might not have come otherwise. Among them were Leo Stein, Leopold Stokowski, Thornton Wilder, Andrew Dasburg, Hartley, Marin, Paul and Rebecca Strand, Jean Toomer, Willa Cather, Carl Van Vechten, Ansel Adams, D. H. Lawrence, and Georgia O'Keeffe.

"Spirit of place" was Luhan's specialty. Beyond her home on the edge of the Taos desert, the Sangre de Cristo mountains rose up like gigantic sails at sea. Outdoors, at the back of the house, one was alone with the sagebrush under a big sky. In the distance, three wooden crosses in one direction and in another a small adobe morada, the private chapel of a Penitente order, were the only human marks on the landscape (Fig. 227). This easy fusion of nature and religion in an endless backyard resonated with

Fig. 225 (top). Mabel Dodge in Taos, ca. 1917.

Fig. 226 (bottom). *"The Big House," home of Mabel Dodge Luhan*, Taos. Postcard dated 1931.

O'Keeffe and made Luhan's commitment to the area understandable. The property today still exhibits physical beauty and awesome silence, a southwestern variant of the sublime.

Luhan's adobe home offered easy access to the local ethnic cultures. The decor of both the big house and the guest quarters comprised indigenous materials, particularly Spanish arts and crafts, including a museum-quality collection of santos and hand-carved traditional furniture. Luhan was one of several Anglo patrons, most of them women, who worked to keep these arts and crafts traditions alive in the ethnic communities. Modernists adopted the adobe Mission Church of Saint Francis of Assisi, only a few minutes away in the village of Ranchos de Taos, as "their" church, so seemingly abstract and cubist was its 1772 construction (see Fig. 232). A few minutes from the house in another direction, a characteristic local cemetery displayed a profusion of white crosses and stone memorials sunk into the desert sands and embellished, always, with artificial flowers and handmade offerings. Also nearby was the Taos pueblo, with its church and remarkable multistoried main house (see Fig. 231). On a still night, visitors to the Luhan house could hear the sounds of drumming across the desert. Within a few days of her arrival, O'Keeffe had gone to her first dance at the pueblo; she would go to several more that summer. In the Taos plaza, visitors were always struck by the Native American presence, integrated into everyday life. There were native men on the square wrapped in blankets that often left only their eyes visible.

At the Taos pueblo O'Keeffe met Tony Luhan (originally Lujan), Mabel's fourth husband, who left a family on the pueblo when he and Mabel were married in 1923 (Fig. 228). With his classic Native American features, his long braids, his quiet and stoic demeanor, his drumming, and his inability to read and write in English, Tony Luhan made a deep impression on most visitors who stayed at Mabel Luhan's house. When he pulled a blanket around his shoulders, he was like one of Edward Curtis's photographs come alive. Furthermore, when he spoke he seemed, to those who reported hearing him, like a wise man, someone who understood his people and could explain their beliefs to outsiders. For some, Willa Cather and D. H. Lawrence among them, Tony Luhan was an important teacher; he would drive them to Indian sites and explain their meaning. That first summer O'Keeffe found him such a wonderful human being that she wrote more about him in her letters than about any other acquaintance she had made. Indeed, she wrote so movingly

Fig. 227. Cross in Mabel Dodge Luhan's backyard, 1991.

about him to his wife, who was out of town recuper-
ating from a hysterectomy, that Mabel Luhan ac-
cused O'Keeffe of having an affair with him while
she was away.

For all her difficulties as a friend, Luhan offered
O'Keeffe something no one has looked at closely
enough: a social and intellectual space that a woman
created and ran according to her own desires. For
the first time since leaving her family home, where
her mother had been the stronger parent, O'Keeffe
found herself in the presence of a self-sufficient
woman who had complete control over an environ-
ment she had constructed. Furthermore, Luhan was
not the only enterprising and productive woman in
Santa Fe and Taos. These two small communities
abounded in smart and artistic women who were at-
tracted to the area's informality, lack of hierarchies,
and social permissiveness. Such women were "claim-
ing this land which used to be thought of as man's
country," protested the writer Jean Toomer, who
spoke harshly of New Mexico's "female fascism—
strong resourceful women who like the starkness
and the isolation of this country."[63] While surely
Toomer had Luhan in mind, he could also have been
referring to the numerous independent women art-
ists, ethnologists, and collectors who had settled in
northern New Mexico, like Mary Cabot Wheel-
wright, who founded a museum of Native American
art, and Dorothy Dunn, who established the Santa
Fe Indian art school. Santa Fe's first bookstore had
been started by a woman, and writers such as Mary
Austin and Alice Corbin Henderson were conspicu-
ous public figures, as was Willa Cather in the sum-
mer. Frieda Lawrence, D. H. Lawrence's widow,
lived in Taos, as did Lady Dorothy Brett, a London
painter whom the Lawrences had convinced to
come with them to New Mexico and who then
settled there. In New York O'Keeffe had women
friends, such as Anita Pollitzer and Ettie Stett-
heimer, but lived day by day in a man's world; in
New Mexico, where Rebecca Strand was her travel-
ing companion, she found herself in a space where
independent women like her were the natural order
of things.[64] These women surely seemed useful
models to someone who by the late 1920s com-
plained that she had too little autonomy in her own
life and had to modify her schedule to accommodate
Stieglitz's needs and demands. In time O'Keeffe
would emulate Luhan, buying property, building

Fig. 228. Tony Luhan, n.d.

a home and studio in Abiquiu, and maintaining a separate summer house and studio at Ghost Ranch. In New Mexico, O'Keeffe took full charge of her own life.

O'Keeffe had plenty of reasons in the summer of 1929 to fall in love with the high-desert country: Mabel and Tony Luhan, the sky and sunshine, and distance from New York and Stieglitz. She also acquired a new car and learned how to drive, two things Stieglitz had always discouraged. "I like what Mabel has dug up out of the Earth here with her Indian Tony crown," O'Keeffe wrote back East, conjuring up a half-peasant, half-Wagnerian Mabel Luhan, wearing her Indian husband headdress the way the Valkyrie wear their Nordic horns and sinking her earth goddess hands deep into southwestern soil. Even if O'Keeffe had little sympathy for Luhan's zealousness, she admired her for getting into the place and growing something. "No one who hasn't seen her at it can know much about this Taos Myth —It is just unbelievable—One perfect day after another."[65]

The following summer O'Keeffe returned to live in Luhan's guest quarters. By the third summer, however, when living there had become as crowded and psychologically demanding as being at Lake George, she found more private quarters. By then she had completed her initiation to the area. But how to paint what she found there? How to get beneath the tinsel of New Mexico, as Lawrence had done in his writing? After her first three summers, and many paintings of her new "place," she was still asking the question. "To me it seems to be a painters [sic] country but God knows nothing worth speaking of has come out of it."[66]

O'Keeffe, like all modernists in the Stieglitz circle, worried about being literal or illustrative in painting and not abstract or spiritual enough. This worry readily surfaced in Taos and Santa Fe, where a dense concentration of realist artists indulged— from a modernist's perspective—in the picturesque and the romantic. Some of the Anglo artists who had settled in New Mexico painted the landscape and some the local architecture, but most painted the ceremonies, rituals, and portraits of Indians or Hispanics in native dress. The members of the Taos Society of Artists, established in 1912—academically

trained bohemian males—were particularly well known for such studies. They represented Indians from the pueblo making pottery, playing the flute, drumming, stringing corn, or performing their dances. Hispanic women were pictured in black shawls and men in straw sombreros. They posed with attributes of Catholic piety: a santos on the wall behind them, a rosary in hand, a church in the background. Artists also portrayed the processions and flagellations of the ancient Penitente sect at Easter time. Rendered with the loose brushwork and high-keyed colors of the impressionists, these canvases collectively attracted buyers and tourists, transforming dusty and quiet Taos into a developing center for the arts (see Fig. 251).

Very few artists could resist the "mystical nonsense of God, the Indian and the good dark earth," as one of them put it.[67] And very few depicted the considerable presence of Anglo culture in New Mexico. The rarity of a social commentary like that in John Sloan's etching *Indian Detour* of 1927, depicting the white tourist trade descending like vultures on a dancer, and his unusual genre scenes of artists and their friends on picnics underline the degree to which Anglo artists interpreted New Mexico as Indian and Hispanic (Fig. 229).

O'Keeffe was drawn as much as others to the constructed romance around Indianness and Spanishness. Though she certainly knew the work of the "Indian painters" of Taos, she had little in common with them and had never been committed to figure painting. But what alternatives were there in Taos for a modernist artist who had made her reputation with paintings of flowers and skyscrapers? One of her most powerful paintings her first summer might have been done at Lake George as easily as in Taos: it was a tall pine tree that soared into the sky outside the mountain cabin where D. H. Lawrence had lived (Fig. 230).

The other work of the first two summers is touristic enough in subject to suggest that O'Keeffe was accurate when she reported that it "took time" to get into a new place. She had to work her way through the obvious picture-making sites before she could get beneath the surface of this foreign landscape. She gravitated toward the landmarks already identified and worked over by earlier painters and photographers. The first summer she painted the desert, the mountains, and the Penitente crosses behind

Fig. 229 (right). John Sloan,
Indian Detour, 1927.
Etching, 6 × 7 ¼ in.

Fig. 230 (below). Georgia O'Keeffe,
The Lawrence Tree, 1929.
Oil on canvas, 31 1⁄16 × 39 3⁄16 in.

Fig. 231. Georgia O'Keeffe, *Taos Pueblo*, 1929.
Oil on canvas, 24 × 40 in.

Mabel Dodge Luhan's spacious hacienda, where she had her studio (see Fig. 237). Once she had learned to drive, she also painted the crosses and desert landscapes of nearby towns and the local landmarks that every visitor went to see: the famous three-story-high pueblo at Taos and views of Ranchos de Taos church (Figs. 231, 232). Artists who "spend any time in Taos have to paint it," O'Keeffe said of the church, which she, like most artists, preferred when seen from the back, where the buttresses make abstract forms.[68] She also tried to paint Indian dances, straining to avoid specifics while evoking their spirit through abstractions, drawing from the costumes, the dance rhythms, the sun, and the sky. The two resulting canvases—one is called *At the Rodeo, New Mexico*—are so elusive in their references that she never repeated the experiment (Fig. 233). And she made a few small still lifes based on local artifacts: a wooden santos of the Virgin Mary (probably from Mabel Dodge Luhan's collection) (Fig. 234) and another of a yellow cactus flower.

In painting the work of local artisans and craftspeople, O'Keeffe was following in the footsteps of Hartley, B. J. O. Nordfeldt, Raymond Jonson, Bert Phillips, and others who had popularized the southwestern still life (Fig. 235). Such paintings depicted objects native to the area, particularly religious or craft objects made by Indians and Hispanics. The usual setups included a santo, a blanket or shawl, a piece of Indian pottery, and perhaps a flower or plant, grouped in a quasi-Cézannesque fashion on a tilted tabletop with abrupt scale changes between objects.

Fig. 232 (facing, top). Georgia O'Keeffe, *Ranchos Church No. 1*, 1929. Oil on canvas, 18¾ × 24 in.

Fig. 233 (facing, right). Georgia O'Keeffe, *At the Rodeo—New Mexico*, 1929. Oil on canvas, 40 × 30 in.

Fig. 234 (facing, left). Georgia O'Keeffe, *Wooden Virgin*, 1929. Oil on canvas, 23¼ × 10⅛ in.

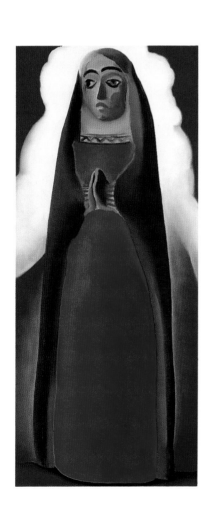

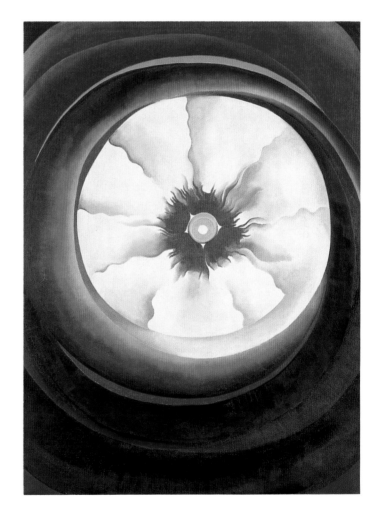

Fig. 235. Marsden Hartley, *El Santo*, 1919.
Oil on canvas, 36 × 32 in.

Arranging a number of indigenous objects together on a table was so much the order of the day that when O'Keeffe chose to paint a *single* santo, a wooden virgin, against a sky from a very close vantage point or, as she did two years later, a single kachina doll against a draped blanket, she was moving toward what would become her own way of making a southwestern still life: one solitary artifact with abstract and allusive references to other regional characteristics (Fig. 236). She tried out this minimalist principle in the four paintings of Christian crosses that she made her first summer in New Mexico.[69] Something of a hybrid between still life and landscape, the cross paintings each present a single artifact with a generalized southwestern landscape of abstracted hills and mesas in the background (Fig. 237).

The common sight of Penitente crosses set against an open rural landscape in New Mexico serves as a constant reminder of the Catholic church's decisive hand in shaping this area's culture. One feels in them the early missionary presence, especially on the Indian pueblos, where the churches and crosses were imposed on native communities many centuries ago. It is not surprising that O'Keeffe, raised a Catholic though she now had no religious practice, would have been attracted by these ubiquitous monuments that rise up from the landscape without warning. During her first New Mexico summer, she painted crosses much as she had painted skyscrapers in New York: as unitary artifacts that encapsulated spirit of place. If a single skyscraper might epitomize the excessive modernity and economic drive of Manhattan, a single cross could represent the religiosity and earth worship that were the Southwest.

In painting the crosses, O'Keeffe used rhetorical strategies she had perfected in her earlier paintings (see Fig. 237). She dramatized them by painting them in intense whites, grays, or blacks, associating them with ghostly spirits, priests, and death. The landscapes behind the crosses are summary and synoptic but rendered with a suggestion of light, both natural and holy, emanating from the hills. Sometimes light arises eerily from the cross itself. As with her flower and skyscraper paintings, O'Keeffe, as if with a zoom lens, moved her viewer unnaturally close to each cross, placing it on a frontal plane.

Although the viewer's eyes sometimes encounter the artifact at a point that seems much too high, magically, the artifact and the background stay in focus. The experience is wondrous, defying nature, giving us an equivalent to the spiritual life O'Keeffe was beginning to identify as the Southwest's salient feature.

Though these works are powerful, O'Keeffe did not paint single crosses of the Southwest again after that first summer.[70] She would paint a cross occasionally on a church, but not as an individual artifact. Crosses must have come to feel too specifically religious, too obviously Catholic, and too easy a reading of the Southwest. Painting crosses, O'Keeffe risked being picturesque, even exploitative, like so many Anglo artists in the area who spent their time painting the quaintness and piety of others. But it is in these hesitant beginnings that we find the first play of ideas that led her to still lifes of a single bone or skull, an invention that fused her secular ecstasy in the high-desert country with her modernist's deep reverence for the religiosity of the Pueblo Indians and Hispanic Catholics.

During her visit to New Mexico in 1930, her second and much shorter summer there, O'Keeffe again painted the ranchos church, but she spent most of her time painting landscapes, as if searching for an indirect way to express her deepening sense of the Southwest. She now broadened her considerations to include the mesas, hills, and deserts. She traveled a lot in the region, discovering and painting the hills and yellow and red cliffs near Abiquiu that would someday become the landscape she lived in and made so much her own.

Feeling as if she were on the verge of something big, she told others how much she hated to leave New Mexico that summer, knowing that the spell would break once she returned to the trees and greenness of Lake George. In her frustration at having to go back to New York just as she was beginning to get a "feel" for the desert, O'Keeffe did something unusual. She packed a barrel of sun-bleached cow and horse bones that she had picked up in the desert and sent it to herself at Lake George, along with at least one Native American ceremonial blanket and some cloth flowers that local Hispanic women wore in their hair and used as decorations on grave sites.[71] She hoped they might enable her to

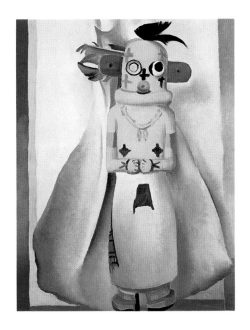

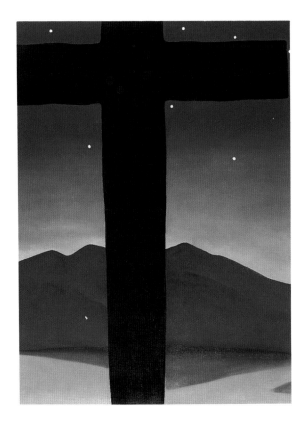

Fig. 236 (top). Georgia O'Keeffe, *Kachina*, 1931. Oil on wood panel, 20 5/8 × 16 in.

Fig. 237 (bottom). Georgia O'Keeffe, *Cross with Stars and Blue*, 1929. Oil on canvas, 40 × 30 in.

keep painting the desert, even amid the lush vegetation of Lake George or the behemoth skyscrapers of New York City.

When Stieglitz saw her new treasures, he was intrigued enough to want to make formal portraits of O'Keeffe with the bones and the blanket. His photographs are remarkable. Four of them represent O'Keeffe playing Indian, wrapping a blanket around herself as the Taos men did—and clarifying that it was this blanket, or one like it, that she used as inspiration for the background of *Cow's Skull—Red, White and Blue* (Fig. 238; see Fig. 219). Others describe her in somewhat strained positions, leaning against the window frame of the Shanty, as they called the small building, and holding the cow's skull she would use in her still life (Fig. 239). Three others show her hands caressing a horse's skull (Fig. 240). In this last set Stieglitz was creating a kind of bone still life at the same time O'Keeffe seems to have begun painting hers, but he never repeated what clearly became her subject and her territory. Stieglitz, now with a heart condition, and not fond of travel, never visited the Southwest.

That fall of 1930 and throughout 1931 O'Keeffe invented her animal bone still lifes, a genre she found so successful that she would work and rework it for the next twenty-five years. The state of New York, of all places, became the birth site of her southwestern bone still lifes, and she continued to paint New Mexico still lifes there. In 1938 *Life* magazine ran a picture essay on O'Keeffe's finding bones and carcasses on the desert, hanging them on her Manhattan penthouse roof, and painting them in her city studio (Fig. 241). By then O'Keeffe had also draped Navajo rugs and blankets over the chairs at the Lake George farmhouse.[72]

Earlier painters like Albert Bierstadt and Frederic Remington had no compunctions about painting the West in their East Coast studios, but the practice is startling for O'Keeffe, who had such high regard for working out of a direct and immediate experience of place. She liked to paint on site *sur le motif* and drew inspiration from specific places. To learn that she painted her Southwests while living amid skyscrapers is a useful corrective, revealing something of the mystique of second-circle theories when they are held up to the light of practice. It also bespeaks O'Keeffe's growing frustrations with her

life, her New York work, and her domestic situation. In 1932 she would collapse and suffer a nervous breakdown. With hindsight painting New Mexico bones in a New York high-rise looks like the desperate move of a woman determined to move her paintings into a new register, different from that of anyone else in her circle. She sought artistic independence and distance from her former dependencies. It can hardly be coincidence that in 1927 Stieglitz took once again to photographing skyscrapers, a subject she now left behind. The art works of both partners acted out their deepening psychological separation and pointed toward the new chapter in O'Keeffe's life and art.

O'Keeffe made animal bones her personal theme as she had flowers and leaves. Bones were secular, free for the taking, and as much an Anglo artifact as an Indian or a Hispanic one. They were also portable; she could mail them back to herself on the other side of the country. She began to collect good bone specimens on her desert walks the way others in the Southwest hunted for santos or kachina dolls. She hung them on her walls and brought them into the studio to concoct her still lifes. We need now to look at how her manipulation of this new subject matter reworked well-established European and American literary and artistic tropes. For unless we understand that bleached animal bones were established as sign systems for meditations about death, ascetic sainthood, the American West, and the American Indian, it is difficult to recapture O'Keeffe's manipulations as well as her dependencies. O'Keeffe did not invent the subject of bones in art so much as she rescued it from clichéd meanings and reinvigorated ideas circulating in her culture. She also depended upon the clichés to help her convey what she took to be New Mexico's special sense of place.

Fig. 238 (facing, left). Alfred Stieglitz, *Georgia O'Keeffe: A Portrait*, 1930. Gelatin silver print, $9\,{}^3/_8 \times 7\,{}^5/_{16}$ in.

Fig. 239 (facing, top right). Alfred Stieglitz, *Georgia O'Keeffe: A Portrait—With Cow Skull*, 1931. Gelatin silver print, $9\,{}^5/_{16} \times 7\,{}^3/_8$ in.

Fig. 240 (facing, bottom right). Alfred Stieglitz, *Georgia O'Keeffe: A Portrait—Hands and Bones*, 1930. Gelatin silver print, $7\,{}^1/_2 \times 9\,{}^3/_8$ in.

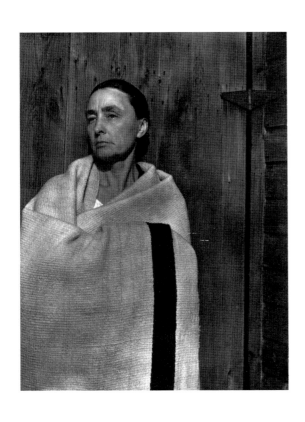

GEORGIA O'KEEFFE TURNS DEAD BONES TO LIVE ART

The horse's skull and pink rose pictured in color on the opposite page may strike some people as strangely curious art. Yet because it was painted by Georgia O'Keeffe, whom they consider a master of design and color, American experts, collectors and connoisseurs will vehemently assure the doubters that it is a thing of real beauty and rare worth.

O'Keeffe's magnificent sense of composition and subtle gradations of color on such ordinarily simple subjects as leaves and bones have made her the best-known woman painter in America today. As such she commands her price. At an art sale O'Keeffe's *Horse's Head with Pink Rose* would bring approximately $5,000. A collector once paid $25,000 for a series of five small O'Keeffe lilies. Elizabeth Arden, the beautician, commissioned O'Keeffe to paint a flower piece for $10,000 last year. Art Critic Lewis Mumford has called her "the most original painter in America today." The Whitney Museum, The Museum of Modern Art, the Brooklyn Museum, the Detroit Institute of Arts, the Cleveland Museum of Art, and the Phillips Memorial Gallery in Washington, D. C. are proud to hang her paintings in their permanent collections. The color reproductions on the following pages include several from a portfolio of twelve O'Keeffes which Knight Publishers issued in November at $50 per copy.

Georgia O'Keeffe was born in 1887 in Sun Prairie, Wis. Her father was Irish, her mother Hungarian. She grew up in Virginia, attended art school in Chicago and New York, gave up painting in 1906 to spend the next ten years working for advertising agencies and teaching art. Her first show occurred in New York in 1916. Since then her talent for painting flowers with great sexy involutions and her flair for collecting ordinary objects and turning them into extraordinary compositions have made her famous.

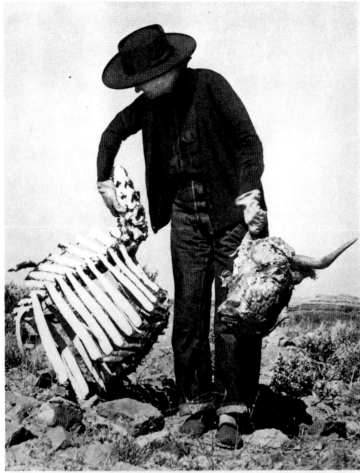

IN NEW MEXICO O'KEEFFE GETS MATERIAL FOR A STILL LIFE BY LUGGING HOME A COW'S SKELETON

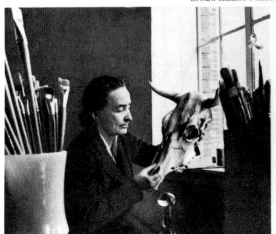

As long as there is light, O'Keeffe paints steadily all day. Here she pastes back a piece of the fragile skull which has broken off. Her best friends call her O'Keeffe, not Georgia.

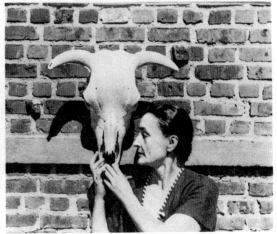

On her penthouse roof in New York O'Keeffe keeps this steer's skull bleached in the sun. She looks upon skulls not in terms of death but in terms of their fine composition.

Fig. 242. Alfred Stieglitz, *Georgia O'Keeffe: A Portrait—Exhibition at An American Place*, 1932 or 1933. Installation view. Gelatin silver print, $7^5/_{16} \times 9^7/_{16}$ in.

The critics took notice when O'Keeffe included her paintings of animal bones among the thirty-three new works in her annual exhibition that opened at An American Place on December 27, 1931. Although O'Keeffe had included southwestern works in two earlier exhibitions, this was the first thoroughly "New Mexico" show. An installation photograph showing *Cow's Skull—Red, White and Blue* in the center of one wall suggests how dramatically O'Keeffe announced her new subject (Fig. 242). There was no checklist, but one critic reported a "half dozen" bone paintings.[73] The reviewer for the *New York Times* noted that after each summer in New Mexico O'Keeffe showed something "strikingly new." When she first came back from New Mexico with paintings of crosses, in 1929, someone, he wrote, suspected "that the artist had 'got' religion down there in the desert of the Southwest. This year

Fig. 241 (facing). "Georgia O'Keeffe Turns Dead Bones to Live Art." From *Life* magazine, Feb. 14, 1938, p. 28, illustrated with photographs by Ansel Adams, Kurt Severin, and Carl Van Vechten.

[1931] the departure represents bleached bones and skulls of horses and cattle."[74] The titles accompanying photographs of the skull still lifes that newspapers ran alongside their reviews were ponderous: surely Stieglitz invented them, for they are in his literary and symbolist style; O'Keeffe usually took a short descriptive approach to titles. One newspaper titled *Cow's Skull—Red, White and Blue* "Death and Transformation," and another called it "Life and Transformation." A painting of a horse's skull with a flower on its head, now known as *Horse's Skull with Pink Rose*, was called "Life and Death," the same title Stieglitz had used for a photograph he made of a leafless tree reaching into the sky (Fig. 243).[75]

Such metaphysical titles, reminiscent of Richard Strauss's title for his musical composition *Death and Transfiguration* (1889), provide insight into one set of meanings that the paintings evoked in Stieglitz and others: they were seen as modern paintings reviving older European traditions where bones served as religious and philosophical meditations upon life and death. They made viewers think of the vanitas or memento mori pictorial tradition where a

human skull in a still life reminded viewers that no one is immortal; all lives end in death (Fig. 244). The skulls were also remembered as the attributes of holy men like Saint Francis or philosophers like Democritus who retreated to meditate in the desert (Fig. 245). When an old master like Salvator Rosa pictured Democritus in the desert, he put animal bones at the philosopher's feet as a sign of his having secluded himself from civilization, represented by the worldly goods he is shown turning from and rejecting. Bones also spelled out the strangeness of the desert where such recluses often retreated. From the Renaissance on, artists had used a sprinkling of sun-dried bones, both animal and human, on parched, dry land to convey the inhospitable wilderness of the desert, particularly that of the Middle East.

With such venerable traditions in mind, critics struggled to picture O'Keeffe in new terms; these paintings, however, threw them off track. They did not know how to talk about them. Paul Rosenfeld, who had always written lyrically and profusely about the erotic and female elements in O'Keeffe's works, published what was for him a terse review in which he looked at the landscapes but avoided any mention of the bone paintings. It was as if he did not know how to reconcile femaleness with the skulls. He characterized O'Keeffe instead as changed, newly ascetic, "a veritable modern Fra Angelico or Suor Angelica." There was "new detachment" in her paintings, he wrote, and "a large, serene, tragic and enthusiastic feeling of life."[76] Henry McBride also wrote of O'Keeffe as a "lady" philosopher brooding on the meaning of life and death. But his review was so tongue-in-cheek that it bordered on sarcasm. The title of his review announced: "Skeletons on the Plain: Miss O'Keeffe Returns from the West with Grewsome Trophies." O'Keeffe, he wrote, "ruminates upon the theme with the perversity of a Hamlet at the grave of Ophelia." He then spent a paragraph wondering, somewhat aimlessly, what class of horses these skulls had belonged to in life—perhaps the "steeds of gallant young Indian warriors" or perhaps just "street-car hacks consigned to worse and worse tasks and finally dying of prosaic starvation." McBride observed in puzzlement that O'Keeffe had added flowers to the skulls: "Why? Miss O'Keeffe is a decorator. Also, possibly, a philosopher. To this

Fig. 243. Georgia O'Keeffe, *Horse's Skull with Pink Rose*, 1931. Oil on canvas, 40 × 30 in.

state, athlete or hack, do we all come, says she. And it's not so bad, she adds. It's even pretty."[77]

In his silly concern about which kind of horse the skulls belonged to, and whether O'Keeffe was a decorator or philosopher, McBride expressed his discomfort with the novelty of these new works and with the woman's hand that had painted them. He found the skulls difficult to assess yet could not dismiss them entirely. "It's not every lady who can go so far," he wrote, wondering if women, whom he considered O'Keeffe's main followers, would pursue her into "the new cult." Maybe, he suggested, these paintings would draw men to them. "Anything about horses interests horsemen. Anyway, there is cause for suspicion that Miss O'Keeffe's clientele is changing its sex. And that, as they say, would be news."[78] He continued his antics, half-teasing, half-serious, making clear his difficulty in understanding why a woman would venture into such a seemingly non-female subject.

Such a reception is fascinating, for it shows critics, even those close to the second circle, awkwardly trying to explain works that they could not read through their usual gendered lenses. There were no precedents, as there were for flowers, to connect women to bones. The best the critics could do was to assume that O'Keeffe was changing character, becoming an artist-philosopher or nun rather than expressing her sexual nature. These reviews were among the first signs that O'Keeffe's public persona was in transition; the Woman Artist of Manhattan was on her way to becoming Saint Georgia of New Mexico.

Once again, O'Keeffe was unhappy with the reviewers' interpretation of her work. "More nonsense has been written about the alleged life and death symbolism in my skull and flower paintings than I care to remember," she would later complain.[79] From the beginning, O'Keeffe consistently claimed that the skull works were about place and region, a set of associations difficult for people like McBride and Stieglitz, who had never been to the desert. In 1930 McBride asked O'Keeffe about her crosses, and she replied: "Anyone who doesn't feel the crosses simply doesn't get that country."[80] Similarly, in 1931 she told a reporter that the new skull paintings "express what I feel about the desert."[81] Yet another critic, Elizabeth McCausland, who

Fig. 244 (top). Philippe de Champaigne, *Still Life or Vanitas* (tulip, skull, and hour glass), n.d. Oil on panel, 11¼ × 14¾ in.

Fig. 245 (bottom). Salvator Rosa, *Democritus in Meditation on the Ending of All Things*, 1650–51. Oil on canvas, 135⁷⁄₁₆ × 84¼ in.

knew O'Keeffe personally, wrote that O'Keeffe, if asked, would reply that these "relics of death coupled with the flowers Mexicans use impartially for weddings and funerals are New Mexico for her."[82] As the artist explained once again in 1939: "I have wanted to paint the desert and I haven't known how. I always think that I can not stay with it long enough. So I brought home the bleached bones as my symbols of the desert. To me they are as beautiful as anything I know."[83]

In calling her bones "symbols of the desert," O'Keeffe placed her works in a symbol system and context that Stieglitz and her New York critics missed completely. They looked east to Europe and the old masters, whereas O'Keeffe, who had no Europe in her background, looked west and to popular tropes of the American desert. She had taught in the Texas panhandle and recalled fondly the Wild West stories her mother had read to her as a child. It was in her youth that the American frontier was declared closed, and an artistic and literary romanticism about the Old West found its way into popular American culture through the Buffalo Bill Wild West Show, Frederic Remington's and Charles

Russell's paintings, Owen Wister's western novels, and the Brandywine circle's magazine illustrations. In many of these pictorial forms, American artists domesticated the old master tradition of bones as signs for the Middle Eastern desert and converted them into regional shorthand for the old American West. They were not a schema for a particular *place* in the West, such as the badlands or the plains, just a generic attribute Americans (most of whom lived in the East) assigned to the *space* of the West: its relentless heat and physical demands and its wildness and lack of cultivation. We can see this trope at work in John Gast's painting *American Progress* (1872), which diagrams the march of civilization from east to west and from right to left (Fig. 246). On the right, where progress begins, is Manhattan, a bustling city, while on the left is the West, depicted as barren land awaiting the white man's arrival and development. The telltales of this barrenness are small clumps of bleached bones among the fleeing Indians and buffalo.

By the turn of the century a few bones scattered prominently in the prairie grass, most often with a buffalo skull in the foreground, where it was

Fig. 246. John Gast, *American Progress*, 1872.
Oil on canvas, 12¾ × 16¾ in.

eye-catching and self-consciously idiomatic, had
become stock-in-trade for the cowboy-and-Indian
painters such as Russell and Remington (Fig. 247).
Such a detail assured that there was no mistaking
where this scene was being enacted. These paint-
ings, created in Manhattan studios as often as in
Montana, were antimodern and antiurban, the art-
ists rejecting their own moment and culture for an
imaginary yesterday when it seemed the world was
simpler and the battle for good over evil clearer and
more decisive. Bleached animal bones not only situ-
ated the action in a certain region but also served as
a metaphor for the death and passing of the old West.

The buffalo skull became a powerful old West
metaphor because most Americans knew something
about the slaughter of these beasts, once numbering
in the millions. Their days of roaming the western
grasslands were over by the 1870s, yet their skele-
tons remained. Indeed, it is fair to say that by 1900
any image of the buffalo, represented as living or
dead—as a body or as a skeleton—encoded a mel-
ancholy message of death and extinction. Anglo-
European culture linked that same message with
the fate of the American Indian: buffalo were not
the only dying species associated with the West. In
an era when whites viewed Indians through a social
Darwinian lens as primitive peoples failing to sur-
vive the inexorable forces of modernization, paint-
ers and writers adopted the popular cant, represent-
ing the buffalo and the Native American as similarly
"doomed" and "vanishing." A buffalo skull—or a car-
cass—in a painting about Indians, then, served as
an elegy not only for an animal species but also for a
race of humans.[84]

The buffalo skull acquired such metaphoric
power by a complex process that affected many sec-
tors of popular and high culture. That it was an ideo-
logical and imaginative fabrication, there can be no
doubt. We need only compare the evocative use of
the buffalo skull in paintings by Albert Bierstadt and
Henry Farny, for instance, with the prosaic pile of
skulls in a contemporary photograph to grasp the ex-
traordinary liberties painters and writers took in ren-
dering their views of the West. In the piles of bones,
the bone pickers, and nearby boxcar documented
in the photograph, we can read the history of com-
merce and greed that virtually destroyed the species
(Fig. 248). First came the hide hunters, who left the
carcasses behind to rot and dry in the sun. The bone

Fig. 247 (top). Frederic Remington, *On the Southern
Plains*, 1907. Oil on canvas, 30⅛ × 51⅛ in.

Fig. 248 (bottom). Buell (photographer), Buffalo bones
ready for loading on Canadian Pacific Railroad boxcar,
Moose Jaw, Sask., ca. late 1880s.

hunters and workers followed. Here they matter-of-factly prepare their booty to ship east, where the bones and horns will be turned into buttons, combs, knife handles, fertilizer, and glue.[85] This was the last stage in the demise of the buffalo in the West, for soon after 1900 there were no more bones to pick.

Out of these harsh facts, however, painters constructed epic and tragedy. In Bierstadt's *The Last of the Buffalo* skulls are neither prairie litter nor commercial goods but pictorial incantations to recall both the noble buffalo and the noble savage (Fig. 249). An Indian warrior and his pony lie dying among the wounded buffalo in the foreground, while in the center a mounted warrior and a charging buffalo intertwine in a fight for life. Both are doomed. The inevitability of their extinction is underlined in the prominent still life of skulls and bones carefully arranged so that we look into the dark holes of their eye sockets just as we must also look into the sad and listless eyes of the dying animals in the foreground. This is the stuff of tragedy: the beautiful and majestic creatures that once

ruled the prairies, both the noble savage and the beast, metamorphosing as we scan the canvas into haunting skulls of death.

Bierstadt's younger contemporary Henry Farny also paired the buffalo's fate with that of the Indian, suggesting how common the trope had become by the turn of the century. In *The Song of the Talking Wire* the single buffalo skull in the background signifies, not just death and the harshness of the terrain, but the entire Indian way of life (Fig. 250). With his ear to the telegraph pole, the Indian in native garb, with his horses and his dead game, is clearly an anachronism. He will never comprehend the white man's technological culture and will go the way of the buffalo. In 1913 when a Native American appeared in profile on one side of the newly minted nickel and a buffalo on the other, the linkage between the two in the American imagination was immortalized.

This fusing of the Indian's fate with that of the buffalo was so pervasive during the years of O'Keeffe's childhood that it would have been impossible for

Fig. 249. Albert Bierstadt, *The Last of the Buffalo*, 1888. Oil on canvas, 71¼ × 119¼ in.

Fig. 250. Henry Farny, *The Song of the Talking Wire*, 1904. Oil on canvas, 22 ⅛ × 40 in.

her not to absorb something of it, given how interested she was in the American West. This convention persisted, moreover, in Taos, where so many of the local artists made careers as painters of Indians. The acknowledged dean of these painters, Joseph Henry Sharp, had been a student of Henry Farny's in Cincinnati before he first visited Taos in 1893 and helped establish its artists' colony "à la Barbizon," as he once wrote a friend.[86] Sharp was knowledgeable about Native American cultures and had a vast collection of Indian artifacts displayed on the walls of his homes and studios (see Fig. 252). He had visited reservations and Indian villages across the country and lived with his wife for eight winters at the Crow Agency in Montana, a town near the Custer Battlefield, before settling year-round in Taos in 1910.

While he could be ethnographic in collecting Indian artifacts and in writing on Indian life, Sharp was anything but scientific in his paintings. Though he knew perfectly well the pronounced differences in dress and customs between the Plains Indians of Montana and the Pueblo natives in Taos, he often blended the dress of one tribe with that of another and intermingled artifacts and aspects of their ceremonies. For him, and for his targeted audience,

Indians were Indians, all of them beautiful but tragic peoples.[87] In Taos he would often make generic "Indian" paintings, asking his local Pueblo models to forgo their own dress for beaded leatherwear he had collected in the North and to perform rituals that were not their own in a tepee of buffalo skin that he had brought from Montana and reconstructed in his Taos studio.

Sharp lamented that "the real, picturesque Indian was fast disappearing," and he often used the buffalo skull that hung on his studio wall as a prop to reprise the vanishing-Indian theme.[88] In *Prayer to the Buffalo* Sharp portrayed an Indian praying before a buffalo skull, drawing on the European tradition of philosophers meditating upon a human skull rather than on any authentic ritual or ceremony (Fig. 251). Some tribes on the Plains erected buffalo shrines. Pueblo tribes, though they did not use the skull in this way, created headdresses of horns and hides for Buffalo Dances, antlers for Deer Dances, and eagles' feathers and beaks for the Eagle Dance (see Fig. 218). For all Sharp's apparent archaeological detail, his paintings, commercially successful, are hodgepodges of fact and fiction, and of Plains Indians and southwestern tribes.

It was the storytelling elements and the costume drama of paintings like those by Sharp and other popular and romantic painters and illustrators of the West in the early century that O'Keeffe avoided in her paintings of animal bones and skulls. She wanted the resonances that artists of the West had attached to bleached bones—of the Indian, the desert, the Wild West, historic America—but not their literalness. As a painter for whom less was always more, O'Keeffe adopted a minimalist approach to painting skulls and bones that mysteriously evokes their cultural meanings without spelling them out. At first she tried painting a skull resting on a blanket, as in the traditional memento mori, but she quickly turned to what became her favored composition, the upright skull hanging or suspended in space. This vertical format referenced yet another

tradition attached to the American West: the habit of sportsmen, collectors, cowboys, and Wild West enthusiasts (including artists) to hang animal heads, antlers, horns, or skulls as decorations on walls and doorways. These were trophies, sometimes gathered on big-game hunts. But in desert country such trophies could come cheap, often as the result of little more than a good walk out among the sagebrush. Taken home, they were shown off in a number of settings, most conspicuous among them the studio of the Anglo artist and the dude ranch.

Photographs suggest that in the 1880s and 1890s artists such as Albert Bierstadt in Dobbs Ferry, on the Hudson River; Joseph Sharp in Cincinnati; and Thomas Hill in Yosemite began to hang skulls on

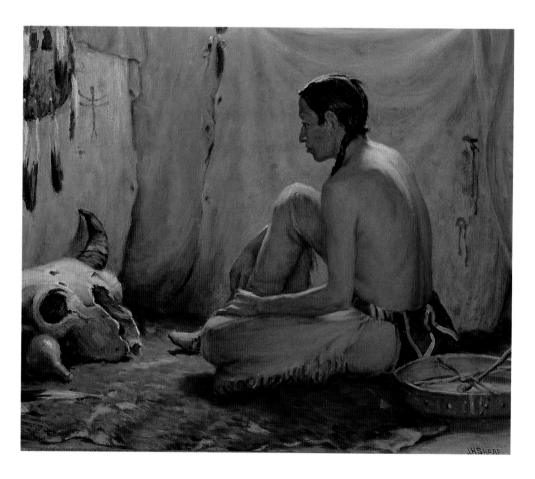

Fig. 251. Joseph Henry Sharp, *Prayer to the Buffalo*, n.d.
Oil on canvas, 20 × 24 in.

Fig. 252. J. H. Sharp with Indian artifacts in his
Taos studio, ca. 1946.

their studio walls alongside other forms of western
memorabilia: animal pelts, antlers, leather and
beaded work, headdresses, moccasins, blankets,
bows and arrows, tomahawks, drums, and some-
times rifles, saddles, and cowboy hats. Such collec-
tions originated in the Gilded Age, when it became
customary for American artists to have large studios,
which served not only as painting spaces but as pub-
lic showplaces for the exotica they had collected on
their travels. Usually they drew their collections
from Europe, the Middle East, and the Orient, as
in William Merritt Chase's famous studio on Tenth
Street in New York. But for painters whose profes-
sional identities were linked to the Wild West, the
collections on the studio walls were drawn from
cowboy-and-Indian culture.

In Taos artists put together a southwestern ver-
sion of the artifact-laden studio, featuring textiles
and pottery they had collected from the local
Pueblo peoples and carvings and pieces of furniture
made by Hispanic artisans. The decorations on such
artifacts were generally more Indian than Spanish
and sometimes, as in the extensive collection of Jo-
seph Sharp, mixed leather and beaded pieces made
by members of northern tribes with blankets and
pottery from the local pueblos (Fig. 252).

A standard prop in these Taos collections was a
buffalo skull, displayed as prominently as if it too
had been crafted by native hands. In photographs
documenting the studios decorated by Walter Ufer,
Bert Phillips, Irving Couse, and Joseph Sharp, the
skull hanging on the wall is as ubiquitous as the

Fig. 253 (top). Will Connell, *Walter Ufer in his Taos studio*, 1932.

Fig. 254 (bottom). Edward A. Kemp, *Entrance to San Gabriel Ranch, Alcalde, New Mexico*, ca. 1925.

piece of native pottery filled with painter's brushes (Fig. 253). The inclusion of a single majestic skull amid the profusion of Indian goods became the "natural" order of things. Like a basket or a piece of pottery, the skull was deemed part of Indian culture and emblematic of a way of life. But because it served symbolic purposes, and was not a precious collectible like the handwork, a collector such as Sharp acquired but a single specimen, which he hung as the centerpiece of his collection. One skull did the trick, locating the collection and the studio space around it through regional references: to the desert, the American West, and the vanishing buffalo and Indian.

Skulls and antlers, when used as decorations on gateways, doorways, and ranch house interior walls, also had strong associations with cowboys, who in rounding up cattle had easy access to good desert finds. Charles Russell, whose early experiences as a ranch hand in Montana gave rise to his public image as Cowboy Painter of America, had a buffalo skull prominently posted by the door to his rustic cabin in Montana. And he used a small ink sketch of a buffalo skull as his signature and trademark. Hung over a doorway, a skull also announced the roughing-it character of a dude ranch. Dude ranches had their heyday after World War I, offering rustic accommodations, simple living, and often spectacular settings to paying guests who wanted to live in open country and experience the life of a cowhand. As often as not these ranches were run by expatriates from the East and offered vacations for urbanites. After two summers at Mabel Dodge Luhan's, O'Keeffe began to rent quarters at a dude ranch. In 1931 she lived in a cottage at the H & M Ranch in Alcalde, a small town halfway between Santa Fe and Taos. The ranch was run by Marie Garland, a well-educated woman from Boston, and her filmmaker husband, both of whom became O'Keeffe's friends.[89] She next moved to the more remote (and more expensive) Ghost Ranch, spectacularly sited in the hollow of magnificent yellow and pink sandstone cliffs; O'Keeffe soon called it home.[90]

As the dude ranch business developed, with ranchers increasingly taking on paying guests, bone decoration became a bit more calculated and deliberate. Together with blankets, hides, and antlers, well-preserved animal skulls would decorate a common room or the cabins where guests lodged. Most

characteristic, however, was the single skull or pair of antlers used as a sign post at the front gate, marking the entrance as that of a ranch. The San Gabriel Ranch in Alcalde had a pair of antlers nailed to the simple wooden entry arch (Fig. 254). And the entrance to Ghost Ranch, where O'Keeffe stayed from 1934 on, was marked very simply "by a cow's skull propped against a rock."[91] By the time Ansel Adams photographed it in the mid-1930s, the skull had been mounted on a pole over a sign for Ghost Ranch (Fig. 255).[92]

As a trophy, then, the single skull (or pair of antlers) functioned in two distinct ways in southwestern Anglo subcultures: as part of a larger collection of Westerniana and as a marker of the desert and of cowboy rusticity. It affirmed the regional identity of artists and cowboys who prided themselves on living under frontier conditions. It was the natural decoration of the desert as the seashell was of the New England coast, an artifact at home in the region but out of place elsewhere. When O'Keeffe began to paint them, skulls and antlers had already found their way into the western saloon as appropriate decorations. They had even migrated to Paris, where a skull was used alongside images of Indians and vaqueros to decorate the facade of the Jockey Club and identify it as an American bar (see Fig. 87). But they were not yet part of the domestic and commercial decorator's trade. They were not yet fashionable; all that would come later. Furthermore, desert trophies belonged to activities conducted predominantly in the male sphere. So comfortable was the skull as a western male symbol that in World War I it was used as a heraldic design on an armed forces badge identifying a division from New Mexico (Fig. 256).[93] Such associations with men's activities made O'Keeffe's appropriation of the object all the more audacious, and confusing to her critics. Perhaps anticipating its capacity to shock, she included in some of her early skull paintings her trademark flowers, as if to soften the transition from her New York work to that of New Mexico. Although she soon eliminated the flowers, they served, for a time, as a grace note of familiarity.

O'Keeffe's skull paintings and the trophy aesthetic share the cultural practice of endowing single desert artifacts with presence by isolating them and ceremoniously centering them in a room or on a gateway. This gave them an aura and associations

Fig. 255 (top). Ansel Adams, *Ghost Ranch*, 1937.

Fig. 256 (bottom). World War I armed forces badge, New Mexico division.

they did not have when dirty, crawling with ants, and half-buried in the sand. Aura brings us back to *Cow's Skull — Red, White and Blue* and a final comparison, this time to a trophy painting, *The Buffalo Head*, by Astley D. M. Cooper (Fig. 257). Cooper's painting gives us as close an encounter with a stuffed trophy head as the one we have with O'Keeffe's cow skull. Both heads are large and vivid, taking up a similar amount of space on identically sized canvases. By looking at the two works side by side, we can understand better how O'Keeffe borrowed from the trophy tradition but also subjected it to a modernist revision that obscured its older narratives.

Cooper's painting belongs to a series of Wild West trompe l'oeil still lifes that followers of William Harnett made in the 1890s and into this century, the peak years of old West fictions as a cultural industry. Invariably at the center of these still lifes was a trophy, usually a big-game head or a pair of antlers, around which the artist arranged hunting weapons and Westerniana. Intended for male viewers in men's spaces, such as saloons and smoking rooms, these paintings unabashedly spelled out masculine stories of hunting, fighting, and conquest.

In Cooper's still life, a particularly dramatic example of the genre, every detail mourns the disappearance of the frontier and its character-building wildness. The buffalo's majestic beauty is summed up in an unblemished taxidermist's specimen, the type prized in the early part of the century by recreational hunters and natural history curators.[94] We cannot miss the point: the head—vivid and lifelike yet hanging on a wall—is dead, the buffalo vanquished. Like the painting itself, the head is not the real thing but a representation of what once was. So too the Indian, whose implements—a tomahawk and a peace pipe—now provide a regal headdress for the buffalo whose fate is so intertwined with his own. Around the head are yet more shadows from the past, old photographs of Indians and their conquerors, all of whom have died. In the pivotal position, tucked into the highest and silkiest hairs of the animal head, is a photograph of Buffalo Bill in military uniform, his handlebar mustache and goatee resembling the horns and beard of the animal he was so famous for hunting. (In his tenure with the Kansas Pacific Railroad he was said to have killed 4,280 buffalo.)[95] His stature as a great Indian fighter is acknowledged by the way the photo nestles into the crossed weapon and peace pipe and is tacked up high and dead center, in the place of honor, looking down on all that he conquered. A second picture of Wild Bill, this time in civilian garb, is at the lower left, near his artist admirer's signature.

Because Cooper takes such care to give his trophies verisimilitude and an implicit narrative, we cannot misread his messages about physical heroism and man's domination over nature. His hyperrealism, which employs a late-nineteenth-century imperialist rhetoric that proclaims one culture's superiority over another, projects a fin-de-siècle sense of unease American men registered at the changes wrought by modernity; one antimodern response was to try and recover an imagined old West where masculinity was unambiguously constructed as physical prowess and heroic actions.[96]

O'Keeffe's *Cow's Skull — Red, White and Blue*, in contrast, did not presume a gendered viewer and did not invoke nostalgia for a heroic past. Her trophy invited her audience, both male and female, in the act of viewing her paintings, to feel alive and well in the present. But she also asked viewers to connect with an old and venerable region of the country. What Cooper worked into a story of western conquest became for O'Keeffe a poetics for a region. She divests her trophy of any moralizing (except, perhaps, that of boosting the Southwest) but holds on to its metaphoric references to the American West. Through her use of equivalents—abstract forms, associative colors, and suggestive light—her painting embraces and references the climate and the landscape of the Southwest as well as the rituals and artifacts of its three populations: the cross and the Crucifixion of Hispanic Catholicism; the dance masks and blankets of native peoples; the sky blue and the ravine-like crack that evoke the landscape; and the skull, itself signifying the desert and its diverse subcultures of Indian, cowboy, priest, and artist. It is a synoptic rhetoric, its associations building on one another to offer a deep reading of place. And then, as a capstone, O'Keeffe floated the idea that this place was America, with her color chord of red, white, and blue.

O'Keeffe's success in reworking the iconography

Fig. 257 (facing). Astley D. M. Cooper, *The Buffalo Head*, ca. 1890. Oil on canvas, 40 × 36 in.

Fig. 258 (top). Malcolm Varon, *Tool and storage shed, O'Keeffe's home, Abiquiu, New Mexico*, 1976.

Fig. 259 (bottom). Todd Webb, *Untitled (Georgia O'Keeffe and Daniel Cotton Rich at Ghost Ranch)*, 1955. Gelatin silver print, 8 × 10 in.

of animal trophies into a modernist idiom gave her a theme she would pursue for the rest of her life. It also led her to collect trophies and use them in her homes as decorations, divested, however, of the usual cowboy-and-Indian associations. When she moved to New Mexico in 1949 after settling Stieglitz's estate and furnished her two homes in Abiquiu and Ghost Ranch, she hung bones, skulls, and antlers on adobe walls just as dude ranchers and male artists of the West had done for several decades. But when she installed them in her homes, she never used them as centerpieces for Indian and Wild West memorabilia (as in the case of Joseph Sharp and Walter Ufer) or as companion pieces for wild animal heads, rifles, and pelts (as was common at dude ranches). Nor did she hang them triumphantly over mantelpieces. She had too many of them to do that. More likely, she placed each bone against an empty wall or on a pole much as she arranged works in Stieglitz's galleries, often off-center, according to some intuitive sense of modern abstract design.[97] Sometimes she hung skulls alone, unaccompanied by other artifacts, to get maximum drama out of the single head gazing mysteriously into space. Sometimes she made them into still lifes, antlers and skulls appearing in casual (even if calculated) arrangements alongside other bones, or with other relics of the natural world that O'Keeffe picked up on her walks and travels: she had a large collection of water-smoothed rocks, as well as shells and pieces of weathered wood, ordered by color, shape, and texture (Fig. 258). While she might include a piece of Indian pottery or a basket, she rigorously eschewed the explicitly ethnic ensemble that members of the Taos Society of Artists had in their studios. The few Indian artifacts O'Keeffe owned, particularly blankets, she used functionally as throws and floor coverings (Fig. 259). On the rare occasion when she did install an Indian piece on the wall, such as the bearclaw necklace Laura Gilpin photographed in her bedroom, it was isolated and alone, installed, like one of her animal skulls, for its independent beauty and evocative power (Fig. 260).

She arranged her treasures with the same economy and simple drama with which she painted them, so much so that photographers quickly saw that they could very easily cut and crop and make their photographs of O'Keeffe's decorations look something like her art. Beginning in the 1950s,

Gilpin, Todd Webb, Eliot Porter, William Clift, and others began to photograph the bones she hung in her home to make their own works of art (Fig. 261). They also began to compose portraits of O'Keeffe holding a bone or posing beside one of her desert trophies. Stieglitz had been the first to sense the power of such imagery when in 1930 he photographed O'Keeffe with a cow's skull (see Figs. 239, 240). As part of his larger composite portrait of his wife, these works convey the emergence of a new O'Keeffe, different from the one he had recorded earlier. Beginning in the mid-1920s, but markedly after 1929, his portrait moved steadily away from her fleshy torso and caressing limbs to picture a more remote, distant, and hermetic figure (Figs. 262, 263). Dressed more severely in black and white, and wearing a dark hood or scarf over her head, she took on an ascetic appearance that eased her public image in a new direction. Stieglitz was the first to propose that O'Keeffe might be nun to his own self-image as priest.

What was nascent in Stieglitz's later photographs of O'Keeffe, as well as in the early reception of her bone paintings, became, over time, a trademark image for O'Keeffe. During the New Mexico half of her life, she rarely posed for a formal portrait except against adobe or the big sky and accompanied by one of her desert skeletons. In photographs by Philippe Halsman, Yousuf Karsh, Arnold Newman, and Todd Webb, among others, images cohere around a uniform iconography, making the bleached desert bone O'Keeffe's special attribute and her public persona that of a contemplative of the desert (Figs. 264–267). Though she never completely shed her mystique as the sensuous woman pouring out her sexuality on paper, New Mexico became the site where she successfully reshaped her public image. The meanings she had revived and reinvented for bones through her paintings now became part of her own lore as an artistic persona, one that merged the nun and the Spanish vaquero with hermit saints in the desert.

Not only was she a willing subject, but she also dressed the part. With her love for natural-colored and simply tailored clothes, she chose cowgirl denim some days, but more often she dressed in black with small touches of white. She wore a variety of hats, hoods, and scarves reminiscent of desert headwear from around the world. With her hair

Fig. 260 (top). Laura Gilpin, *Georgia O'Keeffe Residence*, May–June 1960.

Fig. 261 (bottom). Todd Webb, *On the Portal, Ghost Ranch, Abiquiu*, 1959. Gelatin silver print.

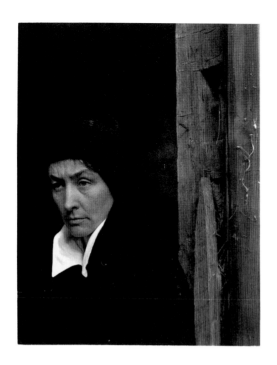

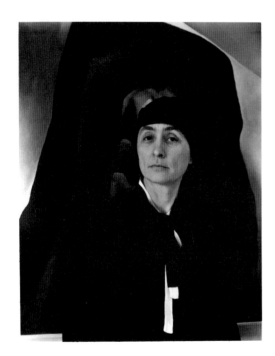

Fig. 262 (top). Alfred Stieglitz, *Georgia O'Keeffe: A Portrait—Head*, 1924. Gelatin silver print, 9½ × 7½ in.

Fig. 263 (bottom). Alfred Stieglitz, *Georgia O'Keeffe: A Portrait—With Painting*, 1930. Gelatin silver print, 9⅜ × 7½ in.

pulled back, and her skin brown and weathered, she increasingly came to look like a native, as at home in this landscape as Native Americans or Hispanics. (As a friend of mine said, her own "good bones" became the subject.) Like a chameleon, borrowing from many different desert traditions, she blended in with the land in a way few Anglos ever managed to do without seeming phony or exploitative. Photographers helped, posing her as a nun in her adobe cell, as a buoyant vaquera, or as a saintly presence walking alone in the desert. Like *Cow's Skull— Red, White and Blue*, her public persona became multicultural in its references but always intensely regional.

In the 1980s when David Bradley, an artist from northern New Mexico, painted his pop art portrait of her, he captured the aura and the presence she had given not just to flowers and bones but, by the end of her life, to herself (Fig. 268). He represented her seated in the desert, painting with a skull nearby. That her pose and dress parody the portrait Whistler made of his mother, once high art but now an overfamiliar and commercialized image, captures what had happened to O'Keeffe. She had become a celebrity icon and an integral part of New Mexican lore and pop culture.

Indeed, O'Keeffe became part of a project she could never have anticipated: she helped invent the idea of the Southwest as a region broken off, as it were, from the rest of the vast American West. As her landscape paintings became known, mesas, lava hills, Penitente crosses, and adobe churches became identified as the Southwest's special terrain. O'Keeffe's bone paintings carried messages about the mixed cultural heritage of the region and her public persona promoted an image of the good and authentic life lived alone on the open land. Today reproductions of her paintings are advertisements for the Santa Fe Opera, and animal bones are a thriving marketplace business throughout the Southwest. It is hard to find bones on the desert anymore but easy to find them at roadside stands or in the shops, cleaned, bleached, and ready to hang on the wall or over the doorway. Today bones serve as a decorator's prop and an essential marker of what is popularly

Fig. 264 (facing). Philippe Halsman, *Georgia O'Keeffe at Her Ranch*, 1948. Gelatin silver print.

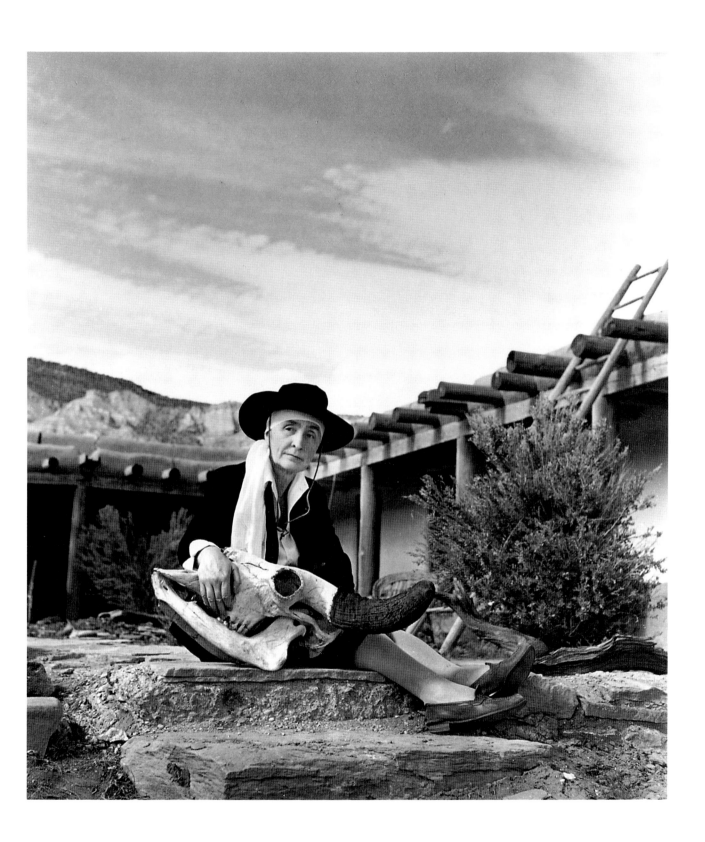

known as the Santa Fe style (Fig. 269). As much as O'Keeffe rescued the representation of bones from turn-of-the-century clichés, she also helped fashion them into new ones. Having cultivated a new regional identity and mythology, she found her art as well as her public persona appropriated and commercialized by them.

One final consideration will conclude this discussion of a milestone painting. This has to do with the red, white, and blue that O'Keeffe wove into it. In a period when modernists were trying to sort out claims for a worthwhile American culture, they used the three colors of the American flag, just as they used a phrase like "Red, White and Blue," or "And the Home of the Brave," or "Home, Sweet Home" to call attention to the self-consciousness of their research and to their ambition, often insecure, to create a homegrown national culture. Such obvious symbols of American pride allowed them to laugh at the thin line between their own efforts to raise the flag on American culture and other people's forms of flag-waving. Demuth, we remember, used the colors of the national flag in his portrait of John Marin; flags and their colors also appear in work by Arthur Dove and Florine Stettheimer.

In the early 1920s O'Keeffe was not on the front lines debating what was or was not American. She was not a theorist or a public advocate. But she was always a keen and wry observer of the fray; and in her paintings about the *new* New York, she participated more fully than anyone in the Stieglitz circle in the international fervor over skyscraper America as the real America. Then, when she rather abruptly left behind skyscrapers to paint adobe churches, crosses, skulls, and mesas, she became more fully engaged in the Americanizing discourse than is generally acknowledged. *Cow's Skull—Red, White and Blue* was one of her most forthright declarations; here she was defining an America different from the Manhattan-centric one others had proposed.

In the 1970s when O'Keeffe was reaching the peak of her fame, she wrote a book about her art, collaborated on a documentary film, and gave a number of important interviews. In all of these she liked to tell an anecdote about *Cow's Skull—Red, White and Blue* that positioned her in the debates of the late 1920s and early 1930s. She relayed the story

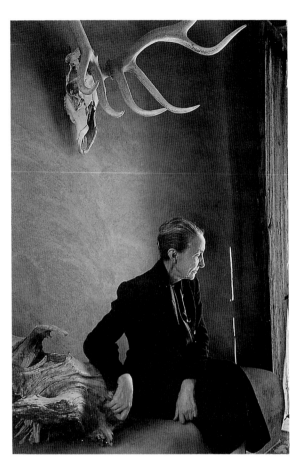

Fig. 265. Yousuf Karsh, *Georgia O'Keeffe*, 1956.

in two versions, both of them presenting her triumphing over artists around her, in one case over the American Scene painters, who by 1931 had begun to get national attention, and in the other over "the city men," a phrase that surely, in her mind, alluded to all artists in New York, but especially to Stieglitz and his colleagues. In both versions, O'Keeffe speaks as the heroine acting alone, independent of any group attachments:

> There was a lot of talk in New York then—during the late twenties and early thirties—about the Great American Painting. It was like the Great American Novel. People wanted to "do" the American scene. I had gone back and forth across the country several times by then, and some of the current ideas about the American scene struck me as pretty ridiculous. To them, the American scene was a dilapidated house with a broken-down buckboard out front and a horse that looked like a skeleton. I knew America was very rich, very lush. Well I started painting my skulls about this time. First, I put a horse's skull against a blue-cloth background, and then I used a cow's skull. I had lived in the cattle country—Amarillo was the crossroads of cattle shipping, and you could see the cattle coming in across the range for days at a time. For goodness' sake, I thought, the people who talk about the American scene don't know anything about it. So, in a way, that cow's skull was my joke on the American scene, and it gave me pleasure to make it in red, white, and blue.[98]

In O'Keeffe's second version of the story, the one that appeared in her 1976 book about her art, she remembered her response to her fellow modernists at the time she began to paint bones.

> As I was working I thought of the city men I had been seeing in the East. They talked so often of writing the Great American Novel—the Great American Play— the Great American Poetry. I am not sure that they aspired to the Great American Painting. Cézanne was so much in the air that I think the Great American Painting didn't even seem a possible dream. I knew the middle of the country—knew quite a bit of the South—I knew the cattle country—and I knew that our country was lush and rich. I had driven across the country many times. I was quite excited over our country and I knew that at that time almost any one of those great minds would have been living in Europe if

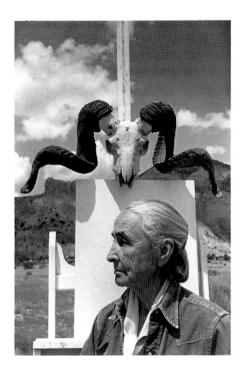

Fig. 266 (top). Arnold Newman, *Georgia O'Keeffe, Ghost Ranch, New Mexico*, 1968. Gelatin silver print. © Arnold Newman.

Fig. 267 (bottom). Todd Webb, *Georgia O'Keeffe, Ghost Ranch, Abiquiu*, 1962. Gelatin silver print.

Fig. 268. David Bradley, *O'Keeffe at Work*, 1984.
Acrylic on canvas, 30 × 24 in.

it had been possible for them. They didn't even want to live in New York—how was the Great American Thing going to happen? So as I painted along on my cow's skull on blue I thought to myself, "I'll make it an American painting. They will not think it great with the red stripes down the sides—Red, White and Blue—but they will notice it."[99]

That O'Keeffe recalls doing battle with not one but two groups of artists, American Scene painters and modernists, says something important about what had happened to American art making by 1931. The claim to creating a newly nationalized American art—or to making "the great American thing"—no longer belonged exclusively to the modernists, be they the machine ageists or the spiritualists. New and younger voices, often coming from far outside Manhattan, were promoting their own ideas

about establishing an indigenous school of contemporary art, none more aggressively than the so-called midwestern Regionalists, such as Thomas Hart Benton and Grant Wood, and their primary critic, Thomas Craven. Arguing for an art about local peoples, folkways, and the landscape, and especially for an art that did not come out of New York, the Regionalists used the word "American" to describe *their* project, making it clear that the search for a national art would no longer be monopolized by artists with whom they did not identify, those they often called the ultramoderns.

The animosity between the modernists and Regionalists is legendary. O'Keeffe despaired of those populists who painted "a dilapidated house with a broken-down buckboard out front," and Benton, whose work she was denigrating, flung insults back at those elite modernists who painted abstract swirls

of color in imitation of the School of Paris. They disliked not only each other's art but also each other's ways of living, dressing, and talking about art. When in 1935 the second circle published twenty-five tributes to Stieglitz in *America and Alfred Stieglitz*, a book of boundless adulation and spiritualized rhetoric, the partisans of Regionalism used the occasion to dethrone the king and take away his kingdom. Benton, in a review he published in a little magazine aptly called *Common Sense*, found the Stieglitz volume self-aggrandizing, filled with hocus-pocus talk, and way out-of-date: Stieglitz's influence was over, and the modern movement was dead. For him the book was hype, about "how a small group of New York cultists can arrogate to themselves and a simple photographer a position of supreme eminence in American culture, a culture from which by their commitments they flee [by going to Europe]."[100] In a more dispassionate review of the book, another supporter of the Regionalist vision of America, John Gould Fletcher, deconstructed the Stieglitz credo, arguing that there was no "single American spirit, but several different kinds of American spirit." There was also, he continued, no one patch of American soil, and Stieglitz's soil was "in closest contact with Europe" and therefore "less authentic than parts of the country at some remove." Fletcher reduced the book to "a spoof cosmopolitan substitute in the place of the honest reality of regional achievement."[101]

Such open antagonism between the two groups was fueled not only by aesthetic differences but also by the desire to control who spoke for American art. The Regionalists promoted a stay-at-home program not all that different from the one Stieglitz espoused, though they managed to convince themselves that New York modernists emulated Paris and were therefore not truly American. And they imagined a native-born, de-Europeanized painting that often used the same Americanizing rhetoric as the postwar cultural nationalists. But they transmuted the meanings they ascribed to words like "home," "soil," and "place" from the realm of religion to that of anthropology. For the Regionalists these words meant small communities, people with common histories and rituals, and Main Streets usually in places far from Manhattan. "Whose art, whose America?" the Regionalists rightly asked, recognizing that for more than fifteen years modern artists in New York

had proposed that they and their city alone spoke for the country.[102]

As the cry for an American art spread beyond New York to other regions, it quickened the pulse of the Stieglitz circle modernists who had been struggling for over a decade with the concept of a homegrown art. Stieglitz became even more boastful of his mission and triumph. In naming his last gallery An American Place in 1929, he not only challenged the European interests of the new Museum of Modern Art just down the street but also resisted newly perceived enemies elsewhere in the country. In his final series of photographs of New York City in 1927–34 he was participating in the national fervor around the notion of place and also rebutting those who would find their America elsewhere (see Fig. 13). Others in his circle responded less defensively but similarly registered the changed national mood as they moved away from their 1920s projects to new ones centered more on places they called home. Charles Demuth discontinued his poster portrait project in 1928 to focus his oil paintings exclusively on industrial scenes in Lancaster, Pennsylvania. Marsden Hartley, always the least focused and most peripatetic of the group, returned to the country from Europe and began, in 1931, a series of Gloucester landscapes, the so-called Dogtown series that he showed at the Downtown Gallery in an exhibition entitled *Pictures of New England by a New Englander* (1932), writing an accompanying poem called "The Return of the Native."[103] In 1932 Paul Strand had his last exhibition at An American Place. He and Stieglitz quarreled; he divorced his wife, Rebecca; and he began to spend more time outside New York City. In 1933 Arthur Dove moved from a boat in a Long Island harbor to the family farmhouse in Geneva, New York, where he worked throughout the depression years. John Marin continued his annual routine of summers in Maine and winters in New Jersey, though he did get bitten briefly by New Mexico fever, visiting Mabel Dodge Luhan's house twice, in 1929 and 1930, at both Luhan's and O'Keeffe's insistence.

In taking herself and her art to New Mexico, O'Keeffe shared in the Regionalist's revolt against Manhattan. As the youngest member of the Stieglitz circle, she responded most decisively to the depression era's intensified rhetoric of "place" and "America." She took modernism further from Manhattan

ANOTHER VICTIM OF SANTA FE STYLE

Fig. 269. Jerome L. Milord, *Another Victim of Santa Fe Style*, 1989. Poster.

than any other member of the second circle and artistically engaged a region where the past was stronger than the present. As she liked to brag, she alone went west of the Hudson and *stayed* in a new place—northern New Mexico—forging a new theme that fundamentally changed the direction of her painting and her life. Her first three trips to New Mexico, in the summers of 1929, 1930, and 1931, began to mark the division between O'Keeffe the New York painter of flowers and skyscrapers and O'Keeffe the southwestern artist of bones and mesas, a process that took twenty years—and the death of Stieglitz—to realize fully. These trips also mark the division between her two critical reputations, the first as a "woman on paper" exploring her own sexuality, and the second as the artist-priestess, Saint Georgia of the Desert.[104] This new persona, slowly invented and elaborated upon, effectively

extended second-circle ideals of soil and spirit for another two generations. As Stieglitz had once been hailed as (and had proclaimed himself) a prophet and holy man, O'Keeffe engendered images of nuns and saints as she lived and worked in New Mexico. His image was that of a public evangelist, hers that of a private mystic. Stieglitz kept the symbolist legacy and its religiosity artistically alive in the first half of the century; O'Keeffe extended its influence through the second.

No wonder then, that O'Keeffe in late life could look back and invest *Cow's Skull—Red, White and Blue* with anecdotal lore, demonstrating how she did things in her own (better) way. Her bemused outrage barely disguises her self-presentation as a seer beneath surfaces—in this case beneath the wrongheadedness and vanity of "the men." Such self-assurance about her place in the history of art

suggests that the anecdote says less about O'Keeffe in 1931 than about O'Keeffe in the 1970s, when she knew the shape her life had taken and could emphasize turning points in her history, clarified with the benefit of hindsight. When she first painted *Cow's Skull—Red, White and Blue*, we know she was anxious about it. Forty years later, when she made a gift of it to the Metropolitan Museum of Art in New York, she could designate it a work of originality, freshness, and, given its reference to the American flag, considerable wit. In the very decade when feminists were deciding how

best to write women into art history, O'Keeffe took to telling her history as she, a woman, wanted it told. She looked back and presented herself in control of her art making and as something of a resistance fighter in her early career. And in this history she situated New Mexico and the creation of the bone paintings at an important juncture in American art. As she told the story about *Cow's Skull—Red, White and Blue* the way she wanted it told, it was she, not others—certainly not the men—who at last had figured out how to paint "the Great American Thing."

HOME,
SWEET HOME

The present is a void, and the American writer floats in that void because the past that survives in the common mind of the present is a past without living value. But is this the only possible past? If we need another past so badly, is it inconceivable that we might discover one, that we might even invent one?

Van Wyck Brooks, "On Creating a Usable Past," 1918

I don't like these things because they are old but in spite of it. I'd like them still better if they were made yesterday because then they would afford proof that the same kind of creative power is continuing.

Charles Sheeler, 1930s

O'Keeffe was right. New York's modern artists found little west of the Hudson that they would have called America. She might have added that they also found little that was worthwhile in the American arts of the past, at least not before 1900. Although the modernists we have been looking at could locate their nation's antiquity in what little they knew of Native American culture, their mindset was primarily presentist and futurist. For them the fine arts of earlier American painters and sculptors were a source of embarrassment, the ultimate proof of the country's provinciality. Typically this generation blamed the repressed Puritan and the rapacious Pioneer for shaping a country unreceptive to the arts. They also bemoaned the lack of any artists to serve as national models. They held up Whitman—and occasionally Edgar Allan Poe and Abraham Lincoln—as worthy of emulation, but in the visual arts American history seemed to them a virtual wasteland. They found nothing to value in American old masters, deeming all realist or descriptive art shallow (illustrative) or corrupt (commercially marketable). Albert Pinkham Ryder, whom some modernists had known before he died in 1917, was about the only past American artist they mentioned regularly in flattering terms. Strange as it may sound to us today, very few Americans in 1920 had any respect for the Hudson River School, and only a small contingent were beginning to find something to value in the works of Thomas Eakins or Winslow Homer.[1] From their vantage point, it seemed best to ignore such an ignoble past and concentrate instead on their own generation, building what they took to be the country's first authentic and original native school of arts. Better to live within the mythos: America was young, innocent, a child

Fig. 270 (facing). Charles Sheeler, *Home, Sweet Home*, 1931. Oil on canvas, 36 × 29 in.

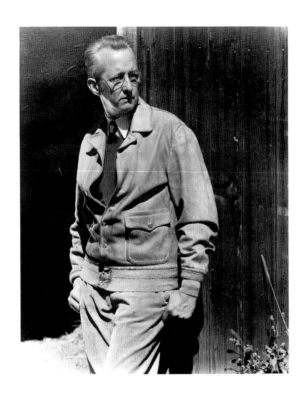

Fig. 271. Edward Steichen, *Charles Sheeler, West Redding, Connecticut*, ca. 1932. Gelatin silver print, 17½ × 13⅞ in.

compared with Europe, where traditions were old, rich, and venerable. Europe had old masters; America, still growing up artistically, was only on the verge of breaking through the barriers of provinciality and three centuries of dependency on European art centers.

This chapter examines some of the first challenges to this antihistorical mind-set, which European artists helped foster by wanting their America to have been born modern. Tentatively before 1920 but with greater assurance thereafter, a few modernists, both writers and artists, began to venture into the American past, looking for something of artistic worth to those working in the present. Over time, these scattered reconnaissance trips yielded results, tempering the prevailing belief that the nation's history of arts and letters was useless and impoverished. In this chapter I focus on the complexities of this early modernist gaze into the past.

Like explorers in a foreign land, a handful of modernists—critics, curators, and artists—by the late 1920s had claimed territory in the American past where they had found inspiration and approval for their own work. This territory had yielded a small group of artifacts (seventeenth-century American furniture, folk art of every sort, clipper ships, factories, and grain elevators) and the works of artists (H. H. Richardson and Louis Sullivan and, tentatively, Homer, Ryder, and Eakins) that suited modernist tastes. The discoverers of this territory established their claims, they said repeatedly, to give modern Americans a sense of something larger than themselves that was national but not European in origin. After World War II their new reading of America's art-historical past seeped into the academy, changing perspectives on American cultural history and redefining the field of study. It completely revised the list of masters—those studied in art history and, even more important, those valued in the marketplace. (As I write this, a late Winslow Homer seascape that had little value for 1920s modernists has sold for $30 million.)[2]

Charles Sheeler was a founding father of what I will call the discourse of "American tradition" or the "usable past" (Fig. 271).[3] If this characterization seems too strong for an exceedingly reserved artist who did no teaching and wrote little, it properly reflects the contributions of Sheeler's art.[4] Sheeler was

a tastemaker, first, because of what he did as an artist and a collector—he furnished his home with carefully chosen early American furnishings—and, second, because of what others wrote about his work as part of an enduring "American tradition." Critics and museum professionals more articulate and insistent than the artist himself cited his art in the 1920s and 1930s, and his habits as a collector, as living proof that an older American tradition was still thriving in the machine age present.

Many people today associate Sheeler exclusively with machine age ideals. His work as both an art photographer and a painter is always included in exhibitions about the machine age and about Precisionism, an American style defined by qualities assumed to be mechanical and machine tooled: hard edges, pristine surfaces, and a cool palette. And so he should be, for Sheeler's credentials as a machine ageist are impeccable. From 1917 to 1921, as a regular participant in the transatlantic circle around Walter and Louise Arensberg, he came to know Marcel Duchamp, Francis Picabia, and Joseph Stella. Like others, he was a great admirer of Duchamp.[5] For several years before 1923, when Stieglitz in effect excommunicated him, he was loosely affiliated with the second circle, especially with Paul Strand, who, like Sheeler, was practicing a new "straight" style of photography and emphasizing cubist abstraction, often using city buildings and mechanical forms as his subject matter.[6] In the early 1920s Sheeler and Strand created the *new* New York film *Manhatta*, and Sheeler made his first Precisionist paintings of skyscraper New York (Fig. 272). By the late 1920s Sheeler had accepted a commission to make a portfolio of photographs of the Ford Motor Company's River Rouge Plant, a series that inspired two pastoral and idealist paintings of factories, *Classic Landscape* and *American Landscape* (Fig. 273). In other photographs and paintings he essayed stark and pristine views of machine age motifs: the ocean liner, the locomotive, the airplane, the telephone, the typewriter, the suspension bridge, the turbine, and industrial smokestacks. Sheeler was still photographing skyscraper New York and painting industrial sites in the 1950s. He died in 1965.

This was one branch of Sheeler's work. Alternatively, and in the very same years, Sheeler took on American sites and artifacts that were old and historical, seemingly far removed from machine age priorities. One of his first bodies of work consisted of photographs and drawings of barns he made in Bucks County, Pennsylvania, a subject he returned to often (see Figs. 278, 279). Throughout his career he also made works of art based on Shaker furniture and decorative ceramic and glass objects drawn from a premodern American past as well as from buildings and interiors he had visited in such historic sites as Colonial Williamsburg and the Ephrata Cloister. In later years his historic repertoire also included old and abandoned mills and factories.

The painting I want to discuss belongs to this second body of work. Sheeler created it in 1931, calling it *Home, Sweet Home*, a title he borrowed from a popular nineteenth-century ballad (see Fig. 270).[7] One of a large series of home interiors, it represented a corner of Sheeler's home in South Salem, New York, with its assortment of American antiques—rag rugs, a Shaker table and bench, an early-nineteenth-century chair—and a modern, streamlined furnace. These objects, though made at different moments and by different communities of artisans, come together in an orderly still life.

By what stylistic devices? And why? What would be the artist's rationale for so self-consciously bringing together a potpourri of American antique furniture and a modern furnace? These are the questions I pose here in an effort to recover the curious and imprecise role of American history for a handful of postwar modernists who ventured to think about the past. In such a painting, I want to suggest, Sheeler participated in a grander project to locate and articulate moments and artifacts that historicized and validated modernist aesthetics. To argue for something valuable in the American cultural past was invariably a revisionist project; it had to work against the authority and pessimism of the Puritan-Pioneer discourse discussed in this book's Introduction, and it had to be compatible with the machine age ideals that dominated avant-garde thinking during this period. Any modernist who spoke encouragingly about the American artifactual past in the 1920s and 1930s began by saying something like this: A closer look suggests that this nation's artistic past is not as bleak as we once thought; some things made in the American past anticipate and contribute to those made in the present. To

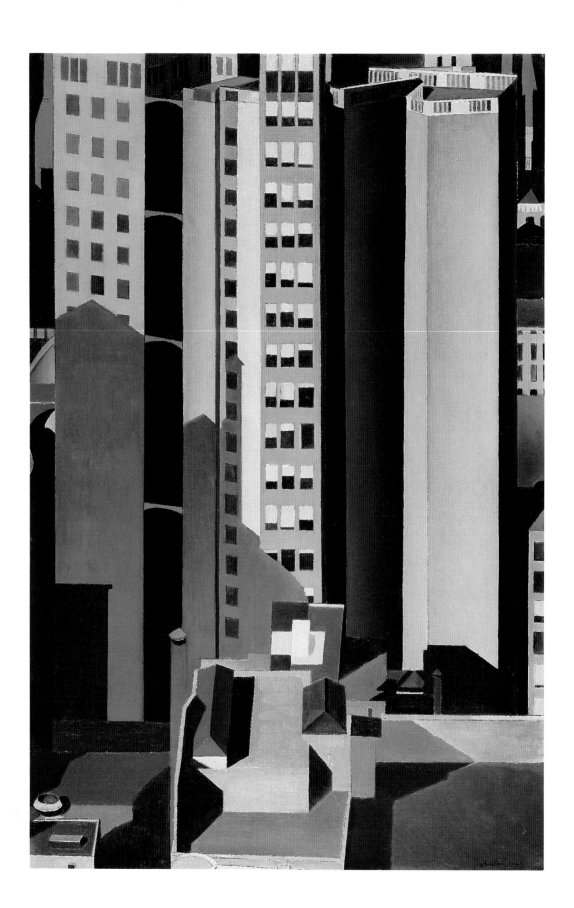

Fig. 273. Charles Sheeler, *American Landscape*, 1930.
Oil on canvas, 24 × 31 in.

understand the place of *Home, Sweet Home* in this revisionism, we need to examine it more closely and uncover some of the structural affinities it shares with other cultural activities in the 1920s.

In particular, I want to consider *Home, Sweet Home* with and against three different postwar cultural projects that sought to revise received judgments about America's provincial past. The first is the work of various collectors and museum curators who in the early decades of the century began to claim distinction and excellence for the furniture and decorative objects made by the country's early builders and skilled artisans. These new artifactual-

Fig. 272 (facing). Charles Sheeler, *Skyscrapers*, 1922.
Oil on canvas, 20 × 13 in.

ists found a rationale for America's separation from Europe in the tools, chairs, houses, and portraits that this "young" nation had produced. Commonly they linked such excellence to patriotism, arguing the duty and rightfulness of preserving things drawn from the colonial period and the great era of revolution and independence. Some expressed a nativist belief that the beauty of such things would educate and Americanize the country's diverse immigrant citizenry. From John D. Rockefeller's Colonial Williamsburg in Virginia to Henry Ford's Greenfield Village near Detroit, or from Henry Mercer's museum of American tools in Pennsylvania to Henry Francis du Pont's period rooms in Delaware, enormous efforts were focused on preserving, restoring, and displaying the built environments and crafted

goods that seemed to offer proof of a national mind independent of Europe. The 1920s raised the curtain on the study of the country's material culture and the formation of museum collections dedicated to American furniture and decorative materials. If we look at *Home, Sweet Home* in relationship to the activities of these curators and collectors of American decorative arts, particularly those involved with the opening of the American Wing at the Metropolitan Museum of Art in 1924, we can perceive the coherence and distinctiveness of Sheeler's investment in uncovering a national past. He was both in the antiquarian sphere and diametrically opposed to it.

The second project in which I want to locate Sheeler is that of another circle of 1920s revisionists, the critic-historicists (cultural critics and art professionals) who investigated the American past because they believed it would help artists and writers in the present. Among their ranks, which cut across modernist circles, there were Van Wyck Brooks, Lewis Mumford, and Constance Rourke in cultural criticism; Holger Cahill, Juliana Force, and Lloyd Goodrich in New York's museums of modern art; Edith Halpert, a private dealer; Abigail Aldrich Rockefeller, a collector; and D. H. Lawrence, a transatlantic. For this group, the creation of an aesthetic past had to be functional: their aim was, not to honor forefathers, but to bolster those in the present trying to do fresh and authentic American work. Or so they argued. Nationalist in their focus, they drew a hard line between their presentist goals and the moral romancing of the past they attributed to museum antiquarians, colonial revivalists, and zealous groups like the Daughters of the American Revolution. Furthermore, none of them presumed to revive the past in a disinterested fashion. In other words, none worked from the motivations of the academic historian determined to understand why things happened as they did. Rather, they wrote or created exhibitions or built collections with the stated intention of deepening the present by giving it an identifiable past. They wanted to throw out received history, proclaiming it genteel and sterile, and to search for role models and works of art and literature that contemporary American artists, without embarrassment, might adopt as constituting a national heritage. They spoke of the past in the present tense as passionate advocates for contemporary arts and letters.

The third revisionist project that helps to decipher the complexities of *Home, Sweet Home* is in many ways a subset of the second: the recovery by Sheeler and others of a large, diverse group of vintage artifacts that came to be known en bloc as American folk art. Sheeler, like other artists, collected and exhibited pieces of folk art as part of his larger activity of building a collection of early American furniture. Typically, he made scant records of his activities, leaving it to others to articulate the goals and enthusiasms of the first generation of folk art collectors. Most important, he stands out as a painter whose art was often used by folk art enthusiasts, Edith Halpert in particular, as living proof of an ancestral relation between the folk artist of yore and the modern artist of today.

The interplay of these three overlapping projects—those of the antiquarians, the critic-historicists, and the early folk art collectors and curators—explains the cultural dissonances in Sheeler's *Home, Sweet Home*, a painting where old and new manage to live harmoniously together. It also provides a space for the contradictions of Sheeler's own life as an artist deeply identified with the machine age ethos yet equally engaged by American antiques. It was not easy or commonplace in 1920s New York for progressive artists to "own" an American past; the artists we have looked at in earlier chapters, with the possible exception of O'Keeffe, generally found the American past simultaneously thin and burdensome and altogether suspect. Sheeler, however, bolstered by writers and curators, found a rationale for studying American craft history without losing his credentials as a modernist in the process. What he and the others could not foresee was that the past they invented for the modern present would generate debate and scholarly projects for another half century. Anyone who subsequently asked, "What is American about American art?" and sought answers in stylistic and formalist linkings between the past and the present reformulated and refined an issue that Sheeler was among the first to propose.

Home played a large role in Sheeler's art. He often photographed or painted decorative objects and furniture drawn from his own living spaces (see Figs. 270, 283, 284). While he represented most subjects coolly and analytically, his art about home expressed

his affection for objects that he had personally ac-quired and arranged. Indeed, Sheeler had what com-monly resides in a female sensibility: a doting atten-tion to the little things in a household, to chairs, table, fabrics, and the bibelots on the mantel or ta-bletop. By subjecting these material goods to the rigor of cubist composition, he kept his emotions and his female side under tight control; his art, he always seems to say, is about pictorial problems, not about himself, and not about domesticity. But the artist, by returning time and again to the personal and the domestic, reveals himself happiest when at home, surrounded by beautiful things.

From 1919 to 1926 Sheeler lived in Manhattan, but thereafter he sought out rural villages and small towns in easy commuting distance of New York City, where he maintained a studio. Unlike Duchamp, O'Keeffe, or Stieglitz, who enjoyed city high-rises, Sheeler chose to rent homes in exurban settings rich in historical architecture. Over the years he had homes in South Salem, New York; Ridgefield, Con-necticut; and Irvington-on-Hudson, in Westches-ter County, New York. The South Salem bungalow (unlocated), photographs tell us, had wooden floors, simple detailing, and exposed beams; the Ridgefield house, modern in construction, was nonetheless rus-tic; it boasted wooden beams and fieldstone floors (Fig. 274); the old house in Irvington that the Sheel-ers called Bird's Nest, the gatehouse of an old estate, was built of stone (Fig. 275).

Sheeler began this style of country living in 1910, when he and Morton Schamberg rented a small his-torically important house on the outskirts of Doyles-town in Bucks County, Pennsylvania (Fig. 276). Both men were young—in their mid to late twen-ties. Sheeler had enrolled at the School of Industrial Art from 1900 to 1903 and then spent three years studying with William Merritt Chase at the Pennsyl-vania Academy of the Fine Arts, where Schamberg was in his classes. They became close friends. Choos-ing the little house in Bucks County as a weekend re-treat and painting studio, they followed in the foot-steps of other Philadelphians who had discovered the area's pastoral charms, rural living, and (a con-cern in the early century) healthy air. Though it had not yet acquired its present-day fashionableness or developed its tourist industry, Bucks County, north of Philadelphia and southwest of New York, was al-ready known as a weekend escape for city dwellers.

Fieldstone houses, white wooden barns, cows, and chickens dotted the landscape. Pennsylvania Ger-mans and English Quakers first settled there in the eighteenth century, farming the land and establish-ing pottery kilns for the area's first major manufac-ture. By the early twentieth century artists were beginning to give the county its reputation as an art-ists' domain. Daniel Garber and Edward Redfield made careers as Bucks County impressionists, and the early abstract artists who eventually colonized the town of New Hope became known as the New Hope School.[8]

When Sheeler and Schamberg began to use their Bucks County retreat, both were extracting them-selves from the theatricalities of Chase's style of painting and experimenting with fauvist color and Cézannesque structure. Young and unformed, they were learning the fundamentals of modernism. Just as Schamberg began to find his style, having com-pleted a number of innovative machine abstractions, he died in the devastating influenza epidemic of 1918. Sheeler, by then a convert to cubist aesthetics, moved to Manhattan, joined the machine age ad-vocates who gathered around Louise and Walter Arensberg, and had his brief affiliation with the second Stieglitz circle.

Given that both men were fascinated by high mod-ernism, particularly fauvism and cubism and eventu-ally, in Schamberg's case, dadaism, it is all the more notable that the house they chose to rent was not contemporary but, by American standards, very old, so old that it had already drawn the attention of the Bucks County Historical Society and at least one lo-cal historian, Henry Chapman Mercer. Mercer had seen to the house's repair and preservation and, in 1908, arranged for a concrete marker outside this and other houses in the region. The sign in front of this house read "Colonial House Built by Jonathan Worthington in 1768" (Fig. 277). Built of local field-stone, like many houses in the region, the Worthing-ton house retained many of its original features: a tri-angular hooded doorway, deep windowsills, rough plaster walls, an open-beamed ceiling, and wrought-iron hardware. Inside, a nineteenth-century pot-bellied stove supplied heat during cold weather.[9] Sheeler and Schamberg whitewashed the interior and deliberately left the walls undecorated, a mini-malist aesthetic Stieglitz snidely called Sheeler's "Pennsylvania hut *aesthetique*."[10]

Fig. 274 (top). Charles Sheeler, *Exterior of Sheeler's Ridgefield, Connecticut house*, ca. 1932. Gelatin silver print, $10\frac{1}{4} \times 13\frac{7}{8}$ in.

Fig. 275 (middle). Charles Sheeler, *Photograph of ''Bird's Nest,'' Sheeler's home in Irvington-on-Hudson, New York*, ca. 1943. Gelatin silver print, $5\frac{1}{2} \times 7\frac{7}{8}$ in.

Fig. 276 (bottom). Charles Sheeler, *Doylestown House, Exterior View*, 1917. Southeast facade of the Jonathan Worthington House. Gelatin silver print, $6\frac{5}{8} \times 9\frac{7}{16}$ in.

It was in Bucks County that Sheeler first began to express an appreciation for vernacular craftsmanship and to buy early pieces of American furniture, some of it by the Pennsylvania Germans. He had good mentors, for the area had an active historical society that published regularly on the local architecture and historic sites, and it had Mercer, a most unusual figure, whose legacy echoes throughout the county. A sometime archaeologist, collector, historian, potter, and preservationist, Mercer spent his adult life enhancing and preserving the rural and historical character of Bucks County. He used his wealth to build a collection of more than thirty thousand American tools, utensils, and gadgets so as to instruct contemporary people about everyday life in premodern America. He housed his acres of artifacts in a museum—half barn, half fortress—that he built of poured concrete. Concrete was Mercer's fieldstone; he was obsessed by it. He used the same material to build his home, Fonthill, a meandering arts and crafts castle he had designed. He also opened the Moravian Pottery and Tile Works in yet another set of concrete buildings and revived the local Pennsylvania German traditions in ceramics. Mercer tiles quickly became known and treasured; they were used in many notable arts and crafts structures up and down the eastern seaboard.[11]

Mercer's commitment to preserving the old, particularly vernacular artifacts of technology and architecture, was not lost on Sheeler, who arrived in Bucks County with a modernist sensibility-in-the-making as well as an inchoate instinct to preserve the old. Mercer recognized Sheeler as a kindred spirit and as someone sympathetic to the unspoiled character of Bucks County and the "little house," as Sheeler called it. Through correspondence and occasional personal contact, the two men shared their concern about preserving the house, and when Sheeler stopped renting it in 1926, Mercer bought it and restored its kitchen.

Around 1917 Sheeler made some twenty photographs of the Doylestown house interiors and others of barns in the area (Fig. 278); he also painted a series of barn abstractions over the next few years that transfigured the rambling forms of these structures into taut synthetic cubist compositions (Fig. 279). As Constance Rourke, his early biographer, was the first to recognize, Sheeler began in these works to express his distinctive voice as an artist and to articulate

Fig. 277. Aaron Siskind, *An Overhead Hood*, ca. 1935. Northwest facade of the Jonathan Worthington House. Gelatin silver print, 10 × 8 in.

a relationship between the old and the new. In photographing the little house's interior, he cropped the composition so that the clean bare walls became floating planes, and the structural lines of the building's corners, doorway, hearth, and windows became as pronounced as a Mondrian grid (Fig. 280). Similarly, in his drawings and gouaches of barns, he treated vernacular Pennsylvania architecture as if it were modern, creating large faceted cubist abstractions out of facades, rooflines, windows, and doorways.

Sheeler's discovery that he could wed a consummately twentieth-century style to the specific lines and craftsmanship of local historical architecture was seminal; he would refine and recalibrate the equation for the rest of his life. At first, it was something of an experiment. But in time, the conflation of modern and historical became something more like an aesthetic theory. Increasingly Sheeler's art hypothesized a genealogy of elegance and modernity that began in early American craftsmanship and continued in machine age aesthetics. He articulated this more developed stance in seven paintings of his own living spaces made between 1926 and 1934. Because he called one *American Interior* and another *Americana*, they have become known as Sheeler's Americana series or the American Interiors (see Fig. 284).[12] A third he named *Home, Sweet Home*.

Home, *Sweet Home* was painted in 1931, the same year that O'Keeffe painted *Cow's Skull—Red, White and Blue*, and it is useful for a moment to see them in tandem (see Figs. 214, 270). Together they exemplify how some members of the modernist community were turning by 1931 away from ultramodern to rural America. Both lend support to O'Keeffe's contention that in these years everyone was trying to create "the great American thing"; both refer wittily to home and nation. Both are iconic paintings—a commanding skull in one and an equally prominent chair in the other. And although *Home, Sweet Home* seems much smaller, its dimensions, at 36 by 29 inches, are only a few inches smaller than those of *Cow's Skull—Red, White and Blue*. The perception of smallness arises from Sheeler's depiction of life-size things in miniature; O'Keeffe's skull is larger than life. O'Keeffe large-scale forms are made up of flowing lines. Sheeler's miniaturized world is a composite of straight lines. Her canvas opens out,

Fig. 278 (top). Charles Sheeler, *Bucks County Barn (with Chickens)*, ca. 1916–17. Gelatin silver print, 8 × 10¹⁵⁄₁₆ in.

Fig. 279 (bottom). Charles Sheeler, *Bucks County Barn*, 1923. Tempera and crayon on paper, 19⅝ × 26 in.

conjuring up the emptiness of landscape and a spiritual world of disembodiment and trance. His pulls one into an orderly enclosed space of personal and material possessions. She reveals nothing for certain; he seems to tell all. She refuses to show her hand, shrouding her canvas in unfathomable mystery; he is a stage designer of trompe l'oeil illusions, asking us to believe in the rock-bottom thingness of objects. O'Keeffe calls up history obliquely by reworking old symbolic forms. Sheeler makes history a protagonist by putting American antiques center stage.

Let us look more closely at the illusion Sheeler so skillfully renders. A wooden staircase comes in from the upper left, a rag rug from the lower left; the corners of a Shaker table and bench are in the lower right. In the upper right there is the modern gas heater with a black stovepipe and, behind it, a fireplace that has been boarded up. In the center of the canvas, hardwood floors under four area rugs showcase the key piece in the room: a maple ladder-back armchair from the early nineteenth century. This piece, clearly not modern but antique, is the biggest in the space. The smallest is the black box in shadow at the foot of the stairs, the only object in the room with no sure identity.

This is a lived-in room where the chair is pulled up to the heater as if for warmth. Rugs are scattered on the floor, and a shadow zigzags up the stairs, mimicking the human movement of climbing up and down. A table is nearby for food. Though one would find all these pieces in a living space, here nothing sits askew; the furnishings seem more arranged than in use. There is no human detritus—magazines, dirty dishes, a dust ball or two—the rugs have no wrinkles or turned-up corners, the floorboards and woodwork no nicks or blemishes. And even though there is no window or door, the lighting is intense, as if this were a display space lit by hidden lights rather than a room in a home.

Objects in close proximity arranged on a flat surface—in this case, the floor—is one definition of a still life, a genre Sheeler favored. He liked to arrange decorative objects on tabletops and then photograph and paint them (Fig. 281). But another way to conceptualize the painting, one that captures something of the stiffness and formality of the composition, is to think of it as a formal group portrait. In *Home, Sweet Home*, every object seems on its

Fig. 280. Charles Sheeler, *Doylestown House: Interior with Stove*, ca. 1917. Gelatin silver print, 9⅛ × 6⅛ in.

Fig. 281. Alfred Eisenstaedt, *"He focuses his camera on a still life."* From an article about Charles Sheeler in *Life* magazine, Aug. 8, 1938, p. 42.

best behavior, well groomed and standing perfectly still for its portrait. Such an analogy suggests how much each article of furniture is self-contained and separated from other articles nearby, its contours carefully defined. Although artifacts stand next to or in front of one another, they touch nothing except the floor and rugs on which they sit.

The chair is not only proportionally the largest object in the composition but also (aside from the black box) the only one described in full; every other object is cropped by a framing edge. The chair, fully rendered in three dimensions, throws off a complete shadow. Other forms are flatter planes. The chair is also the object that makes us think most about human beings; it is a kind of humanoid. A ladder-back chair made about 1800 in Pennsylvania, probably in the Delaware Valley, it suggests a seated body (Fig. 282).[13] And given the way the artist animated the form—the trapezoidal rush seat and the top of the arms give off golden light—a spectral presence inhabits the very space a body would take up in the chair. One can imagine the chair as the patriarch, surrounded by members of his extended family, in a portrait by John Singleton Copley. The gray metal furnace and the heavyset table could be seen as male, the patterned rugs as female figures. Or perhaps, given that the chair's left arm is longer than the right, implying an intimacy with the furnace, and the furnace is wearing a full-length dress, the furnace is the wife, standing at his side. The little black box is the family dog.

Craft or manufacture is another trait that draws this set of artifacts into a family circle. With the exception of the factory-built heater, everything in this room, including the rugs on the floor, furniture, fireplace trim, floorboards, and stairway, is handmade. Furthermore, all are plain, not high-style objects, simple and geometric. None comes from such a period as the Victorian or Second Empire, when lavish embellishment and ornamentation were essential features of craftsmanship. None is authored, in the sense of having a distinctive signature style. Their makers, mostly nineteenth-century, are anonymous, the table and house detailing crafted by men, the rugs woven by women.

The steel gray furnace is the exception, and its contemporary design and manufacture should seem incongruous in a setting where everything else has the patina of age and is constructed by hand of

natural materials. Yet clearly it is a comfortable member of the family, for it shares formal qualities with the other artifacts. Its streamlined boxiness, its planar construction, and its lack of any ornamentation put it into a harmonious relationship with the older household goods. This is a family portrait of things related aesthetically, not historically.

Sheeler includes his own art in this stylistic lineage by painting in a late cubist style that has many of the same formal qualities as the assembled artifacts. Along with the furnace, the painting itself is a modern participant. Like the furnace or the Shaker table, Sheeler's painting style can be described as streamlined, geometric, and plainspoken, without painterly flourishes or showmanship. Though Sheeler took complicated lessons here from synthetic cubism, photography, and other machine age styles, what most viewers see is a matter-of-fact painting. Unless we take the time to concentrate on how it was made—this is almost always the case with a Sheeler painting—we underestimate how elaborate his artistic calculations really were. Sheeler was a stealth painter. He worked hard to make it look as if he did no work at all.

To see his craftsmanship, it helps to conceptualize the painting as a jigsaw puzzle, the kind five-year-olds can put together. This painting, however, is an art deco puzzle whose pieces angle and zigzag. Many of the puzzle pieces are geometric forms—triangles, squares, trapezoids—but none is perfectly formed. They are all a little cockeyed, as if the artist used a large pair of scissors, difficult to control. The corner of the table is not quite an equilateral triangle, and the end of the bench, with only three of four edges perfect, skews the rectangle. None of the rugs has all four of its corners, and the staircase is cut into several zigzag shapes that nicely disguise what they represent. Such is the nature of puzzle pieces: they are fragments of things, never wholes. Each piece is a section of something larger.

There are other peculiarities in *Home, Sweet Home* that might challenge the puzzle maker. Some pieces, like the table and the bench, are seen from above, while the chair is seen from the side and the fireplace straight on. The floorboard lines do not recede but tilt upward, and those that form the chair's seat and outrageously long arms would flunk any perspective test. The staircase refuses to recede and pops in and out like an optical yo-yo. Furthermore,

Fig. 282. Sheeler's armchair, American, ca. 1800. Maple, 44 × 24¼ × 18¼ in.

the scale of things runs against visual experience. The corner of the Shaker table is so small that it appears much further away from us than the chair in the center, which is proportionally much larger than everything else in the room. The pink bricks at the hearth are minuscule, and the rugs are all in different scales, the one with the zigzag pattern unnaturally large, the one by the bench dollhouse size.

Sheeler could make these subtle adjustments, all of which seem compositionally "right," deliberately in his paintings, but more fortuitously in his photographs, because the camera's optics allowed him less liberty. The painting *American Interior* that Sheeler based on a photograph of his living room in South Salem is a blown-up detail of the photograph (Figs. 283, 284). Sheeler liked to photograph from high on a ladder, giving him the bird's-eye view he also favored in his paintings. Looking down through his lens, Sheeler could crop the edges of his ensemble and make the floor tilt upward. But the spatial relationship between things in the photograph remains relatively clear and rational, whereas in the painting Sheeler radically foreshortened the lines of furniture and made decorative objects loom large while cropping the daybed. The photograph shows much more depth of field and offers numerous clues to the scale of elements, especially if we take as our measure the smaller items such as plates, magazines, or a lamp. The rugs and floorboards in the photograph clearly map out the ground plane, and light, artificially produced from the right, consistently

Fig. 284 (facing). Charles Sheeler, *American Interior*, 1934. Oil on canvas, 32½ × 30 in.

Fig. 283. Charles Sheeler, *South Salem, Living Room*, 1929. Gelatin silver print, 7³⁄₁₆ × 9⁹⁄₁₆ in.

illuminates the furniture; shadows of the goods always fall to the left.

But in the painting *American Interior*, as in *Home, Sweet Home*, there is no detectable light source, and shadows seem intentionally confounding. They do not happen according to nature. In *Home, Sweet Home* the table casts a shadow under itself and to the right while the chair casts wonderfully spooky shadows both under itself and way beyond to the left. The shadows cast on the stove and zigzagging up and down the stairs are artificial patterns rather than nature's way of working. Even if we were to imagine this scene as artificially lighted —Sheeler often used photographic lamps in his work—the shadows are willfully inconsistent.

The insistence on straight lines is similarly perverse. For Sheeler, all the edges of objects become straight lines, as do the patterns in the rugs and the outlines of shadows. They are not made by a rule, however, and thus differ from the mechanical-looking lines of a painting by Gerald Murphy or Charles Demuth, or a drawing by Picabia. Sheeler's have the character of hand-drawn lines, sure in their delineation but clearly handcrafted. If we squint at the painting, looking only at the main lines of the composition, we realize the degree to which these lines control our eye movements; like directional signals, they tell the eye to angle here and then there, creating a zigzag movement through the painting that is highly staged and carefully managed. These lines create an architectonic structure that does some of the hard work of holding the puzzle together.

That is the wonder of it. The pieces of the composition lock together so snugly and precisely that one wonders how the artist made it happen without dozens of preparatory sketches. Yet none exist for any of his paintings; either he destroyed them all, or he did the calculations as he painted.

By now, this lengthy discussion of Sheeler's picture-making strategies may have worn out my reader's patience, especially since Sheeler obviously borrowed so much of the infrastructure of his paintings from the lessons of synthetic cubism. So why burden the discussion with a puzzle metaphor? Seeing how the things fit together, as if in a puzzle, in fact clarifies the difference between Sheeler's cubist structure and that of, say, the Parisian artists. Just as Murphy's cubism was not Léger's, Sheeler's is

not Picasso's or Juan Gris's. The thingness of material goods counted for much more in American modernism than in Parisian modernism.[14] Murphy's art protected and maintained specific modern design elements in billboards, brand-name goods, and advertising. Sheeler foregrounded the edges, the surfaces, the colors, and the forms particular to his antique furniture. The cubist structure in the work of both American artists is there only secondarily. In *Home, Sweet Home* the illusionistic description of things in a room draws us in, and only then do we discover the cockeyed distortions and visual play. In a Parisian work the process would be just the opposite; we would first read the artist's pictorial manipulations and then try to piece together small pictorial clues that refer back to the objects that gave rise to such imaginative abstractions. The mind and hand of the French cubist are aggressively obvious, whereas in Sheeler the represented objects mask his painterly hand. His craftsmanship is like that of the men and women who made the rugs and furniture in his painting. It is well done, clean lined, cool, restrained. The artist hides his learnedness. As he himself once put it, "I favor the picture which arrives at its destination without the evidence of a trying journey rather than the one which shows the marks of battle. An efficient army buries its dead."[15] He might have said the same about what appealed to him in all the pieces of furniture in his picture. No showmanship. Just honest craft.

In *Home, Sweet Home*, then, the artist self-consciously locates himself in a family tree with selected craftsmen and craftswomen of the past. He claims a lineage that goes back to the maker of an American ladder-back chair of 1800. Giving his contemporary style a craft ancestry was a new way of thinking about American machine age aesthetics. Sheeler made the past, or representations of it, safe for modernists.

Entering the painting from above the floor and furniture, we hover strangely above this homelike space. The orderly presentation and hermetic cleanliness of *Home, Sweet Home* reinforce our sense that we are outsiders looking into a staged presentation. We might well be on the street, peering through glass at a department store display where all the goods are arranged a bit askew. Or we might be

Fig. 285. Hudson-Fulton Celebration exhibition
at the Metropolitan Museum of Art, 1909.

looking over a velvet rope into a museum period
room. For like Sheeler's painting, period rooms are
intended as illusions, hermetically sealed spaces that
transport viewers into a domestic setting from an-
other era. The curators and designers who create
such spaces want us to imagine ourselves in a home
of another time and not in a museum of today. To fos-
ter the illusion, they meticulously re-create the archi-
tecture, usually board by board from the original;
windows are lit artificially to give the impression of
sunlight streaming through them; and staircases
lead out of the room to (imaginary) second stories.
Decorated with furniture appropriate to the period
and style, the rooms are arranged to appear "natu-
ral"—a chair is awry, a table is set—as they might
have looked when the room was lived in.[16]

 Yet for all the curatorial effort to make period
rooms look alive, such arrangements are inevitably
static. They never change from one visit to the next.
Nothing ever looks jostled or wrinkled, and it is
hard to people them in our imaginations. Period
rooms often venerate the beauty of early American
objects and their craftsmanship—and say little
about the people who made or used them. This

was particularly true of period rooms in the 1920s,
to which Sheeler's painting bears such a striking
resemblance.

 The period room came of age in this country after
World War I when major museums like the Metro-
politan began to display their newly acquired collec-
tions of early American decorative arts in rooms sal-
vaged from architecturally distinguished homes.
Collecting and preserving furniture from the colo-
nial and early national periods had begun much ear-
lier, but as the work of private collectors and an oc-
casional historical society. And a colonial revival in
architecture and furniture had flourished since the
late nineteenth century.[17] But only in the early twen-
tieth century did museums begin to collect and dis-
play original decorative arts made in the colonies.
One of the first important exhibitions of this mate-
rial was the Hudson-Fulton Celebration of 1909 at
the Metropolitan Museum, to which private collec-
tors lent pieces of American furniture made before
1815, the year Robert Fulton died. Three galleries,
chronologically ordered, displayed chairs and tables
along with works in silver and porcelain along
their walls (Fig. 285). Such a presentation, which

highlighted individual pieces, was also one of the first instances of classifying styles of American workmanship without any accompanying European pieces for comparison. Showcasing colonial American furniture, the exhibition suggested that the country had produced more elegant and accomplished furnishings than popular stories of puritan austerity and wilderness pioneers would have it. Telling a history of any aspect of American artistic production without reference to Europe was a new idea, and it struck a deep chord of public approval.[18]

The success of the Hudson-Fulton exhibition stimulated the creation of a permanent display space for early American decorative arts. In 1924, after a dozen years of concentrated collecting, the Metropolitan Museum opened its American Wing with fanfare and acclaim. Consisting of sixteen period rooms and three large exhibition galleries spread out over three floors, the new wing offered a sumptuous pageant of living spaces in the colonies and the early republic (Fig. 286). Given the grandeur and ambition of the space, the opening elicited a great deal of critical response. For many it was a

revelation: the country had an artifactual past worthy of museum attention. "American Art Really Exists, Collection in New Wing of the Metropolitan Museum Refutes Critics of U.S. Culture," read one newspaper headline.[19] Over the next quarter century there would be an explosion of period rooms open to the public.[20] In time, museums began to dedicate whole departments to the American arts, separate from those for European collections— a major change in museological practice.

The creator of the American Wing was R. T. H. Halsey (1865–1943), a trustee at the Metropolitan Museum and a volunteer curator who traced his family back to the earliest days of the American colonies.[21] One of his grandfathers, he liked to recall, had served on General Washington's staff. Halsey was wealthy, a member of the New York Stock Exchange, and an indefatigable collector. It was his energy and charismatic personality that brought the American Wing into being. Halsey made into grand style what had previously been found in the occasional re-creation of a New England kitchen or a colonial parlor at world's fairs and adventuresome

Fig. 286. Bedroom from Hampton, New Hampshire (Shaw House), 1740–60, as installed and furnished in the American Wing at the Metropolitan Museum of Art in 1924.

historical societies. George Francis Dow's installations of early American rooms at the Essex Institute in Salem, Massachusetts, was one of the most important of these precedents. As early as 1907 Dow had opened a parlor, bedroom, and kitchen of the year 1800, putting period furniture into domestic settings decorated with woodwork taken from early Massachusetts houses (Fig. 287). Viewers looked into the rooms through the one wall of each that was made of glass.[22]

Halsey's American Wing purported to trace the American decorative arts to 1825, a period he and his contemporaries generally described as "colonial." Thereafter came the Victorian era and the arrival of machine-tooled goods—the end of significant American craftsmanship to Halsey and most others at the time. Halsey focused on high-style work from the colonies and early republic; he showcased the most exquisite examples of craftsmanship he and the museum had been able to collect. Whenever he had the information, he named the furniture maker and his workshop or the piece's place of origin. Furthermore, he and his fellow organizers

prided themselves on their rigor, putting in each room only authentic pieces from the same American locale and period as the interior architecture. European imports were acceptable only if they were appropriate to the period being depicted; northern imports would be placed in southern interiors, and vice versa, only with solid historical evidence of the practice. Halsey also furnished the rooms sparsely. He stated his goals upon beginning to create the wing: "We should endeavor to show in the rooms things which have class. The furnishings should be restrained and no semblance of crowding permitted." And then, as if he had the more densely furnished Essex installations in mind, he added, "The exhibition of the quaint and curious should be left to our historical museums."[23]

Furnishing period rooms with a few uniformly excellent objects from one region and one moment in time inevitably affected the look of these period rooms. This is not the way most people lived then, or live now, and the Metropolitan's first period rooms look highly artificial and staged, especially if compared with the parlor at Essex, where Dow used

Fig. 287. Parlor furnished in the style of ca. 1800 by George Francis Dow in 1907 for the Peabody Essex Museum, Salem, Massachusetts.

reproductions to fill in for furnishings he could not obtain in the original. Dow put music on the piano rack, decorative objects on the mantel and the hearth, and furniture at angles and in close quarters. Halsey, in comparison, created the formal and underfurnished Almodington Room (Fig. 288). He set each piece far enough away from the others so that its lines, contours, and individuality were preserved. He emphasized the formal characteristics of individual pieces rather than the ensemble. Dow's parlor looked cozy and warm, Halsey's austere and cool.

Homer Keyes, the editor of the new magazine *Antiques*, itself an index of a new national interest, found this sparseness so objectionable that he centered his review on the pressure he felt "to admire" and "to *see*" but not "to *feel* the character of the homes of his ancestors" (emphasis in original). He complained of "the absence of such lesser household equipment as coverings on the floors, books on the tables, garments hung against the walls or cast across chair backs, and those innumerable half useful, half decorative accumulations which constitute the spoor of family existence." Pieces did not, he continued, come together as a "true ensemble."[24]

The austere arrangement of furniture in Halsey's period rooms resonates with Sheeler's paintings of domestic interiors such as *Home, Sweet Home*. Coolness and intellectual severity make the ensembles of American antiques in the rooms and the painting look self-consciously arranged. Neither the three-dimensional space nor the two-dimensional representation admits of clutter or random placement. In both, abstract pattern and repetition, as much as patterns of use, dictate the positioning of chairs and smaller decorative pieces, and considerable air and emptiness surround the larger ones, like Sheeler's high-back chair. This "negative" space calls attention to the contours of individual pieces and the way they sit on the ground. It helps focus viewers on style and craftedness. It venerates, we could say, the bodies of these pieces of furniture, displacing the humans who made or used them in favor of an emphasis on form and style.

The modernist aesthetic so pronounced in Sheeler's painting lies just below the surface of the Metropolitan's period rooms. Both Halsey and Sheeler put a premium on form and abstract arrangement and disdained storytelling and passion. Both privileged

Fig. 288. The Almodington Room, as originally installed in the American Wing at the Metropolitan Museum of Art in 1925.

style and connoisseurship over the use and function of things in the past. Both feared arousing sentiments about objects that they themselves clearly loved. Their cool and dispassionate attitude, anti-Victorian and promodernist, would in time engender a passion and sentiment about form itself and launch an age of formalism.

In Halsey, in other words, the vigorous promotion of American-made (non-European) artifacts had a covert formalist bent; in Sheeler the sentiments of a booster lurked just below the cool cubist facets of his modern painting. Yet both were making a similar case for the beauty of early American crafts over those from other cultures. One advocated high style, the other vernacular furnishings. That Sheeler called his painting *Home, Sweet Home* bespeaks the complexity of his attitudes. Its title, the same as that of a popular Victorian song, refers to the painting's literal subject: a furnished room in Sheeler's own home. The painting even includes a hearth, over which embroidered "Home, Sweet Home" decorations often hung. Given that the artifacts in the painting were all American made, the title also referenced the greater home of country and nation. And as so often was the case with the titles modernists chose for their paintings, this one simultaneously teetered on the edge of poking fun at popular sentiments about home and country and promoting a group of native artifacts that were not yet valued by the culture at large. The painting wrapped up sentiment on behalf of early American craftsmanship as modernist irony. As a title it both mocked the Victorian sentimentality of the original song and indulged a little in it.

Both Halsey's and Sheeler's projects revised prevailing Puritan-Pioneer narratives that emphasized the country's provinciality and crudeness. Both men felt they had uncovered pre-Victorian American workmanship of museum quality that could stand up to comparisons with European. But they were strange bedfellows and in fact parted company in the nature of the artifacts they promoted and the purposes to which they put their nationalist sentiments.

If Sheeler was first and foremost a modernist giving birth to a new mystique about an indigenous American style, Halsey was an antiquarian mythologizing the founding fathers' values and way of life. Halsey was more politically conservative, upper class, and openly patriotic. Assuming (and wanting) his audience to be of one mind, he called a handbook for the American Wing *The Homes of Our Ancestors*. In it he expressed the hope that the rooms would not only teach appreciation for American artistic achievements but also engender patriotism and pride. He also spoke as a nativist worried that immigration was destroying the country's unity; the wing, he said, would "Americanize" foreigners who do not know the country's history.[25]

For Halsey, "the homes of our ancestors" meant those of the wealthiest, most powerful citizens, furnished with the work of the best artisans of the pre-1825 era. He was interested neither in subcultures like the Shakers or the Pennsylvania Germans, nor in things used by the lower to middling classes. His installations showed how the white merchant class lived on the eastern seaboard before the industrial revolution. Furthermore, because Halsey laid out the rooms in chronological sequence, the American Wing appeared to tell an American success story. As one walked from the austere seventeenth-century rooms into the opulent eighteenth-century ones, life inevitably seemed to get better. Years of deprivation and struggle in the early colonies gave way to sophisticated cosmopolitan living.

Sheeler, in contrast, cared nothing for chronology. With objects dating from around 1800 (the chair) to around 1930 (the furnace and the painting itself), *Home, Sweet Home* told a story of stylistic continuities, not one of cultural evolution and change. Furthermore, he advocated plain-style furniture produced by anonymous artisans, being among the very first to find beauty in Shaker furniture, of which he had many pieces. He included Shaker furniture in his Americana series as early as 1926. (Several decades would have to pass before curators at the Metropolitan added Shaker pieces to the museum's collection.)[26] Rarely did the artist know the name of the artisans who had made the pieces he collected; their anonymity gave his furniture a populist "aura." It would be only a short step to declare, as many around Sheeler began to do, an American grassroots sensibility or mind that favored straightforward, no-nonsense forms. To this proposition we shall shortly return.

Sheeler's work, then, indirectly celebrated the democratic impulse in American history and the presumed youthfulness and innocence of vernacular

expression. Like Halsey, he searched for meaning in a national past and an artistic heritage, but without Halsey's Anglo-Saxon rhetoric or pronounced patriotism and nativism. Like other modernists, Sheeler consciously distanced himself from antiquarians and neocolonial decorators. But he sensed the thin line between his own activities as a collector touting the aesthetics and plain-style craftsmanship of American antiques and those of the establishment that so often spoke of the inherent goodness or moral qualities of old ancestral things. Thus the defensive quality and the convoluted logic of his statement, often quoted, that the date when the furniture was made, or its pedigree, did not matter to him. He liked what he liked, not because it was vintage, but because it looked modern, as if it had been made yesterday. "I don't like these things because they are old but in spite of it. I'd like them still better if they were made yesterday because then they would afford proof that the same kind of creative power is continuing."[27]

Sheeler never wrote about the American Wing, but we can guess that his views would have resembled those of Lewis Mumford, who liked best Halsey's seventeenth-century rooms, with their plain and spartan furniture, which had "austere qualities that are similar to those we find today in machinery; their beauty is the beauty of nice proportion, sound workmanship, keen design." But Mumford dismissed the rest of the rooms, representing the period from 1750 to 1825, as "a spinsterly desire for ancestors," describing Halsey's efforts as unmanly and sexless. Like those in the second Stieglitz circle, with which he was then aligned, Mumford often used gendered language and was ever alert to evidence of American materialism and bourgeois vulgarity (that ugly v-word again) in the past. To him, eighteenth-century furniture bespoke a culture given to "conspicuous waste—always edging into vulgarity." With two of the three floors of the American Wing given over to the early national period, he worried lest they exert a proportional influence on present-day taste.[28]

For Mumford and other modernists like Sheeler, then, high style was suspect, vulgar, expressing the materialism of the pioneer mentality. Halsey, in contrast, thought the rooms Mumford dismissed his best, demonstrating the period when "our American Styles in architecture and furniture found even

fuller expression." He was guarded, though, in his judgments, underlining always the European precedents for colonial artifacts. He would make no claim, he said, that "colonial art is great art. From the art standpoint it cannot be compared with that of Raphael, Michael Angelo, Cellini, and numerous others, any more than the simple lyric 'Home, Sweet Home' can be compared with 'Tannhäuser.'"[29]

For Sheeler "Home, Sweet Home," a popular ballad celebrating the common person's humble abode, expressed something close to his own ideals. "'Mid pleasures and palaces though we may roam, / Be it ever so humble there's no place like home! / A charm from the skies seems to hallow us there, / Which seek thro' the world, is ne'er met with elsewhere; / Home! Home! sweet, sweet home"— these were lines Sheeler could endorse, even if tongue-in-cheek. Unlike Halsey, who was always looking over his shoulder to Europe, Sheeler cared less about comparing American production with *Tannhäuser* than about locating humble domestic artifacts of earlier centuries that confirmed his own identity as a modern American artist.

Like his friend William Carlos Williams, who in 1925 left behind his days as an automatist poet to write a book about figures he admired in American history, calling it *In the American Grain*, Sheeler aspired to uncover a national artistic ancestry. In our own age of identity politics the creation of pasts is a familiar idea, and in many ways artists like Williams and Sheeler modeled how it might be done. They argued for a selective past, one that nourished them in the present by offering new archival sources, new role models, and new histories. Of late, pasts have been built in support of identities based on race, ethnicity, and sexuality. In the 1930s the identity important to many artists was based on region. In the 1920s, as we have seen throughout this book, identity for modernists like Sheeler was based on definitions of Americanness. The issue was whether America had a useful identity separate, and different, from that of Europe, whose cultural achievements everyone agreed were considerable.

Sheeler's desire to locate something coherently American in the past links him to a second and much broader quest that, by the late 1920s, can be found in almost every sector of the country's arts

and letters. Beginning in the 1920s but especially in the 1930s, adventuresome scholars began to agitate in their colleges and universities for courses that separated out American experience from that of England and Europe. Fitfully, universities began to offer courses, first in American history; then in American literature as a subdivision of English; and finally, in the history of American art and material culture. Efforts to find special qualities and unique stories in American history and artifacts also gave rise to a new field, American Studies (or American Civilization, as it was sometimes called), which began to flourish in the 1930s in such notable universities as Harvard and Yale.[30] Scholars in the academy such as Vernon Parrington, Samuel Eliot Morison, Perry Miller, F. O. Matthiessen, Henry Nash Smith, and Leo Marx in history and literature; Oskar Hagen and Oliver Larkin in the history of art; and John Kouwenhoven in the history of material culture began to make the study of American history and culture a field of its own.[31]

In general these newly styled Americanists, as they came to be called, concentrated on American exceptionalism, defining what was peculiar and special to the national experience. Instead of judging historical events and figures against those of Europe, they examined the American past as a set of events unfolding in the cultural and geographical setting of the New World. The discourse they formulated loosely in the 1920s and early 1930s became more theorized and academically rigorous in later decades and dominated professional study during the two decades after World War II. In the late 1960s a new generation of revisionists began to dismantle it, challenging its basic premise: that there was "one" grand narrative of history that defined the American experience or the making of an American mind.

Sheeler, with his desire to fit his work into a lineage of crafted goods made by anonymous Americans, helped initiate this exceptionalist discourse in the fine arts, as did his counterpart, R. T. Halsey. Halsey not only designed the American Wing but also offered pioneering courses on the American decorative arts as early as 1928.[32] Sheeler's closer allies, however, were fellow modernists, particularly such literati as Van Wyck Brooks, whose writings about American literature in turn inspired people like Lewis Mumford and Constance Rourke to

rethink the history of both American art and literature. All of them were cultural critics, trained not in history but in literature, who increasingly turned to a study of the past as a way of understanding and interpreting the present. Highly selective in what they chose to study, they dismissed a great deal of American history as useless and depressing. In general they had few good words for anything they deemed genteel or aristocratic or fashionable—American colonial high style or Victorian styles, for instance. But at the same time, they rediscovered neglected figures—Henry David Thoreau, Herman Melville, Nathaniel Hawthorne, Albert Pinkham Ryder, Thomas Eakins, Winslow Homer, Shaker craftsmen, folk artists, folk humorists—who, they argued, even in their failures offered models and inspiration for American moderns.

Mumford's 1924 review of the American Wing is a case in point. It registered his summary judgment against all the eighteenth-century rooms for their vulgarity and materialism. One of his most radical criticisms, however, was that the wing was too even-handed and comprehensive: "An exhibition of historical art is justified when it gives us the courage to make our own history." He encouraged visitors to the wing to be guarded and suspicious in their viewing. We need to "wander through these rooms and find out for ourselves what there is in American traditions that we can build upon; what there is which genuinely unites us with our past and promises a legitimate offspring in fresh art." In other words, he exhorted viewers to find their own serviceable history. To this end the only useful rooms were the seventeenth-century ones where there was no commercialism, only a "spartan art [that] was produced by the woodturner, the carpenter, the blacksmith. . . . There or nowhere is our America."[33]

Sheeler, as a collector of furniture, was a good example of what Mumford called for in his review, an artist who selected from the great inventory of the American past and saw in it the makings of a tradition. Though modern-day scholars commonly call Sheeler's tastes "ahistorical" or "eclectic," this description reflects their own postexceptionalist views on the history of objects, not the 1920s directives by which Sheeler built his collection. In fact, Sheeler was rigorously selective in choosing works from the American past; each piece had aesthetic and social kinship to all the others. Though he left no

Fig. 289. Charles Sheeler, *South Salem Interior*, 1929.
Gelatin silver print, $7\frac{5}{16} \times 9\frac{1}{2}$ in.

inventory of his collection, his art, which documents much of it, suggests that most of what he had dated to the nineteenth century.[34] He began his collecting in Bucks County, but his many pieces of Shaker furniture were the heart of his collection. He supplemented these pieces with other plain-style furnishings that had strongly stated contours, accentuated geometries, or repeated patterns. He had a special fondness for simple but stately chairs and filled his homes with them: slat-back chairs, Windsor chairs, and chairs with seats woven of grass or rushes (Fig. 289). He also had at least one modern chair; in his lovely drawing of his wife Katherine, she sits in a Breuer chair (Fig. 290). When he designed patterns for textiles in the late 1930s, all of them using a repeated geometric pattern, he had an armchair covered in one of them.[35]

Some of his pieces—rag rugs, pressed glass, a quilt, folk paintings, a Pennsylvania German chest—came from the Victorian era, which commonly modernists loved to hate. Yet here Sheeler's disregard for chronology and his high regard for aesthetics and handwork allowed him to collect pieces from a period that was in general disrepute during the 1920s. Victorian, to this generation, generally meant highly ornamented decoration and machine-aided manufacture. Sheeler had no use for either. But if he could find handcrafted pieces whose aesthetic properties harmonized with, or helped dramatize the severity and plain style of, his larger furniture, he used them in his ensembles, regardless of their date. He also collected an occasional non-American piece like the black Etruscan vessel that he valued highly and sometimes painted and

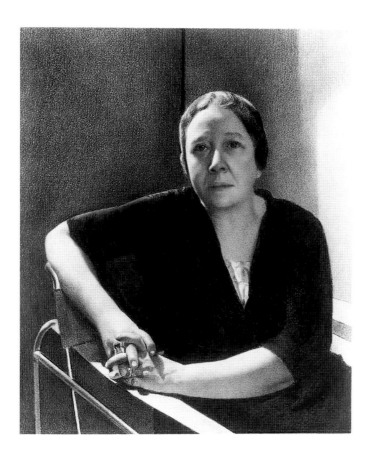

Fig. 290. Charles Sheeler, *Portrait (Katharine)*, 1932.
Charcoal on paper, 9½ × 8 in.

photographed. Like his American decorative objects, the Etruscan pitcher features a basic bulbous form with a simple scalloped lip and functional handle.

Mumford and Sheeler were participants, then, in what we might think of as a history-for-modern-art's-sake movement in the 1920s. They self-consciously went back into American history, not to recover it with any completeness or pretense to objectivity, but to assemble traditions over time upon which machine age moderns could build. Often designated cultural nationalists in the literature, they could also be called critic-historicists, as I described them at the opening of this chapter.[36] They were critics in that they aimed to shape contemporary production and made sharp aesthetic distinctions between acceptable and unacceptable taste. They were historicists in that they looked for continui-

ties across the centuries, no matter how selective or loosely construed, and used research tools and academic rhetoric to bolster their claims.

Van Wyck Brooks, in his well-known essay "On Creating a Usable Past," published in the *Dial* in 1918, defined the task that Sheeler, Mumford, and others pursued. Finding the current histories of American literature sterile and overly genteel, and believing a cultural renaissance in American arts and letters was at hand, he called for the invention of a new American past to sustain contemporary writers in their work. Europeans, he claimed, had a rich past to pick and choose from, but in America "the professorial mind . . . puts a gloss upon the past that renders it sterile for the living mind." It simply "reaffirms the values established by the commercial tradition." He called for a "vital criticism" that

would rewrite history and include "all manner of queer geniuses" who have "meaning for us now." Calling this a "usable past," he argued that it would give modernists a "sense of brotherhood in effort and in aspiration which is the best promise of a national culture."[37] In his own work he went on to write about Henry James, Mark Twain, Washington Irving, and the New England transcendentalists.[38]

One of Brooks's most influential converts was Lewis Mumford, whose earliest writings about the American past included fresh looks not only at literary figures but also at those in art and architecture. Something of an autodidact, Mumford had taken courses in New York at City College, Columbia University, and New York University, but never a degree. He was close to members of the second Stieglitz circle, especially Paul Rosenfeld, and, like Rosenfeld, made his living as a critic of American culture. Between 1924 and 1931 he wrote four books, *Sticks and Stones* (1924), *The Golden Day* (1926), *Herman Melville* (1929), and *The Brown Decades* (1931), in which he located a host of American architects, artists, and writers whose careers offered sustenance, he felt, to present practitioners. In all these studies, he maintained that when he looked close, the American past was neither as dismal nor as shallow as he had once assumed. Optimistically, he called upon his contemporaries to use his revised past as inspiration for the present. Mumford wrote in italics at the conclusion of *The Golden Day*, *"Allons! the road is before us!"* And at the end of *The Brown Decades* he asked, "Does this work lead toward our own generation? In a measure, at least, yes. Toward even more solid achievement beyond our own? Let us hope so."[39]

Seeking continuities in American expression, Mumford found them arising from internal developments—Puritan beginnings, American capitalism, the Civil War, changes in technology—rather than from a dialogue with European events and schools of thought. His studies leave Europe aside by the mid nineteenth century, when he believed an "American mind" has been formed. From this point on, he situated schools of thought in the country's own political and social history, thus setting off his studies from earlier art histories that had been written as accounts of schools and masters beholden to European training and fashions. For several decades the ruling premise had been, as in Samuel Isham's

History of American Painting (1905), to contextualize American work in schools of European thought: "The fundamental and mastering fact about American painting is that it is no way native to America but is European painting imported, or rather transplanted, to America, and there cultivated and developed; and even that not independently. . . . There is no local tradition or influence."[40] If other art critics, like Sadakichi Hartmann and Charles Caffin, were much more sympathetic to modern movements than Isham, they nonetheless wrote their prewar histories of American art as he did, with one eye always on Europe.[41]

Mumford paid scant attention to European supremacy. For him, a great American literature and architecture developed well before the Civil War— he called the period the Golden Day—while the American visual arts began to bear fruit after the war, during what he called the Brown Decades. Like Van Wyck Brooks, he often spoke to artists' failures in a country handicapped by Puritan and Pioneer mentalities. Indeed, many American painters failed to meet Mumford's requirements for a usable past. The colonial painters were too sober and inexpressive and the successful artists and mainstream craftsmen of the antebellum era and the Gilded Age too closely tied to an era of greed and limited vision. The Hudson River School painters were mere illustrators—too realist in style, narrow in vision, and limited in subject. (Their revival would not begin in earnest until the 1940s and 1950s.)[42] Mumford, like other modernists, felt a deep animosity toward any form of American realism, generally condemning it as shallow and illustrative.

Among painters, Mumford could most easily praise Ryder, picturing him as a symbolist and an expressionist who, in modern fashion, used his thick brush to render feelings in abstract form. Rosenfeld had already presented Ryder in these terms in *The Port of New York*. In *The Brown Decades* Mumford echoed many of Rosenfeld's judgments on Ryder, seeing his work as a bridge from the Brown Decades to the second Stieglitz circle, with which Mumford ends his book. Like Alfred Stieglitz, John Marin, and Georgia O'Keeffe, Ryder "consciously used the objects of the external world as symbols of the emotions and feelings he sought to express."[43]

Mumford's revisionism, dismissive of artists popular in their own lifetimes but newly appreciative of

figures whose lives could be recounted as struggles against a rapacious American society, was both critical and historical. The more marginal the artist and the more failure he had suffered in his own life, the more attractive he tended to be to critic-historicists, who celebrated the survival of American artists in inhospitable environments. Indeed, they made an honorable American tradition of the artist's struggle against an unsympathetic public, with contemporary artists only the latest in a long line of resistance fighters. Writers like Thoreau, Hawthorne, and Melville, who had been critical of American culture, were now pictured as models of antimaterialist activism, and their works became the new canon in American literature. The same happened in art history to Ryder and Eakins and, soon after, to Homer. They were reevaluated in part because deep alienation from materialist society could be read in each of their life stories. Lloyd Goodrich, a young modern painter and critic who in the 1920s began the first modern biography of Eakins, interpreted him as an isolated figure, a genius opposed to the "feminine" culture of late-century aesthetes, and an uncompromising realist—a brutally honest, sober "masculine" painter who revolted against puritanism and gentility, only to be neglected and misunderstood in his lifetime. Goodrich set the tone and approach used to interpret the artist's work for nearly a half century.[44]

The words "honesty," "directness," "simplicity," and "innocence" run like a thread through the revisionists' language, identifying the degree to which critic-historicists filtered their revivals through the same set of modernist values Sheeler brought to American antiques. Mumford praised Eakins for "a salty directness, an absence of pretense and sham" and found in Ryder a "divine innocent."[45] For Goodrich, Eakins had an "eye as innocent as a primitive, observing things as if they had never been painted before."[46] Homer, too, Goodrich argued, "all his life . . . remained fundamentally naive."[47] While such statements seem preposterous to us today, knowing what we do about the learnedness of all three artists, they clarify the grounds on which a new canon of American arts and letters was erected. American modernists between the wars assigned their newly identified artistic ancestors the very same Americanist qualities they wanted to see in themselves; they were innocents, children, compared with

worldly Europeans, and they spoke a direct, simple, and unaffected speech. These qualities, moreover, were not just temperamental but also deeply embedded in their art.

Sheeler shared these values and searched for them when putting together his own usable past, but his revisionism went in a different direction. Like many modernists he remained unconvinced by Homer, Ryder, and Eakins, whose technique and control of the brush he deemed too poor to be acceptable ancestry. Homer, he wrote, offered "the realism of the stage-drop"; Eakins's "sense of craft" was too "clinical"; and Ryder overworked his canvases and "had no sense of the painter's materials."[48] Ironically, given his admiration for craft, Sheeler chose for his family tree American painters who had little training whatsoever: the folk painters in the American past whose childlike innocence, simplicity, and directness seemed written into every fiber of their work.

Holger Cahill, one of the first curators to bring American folk art into the modernist orbit, recalled finding a theorem (stencil) watercolor *Glass Bowl with Fruit* for only $3.50 in a shop in New Haven and being so excited about his bargain that on the way home he "stopped at Ridgefield, Connecticut where Charles Sheeler lived at that time. . . . I said to him, 'Charles, how would you like to have done this?' He held it in his hands and looked at it and said, 'My God, I wish I could. There is severity there, a spareness. It's something like the quality of poetry'" (Fig. 291).[49] In a more formal statement, Sheeler explained the attraction of folk art: it shows "us something of the character of the people of the time in which it was produced, and it often has characteristics common to the most satisfying expressions of any period: simplicity of vision and directness of statement with a considerable sensitiveness and originality in the use of the medium."[50]

In 1915 no artist or curator or scholar could have said such things. Conversely, by 1935 no history of American art could be written without discussing the "simplicity of vision" said to reside in folk art. In one generation, a body of work that had little market value or historical significance was located, named, collected, researched, put into market play, and shown in museums across the country. The

Fig. 291. Artist unknown, *Glass Bowl with Fruit*, ca. 1860. Watercolor and ink on paperboard, 18 × 14 1/16 in.

recovery was explosive. Unlike the seventeenth- and eighteenth-century decorative arts shown at the Metropolitan, which had been collected privately for several decades before entering the museum, folk art as a pursuit quickly passed from artists, who sought out examples for fun and pleasure, to museums, wealthy collectors, and commercial galleries. It is an extraordinary story that should be more tightly woven into Sheeler's career and into the history of American modernism after World War I. In the very decade when skyscrapers and machine-made objects seemed to define the country, modernists contrapuntally searched the past for a particular sort of historical ancestors: simultaneously old, American, and modern.[51]

The first modernist collectors described their new discoveries variously as folk, primitive, popular, pioneer, naive, and provincial. Eventually "folk art" became the preferred term for a general category comprising different media, genres, and artist types.[52] Sheeler had tinsel paintings and landscapes from the Northeast, pottery and furniture from the Pennsylvania Germans, and Shaker pieces, all of which were considered "folk art" at the time. The term also covered the New England Freake painter of around 1670, that of the early-eighteenth-century patroon limners from New York, provincial portrait and landscape paintings by mid-nineteenth-century itinerant artists, frakturs by the Pennsylvania Germans, santos from the Southwest, cigar-store Indians, figureheads, whirligigs, weather vanes, tombstone carvings, hooked rugs, needlework, mourning pictures, and theorem paintings. Much of this work was made during the nineteenth century for a growing middle class, whose tastes and needs were often met by itinerant artists and small-town artisans with little formal training who worked through rote formulas. Some of it was made by women practicing the "ladies'" arts of watercolor, needlework, and calligraphy. And some of it, such as artifacts from Shaker or Pennsylvania German communities or from the Catholic Southwest, was regional, religious, and ethnic.

To the first enthusiasts of folk materials, such distinctions were unimportant and unnecessary. The earliest of them put folk art on their walls for the aesthetic pleasures of its form and style and for its popular and democratic associations. They liked the way folk canvases privileged flat abstract forms over

three-dimensional ones and design over perspective and modeling. Sculptors praised the early carvers' handworking of wood and stone into toys, trade signs, or figureheads far outside the high-art traditions of marble and bronze. Some celebrated the innocence of this nonacademic art, presuming that because so many folk artists were nameless, they worked outside the margins of polite or official culture. Neither historical precision nor coherence of periodization mattered as much as the qualities ascribed to the art. Enthusiasts were so cavalier about dates that one enthusiast thought a nineteenth-century provincial portrait called *Dover Baby* (for the town in which it was bought) might be by the "same artist as painted the Freake portraits." He published it as "possibly seventeenth century."[53] They could also be endlessly expansive in defining the stylistic elements of folk art. Edith Halpert, Sheeler's dealer, showed Raphaelle Peale's very polished and well-crafted *After the Bath* and, some years later, still lifes by William Harnett in her folk art gallery. She was comfortable not only grouping them all together as ancestors of the moderns, but also linking them to Sheeler in particular. "Perhaps more than any other artist, Sheeler is part of a purely American tradition stemming from the meticulous folk artists and continuing through Raphael Peale and Harnett, little influenced by foreign sources."[54] It did not matter to Halpert that Peale painted earlier than most of the folk artists and decades before Harnett. She dwelled on "an American tradition" untouched by Europe and was instrumental in formulating it.

Modernist artists—including Sheeler, who probably came to folk art through his early collecting of furniture and antiques in Pennsylvania—were foremost among the New Yorkers who saw in folk art America's first important artists. Others "got the folk art fever," as Holger Cahill called it, when they visited Hamilton Easter Field's summer art colony in Maine.[55] Field, trained as an artist in Paris, had family money that allowed him to teach and support young artists and to collect works of art.[56] In 1920 he founded *The Arts*, a progressive art periodical. He also set up two small schools and art colonies for modern artists, one in Brooklyn Heights and the other in the picturesque coastal town of Ogunquit, Maine. In time he acquired a large island home on Perkins Cove, along with several fishing shacks and two old barns set back from the shoreline. Some of these buildings he converted into artist studios and furnished inexpensively with early American furniture and hooked rugs from local shops and attics.

What Field took to be appropriate country furnishings became objects of desire for those such as Robert Laurent (Field's heir) and the artists William and Marguerite Zorach, Bernard Karfiol, Wood Gaylor, Niles Spencer, Stefan Hirsch, Adelaide Lawson, Peggy Bacon, Alexander Brook, Yasuo Kuniyoshi, and Katherine Schmidt, who stayed in Field's cottages and by the time of his sudden death in 1922 had all begun to buy Americana. One artist, searching for folk material in old attics and barns, at country auctions, and in antique shops, vividly remembered hearing about a "hunting trip that Karfiol, Laurent, and Kuniyoshi took to a Quaker village. They claimed to have been gone for two or three days, spent approximately twenty-seven dollars between them, and had to hire a truck to bring back their early American treasures."[57] Not only were these things "more beautiful than regular manufactured products," wrote Zorach of his own finds, "but they were much cheaper, and a lot of us had acquired houses and had very little to furnish them with. Hunting antiques was great sport and lots of excitement."[58]

In 1924 these artists loaned some of their finds to a small exhibition of folk art at the Whitney Studio Club, an event that looms large in retrospect as the first of its type. The Whitney Studio Club, with two small galleries, was an important gathering place for artists at the time. Its membership of some three hundred modern artists included many who had been collecting folk materials. At the time of the exhibition Sheeler lived in one of the club's two apartments, working for the club's director, Juliana Force, who lived in the other. Henry Schnakenberg, an artist and club member, organized the exhibition, called simply *Early American Art*, including in it forty-five works: provincial portraits, a figurehead, a plaster cat, a pewter pitcher and sugar bowl, and a brass bootjack in the shape of a woman with spread legs as well as two paintings of Hudson River steamboats by John and James Bard that Schnakenberg himself had found in a Brooklyn chophouse and a cigar-store Indian— a short-skirted squaw holding a bunch of tobacco leaves—he had borrowed from a shop owner.[59]

Sheeler did the photography for the eight-page catalogue and loaned three of his folk paintings: a landscape, a portrait of a woman, and a watercolor entitled *'Twas Ever Thus.*

By all accounts, it was a playful event. Traces of dadaist humor lingered in the air—from Duchamp's earlier defense of "bad" taste and endorsement of the nonacademic paintings by Louis Eilshemius to Robert Coady's praise in *The Soil* not only for plumbing and Charlie Chaplin but also for colonial architecture, cigar-store Indians, and Indian beadwork.[60] In exalting "bad" art, the moderns once again pitted themselves against refined taste and gentility. Not by accident, the galleries and museums of modern art in New York began to show early American antiques in the same year that the Metropolitan Museum unveiled its version in the American Wing. Uptown it was Duncan Phyfe and Philadelphia highboys; downtown it was Edward Hicks and the carvers of shop signs. Uptown, establishment taste for fine goods; downtown, vanguard taste for the lowly and the vulgar: high art versus low, elite versus popular, learnedness versus innocence. Exhibitions both uptown and downtown boosted American artifacts, but those uptown promoted the art of our sacred forebears and those downtown, the art of the equally sacred common man.

On the occasion of the 1924 exhibition a relationship between modern and folk began to be articulated in the press. Critics found modernity in these old things. One of them wrote, "The strange thing is that most of these very old fashioned pictures give one vividly the sense of exactly the thing our most modern painters" are doing. Another declared contemporary and folk art interchangeable: "The flowers lent by Robert E. Locker [*sic*] and said to have been done by an ancestor might have been painted by Locker himself. 'Portrait of a Woman' lent by Charles Sheeler, suggests a Sheeler photograph, and the cat owned by Katherine Schmidt looks quite familiar."[61]

The associations between old and modern, which at first seemed coincidental, very quickly developed into more serious discussions of an ongoing American "tradition." What began as simple enjoyment of characteristics shared by generations widely separated in time became a way of championing inherent national character. By 1931 Henry McBride, always an astute critic, noted that "the sins and

shortcomings" of folk art were being ignored. Younger artists "acknowledge the little-known painters to be their great-grandfathers and great-grandmothers and seem to relish the fact that at least they have an ancestry." If he chided the artists, McBride was also sympathetic, concluding that perhaps it did not matter that folk artists had shortcomings, for at least they were American. "They are our forebears and that is enough."[62]

Some of those responsible for such rationalizations were among Sheeler's most important supporters and allies: Juliana Force, Holger Cahill, Edith Halpert, and Abigail Aldrich Rockefeller, who, as collectors, dealers, and curators of modern art, gave the idea of folk ancestry for modernists its most coherent articulation. Deeply committed to supporting modern artists, all of them were influential, both directly and indirectly, in shaping Sheeler's career and his reputation as an American modern.

Juliana Force effectively administered the Whitney Studio Club for the sculptor and heiress Gertrude Vanderbilt Whitney, who was its patron. In 1923, when Sheeler was no longer welcomed by Stieglitz, Force offered Sheeler and his wife Katherine an apartment at the club on West Eighth Street rent-free for eighteen months in exchange for some photography and help in the galleries.[63] Around the Whitney Studio Club, Stieglitz was generally seen as a pompous art czar, whose favors extended only to a chosen few. He had his seven artists, said Force, while she looked after the "other hundred and ten million."[64]

Sheeler and Force shared a passion for country houses, early American furniture, and folk art. Beginning during the war years, Force had assembled a remarkable collection of early American furniture, featuring Shaker pieces and anonymously crafted ladder-back chairs, tables, chests, and benches of the same country style Sheeler had in his home (Fig. 292).[65] In the late 1920s she furnished a large country house called Barley Sheaf Farm outside Doylestown, Pennsylvania, with her Americana as well as a house in South Salem, New York, the village where Sheeler and the artist collectors Alexander Brook and Peggy Bacon lived. She named it Shaker Hollow, after its furnishings. In 1932 when she redecorated her apartment at the Whitney, she surprised many with a full-blown display of high-style Victorian furniture, taking the taste for nineteenth-

century plain style into an entirely new revival (Fig. 293). On the walls she hung art by modern artists associated with the Whitney. Such a pairing was extremely outré at the time, rebellious even, and the new ancestry for modern art it offered had few takers. A taste for ornate Victoriana would not begin in earnest for another decade.[66] On the forefront as a collector, Force also pioneered in the museum; it was under her aegis that the 1924 folk art exhibition premiered at the Whitney Studio Club. In 1929 the club dissolved to become the Whitney Studio Galleries, which in 1931 became the Whitney Museum of American Art. As the museum's inaugural director, Force hosted the first exhibition of Shaker art in 1935.

By her example and leadership Force helped make folk art companionable with contemporary art. Her colleague Edith Halpert, the founder and director of the Downtown Gallery, promoted folk art as if it were modern.[67] Her gallery was one of the most important commercial outlets for modern artists of the day. By the end of 1931 she had become so convinced that folk and modern art belonged together, and would sell in combination, that she expanded her gallery and called one of the rooms on the second floor the American Folk Art Gallery. Many of the modern painters she represented were Whitney Studio Club members. She showed Sheeler for the first time in 1931 and exhibited and sold his work for the rest of his life. Trained first as an artist, Halpert and her husband, Samuel Halpert, a painter, spent part of the summers of 1926 and 1927 in Ogunquit, where she came in contact with folk art enthusiasts and purchased her first pieces. A creative and enterprising woman, Halpert began to market a few pieces of folk art at her newly opened Downtown Gallery as the perfect complement to her main fare. She also began to market an interpretation of folk art as modern art *avant la lettre*. She taught her clients to appreciate folk art because it was old but did not look old. In a draft for the press release for *American Ancestors*, her first exhibition in the folk art gallery, she issued a forceful statement about her rationale for having two galleries:

The collections of the American Folk Art Gallery show very definitely the relation of American folk painting to modern painting. There is a disregard for imitative realism and a concentration of design problems in this

Fig. 292 (top). Entrance hall at Juliana Force's Barley Sheaf Farm, Holicong, Bucks County, Pennsylvania.

Fig. 293 (bottom). Drawing room at Juliana Force's apartment, 10 West Eighth Street, New York, ca. 1932–36.

SHEELER

NOTHING IS SO ASTONISHING AS TRUTH

Fig. 294. Cover of brochure for Charles Sheeler exhibition at the Downtown Gallery, 1931.

folk expression with which the modern artist finds himself very much in sympathy and which relates modern art in America to what is best in the American folk tradition of the past two hundred years. This relationship between what is most characteristically American in the art of this country in the last two centuries, with what is being done by contemporary American artists, demonstrates a continuity in the American Art tradition which has not heretofore been noted by American art historians. It is this relationship and continuity which is being stressed by the American Folk Art Gallery, and by the Downtown Gallery which is sponsoring the new enterprise.[68]

Halpert made the relationship between folk and modern as natural as that of family members. Dissociating herself from antiquarians exhibiting colonial American art, she conceptualized her artist ancestors as a living past, not a dead one, as at the Metropolitan Museum. She used the term "American ancestors," she explained, to refer, "not . . . to ancestral portraits but to the ancestors of American contemporary painting."[69] No one benefited more from her linking of folk and contemporary art than Sheeler, whose works she sold for thirty-five years by putting him into what she called, repeatedly, an American tradition; she never lost an opportunity to teach her clients that Sheeler's work was "an American fact."[70] In her first press release about Sheeler in 1931 she extolled his all-American virtues and named him heir to a long line of native talent:

If there can be said to be a distinctive American quality in contemporary American painting, that quality is to be found in the work of Charles Sheeler. His pictures have the clarity, the purity of form, and the rigid adherence to essentials—characteristic of the American mind as evidenced by our architects and engineers. Mr. Sheeler sees clearly, analytically, almost scientifically, yet his work shows a firm conception of form. He rejects all outward signs of sentimentality, as a reaction to the sloppy painting of impressionism.

Mr. Sheeler's paintings and drawings show a distinct connection with the work of the Colonial and early American painters, and the Folk Artists of the early 19th century.[71]

To buttress her statement, Halpert put *Home, Sweet Home* on the cover of the exhibition's

brochure (Fig. 294). And she opened her first *American Ancestors* exhibition at the Folk Art Gallery a few days after the Sheelers came down from the main gallery. *Home, Sweet Home* served, in effect, as a promotion not only for Sheeler's work but also for the Americana Halpert was selling in her "other" gallery. Even at Sheeler's death she maintained the connection, installing pieces of folk art and Shaker furniture that Sheeler had collected in a memorial exhibition of his paintings in 1966.[72]

Force and Halpert were just two of a growing number of curators and critics eager to exhibit this decidedly historical material as ancestor to the modern.[73] Another was Edgar Holger Cahill, a talented scholar initiated to folk art in the summer of 1927 when he visited Ogunquit.[74] For a time, he was Halpert's partner, finding pieces for her Folk Art Gallery.[75] His most important contributions, however, lay in his ability to organize dazzling exhibitions of this new material, accompanied by well-researched and clearly written catalogues. Cahill became the first true scholar of folk art.

After two pioneering folk art exhibitions at the Newark Museum, one of the most liberal and innovative museums in the country, Cahill served briefly as acting director of the Museum of Modern Art, then only three years old but already a major player in the usable past project. There in 1930 the young curator Alfred Barr hosted a Homer, Eakins, and Ryder exhibition, securing the reputations of those three artists as old masters for American modernists.[76] Two years later Cahill organized the blockbuster exhibition *American Folk Art: The Art of the American Common Man*, which included more than 150 paintings and 25 pieces of sculpture. It put folk art into national consciousness, touring five city museums after its inauguration at the Museum of Modern Art: Providence; Boston; Kansas City; Greenwich, Connecticut; and White Plains, New York. Accompanied by Cahill's thoughtful catalogue, the exhibition spoke to the simple honesty and unconventionality of folk art. The catalogue itself, in language that radically revised prevailing opinion, defended the Puritans, who had been blamed for keeping art from flowering in the country. "Many writers," Cahill wrote, think that "the American people is not given to esthetic expression and that Puritanism is to blame for this national deficiency. . . . Yet it is a fact to be remarked that the earliest development of American art took place in the Puritan and Quaker sections." By locating the origins of folk art in the Puritan sensibility, he redeemed what so many considered the enemy. The Puritans, he wrote, "were wedded to an austere and simple way of living, but austerity and simplicity have never been a bar to art expression in any age of the world."[77]

What was not well known at the time was that Cahill drew this exhibition almost entirely from the newly formed folk art collection of Abigail Aldrich Rockefeller, which he and Halpert had quietly shaped.[78] A collector of contemporary art as well and a founder of the Museum of Modern Art, Mrs. Rockefeller was one of Halpert's best clients for both folk and modern work, and her purchases reinforced the idea of an American tradition of which Sheeler was an important part. A significant patron of his work, she bought his *American Landscape* (see Fig. 273), *Self-Portrait*, and *White Barn* and commissioned him to make photographs and paintings at Colonial Williamsburg.[79] In her New York townhouse gallery, she and Halpert mixed folk and modern pieces just as Halpert had done in the Downtown Gallery.[80]

So natural did the kinship of folk and modern work appear in the 1930s that Mrs. Rockefeller gave fifty-four folk works to the Museum of Modern Art and spoke of placing the entire collection there. But by the late 1930s, as the rise of Nazism and Fascism abroad began to discredit the links between art and nationalism and modern painters turned increasingly to abstraction, folk art began to appear illplaced in museums of modern art. The Museum of Modern Art transferred some of its pieces to the Metropolitan Museum. In 1939 the Rockefellers decided to place Mrs. Rockefeller's folk art collection in Colonial Williamsburg, which her husband, John D. Rockefeller, Jr., had restored. Yet the decision to install nineteenth-century artifacts, many of them from New England, in an eighteenth-century Virginia restoration was no more historically appropriate than housing them at the Museum of Modern Art. In 1954, six years after Abby Rockefeller's death, Mr. Rockefeller rectified the mismatch by providing funds to create a new institution, today the Abby Aldrich Rockefeller Folk Art Center, on the outskirts of the restoration area. Things were returned from the Metropolitan and the Museum of Modern Art to make the collection complete.[81]

Fig. 295. The Nadelmans' Museum of Folk Arts,
Alderbrook, New York, ca. 1932.

The formation of Abby Aldrich Rockefeller's collection illustrates folk art's quick movement from attics to artists' studios to museums of modern art and, finally, to museums of folk art. What in 1924 had been an artists' enthusiasm, with lingering dadaist overtones of undermining official taste by exalting crude and unpolished art forms, had by 1931 become a serious market commodity with an increasingly weighty cultural presence. What had begun in fun became competitive as antique dealers, historical societies, and antiquarians joined the recovery effort. By 1936 an art gallery in Macy's was advertising a sale of "American Folk Art which dates back as far as 1800."[82] Folk artifacts were now priced out of range for most artist collectors. Economic depression and personal circumstances forced many of the early collectors, Juliana Force among them, to sell all or some of their collections. The final act of this steady move from attic to museum came in 1961, when a group of New York collectors founded the Museum of Early American Folk Art; two years later they opened the doors to galleries carved out of a rented townhouse on West Fifty-third Street, just a few doors down from the Museum of Modern Art. Folk art stayed downtown from the Metropolitan, next door to the institution that did so much to seed the idea that folk art was both American and modern.[83]

The recovery of folk art significantly paralleled what happened to African art in the early decades of the century. It was an American variant of primitivizing, repeating the pattern of transformation that tribal arts underwent as they moved from ethnographic museums to progressive artists' studios, the commercial market, and, finally, the art museum. A Museum of Primitive Art, for many of the same reasons as the Museum of American Folk Art, was founded in a townhouse across the street from the Museum of Modern Art garden. Early exhibitions of African art, moreover, sometimes coincided with those of folk material and were organized by the same people.[84] Folk art enthusiasts used a mythologizing vocabulary similar to that of the primitivists, celebrating the supposed freedoms of the untrained artist and romanticizing preindustrial communities. When Americans pictured the art of their ancestors as charming, naive, intuitive, and childlike, they infantilized folk artists and pictured them as without culture, or at least without a superior culture like their own. They treated folk artists as "other."

Lest the folk art recovery project be seen as *only* primitivizing, however, let me underline how much the conversation around folk art focused on its being "ours" rather than "others'." The appetite for an indigenous folk, while primitivizing and romanticizing, expressed a desire for an imagined blood

relationship to a national past. Artists, critics, and curators collected specifically American primitives and did not mingle them with African works—or, for that matter, with Italian or Flemish primitives. Sheeler, commissioned to photograph pieces of African art, had plenty of opportunities to acquire tribal pieces, but he did not. Though he acquired an occasional Etruscan vase or Breuer chair from a culture outside his own, such pieces were the exceptions that proved the rule: his pieces were primarily of American origin.

Sheeler's purity, his insistence on the native made, differentiate his collecting activities from those of Elie Nadelman, a Polish-born artist (and the one major European) who added his voice in praise of American vernacular objects. A sculptor who immigrated during the war years, Nadelman became an avid collector of folk art, some of it American. He had received his art training in Munich, where he developed an interest in the toys, dolls, and glass paintings at the Bayerisches Nationalmuseum. After twelve years in Paris, he came to New York in 1914, and married a wealthy American widow who had been collecting laces and embroideries. Together the two of them began to collect Shaker furniture, whaling pictures, fraktur, cigarstore Indians, wrought iron works, toys, dolls, wagons, and sleighs—"folk art" of every description. They acquired hundreds, sometimes thousands, of examples from both Europe and America, housing their collection on their estate in Riverdale-on-Hudson. By 1926 the collection had its own building and was opened to the public (Fig. 295). Though his collecting was multinational and more catholic than that of Sheeler and others, Nadelman's intensity as a collector, as well as his own practices as a sculptor—his witty cherry wood carvings used abstract forms associated with old dolls and toys—gave transatlantic authority to the kinship Americans wanted to find between folk and modern.[85]

Sheeler's deep identification of his own art with Americana appears forcefully in the photographs he made of his living spaces in South Salem and Ridgefield (Fig. 296). Like O'Keeffe, Sheeler created domestic interiors that were not just extensions of his art but art forms in themselves.[86] While O'Keeffe's was an organicized aesthetic—she mixed bones,

Fig. 296 (top). Charles Sheeler, *Untitled* (Charles Sheeler's home, Ridgefield, Connecticut), 1939. Gelatin silver print, 9⁹⁄₁₆ × 7¹⁄₂ in.

Fig. 297 (bottom). Pieter Vanderlyn (attributed to), *Miss Van Alen*, ca. 1720. Oil on canvas, 31¹⁄₄ × 26¹⁄₈ in.

Fig. 298. Charles Sheeler, *South Salem*, 1929.
Gelatin silver print, 7 ⅛ × 9 ½ in.

rocks, and weathered wood with a modern butterfly chair, a Calder mobile, and chairs draped in loose white cotton slipcovers—Sheeler's was geometric, combining straight-edged crafted goods from the past with good machine age design from the present. O'Keeffe liked bare walls, only occasionally hanging a piece of her own or anyone else's art on her walls (see Fig. 260). Sheeler, in contrast, hung many things on his walls, always in tidy arrangements with his furniture and decorative arts. Under his orchestration these things, though disparate, looked aesthetically right together. The picture hanging on the wall over his Shaker table in one of his Ridgefield photographs, for instance, is a reproduction of the portrait of Miss Van Alen, circa 1720, a painting attributed to Pieter Vanderlyn, a patroon painter from Albany working in the early eighteenth century and considered a folk artist at the time (Fig. 297; see also Fig. 296). Sheeler liked the painting so much that he once compared it to works by Veláz-quez.[87] In his photograph the print is just a small

detail, but its shape and placement by the doorway pull it into a family relationship with other rectangular shapes. In another photograph, this time of his living room in South Salem, his own oil painting *Upper Deck*, representing a modern ocean liner, is rendered compatible with his Shaker table and the objects on the table and chest (Figs. 298, 299). The individual pieces of ceramic and glassware were carefully spaced to echo the still and statuesque vertical forms in the painting.

The relationships Sheeler drew between disparate objects make these photographs telling. They are not simple documentary shots. Strictly speaking, the things in them are twice composed: once when the artist arranged them three-dimensionally in his living space and again when he composed and cropped the edges of the photograph in the lens of the camera. In both cases the artist created formal

Fig. 299 (facing). Charles Sheeler, *Upper Deck*, 1929.
Oil on canvas, 29 ⅛ × 22 ⅛ in.

Fig. 300. Charles Sheeler, *Living Room of New York Apartment of Louise and Walter Arensberg (Southeast Corner)*, ca. 1918. Gelatin silver print, 7⁹/₁₆ × 9⁵/₈ in.

relationships of objects in which every piece is made to seem aesthetically comfortable with its neighbors. Just as in *Home, Sweet Home*, nothing looks out of place, and everything interacts in a pleasing harmony.

To sense how carefully and self-consciously Sheeler drew these relationships we need only look to the photographs he made for Walter and Louise Arensberg of their New York apartment on Sixty-seventh Street. There objects do not talk to one another in the same way (Fig. 300). Like Sheeler, the Arensbergs pioneered in living with plain-style American furniture, and the artist helped them make purchases.[88] They also put together a remarkable collection of international modernist art. When Sheeler photographed their rooms, he showed off both collections but the Arensbergs' paintings and furniture do not interrelate. The antique furniture

looks vintage and occupies the floor; the collection looks modern and occupies the wall. The two ensembles comfortably cohabit the space but do not come together, as they did in Sheeler's homes, as an American genealogy of forms.

For one brief moment, Sheeler seemed so taken with the symbiosis he and others were finding between modern work and folk art that he tried his hand at a modern folk picture. In *Vermont Landscape* he used the awkward perspective of nineteenth-century rural landscapes to paint a village scene, including even a quaintly old-fashioned horse and buggy (Fig. 301). He was not alone in experimenting; others, such as Marguerite and William Zorach and Kuniyoshi, also made

Fig. 301 (facing). Charles Sheeler, *Vermont Landscape*, 1924. Oil on canvas, 18 × 24 in.

Fig. 302. Yasuo Kuniyoshi, *Boy Stealing Fruit*, 1923.
Oil on canvas, 20 × 30 in.

self-consciously pseudo-folk works. In *Boy Stealing Fruit*, Kuniyoshi mimicked the large bulbous heads, flat fingers, and pudgy arms of folk portraiture (Figs. 302, 303). The results were never very satisfying. Sheeler, for one, seldom ventured the exercise. "I feel that the *naive* may not be reverted to now with similar conviction . . . ," he later wrote. "[W]e live in an age that is already highly sophisticated . . . the artists should be in keeping with the spirit of the age."[89] Increasingly he moved toward exploring the affinities he detected between the vernacular styles of yesterday and modern styles of his own day. When in the mid-1930s he designed salt and pepper shakers, as well as a silver teaspoon, he referenced colonial prototypes but did not copy them. Rather he stripped down the forms so radically that the pieces announce their modernity as well as their kinship with the past (Fig. 304).

Sheeler invented a way to make his art modern and simultaneously a part of a historical continuum.

In this he had few models, for American artists, unlike their French counterparts, were not accustomed to referencing their own visual culture. For so long they had believed there were no old American masters or mistresses of worth. In postwar Paris when modern artists and critics called for a return to classicism, artists went to the Louvre to find a celebrated collection of classical antiquities and national treasures—Poussin, David, Ingres, Delacroix. In New York, there was no comparable storehouse of American visual material. It was Sheeler's generation that began the process of forming collections of American masterworks. That the modernists among them turned to naive rather than learned art, to the anonymous artisan rather than the old master, seems in retrospect "natural." In doing so they confirmed a prevailing modernist trope: Europe was old, with centuries of heritage, while America was young and unworldly. The same transatlantic dynamic that made Gerald Murphy appear youthful,

Fig. 303 (top). Artist unknown, *Baby with Doll*, 1840–50. Oil on canvas, 15¾ × 12¼ in.

Fig. 304 (bottom). Charles Sheeler, *Untitled* (Silver teaspoon, silver salt and pepper shakers; designed by Charles Sheeler, 1934–36), 1939. Gelatin silver print, 7¼ × 4⅝ in.

Fig. 305. Edward Hicks (attributed to), *The Peaceable Kingdom*, 1832–34. Oil on canvas, 17¼ × 23¼ in.

innocent, and therefore American to the French sent artists like Charles Sheeler in search of naive ancestors so that he might seem American to himself. When "skyscraper primitives," as American modernists were once called, felt the need for ancestors, they looked for artists who fit the international clichés about their country's youthfulness, provinciality, and lack of sophistication. Having often been deflated by such labeling and put down as artists, Sheeler and others turned the tables by making provinciality into a virtue. In claiming New England untutoreds and Shaker innocents as "our" tradition, they in effect asserted the kinship of their own art with the prevailing mythology that defined America. Occasionally Europeans helped them out. When Fernand Léger came to New York and saw the work of Edward Hicks for the first time in 1931,

he declared him "a more important man in the history of art than the French Rousseau, and referred to his 'The Peaceable Kingdom' as the greatest painting he saw in this country" (Fig. 305). Or so the American press reported.[90] This too had become a trope: the European modernist in New York assuring an insecure American public that the country had produced an artist of genius.

By 1930, then, a new paradigm had appeared, positing a distinctly American tradition of plainness, simplicity, and functionalism. This tradition was said to have manifested itself first in early American (even Puritan) building and furniture styles; then it reappeared in a variety of nineteenth-century folk forms and in the design of the American clipper

ships; and in modern times it could be discerned in the American skyscraper and factory. Finally, the art of Sheeler and other Precisionists (Demuth, O'Keeffe, and Preston Dickinson, for example) provided evidence that the same practical and no-nonsense American mind formed during the colonial period survived in the early twentieth century. What happened between these moments of high creativity was conveniently forgotten or deemed corrupt in form and therefore not part of a usable past.

Sheeler helped shape the new paradigm, but, even more important, his art was used by others, especially critics and Halpert, as sure proof that an active American tradition still existed. Sheeler, in fact, was never as single-minded or surefooted about his Americanness as his critics. He often talked about the European old masters who influenced him: Piero della Francesca, Mantegna, Rembrandt, or Velázquez. But his critics did not. In 1923 Forbes Watson found in Sheeler an "American modern" whose taste was the same as that found in early American architecture, as well as in the clipper ships of the early nineteenth, and the airplane of the early twentieth, century. "Moreover, in the clean-cut fineness, the cool austerity, the complete distrust of superfluities which we find in some pieces of early American furniture, I seem to see the American root of Sheeler's art." For Helen Appleton Read in 1924 Sheeler "continues to give us in his clear, clean painting a combination of the naiveté of the American primitive and the sophistication of its modern version." In 1926 Robert Allerton Parker found "an affinity between the mind of this artist and those builders and craftsmen of past centuries who created out of humble and neglected and spare materials a beauty at once expressive and enduring."[91] Such characterizations led Stieglitz and Strand to a catty exchange of letters in which Strand described Sheeler's work as having "all the perfection of an expensive mausoleum—made in America."[92]

A book about Sheeler solidified his reputation as an artist in the American grain. *Charles Sheeler: Artist in the American Tradition* appeared in 1938. Written by Constance Rourke, an independent critic-scholar, and published by Harcourt, Brace and Company, a major trade publisher, this was not only the first book about Sheeler but also a pioneer in a literary genre that today has become a stock-in-

trade: the single-artist monograph.[93] At the time, Rourke's study of Sheeler was one of the few ever ventured of a living American artist. The artist was in his mid-fifties when it was published.[94]

Rourke was intimately tied to the usable-past project. Having graduated from Vassar College, she taught in the college's English Department and then, inspired by Van Wyck Brooks's call for fresh assessments of American culture, left teaching for full-time research and writing.[95] Of the critic-historicists, Rourke was the one who took popular and vernacular culture seriously. If Mumford looked for new high-culture models in the American past, Rourke sought folk heritages in theater, in humor, in Shaker culture, in Negro literature, in barns and furniture, and in popular heroes like Davy Crockett and Paul Bunyan. She was particularly interested in discovering how folk forms of the past animated American writers in the present. Beginning with articles on vaudeville and Paul Bunyan, Rourke, in her most influential book, *American Humor: A Study of the National Character*, traced the evolution of American humor from the Yankee trader, the western backwoodsman, and the minstrel man straight on through Emerson and Henry James to Ring Lardner and Sinclair Lewis. Next she produced a book on Davy Crockett.[96] She then turned to Charles Sheeler. To prepare, she visited the artist in his home and interviewed him extensively; she also had access to an autobiography that Sheeler had begun but not finished, from which she quoted at length.[97] That she and her mother furnished their home with American antiques was one bond between them; that Sheeler's art seemed rooted in the vernacular, her subject of expertise, was another.

Rourke's book traced Sheeler's development as an artist and the evolution of his style. But the focus throughout the book is the issue of a common American lineage; Rourke wanted to investigate, she said in the preface, how the artist's choices "reveal some of our fundamental traditions and resources." Sheeler's work suggested that "possibly our soil has not been too shallow for a full creative expression" and that his "lineage in art is unmistakably our own." She offered a decidedly revisionist study, one that would dispute any pessimism about the arts in America. Restating the usable-past philosophy, she promised to show that "traditions were being slowly created in our formative years which may be richly

employed by the contemporary worker in the arts."[98]

With her focus on the native in Sheeler's work, Rourke struggled when she spoke about Sheeler's education in Europe, and his deep admiration for European artists; these are some of the most awkward and unresolved analyses in the book. But in locating the "Americanness" of Sheeler's work, she formulated rigorous and complexly stated ideas. The most powerful chapter is the third, where Rourke lets her own voice and theoretical bent dominate. She talks about the young Sheeler in Bucks County struggling to make sense of his training in French cubism while surrounded by provincial American architecture which was "plain and spare." He begins to make paintings and photographs of the local architecture. But this change in subject, Rourke suggests, was not in itself significant; only when Sheeler reformulated cubism to conform to the native aesthetic of large, clean, and simple forms did his work become native. "Certainly the American subject has not sufficed to create a strongly defined American art; if this were true we would have had the substantial fiber of a tradition almost from the beginning. . . . It is by the use of form that the individual artist makes his art distinctive. It is the consistent print of form in successive periods which gives a national tradition its character."[99]

Rourke, in other words, looked for form, not subject matter, in defining the American tradition. Sheeler's absorption while studying Bucks County barns of "*Urformen*," or "source-forms," as Rourke described them, transformed him from a student of French cubism into an American painter.[100] By adapting the plainness, unity, and craftsmanship of these vernacular buildings to cubism, he built on something Rourke identified as a classic American form that reappears off and on in American culture, in places like the barns of Bucks County and New England, stone houses in Maryland, or slave quarters in Louisiana. These vernacular characteristics of earlier centuries became the dynamics of a new high art when they reappeared in Sheeler's "sense of order, function, and design, which with all our sprawling breadth we never seem to have lost."[101]

Those puzzle pieces, as I called them earlier, were Rourke's *Urformen*. In finding Sheeler's Americanness in a basic rhetorical form, Rourke spoke, not of influences, but of a shared culture. She argued for a kinship and genealogy of forms over time rather than causality. That the artist had lived in Bucks County at the start of his career and surrounded himself with vernacular furniture and crafts was useful in explaining the circumstances under which his art matured, but she made clear that the artist's own experience as a modern American of the machine age formed his art, not some nostalgia or sentiment for the past. For Rourke, in other words, Sheeler was not a neocolonial or neofolk artist; he did not self-consciously resurrect the past. Nor was he an American Scene painter, a group Rourke accused of using subject matter rather than form to convey Americanness. He was, instead, an artist who worked out of some cultural center in the present, revealing through the craftsmanship of his clean forms, his spareness of composition, and his clarity of light some of the most basic and enduring of American traits.

Rourke's elegant analysis depends upon one of the most abiding tenets of nationalism: that there is something like a single national mind, which the best artists of a country engage and maintain, producing variations of an ongoing national aesthetic. Such analysis, pursued zealously and authoritatively and attached to racial or religious groupings, can be an extremely dangerous tool, as it became in many countries during the 1930s and during World War II. When nationalist intellectuals like Brooks, Rourke, and Mumford uncovered evidence of an American mind and used it to radically reorient American arts and letters, they were too liberal and self-critical to imagine any dangers to their pursuit. For them the discovery of an ongoing American aesthetic was liberating and reinforcing. It put them on the offensive rather than the defensive. Having grown up deracinated and embarrassed by their provinciality, they were intellectually recharged by uncovering so much creativity in the American past; they became boosters and positive thinkers, to the extent that today it seems surprising how much faith they asked of their readers. For there was ultimately something mystical and unexplained about the idea of an American tradition. (It was never clear whether there was just one tradition or many, for instance. And no one plausibly explained how the functionalism of clipper ships passed down through the generations to reappear in modern art.) But in their work, these intellectuals brought together cultural studies,

nationalism, and modernism in such new and imaginative ways that they laid a foundation for a brand-new appreciation of American arts and letters—not because these compared well with the arts and letters of Europe but because they were "ours" and could now be judged on their own terms. Such a separatist quest so excited the next two generations of critics and scholars that the investigation of artistic and literary Americanness dominated the academy right through the cold war. The belief in an American mind (character, tradition), formed of exceptional circumstances, helped underwrite an era of worldwide American influence and military expansion abroad.

In her study Rourke paid little attention to *Home, Sweet Home*; indeed, she never analyzed any piece of Sheeler's art at length. Though she concentrated on the issue of form, she lacked the skill of formal analysis that would arrive with the next generation of art critics. But had Rourke parsed *Home, Sweet Home* as I have here, seeing in it a formal visualization of a lineage of forms and craft, she might well, like Halpert, have used it on the cover of her study. For it was a painting that embodied Rourke's thesis more perfectly than she seemed to understand. Sheeler gave visual form to a national aesthetic perpetuated from early American culture to the present, just as she did verbally. Sheeler and Rourke participated in the same discursive quest; but his visual presentations, we can say, gained in art-historical stature by her more public and elaborate insistence that his work be seen as indigenous and in the American grain. The artist and his interpreters were partners in constructing "Americanness" and in fostering a new appreciation for "American things."

Sheeler was a reserved man. This quality comes through in the ways he hides his brushstrokes and rigorously orders his canvases. Spontaneity or impulsiveness are not words associated with his art. But he had passions. This we know from his avid collecting and from his lifelong dedication to his art making. These are the passions that shine through *Home, Sweet Home*, which, in the final analysis, is a self-portrait of an artist uncomfortable with self-expression. The chair, so prominent and regal, is the artist's surrogate, the things around it the historical artifacts he elected for his artistic family. It is a subconscious portrait of the artist's private self, his interior self, passing as a domestic space. In such indirection it reminds us of Demuth's portrait posters, in which the artist similarly displaced bodies with things. Both artists were exquisite craftsmen and created the most careful and elaborate cubist compositions coming out of New York. In such attention to their modernist craft, they were clearly handworkers in an industrialized world where the handmade was increasingly rare. That tension in their work—making beautiful handwrought things about machine-made America—ultimately runs through most of the art in this book, though nowhere more poignantly than in Sheeler's. Only Duchamp accepted the incompatibility and consciously divested his art of personal craftsmanship. For Sheeler, however, the use of human hands to fashion simple, beautiful things was fundamental; it was what he most cared about. It was his passion. *Home, Sweet Home* is about love for the work of the hands, both past and present; yet he states this so indirectly, so formally, and so archly that we must work hard to uncover his ardor.

It was a matter of personal pride that Sheeler hid his feelings and his manual dexterity. This was partly his temperament; from all the evidence, he was a very deliberate and controlled individual. But his high modernism also favored form over feelings, composition over biography. Even more than most modernists, Sheeler abhorred the sentimental. One consequence of his suppressed passion was that critics described his work as practical, austere, pristine, classical, functional, crafted, direct, democratic, and vernacular—the vocabulary they also used for seventeenth-century furniture, folk art, clipper ships, and other noteworthy things in the American tradition.

It seemed natural, then, that first in the 1920s and 1930s and then in the 1950s and 1960s Sheeler's art caught the eye of modernist intellectuals, initiating a new inquiry: What was American about American art? In the 1920s and 1930s this question was implicit in Sheeler's work and in the way his circle of critics interpreted him. By the time I came to study art history in the 1960s, Sheeler was presented as sure proof that there was something American about American art. Indeed, a belief in the exceptionalism of the American visual arts constitutes the legacy of Sheeler and other first-generation American modernists. To that legacy, we now turn.

THE AMAZING CONTINUITY

I felt close to the spirit of Indian art. My work came from some spirit or force in America, not Europe.

Richard Pousette-Dart, 1985

The Freeways, the Safeways, the skylines, speed, and deserts—these are America, not the galleries, churches, and culture.

Jean Baudrillard, *America*, 1986

I began this study wondering why so many scholars in the 1960s sought to describe the Americanness of American art. By now, I hope I have convinced my readers that Americanness first became an issue because of the convoluted ways the modernist project was nationalized in America and abroad after World War I. Postwar calls for a "new spirit" arose in both Paris and New York, and diverse artists became newly concerned with place, home, roots, traditions, continuities, and what was "ours" and what was "theirs." In this inward-looking climate, artists on both sides of the Atlantic typecast America as an extremely modern country without a history and defined themselves for or against the life it represented. They produced a variety of modern works evoking American things and places.

Earlier histories of American modernism have often concluded that this move to "American things" and away from prewar experimentation with styles of abstraction was a rearguard action, at least stylistically. And they have characterized the postwar era in the arts as one of innocence, false starts, and dashed hopes. This phase of modernism, it is generally thought, ended with a whimper during the Great Depression and had little impact on what later transpired in New York art circles. Barbara Rose, whose writings were instrumental in making modern American art of the interwar period visible and worthy of study, wrote in the late 1960s: "The collapse of American modernism in the twenties was more complete, tragic, and inevitable than the European détente."[1]

But what impresses me, writing thirty years after Rose, from a position "post" or outside the great modernist decades, is the legacy the artists left. In ways rarely studied or commented on, post–World

Fig. 306 (facing). Stuart Davis, *The Paris Bit*, 1959. Oil on canvas, 46 × 60 in.

339

War I culture initiated patterns of behavior and artistic paradigms that persisted for at least the next two generations. Some of this legacy endures today. So I title this epilogue "The Amazing Continuity," lifting the twangy phrase from Stuart Davis, who used it in his notebooks and, in a calligraphic squiggle, in *Visa* (1951), one of his great late paintings. It seems fitting to appropriate the words from Davis's remarkable repertoire of slang phrases and jive talk, for he was an artist who kept 1920s tenets alive right up to the advent of postmodernism, which coincided, more or less, with his death in 1964.[2]

One amazing continuity was the persistent dream of creating art forms that were both modern and American, a dream that took stronger hold with the passage of time. New groups of artists and their critics, from the Regionalists to the abstract expressionists, used the same Americanizing language, always arguing for their own primacy of position in the art world of their day. The nationalist rhetoric circulating during the 1920s helped the Regionalists articulate their vision. By 1930, in fact, critics and artists of any persuasion could legitimate their artistic efforts by describing them as the work of an American artist with hands deep in American soil.

Indeed, the Regionalists incurred the modernists' wrath because they co-opted the rhetoric of cultural nationalism but used it to describe a radically different program. What had been the province of an elite group of New York artists and intellectuals was now taken over by populist artists and their critics, often anti-intellectual and politically isolationist. The Regionalists found America neither in the city nor in its icons of modernity but in the people and community rituals of the hinterlands. They prided themselves on being part of, and speaking to, the common classes, using realist and figurative styles to describe places in America the transatlantics never saw or cared about. Often they emphasized their differences by representing themselves as modern or contemporary artists and the cubists and abstract artists as "ultra-modern" extremists, influenced by the School of Paris and identified with New York. Calling them sophisticated and cosmopolitan, learned, abstract, and highbrow, partisans of Regionalism asserted modernists were also European in their interests and hence un-American.[3] "They *adopted*

European technique without *adapting* it to the national spirit," Peyton Boswell, the pro-Regionalist critic, wrote of Marsden Hartley, Charles Demuth, Arthur Dove, John Marin, and Stuart Davis. "We hail them as fine artists, but not as 'American' artists; they are the remnant of the once powerful international contingent."[4] Stuart Davis, furious at such accusations, wrote angrily in his notebooks: "I am an American, born in Philadelphia of American stock. I studied art in America. I paint what I see in America, in other words, I paint the American scene."[5] Like Alfred Stieglitz, Georgia O'Keeffe, and others, Davis intensified his claims for his own Americanness in the heat of an attack from what he deemed an artistic right wing.

The modernists' Great American Thing became the Regionalists' Great American Scene. Fighting to take the phrase—and all its claims—away from the New York modernists, the Regionalists argued for realist depictions of rural and small-town subject matter that represented American life people could understand. They also disputed the modernists' elitist and snobbish views of "provinciality." For most modernists, "provincial" described the dispiriting inadequacy of American culture and the country's longstanding dependence on Europe. They resolved not only to rid art of its colonial relationship to Paris but also to fight provinciality at home, pitting their own cosmopolitan virtues against the small-mindedness and narrow worldview of "the little old lady from Dubuque" —the *New Yorker* magazine's designation for the person it would *not* address when it began publishing in 1925.[6] The Regionalists also urged cultural independence from Europe, but they wanted to redeem the little old lady from Dubuque—and her rocking chair and porch—for she was their grandmother and her home was the place where they had grown up. For one brief decade when they gained national attention for their aggressive campaign on behalf of the provinces and hinterlands, the Regionalists and other American Scene painters succeeded in making provinciality a highly publicized American virtue.

During World War II, the country's art critics and patrons once again began to focus on New York modernism, primarily on a new group of abstract artists including Jackson Pollock, Mark Rothko, Willem de

Kooning, Clyfford Still, and Barnett Newman. That this group was fairly quickly identified as a "New York School" of artists suggests one obvious continuity with the early modernist past. But there were others. During the war European artists once again flowed into Manhattan, seeking refuge. Piet Mondrian, Amédée Ozenfant, Fernand Léger, André Masson, Yves Tanguy, Marc Chagall, Salvador Dalí, Jacques Lipchitz, and Matta were among them. Once again New York received its artist visitors with warmth and attentiveness, the press talking boldly of New York City's having the potential to become a new international art center. And once again a modern American art of abstraction—now larger in scale—became the center of critical attention. To explain and to boost the arrival of the New York School, modernist critics, poets, and artists formed alliances and communities just as they had done after World War I. Critics still weighed the art made in New York ("ours") against art made by the School of Paris ("theirs"). But now American-based writers were far more assured in their cultural judgments and talked of triumphing over the European art center. American abstract art went beyond mere equality to exceed anything produced abroad.

Just like the early modernists, artists and critics of the New York School projected themselves as born anew, without ties to a local ancestry. They imagined that their lineage ran back to early-twentieth-century Paris, not Manhattan. In 1946, when John Johnson Sweeney created an exhibition at the Museum of Modern Art on the work of the European artists who had immigrated to New York during World War II, he took no notice of the similar artistic influx of 1915. Instead, he drew his analogy to an earlier moment, in 1870, when European artists fled to London. In his preface to a series of interviews with the eleven artists in the exhibition, Sweeney wrote: "During the late war [World War II] America has had the privilege of playing host to many leading artists of our time. During the Franco-Prussian War of 1870 England enjoyed a similar privilege. Few records, however, have survived of the activities and interests of the great French impressionists . . . who spent . . . that struggle in London."[7] By the late 1940s the small iconoclastic transatlantic community that a quarter of a century earlier had boldly predicted the coming of a great American modern art was forgotten, if not erased. No one recalled

Henry McBride's boasting back in 1929 with his New York colleagues that "Paris is no longer the capitol of Cosmopolis. New York . . . has become the battleground of modern civilization."[8]

When Clement Greenberg, the dean of contemporary criticism at the time, wrote an occasional essay on figures like Thomas Eakins and Winslow Homer or on the American primitives, all by then in the American canon, he always alluded to, even despaired of, their provinciality, which he linked to impoverished American conditions. In an essay on John Marin, Greenberg credited the artist with originality but blamed him for smallness of ambition. Marin failed to achieve greatness because of the "limits set by the circumstances of American art culture in his time as much as by his own temperament or talent." He was too "arty," a product of the "'Art-and-America' mystique and the art evangelism" of the Stieglitz circle.[9] Greenberg particularly disdained Stieglitz and his house critics for "a formless vapor of messianic emotion, esotericism, and carried-away, irresponsible rhetoric having scarcely any relation to the art in question."[10] O'Keeffe he accused of "private worship and the embellishment of private fetishes with secret and arbitrary meanings."[11]

Only with the American artists of his generation, Greenberg asserted, had the battle against inherent cultural provinciality finally been won. In taut, highly calibrated essays Greenberg focused on how the new American abstractions of Jackson Pollock, Willem de Kooning, Barnett Newman, and Clyfford Still were pushing the pictorial innovations of cubism and neoplasticism toward radically new formulations of space and composition. Their lineage was European, their ancestors Picasso and Mondrian, Greenberg's models of excellence. They were the *great* artists who had established the philosophical goal of modern art: to divest painting and sculpture of all properties not inherent in their media (figuration, mimesis, perspective, and so forth). Greenberg —his teachings in retrospect aggressive and hawkish and immensely influential—congratulated New York in finally creating an art movement indebted to, but out ahead of, the School of Paris.

With today's hindsight, it is clear that Greenberg revived the cultural boosterism that McBride, Paul Rosenfeld, Stieglitz, and other New York modernists had introduced into art politics after World War I.

He most clearly resembled Rosenfeld, as an insider critic; he was a consultant and friend to the modern artists he wrote about. He was also a highbrow New York intellectual who deemed the triumph of abstract painting in New York a measure of American civilization. If Rosenfeld as a booster had been uneasy, hopeful, but not absolutely sure that the artists in the second Stieglitz circle would someday measure up to their colleagues abroad, Greenberg was overconfident, certain that his New York artist colleagues were now the most innovative in the world.

Harold Rosenberg was yet another American booster who helped define the New York School, writing lyrically and imagistically about the processes used by the new generation of abstract painters. He was especially good at historicizing Pollock and other action painters and saw in them a raw youthfulness linked in his mind to older American traditions. In his 1954 essay "Parable of American Painting," Rosenfeld identified "Coonskinism" as an honorable American trait, defining it as a certain stylelessness, a lack of formality, innocence, and a predisposition to begin always anew. Coonskinism for him was the opposite of "Redcoatism," art making based on learning, skills, refinement, and professionalism. Imagining the two isms first warring with each other during the Revolution, Rosenberg clearly favored artists whose works displayed elements of Coonskinism: Walt Whitman, Herman Melville, Thomas Eakins, Albert Pinkham Ryder, and folk painters. But in the abstract expressionists of his own day Rosenberg found his exemplars: "Coonskinism as a principle won ascendancy in American painting for the first time during World War II. With no new styles coming from Europe . . . American artists became willing to take a chance on unStyle or antiStyle."[12]

Rosenberg's essay is a strong reminder of how much the formation of the New York School depended on the cultural introspections of Manhattan's avant-garde in the 1920s and 1930s. In naming and defining Coonskinism as an old and venerable national trait, Rosenberg followed the model of the critical essay established by Van Wyck Brooks and the other critic-historicists, especially Constance Rourke. His "Parable" essay created a usable past for the New York School artists by fitting them into a long American tradition of unworldly innocence and primitive bluntness. He saw in these artists the same qualities he found in American folk painting, an affinity between old and new that had earlier been attached to Charles Sheeler.

The gravitation of Jackson Pollock, Barnett Newman, and other New York painters toward the study of Native American life and rituals, especially sand painting, also depended on models established by the first generation of modernists. D. H. Lawrence and artists like O'Keeffe and Hartley were first to construct Indian art as the modern artists' national ancestry and speak longingly of the spiritual link between their own art making and the Indians' sacred myths and communion with the earth. They opened up the idea that a modern American art could be more authentic if it borrowed from Native American peoples rather than from the remote cultures of Africa and Oceania. This early modernist template, as the recent scholarship of W. Jackson Rushing helps explain, knit together primitivizing, modernist, and nationalist goals into a peculiarly American artistic discourse that the young abstract expressionists absorbed and perpetuated. When Richard Pousette-Dart, an abstract painter who came of age after World War II, told an interviewer that in the 1940s he "felt close to the spirit of Indian art" and that his work from that time came "from some spirit or force in America, not Europe," his declaration of cultural allegiance and spiritual bonding with native cultures virtually played back comments made by members of the Stieglitz second circle.[13]

Pousette-Dart was also offering a corrective to Eurocentric interpretations of abstract expressionism that began with Greenberg and still dominate scholarship today. He reminds us that members of his generation need to be studied for the ways they continued habits of mind forged fifty years earlier in New York. The metaphors for modernist Manhattan invented by Joseph Stella's generation did not die with them but were absorbed and reworked by members of the New York School. The pictorial evidence is stunning.[14] A glance at city paintings by Mark Tobey (1935), Franz Kline (1955), and Ellsworth Kelly (1962) suggests how avant-garde circles continued to translate New York as soaring lines, neon carnivals, and thunderous energies (Figs. 307–309). A good argument can be made that Tobey's late

Fig. 307 (facing). Mark Tobey, *Broadway*, 1935–36. Tempera on composition board, 26 × 19 3/16 in.

canvases of abstract "white writing" began in his en-
ergetic scribbles representing the New York crowds
of Broadway and that Kline's huge abstractions of
bold black strokes on white canvases originated in
New York's much-heralded modern architecture.
Skyscrapers and bridges may also linger just below
the surface of many of Kelly's later minimalist ab-
stractions, subliminally present despite the absence
of specific allusions, nourished by a pictorial rheto-
ric about American energy and engineering that
had been in the making since the turn of the cen-
tury. By the 1940s American abstract artists claimed
to be transnational and universal, but their vocabu-
laries, when contextualized within the early modern-
ist construct of New York and New Yorkness, sug-
gest otherwise. The interchangeability of "New
Yorkness" and "Americanness" that resides in these
metaphors offers further reason to rethink the New
York School in the broader context of cultural
nationalism.

N ot all modern American artists during the 1940s
and 1950s responded to the pressures of European
surrealism and the teachings of Freud, Jung, Wassily
Kandinsky, and Hans Hofmann that instructed the
young abstract expressionists. A few kept the goals
and ideals of early modernism central to their work.
Among them were John Marin, Georgia O'Keeffe,
and Charles Sheeler, whose late careers came after
World War II. But other artists whose careers peaked
much later also stayed true to the artistic values of
the 1920s and early 1930s.

Stuart Davis is a major case in point. Born in
1892, a decade or more after the artists we have
been studying, he exhibited watercolors at the Ar-
mory Show of 1913. By his late twenties and early
thirties, he was reading *Soil* magazine and hearing
the dadaists and *Broom* magazine vulgarians argue
for the beauty and Americanness of billboards,
brand-name products, and popular culture. Always a
quick study, he began to talk their slang. "I do not be-
long to the human race," he wrote in his notebook in
1921, "but am a product made by the American Can
Co. and the *New York Evening Journal*."[15] He also
became an early devotee of American jazz, a passion

Fig. 309. Ellsworth Kelly, *Brooklyn Bridge, VII*, 1962.
Oil on canvas, 92$\frac{1}{8}$ × 37$\frac{5}{8}$ in.

Fig. 308 (facing). Franz Kline, *The Bridge*, ca. 1955.
Oil on canvas, 80 × 52$\frac{3}{4}$ in.

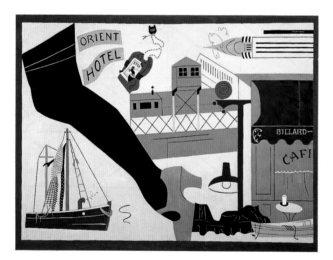

Fig. 310 (top). Stuart Davis, *Lucky Strike*, 1924.
Oil on paperboard, 18 × 24 in.

Fig. 311 (bottom). Stuart Davis, *New York–Paris No. 1*,
1931. Oil on canvas, 39 × 51¾ in.

that informed his painting for the rest of his life. Beginning as an Ashcan painter, he soon turned to synthetic cubism to paint still lifes of modern goods that led him to his own variant of "billboard cubism." In one composition he made a self-consciously American version of a French cubist café still life (Fig. 310). Along with the pipe and cigarette papers common to Continental cubist works he included a modern package of Lucky Strike cigarettes. (These emblems were not only cubist but also personal; Davis was a heavy smoker.) Instead of a French newspaper, he featured a page of the *New York Evening Journal* with the comics and a prominent headline, "Classy Field Opposes Ray in 3,000 Meters," that the 1920s pop culturists found characteristically American.[16] In other paintings he featured an Odol mouthwash bottle, its design and typography emphatically modern, the product itself a popular pharmaceutical in the American market.[17]

Like other artists, Davis spent a year in Paris struggling to figure out his relationship to Europe. Upon returning to New York in 1929, he was struck by the city's "gigantism" in relation to Paris but sounded the usual refrain: Paris was not home; New York was where he belonged. The time abroad "demonstrated to me that work being done here was comparable in every way with the best of the work over there by contemporary artists. It proved to me that one might go on working in New York without laboring under an impossible artistic handicap. It allowed me to observe the enormous vitality of the American atmosphere as compared to Europe and made me regard the necessity of working in New York as a positive advantage."[18] In a series of three paintings he called *New York–Paris* he inscribed the cross-cultural exchanges at the heart of transatlantic modernism. In *No. 1* a typical corner café of Paris sits below New York's Chrysler Building, rendered sideways as a fountain pen making cloud squiggles in the sky (Fig. 311). A flapper leg darts across the composition, a station of New York's elevated railway hangs across the middle, and at the lower left, a Gloucester fishing schooner chugs along. (Davis often summered in Gloucester, Massachusetts.) A tobacco pouch with its brand name, Stud, and signature horse dangles by its cord.

In 1927 Davis began to be represented by Edith Halpert, and until his death thirty-five years later he remained unwaveringly loyal to the 1920s ideal of an

Fig. 312. Stuart Davis, *Colonial Cubism*, 1954.
Oil on canvas, 39 5/16 × 79 1/8 in.

American style structured on cubism and calibrated to express urban street life and popular culture. He managed to stay fresh by continually refining his style, learning from the abstract expressionists even though he hated their (to him) vacuous surfaces, existential posturings, and spiritual rhetoric. The Intra-subjectives, he called them.[19] As if to denounce the mythological and religious rhetoric that Newman and Still made standard for the day, he used brand-names and slang aggressively in his own compositions and in his titles. Yet under their influence his canvases got larger, his compositions more allover, his vocabulary more abstract, his colors hotter, and his surfaces structurally more complicated and demanding. But he never joined the expressionist camp, remaining informed but unconvinced. His period eye remained that of circa 1925. Elaine de Kooning, a perceptive critic as well as a painter in the 1950s, understood this when she described Davis as a "red, white and blue" painter. She saw that his references came from a sourcebook in-

vented by artists in the twenties. "The brittle animation of his art relates to jazz, to movie marquees, to the streamlined decor and brutal colors of gasoline stations, to the glare of neon lights . . . to the big, bright words that are shouted at us from bill-boards. . . . although his pictures are not big. . . . If one were slapped against a building like a bill-board, it would hold its own."[20] Though in 1957 such a review made Davis appear retrograde, out of sync with his peers, it would have thrilled Murphy and Demuth, who thirty years earlier received no such praise or understanding from an American critic.

Davis was a writer, a theorist, and an intellectual and, like Duchamp in his American readymades, reflected upon the nature of transatlantic modernism and the Paris–New York axis. In *Colonial Cubism* he both acknowledged his indebtedness to Parisian cubism and simultaneously proclaimed his emancipation from it (Fig. 312). Using brash oranges, a strong blue, and black and white—a loud color chord no self-respecting artist in Paris would employ—Davis

promoted a blunt and forthright American variant of French cubism. The "colonial" of his title was a double entendre. It meant "provincial" vis-à-vis Paris, the birthplace of modernism, and it referred to the aesthetic qualities found in colonial American architecture. In the boxiness and mitered edges of the cubist shapes, Davis referenced the squat salt-box houses of early America; the white tower in the center could be a colonial church spire, and the two white blobs at upper right, clouds. The star, lower left, seems to have floated off the national flag.

In 1959 Davis painted again the composition of a work made in Paris in 1928, *Rue Lippe*, calling it *The Paris Bit* (Fig. 313; see Fig. 306). In it he rearticulated the 1920s New York–Paris theme by drawing the wiry outlines of the earlier painting in black: an imagined Parisian square with a milk bottle, a mug of beer (in the shape of a hat) and a syphon bottle standing on a platform that was both a street and the counter or table of a café. But the drawing of the ear-

lier painting is now animated by abstract forms of red, white, and blue, the colors of both the French and American flags. The compositional field is uniformly activated, a stylistic achievement highly valued at the time by the abstract expressionists and their critics. And while the painting's forms emit something of the swashbuckling energy of a Pollock or de Kooning, they retain references to the billboards, brand names, jazz, and cubism that Davis drew from all his life. The raucous surface of forms that bend and strut and the constant play with letters and words (Hotel, Belle France, Pad, Eau, his own signature in mirror image, a huge '28 in the upper left) hark back to the 1920s, when Demuth and Gerald Murphy, Matthew Josephson and Malcolm Cowley were trying to forge an American-style modern art. At the top of the painting Davis wrote, "Lines Thicken," as if taking a line from a recipe or a musical composition, referring not only to the bold red frame painted around the edge of the canvas,

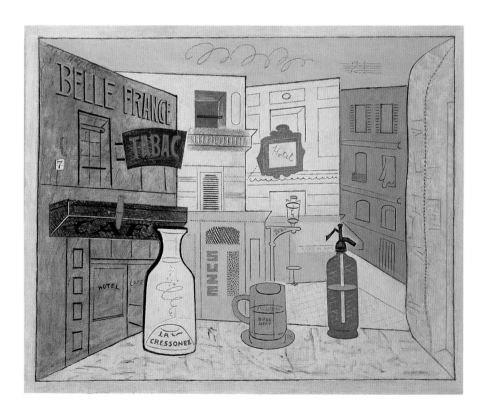

Fig. 313. Stuart Davis, *Rue Lippe*, 1928.
Oil on canvas, 32 × 39 in.

but also to the changes his own style had undergone in the intervening thirty years. Since 1928, the year he painted *Rue Lippe* in Paris, his lines indeed had thickened and his forms had become more abstract and complex.

Thus *The Paris Bit*, while paying homage to his poet friend Bob Brown, who had died a few days before Davis started the painting, is also one of the artist's most profound meditations on the "amazing continuity" between his youthful art of the 1920s and his mature style of the 1950s. Its title constitutes a seasoned painter's riff on his youth in Paris, when his cubism was primitive and his awe transparent, reprised now in an assured signature style crafted from Parisian cubism and American things. This was Davis's own expression of triumph over both the School of Paris and the New York School.

Davis had a good sense of humor and once mimicked Léger's habit of finding artists like Gerald Murphy and Edward Hicks "the most American" of their

day by naming Léger "the most American painter painting today."[21] It was not preposterous: Léger raved about billboards and industrial culture, as well as about America, and was a great friend and teacher of many American artists. Davis felt his influence early on, as did George L. K. Morris, another painter who began his career in the 1920s and maintained the early modernist's desire to Americanize cubism.[22] Like Davis, Morris was an intellectual; he edited the little magazine *Miscellany* (1929–31) and wrote for the *Partisan Review*. He especially admired Léger and Ozenfant and studied with them in Paris in 1928. When Morris returned from his Parisian apprenticeship, he began to articulate the need for an Americanized abstract art and to paint Légeresque abstractions based on Native American themes (Fig. 314).[23]

If Davis extended machine age ideals into mid-century, Morris promoted primitivist ones, maintaining that the country's only indigenous

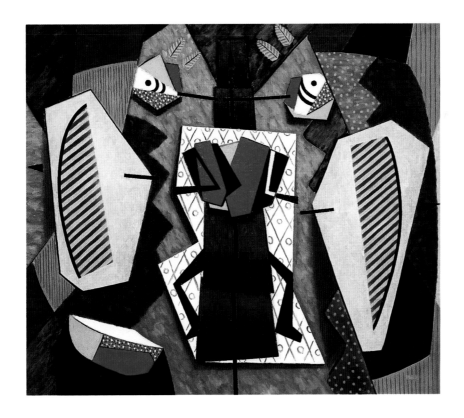

Fig. 314. George L. K. Morris, *Indians Hunting No. 4*, 1935.
Oil on canvas, 35 × 40 in.

Fig. 315. George L. K. Morris, *Times Square, A.M.*, 1973.
Oil on canvas, 91 × 120 in.

civilization was American Indian. "The essential im-
pulse in the search for an authentic culture," he wrote
in 1938, "must be a movement backward . . . , until
the artist can find a place to rest his feet securely. . . .
If an authentic American culture is to arise, we must
go back to a beginning. My work . . . is the attempt
to find such a beginning." Much like Hartley twenty
years earlier, Morris found his "American voice," as
he called it, by marrying synthetic cubism to im-
agery of Indians in native dress and rituals. He also
continued the early modernists' embrace of the
American folk artist as a suitable ancestor: "The
only tradition with a genuine American flavor," he
wrote, was "the severe portraits by sign-painters in
the New England country districts." On another oc-
casion he praised folk pieces because they "show
that Americans were once a people for whom plastic
. . . sensibility was natural and inborn."[24]

Morris later turned to cityscapes, delirious and
nocturnal, that stylistically updated Joseph Stella's
Voice of the City of New York Interpreted but did

not rewrite the underlying metaphors (Fig. 315).
Such paintings, like those we looked at by Tobey and
Kline, remind us of the extraordinary staying power
of the early modernist's three New Yorks—the
Cyclopean City, the City Electric, and the City De-
lirious. While artists have proposed alternative New
Yorks—Edward Hopper's and George Segal's lonely
low-rise Manhattan comes to mind—artists of the
past fifty years have by and large perpetuated the
modernist paradigm of the *new* New York: over-
powering bridges and buildings, congested streets,
and a visceral assault on the senses. No one has done
it with more animation and humor than Red Grooms
in his wacky assemblage of sculptures called *Ruckus
Manhattan*. Viewers have to walk through the sculp-
ture to experience it (Fig. 316). When *Ruckus Man-
hattan* is displayed in downtown Manhattan, part of

Fig. 316 (facing). Red Grooms with Ruckus Manhattan
Construction Co., *Ruckus Manhattan: Rector Street*,
1975–76. Mixed media.

the fun is in strolling through a three-dimensional cartoon of the beloved New York monuments, taxis, subways, and pedestrians that lie just outside the door of the gallery.

But the latest walk-through New York—this time by a real estate developer rather than an artist—takes the *new* New York experience to new extremes and a new location. New York, New York—the name taken from the popular song—is a new theme casino in Las Vegas (Fig. 317). Miniaturized (but still large) replicas of New York's most famous skyscrapers soar skyward, sheathing a high-rise hotel and gaming rooms and conjuring up a paradigmatic Manhattan on the desert. But that is not all. The simulacrum of the *new* New York is even more perfect: a miniaturized Statue of Liberty, Brooklyn Bridge, Coney Island rollercoaster, Grand Central Station, and subway draw in the Vegas crowds, which jostle over the bridge and into the railway station, bathed in the brash glow of neon lights. The architectural compression is uncanny and so well done and earnestly re-created that it takes one's breath away. The designers know their iconography; they are learned students of the mythos. New York's modernist icons may be rendered today with humor and nostalgia, and in an often hackneyed form, but they cannot be denied. They are part of our common visual language. The *new* New York is nearly a century old now, but its constellation of monuments and its sensory experiences still define the city—and by extension America—in people's imaginations.

Fig. 317 (above). New York, New York Hotel and Casino, Las Vegas, Nevada.

Foreigners, in particular—the artists, architects, and writers who still cross the Atlantic (and now the Pacific)—bring many of the same expectations Europeans brought with them in 1915. Visitors come to indulge in America's supermodernity, not its arts—in the familiar skyscrapers, neon, and fabled energy of New York but also in American popular culture as exemplified by Los Angeles and Las Vegas. What they once sought at Coney Island, they now look for in Hollywood and at Disneyland. Their itinerary may still include sports—football along with hockey, baseball, and big-city marathons—and the commercial landscapes they visit are more likely to comprise fast food chains and shopping malls than factories. Occasionally foreigners travel to the desert, wilderness sights, or Native American reservations. But

like their predecessors over a half century ago, they are not generally drawn by the country's historical monuments, battlefields, museums, parks, and gardens. If they are French and write about their experiences, like Jean Baudrillard, who published *Amérique* in 1986, they may say less than earlier visitors did about American women and blacks but still find no high culture (or cuisine) to equal their own. In Baudrillard's view, "the Freeways, the Safeways, the skylines, speed, and deserts—these are America, not the galleries, churches, and culture."[25]

Baudrillard's account, shot through with worldly despair, sees America writ large in many of the same microcosms that his countryman Jules Huret analyzed earlier in the century. Like Huret, Baudrillard generalized about America from his experiences in Manhattan. "The American street," Baudrillard wrote, is "always turbulent, lively, kinetic, and cinematic, like the country itself, where change. . . . assumes virulent forms." As his countrymen have done for decades, he theatricalized the "whirl" of New York City, the "crazy city" where "the mad have been set free," viewing Manhattan as strange and uncomfortable. Watching the New York marathon, he found it unimaginable and violent, as Huret once found football games and Coney Island. It was an "end-of-the-world show" for Baudrillard, "a form of demonstrative suicide, suicide as advertising." The runners have a national disease; they are self-indulgent braggarts, each boasting, Baudrillard maintains, "I ran the New York marathon: I did it!"[26]

When Baudrillard described American values, he framed his criticism on the traditional binary opposition of "them" versus "us," and he used many of the same terms the early-twentieth-century visitors had used, though now despairingly. The country is "completely rotten with wealth, power, senility, indifference, puritanism and mental hygiene, poverty and waste, technological futility and aimless violence." Now France was at the margins and America the powerful center. Lamenting Americanization around the globe, Baudrillard was simultaneously appalled and fascinated: "The entire world continues to dream of New York, even as New York dominates and exploits it."[27]

Such late-twentieth-century meditations about America remind us how extraordinarily powerful and long-lasting modernist habits and descriptors have been.[28] Had Baudrillard commented on the country's small towns, or on cities like Boston or Seattle, or on labor strife, the current museum mania, or the multiplicity of ethnic cuisines that have changed America's eating habits—*that* would constitute a change in the paradigm. But instead he recycled all the stock images foreigners used. His emphasis on rush-hour crowds and the predominance of advertising underscores just how completely early-twentieth-century international modernism has mapped the debate in Europe about American culture: American modernity versus European traditionalism, high culture versus low, New York versus Paris. That Baudrillard judged all of America by a few square miles of city life is the most ingrained modernist legacy of them all.

Not only intellectuals but also artists have continued to flow into Manhattan from cultural centers elsewhere. A place that in 1915 was an unusual destination for modernists exerted an increasing pull on Parisians as well as on artists from London, Berlin, Milan, Tokyo, and Mexico City. Throughout the 1930s and 1940s artists as varied as Le Corbusier, Frida Kahlo, and Mondrian perpetuated the mythos, though not always with the exuberance and marvel that the earliest modernists brought to the task.[29] When the Mexican painter Kahlo was in New York, in the early 1930s, with her husband, Diego Rivera, she expressed her unhappiness in anti-Manhattan and anticapitalist paintings, by turning modernist referents for America into vehicles of satire and despair. In *My Dress Hangs There*, Kahlo depicted American values with two icons perched high on columns: a toilet (plumbing) and a sports trophy (physical fitness) (Fig. 318).[30] Strung up between the two and profiled against a skyline of skyscrapers, one of the many handmade Tehuana dresses that she owned represented Kahlo herself—a sign of her foreignness, her femaleness, and of her socialist commitment to Mexico's peasant poor. All around her dress, isolating it even further, are garish signifiers of American government and modernity: a telephone, a peeling movie screen with an image of a harlot-like Mae West, Federal Hall National Memorial (formerly the U.S. Subtreasury Building and before that the U.S. Customhouse), the stained-glass window of Trinity Church in which the crucifix becomes a red dollar sign, a gas pump with the Texaco logo, industrial water tanks, smokestacks, and ventilators. In the distant background there is the Statue

Fig. 318. Frida Kahlo, *My Dress Hangs There*, 1933.
Oil and collage on masonite, 18 × 19½ in.

of Liberty and the skyscraper-studded island of Manhattan. Reprising the standard image for transatlantic exchange, an ocean liner sails into the Port of New York. At the bottom of the picture, just under Kahlo's own dress, is a New York bridge and photographs collaged onto the canvas representing Manhattan's famous congestion. But because of the depression and Kahlo's politics, these are not the celebrated frenzied crowds of Broadway but breadlines and striking workers. At the right, summing up Kahlo's condemnation of the United States, a trash can overflows with waste.

While Kahlo did not invent most of these tropes —by 1933 they were in international circulation— she radically reworked them to protest American values and inequities of wealth. The breadlines substituted for street crowds and the telephone line tying together the skyscrapers, Federal Hall, and Trinity Church convert the joyousness or humor these images usually convey into a scathing critique of capitalism. Introducing her own peasant dress into this mountain of male achievements and contrasting its simplicity with the tight, glittering gown of a Hollywood siren, Kahlo inserted feminist politics into the *new* New York iconography. This is not the rosy romance of *américanisme* but an angry rebuttal to it.

Mondrian, in contrast, came to New York in 1940 prepared to revel in its modernity. And he did, in both his personal life and his art. In his sixties, the Dutch painter responded wholeheartedly to the architecture, the night lights, the street frenzy, and particularly jazz—one of his friends was Stuart Davis, who knew the jazz scene well. Mondrian was so content that he wanted to expatriate. He applied

Fig. 319. Piet Mondrian, *Broadway Boogie Woogie*,
1942–43. Oil on canvas, 50 × 50 in.

for American citizenship but died from pneumonia in 1944 before it was granted. Though he worked in an austere and difficult language of abstraction, his art underwent remarkable changes in New York.[31] He speeded up the optical shifts in his nonobjective paintings, used livelier color chords, and invented titles more reminiscent of jazz music than of his own earlier works, many simply called *Composition*. In two of his important New York paintings, *Broadway Boogie Woogie* (Fig. 319) and *Victory Boogie Woogie*, his black grids became colored ones, and his stately blocks of primary color transmuted into much smaller squares. In the first of these, the surface is knit tightly together but flickers with activity, the eye bouncing from node to node.

While there are formalist explanations for these changes (the availability of colored tapes to make

preparatory studies, for instance, and the artist's research into allover compositions), it is also clear that Mondrian had a bit part in chasing after the Great American Thing. By the 1940s he was working within a well-rehearsed paradigm of European artists coming to Manhattan and making art about the *new* New York. It may even be that he felt a certain transatlantic pressure to register his sensations of New York—to enter his voice, as it were, into the pictorial record and show his colleagues how a master of European abstraction could respond to the mythos. Francis Picabia had done something similar twenty-five years earlier when he made his abstract "impressions" of New York and told the press that they were his sensations of a city on the move (see Figs. 40, 41). Mondrian said his first painting of New York was "what New York meant to me when I

first saw it from the boat," and his second, "the city as it appeared to me after living in it."[32]

Not long after Mondrian died, another Dutch artist, Willem de Kooning, one of the great abstract painters of the New York School, surprised New York critics by introducing recognizable female heads that reference American movie stars and pin-ups. While much ink has been spilled analyzing why de Kooning brought back the figure while others remained true to abstraction, no one has considered how *américanisme* might have influenced an artist who began life in Europe and then immigrated to New York. In de Kooning's paintings, the figure constitutes a late reprise of the European male's longstanding love-hate affair with robust, highly sexualized American women and their bigger-than-life representations in the media. In effect, he returned to

the 1920s and brought back the American girl, the advertisement, and the billboard.

Something similar happened to the Dutch architect Rem Koolhaas, who immersed himself in the writings of early-twentieth-century architects on Manhattan and in representations of the *new* New York when it was in formation: vintage postcards, magazine illustrations, and architectural renderings. In 1978 he published a zany and irrepressible but deeply knowledgeable treatise called *Delirious New York: A Retroactive Manifesto for Manhattan*. His partner, Madelon Vriesendorp, a watercolorist, made the illustrations, wittily informed by older pictorial conventions (Fig. 320). As we near the centenary of the advent of *américanisme*, Koolhaas and Vriesendorp demonstrate that parts of the tradition are alive and well; visiting artists and architects still

Fig. 320. Madelon Vriesendorp, *Freud Unlimited*, 1974.
Watercolor/gouache, approximately 18 × 24 in.

marvel at Manhattan and respond to it in words and pictures. Koolhaas's affection for the New York mythos may well exceed his love for the city itself.

Around 1960 the emergence of pop art in New York once again generated heated exchanges over the relationship of art to the American street. Faced with Andy Warhol's silk-screened Campbell's soup cans or Roy Lichtenstein's gigantic paintings of comic book heroes, the champions of abstract expressionism were indignant. Their reactions were no less sanctimonious and protective of high-minded art than those of Paul Rosenfeld, Waldo Frank, and Alfred Stieglitz forty years earlier. One offended critic, excoriating those he called the New Vulgarians, wrote: "The truth is that the art galleries are being invaded by the pin-headed and contemptible style of gum-chewers, bobby soxers, and worse, delinquents."[33] Pop was kitsch pretending to be art, maintained other defenders of the New York School, who considered abstract art a buffer against the banalities that threatened any possibility of an American high culture.

Other critics, generally younger, defended the new artists with the gusto of Matthew Josephson and other pop culturists who had embraced the poetry of advertising jingles after World War I. Not only, its supporters argued, was pop art fun and irreverent, but it also suited the loud, messy commercialized landscape of modern life. Furthermore, pop legitimately incorporated the forms and images of the mass media. And finally, at a formal level, pop art used the formal elements of abstract art, especially minimalism, to transform the banal and the everyday into museum icons; pop art was anti-elitist and democratic. Whereas earlier the symbolist artists and their romanticism had been derided, now it was the abstract expressionists and their heroics. To the pop artists, the abstract expressionists indulged in self-expression and existentialist angst. "I am for an art . . . that does something other than sit on its ass in a museum," Claes Oldenberg wrote, a comment that was quoted widely, as was Robert Rauschenberg's statement, "Painting relates to both art and life. Neither can be made. (I try to act in that gap between the two.)"[34]

The greatest difference between the apologists for vulgarity in the 1920s and 1960s was that the later ones drew evidence from the history of modern art, especially American art. In the early century, artists defended billboard aesthetics as quintessentially American; to use the adman's forms was to work in an American way. In the 1960s, however, critics and curators went further. As the first generation to have been schooled in the history of art, especially modern art, they tried to fit pop art into historical traditions of art making. Some found precedents in cubist collages by Picasso and Georges Braque that incorporated commercial imagery; others pointed to comic book fragments in Kurt Schwitters's work. Still others evoked Georges Seurat's admiration for fin-de-siècle posters and Léger's defense of billboards. But most often critics liked to show that pop art fit naturally into an American line of work that went back to folk artists and the trompe l'oeil still-life painters William Harnett and John F. Peto. They construed these artists' vernacular bluntness and graphic clarity as pop art's proper ancestry and juxtaposed Jasper Johns's flag paintings with a nineteenth-century "folk" gateway in the shape and colors of an American flag. This gate became "early pop art," giving it even greater value when in 1962 it became the first acquisition of New York's new Museum of American Folk Art.[35]

Critics also named Demuth, Murphy, and Stuart Davis as examples of proto-pop, pre-pop, or pre-echoes of Pop.[36] Marcel Duchamp's readymades took on new stature, and the artist himself, an aging émigré living in New York City, found himself once again in the center of an American art movement sometimes called conceptual art or neodadaism. Gerald Murphy, who lived near Manhattan, remained completely unknown as a painter. But in a climate sympathetic to pop art, his small oeuvre was suddenly rediscovered, particularly his canvas *Razor* (Fig. 69), which looked ancestral to Warhol's soup cans. Though Demuth was no longer alive, his *Figure 5 in Gold* also enjoyed its first widespread recognition in the 1960s, when it was often reproduced as an example of early pop art. And Stuart Davis, in his seventies, found himself saluted for his steadfast dedication to the everyday landscape of signs and gas stations.

It was not just critics who positioned pop artists in explicit historical relationships with American artists of the past; the artists themselves jumped on the genealogical bandwagon. Robert Indiana reworked

Demuth's *Figure 5 in Gold* (see Figs. 169, 213) and quoted directly from the poetry of Hart Crane and the Brooklyn Bridge paintings of Joseph Stella, as well as from Walt Whitman and Herman Melville. More recently Indiana created a series called *The Hartley Elegies* (1989–94), reworking Hartley's *Portrait of a German Officer*.[37] Marisol, whose hand-carved figures with exaggerated proportions came to notice in the 1960s, made clear-cut analogies between her work and earlier American folk art (Fig. 321; see Fig. 303). And Andy Warhol, a voracious collector, made Americana one of his passions. Beginning in the 1950s, he began to buy hooked rugs, quilts, carousel horses, vernacular portraits, weather vanes, and cigar-store figures, all American made and valued at the time as the work of America's first "genuine" school of art.[38] Warhol may not have referred directly to Americana in his own art, but in his celebrity portraits, first of Marilyn Monroe, the Mona Lisa, and Jacqueline Kennedy, and later of society figures, he reformulated and revived the modernist portrait, a central project in the 1920s that had disappeared in the intervening years.

When Sheeler and other modernists of his generation historicized a relationship between their work and an artifactual past, they were selective in their references and less obvious in their appropriations. They worried lest any excessive sentiment for the past be identified as antiquarianism, a rampant phenomenon of their day. Furthermore, they had to invent an ancestry, having no textbooks to guide them. Pop artists, in contrast, were promiscuous and bold in their appropriations from the past. They showed off their knowledge of the history of art, a subject that had entered the university curriculum and become popular during the intervening forty years, by quoting from European old masters as well as American ones. Some artists reworked museum favorites by Leonardo da Vinci, Velázquez, and Ingres. Some quoted from colonial American art history, including masters like John Singleton Copley and Benjamin West. And many referenced painters in the very select modernist trajectory Greenberg argued for: Manet, late Monet, Matisse, Picasso, and Mondrian. So many pop artists made "art about art" that in 1978 the Whitney Museum held an exhibition by that name.[39]

The world of art was theirs to choose from, and pop artists used art of the past as just one element in

Fig. 321. Marisol, *Baby Girl*, 1963. Wood and mixed media, 74 × 35 × 47 in.

their image banks, alongside those provided by the comics and advertising. Their catholicity of view enabled them to change the modernist paradigm by looking back at the past with a sense of neither embarrassment nor triumph. They opened up the history of modern art, helping others to see that the first American modernist artists had been banished from view. Scholars too in the 1960s were taking the first steps toward an art-historical revisionism that is still playing itself out. It would, in time, collapse and discredit not only Greenberg's narrow view of the history of American modern art but also the legacy of American exceptionalism that lay behind it. And with these efforts, the modernist era came to a close.

Readers who have followed my account to this point will have acquired, I trust, a new appreciation of the complex roots and varied ramifications of the quest for the Great American Thing. I also hope my book will allow readers to share what is to me one of the great joys of being a historian, the wonderful way learning about the past clarifies the present. In my daily life I relish the shock of recognition that comes when I stumble upon small and unexpected instances of *américanisme* and other echoes of the fervent debates about art and national identity between the wars. Let me cite three examples, assured that my readers will find others. A while ago I attended a Fourth of July concert and was handed a program. Reading down the selections to be played, I realized that the interwar period gave us not only art that was red, white, and blue but also an equivalently colored musical repertoire, one deemed especially appropriate today for national holidays. The program included "Buckaroo Holiday," from *Rodeo*, and *Fanfare for the Common Man*, both by Aaron Copland, and the overtures to *Girl Crazy* and *An American in Paris* by George Gershwin—American composers who came of age during the 1920s. (Inevitably the concert concluded with the *1812 Overture*, which, while not an artifact of *américanisme*, nevertheless was played to the accompaniment of red, white, and blue fireworks!) On another occasion I saw with new eyes Saul Steinberg's much-reproduced map of the New Yorker's view of the United States. With its crowded island of skyscrapers and brownstones, stretching almost all the way to the Pacific Ocean, it omits the vast heartland of the country and its regional diversity. On this map Manhattan *is* America, an equation unabashedly (and wittily) persisting three-quarters of a century after its invention. That it was conceived by an artist with a European eye—Steinberg was born in Romania and educated in Italy before coming to Manhattan—reinforces the pleasure I find in the image. And last, as I bring this epilogue to a close, at a recent exhibition of motorcycles organized by the Guggenheim Museum in New York, I can report my pleasure in coming across a 1933 artifact whose color and lines recalled for me the fire engine in Demuth's *Figure 5 in Gold*. It was a sleek machine, red, streamlined, and looking very much like a Harley Davidson. But the real treat came when I read the object's label. Called the "Dollar V4," the machine was French, not American, designed by one Maurice Chaise, a French engineer. In the spirit of true *américanisme*, Chaise named his company Dollar to make it sound American and to underline the Americanness of his cycle's design. I also learned that the Dollar company did not survive the Second World War. Given what I knew about the ebb and flow of *américanisme*, that too made historical sense.

NOTES

ABBREVIATIONS

AAA Archives of American Art, Smithsonian
Institution, Washington, D.C.
YCAL Yale University, Collection of American
Literature, Beinecke Rare Book and
Manuscript Library

PREFACE

1. John W. McCoubrey, *American Tradition in Painting* (New York, 1963), 8.

2. Barbara Novak, *American Painting of the Nineteenth Century: Realism, Idealism and the American Experience* (New York, 1969), 9.

3. Georgia O'Keeffe, *Georgia O'Keeffe* (New York, 1976), n.p.

4. See, for example, Linda Jones Docherty, "A Search For Identity: American Art Criticism and the Concept of the 'Native School,' 1876–1893," Ph.D. diss., University of North Carolina, 1985.

5. Quoted in Gordon Hendricks, *The Life and Work of Thomas Eakins* (New York, 1974), 271.

6. Robert Henri, *The Art Spirit: Notes, Articles, Fragments of Letters, and Talks to Students, Bearing on the Concept and Technique of Picture Making, the Study of Art Generally, and on Appreciation* (1923; reprint, Philadelphia, 1960).

7. Irving Sandler, *The Triumph of American Painting: A History of Abstract Expressionism* (New York, 1970), 31.

8. In my eagerness to offer a corrective, I am aware that I do injustice to the views of Americans such as T. S. Eliot, Ezra Pound, and Harold Stearns, who expatriated to Europe after the war and felt deeply alienated from their country of birth. This is the underbelly to my story, but my point is that it is not always the underbelly that rules the beast.

9. Rosalind Krauss, "In the Name of Picasso," *October* 16 (spring 1981): 7.

10. Raymond Williams, *The Politics of Modernism: Against the New Conformists* (London, 1989), 45.

11. The newest scholarship on the Harlem Renaissance looks less at individual figures than at racial interactions and crossovers between black and white communities in the 1920s in both Paris and New York. See, for example, George Hutchinson, *The Harlem Renaissance in Black and White* (Cambridge, Mass., 1995); and Ann Douglas, *Terrible Honesty: Mongrel Manhattan in the 1920s* (New York, 1995). This is a profitable shift in emphasis. And here I see ways to place some elements of the Harlem Renaissance within the parameters of my own work. To give but one example: Alain Locke's *New Negro*, published in 1925, was illustrated with African masks; drawings and decorative designs by Aaron Douglas; and two drawings by the Mexican caricaturist Miguel Covarrubias. Most prominent—both on the cover and throughout the book's pages—were the reproductions of portraits of African Americans by Winold Reiss, a white German painter who immigrated to New York in 1913 where he taught Aaron Douglas, among others. See Jeffrey C. Stewart, *To Color America: Portraits by Winold Reiss* (Washington, D.C., 1989), and *Winold Reiss: An Illustrated Checklist of His Portraits* (Washington, D.C., 1990). The presence of Reiss's works seems to embarrass some scholars. How else to explain their complete elimination from the latest edition of *The New Negro* (ed. Alain Locke, with an introduction by Arnold Rampersand [New York, 1992])? But from the vantage of this study, Locke's use of a European's art to support his own call for a new Negro art exemplifies how 1920s transatlantic modernism worked, across racial as well as national boundaries. Many European artists who visited America went straightaway to Harlem as part of their tour of New York's exotic sights. Fortunato Depero of Italy and Edward Burra from England, to name but two, made many paintings of Harlem subjects that they took back with them to Europe. Just as European touristic adulation of skyscrapers and plumbing helped define what was American about American life, so did the European fascination with "blackness" and black "moderns." Winold Reiss was a part of the intercultural process by which the identity of the "New Negro" was formed. One needs to think more about how the European fascination with black American life enhanced self-understanding and self-picturing in Harlem—just as European admiration of American engineering played a similar supportive role in downtown art circles.

12. Stieglitz's response is reported in a letter from Anita Pollitzer to Georgia O'Keeffe, Jan. 1, 1916, repub-

lished in *Lovingly, Georgia: The Complete Correspondence of Georgia O'Keeffe and Anita Pollitzer*, ed. Clive Giboire (New York, 1990), 115.

13. Ernest Gellner, *Nations and Nationalism* (Ithaca, N.Y., 1983); Benedict Anderson, *Imagined Communities: Reflections on the Origin and Spread of Nationalism* (London, 1983); and Eric Hobsbawm and Terence Ranger, *The Invention of Tradition* (Cambridge, 1983).

14. Ernest Gellner, *Thought and Change* (London, 1964), 169, quoted in Anderson, *Imagined Communities*, 6.

15. Angela Miller, *The Empire of the Eye: Landscape Representation and American Cultural Politics, 1825–1875* (Ithaca, N.Y., 1993), 17.

16. Michael Baxandall, "The Period Eye," chapter 2 of *Painting and Experience in Fifteenth-Century Italy: A Primer in the Social History of Pictorial Style* (Oxford, 1972), 29–108.

INTRODUCTION: SPIRITUAL AMERICA

1. Frederick Lewis Allen, *Only Yesterday: An Informal History of the 1920s* (1931; reprint, New York, 1959). William E. Leuchtenburg, *The Perils of Prosperity, 1914–1932* (Chicago, 1958), offers another classic examination of this period.

2. The American Legion, founded in 1919, was dedicated specifically to "Americanism." The preamble to its creed promised "to foster and perpetuate a 100 per cent Americanism," using a phrase that circulated widely in the 1920s. The Freemasons also dedicated themselves to promoting "100 percenters." When used by service clubs, veterans, or members of the Daughters of the American Revolution or the increasingly powerful Ku Klux Klan, the phrase protected a host of ugly racist, nativist, and WASP prejudices. See Raymond Moley, Jr., *The American Legion Story* (New York, 1966), 364–76; and Lynn Dumenil, *Freemasonry and American Culture, 1880–1930* (Princeton, N.J., 1984), 115–47.

3. The literature on cultural nationalism, especially its literary arm, is large. When I began my work, I got my grounding in this material through Claire Sacks, "The *Seven Arts* Critics: A Study of Cultural Nationalism in America, 1910–1930," Ph.D. diss., University of Wisconsin, 1955; and Hugh M. Potter, "The 'Romantic Nationalists' of the 1920s," Ph.D. diss., University of Minnesota, 1964. See also Arthur Frank Wertheim, *The New York Little Renaissance: Iconoclasm, Modernism, and Nationalism in American Culture, 1908–1917* (New York, 1976); Edward Abrahams, *The Lyrical Left: Randolph Bourne, Alfred Stieglitz, and the Origins of Cultural Radicalism in America* (Charlottesville, Va., 1986); and Casey Nelson Blake, *Beloved Community: The Cultural Criticism of Randolph Bourne, Van Wyck Brooks, Waldo Frank, and Lewis Mumford* (Chapel Hill, N.C., 1990).

4. Paul Rosenfeld, *Port of New York: Essays on Fourteen American Moderns* (New York, 1924). A later edition, without the illustrations and with an introductory essay by Sherman Paul, was published first in cloth and then in paper (Urbana, Ill., 1961, 1966). My citations will be to this 1961/1966 edition since it is easier to come by.

5. Edna Bryner Schwab, a novelist and the executor of Rosenfeld's estate, gave his collection of O'Keeffe, Marin, Dove, Hartley, and others to her alma mater, Vassar College. See Dennis Anderson, "The Vassar Connection: Paul Rosenfeld, Edna Bryner Schwab, and Alfred Stieglitz," *Vassar Quarterly* (spring 1988): 27–31.

6. For the cultural nationalists, it was an article of faith that New York City could someday be to America what Paris was to France: the nation's art center. One of the earliest arguments for New York as an art center was published in 1903 by Herbert Croly, who in 1914 was one of the founders of the *New Republic*: "New York is the most national of American cities, and since the cultural basis of a modern literature or art is not municipal or provincial, but necessarily national, New York is the one American city in which something considerable may happen." Herbert Croly, "New York as the American Metropolis," *Architectural Record* 13 (Mar. 1903): 205. Near the end of his life Rosenfeld wrote an essay, "When New York Became Central," *Modern Music* 20 (Jan.–Feb. 1943): 83–89, in which he pinpoints 1915 as the year in which New York began to be "central" to the international world of music. This shift to New York as the country's seat for progressive art also signaled that Boston and Philadelphia, once the country's centers for contemporary art making, were no longer serious contenders.

7. Gorham Munson, "The Mechanics of a Literary Secession" *S4N* 22 (Nov. 1922): n.p.

8. Rosenfeld, *Port of New York*, 275, 240.

9. Jerome Mellquist and Lucie Wiese, eds., *Paul Rosenfeld: Voyager in the Arts* (New York, 1948). Wilson's essay, from which the quotations in my text are drawn, is the first tribute, "Paul Rosenfeld: Three Phases," 3–19.

10. Rosenfeld, *Port of New York*, 289.

11. Ibid., 281–82.

12. Ibid., 283–84. Rosenfeld's circle often represented the difference between Europe and America as a drop in altitude or temperature. See Van Wyck Brooks, *Days of the Phoenix: The 1920s I Remember* (New York, 1957), 3: "It took me twenty years or more to live down what I felt then [in the 1920s and earlier], a frequently acute homesickness for the European scene, for I had experienced all too fully the widely shared consciousness of a drop in one's emotional thermometer on returning from Europe. It was like the change, for a swimmer, from salt water to fresh."

13. Rosenfeld, *Port of New York*, 285, 286, 287.

14. Ibid., 288, 289.

15. Ibid., 289.

16. Ibid., 290, 291, 292.

17. Ibid., 292, 293.

18. Ibid., 294, 295.

19. Ibid., 295.

20. Studies of Rosenfeld include Mellquist and Wiese, eds., *Paul Rosenfeld;* Bruce Butterfield, "Paul Rosenfeld: The Critic as Autobiographer," Ph.D. diss., University of Minnesota, 1962; and Hugh M. Potter, *False Dawn: Paul Rosenfeld and Art in America, 1916–1946* (Ann Arbor, Mich., 1980).

21. Paul Rosenfeld, "Whistler and Japanese Art," *Yale Literary Magazine* 75 (Nov. 1909): 55–61, and "Aubrey Beardsley," *Yale Literary Magazine* 75 (June 1910): 444–46.

22. Rosenfeld, *Boy in the Sun* (New York, 1928). Accounts of Rosenfeld's early life generally draw on this autobiography. Both parents were mentally unstable, and both were dead before Rosenfeld had reached full adulthood. One senses that Rosenfeld early on used music, literature, and introspective writing to work through family dysfunction and the anti-Semitism he encountered in many parts of his life.

23. In the 1920s Rosenfeld wrote or helped to edit twelve books. See, for example, Paul Rosenfeld, *Men Seen: Twenty-Four Modern Authors* (New York, 1925), *Musical Chronicle, 1917–1923* (New York, 1923), and *By Way of Art: Criticisms of Music, Literature, Painting, Sculpture, and the Dance* (New York, 1928). For a very useful compilation, see Charles L. P. Silet, *The Writings of Paul Rosenfeld: An Annotated Bibliography* (New York, 1981).

24. *Seven Arts* (Nov. 1916): 52. Waldo Frank probably drafted this editorial as a prospectus to promote the journal. See Wertheim, *New York Little Renaissance*, 178.

25. Louis Untermeyer, "Roots and Skyscrapers," in *From Another World: The Autobiography of Louis Untermeyer* (New York, 1939). Untermeyer was one of the magazine's literary editors, as was James Oppenheim, who wrote his reminiscence of the journal in "The Story of the *Seven Arts*," *American Mercury* 20 (June 1930): 156–64.

26. Romain Rolland, "America and the Arts," trans. Waldo Frank, *Seven Arts* 1 (Nov. 1916): 47–51.

27. There were, however, major differences between them. Unlike Rosenfeld, Frank engaged continually in left-wing political movements. In World War I Frank registered for the draft as a pacifist; in the 1930s he was active in left-wing causes, including the American Writers' Congress; and throughout his life he was involved in Latin American politics and governmental affairs. Whereas Rosenfeld never married, Frank was husband to three wives over his lifetime and the father of several children. Rosenfeld had an independent income while Frank wrote for his living. The competitiveness between them and sibling ri-

valry that erupted in the early 1920s is nicely analyzed in "The Frank Affair," in Potter's *False Dawn*, 92–109. Rosenfeld did not include an essay on Waldo Frank in *Port of New York*, a notable omission, especially since he did include an essay on Frank's wife, Margaret Naumburg, a Montessori teacher and a progressive educator. In *Men Seen*, 89–109, Rosenfeld republished his essay "The Novels of Waldo Frank," *Dial* 70 (1921): 95–105, harshly criticizing Frank's writing for being too abstract, uncontrolled, and undisciplined, ironically the very same criticisms Rosenfeld's work elicited from his peers. The two men believed in the same cultural values but as critics felt obliged to air their differences publicly. For earlier thoughts on the two men, see my "Apostles of the New American Art: Waldo Frank and Paul Rosenfeld," *Arts Magazine* 54 (Feb. 1980): 159–63.

28. Waldo Frank, *Our America* (New York, 1919). Among the European editions of this work are *Notre Amérique*, trans. H. Boussinesq (Paris, 1920), and *The New American* (London, 1922). See also *The Rediscovery of America: An Introduction to a Philosophy of American Life* (New York, 1929). The basic biographical and critical sources for Waldo Frank are William Bittner, *The Novels of Waldo Frank* (Philadelphia, 1958); Paul J. Carter, *Waldo Frank* (New York, 1967); Jerome W. Kloucek, "Waldo Frank: The Ground of His Mind and Art," Ph.D. diss., Northwestern University, 1958; and *Memoirs of Waldo Frank*, ed. Alan Trachtenberg (Amherst, Mass., 1973).

29. Reprinted in Waldo Frank, *In the American Jungle, 1925–1936* (New York, 1937), 3–15.

30. See, for example, Malcolm Cowley, *Exile's Return* (New York, 1934); Matthew Josephson, *Life among the Surrealists: A Memoir* (New York, 1962); Grant Wood [attrib.; written by Park Rinard], "Return from Bohemia," D24, AAA, 161–295; Thomas Hart Benton, *An Artist in America* (New York, 1937); Marsden Hartley, "Return of the Native" (1932), reprinted in Townsend Ludington, *Marsden Hartley: The Biography of an American Artist* (Boston, 1992), 215, and "On the Subject of Nativeness— A Tribute to Maine" (1937), reprinted in *On Art, by Marsden Hartley*, ed. Gail R. Scott (New York, 1982), 112–15. Stieglitz too, as Sarah Greenough pointed out to me, fits this paradigm. In narrating the events of his early career to Dorothy Norman, he located his conversion experience on the day he photographed *The Terminal*, when a number of recent experiences in New York converged to convince him that "America was saved for me. I was no longer alone." See Dorothy Norman, *Alfred Stieglitz: An American Seer* (1960; reprint, New York, 1973), 37.

31. See Potter, *False Dawn*, 93–98, for a synopsis of *Our America* and its impact on Rosenfeld.

32. Frank, *Our America*, 227.

33. Brooks was notable as a Gentile among the cultural nationalists, most of whom were from Jewish fami-

lies. Oppenheim wrote that Brooks's becoming an associate editor of the *Seven Arts* relieved the editorial board "of the onus of being non-Anglo-Saxon"; see "The Story of the *Seven Arts*," 158. For an essay discussing the new and weighty Jewish presence in this generation of American intellectuals and their ideals of cosmopolitanism, see David A. Hollinger, "Ethnic Diversity, Cosmopolitanism, and the Emergence of the American Liberal Intelligentsia," *American Quarterly* 27 (May 1975): 133–51. My thanks to Lise Bloom for alerting me to this article, which sees Rosenfeld as a pivotal influence on Edmund Wilson, a Gentile who was then a model for Alfred Kazin and Lionel Trilling, the next generation of Jewish literary critics.

34. Van Wyck Brooks, *The Wine of the Puritans: A Study of Present-Day America* (London, 1908).

35. Ibid., 46–47.

36. Van Wyck Brooks, "America's Coming-of-Age" (1915), reprinted in *Three Essays on America* (1934; reprint, New York, 1970), 79. For a study of Brooks, the man and his writings, see James Hoopes, *Van Wyck Brooks: In Search of American Culture* (Amherst, Mass., 1977).

37. Rosenfeld, *Port of New York*, 54. Brooks most thoroughly examines American writers whose nationality he believed destined them to failure in *The Ordeal of Mark Twain* (New York, 1920) and *The Pilgrimage of Henry James* (New York, 1925).

38. Peter Minuit [Paul Rosenfeld], "291 Fifth Avenue," *Seven Arts* 1 (Nov. 1916): 61–65; and Waldo Frank, "Emerging Greatness," *Seven Arts* 1 (Nov. 1916): 73–78.

39. At one point, Frank openly rebelled against this inequality of relationship and wrote Stieglitz a letter complaining of the older man's inability "to enter into a relationship of equality with men"; see Waldo Frank to Alfred Stieglitz, July 31, 1923, Stieglitz Collection, YCAL.

40. Edmund Wilson, "Paul Rosenfeld, Three Phases," in Mellquist and Wiese, eds., *Paul Rosenfeld*, 7.

41. Rosenfeld, *Port of New York*, 288.

42. The sister of Paul's maternal grandmother married Joseph Obermeyer, the father of Stieglitz's first wife. Potter, *False Dawn*, 12. My thanks to Sandra Phillips for alerting me to this connection. I have found only one instance of Rosenfeld's trying to make something of it. In a letter to Philip Platt, a friend from Yale, Aug. 23, 1915, he added a postscript: "Camera being 'tried out.' Have oh so much to learn in spite of being cousin to A. Stieglitz." Stieglitz Collection, YCAL.

43. Rosenfeld's biographers give no specifics other than failing health for his death. When he died, Rosenfeld was no longer a cultural force. He had lost much of his family income in the financial crash of 1929 and in succeeding years continued to write, but without the considerable influence he had once exerted.

44. Stieglitz gave Strand a one-person exhibition at 291 in 1916 and showed O'Keeffe in a group exhibition that same year. The last exhibition at 291, Apr. 3–May 14, 1917, was of O'Keeffe's work. Along with Frank and Rosenfeld, Strand and O'Keeffe belonged to a younger generation; all of them were born between 1887 and 1890. Stieglitz was born in 1864 and Anderson in 1876.

45. The association with Europe was so close in the early years that even an exhibition of American painters—John Marin and Alfred Maurer in 1908—consisted of work sent from Paris, where they then both lived. Stieglitz had not yet met either of them. Max Weber's first exhibition at 291, in 1911, was of paintings created in Paris when the artist associated closely with Matisse and the Parisian cubists. For a study of the first circle, see William Innes Homer, *Alfred Stieglitz and the American Avant-Garde* (Boston, 1977). In Steven Watson's *Strange Bedfellows: The First American Avant-Garde* (New York, 1991), the first circle and the beginnings of the second are positioned alongside other avant-garde groups in art and literature active in the first two decades of the century.

46. Many forces seem to have contributed to the closing of 291. With the disruption of war came the difficulty of obtaining works from abroad; funding Stieglitz had once received from his wife was no longer his to spend; the number of visitors at 291 dwindled; and the subscription list of *Camera Work* fell from a onetime high of 647 to 37. Dispirited and not absolutely clear as to his direction, Stieglitz closed down both operations in 1917.

47. Anderson Galleries, *The Forum Exhibition of Modern American Painters* (New York, 1916), 5, reprinted in the Arno Series of Contemporary Art, no. 19 (New York, 1968). At least two reprises of this exhibition have been organized. See American Contemporary Gallery, *Commemorating the Fiftieth Anniversary of the Forum Exhibition of Modern American Painters* (New York, 1966); and Whitney Museum of American Art at Philip Morris, *The Forum Exhibition: Selections and Additions* (New York, 1983).

48. Henry McBride, *New York Sun*, Mar. 14, 1925, 13.

49. It has long been recognized that Stieglitz and the painters he drew into his circle lived and worked within symbolist paradigms. In 1975 Allan Sekula, for one, wrote, "Stieglitz invented himself in Symbolist clichés," in "On the Invention of Photographic Meaning" (1975), reprinted in Victor Burgin, ed., *Thinking Photography* (London, 1982), 84–104. For Abigail Solomon-Godeau, Stieglitz "was as much a product of the nineteenth century as the twentieth," his art "always inflected (and occasionally limited) by what had been his first conception of the modern: *fin-de-siècle* symbolism and Whistlerian aestheticism." "Back to Basics: The Return of Alfred Stieglitz," *Afterimage* 12 (summer 1984): 22. See also Rosalind Krauss, "Alfred Stieglitz's 'Equivalents,'" *Arts Magazine* 54 (Feb. 1980): 134–37; Sarah E. Greenough, "How Stieglitz Came to Photograph Clouds," in *Perspectives on Photography: Essays in Honor of Beaumont Newhall* (Albuquerque, N.M., 1986); and Charles C. Eldredge, "Nature Symbol-

ized: American Painting from Ryder to Hartley," in Los Angeles County Museum of Art, *The Spiritual in Art: Abstract Painting, 1890–1985* (Los Angeles, 1986), 113–29. What needs further probing is why French symbolist structures took such firm root in the United States and maintained such a strong and highly influential presence in New York modernism during the 1920s and on into the century. Here Edmund Wilson's *Axel's Castle: A Study in the Imaginative Literature of 1870–1930* (New York, 1931) serves as an excellent introduction to a parallel phenomenon in American literature.

50. Arthur Symons, *The Symbolist Movement in Literature*, rev. and enl. ed. (New York, 1919), 185–88.

51. Grange Woolley, *Stéphane Mallarmé, 1842–1898* (1942; reprint, New York, 1981), 45–50.

52. The seventh was Charles Demuth, whom Stieglitz was exhibiting for the first time.

53. Anderson Galleries, *Alfred Stieglitz Presents Seven Americans* (New York, 1925), 2.

54. Margaret Breuning, "Seven Americans," *New York Evening Post*, Mar. 14, 1925, sec. 5, p. 11; and Helen Appleton Read, "News and Views on Current Art: Alfred Stieglitz Presents Seven Americans," *Brooklyn Daily Eagle*, Mar. 15, 1925, 2B.

55. Georgia O'Keeffe to Henry McBride, Jan. 16, 1927, in Jack Cowart and Juan Hamilton, with Sarah Greenough, *Georgia O'Keeffe: Art and Letters* (Washington, D.C., 1987), 185.

56. Ibid., O'Keeffe to Waldo Frank [summer 1926], 184.

57. Brooks, *Days of the Phoenix*, 102.

58. Sherwood Anderson, "Seven Alive," in Anderson Galleries, *Seven Americans*, 3.

59. Arnold Rönnebeck, "Through the Eyes of a European Sculptor," ibid., 5–7.

60. Alfred Stieglitz to Sherwood Anderson, Lake George, Aug. 7, 1924, Stieglitz Collection, YCAL.

61. Paul Rosenfeld, "Musical Chronicle," *Dial* 75 (Nov. 1923): 518–20. See also "Musical Chronicle," *Dial* 74 (Mar. 1923): 324–28, about "the elegant little vulgarisms" to be found in Milhaud and the "cleverness" of the Six.

62. Wilson, "Paul Rosenfeld: Three Phases," in Mellquist and Wiese, eds., *Paul Rosenfeld*, 5, 12.

63. In *The Politics of Modernism: Against the New Conformists* (London, 1989), Raymond Williams used this term to refer to writers like T. S. Eliot and W. B. Yeats. I thank Harry Harotunian for suggesting the aptness of Williams's formulation.

64. The definitive exploration of turn-of-the-century antimodernism in America is T. J. Jackson Lears, *No Place of Grace: Antimodernism and the Transformation of American Culture, 1880–1920* (New York, 1981).

65. Williams, *The Politics of Modernism*, 54–55.

66. For earlier commentary on Picabia's portrait of Stieglitz, see William Innes Homer, "Picabia's *Jeune Fille américaine dans l'état de nudité* and Her Friends," *Art Bulletin* 57 (Mar. 1975): 111; and William A. Camfield, *Francis Picabia: His Art, Life, and Times* (Princeton, N.J., 1979), 83–84. In 1915, when Picabia made this portrait, he, Marius de Zayas, Paul Haviland, and others were trying to convince Stieglitz to change his allegiances. They wanted him to sell modern art more aggressively and commercially and to sponsor a publication sympathetic to machine age aesthetics and commentary. For a very brief moment in 1915 Stieglitz gave his blessing to the establishment of the Modern Gallery, run by de Zayas, and to the publication of *291*, a new little magazine edited by de Zayas, Haviland, Picabia, and Agnes Ernst Meyer. Picabia's portrait of Stieglitz appeared on the cover of *291* in July–Aug. 1915. Stieglitz quickly broke with both ventures, so contrary were they to his own beliefs.

67. Peter Minuit [Paul Rosenfeld], "291 Fifth Avenue," 61.

68. Alfred Stieglitz to Sherwood Anderson, July 5, 1924, Stieglitz Collection, YCAL.

69. Marsden Hartley to Alfred Stieglitz, Aug. 2, 1920, Stieglitz Collection, YCAL.

70. John Marin, "Here It Is," *MSS*, no. 2 (Mar. 1922).

71. Alfred Stieglitz to Paul Strand, June 8, 1919, Stieglitz Collection, YCAL.

72. Alfred Stieglitz to Waldo Frank, Oct. 25, 1920, Stieglitz Collection, YCAL.

73. Alfred Stieglitz to Paul Rosenfeld, Nov. 9, 1924, Stieglitz Collection, YCAL.

74. Georgia O'Keeffe to Sherwood Anderson, Lake George, Nov. 11, 1924, in Cowart, Hamilton, and Greenough, *Art and Letters*, 179.

75. Paul Strand to Alfred Stieglitz, Colorado, [no month given] 13, 1926, Stieglitz Collection, YCAL.

76. Frank, *Our America*, 171.

77. These essays are collected in Frank, *In the American Jungle*.

78. Ibid., "The Comedy of Commerce" (1925), 116–19.

79. For the new features in Marin's New York work, see, for example, 25.20, 25.31, 25.61, 28.73, 29.7, and 29.42 in Sheldon Reich, *John Marin: A Stylistic Analysis and Catalogue Raisonné* (Tucson, Ariz., 1970), vol. 2.

80. Alfred Stieglitz to Sherwood Anderson, Aug. 9, 1926, Stieglitz Collection, YCAL. Given that it was August, O'Keeffe was undoubtedly painting from nature when she made this complaint. Stieglitz agreed with her that her paintings were not about today, characteristically adding his own pressure on her to remain a flower painter. "And so may be that's what she best do instead of hitching up with the huge Machine."

81. For an analysis of these paintings, see Anna C. Chave, "*Who Will Paint New York?* 'The World's New Art Center' and the Skyscraper Paintings of Georgia

O'Keeffe," *American Art* (winter/spring 1991): 86–108. O'Keeffe returned to urban structures two more times in her long life. In 1932 she created a design for a mural of skyscrapers and in 1948 a painting of Brooklyn Bridge.

82. Georgia O'Keeffe to Waldo Frank, Jan. 10, 1927, in Cowart, Hamilton, and Greenough, *Art and Letters*, 185.

83. Elizabeth Duvert, "Georgia O'Keeffe's Radiator Building: Icon of Glamorous Gotham," *Places: Quarterly Journal of Environmental Design* 2 (1985): 16.

84. In a letter to Waldo Frank in the summer of 1929, Stieglitz wrote: "I did finally find a release in flying!— And learning to run a car and bought a Victrola," Stieglitz Collection, YCAL. See also Stieglitz to Arthur Dove, in *Dear Stieglitz/Dear Dove*, ed. Ann Lee Morgan (Newark, Del., 1988), 177, where Stieglitz writes, "If I were young enough I'd certainly get a machine [airplane]." This 1929 summer was the first O'Keeffe spent in New Mexico. She had her car driven back to Lake George, where Stieglitz was in residence. Stieglitz photographed O'Keeffe with her cars on several occasions from 1929 into the early 1930s.

85. Mumford, "The Metropolitan Milieu," in Waldo Frank et al., eds., *America and Alfred Stieglitz: A Collective Portrait* (Garden City, N.Y., 1934), 51. For a discussion of Stieglitz's late city photographs, see Joel Smith, "How Stieglitz Came to Photograph Cityscapes," *History of Photography* 20 (winter 1996): 320–31.

86. For the mixture of organic and mechanical vocabularies in early-twentieth-century writers, see Cecelia Tichi, *Shifting Gears: Technology, Literature, Culture in Modernist America* (Chapel Hill, N.C., 1987), especially chapter 1, "Trees, Animals, Engines," 17–40.

87. For studies of these works, see Judith K. Zilczer, "Synaesthesia and Popular Culture: Arthur Dove, George Gershwin, and the 'Rhapsody in Blue,'" *Art Journal* 44 (winter 1984): 36–66; and Donna M. Cassidy, "Arthur Dove's Music Paintings of the Jazz Age," *American Art Journal* 20 (1988): 4–23.

88. Ann Lee Morgan, *Arthur Dove: Life and Work, with a Catalogue Raisonné* (Newark, Del., 1984), 51.

89. Among others, Judith Tick uses the term "transcendent modernism" in "Ruth Crawford's 'Spiritual Concept': The Sound-Ideals of an Early American Modernist, 1924–1930," *Journal of the American Musicological Society* 44 (summer 1941): 221–35; and Necia Gelker, "Transcendental Modernism, 1908–1917: America's Tradition of the New and the Revolt against the Hobgoblin of Little Minds," Ph.D. diss., University of Southern California, 1996.

90. Alfred Stieglitz to Sheldon Cheney, Aug. 24, 1923, Stieglitz Collection, YCAL.

91. Charles Demuth to Alfred Stieglitz, Dec. 12, 1929, Stieglitz Collection, YCAL.

92. Georgia O'Keeffe, quoted in Blanche C. Matthias,

"O'Keeffe and the Intimate Gallery: Stieglitz Showing Seven Americans," *Chicago Evening Post Magazine of the Art World* 2 (Mar. 1926): 1, 14. For scholarly discussions of nationalism and the Stieglitz circle, see Matthew Baigell, "American Landscape Painting and National Identity: The Stieglitz Circle and Emerson," *Art Criticism* 4 (1987): 27–47, and "American Art and National Identity: The 1920s," *Arts Magazine* 61 (Feb. 1987): 48–55; and Timothy Robert Rodgers, "False Memories: Alfred Stieglitz and the Development of the Nationalist Aesthetic," in David Winton Bell Gallery, Brown University, *Over Here! Modernism, The First Exile, 1914–1919* (Providence, R.I., 1989), 59–66.

93. Paul Strand, "John Marin," *Art Review* 1 (Jan. 1922): 23.

94. Rosenfeld, *Port of New York*, 262; and Search-Light [Waldo Frank], *Time Exposures* (New York, 1926), 178.

95. Norman, *Alfred Stieglitz*, 169.

96. Herbert J. Seligmann, *Alfred Stieglitz Talking: Notes on Some of His Conversations, 1925–1931* (New Haven, Conn., 1966). Seligmann recorded this story and others like it between 1925 and 1931 as he listened to Stieglitz in his galleries. Other stories Stieglitz told were recorded and published by Dorothy Norman, most notably as a running series in *Twice a Year* (1938–47), a journal she edited and dedicated to Stieglitz. In 1960 she wove these stories into a biographical narrative and published it as *Alfred Stieglitz: An American Seer*.

97. William Carlos Williams, in an attack on Stieglitz's arrogance, reported this story after Stieglitz had died, in an unpublished manuscript, "What of Alfred Stieglitz?" 1946, Stieglitz Collection, YCAL. He wrote that this was one of Stieglitz's favorite stories, adding, "He wanted to be God and in his little shitty hole of an office building he was God."

98. Rosenfeld, *Port of New York*, 260.

99. Stieglitz frequented the horse races, especially when he was at Lake George and could go to the track at nearby Saratoga. "The horse symbolized to him," Mumford wrote, "something essential in the life of man: that deep animal vitality he had too lightly turned his back on and renounced in his new mechanical preoccupations." Mumford went on to say that Stieglitz envisioned, but never realized, a series of photographs "of the heads of stallions and mares, of bulls and cows, in the act of mating, hoping to catch in the brute an essential quality that would symbolize the probably unattainable photograph of a passionate human mating." Mumford, "Metropolitan Milieu," in Frank et al., eds., *America and Alfred Stieglitz*, 53–54.

100. Thomas Hart Benton, *A Thomas Hart Benton Miscellany: Selections from His Published Opinions, 1916–1960*, ed. Matthew Baigell (Lawrence, Kans., 1971), 74.

101. Harnessing and gelding as images of sexual and

puritanical repression were common in the period. In 1915 Marius de Zayas spoke of American art critics who "believe themselves stallions when they are but geldings." *291*, nos. 5–6 (July–Aug. 1915): n.p. Robert Henri wrote about Americans: "We harness up the horse, we destroy his very race instincts, and when we want a thrill for our soul we watch the flight of the eagle," in *The Art Spirit: Notes, Articles, Fragments of Letters, and Talks to Students, Bearing on the Concept and Technique of Picture Making, the Study of Art Generally, and on Appreciation* (1923; reprint, Philadelphia, 1960), 149. In 1925, when John Dos Passos reported his publishers' objections to his language in *Manhattan Transfer*, he called it "the battle with the gelding shears." Quoted in Townsend Ludington, *John Dos Passos* (New York, 1980), 240. A line from e. e. cummings's "Poem, or Beauty Hurts Mr. Vinal" (1926) speaks of "delicately gelded (or spaded) gentlemen (and ladies)." In *100 Selected Poems by e. e. cummings* (New York, 1926), 19–20. Stieglitz is quoted in Dorothy Norman, *Alfred Stieglitz*, 240 n. 7, as recalling with pleasure workhorses on the streets in Paris "throbbing, pulsating, their penises swaying held erect—swaying—shining. . . . In New York such a thing would not have been permitted, all the horses in the city being geldings."

102. Rosenfeld, *Port of New York*, 292.

103. Sherwood Anderson to Van Wyck Brooks, May 31, 1918, in *The Letters of Sherwood Anderson*, ed. Howard Mumford Jones (New York, 1953), 39.

104. Alfred Stieglitz to Sherwood Anderson, Dec. 10, 1925, Stieglitz Collection, YCAL.

105. Rosenfeld, *Port of New York*, 153; and Frank et al., eds., *America and Alfred Stieglitz*, 303.

106. Paul Strand to Arthur Dove, July 20, 1920, Arthur G. Dove Papers, AAA. The quotation is cited in Sarah E. Greenough, "From the American Earth: Alfred Stieglitz's Photographs of Apples," *Art Journal* 41 (spring 1981): 53 n. 24. For other commentary on this flight to the country, see Potter, "The 'Romantic Nationalists,'" 150–51.

107. Brooks, *Days of the Phoenix*, 2.

108. Sherwood Anderson, *A Story Teller's Story* (New York, 1924), quoted in Potter, *False Dawn*, 112–13, along with a 1921 letter from Paul Rosenfeld to Alfred Stieglitz characterizing Paris as "the beauty of the past."

109. Frances O'Brien, "Americans We Like: Georgia O'Keeffe," *Nation* 12 (Oct. 1927): 361–62.

110. Paul Strand, "Marin Not an Escapist," *New Republic* 55 (July 1928): 254.

111. Alfred Stieglitz to Waldo Frank, July 1, 1921, Stieglitz Collection, YCAL.

112. It is well known that Stieglitz often did not practice what he preached and sullied his hands and reputation by making some rather spectacular commercial transactions. See, for example, Timothy Robert Rodgers, "Alfred Stieglitz, Duncan Phillips, and the '$6,000 Marin,'" *Oxford Art Journal* 15 (1992): 55–56.

113. Wilson, "Paul Rosenfeld: Three Phases," in Mellquist and Wiese, eds., *Paul Rosenfeld*, 6.

114. See Greenough, "From the American Earth," 46–54.

115. Marsden Hartley, *Adventures in the Arts: Informal Chapters on Painters, Vaudeville, and Poets* (New York, 1921); Anderson, *A Story Teller's Story*; and Rosenfeld, *Men Seen* and *By Way of Art*. The first issue of *American Caravan* in 1927, edited by Mumford, Rosenfeld, Brooks, and Arthur Kremborg, was dedicated to Stieglitz.

116. See, for example, Paul Strand, "Alfred Stieglitz and Machine," *MSS* 2 (Mar. 1922): 6–7; "John Marin," *Art Review* 1 (Jan. 1922): 22–23; "Georgia O'Keeffe," *Playboy* (July 1924): 16–20; and Waldo Frank, "Alfred Stieglitz, the World's Greatest Photographer," *McCall's* 54 (May 1927): 24, 107–8; "The American Art of John Marin," *McCall's* 54 (June 1927): 27, 61–62; and "Georgia O'Keeffe," *McCall's* (Sept. 1927): 31, 80. Charles Demuth wrote the forewords to brochures for two exhibitions of work by Georgia O'Keeffe at the Intimate Gallery: *Georgia O'Keeffe Paintings, 1926* and *Georgia O'Keeffe Paintings, 1928*; and Marsden Hartley wrote "Georgia O'Keeffe, a Second Outline in Portraiture," for the exhibition at An American Place, Jan. 7–Feb. 27, 1936.

117. *Letters of John Marin*, ed. Herbert J. Seligmann (New York, 1931), was published by An American Place. By this time Seligmann had also spent six years writing down his and others' conversations with Stieglitz, which appeared as the book *Alfred Stieglitz Talking*. See also Jerome Mellquist, *The Emergence of an American Art* (New York, 1942); Norman, *Alfred Stieglitz*; and Mellquist and Wiese, eds., *Paul Rosenfeld*.

118. Henry McBride, "Georgia O'Keeefe's [*sic*] Work Shown: Fellow Painters of Little Group Become Fairly Lyrical over It," *New York Sun*, Jan. 15, 1927, 22B.

119. Frank, et al., eds., *America and Alfred Stieglitz*, 3–5.

120. *Stieglitz Memorial Portfolio, 1864–1946* (New York, 1947). Compiled by Dorothy Norman and published by Twice a Year Press, this collection included eighteen reproductions of Stieglitz photographs and had a more limited circulation than *America and Alfred Stieglitz*. Thus it is less well known and acknowledged by those who have studied Stieglitz as cultural saint.

121. Thomas Hart Benton made this same connection sixty years ago in "America and/or Alfred Stieglitz," *Common Sense* 4 (Jan. 1935): 25.

122. A good study of the new selling techniques invented in the 1920s and 1930s is Roland Marchand, *Advertising the American Dream: Making Way for Modernity, 1920–1940* (Berkeley and Los Angeles, 1985). Advertisers, like artists, became, in Marchand's words, "apostles" and "millionaires" of modernity (xxi).

123. Thomas Hart Benton to Stieglitz, Jan. 1, 1935, Stieglitz Collection, YCAL.

124. In 1949 O'Keeffe gave the Metropolitan Museum of Art and the Art Institute of Chicago large bequests from the Stieglitz art collection, with smaller groups of works going to the National Gallery of Art and the Philadelphia Museum of Art. To Fisk University, in Nashville, Tennessee, O'Keeffe contributed over a hundred works to a collection of art that Carl Van Vechten began for the African American university. She gave a master set of photographs by Stieglitz to the National Gallery of Art. Other museums across the country received a few works each. In 1951 she gave the extraordinary Stieglitz archives to the Beinecke Library.

CHAPTER ONE: AMÉRICANISME

1. The immense bibliography on Duchamp in general, and on *Fountain* specifically, has recently been catalogued in Pontus Hulten, ed., *Marcel Duchamp: Work and Life* (Cambridge, Mass., 1993). But no one, surprisingly, has focused on Duchamp as a bicontinental modernist whose American readymades inscribe his foreign perspective on New York culture. As I work my way though this argument, I am grateful to the many Duchamp scholars who have helped to shape or confirm my thinking. When I first drafted this chapter in the summer of 1986, I did not know that William Camfield was soon to publish a major study of *Fountain*. Both of us, it turns out, were coming to similar conclusions about the meaning of *Fountain* to Duchamp in 1917. Since Camfield's work is more historiographic and archaeological than my own, it has been especially rich for me, and I want to single out my gratitude for its wealth of sources and argumentation: William A. Camfield, *Marcel Duchamp, Fountain* (Houston, Tex., 1989). Two recent studies also add considerably to what we know about Duchamp and his years in New York: Kirk Varnedoe and Adam Gopnik, *High and Low: Modern Art and Popular Culture* (New York, 1990); and Francis M. Naumann, *New York Dada, 1915–23* (New York, 1994). And I have been able to clarify a few biographical details thanks to Calvin Tomkins, *Duchamp: A Biography* (New York, 1996). See also Francis M. Naumann, with Beth Venn, *Making Mischief: Dada Invades New York* (New York, 1996).

2. Sarah E. Greenough in "Lake George Dada," a lecture given at the San Francisco Museum of Modern Art on Sept. 21, 1996, persuasively argued that Dada may have had some effect on Stieglitz, who exhibited rare humor and irony in an occasional photograph, such as *Spiritual America*, taken between 1918 and 1923.

3. Beatrice Wood, *I Shock Myself: The Autobiography of Beatrice Wood* (Ojai, Calif., 1985), 30. Some scholars think that Stieglitz did not know Duchamp had authored *Fountain* when he photographed it. See Thierry de Duve, "Given the Richard Mutt Case," in *The Definitively Unfinished Marcel Duchamp*, ed. de Duve (Cambridge, Mass., 1991), 203–7, 228 n. 27.

4. Much is made today of whether Duchamp took any role in posing *Fountain* for this photograph, which has all the hallmarks of Stieglitz's mature style. According to the only eyewitness report on *Fountain's* short-lived installation at the exhibition, the object was on its back and "perched high on a wooden pedestal: a beautiful, white enamel oval form gleaming triumphantly on a black stand." Wood, *I Shock Myself*, 29–30. The photograph seems to replicate this description, with a white pedestal substituting for the black.

5. My thanks to Robbie Reid and Merrill Falkenberg for helping me find an appropriate analogy.

6. For an excellent account of the exhibition, see Francis M. Naumann, "The Big Show: The First Exhibition of the Society of Independent Artists, Part I," *Artforum* 17 (Feb. 1979): 34–39; and Part II 17 (Apr. 1979): 49–53. See also Naumann, *New York Dada*, 176–91.

7. "His Art Too Crude for Independents," *New York Herald*, Apr. 14, 1917, 6.

8. Wood, *I Shock Myself*, 29–30.

9. On the last page of the magazine, "In Preparation P•E•T" appeared under an ad for cigarettes, announcing that the next issue of the *Blind Man* was in process. Francis Naumann has decoded this as more wordplay, PET being an acronym for Marcel Duchamp and Henri-Pierre Roché. *New York Dada*, 110. Roché liked to call Duchamp Victor or Totor for short. So PET could be the first letters of "Pierre et Totor." I suggest that it is also a reference to the dog leading the blind man on the cover to revelation and enlightenment. The same play is in the graphics on the title page where the *H* in the title's "the" is bigger; it stands for Henri, who wrote the main editorial. "THE," then, could be read as an anagrammatic reference to Totor et Henri. All quotations in this paragraph are from *The Blind Man*, 1 (Apr. 10, 1917): 3–6.

10. Camfield, *Marcel Duchamp, Fountain*, 34ff. The comments I quote here, familiar in the Duchamp literature, are drawn from the unsigned editorial "The Richard Mutt Case," *Blind Man* 2 (May 1917): 5. While it is not clear exactly who wrote this little piece, which may have been a team effort, I agree with Camfield that it expresses Duchamp's thinking at that moment, as, most probably, did the "Buddha of the Bathroom" essay, pp. 5–6, written by his close friend Louise Norton. Norton or Beatrice Wood may also have had a hand in drafting the editorial.

11. Francis M. Naumann, "Amicalement, Marcel: Fourteen Letters from Marcel to Walter Pach," *Archives of American Art Journal* 29 (1989): 37–41.

12. Leo Stein, quoted in James R. Mellow, *Charmed Circle: Gertrude Stein and Company* (New York, 1974), 295. Though Jules Pascin and Elie Nadelman are not in-

cluded in this chapter, in coming to America and taking up citizenship, they participated in the same cultural migration as Duchamp. Thanks to Elizabeth Turner for alerting me to this reference.

13. For discussion of Duchamp's influential participation in the Société Anonyme, see Ruth L. Bohan, *The Société Anonyme's Brooklyn Exhibition: Katherine Dreier and Modernism in America* (Ann Arbor, Mich., 1982); and Robert L. Herbert, Eleanor S. Apter, and Elise K. Kenney, eds., *The Société Anonyme and the Dreier Bequest at Yale University: A Catalogue Raisonné* (New Haven, Conn., 1984).

14. Although others have maintained that the photographs of American silos that Le Corbusier published in *L'Esprit Nouveau* and *Vers une architecture* came from Walter Gropius, Ozenfant insisted that it was Roché who obtained them. Amédée Ozenfant, *Mémoires, 1886–1962* (Paris, 1968), 113 n.

15. Guillaume Apollinaire, "The New Spirit and the Poets" (1917), in *Selected Writings of Guillaume Apollinaire*, intro. and trans. Roger Shattuck (New York, 1950), 236.

16. Albert Gleizes, "The Impersonality of American Art," *Playboy* 4–5 (1919): 25. In this instance, Gleizes tried to make a virtue out of the Americans' lack of originality by arguing that it made for an impersonality of style rather than the obsessive search for individualism he found in Europe.

17. [Henry McBride], "The Nude-Descending-a-Staircase Man Surveys Us," *New York Tribune*, Sept. 12, 1915, sec. 4, p. 2.

18. "Picabia, Art Rebel, Here to Teach New Movement," *New York Times*, Feb. 16, 1913, sec. 5, p. 9.

19. On Dec. 19, 1914, Metzinger wrote to Gleizes, who was at the front, that "the artistic center of tomorrow will perhaps be New York." Gleizes Archives, Centre Georges Pompidou, Paris.

20. That Stieglitz was always more cordial to Duchamp and Picabia than to many of his American colleagues bespeaks the admiration, sometimes bordering on awe, that the American avant-garde had for their French counterparts.

21. Sarah Addington, "New York Is More Alive and Stimulating Than France Ever Was, Say Two French Painters," *New York Tribune*, Oct. 9, 1915, 7.

22. *New York Tribune*, Oct. 24, 1915.

23. Reported by Elizabeth Eyre, in her "Letters of Elizabeth," *Town and Country* 80 (Feb. 15, 1924): 30.

24. Francis Picabia, "'How New York Looks to Me,'" *New York American*, Mar. 30, 1913, magazine section, p. 11.

25. [McBride], "Nude-Descending-a-Staircase Man," 2.

26. "Marcel Duchamp Visits New York," *Vanity Fair* 5

(Sept. 1915): 57; and [McBride], "Nude-Descending-a-Staircase Man," 2.

27. Daniel Robbins, "The Formation and Maturity of Albert Gleizes: A Biographical and Critical Study, 1881 through 1920," Ph.D. diss., Institute of Fine Arts, New York University, 1975, 201. Albert and Juliette Roche Gleizes, both journal keepers and essay writers, left considerable testimony about their impressions of the New World. See the Papers of Albert Gleizes and Juliette Roche, Centre Georges Pompidou, Paris. Juliette's short story about America and their art friends there—"La Minéralisation de Dudley Craving MacAdam"—was published in *La Vie des Lettres et des Arts* 8 (1922): 22–271, and reprinted as a booklet by Croutzet and Depost (Paris, 1924). See also Juliette Roche, *Demi cercle* (Paris, 1920), an anthology of poems and essays she wrote during her stay in New York. The Gleizeses' memoirs are just one part of a very rich literature of reminiscences by members of the French community in New York during the second decade of the twentieth century. See also Gabrielle Buffet-Picabia, "Arthur Craven and American Dada," and "Some Memories of Pre-Dada: Picabia and Duchamp," in *The Dada Painters and Poets: An Anthology*, ed. Robert Motherwell (New York, 1951), 14–17, 253–67; and Henri-Pierre Roché's posthumously published novel *Victor: Marcel Duchamp* (Paris, 1977).

28. Goethe, trans. Peter H. von Blanckenhagen, quoted in Samuel Bing, *Artistic America, Tiffany Glass, and Art Nouveau*, intro. Robert Koch, trans. Benita Eisler (Paris, 1896; reprint, Cambridge, Mass., 1970), 186.

29. Bing, *Artistic America*, 13. For a contemporary evaluation of this treatise by Bing, see Gabriel P. Weisberg, "S. Bing and *La Culture artistique en Amérique*: A Public Report Reexamined," *Arts Magazine* 61 (Mar. 1987): 59–63.

30. Albert Gleizes, quoted in "French Artists Spur on an American Art," *New York Tribune*, Oct. 24, 1915, sec. 4, p. 2.

31. Picabia, "'How New York Looks to Me,'" 11.

32. [McBride], "Nude-Descending-a-Staircase Man," 2.

33. Paul Bourget, *Outre-mer (notes sur l'Amérique)*, 2 vols. (Paris, 1895); Paul Auguste Marie Adam, *Vues d'Amérique (ou La Nouvelle Jouvence)* (Paris, 1906); Raymond Gros and François Bournand, *Au pays du dollar: Notes, indiscrétions, souvenirs* (Paris, 1908); François Bournand, *Au pays de l'énergie: Impressions de voyages, notes et souvenirs* (Isle, 1910); Jules Huret, *L'Amérique moderne* (Paris, 1911); and Pierre Daye, *Sam (ou Le Voyage dans l'optimiste Amérique)* (Paris, 1922). For a good index to French travel literature about the United States, see Frank Monaghan, *French Travellers in the United States, 1765–1932: A Bibliography* (New York, 1933). Also very helpful in this chapter and the next was David Strauss, *Menace in the West: The Rise of French*

Anti-Americanism in Modern Times (Westport, Conn., 1978).

34. The literature on this subject is immense, but I have benefited in particular from two general anthologies of the subject: Marc Pachter, ed., *Abroad in America: Visitors to the New Nation, 1776–1914* (Reading, Mass., 1976); and Bayrd Still, *Mirror for Gotham: New York as Seen by Contemporaries from Dutch Days to the Present* (New York, 1956).

35. Pierre Cabanne, *Dialogues with Marcel Duchamp*, trans. Ron Padgett (New York, 1971), 57.

36. Henry Woodd Nevinson, *Farewell to America* (New York, 1922), as quoted in George Knoles, *The Jazz Age Revisited: British Criticism of American Civilization during the Twenties* (Stanford, Calif., 1955), 135.

37. Georges Duhamel, *America the Menace: Scenes from the Life of the Future*, trans. Charles Miner Thompson (New York, 1931), 177.

38. Tomkins, *Duchamp*, 161–65,

39. Huret, *L'Amérique moderne*, 115–19.

40. The most common way to describe spectacles in America was to find a Parisian equivalent and then tell the reader to imagine it "une mille fois." Broadway, for example, was "la Place Clichy, une mille fois." It was the French version of the Texas syndrome applied to American spectacles.

41. Huret, *L'Amérique moderne*, 27.

42. Both of these stereotypes begin in the early nineteenth century. See Theodore Zeldin's chapter "Attitudes to Foreigners" in *France, 1848–1945* (Oxford, 1977), 2:126–38.

43. Huret, *L'Amérique moderne*, especially 175–201.

44. Ibid., 86–96.

45. The Whitman mania found its greatest French celebrant in Léon Bazalgette, whose biography of Whitman and full translation of *Leaves of Grass* both summarized the earlier generation's interests and spawned the next one's; see his *Walt Whitman: L'Homme et son oeuvre* (Paris, 1908), and *Feuilles d'herbe*, 2 vols. (Paris, 1909). The definitive study of *Whitmanisme*, both in symbolist and modernist literature, is Betsy Erkkila, *Walt Whitman among the French: Poet and Myth* (Princeton, N.J., 1980). See also Gay Wilson Allen, ed., *Walt Whitman Abroad: Critical Essays from Germany, France, Scandinavia, Russia, Italy, Spain and Latin America, Israel, Japan, and India* (Syracuse, N.Y., 1955).

46. Joris Karl Huysmans, *Against Nature*, trans. Robert Baldick (Baltimore, 1959), 110–14.

47. For an English translation, see Alfred Jarry, *The Supermale*, trans. Barbara Wright (New York, 1977). Nancy Ring has also looked at French literature about the American woman in "New York Dada and the Crisis of Masculinity: Man Ray, Francis Picabia, and Marcel Duchamp in the United States, 1913–1921," Ph.D. diss., Northwestern University, 1991, 185–89.

48. Alfred Jarry, "Barnum," *La Revue Blanche*, Jan. 1, 1902.

49. See, for instance, Guillaume Apollinaire, "A propos de Walt Whitman," *Mercure de France* 106 (Dec. 1913): 864; Harrison Reeves, "Les Epopées populaires américaines," *Les Soirées de Paris* 22 (Mar. 1914): 165–71; Maurice Raynal, "Le Boxeur et son ombre," *Les Soirées de Paris* 26–27 (July–Aug. 1914): 434–45; and Alan Seeger, "Le Baseball aux Etats-Unis," *Les Soirées de Paris* 26–27 (July–Aug. 1914): 447–51.

50. Guillaume Apollinaire, "Funérailles de Walt Whitman racontées par un témoin," *Mercure de France* 102 (Apr. 1913): 658–59. For one account of the uproar, see Erkkila, *Walt Whitman*, 199–200.

51. Fabian Lloyd [Arthur Craven], "To Be or Not to Be . . . American," *L'Echo des Sports* (June 10, 1909); trans. Terry Hale and reprinted in *Four Dada Suicides: Selected Texts of Arthur Craven, Jacques Rigaut, Julien Torma, and Jacques Vaché* (London, 1995), 33–36. Thanks to Steve Watson for giving me a copy of this essay.

52. Arthur Craven, "Sifflet," *Maintenant* 1 (Apr. 12, 1912), reprinted in *Soil* 1 (Dec. 1916): 36.

53. *La Vie Parisienne* (May 3, 1913): 309, as quoted in William A. Camfield, *Francis Picabia: His Art, Life, and Times* (Princeton, N.J., 1979), 57.

54. The term "modernolatry" was used by Pär Bergman, who studied the shared literary and artistic aims of the Italian futurists and the French Puteaux circle in *"Modernolatrià" et "simultaneità": Recherches sur deux tendances dans l'avant-garde littéraire en Italie et en France à la veille de la première guerre mondiale* (Uppsala, 1962). See also Marjorie Perloff, *The Futurist Moment: Avant-Garde, Avant-Guerre, and the Language of Rupture*, 3 vols. (Chicago, 1986).

55. Fernand Léger, "Contemporary Achievements in Painting," *Les Soirées de Paris* (1914), reprinted in *Functions of Painting*, ed. Edward F. Fry, trans. Alexandra Anderson (New York, 1973), 12.

56. Ibid., 17.

57. Apollinaire's statements come from "The Renaissance in the Decorative Arts," 1912, reprinted in *Apollinaire on Art: Essays and Reviews, 1902–1918*, ed. LeRoy C. Breunig, trans. Susan Suleiman (London, 1972), 241.

58. Marcel Duchamp, translated and quoted in Kynaston McShine, "La Vie en rrose," in *Marcel Duchamp*, ed. Anne d'Harnoncourt and Kynaston McShine (New York, 1973), 128. Léger recounted the same episode in an interview with Dora Vallier, "La Vie dans l'oeuvre de Fernand Léger," *Cahiers d'Art* 29 (1954): 140.

59. Charles Baudelaire, "The Salon of 1846," in *Art in Paris, 1845–1862: Salons and Other Exhibitions Reviewed by Charles Baudelaire*, trans. and ed. Jonathan Mayne (London, 1965), 117. For one essay articulating the new beauty as it was understood in 1913 by some members of the Puteaux group, see Henri-Martin

Barzun, "La Génération des temps dramatiques et la 'beauté nouvelle,'" *Poème et Drame* 2 (Jan. 1913): 41, cited in Christopher Green, *Léger and the Avant-Garde* (New Haven, Conn., 1976), 322 n. 5.

60. "A Post-Cubist's Impressions of New York," *New York Tribune*, Mar. 9, 1913, sec. 2, p. 1.

61. Picabia, "'How New York Looks to Me,'" 11.

62. Initially enthusiastic, as evidenced both in his writings and his art, Gleizes became disillusioned with New York; sought solace in the works of the American Indian and in Catholicism; and eventually, after returning to France, retreated from urban life in 1927 and formed Moly-Sabata, a utopian artists' colony in Sablons. His collective advocated a return to agriculture and the spiritual values of using one's hands to work and live close to the soil. See Daniel Robbins, *Albert Gleizes, 1881–1953: A Retrospective Exhibition* (New York, 1964), 23–24.

63. For a decoding of these portraits, see Camfield, *Francis Picabia*, 71–109; William Innes Homer, "Picabia's *Jeune Fille américaine dans l'état de nudité* and Her Friends, *Art Bulletin* 57 (Mar. 1975): 57, 110–115; Varnedoe and Gopnik, *High and Low*, 268–70; and Naumann, *New York Dada*, 56–75. Nancy Ring, in "New York Dada and the Crisis of Masculinity," 187–93, looks carefully at gender issues in Picabia's portraits. For the very first of these portraits, a watercolor entitled *Mechanical Expression Seen through Our Own Mechanical Expression*, done in New York in 1913, see Willard Bohn, "Picabia's 'Mechanical Expression' and the Demise of the Object," *Art Bulletin* 67 (Dec. 1985): 673–77.

64. "French Artists Spur on an American Art," *New York Tribune*, Oct. 24, 1915, sec. 4, p. 2.

65. For a suggestive article about some of the origins of this mechanical style, see Molly Nesbit, "Ready-Made Originals: The Duchamp Model," *October* 37 (summer 1986): 53–64.

66. "Apropos of Myself," unpublished notes for a lecture at the City Art Museum of Saint Louis, Missouri, Nov. 24, 1964, quoted in *Marcel Duchamp*, ed. d'Harnoncourt and McShine, 272.

67. Duchamp's first New York exhibitions after his arrival were in April 1916. He showed "two readymades" at a group exhibition at the Bourgeois Galleries, one of them *Traveler's Folding Item*. At the Montross Gallery, where he showed with Jean Crotti, Albert Gleizes, and Jean Metzinger, he exhibited *Pharmacie*. Crotti exhibited an "object made out of electric lights of different colors which go on and off, called *The Mechanical Forces of Love in Motion*." These three objects were reported on—totally without sympathy or understanding—by Juliette Gleizes in her unpublished memoirs, L4675, Centre Georges Pompidou, Paris. See also Naumann, *New York Dada*, 100–104.

68. Michel Butor, "Reproduction interdite," *Critique* 334 (Mar. 1975): 270–72.

69. Tomkins, *Duchamp*, 156–57, citing an unpublished interview with Duchamp by Harriet and Sidney Janis, 1953.

70. For references to the race, but few specifics, see *George Grosz: An Autobiography*, rev. ed., trans. Nora Hodges (New York, 1983), 140; and Walter Mehring, *Berlin Dada: Eine Chronik mit Photos und Dokumenten* (Zurich, 1959), 50–52. Blaise Cendrars's "Profond aujourd'hui" was first published in 1917, then translated into English by Harold Loeb and published as "Profound Today," *Broom* 1 (Jan. 1922): 265–67. It is reprinted in *Selected Writings of Blaise Cendrars*, ed. Walter Albert (New York, 1966), 228–31.

71. Molly Nesbit and Naomi Sawelson-Gorse, "Concept of Nothing: New Notes by Marcel Duchamp and Walter Arensberg," in *The Duchamp Effect*, ed. Martha Buskirk and Mignon Nixon (Cambridge, Mass., 1996), 141–42.

72. Letter from Duchamp to Jean Crotti, July 8, 1918, quoted in Tomkins, *Duchamp*, 204.

73. He first used the word in a letter to his sister, Suzanne Duchamp, ca. Jan. 15, 1916, AAA, quoted in Francis M. Naumann, "*Affectueusement, Marcel*: Ten Letters from Marcel Duchamp to Suzanne Duchamp and Jean Crotti," *Archives of American Art Journal* 22 (spring 1983): 2–19.

74. The word "ready-made" was not a twentieth-century invention but can be traced back, when used as an adjective, to the eighteenth century. See Varnedoe and Gopnik, *High and Low*, 423 n. 83. See also Neil McKendrick, John Brewer, and J. H. Plumb, *The Birth of a Consumer Society: The Commercialization of Eighteenth-Century England* (Bloomington, Ind., 1982), 83.

75. Robert Rosenblum, "Cubism as Pop Art," in *Modern Art and Popular Culture: Readings in High and Low*, ed. Kirk Varnedoe and Adam Gopnik (New York, 1990), 127.

76. By looking at a 1917 telephone book, Francis Naumann determined that Duchamp probably bought the urinal from the J. L. Mott Iron Works Company at 118 Fifth Avenue; see Naumann, "The Big Show," 39 n. 16. Kirk Varnedoe has speculated that while Mott was the prestigious name in plumbing, the kind of urinal Duchamp purchased may have come from another supplier; see Varnedoe and Gopnik, *High and Low*, 274–77. But Molly Nesbit and Naomi Sawelson-Gorse, "Concept of Nothing," 173 n. 102, argue for the Stevens Ventilating Urinal, an older model from Mott, that sold for $39 in the 1890s.

77. Otto Hahn, "Passport No. G255300," *Art and Artists* 1 (July 1966): 10.

78. Ibid.

79. Quoted in Naumann, "The Big Show," 39 n. 16.

80. Louis Lozowick, *Survivor from a Dead Age: The Memoirs of Louis Lozowick*, ed. Virginia Hagelstein

Marquardt (Washington, D.C., 1997), 176. I am grateful to Barbara Zabel for leading me to these passages.

81. Hahn, "Passport No. G255300," 10.

82. Kirk Varnedoe makes the best case for the intersection of Duchamp's readymades and commercial modes of presentation: "Duchamp is the crucial figure through whom modern art's progress becomes entwined not just with commercial modes of representation, but with advertising's attempts to affect people's immediate relation to the objects themselves, by strategies of display or changes in context and scale." See Varnedoe and Gopnik, *High and Low*, 270.

83. Marcel Duchamp, "Apropos of 'Readymades,'" a talk given at the Museum of Modern Art, New York, Oct. 19, 1961, published in *Salt Seller: The Writings of Marcel Duchamp* [*Marchand du sel*], ed. Michel Sanouillet and Elmer Peterson (New York, 1973), 141–42.

84. See Ellen Lupton, *Mechanical Brides: Women and Machines from Home to Office* (New York, 1993), 43.

85. Arturo Schwarz, *The Complete Works of Marcel Duchamp* (New York, 1969), 463. The rod may have been Schwarz's idea, but whether the cover was displayed on a rod or resting on a flat surface, its erotic nature remained intact.

86. Michael R. Taylor, "Rrose Sélavy, Prostituée de la rue aux Lèvres: Levant le voile sur l'alter ego érotique de Marcel Duchamp," in *Fémininmasculin: Le Sex de l'art* (Paris, 1995), 284 n. 5.

87. Nixola Greeley-Smith, "More Art in Rubbers, Avers Cubist, 'Than a Pretty Girl': Depicts Love Idea on Glass," *Washington Post*, Apr. 9, 1916, sec. 2, p. 7. The French exiles' interest in American women was more than academic. Roché carried on, simultaneously, affairs with as many as three American women, recording the intimate details meticulously in his diaries. "He was one of the greatest diarists and most active lovers in recorded history." See Carlton Lake and Linda Ashton, *Henri Roché: An Introduction* (Austin, Tex., 1991), 9–10, 216–19. Duchamp, though not a keeper of a diary, also had numerous affairs with women in New York.

88. Norton, "Buddha of the Bathroom," 5–6; and Wood, *I Shock Myself*, 30.

89. Gertrude Stein, *The Letters of Gertrude Stein and Carl Van Vechten, 1913–1946*, ed. Edward Burns (New York, 1986), 58–59; quoted in Camfield, *Marcel Duchamp, Fountain*, 35. The Apollinaire quotation is in Katia Samaltanos, *Apollinaire: Catalyst for Primitivism, Picabia, and Duchamp* (Ann Arbor, Mich., 1984), 101.

90. Norton, "Buddha of the Bathroom," 5.

91. Walter Arensberg, quoted in Wood, *I Shock Myself*, 29.

92. W. H. de B. Nelson, "Aesthetic Hysteria," *International Studio* 61 (June 1917): 125.

93. For other comparisons of Brancusi and Duchamp, see Camfield, *Marcel Duchamp, Fountain*, 55–56; and Varnedoe and Gopnik, *High and Low*, 277.

94. Jeffrey Weiss, *The Popular Culture of Modern Art: Picasso, Duchamp, and Avant-Gardism* (New Haven, Conn., 1994), 133–36.

95. Naumann, *New York Dada*, 43.

96. This was a full-page ad that ran in *The Arts* 1 (Feb.–Mar. 1921): 64.

97. See Katherine Jánszky Michaelson and Nehama Guralnik, *Alexander Archipenko: A Centennial Tribute* (Washington, D.C., 1986), 47–57.

98. Pontus Hulten, "'The Blind Lottery of Reputation' or the Duchamp Effect," *Marcel Duchamp*, 16.

99. Duchamp, quoted in Schwarz, *Marcel Duchamp*, 462, gives this readymade a 1916 date. Duchamp signed what he recalled as "a huge old fashioned painting behind us—a battle scene I think," Café des Artistes, 1 West Sixty-seventh Street.

100. See Moira Roth, "Marcel Duchamp in America: A Self Ready-Made," *Arts Magazine* 59 (May 1977): 92–96, for the artist as dandy.

101. In 1915 John Cotton Dana, the imaginative founder and director of the Newark Museum, organized an exhibition of New Jersey clay products that traced ceramics from the seventeenth century to modern times. In it he included modern bathroom fixtures, quoting someone who said that "so far, the great contribution of American art is the American bathroom." The art world, it was reported, was willing to see sanitary fixtures as contributions to health, but certainly not as art. See Holger Cahill, *A Museum in Action* (Newark, N.J., 1944), 25–26. My thanks to Francis Naumann and Alan Moore for this reference.

102. "Marcel Duchamp, Iconoclast: A Complete Reversal of Art Opinions," *Arts and Decoration* 5 (Sept. 1915): 428.

103. Duchamp's note, dated Jan. 1916, can be found in Duchamp, *Salt Seller*, ed. Sanouillet and Peterson, 75; Craig Adcock, "Marcel Duchamp's Approach to New York: 'Find an Inscription for the Woolworth Building as a Ready-Made,'" *Dada/Surrealism* 14 (1985), makes the point that the Woolworth Building, begun in 1913, was not completed until 1918. The Stieglitz quotation is from his "I Photograph the Flatiron—1902," *Twice a Year* 14–15 (fall–winter 1946): 189.

104. Anita Brenner, *Idols behind Altars* (New York, 1929), 282; and D. H. Lawrence, *Studies in Classic American Literature* (1923; reprint, New York, 1964), vii–viii.

105. Diary of Arthur Dove, Dec. 4, 1924, quoted in Ann Lee Morgan, *Arthur Dove: Life and Work, with a Catalogue Raisonné* (Newark, Del., 1984), 51.

106. Frank Crowninshield, "From a Friend," *Blind Man* 2 (May 1917): 10.

107. William C. Agee, "Morton Livingston Schamberg: Notes on the Sources of the Machine Images," *Dada/Surrealism* 14 (1985), establishes that Schamberg completed his first machine painting in early 1915, before he met either Duchamp or Picabia.

108. Robert J. Coady, "American Art," *Soil* 1 (Jan. 1917): 55.

109. For biographical details about Coady, see Judith K. Zilczer, "Robert J. Coady, Forgotten Spokesman for Avant-Garde Culture in America," *American Art Review* 2 (Sept.–Oct. 1975): 77–89, and "Robert J. Coady, Man of *The Soil*," *Dada/Surrealism* 14 (1985): 31–43. For characterizations of him by his contemporaries, see Robert Alden Sanborn, "A Champion in the Wilderness," *Broom* 3 (Oct. 1922): 174–79; and Gorham B. Munson, "The Skyscraper Primitives," *Guardian* 1 (Mar. 1925): 164–78.

110. Alfred Kreymborg, *Troubadour: An Autobiography* (New York, 1925), 210; and Matthew Josephson, quoted in Edward Lloyd Paynter, "The Modern Sphinx: American Intellectuals and the Machine, 1910–1940," Ph.D. diss., University of California at Berkeley, 1971, 429 n. 33.

111. Naumann, "*Affectueusement, Marcel,*" 14; and Henri-Pierre Roché, "The Blind Man," *Blind Man* 1 (Apr. 1917): 6.

112. Letter from Robert Coady to Jean Crotti, *Soil* 1 (Dec. 1916): 32.

113. Robert J. Coady, "American Art," *Soil* 1 (Dec. 1916): 3–4.

114. Robert J. Coady, "The Indeps," *Soil* 1 (July 1917): 205.

115. Mireille Havet, quoted in Pierre Cobret de Lanux, *Young France and New America* (New York, 1917), 122–23.

116. Ibid., 41.

117. Ibid., 146. A measure of this outreach was the new willingness of French ambassadors to the United States to learn, and speak in, English. Jules Cambon, who was the French ambassador from 1897 to 1902, could not speak English, but his long-term successor in Washington, D.C., J. J. Jusserand (1902–20), not only spoke, but also wrote his memoirs in, English. Jusserand was particularly proud of the way he had brought the two countries closer together. Zeldin, *France, 1848–1945,* 2:132.

118. *The Daybooks of Edward Weston,* ed. Nancy Newhall (Millerton, N.Y., 1973), 1:132–34. Marsden Hartley, "The Beautiful Neglected Arts," *Little Review* 6 (Apr. 1920): 59. See also Amy Conger, "Edward Weston's Toilet," *New Mexico Studies in the Fine Arts* 9 (1984): 36–42. Weston delighted in showing his photographs of toilets, made in Mexico, to Diego Rivera, another bathroom enthusiast.

1. For detailed accounts of American artists in postwar Paris, see Elizabeth Hutton Turner, *American Artists in Paris, 1919–1929* (Ann Arbor, Mich., 1988), and Elizabeth Hutton Turner with Elizabeth Garrity Ellis and Guy Davenport, *Americans in Paris, 1921–1931: Man Ray, Gerald Murphy, Stuart Davis, Alexander Calder* (Washington, D.C., 1996).

2. Murphy made this comment to Calvin Tomkins in 1962; it is quoted in William Rubin, *The Paintings of Gerald Murphy* (New York, 1974), 9; for Stuart Davis's comment, see his "Autobiography," in *Stuart Davis* (New York, 1945), reprinted in Diane Kelder, ed., *Stuart Davis* (New York, 1971), 27.

3. Ann Douglas, *Terrible Honesty: Mongrel Manhattan in the 1920s* (New York, 1995), 108, provides these estimates.

4. Calvin Tomkins, *Living Well Is the Best Revenge* (New York, 1971). Other sources for Murphy's biography are Rubin, *Paintings of Gerald Murphy*; Honoria Murphy Donnelly and Richard N. Billings, *Sara and Gerald: Villa America and After* (New York, 1982); and *Letters from the Lost Generation: Gerald and Sara Murphy and Friends,* ed. Linda Patterson Miller (New Brunswick, N.J., 1991). Miller gives a rare glimpse into Murphy's more troubled side, his need to be liked, and his obsessive perfectionism. Amanda Vaill, *Everybody Was So Young: Gerald and Sara Murphy, a Lost Generation Love Story* (Boston, 1998), furthers the exploration of the Murphys' life together.

5. John Dos Passos, *The Best Times: An Informal Memoir* (London, 1966), 146–47.

6. Tomkins, *Living Well,* 29.

7. Vaill, *Everybody Was So Young,* 199, 206, 243.

8. Reported in Rubin, *Paintings of Gerald Murphy,* 17.

9. Rick Stewart, *An American Painter in Paris: Gerald Murphy* (Dallas, Tex., 1986), reproduces all eight works in color.

10. Murphy reported Picasso's remark in an undated letter to Philip Barry. Mrs. Ellen Barry kindly shared it with me.

11. Tomkins, *Living Well,* 30.

12. Dos Passos, *The Best Times,* 146.

13. This portrait was reproduced in *Bulletin de la Vie Artistique* 22 (Nov. 15, 1924): 498. Its location today is unknown. My thanks to Christian Derouet, who sent me his essay "*Vue de New York* par Jacques Mauny," *Revue du Louvre* 4 (1987): 298, in which he reproduces it.

14. Jacques Mauny, "New York 1926," *L'Art Vivant* 2 (Jan. 15, 1926): 58. It is noteworthy that Murphy had no significant contact with American painters, and certainly not with Sheeler and Dickinson. From his perspective in France, "There seemed to be no U.S. painters working in

the modern manner." See Gerald Murphy's notes written for Douglas MacAgy, MacAgy Papers, AAA. He did not even mention Patrick Henry Bruce, a very gifted American painter in Paris at the time. Although he did know Man Ray, I suspect he did not know other American artists.

15. No one said anything, that is, until the experts "rediscovered" him. Only in 1956, when Rudi Blesh wrote admiringly of Murphy's art, and in 1960, when Douglas MacAgy included two Murphy paintings in an exhibition, did Murphy surface in his home country and among his friends as a significant painter. In 1974 his work was shown in a one-person exhibition at the Museum of Modern Art in New York, and in 1986 there was another retrospective—if one can call it that for eight paintings—at the Dallas Museum of Art. Today, historians routinely locate his work in the context of the so-called American Precisionists—Sheeler, Dickinson, Demuth, Niles Spencer—and the historians of French art in the 1920s all but ignore him.

16. Ernest Hemingway, *A Moveable Feast* (1964; reprint, New York, 1965), 205–9.

17. Archibald MacLeish, "There Was Something about the Twenties," *Saturday Review* (Dec. 31, 1966): 10–13. By the 1980s, having written a foreword for the Museum of Modern Art exhibition, MacLeish had come around to seeing that Murphy had significant talent as a painter. "Murphy turns out now to have been probably the most interesting of American painters in Paris. Picasso thought he was. Those ten paintings are pretty good proof of it!" *Archibald MacLeish: Reflections*, ed. Bernard A. Drabeck and Helen E. Ellis (Amherst, Mass., 1986), 42.

18. Dos Passos, *The Best Times*, 146, 153.

19. The painting *Villa America* came to light only in the mid-1980s. For the story of its discovery and an analysis of it, see William M. Donnelly, "On Finding a Gerald Murphy," *Arts Magazine* 59 (May 1985): 78–80; and William C. Agee, "Gerald Murphy, Painter: Recent Discoveries, New Observations," *Arts Magazine* 59 (May 1985): 81–89.

20. Vaill, *Everybody Was So Young*, 163.

21. Donnelly, *Sara and Gerald*, 12.

22. Man Ray to Ferdinand Howald, Aug. 18, 1921, Howald Collection, Ohio State University Libraries, Columbus, Ohio. For Man Ray as a *transatlantique*, see Elizabeth Hutton Turner, "Transatlantic," in *Perpetual Motif: The Art of Man Ray*, ed. Merry Foresta et al. (Washington, D.C., 1988), 136–73.

23. The popularity of modern ballets with American themes needs further study. Besides *Parade*, these include Diaghilev's 1924 commissioning of John Carpenter, an American composer who had done a ballet score based on Krazy Kat, to do one called *Skyscrapers*, based on New York's fabled energy. (See Howard Pollack, *Skyscraper*

Lullaby: The Life and Music of John Alden Carpenter [Washington, D.C., 1995], 210–48.) That same year the Ballets Suédois paid Edmund Wilson to go to California to convince Charlie Chaplin to perform in a ballet Wilson had written. Wilson bragged that his ballet was "the most titanic thing of the kind . . . and will make the productions of Milhaud and Cocteau sound like folk-song recitals. It is written for Chaplin, a Negro comedian, and seventeen other characters, full orchestra, movie machine, typewriters, radio, phonograph, riveter, electromagnet, alarm clocks, telephone bells and jazz band." Edmund Wilson, *The Twenties: From Notebooks and Diaries of the Period*, ed. Leon Edel (New York, 1975), 153–54. In 1928 Diego Rivera did the designs for a ballet called *H.P.*, short for "horse power," about a boy and girl from Tijuana, an American Girl, and downtown New York, among other things. It was first performed in 1932 at the Philadelphia Academy of Music. Diego Rivera, *My Art, My Life: An Autobiography* (New York, 1960), 159. For commentary that begins to study this work, see the essays by Robert M. Murdock and especially Gail Levin in *Paris Modern: The Swedish Ballet, 1920–1925*, ed. Nancy Van Norman Baer (San Francisco, 1995), 108–27.

24. For some of Cocteau's early writings on American popular culture, see his *Le Coq et l'arlequin: Notes autour de la musique* (Paris, 1918). Gerald Murphy told of Picasso's showing him his big box filled with thousands of pictures and clippings of Abe Lincoln that the Spaniard said he had been collecting "since I was a child." Tomkins, *Living Well*, 38. Gertrude Stein reports that Picasso asked her once whether she thought he looked like President Lincoln. The two of them liked to look together at photographs of the American Civil War. Stein regularly saved the comic pages of American newspapers for Picasso, causing trouble when Picasso and Fernande Olivier separated and Stein did not have a second set to give to Fernande. Gertrude Stein, *The Autobiography of Alice B. Toklas* (New York, 1933), 18–19, 28–31. For a summary of Picasso's other American passions, see Robert Rosenblum, "Cubism as Pop Art," in *Modern Art and Popular Culture: Readings in High and Low*, ed. Kirk Varnedoe and Adam Gopnik (New York, 1990), 127.

25. See Richard H. Axsom, *"Parade": Cubism as Theater* (New York, 1979), 42; and particularly Deborah Menaker Rothschild, *Picasso's "Parade": From Street to Stage* (New York, 1991), 79–83, 95. Rothschild itemizes the specific movies and movie star types that Cocteau and Picasso were drawing on for her costume as well as her actions.

26. Cocteau's stage directions are quoted in Axsom, *"Parade,"* 46.

27. Rothschild, *Picasso's "Parade,"* 165, 171. The cakewalk, an African American folk dance that mimicked the strutting gait of white plantation society, came to Europe

in the early 1900s as a minstrel act. Enthusiasm for the cakewalk, as well as ragtime music, anticipated the European embrace of jazz as America's indigenous musical form.

28. Axsom, *"Parade,"* 44.

29. Rothschild, *Picasso's "Parade,"* 88–89.

30. Arthur Michel, "Swedish Ballet Celebrated Folk Form," *Dance Magazine* 17 (Apr. 1943): 38, quoted in Rubin, *Paintings of Gerald Murphy,* 25, 28.

31. Jeffrey S. Weiss, "Picasso, Collage, and the Music Hall," in *Modern Art and Popular Culture,* ed. Varnedoe and Gopnik, 82–115, discusses and illustrates newspaper headlines and pagination used as decor and costumes in French revues.

32. Murphy is quoted in "American Ballet Will Give Paris All the Latest Broadway Whims," *New York Herald* (Paris), Oct. 25, 1923, p. 6.

33. Quoted in Rubin, *Paintings of Gerald Murphy,* 29, from the *New York Herald* (Paris), Oct. 25, 1923, 6.

34. Rubin, *Paintings of Gerald Murphy,* 22; and Turner, *American Artists in Paris, 1919–1929,* 61.

35. The ballet was performed sixty-nine times, not only in Paris but also in New York, Philadelphia, and other American cities. See Murdoch, "Gerald Murphy, Cole Porter," 115.

36. See Judith A. Merkle, *Management and Ideology: The Legacy of the International Scientific Management Movement* (Berkeley and Los Angeles, 1980). For an excellent discussion of Le Corbusier's and other European architects' romance with American skyscrapers and grain elevators, see Reyner Banham, *A Concrete Atlantis: U.S. Industrial Building and European Modern Architecture, 1900–1925* (Cambridge, Mass., 1986). See also Jean-Louis Cohen, *Scenes of the World to Come: European Architecture and the American Challenge, 1893–1960* (Paris, 1995).

37. For the poster crisis, see Victoria de Grazia, "The Arts of Purchase: How American Publicity Subverted the European Poster, 1920–1940," in *Remaking History,* ed. Barbara Kruger and Phil Mariani (Seattle, Wash., 1989), 220–57. Another version of this essay, "The American Challenge to the European Arts of Advertising," is in *The 1920s: Age of the Metropolis,* ed. Jean Clair (Montreal, 1991), 236–49. For a personal account of the influence of American media on his varied businesses, see Marcel Bleustein-Blanchet, *The Rage to Persuade: Memoirs of a French Advertising Man,* trans. Jean Bodewyn (1947; reprint, New York, 1982). Among other entrepreneurial activities, Bleustein-Blanchet established the first "drugstores" in Paris.

38. [Emile Malespine], "Après l'art nègre l'art aztèque," *Manomètre* 1 (July 1922): 4–5, translated in Musée d'art moderne de la ville de Paris, *Léger et l'esprit moderne: Une Alternative d'avant-garde à l'art non-objectif, 1918–1931* (Paris, 1982), 149.

39. Guillaume Apollinaire, "L'Esprit nouveau et les poètes," 1917, translated and reprinted in Francis Steegmuller, *Apollinaire: Poet among the Painters* (1963; reprint, New York, 1986), 278.

40. Ibid., 289.

41. For studies of nationalism and French art after the war, see Christopher Green, *Cubism and Its Enemies: Modern Movements and Reaction in French Art, 1916–1928* (New Haven, Conn., 1987); Kenneth E. Silver, *Esprit de Corps: The Art of the Parisian Avant-Garde and the First World War, 1914–1925* (Princeton, N.J., 1989); and Romy Golan, *Modernity and Nostalgia: Art and Politics in France between the Wars* (New Haven, Conn., 1995).

42. Philippe Soupault's "Le Cinema U.S.A.," is reprinted in Soupault, *Ecrits de cinema,* ed. Alain Virmaux and Odette Virmaux (Paris, 1979). Soupault, "The American Influence in France," *Chapbook,* no. 38, trans. Babette Hughes and Glenn Hughes (Seattle, Wash., 1930), 22.

43. Matthew Josephson, *Life among the Surrealists: A Memoir* (New York, 1962), 123.

44. For Man Ray and Picabia, see Foresta et al., *Perpetual Motif: The Art of Man Ray,* 91, 141 n. 10. Elizabeth Hutton Turner talks of Pascin's and Kiki's Americanisms in *American Artists in Paris, 1919–1929,* 82–101.

45. Janet Flanner speaks of Pierre de Massot's addiction to Coca-Cola in her introduction to *Paris Was Yesterday, 1925–1939* (New York, 1972), xiv.

46. Turner, *American Artists in Paris, 1919–1929,* 163.

47. Edmund Wilson, Jr., "The Aesthetic Upheaval in France: The Influence of Jazz in Paris and the Americanization of French Literature and Art," *Vanity Fair* (Feb. 1922): 49, 100.

48. Malcolm Cowley, *Exile's Return* (New York, 1934), 119.

49. Ibid., 93.

50. Ibid., 106–7. "As a spectacle, America is more poignant in Paris than in New York!" Harold E. Stearns wrote in 1921. "So this is Paris!" *Freeman* 5 (July 5, 1921): 398.

51. Josephson, *Life among the Surrealists,* 124–27. Something similar had happened in 1911 when the young and not-yet-famous Irene and Vernon Castle danced American dances in Paris and discovered themselves "huge favorites of the international crowd." See Lewis A. Erenberg, *Steppin' Out: New York Nightlife and the Transformation of American Culture, 1890–1930* (Westport, Conn., 1981), 159.

52. Gorham Munson, "The Skyscraper Primitives," *Guardian* 1 (Mar. 1925): 164–78. The phrase was used in more recent times as a book title: Dickran Tashjian, *Skyscraper Primitives: Dada and the American Avant-Garde, 1910–1925* (Middletown, Conn., 1975).

53. Quoted and interpreted in Betsy Erkkila, *Walt Whitman among the French: Poet and Myth* (Princeton, N.J., 1980), 236. William Carlos Williams reported this incident in his *In the American Grain* (New York, 1925), 107.

54. Gertrude Stein, *Wars I Have Seen* (New York, 1945), 250.

55. Gertrude Stein, response in "Why Do Americans Live in Europe?" *Transition* 14 (fall 1928): 97.

56. Gertrude Stein, *Everybody's Autobiography* (New York, 1937), 102–3.

57. Interview with Virgil Thomson reported in John Rockwell, "Virgil Thomson's 'Saints' Goes Marching On," *New York Times*, Nov. 9, 1986, sec. 2, p. 12.

58. Gertrude Stein, *Lectures in America* (New York, 1935), 160–61.

59. Seton Hall University, *Louis Lozowick, 1892–1973* (South Orange, N.J., 1973), 3.

60. Louis Lozowick, *Survivor from a Dead Age: The Memoirs of Louis Lozowick*, ed. Virginia Hagelstein Marquardt (Washington, D.C., 1997), 226, 235–36.

61. Ibid., 176–77.

62. Ibid., 249.

63. For descriptions of George Grosz's romance with America, see *George Grosz: An Autobiography*, rev. ed., trans. Nora Hodges (New York, 1983); Beth Irwin Lewis, *George Grosz: Art and Politics in the Weimar Republic* (Madison, Wis., 1971); and Uwe M. Schneede, *George Grosz: His Life and Work*, trans. Susanne Flatauer (London, 1979).

64. As recalled by Walter Mehring and quoted in Lewis, *Grosz*, 25.

65. See John Willett's discussion of the German writers' fascination with Anglo-Saxon cultures in his *Theatre of Bertolt Brecht: A Study from Eight Aspects* (London, 1959), 68–70; Beeke Sell Tower, *Envisioning America: Prints, Drawings, and Photographs by George Grosz and His Contemporaries, 1915–1933* (Cambridge, Mass., 1990); and Helen Adkins, "George Grosz and the American Dream," in *The 1920s*, ed. Clair, 284–99.

66. Louis Lozowick, "The Americanization of Art," in *The Machine Age Exposition* (New York, 1927), 18–19. Progressive Dutch and German architects were among the first to come on pilgrimage to America and to publish influential writings about the American factory, grain elevator, and skyscraper, which were to architects what plumbing and jazz were to European painters and sculptors. For recent studies of some of these interests, see Banham, *A Concrete Atlantis*; and Cohen, *Scenes of the World to Come*. For an early travel account by a European architect, see Hendrik Petrus Berlage, *Amerikaansche Reisherinneringen* (Rotterdam, 1913). Samuel Bing was one of the first Europeans to see and write about skyscrapers; see his "La Culture artistique en Amérique" (1895), in *Artistic America, Tiffany Glass, and Art Nouveau*, trans.

Benita Eisler (Paris, 1896; reprint, Cambridge, Mass., 1970), 11–192.

67. Edith Halpert to Max Weber, 1929.8.7, Halpert Papers, AAA.

68. Lozowick, *Survivor from a Dead Age*, 205.

69. The principal source of scholarship on John Storrs is Noel Frackman, *John Storrs* (New York, 1987). See page 31 for this quotation of a draft letter to Horace Traubel, undated, John Storrs Papers, box 4, AAA.

70. In the 1920s Copland was a *transatlantique*, going back and forth across the sea four times during the decade. See Aaron Copland and Vivian Perlis, *Copland, 1900 through 1942* (New York, 1984).

71. "U.S. Composer's Weird Symphony Is Given in Paris," *New York Herald* (Paris), Saturday, Jan. ?, 1924, cited in Linda Whitesitt, *The Life and Music of George Antheil, 1900–1959* (Ann Arbor, Mich., 1983), 20–21.

72. Ezra Pound, "George Antheil," *Criterion: A Quarterly Review* 2 (Apr. 1924): 323, cited in Whitesitt, *George Antheil*, 18.

73. Phyllis Rose, *Jazz Cleopatra: Josephine Baker in Her Time* (New York, 1989), 147.

74. William Rubin has recently identified a body of works by Picasso that are of Sara's features and dress. "The Pipes of Pan: Picasso's Aborted Love Song to Sara Murphy," *Art News* 93 (May 1994): 138–47. He speculates that Picasso was in love with her and that they may have had a brief affair.

75. The flat roof was a much discussed and debated innovation in modern architecture, praised for giving geometry to a building and avoiding the picturesqueness of peaked roofs. See, for example, Adolf Behne, "The Aesthetics of the Flat Roof," trans. in *The Weimar Republic Sourcebook*, ed. Anton Kaes, Martin Jay, and Edward Dimendberg (Berkeley and Los Angeles, 1994), 449. Published originally in *Das Neue Frankfurt* 7 (1926–27): 163–64.

76. Of the various descriptions of the villa, I relied on Vaill's, which is the most complete. *Everybody Was So Young*, 158–60.

77. Le Corbusier, quoted in Musée d'art moderne de la ville de Paris, *Léger et l'esprit moderne*, 164, 169 n. 60.

78. Ellen Barry, interview by author, Oct. 28, 1980; Rubin, *Paintings of Gerald Murphy*, 36; and Vaill, *Everybody Was So Young*, 116.

79. Blaise Cendrars, "Advertising = Poetry" (1927), in Blaise Cendrars, *Selected Writings of Blaise Cendrars*, ed. Walter Albert (New York, 1966), 242.

80. Murphy's painting *Ball Bearing* (1926) is lost. In 1920 Paul Strand also made an advertising photograph for Hess-Bright ball bearings that was published as a frontispiece in *Broom*, Nov. 1922. Léger designed the catalogue cover for a 1927 Machine-Age Exposition in New York around a cubistically rendered ball bearing, and in 1934

the Museum of Modern Art in New York used a photograph of a ball bearing to advertise its *Machine Age* exhibition.

81. For an excellent pictorial survey of the "new spirit," see Musée d'art moderne de la ville de Paris, *Léger et l'esprit moderne.*

82. In 1962, in response to requests from Douglas MacAgy, Murphy handwrote two twelve-page sets of notes on his biography and paintings. Murphy MSS, MacAgy Papers, AAA. MacAgy used these notes for his important article introducing American audiences to Murphy's work, "Gerald Murphy: 'New Realist' of the Twenties," *Art in America* 51 (Apr. 1963): 49–57. The quotation in the text is from the Murphy MSS.

83. Fernand Léger, "The Spectacle: Light, Color, Moving Image, Object-Spectacle," *Bulletin de l'effort moderne* (Paris, 1924), reprinted in Léger, *Functions of Painting,* ed. Edward F. Fry, trans. Alexandra Anderson (New York, 1973), 44.

84. MacAgy, "Gerald Murphy," 52; and Vaill, *Everybody Was So Young,* 113.

85. Hemingway, *A Moveable Feast,* 206. For a careful analysis of the reasons behind Hemingway's harsh words about the Murphys in this book, see Linda Patterson Miller, "Gerald Murphy and Ernest Hemingway," parts 1 and 2, *Studies in American Fiction* 12 (spring 1985): 129–44, and 13 (fall 1985): 1–13.

86. MacAgy, "Gerald Murphy," 52.

87. For this extraordinary photograph, I thank Christian Derouet, who published it in Musée national d'art moderne, *Fernand Léger: La Poésie de l'objet, 1928–1934* (Paris, 1981), 9. "American's Eighteen-Foot Picture Nearly Splits Independent Artists," *New York Herald* (Paris), Feb. 8, 1924, 1.

88. Salon des Indépendants, *Le Crapouillot* (Mar. 1, 1924), 19; "Le Salon des Indépendants," *Les Nouvelles Littéraires* (Feb. 9, 1924), 3, quoted in Turner, *Americans in Paris, 1921–1931,* 64.

89. Tomkins, *Living Well,* 30; and Turner, *Americans in Paris, 1921–1931,* 101.

90. "American's Eighteen-Foot Picture," 1–2.

91. Rosenfeld reports that "Gerald Murfey [*sic*] and Don Hyde have invented a safety razor which they call the 'Cross' razor." Paul Rosenfeld to Philip Platt, Feb. 26, 1913, Stieglitz Collection, YCAL.

92. "Inquiry among European Writers into the Spirit of America," *Transition* 13 (summer 1928): 256.

93. Le Corbusier, *Towards a New Architecture* (New York, 1927), 89; originally published as *Vers une architecture* (Paris, 1923).

94. Philippe Soupault, *Poésies complètes, 1917–1927* (Paris, 1937), 78. For Dove's *Pen and Razor Blade,* see Ann Lee Morgan, *Arthur Dove: Life and Work, with a Catalogue Raisonné* (Newark, Del., 1984), 25.14, 143–44.

95. "Love of Nice Things," *New York Times,* Dec. 3, 1927, sec. 1, p. 14.

96. MacAgy Papers, AAA.

97. Three Stars was a Swedish label, but the matches were manufactured at various times in Britain and America. Today Three Stars continues to manufacture matches in Jönköping, Sweden (per my correspondence with Swedish Matches, 1988–89). By not identifying the parent company as Swedish, Murphy left the impression that, like the pen and razor, the matches were an American product.

98. For information on Parker pen history, I thank my Stanford colleague Jody Maxmin, who directed me to Glen B. Bowen, *Collectible Fountain Pens: Parker, Sheaffer, Wahl-Eversharp, Waterman* (Glenview, Ill., 1982). See also Cliff Lawrence, *Fountain Pens: History, Repair, and Current Values* (Paducah, Ky., 1977); "Parker Duofold, Part Two," *Pen Fancier's Newsletter* 4 (Apr. 1981): 12–19; and Giorgio Dragoni and Giuseppe Fichera, *Fountain Pens: History and Design* (Milan, 1997), 109.

99. Bowen, *Collectible Fountain Pens,* 13.

100. Undated letter from Gerald Murphy to Philip Barry, quoted in Rubin, *Paintings of Gerald Murphy,* 46 n. 83.

101. Murphy MSS, MacAgy Papers, AAA.

102. Dos Passos, *The Best Times,* 146.

103. Guy Debord, *Society of the Spectacle* (Detroit, Mich., 1983); originally published as *La Société du spectacle* (Paris, 1967).

104. Fernand Léger, "The Machine Aesthetic: The Manufactured Object, the Artisan, and the Artist," *Bulletin de l'effort moderne* (Paris, 1924), trans. and reprinted in Léger, *Functions of Painting,* 61.

105. Ibid., 59.

106. Fernand Léger, "New-York vu par F. Léger," *Cahiers d'Art* (1931), dedicated to Sara Murphy, was trans. and reprinted as "New York," in Léger, *Functions of Painting,* 84.

107. Murphy MSS, MacAgy Papers, AAA.

108. Léger and Murphy met by the late fall of 1921 and became close friends. In 1923, thanks to Léger's recommendation of Murphy, both worked for the Ballets Suédois, Murphy on the ballet *Within the Quota* and Léger on *The Creation of the World.* The two ballets were on the same program. Murphy loaned Léger his Paris studio for experiments with film and hosted Léger and his wife, Jeanne, often at Villa America. In a passport, Léger used Villa America in Antibes as his address. In the summer of 1931 Léger was with the Murphys for almost a month in Switzerland. In the fall of 1931 Murphy financed and hosted Léger's first trip to America. In 1934 the Légers sailed the Mediterranean with the Murphy family on their yacht and filled a sketchbook with drawings of the trip. And in 1935, when Léger returned to New York, for a one-artist exhibition at the Museum of

Modern Art, the Murphys financed the voyage, and he, in turn, gave them a painting as a gift. Léger visited again in 1938 and spent the war years, 1940–45, in America.

109. Rubin, *Paintings of Gerald Murphy*, 17.

110. Murphy MSS, MacAgy Papers, AAA.

111. Christopher Green, in *Léger and the Avant-Garde* (New Haven, Conn., 1976), 272–73, identified and published the Nov. 1924 Campari advertisement from *Le Matin* that Léger used as a source for *Le Siphon*. I thank him for lending me a photograph of this advertisement.

112. P.F., "Les Petits Expositions," *Journal des Débats* (Jan. 29, 1929), 4, quoted in Elizabeth Garrity Ellis, "View from Paris," in Turner, *Americans in Paris, 1921–1931*, 64.

113. Romy Golan, *Modernity and Nostalgia*, 60.

114. I am grateful to Honoria Murphy Donnelly for allowing me to study her father's notebook in which these ideas appear.

115. "Hicks Called Greatest in America by Léger," *Art Digest* 6 (Dec. 15, 1931): 13. Léger liked to make such pronouncements. In a preface he wrote to an exhibition catalogue, he called Alexander Calder's art "100 percent American." Galerie Percier, *Alexander Calder: Volumes-Vecteurs-Densités/Dessins-Portraits* (Paris, 1931), quoted in Ellis, "View from Paris," 66, in Turner, *Americans in Paris, 1921–1931*.

116. Fernand Léger, "Notes on the Mechanical Element" (1923), in Léger, *Functions of Painting*, 29.

117. See essays such as "Notes on the Mechanical Element" (1923), "The Machine Aesthetic: The Manufactured Object, the Artisan, and the Artist" (1924), and "The Machine Aesthetic: Geometric Order and Truth" (1925), in Léger, *Functions of Painting*, 28–30, 52–66.

118. Fernand Léger, "New York," *Cahiers d'Art* (1931), trans. and reprinted in Léger, *Functions of Painting*, 86.

119. Ibid., 85. Romy Golan points out that by 1931 Léger's enthusiasm for America was cooling as he began to attach tragedy and crisis to the regimented life he saw there. He was also turning away from mechanical subjects to organicized paintings of the natural world. *Modernity and Nostalgia*, 61–83. But his New York essay of 1931 is still one of the most exuberant and unrestrained paeans to the city that any European ever penned. And in 1938 Léger finally tried his hand at painting New York in seven gouache, ink, and pen drawings for a "cinematic mural" proposed for Rockefeller Center. It was never realized. The Statue of Liberty, the harbor, skyscrapers, and industrial smoke are prominently displayed in these preparatory works, which were given anonymously to the Museum of Modern Art in 1966. See Simon Willmoth, "Léger and America," in *Fernand Léger: The Later Years*, ed. Nicholas Serota (London, 1988), 43–54.

120. Lucien Romier, *Qui sera le maître? Europe ou Amérique?* (Paris, 1927); trans. by Matthew Josephson as *Who Will Be Master, Europe or America?* (New York,

1928). See Romy Golan, *Modernity and Nostalgia*, 79–83, for a longer discussion of anti-American views in France in the late 1920s.

121. "Inquiry among European Writers," *Transition* (1928): 248–73.

122. Ibid., 250–51.

123. Ibid., 270.

124. Ibid., 257.

125. Ibid., 252.

126. Ibid., 250.

127. Ibid., 257.

128. Paul Morand, *New York* (Paris, 1930), 197, trans. in Golan, *Modernity and Nostalgia*, 81.

129. Luigi Pirandello, quoted in Antonio Gramsci, "Americanism and Fordism," in *Selections from the Prison Notebooks of Antonio Gramsci*, ed. Quintin Hoare and Geoffrey Nowell Smith (New York, 1971), 277–320.

130. Georges Duhamel, *America the Menace: Scenes from the Life of the Future*, trans. Charles Miner Thompson (New York, 1931), xvi, 181; and H. Michaël Lewis, "Les Derniers Jugements des écrivains français sur la civilisation américaine," Ph.D. diss., University of Poitiers, 1931. See also Michel Collomb, *La Littérature Art Déco: Sur le style d'époque* (Paris, 1987); and David Strauss, *Menace in the West: The Rise of French Anti-Americanism in Modern Times* (Westport, Conn., 1978).

131. Matthew Josephson, "Open Letter to Ezra Pound and Other 'Exiles,'" *Transition* 13 (summer 1928) 101–2.

132. Man Ray, *Self Portrait* (Boston, 1988), 235. There are many markers of the seismic cultural changes that took place in the late 1920s and early 1930s. In what is today a well-known study of the lost generation, Malcolm Cowley's *Exile's Return* used the suicide of Henry Crosby, an American writer in Paris, on Dec. 10, 1929, as his paradigmatic "symbol of change" (242–88).

CHAPTER THREE: AN ITALIAN IN
NEW YORK

1. Katherine S. Dreier, *Stella* (New York, 1923), unpaginated exhibition brochure, published by the Société Anonyme.

2. Stella is included in virtually every study of early-twentieth-century art in this country, where he is often presented as a New York modernist with little notice taken of his being an Italian expatriate. The three major monographs on him and his work are those by Irma B. Jaffe, *Joseph Stella* (Cambridge, Mass., 1970); John I. H. Baur, *Joseph Stella* (New York, 1971); and Barbara Haskell, *Joseph Stella* (New York, 1994). Haskell's book has the most up-to-date bibliography and English translations of Stella's writings. I am deeply indebted to all of this foundational work.

3. John Baur, quoted by Jaffe, *Stella*, 3.

4. Antonio Aniante, probably *L'Italia Letteraria*, ca. 1930–34, quoted in Jaffe, *Stella*, 2.

5. In his "Discovery of America: Autobiographical Notes," written in 1946 at the request of the Whitney Museum and published in *Art News* 59 (Nov. 1960): 65, Stella called the painting *The Voice of the City of New York Interpreted*. At other times critics and scholars have used two shortened forms, *The Voice of the City* and *New York Interpreted*. To preserve the musical portion of his title, so important to Stella and to its period, I use *The Voice of the City* as my shorthand reference.

6. Because of its erratic history *The Voice of the City* is not as much studied as it might be. After spending more than two years creating it, without benefit of a patron or commission, Stella exhibited it Jan. 10–Feb. 5, 1923, in a one-man exhibition at the Société Anonyme gallery; its reception was mild, and no one stepped forward to buy it at its asking price of $25,000. The painting stayed in Stella's studio for fifteen years until two art dealers, concerned about its future, arranged for its sale in 1937 to the Newark Museum for $2,500. There it was shown on an irregular schedule until new painting galleries for the permanent collection opened in the early 1990s, giving it a place of honor.

7. While much of my thinking in this chapter is new, I have explored this painting and its themes in earlier essays: "The *New* New York," *Art in America* 61 (July–Aug. 1972): 59–65; "Joseph Stella and *New York Interpreted*," *Portfolio* 4 (Jan.–Feb. 1982): 40–45; and "The Artist's New York: 1900–1930," in *Budapest and New York: Studies in Metropolitan Transformation, 1870–1930*, ed. Thomas Bender and Carl E. Schorske (New York, 1994), 275–308.

8. Jaffe, who has read all of Stella's unpublished papers, finds that nowhere "does he express happiness" at being in New York. Jaffe, *Stella*, 25. When he speaks of Italy, however, he always does so with tenderness and love. Jaffe collected Stella's writings and reprinted them in Italian in an appendix to her book. She translates parts of them in her text. They are fully translated in Haskell, *Stella*.

9. "New York," in Haskell, *Stella*, 219; and "My Birthplace," in ibid., 218.

10. Jaffe, *Stella*, 5, 25.

11. Ibid., 26, 78.

12. See Bram Dijkstra, *Idols of Perversity: Fantasies of Feminine Evil in Fin-de-Siècle Culture* (New York, 1986).

13. The original titles for all five panels were given in the first publications of the painting: Dreier, *Stella*; and an unsigned photo-essay, "*The Voice of the City*: Five Paintings by Joseph Stella," *Survey* (Nov. 1923): 142–47. In another early article about the painting, the panels are called *The Harbor*, *The Heart of the City*, and *The Bridge*, and the Broadway panels are not given any particular

names: Henry Tyrrel, *World*, Jan. 21, 1923, republished in Italian in *Il Carroccio* 17 (Mar. 1923): 351–55. Eventually the titles evolved to the very simple ones used today. Jaffe added the roman numerals I and II after *The White Way* panels for convenience and clarification (62 n.), and the Newark Museum has continued to use them ever since. But the first titles, while varied, long, and asymmetrical, help to give us a period-specific understanding of the panels.

14. Todd Olson, a former student, was the first to draw my attention to the specificity of detail in this panel. I am indebted to a paper that he wrote in 1981 on *New York Interpreted* for some of the identifications offered here.

15. Rodman Gilder, *The Battery* (Boston, 1936), 277.

16. The information about Samuel F. B. Morse and the monument to wireless operators is found in Fremont Rider, *Rider's New York City and Vicinity* (New York, 1916).

17. *King's Views of New York, 1896–1915, and Brooklyn, 1905*, in a modern compendium by A. E. Santaniello (New York, 1974), has been extremely helpful in identifying details in this panel, as have such early guidebooks as *Rider's New York City*, 117–21.

18. Stella, "Discovery of America," 65.

19. Dreier, *Stella*. This passage, so typical of the way Stella expressed himself, is attributed to him when it is printed again in the unsigned photo-essay "*The Voice of the City*: Five Paintings by Joseph Stella," 142 ("Of the Battery, Stella says . . ."). Whether by Dreier or Stella, this passage is vintage rhetoric about the port, demonstrating once again the special investment modernists made in this Manhattan site.

20. Jaffe, *Stella*, 71.

21. See my *Color of Mood: American Tonalism, 1880–1910* (San Francisco, 1972), 19–22.

22. Stella, "Discovery of America," 65.

23. Jaffe, *Stella*, 77, points out the prison images in these panels.

24. London was the largest, at 4.5 million people, and Paris was the third largest, at 2.7. See "The Second City in the World," *Scientific American* 93 (July 22, 1905): 62.

25. Stella, "Discovery of America," 65.

26. See David G. McCullough, *The Great Bridge* (New York, 1972), for a concise and colorful history of the bridge's construction.

27. Sadakichi Hartmann [Sidney Allan, pseud.], "The 'Flat-Iron' Building: An Esthetical Dissertation," *Camera Work* 4 (Oct. 1903): 39.

28. Karl Baedeker, ed., *The United States, with an Excursion into Mexico: Handbook for Travellers* (Leipzig, Germany, 1893), 30.

29. For a rich compilation of visionary architectural drawings, see Jean-Louis Cohen, *Scenes of the World to Come: European Architecture and the American Challenge, 1893–1960* (Paris, 1995).

30. Katherine Mary Solomonson, "The Chicago Tribune Tower Competition: The Formation of a Corporate Icon," Ph.D. diss., Stanford University, 1991, 115–47, has a good discussion of skyscraper design as an advertisement for its corporate owner.

31. See, for example, Aymar Embury II, "New York's New Architecture," *Architectural Forum* 35 (Oct. 1921): 119–24; and (no author), "Heckscher Building, New York," *Architecture and Building* 54 (Feb. 1922): 17, 19–21.

32. It is first quoted, without attribution, by John Corbin, "The Twentieth Century City," *Scribner's* 33 (Mar. 1903): 260; and then by John Van Dyke, *The New New York* (New York, 1909), 120.

33. Hartmann, "The 'Flat-Iron' Building," 39.

34. George R. Collins, "The American Hotel," in *Gaudi, the Visionary*, ed. Robert Descharnes and Clovis Prévost (New York, 1982), 192–201.

35. See chapter 4, "Dazzling the Multitude," in Carolyn Marvin, *When Old Technologies Were New: Thinking about Electric Communication in the Late Nineteenth Century* (New York, 1988), 152–90. For another fine study of the transformative nature of electricity, see David E. Nye, *Electrifying America: Social Meanings of a New Technology* (Cambridge, Mass., 1991), especially chapter 2, "The Great White Way," 29–84.

36. Ezra Pound, "Patria Mia" (1913), in *Ezra Pound: Selected Prose, 1909–1965*, ed. William Cookson (New York, 1950), 107.

37. William Leach, introduction to chapter 4, "Commercial Aesthetics," in *Inventing Times Square: Commerce and Culture at the Crossroads of the World*, ed. William Robert Taylor (New York, 1991), 234–42, offers an excellent overview of the growth and development of lights on Times Square and the efforts to restrict them elsewhere in New York.

38. J. George Fredericks, *Adventuring in New York* (New York, 1923), 38, quoted in Leach, "Commercial Aesthetics," 234.

39. Leach, "Commercial Aesthetics," 237–38.

40. Sir Philip Burne-Jones, *Dollars and Democracy* (New York, 1904), 20.

41. Louis Baury, "The Message of Manhattan," *Bookman* 33 (Aug. 1911): 596.

42. The *Dictionary of Slang* puts the first use of "rush hour" in about 1898. In 1907 O'Henry spoke of "the 'rush-hour' tide of humanity" in his short story "Trimmed Lamp."

43. Rand McNally's *Rand McNally Fifty Photographic Views of Greater New York* (New York, 1899) offers no nighttime pictures or skyline views of the city, but the *Rand McNally New York Guide to Places of Interest in the City and Environs* (Chicago, 1924) shows scenes such as "Lower Manhattan at Night from the East River," "Luna Park, Coney Island, at Night," and "The Great White

Way"—the last two with electric signs ablaze in sharp focus. The guidebook mentions tours that include Chinatown at night and recommends walks over the East River bridges for views of the skyline. When the *WPA Guide to New York City* was published in 1939, nocturnal views and activities had become one of the city's major attractions: there were evening Circle Line tours and boat trips to Coney Island, and the Empire State Building observation deck stayed open until 1:00 A.M. The guide also includes many illustrations by important contemporary artists of the most popular nighttime sights, such as "Lower Manhattan Seen beneath Brooklyn Bridge," "Times Square," and "Central Park at Night." I take these observations from William Sharpe, "New York, Night, and Cultural Mythmaking: The Nocturne in Photography, 1900–1925," *Smithsonian Studies in American Art* 2 (fall 1988): 3–21.

44. Neil Harris, "Urban Tourism and the Commercial City," in *Inventing Times Square*, ed. Taylor, 82. Studying postcards, guidebooks, memorabilia, and promotional literature, Harris traces the roots of a *new* New York tourist industry back to 1890. From that year to 1920, he argues, the popular imagery and literature produced by the tourist industry had helped to formulate a "consensual image" of New York. The painters and photographers I look at here fit into the same chronology and contribute to the codification of modern New York as a set of specific visual images.

45. Anselm L. Strauss, *Images of the American City* (New York, 1961), 12, 17.

46. See Merrill Schleier, *The Skyscraper in American Art, 1890–1931* (Ann Arbor, Mich., 1986), 33–39, for a good discussion of the picturesque as it affected representations of skyscrapers. For an early essay locating picturesque beauty in modernity, see Sadakichi Hartmann, "A Plea for the Picturesqueness of New York," *Camera Notes* (Oct. 1900): 91–97. See also the discussion of picturesque aesthetics in pictorialist photography by Ulrich F. Keller, "The Myth of Art Photography: An Iconographic Analysis," *History of Photography* 9 (Jan.–Mar. 1985): 1–38. I thank Elizabeth Hutchinson for this last reference.

47. Alvin Langdon Coburn, "Contrasts: New York, Paris, London, Venice, and Liverpool," *Metropolitan Magazine* 26 (Mar. 1908): n.p.

48. O. Henry [William Sydney Porter], "A Night in New Arabia," *Everybody's Magazine* 18 (Mar. 1908): 302. This is just one of many short stories O. Henry wrote about Bagdad-on-the-Subway.

49. Joseph Pennell, quoted in Louis Baury, "The Message of Manhattan," *Bookman* 33 (Aug. 1911): 596.

50. Ezra Pound, "Patria Mia," 107.

51. Schleier, *Skyscraper in American Art*, 20–24, relates how artists like Pennell and Marin began their careers painting monuments in Europe, especially churches

and cathedrals, and therefore, like the writers, had a ready vocabulary for tall and monumental buildings.

52. Francis Hopkinson Smith, *Charcoals of New and Old New York* (New York, 1912), 98; Pound, "Patria Mia," 107.

53. Van Dyke, *New New York*, 207.

54. Ibid., 208.

55. Henry James, *The American Scene* (New York, 1968; originally published 1907), 73.

56. William Dean Howells, *A Hazard of New Fortunes* (Bloomington, Ind., 1976), 76.

57. See, for instance, Henry James's tour in and around New York in *The American Scene*; John Corbin's in *Twentieth Century City* 33 (Mar. 1903): 259–72; and Richard Le Gallienne's in "The Philosopher Walks Up-Town," *Harper's* 123 (1911): 228–38.

58. Van Dyke, *New New York*, 400.

59. For a useful essay about the invention of the skyline and the ways it helped New Yorkers give form to their changing city, see William Robert Taylor, "New York and the Origin of the Skyline: The Commercial City as Visual Text," in his book of essays *In Pursuit of Gotham: Culture and Commerce in New York* (New York, 1992), 23–33. While Taylor is discussing the emergence of New York's skyline view, his point, it seems to me, is easily extendable to other Manhattan tropes that developed at the same time.

60. Ibid.

61. H. G. Wells, *The Future in America: A Search after Realities* (London, 1906), 51.

62. Henry James, *The American Scene*, 76–77.

63. For a handy reference to some of these works, see Edward Bryant, *Pennell's New York Etchings: Ninety Prints by Joseph Pennell* (New York, 1980).

64. It is difficult to know the exact state of the arch when Hassam painted it. A temporary Washington Square arch of wood and plaster, designed by Stanford White, was erected in 1889 to celebrate the one hundredth anniversary of George Washington's inauguration. In 1890 a cornerstone was laid for a permanent arch of a new design by White. Hassam's painting depicts this second arch. Either he painted it after its completion or from plans that showed what the arch would look like when finished. The painting is traditionally dated 1890, when the arch was not yet erected.

65. For the nocturne in photography, see Sharpe, "New York, Night, and Cultural Mythmaking," 3–21.

66. Van Dyke, *New New York*, 178. Bellows's many liberties with the site have confused historians about the locale the painting depicts. But Thomas Pauly, after detective work into the painting's buildings and signs, conclusively identifies the scene as Madison Square. My thanks to him for giving me a copy of his essay "*New York 1911* and the Changing Look of the City."

67. Alfred Stieglitz, "I Photograph the Flatiron—1902," *Twice a Year* 14–15 (fall–winter 1946): 189.

68. Giles Edgerton [Mary Fanton Roberts], "How New York Has Redeemed Herself from Ugliness: An Artist's Revelation of the Beauty of the Skyscraper," *Craftsman* 11 (Jan. 1907): 458.

69. Claude Bragdon, *The Frozen Fountain, Being Essays on Architecture and the Art of Design in Space* (New York, 1932), 25.

70. Jesse Lynch Williams, *New York Sketches* (New York, 1902), 14.

71. Hartmann, "The 'Flat-Iron' Building," 40.

72. One could argue that Marin's application of modern ideas about color, form, and abstraction to long-standing picturesque traditions was what made him Stieglitz's favorite artist. In many ways, Stieglitz did the same thing in his own art.

73. John F. Kasson, *Amusing the Millions: Coney Island at the Turn of the Century* (New York, 1978), 65–91.

74. Haskell, *Stella*, 38–39, summarizes what is known today of Stella's acquaintance with the futurists in Paris.

75. "The Founding and Manifesto of Futurism," in *Marinetti: Selected Writings*, ed. R. W. Flint (New York, 1971), 41; originally published in *Le Figaro* (Paris), Feb. 20, 1909.

76. Ibid. See also Marinetti's essays "Let's Murder the Moonshine," 45–54, and "Against Past-Loving Venice," 55–58.

77. Balla recalled this in a 1952 questionnaire he filled out for the Museum of Modern Art in New York that is quoted in Marianne W. Martin, *Futurist Art and Theory, 1909–1915* (New York, 1978), 173 n. 4.

78. Paul Strand, "Photography and the New God," *Broom* 3 (1922): 257.

79. Ezra Pound, "Patria Mia," 107.

80. Georg Simmel, "The Metropolis and Mental Life" (1903), in *On Individuality and Social Forms* (Chicago, 1971), 324–39; and Max Weber, *The City* (1921), trans. and ed. Don Martindale and Gertrud Neuwirth (New York, 1958).

81. Jaffe makes this helpful distinction between cityscape and "city portraiture" in *Stella*, 65.

82. Ibid.

83. See also Frans Masereel, *Die Stadt* (Munich, 1925).

84. Years ago the film historian Donald Crafton kindly shared with me a list he had drawn up of twenty cinematic city symphonies, from which my examples are drawn.

85. I am indebted to Jan-Christopher Horak in the discussion that follows for much of the historical detail about the film. See his "Modernist Perspectives and Romantic Desire: *Manhatta*," *Afterimage* 15 (Nov. 1987): 8–15. My

own reading of the film differs only occasionally from his. See also Theodore E. Stebbins, Jr., and Norman Keyes, Jr., *Charles Sheeler: The Photographs*, exh. cat., Museum of Fine Arts (Boston, 1987), 17–21; and Scott Hammen, "Sheeler and Strand's 'Manhatta': A Neglected Masterpiece," *Afterimage* 6 (Jan. 1979): 6–7.

86. Harriet Underhill, *New York Tribune*, July 26, 1921, 6, quoted in Horak, "*Manhatta*," 10.

87. Horak, "*Manhatta*," 9.

88. A letter from Alfred Stieglitz to Paul Strand, Oct. 27, 1920, suggests that the film was shown to friends well before it found a commercial venue in New York. The letter from Stieglitz says that Marius de Zayas had seen it, as had Walter Arensberg in California. There is always the possibility that Stella too would have seen it at a private showing. See Horak, "*Manhatta*," 10.

89. See John Joseph Czaplicka, "Prolegomena for a Typology of Urban Imagery: The Pictorial Representation of Berlin, 1870–1930," Ph.D. diss., University of Hamburg, 1984; and Clark V. Poling, "The City and Modernity: Art in Berlin in the First World War and Its Aftermath," in *Art in Berlin, 1915–1989*, exh. cat., High Museum of Art (Atlanta, Ga., 1989), 83–90.

90. See Schleier, *Skyscraper in American Art*, 70 and figure 55.

91. Paul Morand, *New York* (New York, 1930). Published by Flammarion, the Parisian edition had lithographs by Lubbers, while the American edition was illustrated with woodcuts by Joaquin Vaquero.

92. Masereel, born in Belgium, lived his mature life in Paris and Geneva, where he gained a reputation for his woodcuts, many of which he published in *Die Stadt* (Munich, 1925), a picture book that includes prints based on his imaginary impressions of New York as well as Paris. In his storybooks of woodcuts, many of them published by Kurt Wolff, a German publisher, he always demonstrated his pacifist convictions and his concern for the plight of the working classes. He had an avid following, particularly in Germany. His social commentary made him more popular in Germany and Russia than in France and America. *Die Stadt* has been republished as *The City* (New York, 1988).

93. Alice Holdship Ware, "Skyscrapers," *Survey* 56 (Apr. 1, 1926): 35, quoted in Schleier, *Skyscraper in American Art*, 107. For the ballet's plot, see Schleier, 105–7.

94. For a welcome study of the ballet's history, music, and reception, see Howard Pollack, *Skyscraper Lullaby: The Life and Music of John Alden Carpenter* (Washington, D.C., 1995), 210–48.

95. Rem Koolhaas, *Delirous New York: A Retroactive Manifesto for Manhattan* (New York, 1978), 10.

96. Joseph Stella, "Brooklyn Bridge: A Page of My Life." Stella published this essay privately with an illustration of *The Voice of the City* sometime in the early 1920s.

It was then published in *Transition* (June 1929): 16–17, 86–88.

97. See Brom Weber, *Hart Crane: A Biographical and Critical Study* (New York, 1948), 317–20; George Knox, "Crane and Stella: Conjunction of Painterly and Poetic Worlds," *Texas Studies in Literature and Language* 12 (winter 1971): 689–707; and Irma B. Jaffe, "Joseph Stella and Hart Crane: The Brooklyn Bridge," *American Art Journal* 1 (fall 1969): 98–107. It is known that Crane wanted to use a color reproduction of Stella's *Brooklyn Bridge* panel from *The Voice of the City* as a frontispiece to *The Bridge* and wrote Stella in 1929 asking him for permission. For reasons unknown—perhaps the cost—the painting was not used. The only letter we have is Crane's to Stella in 1928, reporting the poet's astonishment at seeing a reproduction of *The Voice of the City* and "the remarkable coincidence that another person, by whom I mean you, should have had the same sentiments regarding Brooklyn Bridge which inspired the main theme and pattern of my poem." *The Letters of Hart Crane, 1916–1932*, ed. Brom Weber (New York, 1952), 333–34.

CHAPTER FOUR: AND THE HOME OF THE BRAVE

1. For a recent study and selected bibliography of the scholarly literature on Demuth, see Barbara Haskell, *Charles Demuth* (New York, 1987). Two useful publications that are not in her bibliography are Betsy Fahlman, *Pennsylvania Modern: Charles Demuth of Lancaster* (Philadelphia, 1983); and Robin Jaffee Frank, *Charles Demuth Poster Portraits, 1923–1929* (New Haven, Conn., 1994).

2. Gerald Murphy, responding to question sent him by Douglas MacAgy, MacAgy Papers, AAA.

3. See for example, Karen Tsujimoto, *Images of America: Precisionist Painting and Modern Photography* (Seattle, 1982); and Richard Guy Wilson, Dianne H. Pilgrim, and Dickran Tashjian, *The Machine Age in America, 1918–1941* (New York, 1986).

4. ". . . leur charme vulgaire et ingénu"; see G.W. [George Waldemar], "Les Expositions," *L'Amour de l'Art* 4 (Nov. 1923): 763. The comment appears in Waldemar's review of a 1923 exhibition of contemporary American paintings by Demuth, Sheeler, and Walt Kuhn at the Galeries Durand-Ruel in Paris. In 1927 Demuth was in a multinational exhibition at the Galerie Bernheim-Jeune. There is also some evidence that Demuth sold two watercolors to the L'Effort Moderne gallery when he was visiting Paris in 1921. See Emily Farnham, *Charles Demuth: Behind a Laughing Mask* (Norman, Okla., 1971), 206.

5. Demuth, in a letter to Stein, Paris, Sept. 6, 1921, Stein Collection, YCAL, asks if he and Duchamp can come to call the next day.

6. Susan Watts Street remembered that Demuth had been at her Paris apartment in 1921 at the same time as Milhaud, Satie, Cocteau, and Man Ray. Emily Farnham, "Charles Demuth: His Life, Psychology, and Works," Ph.D. diss., Ohio State University, 1959, 978.

7. Susan Watts Street told Emily Farnham of Demuth's "snobbism" and meticulous taste, including his choice of notepaper and ink. Farnham, "Demuth: Life, Psychology, and Works," 976. A sample of Murphy's letters on rice paper can be seen in the Archibald MacLeish Manuscript Collection at the Library of Congress.

8. For Demuth's elegant dress and mannerisms, see Marsden Hartley, "Farewell, Charles: An Outline in Portraiture of Charles Demuth—Painter," in *The New Caravan*, ed. Alfred Kreymborg, Lewis Mumford, and Paul Rosenfeld (New York, 1936), 552–62. "Charles," Hartley wrote, "dressed always in the right degree of good taste, English taste of course, carrying his cane elegantly and for service, not for show, as he had always the need of a cane." In my interview with O'Keeffe, Nov. 20, 1980, one of her most prominent memories of Demuth was his elegance. "He always had the top button of his shirt buttoned," she told me. Susan Watts Street recalled that "at Provincetown when everybody else was looking sloppy, Demuth would appear wearing a black shirt, white slacks, a plum-colored scarf tied around his waist, and black laced shoes, highly polished." Farnham, "Demuth: Life, Psychology, and Works," 975.

9. For a witty description of this period style, see Ernest Boyd, "Aesthete: Model 1924," *American Mercury* 1 (Jan. 1924): 51–56.

10. In 1914 Demuth contributed "Between Four and Five," a description of 291, for publication in *Camera Work*, no. 47 (July 1914): 32. Despite the date, this issue of *Camera Work* was not actually published until January 1915. Haskell, *Demuth*, 63 n. 2. This suggests the two men knew each other at least by the fall of 1914. The Demuth-Stieglitz correspondence (YCAL) goes back to 1916, when the first circle was dissolving and the second forming.

11. Edmund Wilson, *The American Earthquake: A Documentary of the Twenties and Thirties* (New York, 1958), 102.

12. Marcel Duchamp, interviewed by Farnham, Jan. 21, 1956; see "Demuth: Life, Psychology, and Works," 973.

13. Paul Rosenfeld, "Art, Charles Demuth," *Nation* 133 (Oct. 7, 1931): 372.

14. Demuth's homosexuality was well known. In the 1950s Emily Farnham interviewed artists about Demuth, and many of them brought up his "little perverse tendency," as Duchamp called it. Stuart Davis said, "Well, if he wasn't [homosexual], I don't know what he was." George Biddle called him "a homosexual 'fin de siècle.'"

Farnham, "Demuth: Life, Psychology, and Works," 973, 971, 952.

For the first scholarship to discuss homosexuality as a component of the artist's life and art, see Gerard Koskovich, "A Gay American Modernist: Homosexuality in the Life and Art of Charles Demuth," *Advocate*, June 25, 1985, 50–52; and Jonathan Weinberg, "'Some Unknown Thing': The Illustrations of Charles Demuth," *Arts Magazine* 61 (Dec. 1986): 14–21. This essay was expanded upon in Weinberg, *Speaking for Vice: Homosexuality in the Art of Charles Demuth, Marsden Hartley, and the First American Avant-Garde* (New Haven, Conn., 1993).

15. Rosenfeld, "Art, Charles Demuth," 372, 371.

16. Paul Rosenfeld, "American Painting," *Dial* 71 (Dec. 1921): 663.

17. Paul Strand, "American Water Colors at the Brooklyn Museum," *Arts* 2 (Jan. 20, 1922): 151–52.

18. Paul Strand to Alfred Stieglitz, Aug. 4, 1924, Stieglitz Collection, YCAL.

19. Georgia O'Keeffe, letter to Blanche Matthias, ca. Apr. 1929, in Jack Cowart and Juan Hamilton, with Sarah Greenough, *Georgia O'Keeffe: Art and Letters* (Washington, D.C., 1987), 188.

20. Hartley, "Farewell Charles," 556–61.

21. George Chauncey, *Gay New York: Gender, Urban Culture, and the Making of the Gay Male World, 1890–1940* (New York, 1994). This very helpful book situates antihomosexual commentary like that of Hartley in ways I had not been able to understand in earlier formulations of this chapter.

22. Hartley, "Farewell, Charles," 561.

23. Eugene O'Neill, *Strange Interlude* (New York, 1928), 12.

24. Jerome Mellquist, *The Emergence of an American Art* (New York, 1942), 336–40.

25. Downtown Gallery Records, AAA. Some of Ritchie's draft was cut when it was printed in the exhibition brochure.

26. Mellquist, *Emergence of an American Art*, 362, 384.

27. In another Stieglitz photograph of Demuth, used as the frontispiece for William Murrell, *Charles Demuth* (New York, 1931), the artist is in half-length, with his left hand splayed on his jacket and the right cupped at his waist in a very mannered pose.

28. The associations of hands with homosexuality could also be turned against modern artists in general. See Thomas Craven, "Effeminacy?" *Art Digest* 10 (Oct. 1, 1935): 10, for an explosive diatribe against the "sensitive" and "effeminate" modern artist whose "pretty," "shapely, slender hands" have become cultish. In this piece, Craven, whose homophobia in other writings is well known, praises the well-formed worker hands of an unnamed artist, no doubt Thomas Hart Benton.

29. Hartley, "Farewell, Charles," 560.

30. Sherwood Anderson, *Winesburg, Ohio: A Group of Tales of Ohio Small-Town Life* (New York, 1919), 7–17.

31. Frank, *Demuth Poster Portraits*, 36.

32. Georgia O'Keeffe, interviewed by author, Nov. 20, 1980, Abiquiu, New Mexico.

33. Mellquist, *Emergence of an American Art*, 339.

34. Andrew Carnduff Ritchie, *Charles Demuth* (New York, 1950), 15.

35. *The Autobiography of William Carlos Williams* (New York, 1951), 52.

36. In late-life reminiscences, Williams and his wife made a point of saying that they never knew Demuth was a homosexual until after he had died. I find this impossible to believe, given how frequently Demuth was typecast by others. Williams, interviewed by Farnham, Jan. 26, 1956; see "Demuth: Life, Psychology, and Works," 988. My friend Edgar Stillman interviewed Williams's widow in 1974 and in a letter of Sept. 4, 1993, sent me some of his notes, in which she spoke of "Sheeler and Charley Demuth," her husband's good men friends. Stillman said that she "pronounced his name Dee-muth, and she looked amused when she mentioned the name—'Bill didn't know he was a homo. He was very shocked when he found that out. Of course Charley never acted different with us.' A robust laugh from the old lady. 'I liked him very much. He was a wonderful man.'"

37. Williams's "Pot of Flowers," in *Spring and All* (n.p., 1923), was based on Demuth's watercolor *Tuberoses* (1922); his "Crimson Cyclamen (To the Memory of Charles Demuth)" was first published in *Adam and Eve and the City* (Peru, Vt., 1936).

38. There is some confusion about what, properly, to call these works. Art historians today speak of them as Demuth's poster portraits, but that term seems to have evolved late in the day. In 1925, when the first ones were exhibited in the *Seven Americans* exhibition at the Anderson Galleries, Stieglitz called them portrait posters, and in correspondence Demuth referred to them simply as his posters. Personally, I think "portrait posters," with poster as the noun rather than the adjective, retains the original meaning Demuth assigned to them.

39. Sarah Greenough, in an unpublished lecture of 1986, "*Equivalents* as Portraits: Portraits as Equivalents," discussed the context for two abstract portraits Stieglitz made: one, six photographs of clouds and a tree presented as a portrait of Katharine Rhoades, the other, three photographs of clouds as a portrait of O'Keeffe. Stieglitz also conceived of his many photographs of O'Keeffe as a "composite portrait." For a discussion of O'Keeffe's abstract portraits, see Charles C. Eldredge, *Georgia O'Keeffe* (New York, 1991), 36–37, who describes *Abstraction-Alexis* as a portrait of water and clouds referring to her brother and his death from poison gas during World War I.

40. For discussion of Demuth's posters, see Isabel Brenner, "Charles Demuth: The Poster Portraits," master's thesis, Hunter College, City University of New York, 1974; Abraham A. Davidson, "The Poster Portraits of Charles Demuth," *Auction* 3 (Sept. 1969): 28–31, and "Demuth's Poster Portraits," *Artforum* 17 (Nov. 1978): 54–57; Haskell, *Demuth*, chapter 6, "Poster Portraits, 1923–1929," 172–91; and Robin Jaffee Frank, *Demuth Poster Portraits*, an exhibition catalogue based on her doctoral dissertation, "Charles Demuth Poster Portraits, 1923–1929," Yale University, 1995. Three essays analyze the Williams poster: James E. Breslin, "William Carlos Williams and Charles Demuth: Cross Fertilization in the Arts," *Journal of Modern Literature* 6 (Apr. 1977): 248–63; Edward A. Aiken, "'I Saw the Figure 5 in Gold': Charles Demuth's Emblematic Portrait of William Carlos Williams," *Art Journal* 46 (fall 1987): 179–84; and Wanda M. Corn, *In the American Grain: The Billboard Poetics of Charles Demuth* (Poughkeepsie, N.Y., 1991). For an article interpreting *Longhi on Broadway* as a poster of Eugene O'Neill, see Timothy Anglin Burgard, "Charles Demuth's *Longhi on Broadway: Homage to Eugene O'Neill*," *Arts Magazine* 58 (Jan. 1984): 110–13.

Haskell argues that the paintings commonly said to be posters of Gertrude Stein and Eugene O'Neill are *not* portraits. See *Demuth*, 186–89. But I share the view of Robin Frank and others that there is enough internal evidence in both works to assign them to O'Neill and Stein and see them as part of the grander poster portrait project.

41. Williams, *Autobiography*, 172.

42. "The Great Figure," in *The Collected Poems of William Carlos Williams, 1906–1939*, vol. 1, ed. A. Walton Litz and Christopher MacGowan (New York, 1986), 174.

43. Breslin, "Williams and Demuth," 261.

44. I'm grateful to Lisa M. Steinman for drawing my attention to the structure of Williams's poem as one consciously adopting a streamlined aesthetic. See her *Made in America: Science, Technology, and American Modernist Poetry* (New Haven, Conn., 1987).

45. Williams, *Autobiography*, 152. Stuart Davis reported to Emily Farnham that in Provincetown he and others called Demuth "'Chuck' just to tantalize him and because the name didn't suit him at all. He was too elegant to be called 'Chuck.'" Farnham, "Demuth: Life, Psychology, and Works," 971.

46. "Souscrivez à Dada. Le seul emprunt qui ne rapporte rien"; quoted in David Steel, "Surrealism, Literature of Advertising and the Advertising of Literature in France, 1910–1930," *French Studies* 41 (July 1987): 287, and translated in Kirk Varnedoe and Adam Gopnik, *High and Low: Modern Art and Popular Culture* (New York, 1990), 260.

47. For prostitution in and around Times Square, see Laurence Senelick, "Private Parts in Public Places," in *In-*

venting *Times Square: Commerce and Culture at the Crossroads of the World*, ed. William R. Taylor (New York, 1991), 329–53.

48. Douglas C. McMurtrie, *Modern Typography and Layout* (Chicago, 1929), 49.

49. Apollinaire, and especially Cendrars and Léger, made frequent reference to the modernity and poetry of the outdoor poster and advertisement and associated it with other modern inventions. See, for instance, Apollinaire's 1912 poem "Zone," first published in *Les Soirées de Paris* 11 (Dec. 1912); and Blaise Cendrars's essay "Advertising = Poetry" (1927), translated and reprinted in Blaise Cendrars, *Selected Writings of Blaise Cendrars*, ed. Walter Albert (New York, 1966), 240–42. For Léger, see the translations of his essays in Fernand Léger, *Functions of Painting*, ed. Edward F. Fry and trans. Alexandra Anderson (New York, 1973), particularly "Contemporary Achievements in Painting" (1914), 12–13; "Notes on the Mechanical Element" (1923), 30; and "The Street: Objects, Spectacles" (1928), 78–80. For an analysis of Léger's views on billboards, see Christopher Green, *Cubism and Its Enemies: Modern Movements and Reaction in French Art, 1916–1928* (New Haven, Conn., 1987), 212–15. See also Varnedoe and Gopnik, *High and Low*, 231ff.

50. To give but one statistic, in the eleven years following the war the number of cars in New York increased about six hundred percent; New York had more cars than all of Europe. See Ann Douglas, *Terrible Honesty: Mongrel Manhattan in the 1920s* (New York, 1996), 17.

51. For bibliographic references and a helpful analysis of the years under review here, see Roland Marchand, *Advertising the American Dream: Making Way for Modernity, 1920–1940* (Berkeley and Los Angeles, 1985).

52. In 1915 a critic mentioned that Demuth had painted two *Sensations of Times Square*, but to my knowledge, they are lost. See Willard Huntington Wright, "Modern American Painters—and Winslow Homer," *Forum* 54 (Dec. 1915): 669. We also know that Demuth tried his hand at Paris views. Emily Farnham reports that he sold two unidentified watercolors called *Views of the City* to L'Effort Moderne gallery in Paris, Oct. 10, 1921, the same year that he made a tempera painting of a Paris street, *Rue du Singe Que Peche*. See *Behind a Laughing Mask*, 206.

In a letter to Stieglitz, Jan. 1, 1929, Demuth, who was still working on *The Figure 5 in Gold*, wrote that he "would love to do something of Broadway" but felt his visits to New York were too short for gathering ideas. "However I may have luck.—I've thought—of it for years." In another letter to Stieglitz, Sept. 26, 1929, Demuth said that Robert Locher called the poster of Gertrude Stein "the only painting which touched Broadway." Demuth was skeptical and added, "I shall really do Broadway, someday, with luck." Both letters are in the Stieglitz Collection, YCAL.

53. Dos Passos's best-known and most ambitious novel in "American speech" is *USA* (New York, 1930).

54. See also Williams's "Della Primavera Transportata al Morale" and "Rapid Transit," in *Collected Earlier Poems* (New York, 1951), 57–64, 282–83.

55. Sadakichi Hartmann [Sidney Allan, pseud.], "The 'Flat-Iron' Building: An Esthetical Dissertation," *Camera Work* 4 (Oct. 1903): 39.

56. The quotation is from Clinton Rogers Woodruff, "To Boycott the Billboard: The Right of the Citizen to an Unposted Landscape," *Craftsman* 8 (Jan. 1908): 434. See also "Billboards," *Art and Progress* 1 (Jan. 1910): 62–64; "The Bill Board Menace," *American Magazine of Art* 11 (Jan. 1920): 94–96; "The Billboard in the Open Country," *American Magazine of Art* 12 (Feb. 1921): 56–57; and "The Billboard Blight in Our Country," *American Magazine of Art* 18 (Nov. 1927): 590–99. An unusual twist to the antibillboard campaign was offered by Thornton Oakley, who argued that if billboards were made by artists rather than sign painters, they would be beautiful. See "The Billboard—a Plea," *American Magazine of Art* 11 (Mar. 1920). My thanks to Merrill Schleier for alerting me to these references. For a much fuller discussion of this issue, see "Posters versus Billboards," in Michele Helene Bogart, *Artists, Advertising, and the Borders of Art* (Chicago, 1995), 79–124.

57. Harold A. Loeb, ed., *The Broom Anthology* (Pound Ridge, N.Y., 1969), xii.

58. Harold A. Loeb, "Foreign Exchange," *Broom* 2 (May 1922): 178, 179.

59. Harold A. Loeb, "The Mysticism of Money," *Broom* 3 (Sept. 1922): 115–30.

60. A long sympathetic article on Coady by Robert Alden Sanborn, "A Champion in the Wilderness," *Broom* 3 (Oct. 1922): 174–79, casts him in the role of a valiant fighter. "Coady was never knocked out," Sanborn wrote, but simply dropped from exhaustion. "Who dares put on the shoes and gloves of this dead champion and take his fighting place in the wilderness of age?"

61. Matthew Josephson, "The Great American Billposter," *Broom* 3 (Nov. 1922): 304–12. An earlier article, much less bombastic than Josephson's but making the same observations about the poetry of magazine advertisements, is John Gould Fletcher's "Vers Libre and Advertisements," *Little Review* 2 (Apr. 1915): 29–30.

62. Malcolm Cowley, "Valuta," *Broom* 3 (Nov. 1922): 250–51, and "Portrait of Leyendecker," *Broom* 4 (Mar. 1923): 240–47.

63. Gilbert Seldes, *The Seven Lively Arts* (New York, 1924). For a list of Seldes's articles on popular culture for *Vanity Fair*, see Louise Heinze, *An Index to Vanity Fair, September 1913–February 1936* (Ann Arbor, Mich., 1967), 37–38. Seldes's article "Toujours Jazz" appeared in *Dial* 75 (Aug. 1923): 151–66. See also Michael G. Kammen, *The Lively Arts: Gilbert Seldes and the Transforma-*

tion of Cultural Criticism in the United States (New York, 1996).

64. Gilbert Seldes, "A Note on Advertising," *New Republic* (July 8, 1925): 180. Seldes recalls his intention to write a book on advertising in the preface of the 1957 edition of *The Seven Lively Arts*, 4.

65. Loeb, "Foreign Exchange," 179.

66. Herbert J. Seligmann, *Literary Review* (May 24, 1924): 770.

67. Malcolm Cowley, "Young Mr. Elkins," *Broom* 4 (Dec. 1922): 52–56; and Matthew Josephson, "Instant Note on Waldo Frank," *Broom* 4 (Dec. 1922): 57–60.

68. Edmund Wilson, "An Imaginary Conversation," *New Republic* (Apr. 9, 1924): 179–82. In one important respect Wilson erred when he characterized Rosenfeld as a "citizen of Europe" defending "the artistic life of Europe." Rosenfeld respected Europe, but not at the expense of his own country, as any reading of his *Port of New York* quickly confirms. Rosenfeld was just as interested as Josephson in promoting a new American art, but he envisioned it in an entirely different form.

69. The same mud-slinging between the two camps animates Hemingway's parody of Sherwood Anderson in *The Torrents* and Hart Crane's poem parodying e. e. cummings: "Of an Evening Pulling Off a Little Experience (with the english language) by EEEEEECCUUUMMMMM-MIIINNNGGGSSS (for short) / NIGHTS 69," in *The Poems of Hart Crane*, ed. Marc Simon (New York, 1986), 179–80.

70. See Malcolm Cowley, *Exile's Return* (New York, 1934); and Matthew Josephson, *Portrait of the Artist as American* (New York, 1930).

71. See, for example, Hartley's essays "The Twilight of the Acrobat," "Vaudeville," and "A Charming Equestrienne," reprinted in his *Adventures in the Arts: Informal Chapters on Painters, Vaudeville, and Poets* (New York, 1921). See also Caroline Scurfield Caffin, *Vaudeville*, (New York, 1914).

72. Walter Gropius, "Die Entwicklung Moderner Industrie Kunst" (1913), quoted and translated by Reyner Banham in *A Concrete Atlantis: U.S. Industrial Building and European Modern Architecture, 1900–1925* (Cambridge, Mass., 1986), 202. Banham looks at the place of the granary and factory in *américanisme*. See also Erich Mendelsohn, *Amerika: Bilderbuch eines Architekten* (Berlin, 1926).

73. For the first discussion and photographs of Lancaster and the sites Demuth painted, see S. Lane Faison, Jr., "Fact and Art in Charles Demuth," *Magazine of Art* 43 (Apr. 1950). More recently, Betsy Fahlman has located many more sites; see her *Pennsylvania Modern* and her "Charles Demuth's Paintings of Lancaster Architecture: New Discoveries and Observations," *Arts Magazine* 61 (Mar. 1987): 24–29. I am indebted to her for responding to my numerous queries about Demuth's life in Lancaster.

74. "Sample Critical Statement," *Contact*, n.d. [1922].

75. Henry McBride, "Modern Art," *Dial* 71 (Dec. 1921): 118–20.

76. Henry McBride, "American Expatriates in Paris," *Dial* (Apr. 1929), reprinted in McBride, *The Flow of Art*, ed. Daniel Cotton Rich (New York, 1975), 256.

77. Charles Demuth to Alfred Stieglitz, Aug. 13, 1921, Stieglitz Collection, YCAL.

78. Charles Demuth to Alfred Stieglitz, Oct. 10, 1921, Stieglitz Collection, YCAL.

79. Charles Demuth to Alfred Stieglitz, Nov. 28, 1921, Stieglitz Collection, YCAL.

80. For discussion of the literary meanings of industrial sites in Demuth's work, see Karal Ann Marling, "*My Egypt*: The Irony of the American Dream," *Winterthur Portfolio* 15 (spring 1980): 25–39.

81. Carol L. Morgan, the former director of the Demuth Foundation, in a letter to me of Oct. 20, 1991, suggested this nice analogy, telling me that calliopes still appear in Lancaster parades. "Charles's father was a skilled amateur photographer; we have images he made . . . at circus parades going past the front of the house."

82. Charles Demuth, letters to Alfred Stieglitz, Dec. 12, 1929, and Oct. 12, 1930, Stieglitz Collection, YCAL.

83. Paul Rosenfeld, "Art, Charles Demuth."

84. Fahlman, "Demuth's Paintings of Lancaster Architecture," 28.

85. Charles Demuth to Alfred Stieglitz, July 1925, Stieglitz Collection, YCAL.

86. See Wendy Wick Reaves, *Celebrity Caricature in America* (Washington, D.C., 1998).

87. Haskell, *Demuth*, 189. Haskell bases her argument on Demuth's having exhibited the work under the title *Design for a Broadway Poster* and his having given it to his close friend, and probably lover, Robert Locher, evidence she takes to mean the portrait was intended to be about Broadway theater. She underlines that it was a gallery dealer, Edith Halpert, who first exhibited it as *Love, Love, Love (Homage to Gertrude Stein)* in 1958. Robin Frank, in her *Demuth's Poster Portraits*, 101–6, uncovered other documentary evidence to give the work to Stein, including that of Locher's admiration for Stein. (He once told an interviewer: "I love that woman. There is only one of her books which I do not own.") Frank also discovered that Locher, who worked in theater, illustration, and interior design, used the mask, as so many homosexuals did, on his illustrations and sometimes worked the image into his signature as a monogram. Most important, to my mind, is the internal evidence of the work itself that seems so weighted to Stein as its sitter. The confusion around the portrait only offers further testament to Demuth's indirection in his portraits for and about homosexuals.

88. Richard Bridgman, *Gertrude Stein in Pieces* (New York, 1970), 71–72.

89. Gertrude Stein, *The Making of Americans: Being*

a *History of a Family's Progress* (Dijon, 1925; first American edition, New York, 1926; reprint, Normal, Ill., 1995), 289. See also 290–309 and 602–610. For this reading of the Stein poster, I am much indebted to Susan Frye, a former student who knew Bridgman's work and this passage and used it convincingly in a term paper she wrote in Dec. 1982 about the painting.

90. James R. Mellow, *Charmed Circle: Gertrude Stein and Company* (New York, 1974), 164.

91. For a fuller examination of this portrait, see Frank, *Demuth's Poster Portraits*, 90–100.

92. This subject has attracted the attention of a number of feminists and literary scholars. A key text from the period itself is Joan Riviere, "Womanliness as a Masquerade," first published in *International Journal of Psychoanalysis* 10 (1929) and reprinted in *Formations of Fantasy*, ed. Victor Burgin et al. (New York, 1986) 35–44. See also Susan Gubar, "Blessings in Disguise: Cross Dressing as Re-Dressing for Female Modernists," *Massachusetts Review* 22 (autumn 1981): 477–508. Judith Butler, "Lacan, Riviere, and Strategies of Masquerade," in *Gender Trouble: Feminism and the Subversion of Identity* (New York, 1990), 43–56. On Abbott's photograph of Flanner, see Terry Castle, "The Gaiety of Janet Flanner," in *The Apparitional Lesbian: Female Homosexuality and Modern Culture* (New York, 1993), 190–91. For Cahun's self-portraits with masks, see François Leperlier, *Claude Cahun, l'écart et la métamorphose* (Paris, 1992); and "The Surrealism of Claude Cahun," in David Bate and François Leperlier, *Mise en Scène: Claude Cahun, Tacita Dean, Virginia Nimarkoh* (London, 1994). Thanks to Jeanne Fraise for help with these references.

93. "Charles Duncan had a fine mind but found that he couldn't paint. He did the big Maxwell House sign at the corner of 48th and Broadway. The Cup was seventeen feet in diameter." Charles Daniel, Demuth's dealer, in an interview with Emily Farnham in "Demuth: Life, Psychology, and Works," 994. For the little biographical information that has been uncovered on Duncan, see William Innes Homer, *Alfred Stieglitz and the American Avant-Garde* (Boston, 1977), 307; and Frank, *Demuth Poster Portraits*, 42–47.

94. Demuth to Stieglitz, July 12, 1926, Stieglitz Collection, YCAL.

95. Several scholars have worked hard to decode these portraits. In my own interpretations here, I have borrowed, in part, from those by Abraham A. Davidson, Edward A. Aiken, and Robin Jaffee Frank, all previously cited.

96. Foreword to *Georgia O'Keeffe, Paintings, 1926*, exh. brochure, Intimate Gallery (New York, 1927); and Demuth to Stieglitz, Jan. 17, 1931, Stieglitz Collection, YCAL.

97. Frank, *Demuth Poster Portraits*, 25.

98. Ibid., 23, 133 n. 30.

99. Ibid., 32.

100. Paul Rosenfeld, *Port of New York: Essays on Fourteen American Moderns* (New York, 1924; reprint, Urbana, Ill., 1961, 1966), 153.

101. Paul Strand, "Marin Not an Escapist," *New Republic* 55 (July 25, 1928): 254.

102. Chauncey, *Gay New York*, 273. See also Kenneth E. Silver's essay "Modes of Disclosure: The Construction of Gay Identity and the Rise of Pop Art," in Donna De Salvo and Paul Schimmel, *Hand-Painted Pop: American Art in Transition, 1955–1962*, ed. Russell Ferguson (Los Angeles, 1992), where he begins to explore this idea in Demuth.

103. Arthur C. Danto, "Charles Demuth," *Nation* (Jan. 23, 1988): 102. My thanks to Cécile Whiting for calling this review to my attention.

104. Milwaukee Art Center, *Pop Art and the American Tradition* (Milwaukee, Wis., 1965); Lucy R. Lippard, *Pop Art* (New York, 1966), 12; and John Russell and Suzi Gablik, *Pop Art Redefined* (London, 1969), 28.

CHAPTER FIVE: THE GREAT
AMERICAN THING

1. Hutchins Hapgood, *A Victorian in the Modern World* (New York, 1939).

2. Although Rebecca Strand, Helen Torr, and Dorothy Norman—all of them practicing artists—were allied with the second circle, O'Keeffe was the only woman Stieglitz granted full membership. He and O'Keeffe were good friends with Florine Stettheimer, but she too was never made a part of the core group.

3. The bibliography on O'Keeffe is immense, and I am indebted to the many scholars who have contributed to the reconstruction of O'Keeffe's biography and development as an artist. A catalogue raisonné, prepared by Barbara Lynes, forthcoming from the National Gallery of Art and the Georgia O'Keeffe Foundation, will be an indispensable and authoritative source of information about the artist. For a selected bibliography and an up-to-date chronology, see the study by Charles C. Eldredge, *Georgia O'Keeffe: American and Modern* (New Haven, Conn., 1993).

4. Barbara Buhler Lynes, *O'Keeffe, Stieglitz, and the Critics, 1916–1929* (Ann Arbor, Mich., 1989).

5. Stieglitz to O'Keeffe, Mar. 31, 1918, in Anita Pollitzer, *A Woman on Paper: Georgia O'Keeffe* (New York, 1988), 159.

6. This essay of 1919 was unpublished until Dorothy Norman printed it in *Alfred Stieglitz: An American Seer* (1960; reprint, New York, 1973), 136–38.

7. Sadakichi Hartmann, *A History of American Art* (Boston, 1901), 1:292–93.

8. See Edmund Wilson, "The Stieglitz Exhibition"

(Mar. 18, 1925), in *The American Earthquake: A Documentary of the Twenties and Thirties* (New York, 1958), 98–101, for example, where Wilson distinguishes between feminine and masculine characteristics and speaks of Marin's "masculine masterpieces"; see also Paul Rosenfeld on "the harmonious release" of Marin's watercolors, the "virile and profound talent" of Dove, and "the gloriously female" art of O'Keeffe, in Rosenfeld, "American Painting," *Dial* 71 (Dec. 1921): 666–70.

9. Paul Rosenfeld, "The Paintings of Georgia O'Keeffe: The Work of the Young Artist Whose Canvases Are to Be Exhibited in Bulk for the First Time This Winter," *Vanity Fair* 19 (Oct. 1922): 56, 112, 114, reprinted in Lynes, *O'Keeffe*, 175–79.

10. Paul Strand's letter to the editor about an O'Keeffe exhibition was printed in "Art Observatory: Exhibitions and Other Things," *New York World*, Feb. 11, 1923, 11M, and reprinted in Lynes, *O'Keeffe*, 193–94.

11. Wilson, "Stieglitz Exhibition," 98–101.

12. Lewis Mumford, *The Brown Decades: A Study of the Arts in America, 1865–1895* (1931; reprint, New York, 1955), 244–45.

13. O'Keeffe to Henry McBride, Feb. 1923, reprinted in Jack Cowart and Juan Hamilton with Sarah Greenough, *Georgia O'Keeffe: Art and Letters* (Washington, D.C., 1987), 171–72.

14. Gladys Oaks, "Radical Writer and Woman Artist Clash on Propaganda and Its Uses," *New York World*, Mar. 16, 1930, woman's section, 1, 3.

15. Joseph Stella, quoted in Irma B. Jaffe, *Joseph Stella* (Cambridge, Mass., 1970), 11–12.

16. Anne Middleton Wagner, *Three Artists (Three Women): Modernism and the Art of Hesse, Krasner, and O'Keeffe* (Berkeley and Los Angeles, 1996), 87.

17. For a selection of these portraits, see Metropolitan Museum of Art, *Georgia O'Keeffe: A Portrait by Alfred Stieglitz* (New York, 1978).

18. Barbara Lynes convincingly demonstrates that O'Keeffe had begun to work against her critics by 1923, after the reviewers of her one-woman exhibition, sounding very much alike, repeatedly stereotyped her as a female artist. Lynes further argues that in 1923 O'Keeffe, to thwart her critics, began to move away from abstraction toward a more figurative and objective painting style. Since every artist had moved away from abstraction by the mid-1920s, I am not convinced by this last point. But I am grateful to Lynes for carefully establishing the moment when O'Keeffe began to rebel. For Lynes's analysis of O'Keeffe's biographic and artistic response to her critics, see Lynes, "The Language of Criticism: Its Effect on Georgia O'Keeffe's Art in the 1920s," in *From the Faraway Nearby: Georgia O'Keeffe as Icon*, ed. Christopher Merrill and Ellen Bradbury (Reading, Mass., 1992), 43–54, and Lynes, "Georgia O'Keeffe and Feminism: A Problem of Position," in *The Expanding Discourse: Feminism and*

Art History, ed. Mary D. Garrard and Norma Broude (New York, 1992), 436–49.

19. O'Keeffe to Mitchell Kennerley, fall 1922, in Cowart, Hamilton, and Greenough, *Art and Letters*, 170–71.

20. O'Keeffe to Mabel Dodge Luhan [1925?], in ibid., 180. Luhan did write an idiosyncratic essay about O'Keeffe, but it was never published. Revealing how vexed the issue of a woman's art could be in the 1920s, she characterized O'Keeffe as a woman working totally out of her unconscious, as if she exerted no control over her work whatsoever, and was deeply critical of Stieglitz for taking too much credit for O'Keeffe's achievements and being too much the showman. See Wagner, *Three Artists*, for a reprint of Luhan's essay, 291–93, and discussion of it, 47–48. See also the discussion in Lynes, *O'Keeffe*, 101–2.

21. Blanche Matthias, "Georgia O'Keeffe and the Intimate Gallery: Stieglitz Showing Seven Americans," *Chicago Evening Post Magazine of the Art World* (Mar. 2, 1926): 1, 14, reprinted in Lynes, *O'Keeffe*, 246–50. For O'Keeffe's letter of thanks and appreciation for the essay, see Cowart, Hamilton, and Greenough, *Art and Letters*, 183.

22. O'Keeffe to Henry McBride [Mar. 1925?], in Cowart, Hamilton, and Greenough, *Art and Letters*, 179.

23. In 1965 O'Keeffe told a journalist that "the men decided they didn't want me to paint New York." They told her to "leave New York to the men. I was furious!" Ralph Looney, "Georgia O'Keeffe," *Atlantic* 215 (Apr. 1965): 108. In her own book, *Georgia O'Keeffe* (New York, 1976), the artist wrote of moving into the thirtieth floor of the Shelton Hotel and being so excited by the views "that I began talking about trying to paint New York. Of course, I was told that it was an impossible idea—even the men hadn't done too well with it." She then relates how her first canvas of New York, *New York with Moon*, was eliminated from the *Seven Americans* exhibition that year, presumably by Stieglitz, "much to my disappointment" (n.p.).

24. Georgia O'Keeffe to Waldo Frank, Jan. 10, 1927, in Cowart, Hamilton, and Greenough, *Art and Letters*, 185.

25. In 1949 O'Keeffe returned to New York as a subject one last time to make her one and only rendition of Brooklyn Bridge, now in the collection of the Brooklyn Museum. This was the year O'Keeffe departed New York for good and moved to New Mexico. Sarah Peters suggests the painting is a valentine, given the shape made by the arches and cables, to Stieglitz's and her life together in Manhattan, now ended. Sarah Whitaker Peters, *Becoming O'Keeffe: The Early Years* (New York, 1991), 21–22. Like Stella, O'Keeffe pictured Brooklyn Bridge as a metaphor of departure as well as arrival.

26. Alfred Stieglitz to Waldo Frank, Aug. 25, 1925, YCAL; quoted in Cowart, Hamilton, and Greenough, *Art and Letters*, 282 n. 33.

27. O'Keeffe to Henry McBride, summer 1929, Cowart, Hamilton, and Greenough, *Art and Letters*, 189.

28. The exceptions to the pattern were the summers of 1932 and 1933, when she had a nervous breakdown and was too ill to travel, and 1939, when she was also sick.

29. Like O'Keeffe, Rebecca Strand made New Mexico her home. In 1933 she and Paul Strand were divorced. Rebecca moved to Taos, where she continued to make art; married William James; and remained for the rest of her life. See Museum of Fine Arts, Santa Fe, Museum of New Mexico, *Rebecca Salsbury James: A Modern Artist and Her Legacy* (Santa Fe, N.M., 1991).

30. Even the most committed feminist art historians focus on O'Keeffe's career when she was with Stieglitz and pay little attention to what happened to her and her art after she went out on her own. This focus suggests both the hold the Stieglitz circle continues to have on the art-historical imagination and the dominance of relationships between women and their partners in studies of women artists. O'Keeffe's biographers, too many to cite, chronicle her years in New Mexico, but without much integration of her art and her life.

31. O'Keeffe used the same head for two other important paintings, *Cow's Skull with Calico Rose* (1931) and *Cow's Skull on Red* (1931/36), which have the same jagged and brittle lines of decay in the lower half of the skull.

32. I'm very grateful to Dr. Timothy R. Johnson, a large-animal veterinarian in Taos, and Dr. William Haines, a veterinarian in Wetherfield, Connecticut, for looking at this image with me and assuring me that the features of O'Keeffe's skull were accurate, if exaggerated.

33. Georgia O'Keeffe, introduction to Metropolitan Museum of Art, *Georgia O'Keeffe*, n.p.

34. Paul Rosenfeld, "Marsden Hartley," in *Port of New York: Essays on Fourteen American Moderns* (New York, 1924; reprint, Urbana, Ill., 1961, 1966), 99–100, delivered the official second-circle thinking about Hartley: "Hartley will have to go back to Maine. For it seems that flight from Maine is in part flight from his deep feelings. . . . [W]hen he has to make his peace with life, it is to this soil, so it would appear, that he must return. Here are his own people; the ones he must accept and understand and cherish. For among them only can he get the freedom of his own soul."

35. William Carlos Williams, "The American Background," in *America and Alfred Stieglitz: A Collective Portrait*, ed. Waldo Frank et al. (Garden City, N.Y., 1934), 29.

36. D. H. Lawrence, *Studies in Classic American Literature* (1923; reprint, New York, 1964), 6.

37. Georgia O'Keeffe, quoted in Calvin Tomkins, "The Rose in the Eye Looked Pretty Fine," *New Yorker* 50 (Mar. 4, 1974): 62.

38. Georgia O'Keeffe to Russell Vernon Hunter, Jan. 1932, in Cowart, Hamilton, and Greenough, *Art and Letters*, 205.

39. O'Keeffe to Dorothy Brett, mid Feb. 1932, in ibid., 206.

40. Georgia O'Keeffe, exhibition statement, 1940, reprinted in an excellent study of this little-known chapter of the artist's career, Jennifer Saville, *Georgia O'Keeffe: Paintings of Hawaii* (Honolulu, 1990), 17.

41. The winter 1990 issue of the *Journal of the Southwest* 32 has a stimulating set of essays entitled "Inventing the Southwest." For a discussion of the promotional schemes offered by Fred Harvey and the Santa Fe Railroad, see particularly Marta Weigle, "Southwest Lures: Innocents Detoured, Incensed Determined," 499–540. See also Weigle, "From Desert to Disney World: The Santa Fe Railway and the Fred Harvey Company Display the Indian Southwest," *Journal of Anthropological Research* 45 (Spring 1989): 115–37; Marta Weigle and Barbara Babcock, eds., *The Great Southwest of the Fred Harvey Company and the Santa Fe Railroad* (Tucson, Ariz., 1996); Sandra D'Emilio and Suzan Campbell, *Visions and Visionaries: The Art and Artists of the Santa Fe Railway* (Salt Lake City, Utah, 1991); and Kathleen L. Howard and Diane F. Pardue, *Inventing the Southwest: The Fred Harvey Company and Native American Art* (Flagstaff, Ariz., 1996).

42. Sylvia Rodriguez, "Art, Tourism, and Race Relations in Taos: Toward a Sociology of the Art Colony," *Journal of Anthropological Research* 45 (spring 1989): 77–99.

43. Alfonso Ortiz, *The Tewa World: Space, Time, Being, and Becoming in a Pueblo Society* (Chicago, 1969); Ortiz, ed., *Handbook of North American Indians*, vol. 9 (Washington, D.C., 1979); and Elsie Clews Parsons, *Pueblo Indian Religion*, 2 vols. (Chicago, 1939).

44. O'Keeffe, *Georgia O'Keeffe*, n.p.

45. For bibliography about the writing contingent in these colonies, see Marta Weigle and Kyle Fiore, *Santa Fe and Taos: The Writer's Era, 1916–1941* (Santa Fe, N.M., 1982); and Arrell Morgan Gibson, *The Santa Fe and Taos Colonies: Age of the Muses, 1900–1942* (Norman, Okla., 1983). For the artists' participation in the colonies, see Van Deren Coke, *Taos and Santa Fe: The Artist's Environment, 1882–1942* (Albuquerque, N.M., 1963); Sharyn Rohlfsen Udall, *Modernist Painting in New Mexico, 1913–1935* (Albuquerque, N.M., 1984); Udall, *Santa Fe Art Colony, 1900–1942* (Santa Fe, N.M., 1987); and Charles C. Eldredge, Julie Schimmel, and William H. Truettner, *Art in New Mexico, 1900–1945: Paths to Taos and Santa Fe* (New York, 1986).

46. James Johnson Sweeney, *Stuart Davis* (New York, 1945), 15.

47. Edmund Wilson, "The Enchanted Forest" (1930–31), reprinted in his *American Earthquake*, 350.

48. Edmund Wilson, "Indian Corn Dance," 1930–31, in ibid., 365.

49. Marsden Hartley to Alfred Stieglitz, Nov. 12, 1914. YCAL.

50. For discussion of Hartley and the American Indian, see Gail Levin, "American Art," in *"Primitivism" in Twentieth Century Art: Affinity of the Tribal and the Modern,* ed. William Rubin (New York, 1984), 2:452–73. See also Ann Temkin, "Marsden Hartley's 'America': The 1914 Indian Compositions," a paper delivered at the Sixth Annual Whitney Symposium on American Art, Apr. 25, 1983.

51. Hartley broke his stay in New Mexico with several months in California during the winter of 1918–19. The articles he wrote are "Tribal Esthetics," *Dial* 65 (Nov. 16, 1918): 399–401; "Red Man Ceremonials: An American Plea for American Esthetics," *Art and Archaeology* 9 (Jan. 1920): 7–14, reprinted as "The Red Man," in his *Adventures in the Arts: Informal Chapters on Painters, Vaudeville, and Poets* (1921; reprint, New York, 1972), 13–29; "The Scientific Esthetic of the Redman," part 1, "The Great Corn Ceremony at Santo Domingo," *Art and Archaeology* 13 (Mar. 1922): 113–19; and "The Scientific Esthetic of the Redman," part 2, "The Fiesta of San Geronimo at Taos," *Art and Archaeology* 14 (Sept. 1922): 137–39.

52. On the efforts to ban or disrupt dances, see Udall, *Modernist Painting,* 173, 222 n. 8.

53. Hartley, "The Red Man," 26–28.

54. Hartley, "Great Corn Ceremony," 115–16.

55. Paul Rosenfeld, "Turning to America: The Corn Dance," in *By Way of Art: Criticisms of Music, Literature, Painting, Sculpture, and the Dance* (New York, 1928), 217–35.

56. D. H. Lawrence, "America, Listen to Your Own," first published in *New Republic,* Dec. 15, 1920, reprinted in *Phoenix: The Posthumous Papers of D. H. Lawrence,* ed. Edward D. McDonald (New York, 1936), 90–91.

57. Stieglitz makes references to Lawrence throughout his letters. To Herbert J. Seligmann, a younger critic in the second circle, he wrote that Lawrence's *Studies in Classic American Literature* "touched me to the quick. The book I have been waiting for for years." Stieglitz to Seligmann, Sept. 9, 1923, YCAL. Seligmann then wrote *D. H. Lawrence: An American Interpretation* (New York, 1924). For a list of books by Lawrence in Stieglitz's and O'Keeffe's library, see Ruth E. Fine, Elizabeth Glassman, and Juan Hamilton with Sarah L. Burt, *The Book Room: Georgia O'Keeffe's Library in Abiquiu* (New York, 1997), 43–45.

58. D. H. Lawrence, "America, Listen to Your Own," in *Posthumous Papers of D. H. Lawrence,* ed. McDonald.

59. For reports on Lawrence's time in America see three personal memoirs: Mabel Dodge Luhan, *Lorenzo in Taos* (New York, 1932); Dorothy Brett, *Lawrence and Brett: A Friendship* (Philadelphia, 1933); and Joseph Foster, *D. H. Lawrence in Taos* (Albuquerque, N.M., 1972). For studies of the effects of this period in America on his writing, see Armin Arnold, *D. H. Lawrence and America* (London, 1958); David Cavitch, *D. H. Lawrence and the New World* (New York, 1969); and James C. Cowan, *D. H. Lawrence's American Journey: A Study in Literature and Myth* (Cleveland, Ohio, 1970).

60. D. H. Lawrence, "New Mexico," *Survey Graphic* (May 1931): 152–55.

61. Ibid., 155.

62. For fresh scholarship on Luhan, see Lois Palken Rudnick, *Mabel Dodge Luhan: New Woman, New Worlds* (Albuquerque, N.M., 1984); and Rudnick, *Utopian Vista: The Mabel Dodge Luhan House and the American Counterculture* (Albuquerque, N.M., 1996).

63. Jean Toomer quoted in Rudnick, *Utopian Vista,* 108.

64. An unpublished paper by the historian Kirsten Swinth, "Friendships among Women Artists: Women's Experience of Art and Work in Twentieth-Century America," 1989, looks closely at the nature of female friendship between O'Keeffe, Strand, Brett, and Luhan. More work of this sort needs to be done.

65. O'Keeffe to Henry McBride, summer 1929, in Cowart, Hamilton, and Greenough, *Art and Letters,* 189.

66. O'Keeffe to Russell Vernon Hunter, late Aug. 1931, in ibid., 204.

67. Kyle Crichton, "Cease Not Living," *New Mexico Quarterly* 5 (1936): 71, quoted in Udall, *Modernist Painting,* 172.

68. O'Keeffe, *Georgia O'Keeffe,* n.p. For artists' interpretations of the church, see Sandra D'Emilio and Suzan Campbell, *Spirit and Vision: Images of Ranchos de Taos Church* (Santa Fe, N.M., 1987).

69. For reproductions and discussion of the cross paintings, see James Moore, "Georgia O'Keeffe's 'Grey Cross with Blue,'" *Artspace* 10 (summer 1986): 32–39.

70. Two years later on the Gaspé Peninsula O'Keeffe painted local crosses, but without the mystique of region and a rich cultural lore these paintings lack the intensity or emotional heat of those she painted during that first summer in Taos.

71. O'Keeffe often talked about how she sent east a barrel of bones, most notably in the book she wrote about herself, O'Keeffe, *Georgia O'Keeffe,* n.p. She talks about the ceremonial blanket and artificial flowers with the critic Ishbel Ross, "Bones of Desert Blaze Art Trail of Miss O'Keeffe," *New York Herald Tribune,* Dec. 29, 1931, 3.

72. Sue Davidson Lowe, "O'Keeffe, Stieglitz, and the Stieglitz Family: An Intimate View," in *From the Faraway Nearby,* ed. Merrill and Bradbury, 15–23.

73. No checklist has been found, but Elizabeth McCausland, reviewing the exhibition, wrote of a "half dozen" bone paintings; see her "Georgia O'Keeffe Exhibits Skulls and Roses of 1931," *Springfield Sunday Union and Republican,* Jan. 10, 1932, E6.

74. Edward Alden Jewell, "Georgia O'Keeffe Shows Work," *New York Times,* Dec. 29, 1931. In this review Jewell quotes from another, unidentified, critic.

75. Henry McBride, "Skeletons on the Plain: Miss O'Keeffe Returns from the West with Grewsome [*sic*] Trophies," *New York Sun*, Jan. 2, 1932, 8; and McCausland, "O'Keeffe Exhibits Skulls and Roses," E6.

76. Paul Rosenfeld, "After the O'Keeffe Show," *Nation* 132 (Apr. 8, 1931): 389.

77. Henry McBride, "Skeletons on the Plain," 8.

78. Ibid.

79. Henry Seldis, "Georgia O'Keeffe at Seventy-eight: Tough-Minded Romantic," *Los Angeles Times West Magazine* (Jan. 22, 1967): 14–17.

80. Henry McBride, "The Sign of the Cross: Georgia O'Keefe's [*sic*] Impressions of the Taos Region Exhibited Here," *New York Sun*, Feb. 8, 1930, 8.

81. Georgia O'Keeffe, quoted in Ross, "Bones of Desert," 3.

82. McCausland, "O'Keeffe Exhibits Skulls and Roses," E6.

83. O'Keeffe, in an exhibition statement for An American Place, *Georgia O'Keeffe* (New York, 1939), n.p.

84. See Julie Schimmel, "Inventing 'the Indian,'" in *The West as America: Reinterpreting Images of the Frontier, 1820–1920*, ed. William H. Truettner (Washington, D.C., 1991), 168–78.

85. For a short history of the buffalo and the ways artists represented them, see Larry Barsness, *The Bison in Art: A Graphic Chronicle of the American Bison* (Fort Worth, Tex., 1976), 124.

86. Joseph Sharp, letter of June 15, 1906, quoted in Forrest Fenn, *The Beat of the Drum and the Whoop of the Dance* (Santa Fe, N.M., 1983), 202.

87. Patricia Trenton and Patrick T. Houlihan, *Native Americans: Five Centuries of Changing Images* (New York, 1989), 205.

88. Ibid.

89. There were at least fourteen dude ranches in the Taos–Santa Fe area in the 1930s, by far the greatest concentration in New Mexico. Lawrence R. Borne, *Dude Ranching: A Complete History* (Albuquerque, N.M., 1983).

90. Arthur Pack, the former publisher of *Nature Magazine*, based in Princeton, New Jersey, bought and developed Ghost Ranch, where he and his family had once boarded to improve the health of a daughter. He and his wife were part of the changing demographics of northern New Mexico in the early part of this century as East and West Coast émigrés arrived with new money and professional skills and began to develop a strong Anglo-centered economic and intellectual life around Santa Fe and Taos. See his autobiography, Arthur Newton Pack, *We Called It Ghost Ranch* (Abiquiu, N.M., 1979).

91. Ibid., 23.

92. The cow's skull is still the logo of Ghost Ranch, but because of vandals a carved sign rather than an actual skull is used. Arthur Pack reported that one day O'Keeffe brought him "a gift of a perfect drawing of a cow's skull which I then and there adopted as the insignia and trademark of the Ghost Ranch" (ibid., 30, 44). This drawing is probably the cow's skull Pack used on the cover of his self-published autobiography.

93. My thanks to William Harden, who told me about, and loaned me, his Thirty-fourth Division patch. Approved for use Oct. 29, 1918, for the Sandstorm Division, the insignia represents a cow's skull on an olla, a Mexican water jar, representing New Mexico, where the division trained during World War I. A more formal neoclassical garlanded skull was used at the entrance of the United States Courthouse built in Santa Fe at the end of the nineteenth century. As the skull passed into more general circulation, art deco designers contemporaneous with O'Keeffe saw its potential for regional references and included it prominently in architectural decorations. This style is known today as pueblo deco.

94. See Donna Haraway, "Teddy Bear Patrimony: Taxidermy in the Garden of Eden, New York City, 1908–1936," in *Primate Visions, Gender, Race, and Nature in the World of Modern Science* (New York, 1989), 26–58.

95. Barsness, *Bison in Art*, 116.

96. See T. J. Jackson Lears, *No Place of Grace: Antimodernism and the Transformation of American Culture, 1880–1920* (New York, 1981).

97. O'Keeffe often hung paintings for Stieglitz in his galleries and did all the installations at An American Place. He had great confidence in her eye and skills as a decorator.

98. O'Keeffe, quoted in Tomkins, "Rose in the Eye," 48, 50.

99. O'Keeffe, *Georgia O'Keeffe*, n.p.; O'Keeffe repeats this version in the documentary film directed and produced by Perry Miller Adato, *Georgia O'Keeffe* (Boston, 1977). Anita Pollitzer, in her memoirs and exchange of letters with O'Keeffe, *A Woman on Paper*, 212, recalls O'Keeffe's telling the same story in a conversation with her "circa 1931." While this could well be true, there is nothing to substantiate it.

100. Thomas Hart Benton, "America and/or Alfred Stieglitz," *Common Sense* 4 (Jan. 1935): 25–35, reprinted in *A Thomas Hart Benton Miscellany: Selections from His Published Opinions, 1916–1960*, ed. Matthew Baigell (Lawrence, Kans., 1971), 65–74; the passage quoted in the text is from 68.

101. John Gould Fletcher, "The Stieglitz Spoof," *American Review* 4 (Mar. 1935): 597, 602.

102. Even though many of the Stieglitz circle did not live in Manhattan, the city was the center of their universe, the place to which they returned, if not to live, then to sell work and replenish their friendships.

103. See Gail R. Scott, "Marsden Hartley at Dogtown Common," *Arts Magazine* 54 (Oct. 1979): 159–65; and Donna M. Cassidy, "'On the Subject of Nativeness':

Marsden Hartley and New England Regionalism," *Winterthur Portfolio* 29 (winter 1994): 227–45. "Return of the Native" was published in *Contact* 1 (May 1932): [28].

104. In the late 1970s O'Keeffe wrote of her multiple selves: "When I look over the photographs Stieglitz took of me—some of them more than sixty years ago—I wonder who that person is. It is as if in my one life I have lived many lives." O'Keeffe, in Metropolitan Museum of Art, *Georgia O'Keeffe*, n.p.

CHAPTER SIX: HOME, SWEET HOME

1. In an undated two-character play, "'You Must Come Over': A Painting, a Play," Charles Demuth struggles to locate great painters in the American past. He finds Washington Allston, perhaps the first important American painter—but he went "mad after returning to America from years spent in Europe." And then there is no one until George Fuller and Homer Martin, both of whom Demuth finds wanting. The play, probably written around 1920, is reprinted in Barbara Haskell, *Charles Demuth* (New York, 1987), 41–42. Of the second Stieglitz circle, Marsden Hartley was the one who took American art of the recent past most seriously. In *Adventures in the Arts: Informal Chapters on Painters, Vaudeville, and Poets* (1921; reprint, New York, 1972), he wrote critically of American artists of the previous generation: Albert Pinkham Ryder, Homer Martin, George Fuller, Winslow Homer, John H. Twachtman, Theodore Robinson, and Rex Slinkard. Among the first to express a taste for American folk art, he devoted an essay to an artist he considered an amateur and a Victorian "primitive," Jennie Vanvleet Cowdery. In the 1930s Hartley's criticism contributed to the revival of interest in John Singleton Copley, Homer, Thomas Eakins, and William Harnett and he continued to champion Ryder. See, for example, the essays collected in *On Art, by Marsden Hartley*, ed. Gail R. Scott (New York, 1982).

2. Carol Vogel, "Sale of Homer Sets Record: William Gates Buys Winslow Homer's 'Lost on the Grand Banks' for $30 Million," *New York Times*, May 5, 1998, A14.

3. For the most recent and fullest treatment of Sheeler's career, see Carol Troyen and Erica E. Hirshler, *Charles Sheeler: Paintings and Drawings* (Boston, 1987); and Theodore E. Stebbins, Jr., and Norman Keyes, Jr., *Charles Sheeler: The Photographs* (Boston, 1987), written to accompany a retrospective exhibition organized by the Boston Museum of Fine Arts. See also Karen Lucic, *Charles Sheeler and the Cult of the Machine* (London, 1991). For my particular slant on Sheeler, two other studies served as essential sources: Susan Fillin Yeh, *Charles Sheeler: American Interiors* (New Haven, Conn., 1987); and Karen Lucic, *Charles Sheeler in Doylestown: American Modernism and the Pennsylvania Tradition* (Allentown, Penn., 1997).

4. Of all the artists looked at in this book, Sheeler was the most reserved and formal in verbal expression. He let others do most of the talking. Although he wrote letters, began an autobiography, and submitted to interviews, he was by and large a cautious thinker and stilted writer. He had a sense of humor, but it was dry and ironic. When he tried to explain his art, he was formal or indirect, or both. When Constance Rourke quoted from his handwritten autobiographical manuscript in her monograph on the artist, she often edited his prose to make it more graceful. The fullest compilation of his writings, including the autobiography, is in the Sheeler papers, AAA.

5. Sheeler, in a letter to Louise Arensberg in 1933, testified to how awestruck American artists were by the French artists who lived among them during World War I. He described his friendship with Duchamp as follows: "It hasn't been one of those friendships that bursts into bloom over night. Perhaps I was too awe-struck in the early years and too readily accepted the prevailing belief that any Franco-American alliance must be on different terms than any other alliance." Nov. 10, 1933, Arensberg Archives, Philadelphia Museum of Art, Twentieth Century Department, quoted in Troyen and Hirshler, *Charles Sheeler*, 45 n. 17.

6. Stieglitz and others in the second circle, especially Paul Strand, took great exception to the review Sheeler wrote of Stieglitz's 1923 retrospective exhibition at the Anderson Galleries. Published in *Arts* (May 1923), Sheeler's review was exceedingly positive, but he failed to follow the party line when he made a critical remark about the "preciousness" of platinum prints and compared qualities he found in Stieglitz photographs to those in old master paintings. Stieglitz, who never had totally embraced Sheeler, now made it clear that they were no longer friends. For Stieglitz, comparing his photographs with paintings was an old-fashioned pictorialist idea, dangerous, moreover, because it blurred the autonomy of the photographic medium. For discussion of this incident, see Stebbins and Keyes, *Charles Sheeler: The Photographs*, 21–23.

7. The music for "Home, Sweet Home" was written by Henry Bishop, an Englishman, its lyrics by John Howard Payne, an American actor in London, who used it in his opera *Clari, The Maid of Milan* (1823). Its greatest popularity as a song was in nineteenth-century America. "It was still such a favorite during the Civil War that, on one occasion, the two opposing armies sang it together during the night watch on either side of the Potomac." William R. Ward, *The American Bicentennial Song Book, 1770s–1870s* (New York, 1975), 1:126.

8. James A. Michener, one of many famous writers and theater people in Bucks County, in 1987 established and endowed the James A. Michener Art Museum, in

Doylestown, to show the work of the artists who flourished there.

9. On both the artist and details of the Worthington house, see Karen Davies, "Charles Sheeler in Doylestown and the Image of Rural Architecture," *Arts Magazine* 59 (Mar. 1985): 135–39.

10. Alfred Stieglitz to Paul Strand, July 12, 1923, YCAL.

11. Visits to the unique Fonthill and the Mercer Museum, as well as the Moravian Pottery and Tile Works, once again in production, should be mandatory for anyone interested in the history of museology, American material culture, and turn-of-the-century eccentricity. For research on Mercer, see Cleota Reed, *Henry Chapman Mercer and the Moravian Pottery and Tile Works* (Philadelphia, 1987); and Steven Conn, "Henry Chapman Mercer and the Search for American History," *Pennsylvania Magazine of History and Biography* 116 (July 1992): 323–55. Michener, who spent his childhood in Mercer's neighborhood, characterized him as a "mad genius" in "Saving the Nation: Henry Mercer's Mad Dash to Capture Living History," *Art and Antiques* (Oct. 1987): 92–97.

12. For an exhibition catalogue essay exploring Sheeler's interiors, both painted and lived-in, see Yeh, *Sheeler: American Interiors*. See also Karen Lucic's exhibition review "Charles Sheeler: American Interiors," *Arts Magazine* 61 (May 1987): 44–47.

13. The chair is identified in Troyen and Hirshler, *Charles Sheeler*, 136 n. 2.

14. Milton W. Brown first began to define these differences fifty years ago, coining the term "Cubist-Realism" to describe an American variant of French cubism. See Brown, "Cubist-Realism: An American Style," *Marsyas* 3 (1943–45): 139–60.

15. Sheeler, quoted in Constance Mayfield Rourke, *Charles Sheeler: Artist in the American Tradition* (New York, 1938), 144.

16. Those who invented the period rooms added set design and anthropology to their previously honed skills as connoisseurs and antiquarians. Not only were they required to have an accomplished eye for historical styles of architecture and furniture as well as fabrics and wall coverings, but they also had to know something about how people lived in the past so as to arrange furniture to illustrate everyday interactions. This reasoning eventually led one academic to urge universities in tenure reviews to treat the creation of period rooms as equivalent to published scholarship. E. McClung Fleming, "The Period Room as a Curatorial Publication," *Museum News* (June 1972): 39–43.

17. For the earliest collecting activities, see Richard H. Saunders, "Collecting American Decorative Arts in New England, Part I: 1793–1876," *Antiques* 109 (May 1976): 996–1002; and "Part II: 1876–1910," *Antiques* 110 (Oct. 1976): 754–63. See also William B. Rhoads, "The

Colonial Revival and American Nationalism," *Journal of the Society of Architectural Historians* 35 (Dec. 1976): 239–54.

18. For a useful history of the collecting of American antiques and their entry into museums, see Elizabeth Stillinger, *The Antiquers: The Lives and Careers, the Deals, the Finds, the Collections of the Men and Women Who Were Responsible for the Changing Taste in American Antiques, 1850–1930* (New York, 1980), 128–32, 160–61. See also Charles B. Hosmer, Jr., *Presence of the Past* (New York, 1965); Dianne H. Pilgrim, "Inherited from the Past: The American Period Room," *American Art Journal* 10 (May 1978): 4–23; and Jane Brown Gillette, "Rooms Once Removed," *Historic Preservation* 43 (July–Aug. 1991): 30–36, 71–72.

19. This headline is reproduced and quoted in Marshall B. Davidson, "Those American Things," *Metropolitan Museum of Art Journal* 3 (1970): 130.

20. Other city museums followed suit and opened period rooms: Philadelphia and Boston in 1928, Brooklyn in 1929, Baltimore in 1930, and Saint Louis in 1930–31. See Pilgrim, "Inherited from the Past," 13.

21. For a study of Halsey, see Wendy Kaplan, "R. T. H. Halsey, An Ideology of Collecting American Decorative Arts," *Winterthur Portfolio* 17 (spring 1982): 43–53. This article is drawn from Kaplan's master's thesis of the same title, University of Delaware, 1980.

22. The period room can be traced to exhibitions and the first open-air museums in Germany, Switzerland, and Scandinavia in the late nineteenth century. George Dow transplanted some of these ideas to the Essex Institute, where he used furniture, rooms, and buildings to tell the early history of Salem. See Hosmer, *Presence of the Past*, 211–17; and Stillinger, *The Antiquers*, 149–54.

23. Halsey to Robert W. de Forest, president of the Metropolitan Museum board of trustees, who funded the American Wing, quoted in Kaplan, "R. T. H. Halsey," 52.

24. Homer Keyes, "The New Metropolitan Wing," *Antiques* 7 (Apr. 1925): 182.

25. In the introduction to a catalogue for the period rooms, Halsey wrote: "Many of our people are not cognizant of our traditions and the principles for which our fathers struggled and died. The tremendous changes in the character of our nation, and the influx of foreign ideas utterly at variance with those held by the men who gave us the Republic, threaten and, unless checked may shake its foundations." R. T. Haines Halsey and Elizabeth Tower, *The Homes of Our Ancestors, As Shown in the American Wing of The Metropolitan Museum of Art of New York* (New York, 1925), xxii.

26. Halsey, however, sometimes pointed to American directness and simplicity as the qualities that set off high-style American goods from their English or European counterparts. "Early American silver, as in the case of our early architecture and furniture, is thoroughly characteris-

tic of the taste and life of the period in America. Simple in design and substantial in weight, it reflects the classic mental attitude of the people." R. T. Haines Halsey, *American Silver* (Boston, 1906), 9–10, quoted in Kaplan, "R. T. H. Halsey," 47.

27. Charles Sheeler, quoted in Rourke, *Sheeler: Artist in the American Tradition*, 136.

28. Lewis Mumford, "American Interiors," *New Republic* 41 (Dec. 31, 1924): 139–40.

29. Halsey and Tower, *Home of Our Ancestors*, xii, xxvi.

30. For in-depth studies of what I quickly summarize here, see Richard Ruland, *The Rediscovery of American Literature: Premises of Critical Taste, 1900–1940* (Cambridge, Mass., 1967); David R. Shumway, *Creating American Civilization: A Genealogy of American Literature as an Academic Discipline* (Minneapolis, Minn., 1994); and Gene Wise, ed., "The American Studies Movement: A Thirty-Year Retrospective," *American Quarterly* 31, special issue (1979).

31. For example, Vernon Louis Parrington, *Main Currents in American Thought: An Interpretation of American Literature from the Beginnings to 1920*, 3 vols. (New York, 1927); Samuel Eliot Morison, *The Oxford History of the United States, 1783–1917*, 2 vols. (London, 1927); Perry Miller, *The Puritans* (New York, 1938); F. O. Matthiessen, *American Renaissance: Art and Expression in the Age of Emerson and Whitman* (London, 1941); Henry Nash Smith, *Virgin Land: The American West as Symbol and Myth* (Cambridge, Mass., 1950); Oskar Hagen, *The Birth of the American Tradition in Art* (Port Washington, N.Y., 1940); Oliver W. Larkin, *Art and Life in America* (New York, 1949); and John Kouwenhoven, *Made in America: The Arts in Modern Civilization* (Garden City, N.Y., 1948), reissued as *The Arts in Modern American Civilization* (New York, 1967).

32. From 1928 to 1932 Halsey taught the country's first courses in American decorative arts at Saint John's College in Annapolis, Maryland. From 1936 to 1942 he taught similar courses at Yale, helping to establish the traditions that have made that university preeminent in material culture studies.

33. Mumford, "American Interiors," 139–40.

34. In 1964–65 many of the Shaker pieces in the Sheeler collection were sold to Hancock Shaker Village, Massachusetts. Correspondence between Sheeler and Edith Halpert, his dealer, about the sale can be found in the Downtown Gallery Records, AAA. The Pennsylvania German dower chest he owned is now in the Palmer Museum of Art at the Pennsylvania State University. Terry Dintenfass of the Dintenfass Gallery and Andrew Dintenfass, her son, bought many other pieces of furniture and decorative arts from Sheeler's widow in the early 1970s. Andrew Dintenfass, telephone conversation with the author, Mar. 1998.

35. In a brief, undated, amateur film of Sheeler and his second wife, Muysa, in their Irvington-on-Hudson home, Muysa is seated in a modern chair covered with fabric that Sheeler designed, and there is a glimpse of what appears to be an Alvar Aalto couch.

36. My term "critic-historicists" also links them to the literary historicists of our own time, whose work not only has similar goals but can also, in some cases, be traced back to 1920s models of scholarship.

37. Van Wyck Brooks, "On Creating a Usable Past," *Dial* 64 (Apr. 11, 1918): 337–41.

38. There were also transatlantic advocates for an American usable past. When D. H. Lawrence wrote his passionate little book *Studies in Classic American Literature* (1923), he reread and interpreted many of the "queer geniuses" Brooks refers to in his essay: Benjamin Franklin, J. Hector St. John (Jean de Crèvecoeur), James Fenimore Cooper, Edgar Allan Poe, Nathaniel Hawthorne, Richard Henry Dana, Jr., Herman Melville, and Walt Whitman. Never missing an opportunity to chide Americans for being ignorant of their own national character, Lawrence characterized himself as a "midwife" birthing anew American classics that Americans themselves dismissed as "children's books." Lawrence effectively laid out a "usable past" and dared the American modernist to immerse himself in the contradictions and struggles of his own national literature. D. H. Lawrence, *Studies in Classic American Literature* (1923; reprint, New York, 1964), vii–1.

39. Lewis Mumford, *The Golden Day: A Study in American Experience and Culture* (New York, 1926), 283; and *The Brown Decades: A Study of the Arts in America, 1865–1895* (1931; reprint, New York, 1966), 248. Alan Trachtenberg's insightful "Mumford in the Twenties" can be found in *Salmagundi* 49 (summer 1980): 29–42.

40. Samuel Isham, *The History of American Painting* (1905; reprint, New York, 1927), 3.

41. Sadakichi Hartmann in his *History of American Art* (Boston, 1901); and Charles Henry Caffin, *The Story of American Painting: The Evolution of Painting in America* (Garden City, N.Y., 1907).

42. See Kevin J. Avery, "A Historiography of the Hudson River School," in *American Paradise: The World of the Hudson River School* (New York, 1987), 3–93; and William H. Truettner, "Nature and the Native Tradition," in *Thomas Cole: Landscape into History*, ed. William H. Truettner and Alan Wallach (New Haven, Conn., 1994), 137–57.

43. Mumford, *Brown Decades*, 242.

44. Lloyd Goodrich, *Thomas Eakins: His Life and Work* (New York, 1933), 154–55. Goodrich's first article on Eakins, "Thomas Eakins, Realist," *Arts* 16 (Oct. 1929): 72–83, announced his desire to make an "apathetic" and "indifferent" public see the importance of this artist. Goodrich wrote his book on the artist with financial help

from Juliana Force, the first director of the Whitney Museum of American Art.

45. Mumford, *Brown Decades*, 218, 226.

46. Goodrich, *Thomas Eakins*, 143.

47. Lloyd Goodrich, *Winslow Homer* (New York, 1944), 204.

48. Sheeler quoted in Rourke, *Sheeler: Artist in the American Tradition*, 184–86.

49. Quoted from the Reminiscences of Holger Cahill, Columbia Oral History Collection, in John Michael Vlach, "Holger Cahill as Folklorist," *Journal of American Folklore* 98 (1985): 151–52. The admired watercolor went into Abigail Aldrich Rockefeller's collection. On another occasion Cahill's assistants on an exhibition of American primitives for the Newark Museum reported that they visited Sheeler and his wife, seeking to borrow several fine tinsel paintings that hung on their dining room walls; Sheeler's wife Katharine felt she could not part with them for the duration of the exhibition. Katharine Coffey, letter to Tom Armstrong, July 24, 1967, in the archives of the Newark Museum, Newark, New Jersey, quoted in Wendy Jeffers, "Holger Cahill and American Folk Art," *Antiques* 148 (Sept. 1995): 328.

50. Sheeler quoted in Rourke, *Sheeler: Artist in the American Tradition*, 183.

51. While people in modernist circles dominated the first twenty years of folk art, occasionally an antiques dealer and antiquarian was involved. Isabel Carleton Wilde, for one, collected and sold folk art as an antiques dealer in Boston. Moreover, folk materials were sometimes shown in historical exhibitions. On the "discovery" of folk art, see my own master's thesis, "The Return of the Native: The Development of Interest in American Primitive Painting," Institute of Fine Arts, New York University, 1965; and Beatrix T. Rumford, "Uncommon Art of the Common People: A Review of Trends in the Collecting and Exhibiting of American Folk Art," in *Perspectives on American Folk Art*, ed. Ian M. G. Quimby and Scott T. Swank (New York, 1980), 15–53.

52. Almost none of the art so described was authentically "folk" expression as understood by today's anthropologists, for it was not born of unchanging traditions in communities isolated from outside influences. In the 1980s young scholars of folklore made it a project to wrest the term "folk" from this vast array of Americana. Waging "term warfare," the literature argued that there was nothing "folk" about this material, that this term was purely a construction of the 1930s and should be eliminated from usage. In some circles their arguments have succeeded in replacing "folk art" with "outsider art," at least as a descriptive term for twentieth-century artists. To describe earlier untutored painters, John Michael Vlach has suggested the perfectly fine term "plain painters," which has not, however, been absorbed into general usage. For a sampling of this literature, see John Michael Vlach, *Plain Painters: Making Sense of American Folk Art* (Washington, D.C., 1988); and Vlach and Simon J. Bronner, eds., *Folk Art and Art Worlds: Essays Drawn from the Washington Meeting on Folk Art* (Ann Arbor, Mich., 1986); and Eugene W. Metcalf, Jr., and Claudine Weatherford, "Modernism, Edith Halpert, Holger Cahill, and the Fine Art Meaning of American Folk Art," in *Folk Roots, New Roots: Folklore in American Life*, ed. Jane S. Becker and Barbara Franco (Lexington, Mass., 1988), 141–65.

53. Guy Eglington, "Art and Other Things," *International Studio* 80 (Feb. 1925): 417–19.

54. ND/40, frame 397, Downtown Gallery Records, AAA. My thanks to Karen Lucic for this citation.

55. Holger Cahill, "Document," *Archives of American Art Journal* 24 (1984): 22–23.

56. For the fullest account of Field's career, see Doreen Bolger, "Hamilton Easter Field and His Contribution to American Modernism," *American Art Journal* 20 (1988): 78–107.

57. The artist Dorothy Varian, conversation with the author, 1965. Varian rented an Ogunquit studio in 1923.

58. William Zorach, *Art Is My Life: The Autobiography of William Zorach* (Cleveland, Ohio, 1967), 88.

59. Henry Schnakenberg, interview by author, May 22, 1965.

60. Coady's list of over a hundred things and personalities that he deemed the real art of America appeared in *Soil* 1 (Dec. 1916): 3–4. In 1921 Coady died at Field's home. Holger Cahill's roots as a folk art advocate began in his own short-lived dadaist group, known as Inje-Inje.

61. *New York Herald*, Feb. 17, 1924; and *New York Times*, Feb. 17, 1924, sec. 7, p. 11. The Robert Locker mentioned in the *Times* was Robert Locher, the contemporary painter and decorator, who was closely associated with Charles Demuth.

62. Henry McBride, "American Primitives," *New York Sun*, Nov. 19, 1931, reprinted in McBride, *The Flow of Art*, ed. Daniel Cotton Rich (New York, 1975), 282–83.

63. Sheeler was one of the Whitney group's most Continental and ultramodern painters, and for the short time that he lived at the club he gave the exhibition program a heightened transatlantic flavor. When he had a small solo exhibition of his work in one gallery, in another he assembled works by those who had influenced him: Picasso, Braque, de Zayas, and particularly Duchamp.

64. For the tensions between Stieglitz and Force, and their very different outlook on how to support artists, see Avis Berman, *Rebels on Eighth Street: Juliana Force and the Whitney Museum of American Art* (New York, 1990), especially 222–28.

65. Berman gives a rich account of Force, her homes, and her influential career. For Barley Sheaf Farm, see ibid., 105–8, 145–49; and Lucic, *Sheeler in Doylestown*, 92.

66. Robert Locher was the interior designer of the

apartment. He also had a hand in decorating Demuth's living and dining room, which is said to have had some Victorian furniture and needlework in it. Both Locher and Demuth did needlework. See the interviews with Robert Locher and Richard Weyland in Emily Farnham, "Charles Demuth: His Life, Psychology, and Works," Ph.D. diss., Ohio State University, 1959, 963–64. In the late 1920s, Grant Wood turned to Victorian homes and furnishings in the Midwest as sources for his paintings. This budding interest in Victoriana—witness Sheeler's naming *Home, Sweet Home* for a famous Victorian song—needs much more study. My thanks to Evelyn Hankins for alerting me to Force's neo-Victorian apartment.

67. For Halpert's early history as an art dealer, see Diane Tepfer, "Edith Gregor Halpert and the Downtown Gallery: Downtown, 1926–1940. A Study in American Art Patronage," Ph.D. diss., University of Michigan, 1989.

68. Press release, dated, in pencil, Sept. 1931 and marked "draft," in Downtown Gallery Records, AAA. This is the exhibition that included Raphaelle Peale's *After the Bath*, which Halpert had discovered. For Sheeler, the Peale painting was another great American ancestor: "One could place it among the Chardins"; quoted in Rourke, *Sheeler: Artist in the American Tradition*, 183.

69. Press release, Dec. 9, 1931, Downtown Gallery Records, AAA.

70. "First TV Art Talk, NBC Television, October 6, 1939," Downtown Gallery Records, AAA. Halpert approved (and may well have written) the script that opened with these words.

71. Press release, Nov. 11, 1931, Downtown Gallery Records, AAA.

72. Press release, Apr. 27, 1966, Downtown Gallery Records, AAA.

73. In 1930, for example, a young Lincoln Kirstein helped to organize the exhibition *American Folk Painting* for the Harvard Society for Contemporary Art. It included not only one hundred paintings but also photographs of early gravestones and designs for tattoos, which had "the most valid and direct links with contemporary art." Harvard Society for Contemporary Art, *American Folk Painting* (Cambridge, Mass., 1930).

74. After a rootless childhood and young adulthood, Cahill came to Manhattan in 1905 and took art history and aesthetics courses at Columbia University and economics with Thorstein Veblen at the New School for Social Research; he became friends with artists like John Sloan, Stuart Davis, and in time Charles Sheeler. At first he made a living as a journalist and as a publicist for progressive artists; he also engaged in avant-garde activities that promoted the use of masks and rituals in performance art. He then traveled to Europe to study folk museums, writing appreciatively upon his return in 1922 of contemporary Native American watercolorists as America's "primitives." Cahill worked for the Newark Museum until

1932, when he became director of exhibitions, and even for a time acting director, at the Museum of Modern Art. In 1935 he became director of the New Deal's Federal Art Program, instituting, among other things, the Index of American Design that included pieces of Shaker furniture from Sheeler's collection. For studies of Cahill, see Jeffers, "Holger Cahill and American Folk Art," 326–35, and "Holger Cahill and American Art," *Archives of American Art Journal* 31 (1991): 2–11; see also Vlach, "Holger Cahill as Folklorist."

75. Both Halpert and Cahill were immigrants to the States, making their lifelong dedication to shaping a new history of American art all the more noteworthy. Edith Halpert was born Edith Gregor Fivoosiovitch in Odessa in 1900, immigrating to this country with her Russian Jewish parents when she was six. Cahill was born Sveinn Krisjan Bjarnarson of a poor farming family in Iceland in 1887. His family immigrated first to Canada in 1889 and then to North Dakota.

76. Museum of Modern Art, *Homer, Ryder, Eakins* (New York, 1930). In the first lines of the preface, Barr points out that appreciation for these masters was on the rise: "Homer, Ryder and Eakins seem of considerably more importance than they did in 1920" (6).

77. Museum of Modern Art, *American Folk Art: The Art of the Common Man in America, 1750–1900* (New York, 1932), 3–4.

78. The two exceptions were numbers 28 and 139 in the catalogue, an overmantel from a New England public building (added to the Rockefeller collection in 1957) and a wooden horse.

79. Sheeler's three paintings of Williamsburg sites are *Governor's Palace, Williamsburg; Bassett Hall;* and *Kitchen, Williamsburg.*

80. Tepfer, "Edith Gregor Halpert," 176.

81. The story of the making of the Abby Aldrich Rockefeller Folk Art Center is told in brief by Beatrix T. Rumford and Carolyn J. Weekley, *Treasures of American Folk Art from the Abby Aldrich Rockefeller Folk Art Center* (Boston, 1989), 8–15.

82. *New York Times*, June 6, 1936.

83. In 1966 the trustees changed the name to the Museum of American Folk Art. In 1984, when its quarters had become too small, the museum left Fifty-third Street; it will soon return to a new facility at 45–47 West Fifty-third Street. That these properties were once owned by members of the Rockefeller family symbolically strengthens the interconnections between the family, folk art, and the Museum of Modern Art.

84. Schnakenberg's exhibition of folk artifacts in 1924, for example, followed an exhibition of African art the previous year and was simultaneous with a small Henri Rousseau exhibition organized by Marius de Zayas. Schnakenberg went on to write one of the earliest articles in an American periodical about the artistic qualities of objects

in the natural history museum. Henry E. Schnakenberg, "Art at the Museum of Natural History," *Arts* 7 (May 1925): 247–64. The artists Marguerite and William Zorach felt that the American folk art they collected was an extension of tastes they had acquired earlier in Paris for African art and Henri Rousseau, as well as Russian icons. Coming back to America, Zorach said that he "spent a good deal of time studying the Eskimo and Mayan, Aztec, and all the primitive arts" he found in museums. William Zorach, letter to the author, July 1965.

85. Economic pressures forced the Nadelmans to sell their entire collection in 1937. Administrators of the New-York Historical Society bought it, selected a large portion for the museum, and then sold the remaining pieces to Mrs. Rockefeller; Brummer Galleries; Henry F. du Pont; the New-York State Historical Association in Cooperstown, New York; and the Metropolitan Museum of Art. For a study that briefly discusses the Nadelmans' museum, see Lincoln Kirstein, *Elie Nadelman* (New York, 1973). In 1930 Kirstein asked Nadelman to loan pieces of his own work to an exhibition of folk art at Harvard so that the relationship between folk and modern could be demonstrated. Nadelman declined, and the two men never did meet. But Kirstein came to know Nadelman's son and widow after the artist died in 1946 and wrote eloquently about his work and attachment to folk art on several occasions.

86. The relationship between art and domestic design in artists' homes deserves more study. Many modernists, like O'Keeffe and Sheeler, appear to have worked as hard on their homes as on their art while others settled for very conventional living places.

87. "The painting of the hands is *naive* but the very beautiful line around the mask of the face is not *naive* at all, and suggests Velasquez, who often painted a face quite flat in the same way with a line around the mask. . . . Color is reduced in these Vanderlyn portraits to a minimum—all is fine organization, characterization, and really fine painting." Sheeler, quoted in Rourke, *Sheeler: Artist in the American Tradition*, 183.

88. In the Sheeler photograph of the Arensbergs' living room (reproduced in Fig. 300) a scholar has identified the furniture as "a simple early American stretcher-base table (a turned burl bowl rests on it), flanked by a Windsor chair and a 'settle'-type chair table. Also against that wall are a child's ladder-back chair, a New England desk-on-frame with a restored front pane, and, leading out of the work to the right, a wooden door with a carved design in massive horizontal stripes, probably remade from a nineteenth-century Pennsylvania German blanket chest." Yeh, *Sheeler: American Interiors*, 13. Yeh credits Beatrice Garvan, curator of decorative arts at the Philadelphia Museum of Art, for helping to identify these pieces (22 n. 41). When the Arensbergs moved to California in 1921, Sheeler bought at least one chair from their

collection and helped them dispose of other pieces (ibid., 22 n. 38).

89. Sheeler, quoted in Rourke, *Sheeler: Artist in the American Tradition*, 183–84.

90. *Art Digest* 6 (Dec. 15, 1931): 13.

91. Forbes Watson, "Charles Sheeler," *Arts* 3 (May 1923): 335–44; Helen Appleton Read, "Annual Exhibition of Whitney Studio Club," *Brooklyn Daily Eagle*, May 11, 1924, sec. B, p. 2; and Robert Allerton Parker, "The Classical Vision of Charles Sheeler," *International Studio* 84 (May 1926): 71.

92. Paul Strand to Stieglitz, Aug. 4, 1924, YCAL.

93. See Joan Shelley Rubin, *Constance Rourke and American Culture* (Chapel Hill, N.C., 1980), and "A Convergence of Vision: Constance Rourke, Charles Sheeler, and American Art," *American Quarterly* 42 (June 1990): 191–222.

94. A mark of Rourke's intellectual intrepidness was her willingness to take on the study of an artist when she had published only one article on art, "American Art: A Possible Future," *American Magazine of Art* 28 (July 1935): 390–404. She was also filling a need. Art history as a professional category was not yet firmly established in this country, and those who were art historians found American art too provincial, and modern art too recent, to warrant their attention. Moreover, Rourke, like Mumford, wrote as a critic of culture, broadly conceived, for whom disciplinary boundaries were soft, even nonexistent.

95. Rourke received many of her first writing assignments from Brooks when he served as editor of the *Freeman*. When she died unexpectedly in 1941, Brooks edited and wrote an introduction to *The Roots of American Culture and Other Essays* (New York, 1942), which she had written as a preliminary to a three-volume study on the history of American culture.

96. Constance Rourke, "Vaudeville," *New Republic* 20 (Aug. 27, 1919): 115–16; "Paul Bunyon [*sic*]," *New Republic* 23 (July 7, 1920): 176–79; *American Humor: A Study of the National Character* (New York, 1931); and *Davy Crockett* (New York, 1934).

97. There is some ambiguity about who initiated the book. Sheeler attached to his handwritten autobiography a note saying he had written the manuscript "at the request of Harcourt Brace to be published by them in 1938. Later I requested that the book be written by Constance Rourke, since I could hardly evaluate my own work. This request was granted and the manuscript was turned over to Constance Rourke for any use she might wish to make of it." Sheeler Papers, AAA. Joan Shelley Rubin, a conscientious biographer of Rourke, credits her and her publisher, Harcourt, Brace and Company, for initiating the project. See Rubin, "A Convergence of Vision," 191.

98. Rourke, *Sheeler: Artist in the American Tradition*, 5.

99. Ibid., 59–88.
100. Ibid., 69.
101. Ibid., 169–70, 187.

EPILOGUE: THE AMAZING CONTINUITY

1. Barbara Rose, *American Art since 1900: A Critical History* (1967; New York, 1975), 92. Rose's scholarship of the 1960s and 1970s greatly influenced me as a young scholar. Along with Milton Brown, she was one of the few who appreciated and understood early-twentieth-century American art.

2. Davis wrote Alfred H. Barr, Jr., a statement on *Visa* on Nov. 3, 1952: "The word 'amazing' was in my mind at that period as being appropriate to the kind of painting I wanted to look at. The word 'continuity' was also in my thoughts for many years as a definition of the experience of seeing the same thing in many paintings of completely different subject matter and style"; quoted in Diane Kelder, ed., *Stuart Davis* (New York, 1971), 102. I am not the first to find this phrase a good descriptor. William C. Agee used it as the subtitle for his essay "Stuart Davis in the 1960s: 'The Amazing Continuity,'" in Lowery Stokes Sims et al., *Stuart Davis, American Painter* (New York, 1991), 82–96.

3. Stuart Davis wrote that "American artists who sought to continue the discoveries of Paris were denounced as unAmerican." Stuart Davis Papers, Aug. 1941, Harvard University Art Museums, Houghton Rare Books Library, Cambridge, Mass. Quoted in Sims et al., *Stuart Davis, American Painter*, 54.

4. Peyton Boswell, Jr., *Modern American Painting* (New York, 1939), 14 (italics in original).

5. Stuart Davis, quoted in James Johnson Sweeney, *Stuart Davis* (New York, 1945), 23.

6. Frederick Lewis Allen, *Only Yesterday: An Informal History of the 1920s* (New York, 1959), 167.

7. James Johnson Sweeney, "Eleven Europeans in America," *Museum of Modern Art Bulletin* 13 (1946): 2.

8. Henry McBride, "American Expatriates in Paris," *Dial* (Apr. 1929), reprinted in McBride, *The Flow of Art*, ed. Daniel Cotton Rich (New York, 1975), 256.

9. Clement Greenberg, "John Marin" (1948), reprinted in Greenberg, *Art and Culture: Critical Essays* (New York, 1960), 181–83.

10. Clement Greenberg, "L'Art américain au XXe siècle," *Temps Modernes* (Aug.–Sept. 1946): 343.

11. Clement Greenberg, "Review of an Exhibition of Georgia O'Keeffe," *Nation*, June 15, 1946, reprinted in Greenberg, *The Collected Essays and Criticism*, ed. John O'Brian (Chicago, 1986), 2:87. Just as Greenberg was penning his denunciations of the second Stieglitz circle in the late 1940s and establishing European precedents for the abstract expressionists, Georgia O'Keeffe was settling the Stieglitz estate and making gifts of the first generation of modernists to major American museums. Her philanthropy should be seen as an effort to stem the tide of amnesia about early modernism then sweeping through avant-garde circles in New York.

12. Harold Rosenberg, "Parable for American Painters," *Art News* 52 (Jan. 1954): 60–63, 74–76, reprinted in Rosenberg as the "Parable of American Painting," in *The Tradition of the New* (1959; reprint, New York, 1965), 13–22.

13. Richard Pousette-Dart, telephone conversation with W. Jackson Rushing, quoted in his essay "Ritual and Myth: Native American Culture and Abstract Expressionism," in *The Spiritual in Art: Abstract Painting, 1890–1985*, ed. Maurice Tuchman (New York, 1986), 277.

14. The *Natural Paradise* exhibition mounted by the Museum of Modern Art during the bicentennial year offers the most stunning instance of this erasure. This exhibition constructed parallels between early American landscape paintings and those of the New York School but completely ignored the even more obvious correspondences and continuities between Abstract Expressionism and early modernist art about Manhattan. See Kynaston McShine, ed., *The Natural Paradise: Painting in America, 1800–1950* (New York, 1976).

15. Stuart Davis, Apr. 1921 entry, Notebook: 1920–22, in a private collection. Quoted in Sims et al., *Stuart Davis, American Painter*, 174, 175 n. 1.

16. See Barbara Zabel, "Stuart Davis's Appropriation of Advertising: The Tobacco Series, 1921–1924," *American Art* 5 (fall 1991): 56–67.

17. Two versions are reproduced in Sims et al., *Stuart Davis, American Painter*, 172–73.

18. Stuart Davis, "Self-Interview," *Creative Art* 9 (Sept. 1931): 211.

19. Noted on one of Stuart Davis's calendars, Jan. 22, 1951, archives of Earl Davis, quoted in John R. Lane, "Stuart Davis in the 1940s," Sims et al., *Stuart Davis, American Painter*, 78.

20. Elaine de Kooning, "Stuart Davis: True to Life," *Art News* 56 (Apr. 1957): 42.

21. Sweeney, *Stuart Davis*, 1945, 13.

22. See Melinda A. Lorenz, *George L. K. Morris, Artist and Critic* (Ann Arbor, Mich., 1982); Hirschl and Adler Galleries, *George L. K. Morris: The Years 1945–1975* (New York, 1979); and William Jackson Rushing, *Native American Art and the New York Avant-Garde: A History of Cultural Primitivism* (Austin, Tex., 1995), 90–95.

23. For a thorough analysis of *Indians Hunting No. 4*, (Fig. 314), see Nicolai Cikovsky, Jr., "Notes and Footnotes on a Painting by George L. K. Morris," *University of New Mexico Art Museum Bulletin* 10 (1976–77): 3–11.

24. George L. K. Morris, "On America and a Living Art," in New York University, *Museum of Living Art: A. E. Gallatin Collection* (New York, 1936), n.p., and Morris,

introduction to *American Abstract Artists, 1939*, in *American Abstract Artists: Three Yearbooks* (New York, 1969), 85. Both quotations are cited in Cikovsky, ibid., 10 n. 17.

25. Jean Baudrillard, *America*, trans. Chris Turner (London, 1989), first published as *Amérique* (Paris, 1986), 104.

26. Ibid., 18–19, 21.

27. Ibid., 23.

28. For an account of a four-month visit to the United States that interlaces fresh observations, especially about American women, with routine ones, see Simone de Beauvoir, *America Day by Day*, trans. Carol Cosman (Berkeley and Los Angeles, 1999; first published in France as *L'Amérique au jour le jour*, 1954).

29. Even Picasso spoke of wanting to come to the United States "but felt he could never overcome his aversion to crossing the ocean." Sidney Janis, "School of Paris Comes to U.S.," *Decision* 2 (Nov.–Dec. 1941): 85.

30. Many have written about this painting. See, for example, Hayden Herrera, *Frida: A Biography of Frida Kahlo* (New York, 1983), 173–75; Herrera, *Frida Kahlo: The Paintings* (New York, 1991), 98–105; and Oriana Baddeley, "'Her Dress Hangs There': De-Frocking the Kahlo Cult," *Oxford Art Journal* 14 (1991): 10–17.

31. Mondrian's shifts in vocabulary after he came to America have been widely discussed; see Nancy J. Troy, *Mondrian and Neo-Plasticism in America* (New Haven, Conn., 1979); E. A. Carmean, Jr., *Mondrian: The Diamond Compositions* (Washington, D.C., 1979); Kermit Swiler Champa, *Mondrian Studies* (Chicago, 1985), 127–41; and Yves Alain Bois et al., *Piet Mondrian, 1872–1944* (Boston, 1994).

32. Piet Mondrian, quoted in Janis, "School of Paris Comes to U.S.," 91. Mondrian's use of geometric abstraction to evoke the dynamism and architecture of New York influenced at least one of his American followers to do the same. See Leon Polk Smith's abstraction *N.Y. City* (1945), in the collection of the Whitney Museum of American Art.

33. Max Kozloff, "'Pop Culture,' Metaphysical Disgust, and the New Vulgarians," *Art International* (Mar. 1962): 36.

34. Claes Oldenburg, "Statement," in Martha Jackson Gallery, *Environments, Situations, Spaces* (1961), reprinted in *Pop Art: A Critical History*, ed. Henry Madoff (Berkeley and Los Angeles, 1997), 213. Robert Rauschenberg, quoted by Alan R. Solomon, *Robert Rauschenberg* (New York, 1963), n.p.

35. For books that mine the history of art for pop art's ancestry, see Tracy Atkinson's catalogue for the Milwaukee Art Center exhibition *Pop Art and the American Tradition* (Milwaukee, Wis., 1965); Lucy R. Lippard, *Pop Art* (New York, 1966), 11–25 (the Flag Gate is reproduced on p. 20); John Russell and Suzi Gablik, *Pop Art Redefined* (London, 1969), 25–28; and Lawrence Alloway, *American Pop Art* (New York, 1974), 115–17.

36. See, for example, John Russell, introduction to Russell and Gablik, *Pop Art Redefined*, 28.

37. See Michael Plante, "Truth, Friendship, and Love: Sexuality and Tradition in Robert Indiana's Hartley Elegies," in Patricia McDonnell, *Dictated By Life: Marsden Hartley's German Paintings and Robert Indiana's Hartley Elegies* (Minneapolis, Minn., 1995), 57–105.

38. See Sotheby's catalogue *The Andy Warhol Collection: Americana and European and American Paintings, Drawings and Prints* (New York, Apr. 19 and 20, 1988).

39. Jean Lipman and Richard Marshall, *Art about Art* (New York, 1978). At the same museum, the excitement about the pop artists' relationship to past American art brought folk art back into the orbit of contemporary art. The Whitney Museum of American Art mounted two spectacular exhibitions of folk art, one of them installed by Marcel Breuer and both accompanied by major scholarly catalogues. Jean Lipman and Alice Winchester, *The Flowering of American Folk Art, 1776–1876* (New York, 1974); and Jean Lipman and Tom Armstrong, eds., *American Folk Painters of Three Centuries* (New York, 1980). Both catalogues include brief histories of the collecting of American folk art and recall the role of artists and the Whitney Studio Club in the early days. During the years of the Whitney's folk art explorations, Patricia Mainardi organized an exhibition for the Queens Museum in New York of American sculptors, folk and modern, to demonstrate not only their affinities but often direct influences. Patricia Mainardi, *American Sculpture: Folk and Modern* (New York, 1977). The catalogue's text is reprinted in an essay of the same name, *Arts Magazine* 51 (Mar. 1977): 107–11.

BIBLIOGRAPHY

LITTLE MAGAZINES CONSULTED

Aesthete, 1925
L'Art Vivant, 1925–39
The Blind Man, 1917
Blues, 1929–30
Broom, 1921–24
Bulletin de L'Effort Moderne, 1924–27
Camera Work, 1903–17
Contact, 1920–23
The Dial, 1880–1929
L'Esprit Nouveau, 1920–25
Hound and Horn, 1927–34
The Little Review, 1914–29
Maintenant, 1912–15
Manumètre, 1922–28
Montjoie!, 1913–14
MSS [Manuscripts], 1922–23
Playboy, 1919–24
Rainbow, 1920
Rongwrong, 1917
S4N, 1919–25
Secession, 1922–24
The Seven Arts, 1916–17
The Soil, 1916–17
Soirées de Paris, 1912–14
391, 1917–24
Transition, 1927–38
Twice a Year, 1938–48
291, 1915–16
U.S.A., 1930

SELECTED REFERENCES

Abrahams, Edward. *The Lyrical Left: Randolph Bourne, Alfred Stieglitz, and the Origins of Cultural Radicalism in America*. Charlottesville, Va., 1986.

Adam, Paul Auguste Marie. *Vues d'Amérique (ou La Nouvelle Jouvence)*. Paris, 1906.

Agee, William C. "Gerald Murphy, Painter: Recent Discoveries, New Observations." *Arts Magazine* 59 (May 1985): 81–89.

———. "Morton Livingston Schamberg: Notes on the Sources of the Machine Images." *Dada/Surrealism* 14 (1985): 66–80.

Aiken, Edward A. "'I Saw the Figure 5 in Gold': Charles Demuth's Emblematic Portrait of William Carlos Williams." *Art Journal* 46 (fall 1987): 179–84.

Allen, Frederick Lewis. *Only Yesterday: An Informal History of the 1920s*. 1931; reprint, New York, 1959.

Allen, Irving Lewis. *The City in Slang: New York Life and Popular Speech*. New York, 1993.

Alloway, Lawrence. *American Pop Art*. New York, 1974.

Anderson, Benedict. *Imagined Communities: Reflections on the Origin and Spread of Nationalism*. London, 1983.

Anderson, Dennis. "The Vassar Connection: Paul Rosenfeld, Edna Bryner Schwab, and Alfred Stieglitz." *Vassar Quarterly* (spring 1988): 27–31.

Anderson, Sherwood. *Winesburg, Ohio: A Group of Tales of Ohio Small–Town Life*. New York, 1919.

———. *A Story Teller's Story*. New York, 1924.

Apollinaire, Guillaume. "Funérailles de Walt Whitman racontées par un témoin." *Mercure de France* 102 (Apr. 1913): 658–59.

———. "A propos de Walt Whitman." *Mercure de France* 106 (Dec. 1913): 864.

———. *Selected Writings of Guillaume Apollinaire*. Translated and with an introduction by Roger Shattuck. New York, 1950.

———. *Apollinaire on Art: Essays and Reviews, 1902–1918*. Edited by LeRoy C. Breunig. Translated by Susan Suleiman. London, 1972.

Arnold, Armin. *D. H. Lawrence and America*. London, 1958.

Axsom, Richard H. *"Parade": Cubism as Theater*. New York, 1979.

Baer, Nancy Van Norman, ed. *Paris Modern: The Swedish Ballet, 1920–1925*. San Francisco, 1995.

Baigell, Matthew. "American Art and National Identity: The 1920s." *Arts Magazine* 61 (Feb. 1987): 48–55.

———. "American Landscape Painting and National Identity: The Stieglitz Circle and Emerson." *Art Criticism* 4 (1987): 27–47.

Banham, Reyner. *A Concrete Atlantis: U.S. Industrial Building and European Modern Architecture, 1900–1925*. Cambridge, Mass., 1986.

Baritz, Loren, ed. *The Culture of the Twenties*. Indianapolis, Ind., 1970.

Barsness, Larry. *The Bison in Art: A Graphic Chronicle of the American Bison*. Fort Worth, Tex., 1976.

Baudrillard, Jean. *America*. Translated by Chris Turner. London, 1989. Originally published as *Amérique* (Paris, 1986).

Baur, John I. H. *Joseph Stella*. New York, 1971.

Baxandall, Michael. *Painting and Experience in Fifteenth-Century Italy: A Primer in the Social History of Pictorial Style*. Oxford, 1972.

Bazalgette, Léon. *Walt Whitman: L'Homme et son oeuvre*. Paris, 1908.

Becker, Jane S., and Barbara Franco, eds. *Folk Roots, New Roots: Folklore in American Life*. Lexington, Mass., 1988.

Benton, Thomas Hart. *An Artist in America*. New York, 1937.

———. *A Thomas Hart Benton Miscellany: Selections from His Published Opinions, 1916–1960*. Edited by Matthew Baigell. Lawrence, Kans., 1971.

Bergman, Pär. *"Modernolatrià" et "simultaneità": Recherches sur deux tendances dans l'avant-garde littéraire en Italie et en France à la veille de la première guerre mondiale*. Uppsala, 1962.

Berman, Avis. *Rebels on Eighth Street: Juliana Force and the Whitney Museum of American Art*. New York, 1990.

Bing, Samuel. *Artistic America, Tiffany Glass, and Art Nouveau*. Translated by Benita Eisler, with introduction by Robert Koch. Paris, 1896; reprint, Cambridge, Mass., 1970.

Bittner, William. *The Novels of Waldo Frank*. Philadelphia, 1958.

Blake, Casey Nelson. *Beloved Community: The Cultural Criticism of Randolph Bourne, Van Wyck Brooks, Waldo Frank, and Lewis Mumford*. Chapel Hill, N.C., 1990.

Bleustein-Blanchet, Marcel. *The Rage to Persuade: Memoirs of a French Advertising Man*. Translated by Jean Bodewyn. New York, 1982. Originally published in French (Paris, 1947).

Bloemink, Barbara J. *The Life and Art of Florine Stettheimer*. New Haven, Conn., 1995.

Bogart, Michele Helene. *Artists, Advertising, and the Borders of Art*. Chicago, 1995.

Bohan, Ruth L. *The Société Anonyme's Brooklyn Exhibition: Katherine Dreier and Modernism in America*. Ann Arbor, Mich., 1982.

Bohn, Willard. "Picabia's 'Mechanical Expression' and the Demise of the Object." *Art Bulletin* 67 (Dec. 1985): 673–77.

———. *The Aesthetics of Visual Poetry, 1914–1928*. Cambridge, Mass., 1986.

Bois, Yves Alain, et al. *Piet Mondrian, 1872–1944*. Boston, 1994.

Bolger, Doreen. "Hamilton Easter Field and His Contribution to American Modernism." *American Art Journal* 20 (1988): 78–107.

Borne, Lawrence R. *Dude Ranching: A Complete History*. Albuquerque, N.M., 1983.

Boswell, Peyton, Jr. *Modern American Painting*. New York, 1939.

Bourget, Paul. *Outre-mer (notes sur l'Amérique)*. 2 vols. Paris, 1895.

Bournand, François. *Au pays de l'énergie: Impressions de voyages, notes et souvenirs*. Isle, 1910.

Bourne, Randolph. *The Radical Will: Selected Writings, 1911–1918*. New York, 1977.

Boyd, Ernest. "Aesthete: Model 1924." *American Mercury* 1 (Jan. 1924): 51–56.

Bragdon, Claude. *The Frozen Fountain, Being Essays on Architecture and the Art of Design in Space*. New York, 1932.

Brenner, Isabel. "Charles Demuth: The Poster Portraits." Master's thesis, Hunter College, City University of New York, 1974.

Breslin, James E. "William Carlos Williams and Charles Demuth: Cross Fertilization in the Arts." *Journal of Modern Literature* 6 (Apr. 1977): 248–63.

Brett, Dorothy. *Lawrence and Brett: A Friendship*. Philadelphia, 1933.

Bridgman, Richard. *Gertrude Stein in Pieces*. New York, 1970.

Brooks, Van Wyck. *The Wine of the Puritans: A Study of Present-Day America*. London, 1908.

———. "On Creating a Usable Past." *Dial* 64 (Apr. 11, 1918): 337–41.

———. *The Ordeal of Mark Twain*. New York, 1920.

———. *The Pilgrimage of Henry James*. New York, 1925.

———. *Three Essays on America*. 1934; reprint, New York, 1970.

———. *Days of the Phoenix: The 1920s I Remember*. New York, 1957.

Brown, Milton W. "Cubist-Realism: An American Style." *Marsyas* 3 (1943–45): 139–60.

———. *American Painting from the Armory Show to the Depression*. Princeton, N.J., 1955.

Bry, Doris. *Alfred Stieglitz: Photographer*. Boston, 1965.

Burgard, Timothy Anglin. "Charles Demuth's *Longhi on Broadway*: Homage to Eugene O'Neill." *Arts Magazine* 58 (Jan. 1984): 110–13.

Burgin, Victor, ed. *Thinking Photography*. London, 1982.

Burne-Jones, Sir Philip. *Dollars and Democracy*. New York, 1904.

Burns, Edward, ed. *The Letters of Gertrude Stein and Carl Van Vechten, 1913–1946*. New York, 1986.

Buskirk, Martha, and Mignon Nixon, eds. *The Duchamp Effect*. Cambridge, Mass., 1996.

Butler, Judith. *Gender Trouble: Feminism and the Subversion of Identity*. New York, 1990.

Butterfield, Bruce. "Paul Rosenfeld: The Critic as Autobiographer." Ph.D. diss., University of Minnesota, 1962.

Cabanne, Pierre. *Dialogues with Marcel Duchamp*. Translated by Ron Padgett. New York, 1971.

Caffin, Caroline Scurfield. *Vaudeville*. New York, 1914.

Caffin, Charles Henry. *The Story of American Painting: The Evolution of Painting in America*. Garden City, N.Y., 1907.

Cahill, Holger. *A Museum in Action*. Newark, N.J., 1944.

Camfield, William A. *Francis Picabia: His Art, Life, and Times*. Princeton, N.J., 1979.

———. *Marcel Duchamp, Fountain*. Houston, Tex., 1989.

Carmean, E. A., Jr. *Mondrian: The Diamond Compositions*. Washington, D.C., 1979.

Carter, Paul J. *Waldo Frank*. New York, 1967.

Cassidy, Donna M. " 'On the Subject of Nativeness': Marsden Hartley and New England Regionalism." *Winterthur Portfolio* 29 (winter 1994): 227–45.

Castle, Terry. *The Apparitional Lesbian: Female Homosexuality and Modern Culture*. New York, 1993.

Cavitch, David. *D. H. Lawrence and the New World*. New York, 1969.

Cendrars, Blaise. *Selected Writings of Blaise Cendrars*. Edited by Walter Albert. New York, 1966.

Champa, Kermit Swiler. *Mondrian Studies*. Chicago, 1985.

Chauncey, George. *Gay New York: Gender, Urban Culture, and the Making of the Gay Male World, 1890–1940*. New York, 1994.

Chave, Anna C. "O'Keeffe and the Masculine Gaze." *Art in America* 78 (Jan. 1990): 114–79.

———. "*Who Will Paint New York?* 'The World's New Art Center' and the Skyscraper Paintings of Georgia O'Keeffe." *American Art* (winter/spring 1991): 86–108.

Cikovsky, Nicolai, Jr. "Notes and Footnotes on a Painting by George L. K. Morris." *University of New Mexico Art Museum Bulletin* 10 (1976–77): 3–11.

Clair, Jean, ed. *The 1920s: Age of the Metropolis*. Montreal, 1991.

Cocteau, Jean. *Le Coq et l'arlequin: Notes autour de la musique*. Paris, 1918.

Cohen, Jean-Louis. *Scenes of the World to Come: European Architecture and the American Challenge, 1893–1960*. Paris, 1995.

Coke, Van Deren. *Taos and Santa Fe: The Artist's Environment, 1882–1942*. Albuquerque, N.M., 1963.

Conger, Amy. "Edward Weston's Toilet." *New Mexico Studies in the Fine Arts* 9 (1984): 36–42.

Conn, Steven. "Henry Chapman Mercer and the Search for American History." *Pennsylvania Magazine of History and Biography* 116 (July 1992): 323–55.

Copland, Aaron, and Vivian Perlis. *Copland, 1900 through 1942*. New York, 1984.

Corn, Wanda M. "The Return of the Native: The Development of Interest in American Primitive Painting." Master's thesis, Institute of Fine Arts, New York University, 1965.

———. *Color of Mood: American Tonalism, 1880–1910*. San Francisco, 1972.

———. "The *New* New York." *Art in America* 61 (July–Aug. 1972): 59–65.

———. "Apostles of the New American Art: Waldo Frank and Paul Rosenfeld." *Arts Magazine* 54 (Feb. 1980): 159–63.

———. "Joseph Stella and *New York Interpreted*." *Portfolio* 4 (Jan.–Feb. 1982): 40–45.

———. *In the American Grain: The Billboard Poetics of Charles Demuth*. Poughkeepsie, N.Y., 1991.

———. "The Artist's New York, 1900–1930." In *Budapest and New York: Studies in Metropolitan Transformation, 1870–1930*, edited by Thomas Bender and Carl E. Schorske, 275–308. New York, 1994.

Cowan, James C. *D. H. Lawrence's American Journey: A Study in Literature and Myth*. Cleveland, Ohio, 1970.

Cowart, Jack, and Juan Hamilton, with Sarah Greenough. *Georgia O'Keeffe: Art and Letters*. Washington, D.C., 1987.

Cowley, Malcolm. *Exile's Return*. New York, 1934.

Crane, Hart. *The Bridge*. New York, 1930.

———. *The Letters of Hart Crane*. Edited by Brom Weber. New York, 1952.

———. *The Poems of Hart Crane*. Edited by Marc Simon. New York, 1986.

cummings, e. e. *100 Selected Poems by e. e. cummings*. New York, 1926.

Czaplicka, John Joseph. "Prolegomena for a Typology of Urban Imagery: The Pictorial Representation of Berlin, 1870–1930." Ph.D. diss., University of Hamburg, 1984.

David Winton Bell Gallery, Brown University. *Over Here! Modernism, The First Exile, 1914–1919*. Providence, R.I., 1989.

Davidson, Abraham A. "The Poster Portraits of Charles Demuth." *Auction* 3 (Sept. 1969): 28–31.

———. "Demuth's Poster Portraits." *Artforum* 17 (Nov. 1978): 54–57.

———. *Early American Modernist Painting, 1910–1935*. New York, 1981.

Daye, Pierre. *Sam (ou Le Voyage dans l'optimiste Amérique)*. Paris, 1922.

de Beauvoir, Simone. *America Day by Day*. Translated by Carol Cosman. Berkeley and Los Angeles, 1999.

Originally published as *L'Amérique au jour le jour* (Paris, 1954).

Debord, Guy. *Society of the Spectacle.* Detroit, Mich., 1983. Originally published as *La Société du spectacle* (Paris, 1967).

de Duve, Thierry, ed. *The Definitively Unfinished Marcel Duchamp.* Cambridge, Mass., 1991.

de Kooning, Elaine. "Stuart Davis: True to Life." *Artnews* 56 (Apr. 1957): 40–42, 54–55.

de Lanux, Pierre Cobret. *Young France and New America.* New York, 1917.

Delaware Art Museum. *Avant-Garde Painting and Sculpture in America, 1910–1925.* Wilmington, Del., 1975.

D'Emilio, Sandra, and Suzan Campbell. *Spirit and Vision: Images of Ranchos de Taos Church.* Santa Fe, N.M., 1987.

———. *Visions and Visionaries: The Art and Artists of the Santa Fe Railway.* Salt Lake City, Utah, 1991.

Derouet, Christian. *"Vue de New York* par Jacques Mauny." *Revue du Louvre* 4 (1987): 298.

De Salvo, Donna M., and Paul Schimmel. *Hand-Painted Pop: American Art in Transition, 1955–1962.* Edited by Russell Ferguson. Los Angeles, 1992.

Descharnes, Robert, and Clovis Prévost. *Gaudi, The Visionary.* New York, 1971.

d'Harnoncourt, Anne, and Kynaston McShine, eds. *Marcel Duchamp.* New York, 1973.

Dijkstra, Bram. *Cubism, Stieglitz, and the Early Poetry of William Carlos Williams: The Hieroglyphics of a New Speech.* Princeton, N.J., 1969.

———. *Idols of Perversity: Fantasies of Feminine Evil in Fin-de-Siècle Culture.* New York, 1986.

Docherty, Linda Jones. "A Search for Identity: American Art Criticism and the Concept of the 'Native School,' 1876–1893." Ph.D. diss., University of North Carolina, 1985.

Donnelly, Honoria Murphy, and Richard N. Billings. *Sara and Gerald: Villa America and After.* New York, 1982.

Donnelly, William M. "On Finding a Gerald Murphy." *Arts Magazine* 59 (May 1985): 78–80.

Dos Passos, John. *Manhattan Transfer.* Boston, 1925.

———. *USA.* New York, 1930.

———. *The Best Times: An Informal Memoir.* London, 1966.

Douglas, Ann. *Terrible Honesty: Mongrel Manhattan in the 1920s.* New York, 1995.

Drabeck, Bernard A., and Helen E. Ellis, eds. *Archibald MacLeish: Reflections.* Amherst, Mass., 1986.

Duchamp, Marcel. *Salt Seller: The Writings of Marcel Duchamp [Marchand du sel].* Edited by Michel Sanouillet and Elmer Peterson. New York, 1973.

Duhamel, Georges. *America the Menace: Scenes from the Life of the Future.* Translated by Charles Miner Thompson. New York, 1931.

Dumenil, Lynn. *Freemasonry and American Culture, 1880–1930.* Princeton, N.J., 1984.

Duvert, Elizabeth. "Georgia O'Keeffe's Radiator Building: Icon of Glamorous Gotham." *Places: A Quarterly Journal of Environmental Design* 2 (1985): 3–17.

Eglington, Guy. "Art and Other Things." *International Studio* 80 (Feb. 1925): 417–19.

Eldredge, Charles C. *Georgia O'Keeffe.* New York, 1991.

———. *Georgia O'Keeffe: American and Modern.* New Haven, Conn., 1993.

Eldredge, Charles C., Julie Schimmel, and William H. Truettner. *Art in New Mexico, 1900–1945: Paths to Taos and Santa Fe.* New York, 1986.

Erenberg, Lewis A. *Steppin' Out: New York Nightlife and the Transformation of American Culture, 1890–1930.* Westport, Conn., 1981.

Erkkila, Betsy. *Walt Whitman among the French: Poet and Myth.* Princeton, N.J., 1980.

Fahlman, Betsy. *Pennsylvania Modern: Charles Demuth of Lancaster.* Philadelphia, 1983.

Faison, S. Lane, Jr. "Fact and Art in Charles Demuth." *Magazine of Art* 43 (Apr. 1950): 122–28.

Farnham, Emily. "Charles Demuth: His Life, Psychology and Works." Ph.D. diss., Ohio State University, 1959.

———. *Charles Demuth: Behind a Laughing Mask.* Norman, Okla., 1971.

Fenn, Forrest. *The Beat of the Drum and the Whoop of the Dance.* Santa Fe, N.M., 1983.

Ferriss, Hugh. *The Metropolis of Tomorrow.* New York, 1986.

Fine, Ruth E., Elizabeth Glassman, and Juan Hamilton, with Sarah L. Burt. *The Book Room: Georgia O'Keeffe's Library in Abiquiu.* New York, 1997.

Flanner, Janet. *Paris Was Yesterday, 1925–1939.* New York, 1972.

Fletcher, John Gould. "Vers Libre and Advertisements." *Little Review* 2 (Apr. 1915): 29–30.

———. "The Stieglitz Spoof." *American Review* 4 (Mar. 1935): 597, 602.

Foresta, Merry, et al. *Perpetual Motif: The Art of Man Ray.* Washington, D.C., 1988.

Foster, Joseph *D. H. Lawrence in Taos.* Albuquerque, N.M., 1972.

Four Dada Suicides: Selected Texts of Arthur Craven, Jacques Rigaut, Julien Torma, and Jacques Vache. Introduction by Roger Conover, Terry Hale, and Paul Lenti. Translated by Terry Hale et al. London, 1995.

Frackman, Noel. *John Storrs.* New York, 1987.

Frank, Robin Jaffee. *Charles Demuth Poster Portraits, 1923–1929.* New Haven, Conn., 1994.

———. "Charles Demuth Poster Portraits, 1923–1929." Ph.D. diss., Yale University, 1995.

Frank, Waldo. *Our America.* New York, 1919.

————. *The New American*. London, 1922.

———— [Search-Light, pseud.]. *Time Exposures*. New York, 1926.

————. "Alfred Stieglitz, the World's Greatest Photographer." *McCall's* 54 (May 1927): 24, 107–8.

————. *The Rediscovery of America: An Introduction to a Philosophy of American Life*. New York, 1929.

————. *In the American Jungle, 1925–1936*. New York, 1937.

————. *Memoirs of Waldo Frank*. Edited by Alan Trachtenberg. Amherst, Mass., 1973.

————, et al., eds. *America and Alfred Stieglitz: A Collective Portrait*. Garden City, N.Y., 1934.

Fredericks, J. George. *Adventuring in New York*. New York, 1923.

Garrard, Mary D., and Norma Broude, eds. *The Expanding Discourse: Feminism and Art History*. New York, 1992.

Gedhard, David, and Phyllis Plous. *Charles Demuth: The Mechanical Encrusted on the Living*. Santa Barbara, Calif., 1971.

Gellner, Ernest. *Thought and Change*. London, 1964.

————. *Nations and Nationalism*. Ithaca, N.Y., 1983.

Gibson, Arrell Morgan. *The Santa Fe and Taos Colonies: Age of the Muses, 1900–1942*. Norman, Okla., 1983.

Gilder, Rodman. *The Battery*. Boston, 1936.

Gleizes, Albert. "The Impersonality of American Art." *Playboy* 4–5 (1919): 25.

Golan, Romy. *Modernity and Nostalgia: Art and Politics in France between the Wars*. New Haven, Conn., 1995.

Goodrich, Lloyd. *Thomas Eakins: His Life and Work*. New York, 1933.

————. *Winslow Homer*. New York, 1944.

Green, Christopher. *Léger and the Avant-Garde*. New Haven, Conn., 1976.

————. *Cubism and Its Enemies: Modern Movements and Reaction in French Art, 1916–1928*. New Haven, Conn., 1987.

Greenberg, Clement. *Art and Culture: Critical Essays*. New York, 1960.

————. *The Collected Essays and Criticism*. 2 vols. Edited by John O'Brian. Chicago, 1986.

Greenough, Sarah E. "From the American Earth: Alfred Stieglitz's Photographs of Apples." *Art Journal* 41 (spring 1981): 46–54.

Greenough, Sarah, and Juan Hamilton. *Alfred Stieglitz: Photographs and Writings*. Washington, D.C., 1983.

Gros, Raymond, and François Bournand. *Au pays du dollar: Notes, indiscrétions, souvenirs*. Paris, 1908.

Grosz, George. *George Grosz: An Autobiography*. Revised edition. Translated by Nora Hodges. New York, 1983.

Guilbaut, Serge. *How New York Stole the Idea of Modern Art: Abstract Expressionism, Freedom and the Cold War*. Chicago, 1983.

Hagen, Oskar. *The Birth of the American Tradition in Art*. Port Washington, N.Y., 1940.

Häger, Bengt. *Ballets Suédois*. Translated by Ruth Sharman. London, 1990.

Halsey, R. T. Haines, and Elizabeth Tower. *The Homes of Our Ancestors, As Shown in the American Wing of The Metropolitan Museum of Art of New York*. New York, 1925.

Hammen, Scott. "Sheeler and Strand's 'Manhatta': A Neglected Masterpiece." *Afterimage* 6 (Jan. 1979): 6–7.

Hapgood, Hutchins. *A Victorian in the Modern World*. New York, 1939.

Haraway, Donna. *Primate Visions, Gender, Race, and Nature in the World of Modern Science*. New York, 1989.

Harris, Neil. *Cultural Excursions: Marketing Appetites and Cultural Tastes in Modern America*. Chicago, 1990.

Hartley, Marsden. "Tribal Esthetics." *Dial* 65 (Nov. 16, 1916): 399–401.

————. "Red Man Ceremonials: An American Plea for American Esthetics." *Art and Archaeology* 9 (Jan. 1920): 7–14.

————. "The Beautiful Neglected Arts." *Little Review* 6 (Apr. 1920): 59.

————. *Adventures in the Arts: Informal Chapters on Painters, Vaudeville, and Poets*. 1921; reprint, New York, 1972.

————. "The Scientific Esthetic of the Redman," part 1, "The Great Corn Ceremony at Santo Domingo." *Art and Archaeology* 13 (Mar. 1922): 113–19.

————. "The Scientific Esthetic of the Redman," part 2, "The Fiesta of San Geronimo at Taos." *Art and Archaeology* 14 (Sept. 1922): 137–39.

————. "Return of the Native." *Contact* 1 (May 1932): [28].

————. *On Art, by Marsden Hartley*. Edited with an introduction and notes by Gail R. Scott. New York, 1982.

Hartmann, Sadakichi. "A Plea for the Picturesqueness of New York." *Camera Notes* (Oct. 1900): 91–97.

————. *A History of American Art*. 2 vols. Boston, 1901.

———— [Sidney Allan, pseud.]. "The 'Flat-Iron' Building: An Esthetical Dissertation." *Camera Work* 4 (Oct. 1903): 36–40.

Harvard Society for Contemporary Art. *American Folk Painting*. Cambridge, Mass., 1930.

Haskell, Barbara. *Arthur Dove*. Boston, 1974.

————. *Marsden Hartley*. New York, 1980.

————. *Charles Demuth*. New York, 1987.

————. *Joseph Stella*. New York, 1994.

Heller, Adele, and Lois Rudnick, eds. *1915, The Cultural Moment: The New Politics, the New Woman, the New Psychology, the New Art, and the New Theatre in America*. New Brunswick, N.J., 1991.

Hemingway, Ernest. *A Moveable Feast*. 1964; reprint, New York, 1965.

Henri, Robert. *The Art Spirit: Notes, Articles, Fragments of Letters, and Talks to Students, Bearing on the Concept and Technique of Picture Making, the Study of Art Generally, and on Appreciation.* 1923; reprint, Philadelphia, 1960.

Herbert, Robert L., Eleanor S. Apter, and Elise K. Kenney, eds. *The Société Anonyme and the Dreier Bequest at Yale University: A Catalogue Raisonné.* New Haven, Conn., 1984.

Herrera, Hayden. *Frida: A Biography of Frida Kahlo.* New York, 1983.

—————. *Frida Kahlo: The Paintings.* New York, 1991.

Hirschl and Adler Galleries. *George L. K. Morris: The Years 1945–1975.* New York 1979.

Hoare, Quintin, and Geoffrey Nowell Smith, eds. *Selections from the Prison Notebooks of Antonio Gramsci.* New York, 1971.

Hobsbawm, Eric, and Terence Ranger. *The Invention of Tradition.* Cambridge, 1983.

Hollinger, David A. "Ethnic Diversity, Cosmopolitanism, and the Emergence of the American Liberal Intelligentsia." *American Quarterly* 27 (May 1975): 133–51.

Homer, William Innes. "Picabia's *Jeune Fille américaine dans l'état de nudité* and Her Friends." *Art Bulletin* 57 (Mar. 1975): 110–15.

—————. *Alfred Stieglitz and the American Avant-Garde.* Boston, 1977.

Hoopes, James. *Van Wyck Brooks: In Search of American Culture.* Amherst, Mass., 1977.

Horak, Jan-Christopher. "Modernist Perspectives and Romantic Desire: *Manhatta.*" *Afterimage* 15 (Nov. 1987): 8–15.

Hosmer, Charles B., Jr. *Presence of the Past.* New York, 1965.

Howard, Kathleen L., and Diane F. Pardue. *Inventing the Southwest: The Fred Harvey Company and Native American Art.* Flagstaff, Ariz., 1996.

Howells, William Dean. *A Hazard of New Fortunes.* Bloomington, Ind., 1976.

Hulten, Pontus, ed., with texts by Jennifer Gough-Cooper and Jacques Caumont. *Marcel Duchamp: Work and Life.* Cambridge, Mass., 1993.

Huret, Jules. *L'Amérique moderne.* Paris, 1911.

Hutchinson, George. *The Harlem Renaissance in Black and White.* Cambridge, Mass., 1995.

Huysmans, Joris Karl. *Against Nature.* Translated by Robert Baldick. Baltimore, 1959.

"Inquiry among European Writers into the Spirit of America." *Transition* 13 (summer 1928): 248–73.

Isham, Samuel. *The History of American Painting.* 1905; reprint, New York, 1927.

Jaffe, Irma B. "Joseph Stella and Hart Crane: The Brooklyn Bridge." *American Art Journal* 1 (fall 1969): 98–107.

—————. *Joseph Stella.* Cambridge, Mass., 1970.

James, Henry. *The American Scene.* New York, 1968. Originally published 1907.

Jarry, Alfred. "Barnum." *La Revue Blanche,* Jan. 1, 1902.

—————. *The Supermale.* Translated by Barbara Wright. New York, 1977.

Jeffers, Wendy. "Holger Cahill and American Art." *Archives of American Art Journal* 31 (1991): 2–11.

—————. "Holger Cahill and American Folk Art." *Antiques* 148 (Sept. 1995): 326–35.

Josephson, Matthew. *Portrait of the Artist as American.* New York, 1930.

—————. *Life among the Surrealists: A Memoir.* New York, 1962.

—————. *The Robber Barons.* New York, 1962.

Kaes, Anton, Martin Jay, and Edward Dimendberg, eds. *The Weimar Republic Sourcebook.* Berkeley and Los Angeles, 1994.

Kammen, Michael G. *The Lively Arts: Gilbert Seldes and the Transformation of Cultural Criticism in the United States.* New York, 1996.

Kaplan, Wendy. "R. T. H. Halsey: An Ideology of Collecting American Decorative Arts." *Winterthur Portfolio* 17 (spring 1982): 43–53.

Kasson, John F. *Amusing the Millions: Coney Island at the Turn of the Century.* New York, 1978.

Kelder, Diane, ed. *Stuart Davis.* New York, 1971.

Keller, Ulrich F. "The Myth of Art Photography: An Iconographic Analysis." *History of Photography* 9 (Jan.–Mar. 1985): 1–38.

Keyes, Homer. "The New Metropolitan Wing." *Antiques* 7 (Apr. 1925): 182.

King, Moses. *King's Views of New York, 1896–1915, and Brooklyn, 1905.* Introduction by A. E. Santaniello. New York, 1974.

Kirstein, Lincoln. *Elie Nadelman.* New York, 1973.

Kloucek, Jerome W. "Waldo Frank: The Ground of His Mind and Art." Ph.D. diss., Northwestern University, 1958.

Klüver, Billy, and Julie Martin. *Kiki's Paris: Artists and Lovers, 1900–1930.* New York, 1989.

Knoles, George. *The Jazz Age Revisited: British Criticism of American Civilization during the Twenties.* Stanford, Calif., 1955.

Knox, George. "Crane and Stella: Conjunction of Painterly and Poetic Worlds." *Texas Studies in Literature and Language* 12 (winter 1971): 689–707.

Koolhaas, Rem. *Delirious New York: A Retroactive Manifesto for Manhattan.* New York, 1978.

Kouwenhoven, John. *Made in America: The Arts in Modern Civilization.* Garden City, N.Y., 1948. Reissued as *The Arts in Modern American Civilization* (New York, 1967).

Kozloff, Max. " 'Pop Culture,' Metaphysical Disgust, and

the New Vulgarians." *Art International* (Mar. 1962): 35–36.

Krauss, Rosalind. "Alfred Stieglitz's 'Equivalents.'" *Arts Magazine* 54 (Feb. 1980): 134–37.

———. "In the Name of Picasso." *October* 16 (spring 1981): 5–22.

Kreymborg, Alfred. *Troubadour: An Autobiography*. New York, 1925.

Kreymborg, Alfred, Lewis Mumford, and Paul Rosenfeld, eds. *The New Caravan*. New York, 1936.

Kruger, Barbara, and Phil Mariani, eds. *Remaking History*. Seattle, Wash., 1989.

Larkin, Oliver W. *Art and Life in America*. New York, 1949.

Lawrence, D. H. *Studies in Classic American Literature*. 1923; reprint, New York, 1964.

———. *Phoenix: The Posthumous Papers of D. H. Lawrence*. Edited by Edward D. McDonald. New York, 1936.

Lears, T. J. Jackson. *No Place of Grace: Antimodernism and the Transformation of American Culture, 1880–1920*. New York, 1981.

Le Corbusier [Charles-Édouard Jeanneret]. *Towards a New Architecture*. New York, 1927. Originally published as *Vers une architecture* (Paris, 1923).

Léger, Fernand. *Functions of Painting*. Edited by Edward F. Fry and translated by Alexandra Anderson. New York, 1973.

———. *Lettres à Simone*. Paris, 1987.

Leperlier, François. *Claude Cahun, l'écart et la métamorphose*. Paris, 1992.

Leuchtenburg, William E. *The Perils of Prosperity, 1914–1932*. Chicago, 1958.

Levine, Lawrence W. *The Unpredictable Past: Explorations in American Cultural History*. New York, 1993.

Lewis, Beth Irwin. *George Grosz: Art and Politics in the Weimar Republic*. Madison, Wis., 1971.

Lewis, H. Michaël. "Les Derniers Jugements des écrivains français sur la civilisation américaine." Ph.D. diss., University of Poitiers, 1931.

Lipman, Jean, and Richard Marshall. *Art about Art*. New York, 1978.

Lipman, Jean, and Alice Winchester. *The Flowering of American Folk Art, 1776–1876*. New York, 1974.

Lipman, Jean, and Tom Armstrong, eds. *American Folk Painters of Three Centuries*. New York, 1980.

Lippard, Lucy R. *Pop Art*. New York, 1966.

Loeb, Harold A., ed. *The Broom Anthology*. Pound Ridge, N.Y., 1969.

Looney, Ralph. "Georgia O'Keeffe." *Atlantic* 215 (Apr. 1965): 106–10.

Lorenz, Melinda A. *George L. K. Morris, Artist and Critic*. Ann Arbor, Mich., 1982.

Lowe, Sue Davidson. *Stieglitz: A Memoir/Biography*. New York, 1983.

Lozowick, Louis. *Survivor from a Dead Age: The Memoirs of Louis Lozowick*. Edited by Virginia Hagelstein Marquardt. Washington, D.C., 1997.

Lucic, Karen. "Charles Sheeler: American Interiors." *Arts Magazine* 61 (May 1987): 44–47.

———. "Charles Sheeler and Henry Ford: A Craft Heritage for the Machine Age." *Bulletin of the Detroit Institute of Arts* 65 (1989): 37–47.

———. *Charles Sheeler and the Cult of the Machine*. London, 1991.

———. *Charles Sheeler in Doylestown: American Modernism and the Pennsylvania Tradition*. Allentown, Penn., 1997.

Ludington, Townsend. *John Dos Passos*. New York, 1980.

———. *Marsden Hartley: The Biography of an American Artist*. Boston, 1992.

Luhan, Mabel Dodge. *Lorenzo in Taos*. New York, 1932.

———. *Movers and Shakers*. Albuquerque, N.M., 1936.

Lupton, Ellen. *Mechanical Brides: Women and Machines from Home to Office*. New York, 1993.

Lynes, Barbara Buhler. *O'Keeffe, Stieglitz, and the Critics, 1916–1929*. Ann Arbor, Mich., 1989.

MacAgy, Douglas. "Gerald Murphy: 'New Realist' of the Twenties." *Art in America* 51 (Apr. 1963): 49–57.

McAlmon, Robert. *Being Geniuses Together, 1920–1930*. 1968; reprint, San Francisco, 1984.

McBride, Henry. *The Flow of Art*. Edited by Daniel Cotton Rich. New York, 1975.

McCoubrey, John W. *American Tradition in Painting*. New York, 1963.

McCullough, David G. *The Great Bridge*. New York, 1972.

McDonnell, Patricia. *Dictated by Life: Marsden Hartley's German Paintings and Robert Indiana's Hartley Elegies*. Minneapolis, Minn., 1995.

———. *Marsden Hartley: American Modern*. Seattle, Wash., 1997.

MacLeish, Archibald. "There Was Something about the Twenties." *Saturday Review* (Dec. 31, 1966): 10–13.

McMurtrie, Douglas C. *Modern Typography and Layout*. Chicago, 1929.

McShine, Kynaston, ed. *The Natural Paradise: Painting in America, 1800–1950*. New York, 1976.

Madoff, Henry, ed. *Pop Art: A Critical History*. Berkeley and Los Angeles, 1997.

Mainardi, Patricia. *American Sculpture: Folk and Modern*. New York, 1977.

Manson, Gorham. "The Skyscraper Primitives." *Guardian* 1 (Mar. 1925): 164–78.

Marchand, Roland. *Advertising the American Dream: Making Way for Modernity, 1920–1940*. Berkeley and Los Angeles, 1985.

Marin, John. *Letters of John Marin*. Edited by Herbert J. Seligmann. New York, 1931.

Marinetti, Filippo Tomaso. *Marinetti: Selected Writings.* Edited by R. W. Flint. New York, 1971.

Marling, Karal Ann. "*My Egypt*: The Irony of the American Dream." *Winterthur Portfolio* 15 (spring 1980): 25–39.

Martin, Marianne W. *Futurist Art and Theory, 1909–1915.* New York, 1978.

Marvin, Carolyn. *When Old Technologies Were New: Thinking about Electric Communication in the Late Nineteenth Century.* New York, 1988.

Marx, Leo. *The Machine in the Garden: Technology and the Pastoral Ideal in America.* New York, 1964.

Masereel, Frans. *The City.* New York, 1988. Originally published as *Die Stadt* (Munich, 1925).

Mauny, Jacques. "New York 1926." *L'Art Vivant* 2 (Jan. 15, 1926): 58.

Mehring, Walter. *Berlin Dada: Eine Chronik mit Photos und Documenten.* Zurich, 1959.

Mellow, James R. *Charmed Circle: Gertrude Stein and Company.* New York, 1974.

Mellquist, Jerome. *The Emergence of an American Art.* New York, 1942.

Mellquist, Jerome, and Lucie Wiese, eds. *Paul Rosenfeld: Voyager in the Arts.* New York, 1948.

Mencken, H. L. *The American Scene: A Reader.* New York, 1965.

Mendelsohn, Erich. *Amerika: Bilderbuch eines Architekten.* Berlin, 1926.

Merkle, Judith A. *Management and Ideology: The Legacy of the International Scientific Management Movement.* Berkeley and Los Angeles, 1980.

Merrill, Christopher, and Ellen Bradbury, eds. *From the Faraway Nearby: Georgia O'Keeffe as Icon.* Reading, Mass., 1992.

Messinger, Lisa Mintz. *Georgia O'Keeffe.* New York, 1988.

Metropolitan Museum of Art. *Georgia O'Keeffe: A Portrait by Alfred Stieglitz.* Introduction by Georgia O'Keeffe. New York, 1978.

———. *American Paradise: The World of the Hudson River School.* New York, 1987.

Michaelson, Katherine Jánszky, and Nehama Guralnik. *Alexander Archipenko: A Centennial Tribute.* Washington, D.C., 1986.

Michener, James A. "Saving the Nation: Henry Mercer's Mad Dash to Capture Living History." *Art and Antiques* (Oct. 1987): 92–97.

Miller, Angela. *The Empire of the Eye: Landscape Representation and American Cultural Politics, 1825–1875.* Ithaca, N.Y., 1993.

Miller, Linda Patterson, ed. *Letters from the Lost Generation: Gerald and Sara Murphy and Friends.* New Brunswick, N.J., 1991.

Milwaukee Art Center. *Pop Art and the American Tradition.* Milwaukee, Wis., 1965.

Moley, Raymond, Jr. *The American Legion Story.* New York, 1966.

Monaghan, Frank. *French Travellers in the United States, 1765–1932: A Bibliography.* New York, 1933.

Montclair Art Museum. *Precisionism in America, 1915–1941: Reordering Reality.* New York, 1994.

Morand, Paul. *New York.* New York, 1930.

Morgan, Ann Lee. *Arthur Dove: Life and Work, with a Catalogue Raisonné.* Newark, Del., 1984.

———, ed. *Dear Stieglitz/Dear Dove.* Newark, Del., 1988.

Morison, Samuel Eliot. *The Oxford History of the United States, 1783–1917.* 2 vols. London, 1927.

Morris, Kelly, and Amanda Woods, eds. *Art in Berlin, 1915–1989.* Atlanta, 1989.

Motherwell, Robert, ed. *The Dada Painters and Poets: An Anthology.* New York, 1951.

Mumford, Lewis. *The Golden Day: A Study in American Experience and Culture.* New York, 1926.

———. *The Brown Decades: A Study of the Arts in America, 1865–1895.* 1931; reprint, New York, 1955.

Munson, Gorham. "The Mechanics of a Literary Secession." *S4N* 22 (Nov. 1922): n.p.

———. "The Skyscraper Primitives." *Guardian* 1 (Mar. 1925): 164–78.

Musée d'art moderne de la ville de Paris. *Léger et l'esprit moderne: Une Alternative d'avant-garde à l'art non-objectif, 1918–1931.* Paris, 1982.

Musée national d'art moderne. *Fernand Léger: La Poésie de l'objet, 1928–1934.* Paris, 1981.

Museum of Fine Arts, Santa Fe, Museum of New Mexico. *Rebecca Salsbury James: A Modern Artist and Her Legacy.* Santa Fe, N.M., 1991.

Museum of Modern Art. *Homer, Ryder, Eakins.* New York, 1930.

———. *American Folk Art: The Art of the Common Man in America, 1750–1900.* New York, 1932.

———. *Charles Sheeler: Paintings, Drawings, Photographs.* New York, 1939.

———. *Three American Romantic Painters: Charles Burchfield, Florine Stettheimer, and Franklin C. Watkins.* New York, 1969.

Naumann, Francis M. "The Big Show: The First Exhibition of the Society of Independent Artists, part I." *Artforum* 17 (Feb. 1979): 34–39.

———. "The Big Show: The First Exhibition of the Society of Independent Artists, part II." *Artforum* 17 (Apr. 1979): 49–53.

———. "*Affectueusement, Marcel*: Ten Letters from Marcel Duchamp to Suzanne Duchamp and Jean Crotti." *Archives of American Art Journal* 22 (spring 1983): 2–19.

———. "*Amicalement, Marcel*: Fourteen Letters from Marcel to Walter Pach." *Archives of American Art Journal* 29 (1989): 37–41.

———. *New York Dada, 1915–23*. New York, 1994.

Naumann, Francis M., with Beth Venn. *Making Mischief: Dada Invades New York*. New York, 1996.

Nelson, W. H. de B. "Aesthetic Hysteria." *International Studio* 61 (June 1917): 125.

Nesbit, Molly. "Ready-Made Originals: The Duchamp Model." *October* 37 (summer 1986): 53–64.

Neue Gesellschaft für bildende Künst. *America: Traum und Depression, 1920–1940*. Berlin, 1980.

Nevinson, Henry Woodd. *Farewell to America*. New York, 1922.

Newman, Sasha M. *Arthur Dove and Duncan Phillips: Artist and Patron*. Washington, D.C., 1981.

New York University. *Museum of Living Art: A. E. Gallatin Collection*. New York, 1936.

Norman, Dorothy. *Alfred Stieglitz: An American Seer*. 1960; reprint, New York, 1973.

Novak, Barbara. *American Painting of the Nineteenth Century: Realism, Idealism and the American Experience*. New York, 1969.

Nye, David E. *Electrifying America: Social Meanings of a New Technology*. Cambridge, Mass., 1991.

O'Keeffe, Georgia. *Georgia O'Keeffe*. New York, 1976.

———. *Lovingly, Georgia: The Complete Correspondence of Georgia O'Keeffe and Anita Pollitzer*. Edited by Clive Giboire. New York, 1990.

Oppenheim, James. "The Story of the *Seven Arts*." *American Mercury* 20 (June 1930): 156–64.

Ozenfant, Amédée. *Foundations of Modern Art*. Translated by John Rodker. New York, 1952.

———. *Mémoires, 1886–1962*. Paris, 1968.

Pachter, Marc, ed. *Abroad in America: Visitors to the New Nation, 1776–1914*. Reading, Mass., 1976.

Pack, Arthur Newton. *We Called It Ghost Ranch*. Abiquiu, N.M., 1979.

Parrington, Vernon Louis. *Main Currents in American Thought: An Interpretation of American Literature from the Beginnings to 1920*. 3 vols. New York, 1927.

Pastier, John, et al. "Skyscraper View." *Design Quarterly* (Special Issue) 140 (1988).

Paynter, Edward Lloyd. "The Modern Sphinx: American Intellectuals and the Machine, 1910–1940." Ph.D. diss., University of California at Berkeley, 1971.

Perloff, Marjorie. *The Futurist Moment: Avant-Garde, Avant-Guerre, and the Language of Rupture*. 3 vols. Chicago, 1986.

Peters, Sarah Whitaker. *Becoming O'Keeffe: The Early Years*. New York, 1991.

Pilgrim, Dianne H. "Inherited from the Past: The American Period Room." *American Art Journal* 10 (May 1978): 4–23.

Platt, Susan Noyes. *Modernism in the 1920s: Interpretations of Modern Art in New York from Expressionism to Constructivism*. Ann Arbor, Mich., 1981.

Pollack, Howard. *Skyscraper Lullaby: The Life and Music of John Alden Carpenter*. Washington, D.C., 1995.

Pollitzer, Anita. *A Woman on Paper: Georgia O'Keeffe*. New York, 1988.

Potter, Hugh M. "The 'Romantic Nationalists' of the 1920s." Ph.D. diss., University of Minnesota, 1964.

———. *False Dawn: Paul Rosenfeld and Art in America, 1916–1946*. Ann Arbor, Mich., 1980.

Pound, Ezra. *Ezra Pound: Selected Prose, 1909–1965*. Edited by William Cookson. New York, 1950.

Quimby, Ian M. G., and Scott T. Swank, eds. *Perspectives on American Folk Art*. New York, 1980.

Rand McNally and Company. *Rand McNally Fifty Photographic Views of Greater New York*. New York, 1899.

———. *Rand McNally New York Guide to Places of Interest in the City and Environs*. Chicago, 1924.

Rathbone, Belinda, et al. *Georgia O'Keeffe and Alfred Stieglitz: Two Lives, A Conversation in Paintings and Photographs*. Edited by Alexandra Arrowsmith and Thomas West. Washington, D.C., 1992.

Reaves, Wendy Wick. *Celebrity Caricature in America*. Washington, D.C., 1998.

Reed, Cleota. *Henry Chapman Mercer and the Moravian Pottery and Tile Works*. Philadelphia, 1987.

Reich, Sheldon. *John Marin: A Stylistic Analysis and Catalogue Raisonné*. 2 vols. Tucson, Ariz., 1970.

Rhoads, William B. "The Colonial Revival and American Nationalism." *Journal of the Society of Architectural Historians* 35 (Dec. 1976): 239–54.

Rider, Fremont. *Rider's New York City and Vicinity*. New York, 1916.

Ring, Nancy. "New York Dada and the Crisis of Masculinity: Man Ray, Francis Picabia, and Marcel Duchamp in the United States, 1913–1921." Ph.D. diss., Northwestern University, 1991.

Ritchie, Andrew Carnduff. *Charles Demuth*. New York, 1950.

Rivera, Diego. *My Art, My Life: An Autobiography*. New York, 1960.

Riviere, Joan. "Womanliness as a Masquerade." *International Journal of Psychoanalysis* 10 (1929); reprinted in *Formations of Fantasy*, ed. Victor Burgin et al. (New York, 1986).

Robbins, Daniel. *Albert Gleizes, 1881–1953: A Retrospective Exhibition*. New York, 1964.

———. "The Formation and Maturity of Albert Gleizes: A Biographical and Critical Study, 1881 through 1920." Ph.D. diss., Institute of Fine Arts, New York University, 1975.

Roberts, Mary Fanton [Giles Edgerton, pseud.]. "How New York Has Redeemed Herself from Ugliness: An Artist's Revelation of the Beauty of the Skyscraper." *Craftsman* 11 (Jan. 1907): 458–71.

Robertson, Bruce. *Reckoning with Winslow Homer:*

His Late Paintings and Their Influence. Cleveland, 1990.

Robinson, Roxana. *Georgia O'Keeffe: A Life.* New York, 1989.

Roché, Henri-Pierre. *Victor: Marcel Duchamp.* Paris, 1977.

Roche, Juliette. *Demi cercle.* Paris, 1920.

———. "La Minéralisation de Dudley Craving Mac-Adam." *La Vie des Lettres et des Arts* 8 (1922): 22–271; reprint, Paris, 1924.

Rodgers, Timothy Robert. "Alfred Stieglitz, Duncan Phillips, and the '$6,000 Marin.'" *Oxford Art Journal* 15 (1992): 55–56.

Rodriguez, Sylvia. "Art, Tourism, and Race Relations in Taos: Toward a Sociology of the Art Colony." *Journal of Anthropological Research* 45 (spring 1989): 77–99.

Romier, Lucien. *Who Will Be Master, Europe or America?* Translated by Matthew Josephson. New York, 1928. Originally published as *Qui sera le maître? Europe ou Amérique?* (Paris, 1927).

Rose, Barbara. *American Art since 1900: A Critical History.* 1967; reprint, New York, 1975.

Rose, Phyllis. *Jazz Cleopatra: Josephine Baker in Her Time.* New York, 1989.

Rosenberg, Harold. *The Tradition of the New.* 1959; reprint, New York, 1965.

Rosenfeld, Paul. *Port of New York: Essays on Fourteen American Moderns.* New York, 1924; reprint, Urbana, Ill., 1961, 1966, with an introduction by Sherman Paul.

———. *Men Seen: Twenty-Four Modern Authors.* New York, 1925.

———. *Musical Chronicle, 1917–1923.* New York, 1923.

———. *Boy in the Sun.* New York, 1928.

———. *By Way of Art: Criticisms of Music, Literature, Painting, Sculpture, and the Dance.* New York, 1928.

Roth, Moira. "Marcel Duchamp in America: A Self Ready-Made." *Arts Magazine* 59 (May 1977): 92–96.

Rothschild, Deborah Menaker. *Picasso's "Parade": From Street to Stage.* New York, 1991.

Rourke, Constance Mayfield. *American Humor: A Study of the National Character.* New York, 1931.

———. *Davy Crockett.* New York, 1934.

———. "American Art: A Possible Future." *American Magazine of Art* 28 (July 1935): 390–404.

———. *Charles Sheeler: Artist in the American Tradition.* New York, 1938.

———. *The Roots of American Culture and Other Essays.* Edited and with an introduction by Van Wyck Brooks. New York, 1942.

Rubin, Joan Shelley. *Constance Rourke and American Culture.* Chapel Hill, N.C., 1980.

———. "A Convergence of Vision: Constance Rourke, Charles Sheeler, and American Art." *American Quarterly* 42 (June 1990): 191–222.

Rubin, William. *The Paintings of Gerald Murphy.* New York, 1974.

———. "The Pipes of Pan: Picasso's Aborted Love Song to Sara Murphy." *Art News* 93 (May 1994): 138–47.

———, ed. *"Primitivism" in Twentieth Century Art: Affinity of the Tribal and the Modern.* 2 vols. New York, 1984.

Rudnick, Lois Palken. *Mabel Dodge Luhan: New Woman, New Worlds.* Albuquerque, N.M., 1984.

———. *Utopian Vistas: The Mabel Dodge Luhan House and the American Counterculture.* Albuquerque, N.M., 1996.

Ruland, Richard. *The Rediscovery of American Literature: Premises of Critical Taste, 1900–1940.* Cambridge, Mass., 1967.

Rumford, Beatrix T., and Carolyn J. Weekley. *Treasures of American Folk Art from the Abby Aldrich Rockefeller Folk Art Center.* Boston, 1989.

Rushing, William Jackson. *Native American Art and the New York Avant-Garde: A History of Cultural Primitivism.* Austin, Tex., 1995.

Russell, John, and Suzi Gablik. *Pop Art Redefined.* London, 1969.

Sacks, Claire. "The *Seven Arts* Critics: A Study of Cultural Nationalism in America, 1910–1930." Ph.D. diss., University of Wisconsin, 1955.

Samaltanos, Katia. *Apollinaire: Catalyst for Primitivism, Picabia, and Duchamp.* Ann Arbor, Mich., 1984.

Sandler, Irving. *The Triumph of American Painting: A History of Abstract Expressionism.* New York, 1970.

Saunders, Richard H. "Collecting American Decorative Arts in New England, Part I: 1793–1876." *Antiques* 109 (May 1976): 996–1002.

———. "Collecting American Decorative Arts in New England, Part II: 1876–1910." *Antiques* 110 (Oct. 1976): 754–63.

Saville, Jennifer. *Georgia O'Keeffe: Paintings of Hawaii.* Honolulu, 1990.

Sawada, Mitziko. *Tokyo Life, New York Dreams: Urban Japanese Visions of America, 1890–1924.* Berkeley and Los Angeles, 1996.

Schleier, Merrill. *The Skyscraper in American Art, 1890–1931.* Ann Arbor, Mich., 1986.

Schneede, Uwe M. *George Grosz: His Life and Work.* Translated by Susanne Flatauer. London, 1979.

Schwarz, Arturo. *The Complete Works of Marcel Duchamp.* New York, 1969.

Scott, Gail R. "Marsden Hartley at Dogtown Common." *Arts Magazine* 54 (Oct. 1979): 159–65.

Seigel, Jerrold. *The Private Worlds of Marcel Duchamp: Desire, Liberation, and the Self in Modern Culture.* Berkeley and Los Angeles, 1995.

Seldes, Gilbert. *The Seven Lively Arts.* New York, 1924.

Seligmann, Herbert J. *Alfred Stieglitz Talking: Notes on Some of His Conversations, 1925–1931*. New Haven, Conn., 1966.

Serota, Nicholas, ed. *Fernand Léger: The Later Years*. London, 1988.

Seton Hall University. *Louis Lozowick, 1892–1973*. South Orange, N.J., 1973.

Sharpe, William. "New York, Night, and Cultural Myth-making: The Nocturne in Photography, 1900–1925." *Smithsonian Studies in American Art* 2 (fall 1988): 3–21.

Shi, David E. *Matthew Josephson: Bourgeois Bohemian*. New Haven, Conn., 1981.

Shumway, David R. *Creating American Civilization: A Genealogy of American Literature as an Academic Discipline*. Minneapolis, Minn., 1994.

Silet, Charles L. P. *The Writings of Paul Rosenfeld: An Annotated Bibliography*. New York, 1981.

Silver, Kenneth E. *Esprit de Corps: The Art of the Parisian Avant-Garde and the First World War, 1914–1925*. Princeton, N.J., 1989.

Simmel, Georg. *On Individuality and Social Forms*. Chicago, 1971.

Sims, Lowery Stokes, et al. *Stuart Davis, American Painter*. New York, 1991.

Smith, Francis Hopkinson. *Charcoals of New and Old New York*. New York, 1912.

Smith, Henry Nash. *Virgin Land: The American West as Symbol and Myth*. Cambridge, Mass., 1950.

Smith, Joel. "How Stieglitz Came to Photograph Cityscapes." *History of Photography* 20 (winter 1996): 320–21.

Smith, Terry. *Making the Modern: Industry, Art and Design in America*. New York, 1993.

Solomon, Alan R. *Robert Rauschenberg*. New York, 1963.

Solomon-Godeau, Abigail. "Back to Basics: The Return of Alfred Stieglitz." *Afterimage* 12 (summer 1984): 22.

Solomonson, Katherine Mary. "The Chicago Tribune Tower Competition: The Formation of a Corporate Icon." Ph.D. diss., Stanford University, 1991.

Soupault, Philippe. "The American Influence in France." *Chapbook*, no. 38. Translated by Babette Hughes and Glenn Hughes. Seattle, Wash., 1930.

———. *Poésies complètes, 1917–1927*. Paris, 1937.

———. *Ecrits de cinéma*. Edited by Alain Virmaux and Odette Virmaux. Paris, 1979.

Stearns, Harold E., ed. *Civilization in the United States: An Inquiry by Thirty Americans*. New York, 1922.

Stebbins, Theodore E., Jr., and Norman Keyes, Jr. *Charles Sheeler: The Photographs*. Boston, 1987.

Steegmuller, Francis. *Apollinaire: Poet among the Painters*. 1963; reprint, New York, 1986.

Steel, David. "Surrealism, Literature of Advertising and the Advertising of Literature in France, 1910–1930." *French Studies* 41 (July 1987): 283–97.

Stein, Gertrude. *The Making of Americans: Being a History of a Family's Progress*. 1925; reprint, Normal, Ill., 1995.

———. *The Autobiography of Alice B. Toklas*. New York, 1933.

———. *Lectures in America*. New York, 1935.

———. *Everybody's Autobiography*. New York, 1937.

———. *Wars I Have Seen*. New York, 1945.

Steinman, Lisa M. *Made in America: Science, Technology, and American Modernist Poetry*. New Haven, Conn., 1987.

Stern, Rudi. *Let There Be Neon*. New York, 1979.

Stewart, Jeffrey C. *To Color America: Portraits by Winold Reiss*. Washington, D.C., 1989.

———. *Winold Reiss: An Illustrated Checklist of His Portraits*. Washington, D.C., 1990.

Stewart, Rick. "Charles Sheeler, William Carlos Williams, and Precisionism: A Redefinition." *Arts Magazine* 58 (Nov. 1983): 100–114.

———. *An American Painter in Paris: Gerald Murphy*. Dallas, Tex., 1986.

Stieglitz, Alfred. "I Photograph the Flatiron—1902." *Twice a Year* 14–15 (fall–winter 1946): 189.

Still, Bayrd. *Mirror for Gotham: New York as Seen by Contemporaries from Dutch Days to the Present*. New York, 1956.

Stillinger, Elizabeth. *The Antiquers: The Lives and Careers, the Deals, the Finds, the Collections of the Men and Women Who Were Responsible for the Changing Taste in American Antiques, 1850–1930*. New York, 1980.

Stovall, Tyler. *Paris Noir: Africans in the City of Light*. Boston, 1996.

Strand, Paul. "American Water Colors at the Brooklyn Museum." *Arts* 2 (Jan. 20, 1922): 151–52.

———. "John Marin." *Art Review* 1 (Jan. 1922): 22–23.

———. "Alfred Stieglitz and Machine." *MSS* 2 (Mar. 1922): 6–7.

———. "Photography and the New God." *Broom* 3 (1922): 255–58.

———. "Georgia O'Keeffe." *Playboy* (July 1924): 16–20.

———. "Marin Not an Escapist." *New Republic* 55 (July 25, 1928): 254.

Strauss, Anselm L. *Images of the American City*. New York, 1961.

Strauss, David. *Menace in the West: The Rise of French Anti-Americanism in Modern Times*. Westport, Conn., 1978.

Sussman, Elisabeth, with Barbara J. Bloemink, and a contribution by Linda Nochlin. *Florine Stettheimer: Manhattan Fantastica*. New York, 1995.

Sweeney, James Johnson. *Stuart Davis*. New York, 1945.

———. "Eleven Europeans in America." *Museum of Modern Art Bulletin* 13 (1946): 2.

Symons, Arthur. *The Symbolist Movement in Literature.* Revised and enlarged edition. New York, 1919.

Tashjian, Dickran. *Skyscraper Primitives: Dada and the American Avant-Garde, 1910–1925.* Middletown, Conn., 1975.

Tate Gallery. *Léger and Purist Paris.* London, 1970.

Taylor, William Robert. *In Pursuit of Gotham: Culture and Commerce in New York.* New York, 1992.

———, ed. *Inventing Times Square: Commerce and Culture at the Crossroads of the World.* New York, 1991.

Tepfer, Diane. "Edith Gregor Halpert and the Downtown Gallery: Downtown, 1926–1940; A Study in American Art Patronage." Ph.D. diss., University of Michigan, 1989.

Thomas, F. Richard. *Literary Admirers of Alfred Stieglitz.* Carbondale, Ill., 1983.

Tichi, Cecelia. *Shifting Gears: Technology, Literature, Culture in Modernist America.* Chapel Hill, N.C., 1987.

Tick, Judith. "Ruth Crawford's 'Spiritual Concept': The Sound-Ideals of an Early American Modernist, 1924–1930." *Journal of the American Musicological Society* 44 (summer 1941): 221–35.

Tomkins, Calvin. *Living Well Is the Best Revenge.* New York, 1971.

———. *Duchamp: A Biography.* New York, 1996.

Tower, Beeke Sell. *Envisioning America: Prints, Drawings, and Photographs by George Grosz and His Contemporaries, 1915–1933.* Cambridge, Mass., 1990.

Trachtenberg, Alan. "Mumford in the Twenties." *Salmagundi* 49 (summer 1980): 29–42.

Troy, Nancy J. *Mondrian and Neo-Plasticism in America.* New Haven, Conn., 1979.

Troyen, Carol, and Erica E. Hirshler. *Charles Sheeler: Paintings and Drawings.* Boston, 1987.

Truettner, William H., ed. *The West as America: Reinterpreting Images of the Frontier, 1820–1920.* Washington, D.C., 1991.

Tsujimoto, Karen. *Images of America: Precisionist Painting and Modern Photography.* Seattle, Wash., 1982.

Tuchman, Maurice, ed. *The Spiritual in Art: Abstract Painting, 1890–1985.* New York, 1986.

Turner, Elizabeth Hutton. *American Artists in Paris, 1919–1929.* Ann Arbor, Mich., 1988.

Turner, Elizabeth Hutton, with Elizabeth Garrity Ellis and Guy Davenport. *Americans in Paris, 1921–1931: Man Ray, Gerald Murphy, Stuart Davis, Alexander Calder.* Washington, D.C., 1996.

Udall, Sharyn Rohlfsen. *Modernist Painting in New Mexico, 1913–1935.* Albuquerque, N.M., 1984.

———. *Santa Fe Art Colony, 1900–1942.* Santa Fe, N.M., 1987.

Untermeyer, Louis. *From Another World: The Autobiography of Louis Untermeyer.* New York, 1939.

Vaill, Amanda. *Everybody Was So Young: Gerald and Sara Murphy, a Lost Generation Love Story.* Boston, 1998.

Van Dyke, John Charles. *The New New York: A Commentary on the Place and the People.* New York, 1909.

———. *The Autobiography of John C. Van Dyke: A Personal Narrative of American Life, 1861–1931.* Edited by Peter Wild. Salt Lake City, Utah, 1993.

Van Leeuwen, Thomas A. P. *The Skyward Trend: Five Essays on the Metaphysics of the American Skyscraper.* Amsterdam, 1986.

Varnedoe, Kirk, and Adam Gopnik. *High and Low: Modern Art and Popular Culture.* New York, 1990.

———, eds. *Modern Art and Popular Culture: Readings in High and Low.* New York, 1990.

Vlach, John Michael. "Holger Cahill as Folklorist." *Journal of American Folklore* 98 (1985): 148–62.

———. *Plain Painters: Making Sense of American Folk Art.* Washington, D.C., 1988.

Vlach, John Michael, and Simon J. Bronner, eds. *Folk Art and Art Worlds: Essays Drawn from the Washington Meeting on Folk Art.* Ann Arbor, Mich., 1986.

Wagner, Anne Middleton. *Three Artists (Three Women): Modernism and the Art of Hesse, Krasner, and O'Keeffe.* Berkeley and Los Angeles, 1996.

Walch, Peter, and Thomas F. Barrow, eds. *Perspectives on Photography: Essays in Honor of Beaumont Newhall.* Albuquerque, N.M., 1986.

Watson, Forbes. "Charles Sheeler." *Arts* 3 (May 1923): 335–44.

Watson, Steven. *Strange Bedfellows: The First American Avant-Garde.* New York, 1991.

Weber, Brom. *Hart Crane: A Biographical and Critical Study.* New York, 1948.

Weigle, Marta. "From Desert to Disney World: The Santa Fe Railway and the Fred Harvey Company Display the Indian Southwest." *Journal of Anthropological Research* 45 (spring 1989): 115–37.

———. "Southwest Lures: Innocents Detoured, Incensed Determined." *Journal of the Southwest* 32 (winter 1990): 499–540.

Weigle, Marta, and Kyle Fiore. *Santa Fe and Taos: The Writer's Era, 1916–1941.* Santa Fe, N.M., 1982.

Weigle, Marta, and Peter White. *The Lore of New Mexico.* Albuquerque, N.M., 1988.

Weinberg, Jonathan. *Speaking for Vice: Homosexuality in the Art of Charles Demuth, Marsden Hartley, and the First American Avant-Garde.* New Haven, Conn., 1993.

Weisberg, Gabriel P. "S. Bing and *La Culture artistique en Amérique*: A Public Report Reexamined." *Arts Magazine* 61 (Mar. 1987): 59–63.

Weiss, Jeffrey. *The Popular Culture of Modern Art: Picasso, Duchamp, and Avant-Gardism.* New Haven, Conn., 1994.

Wells, H. G. *The Future in America: A Search after Realities.* London, 1906.

Wertheim, Arthur Frank. *The New York Little Renaissance: Iconoclasm, Modernism, and Nationalism in American Culture, 1908–1917.* New York, 1976.

Weston, Edward. *The Daybooks of Edward Weston.* 2 vols. Edited by Nancy Newhall. Millerton, N.Y., 1973.

Whitesitt, Linda. *The Life and Music of George Antheil, 1900–1959.* Ann Arbor, Mich., 1983.

Whitman, Walt. *Feuilles d'herbe.* 2 vols. Translated by Léon Bazalgette. Paris, 1909.

———. *Walt Whitman Abroad: Critical Essays from Germany, France, Scandinavia, Russia, Italy, Spain and Latin America, Israel, Japan and India.* Edited by Gay Wilson Allen. Syracuse, N.Y., 1955.

"Why Do Americans Live in Europe?" *Transition* 14 (fall 1928): 97.

Willett, John. *The Theatre of Bertolt Brecht: A Study from Eight Aspects.* London, 1959.

Williams, Jesse Lynch. *New York Sketches.* New York, 1902.

Williams, Raymond. *The Politics of Modernism: Against the New Conformists.* London, 1989.

Williams, William Carlos. *In the American Grain.* New York, 1925.

———. *The Autobiography of William Carlos Williams.* New York, 1951.

———. *Collected Earlier Poems.* New York, 1951.

———. *The Collected Poems of William Carlos Williams, 1906–1939.* 2 vols. Edited by A. Walton Litz and Christopher MacGowan. New York, 1986.

Wilson, Edmund. "An Imaginary Conversation." *New Republic* (Apr. 9, 1924): 179–82.

———. *Axel's Castle: A Study in the Imaginative Literature of 1870–1930.* New York, 1931.

———. *The American Earthquake: A Documentary of the Twenties and Thirties.* New York, 1958.

———. *The Twenties: From Notebooks and Diaries of the Period.* Edited by Leon Edel. New York, 1975.

Wilson, Richard Guy, Dianne H. Pilgrim, and Dickran Tashjian. *The Machine Age in America, 1918–1941.* New York, 1986.

Wise, Gene, ed. "The American Studies Movement: A Thirty-Year Retrospective." *American Quarterly* 31, special issue (1979).

Wood, Beatrice. *I Shock Myself: The Autobiography of Beatrice Wood.* Ojai, Calif., 1985.

Woolley, Grange. *Stéphane Mallarmé, 1842–1898.* 1942; reprint, New York, 1981.

Yeh, Susan Fillin. *Charles Sheeler: American Interiors.* New Haven, Conn., 1987.

Yount, Sylvia, and Elizabeth Johns. *To Be Modern: American Encounters with Cézanne and Company.* Philadelphia, 1996.

Zabel, Barbara. "Louis Lozowick and Technological Optimism of the 1920s." Ph.D. diss., University of Virginia, 1978.

———. "Stuart Davis's Appropriation of Advertising: The Tobacco Series, 1921–1924." *American Art* 5 (fall 1991): 56–67.

Zeldin, Theodore. *France, 1848–1945.* 2 vols. Oxford, 1977.

Zilczer, Judith K. "Robert J. Coady, Forgotten Spokesman for Avant-Garde Culture in America." *American Art Review* 2 (Sept.–Oct. 1975): 77–89.

———. "Synaesthesia and Popular Culture: Arthur Dove, George Gershwin, and the 'Rhapsody in Blue.'" *Art Journal* 44 (winter 1984): 36–66.

———. "Robert J. Coady, Man of *The Soil*." *Dada/Surrealism* 14 (1985): 31–43.

Zorach, William. *Zorach Explains Sculpture: What It Means and How It Is Made.* New York, 1947.

———. *Art Is My Life: The Autobiography of William Zorach.* Cleveland, Ohio, 1967.

ACKNOWLEDGMENTS

Like the cross-sectioned trunk of an ancient redwood, this book has many growth rings, each standing for the years gone by and for the people and institutions who have helped me in ways large and small. Some of these rings are so tightly compressed that I am sure to miss them in my accounting here, but I hope that the heft of the book's endnotes will repay the debts not named here.

The centermost ring stands for my teachers. Milton Brown, Robert Goldwater, H. W. Janson, and Joshua Taylor will never hold this book, but I want to remember each of them here for encouraging me to set my sights higher. All were scholars who not only taught and wrote but also built programs and institutions, giving so much back to the history of art they loved. Colin Eisler and Robert Rosenblum, also my teachers, permitted me, by their example, to indulge a catholicity of scholarly interest and taste in art. Thirty years ago Barbara Rose, though never my teacher, wrote so compellingly about this country's first modernists that I began to look closely at their art and careers.

In the heartwood of my metaphoric tree are also the many unsung librarians and archivists whose labors have eased my own. At the Stanford University library, which has miraculously retained a tradition of superior service, even during an era of budget stringency, I give special thanks to the former librarians Amanda Bowen and Margie Grady and to the present library staff, especially Alex Ross, Peter Blank, Linda Treffinger, and Sonia Moss. On the *other* coast, my library of choice has been the National Museum of American Art. Having worked in that heavenly place during four long stays in the past twenty years, I have accumulated massive debts for favors extended, including the use of a photocopying machine; I extend my hand to everyone on the library staff, naming only a few—past and present—to stand for the many: William Walker, Katherine Martinez, Cecilia Chin, and Pat Lynagh.

No one can study early-twentieth-century modern American art without logging significant time in the Beinecke Rare Book and Manuscript Library at Yale University, home of the Alfred Stieglitz archives and other modernist collections, curated formerly by Donald Gallup and now by Patricia C. Willis. My thanks to both of them for maintaining the quality and accessibility of these valuable papers. The same goes for the Archives of American Art, where over the past quarter century the holdings of artists' papers, oral interviews, sketchbooks, and ephemera have grown exponentially into the richest of resources. The present director, Richard Wattenmaker, and Garnett McCoy, Judith Throm, and Catherine Stover have all helped me locate papers and photographs in the Smithsonian home office. Patricia Junker has done the same at the M. H. de Young Memorial Museum, whose American art department houses a set of the archives' microfilms; Paul Karlstrom, who was the founding regional director, first of the northern and then the southern California office of the archives, has long been a friend and helpful colleague.

At the Georgia O'Keeffe Foundation I had the good fortune to work with its very able president, Elizabeth Glassman, and its staff, Judy Lopez, Georgia Smith, Mikka Gee, and Sarah Burt. Carol Morgan, the former director of the Demuth Foundation, and Cheri Markowitz, her successor, have graciously responded to queries and requests for photographs. Thanks also to those who have helped me over the years at the Library of Congress, the Mills College library, the Whitney Museum, the Museum of Modern Art in New York, and The Fine Arts Museum of New Mexico.

Some of the darkest rings on my book's tree trunk stand for the juries and selection committees who awarded me grants to research and write. A postdoctoral fellowship at the National Museum of American Art helped me begin this project; as a fellow at the Woodrow Wilson Center I struggled to find the book's structure. During a year at the Stanford Humanities Center, I completed a quite different book but in the process realized, quite unexpectedly, that European modernism had to become a large part of this study. That drove me back to the libraries and to Paris, where the American Council of Learned Societies funded a summer's work. Finally, in 1987, thanks to the dedicated efforts of Charles Eldredge and Elizabeth Broun, then director and deputy director of the National Museum of American Art, I was invited to be the museum's first Smithsonian Regents Fellow, an opportunity I used to draft the book's first chapters. I knew then that the book was finally on its way.

Grants from the Ruth Levison Halperin Fund and the James and Doris McNamara Fund in the Department of Art and Art History at Stanford University have provided me with graduate student research assistance and with

help purchasing books and photographs. The office of the Dean of Humanities and Sciences also helped defray the costs of reproductions for this book, as did a generous grant from the Society for the Preservation of American Modernists.

For essential office and administrative support at Stanford University, I want to thank Sue Dambrau, Mona Duggan, Stacie Gipson, Gwen Lorrain, Elizabeth Martin, and Susan Sebbard. Nicole Squiers of our slide library made a number of photographs for this book, and Sybil Hudson, her colleague, helped locate images I remembered but could not find. They were all part of a collective effort to launch this book.

So were many of my students over the years. Their various handwritten references and jottings often catch me off-guard when I come upon them in my files, eliciting memories of the days when they were students. Many of them are already productive scholars, and others soon will be: Laura Barneby, Susan Dennis, Mary Lou Hansen, Elizabeth Hutchinson, Gerard Koskovich, Carrie Lambert, Tirza Latimer, Margaret Proskauer Lawrence, Rael Lewis, Michelle Meyers, Ellen Todd, Charlotte Wellman, Cécile Whiting, and Leslie Wright. Some of them were in our graduate program thanks to a gift from an anonymous donor to support the study of American art and material culture at Stanford. My most recent research assistant, Jeanne Fraise, conscientiously compiled the bibliography and helped bring the book to completion.

My same files contain letters, jottings on napkins, and (more recently) e-mails from a host of friends and scholarly colleagues who have helped me locate photographs and information. It is a pleasure to record my long overdue thanks to William Agee, Dennis Anderson, Thomas Bender, Avis Berman, Bruce Bernstein, Celia Betsky, Judith Bettleheim, Lisa Bloom, Michele Bogart, William Camfield, Whitney Chadwick, Susan Ciriclio, Jean-Louis Cohen, Christian Derouet, Linda Docherty, Gladys Fabre, Betsy Fahlman, Susan Fellin-Yeh, Alan Fern, Ruth Fine, Lois Fink, Susan Grant, Christopher Green, Neil Harris, Lynda Hartigan, Barbara Haskell, Robert Herbert, William Homer, Michael Kammen, Bob and Ginny Laughlin, Sidney Lawrence, Larry Levine, Harry Lowe, Townsend Ludington, Patricia McDonnell, the late Lillian Miller, Ann Lee Morgan, Alexander Nemerov, Claire Nova, Brian O'Doherty, the late Daniel Robbins, Moira Roth, Lois Rudnick, Merrill Schleier, Carl Schorske, Kenneth Silver, Fronia Simpson, Katherine Solomonson, Lisa Steinmen, Elizabeth Stillinger, Kirsten Swinth, Diane Tepfer, Cecelia Tichi, Calvin Tomkins, Alan Trachtenberg, Carol Troyon, William Truettner, Elizabeth Turner, Sharon Udall, Anne Wagner, Jean Yellin, Barbara Zabel, and Judith Zilczer. In Santa Fe, when I was doing research, Beth and Charles Miller gave me a home at *Sol y Sombra*. For high-spirited exchanges about titles for my

book, inconclusive and without consensus, I fondly remember Marc Pachter and Bruce and Deborah Berman in Washington, D.C.

It was my good fortune to meet two of the artists I discuss in my book. For arranging a visit with Charles Sheeler in 1964, I want to thank Peggy Alexander, an old family friend, and for smoothing my way to interview Georgia O'Keeffe in 1980, I thank Sarah Greenough. Honoria Murphy Donnelly, the daughter of Gerald Murphy, and her husband, William Donnelly, kindly shared their memories and archives; it saddens me that neither of them lived to see this book published. Barney Ebsworth and Myron Kunin generously opened their private collections of early-twentieth-century American art when I visited their hometowns. I also had access to a third great collection, assembled by Mr. and Mrs. William Lane and now housed at the Boston Museum of Fine Arts. Saundra Lane graciously granted me access to her collection of Sheeler photographs, and Karen Haas, the Lane curator, cheerfully responded to my many requests. Joan Washburn and Virginia Zabriskie, veteran directors of the two New York galleries that carry their names, have each had occasion to help. Breakfasts and lunches with Jay Maroney, friend and art dealer, have always given me good laughs and fresh thoughts about the early American modernists we study and admire.

To the many colleagues who bent their busy schedules and found time to comment upon individual chapters, I want to extend thanks while holding them completely blameless: Karen Lucic, Barbara Buhler Lynes, Charles Eldredge, Sarah Greenough, Francis Naumann, and Steven Watson. Each raised my expectations for what I might accomplish and helped me identify new sources and obtain photographs. I'm grateful, too, for the incisive reports I received from two anonymous readers of my manuscript and to Ann Jensen Adams, who read it as a member of the University of California Press's Editorial Committee. Elizabeth Johns, a friend of immeasurable depth and wisdom, gave me an invaluable reading of the entire manuscript as it reached its final stages. Eunice Lipton, a tough-love kind of friend, was nothing short of my personal trainer on the project. She was there every mile of the way. The only person outside of my household to read first drafts, Eunice was a brilliant and incisive critic, using bribes and threats to get me to the finish line. Thanks to Ken Aptekar, too, for good food and friendship.

My team at the University of California Press included James Clark, the director, who had uncommon affection and vision for this book. Deborah Kirshman solicited the manuscript and marshaled her considerable skills as a strategist and fundraiser to bring the project to completion. Stephanie Fay edited the manuscript with concision, masterfully turning sow's ears into purses. Jennifer Toleikis Abrams, the book's picture editor, met the challenges of locating illustrations from almost three hundred

different sources, a task made all the more difficult by to-day's poorly regulated and labyrinthine procedures for acquiring rights, permissions, and photographs. The book's designer, Christine Taylor of Wilsted & Taylor Publishing Services, was the perfect partner for this project; her knowledge of typography and her sensitivity to the juxtaposition of word and image grace every page. Nancy Evans, also of Wilsted & Taylor, contributed her sharp editorial eye to the book's final design.

Finally, I must acknowledge those members of my team who have been with this project since its inception; their rings on the tree are easy for me to pick out. Keith and Lydia Jones, my father and mother, have never ceased to be interested in my work; that I have not asked my father to use a red pencil on this manuscript is his reward for more than fifty years of earlier service as familial editor. My sister, Marcia, and her husband, Bruce Rothwell, along with my brother, Keith, and his wife, Alison Kirby Jones, and Don, Collette, Steven, David, Michelle, Jason, Robert, Diane, Katie, Sam, Forrest, and Tessa have given me the joys of a dependable family circle, as have the Corns and Hafners, especially Dorothy, John, and Carol. At the center of my family circle is Joe Corn, with whom I teach, jog, cook, dance, garden, build houses, and write books. Every page of this volume bears the mark of his help and advice.

ILLUSTRATIONS

© 1998 Artists Rights Society (ARS), New York / ADAGP, Paris. **Page 64**

Fig. 42. Albert Gleizes, *Bridges of Paris*, 1912. Oil on canvas, 23⅜ × 28½ in. Museum Moderner Kunst Stiftung Ludwig, Wien. © 1998 Artists Rights Society (ARS), New York / ADAGP, Paris. **Page 65**

Fig. 43. Albert Gleizes, *On Brooklyn Bridge*, 1917. Oil on canvas, 63¾ × 51 in. The Solomon R. Guggenheim Museum, New York. Gift, Solomon R. Guggenheim, 1938. Photograph by David Heald. © The Solomon R. Guggenheim Foundation, New York. © 1998 Artists Rights Society (ARS), New York / ADAGP, Paris. **Page 65**

Fig. 44. Albert Gleizes, *Chal Post*, 1915. Oil and gouache on board, 40⅛ × 30⅛ in. The Solomon R. Guggenheim Museum, New York. Gift, Solomon R. Guggenheim, 1938. Photograph by David Heald. © The Solomon R. Guggenheim Foundation, New York. © 1998 Artists Rights Society (ARS), New York / ADAGP, Paris. **Page 65**

Fig. 45. Francis Picabia, *Portrait d'une jeune fille américaine dans l'état de nudité*, 1915. From *291*, Nos. 5–6 (July–Aug. 1915). © 1998 Artists Rights Society (ARS), New York / ADAGP, Paris. **Page 67**

Fig. 46. Advertisement for the Red Head Priming Plug. From *The Motor* (Dec. 1914). Photograph courtesy William Innes Homer. **Page 67**

Fig. 47. Francis Picabia, *Américaine*, cover for *391* (July 1917). © 1998 Artists Rights Society (ARS), New York / ADAGP, Paris. **Page 67**

Fig. 48. Marcel Duchamp, *Moulin à café (Coffee Mill)*, 1911. Oil on board, 28¾ × 13 in. Tate Gallery, London / Art Resource, New York. © 1998 Artists Rights Society (ARS), New York / ADAGP, Paris / Estate of Marcel Duchamp. **Page 68**

Fig. 49. Coffee mill that belonged to Mary Reynolds. From Pontus Hulten, *Marcel Duchamp: Work and Life* (Cambridge, Mass., 1993), p. 57. **Page 68**

Fig. 50. A chocolate grinder. From Jean Clair, *Marcel Duchamp: Catalogue Raisonné*, fig. 294, p. 186. **Page 69**

Fig. 51. Marcel Duchamp, *Chocolate Grinder, No. 2*, 1914. Oil, thread, and pencil on canvas, 25½ × 21¼ in. Philadelphia Museum of Art: The Louise and Walter Arensberg Collection. © 1998 Artists Rights Society (ARS), New York / ADAGP, Paris / Estate of Marcel Duchamp. **Page 69**

Fig. 52. Marcel Duchamp, *Bicycle Wheel*, 1951 (third version, after lost original of 1913). Metal wheel mounted on painted wood stool, 50½ × 25½ × 16⅝ in. The Museum of Modern Art, New York. The Sidney and Harriet Janis Collection. © 1998 Artists Rights Society (ARS), New York / ADAGP, Paris / Estate of Marcel

Duchamp. Photograph © 1999 The Museum of Modern Art, New York. **Page 70**

Fig. 53. Marcel Duchamp, *Bottlerack*, ca. 1936 (after lost original of 1914). Photograph by Man Ray. © 1998 Artists Rights Society (ARS), New York / ADAGP, Paris / Estate of Marcel Duchamp. © Man Ray Trust / ARS / Telimage, Paris. **Page 70**

Fig. 54. J. L. Mott Iron Works, showroom, New York, 1914. Courtesy of The Menil Collection, Houston. **Page 71**

Fig. 55. Marcel Duchamp, *In Advance of the Broken Arm*, 1915. Wood and galvanized iron snow shovel, height 48 in. © Yale University Art Gallery. Gift of Katherine S. Dreier to the Collection Société Anonyme. © 1998 Artists Rights Society (ARS), New York / ADAGP, Paris / Estate of Marcel Duchamp. **Page 71**

Fig. 56. Marcel Duchamp, *Traveler's Folding Item*, 1964 (after lost 1916 original). Black plastic, 9¹⁄₁₆ × 16 × 11½ in. Collection of the John and Mable Ringling Museum of Art, Sarasota, Fla.: Gift of the Mary Sisler Foundation. © 1998 Artists Rights Society (ARS), New York / ADAGP, Paris / Estate of Marcel Duchamp. Photograph courtesy Jerrold Seigel. **Page 73**

Fig. 57. Bud (H. C.) Fisher, *Portrait of Augustus Mutt*. From Robert C. Harvey, *The Art of the Funnies: An Aesthetic History* (Jackson, Miss., 1994), p. 41. **Page 73**

Fig. 58. Alfred Stieglitz, *Fountain*, 1917 (cropped version). Gelatin silver print, 4¼ × 7 in. Philadelphia Museum of Art: The Louise and Walter Arensberg Collection. **Page 76**

Fig. 59. Marsden Hartley, *The Warriors*, 1913. Oil on canvas, 47¾ × 47½ in. Curtis Galleries, Minneapolis, Minn. **Page 77**

Fig. 60. Constantin Brancusi, *Princess X*, 1915–16. Polished bronze on limestone block, 22⅝ × 9 × 16¼ in. Philadelphia Museum of Art: The Louise and Walter Arensberg Collection. Photograph by Graydon Wood, 1994, Philadelphia Museum of Art. © 1998 Artists Rights Society (ARS), New York / ADAGP, Paris. **Page 78**

Fig. 61. Marcel Duchamp, "Archie Pen Co." advertisement, 1921. From *The Arts* (Feb.–Mar. 1921). Art and Architecture Collection, Miriam and Ira D. Wallach Division of Art, Prints, and Photographs, The New York Public Library, Astor, Lenox and Tilden Foundations. © 1998 Artists Rights Society (ARS), New York / ADAGP, Paris / Estate of Marcel Duchamp. **Page 79**

Fig. 62. Baroness Elsa von Freytag-Loringhoven and Morton Schamberg, *God*, ca. 1918. Miter-box and cast-iron plumbing trap, height 10½ in. Philadelphia Museum of Art: The Louise and Walter Arensberg Collection. **Page 82**

Fig. 63. Man Ray, *New York 17*, 1966. Original work lost. Chrome-plated bronze and brass and painted brass vise, 17⅜ × 9¼ × 9¼ in. Hirshhorn Museum and Sculpture Garden, Smithsonian Institution, Gift of Joseph H. Hirshhorn, 1972. © 1998 Man Ray Trust / Artists Rights Society, New York / ADAGP, Paris. **Page 83**

Fig. 64. Man Ray, *Export Commodity* or *New York*, 1920. Metal bearings and glass jar, height 11 in. © 1998 Artists Rights Society (ARS), New York / ADAGP, Paris. © Man Ray Trust / ARS / Telimage, Paris. **Page 83**

Fig. 65. Marcel Duchamp, *Air de Paris* (*50 cc of Paris Air*), 1919. Glass, height 5¼ in. Philadelphia Museum of Art: The Louise and Walter Arensberg Collection. © 1998 Artists Rights Society (ARS), New York / ADAGP, Paris / Estate of Marcel Duchamp. **Page 84**

Fig. 66. Man Ray, *Trans Atlantique*, 1921. Collage, size and location unknown. Photograph by Guerin. © 1998 Artists Rights Society (ARS), New York / ADAGP, Paris. © Man Ray Trust / ARS / Telimage, Paris. **Page 84**

Fig. 67. *"Which is the Monument?"* Two-page spread from *The Soil* (Jan. 1917). **Page 86**

Fig. 68. Edward Weston, *Excusado*, 1925. Gelatin silver print, 9½ × 7½ in. Collection, Center for Creative Photography, The University of Arizona, Tucson. © 1981 Center for Creative Photography, Arizona Board of Regents. **Page 88**

Fig. 69. Gerald Murphy, *Razor*, 1924. Oil on canvas, 32⅝ × 36½ in. Dallas Museum of Art, Foundation for the Arts Collection. Gift of the artist. Reprinted with permission of Honoria Murphy Donnelly. **Page 90**

Fig. 70. John Held, *The Gentle Sex and the Machine Age—The Present Day*. From *Liberty* magazine, Sept. 12, 1931. Courtesy Illustration House, Inc. **Page 92**

Fig. 71. Félix Delmarle, *The Port*, 1914. Oil on canvas, 25½ × 19¾ in. Los Angeles County Museum of Art, promised gift of James and Ilene Nathan. **Page 93**

Fig. 72. Paul Colin, *Jazz Band* (from *Le Tumulte Noir*), 1927. Lithograph with pochoir coloring on paper, 18 × 25 in. The National Portrait Gallery, Smithsonian Institution. **Page 93**

Fig. 73. Gerald Murphy on front porch of the Steele Camp in Saranac, 1934 or 1935. Photograph by Richard Myers. Photograph courtesy Frances Myers Brennan. **Page 94**

Fig. 74. Man Ray, *Portrait of Sara Murphy and Her Children*, summer 1926. © 1998 Man Ray Trust / Artists Rights Society, New York / ADAGP, Paris. Photograph courtesy Calvin Tomkins / Random House. **Page 94**

Fig. 75. A Murphy picnic at the Plage de la Garoupe, Cap d'Antibes. Photograph courtesy Honoria Murphy Donnelly. **Page 95**

Fig. 76. Jacques Mauny, *Gerald Murphy*, 1924. Medium, size, and location unknown. Reproduced in *Bulletin de la Vie Artistique*, 22 (Nov. 15, 1924): 498. Photograph courtesy Christian Derouet. **Page 97**

Fig. 77. Jacques Mauny, *New York*, 1925. Oil on canvas, 17 × 21⅜ in. Philadelphia Museum of Art: A. E. Gallatin Collection. **Page 97**

Fig. 78. Jacques Mauny, page from "New York, 1926," in *L'Art Vivant* 2, no. 26 (Jan. 15, 1926), p. 58. **Page 98**

Fig. 79. Gerald Murphy, *Villa America*, 1924. Oil and gold leaf on canvas, 14½ × 21½ in. Curtis Galleries, Minneapolis, Minn. Photograph courtesy Honoria Murphy Donnelly. **Page 99**

Fig. 80. Pablo Picasso, costume for French Manager from *Parade*, 1917. Dance Collection, The New York Public Library for the Performing Arts, Astor, Lenox and Tilden Foundations. **Page 101**

Fig. 81. Pablo Picasso, costume for American Manager from *Parade*, 1917. Dance Collection, The New York Public Library for the Performing Arts, Astor, Lenox and Tilden Foundations. **Page 101**

Fig. 82. Marie Chabelska as the Little American Girl in *Parade*, 1917. Réunion des Musées Nationaux—Musée Picasso, Paris. **Page 101**

Fig. 83. Gerald Murphy, program design for *Within the Quota*, 1923. Watercolor, gouache, and collage on paper, 10¾ × 8 3/16 in. Photograph courtesy Honoria Murphy Donnelly. **Page 102**

Fig. 84. Gerald Murphy, painted backdrop and costumes for *Within the Quota* (shown in performance), 1923. Musée d'Art Moderne de la ville de Paris, *Cinquantenaire des Ballets Suédois 1920–1925* (Paris, 1970), p. 68. **Page 103**

Fig. 85. "The Cunarder 'Aquitania,' which carries 3,600 persons, compared with various buildings." From Le Corbusier, *Towards a New Architecture* (1927), p. 92. **Page 105**

Fig. 86. *Life*—Sunday Edition, financial page parody, Sept. 7, 1922. **Page 105**

Fig. 87. The Jockey Club on boulevard du Montparnasse, Paris. Roger-Viollet, Paris. © Harlingue-Viollet. **Page 106**

Fig. 88. Gino Severini, *Nature Morte: Quaker Oats*, 1917. Oil on canvas, 24⅜ × 20 in. Estorick Foundation, London, UK / Bridgeman Art Library, London / New York. © 2000 Artists Rights Society (ARS), New York / ADAGP, Paris. **Page 107**

Fig. 89. George Grosz, *Memory of New York*, 1915–16. Lithograph on Japan paper, 19½ × 15⅜ in. Courtesy of the Busch-Reisinger Museum, Harvard University Art Museums, Museum Purchase. © President and Fellows

Oil on canvas, 27 ⅛ × 22 ½ in. The Phillips Collection, Washington, D.C. **Page 169**

Fig. 148. Childe Hassam, *Lower Manhattan (View down Broad Street)*, 1907. Oil on canvas, 30 ¼ × 16 in. The Herbert F. Johnson Museum of Art, Cornell University. On loan from the Willard Straight Hall Collection, Cornell University. Gift of Mrs. Leonard K. Elmhirst. **Page 170**

Fig. 149. Alfred Stieglitz, *Icy Night*, 1898. Carbon print, 10 ¼ × 13 ½ in. National Gallery of Art, Alfred Stieglitz Collection. © 1998 Board of Trustees, National Gallery of Art, Washington, D.C. **Page 171**

Fig. 150. John Sloan, *The City from Greenwich Village*, 1922. Oil on canvas, 26 × 33 ¾ in. National Gallery of Art, Gift of Helen Farr Sloan. © 1998 Board of Trustees, National Gallery of Art, Washington, D.C. **Page 172**

Fig. 151. John Sloan, *Fifth Avenue, New York*, 1909. Oil on canvas, 32 × 26 in. Private collection. Courtesy Kraushaar Galleries, New York. **Page 173**

Fig. 152. George Bellows, *New York*, 1911. Oil on canvas, 42 × 60 in. National Gallery of Art, Collection of Mr. and Mrs. Paul Mellon. © 1998 Board of Trustees, National Gallery of Art, Washington, D.C. **Page 174**

Fig. 153. John Marin, *Movement, Fifth Avenue*, 1912. Watercolor, 17 × 13 ¾ in. The Art Institute of Chicago, Alfred Stieglitz Collection, 1949.554. Photograph © 1998, The Art Institute of Chicago. All rights reserved. Photograph by Kathleen Cuthbert-Aguilar, Chicago. **Page 176**

Fig. 154. Max Weber, *New York 1913*. Oil on canvas, 40 × 32 in. Thyssen-Bornemisza Collection. **Page 177**

Fig. 155. Max Weber, *New York at Night*, 1915. Oil on canvas, 33 ⅞ × 20 1/16 in. Jack S. Blanton Museum of Art, The University of Texas at Austin, Gift of Mari and James A. Michener, 1991. Photograph: George Holmes. **Page 177**

Fig. 156. Max Weber, *Rush Hour, New York*, 1915. Oil on canvas, 36 ¼ × 30 ¼ in. National Gallery of Art, Gift of the Avalon Foundation, © 1998 Board of Trustees, National Gallery of Art, Washington, D.C. **Page 177**

Fig. 157. Joseph Stella, *Battle of Lights, Coney Island, Mardi Gras*, 1913–14. Oil on canvas, 76 × 85 in. Yale University Art Gallery. Bequest of Dorothea Dreier to the Collection Société Anonyme. **Page 178**

Fig. 158. Giacomo Balla, *Street Light*, 1909. Oil on canvas, 68 ¾ × 45 ¼ in. The Museum of Modern Art, New York. Hillman Periodicals Fund. Photograph © 1999 The Museum of Modern Art, New York. © Giacomo Balla / Licensed by VAGA, New York, N.Y. **Page 180**

Fig. 159. Robert Delaunay, *The City of Paris*, 1910–12. Oil on canvas, 105 ⅛ × 159 ⅞ in. Collections Musée

National d'Art Moderne / Centre de Création Industrielle—Centre Georges Pompidou. Photograph: Photothèque des collections du Mnam/Cci. **Page 181**

Fig. 160. Otto Dix, *Großstadt (Triptychon) (Big City [Triptych])*, 1927–28. Mixed media on wood, 71 ¼ × 156 ¾ in. Galerie der Stadt Stuttgart. **Pages 182–183**

Fig. 161. Paul T. Frankl, Combination Desk and Bookcase, ca. 1927. California redwood trimmed with black lacquer, 86 ½ × 64 ½ × 33 ½ in. Grand Rapids Art Museum, Gift of Dr. and Mrs. John Halick, 1984.7.2. Photograph: Mark A. Deremo. **Page 184**

Fig. 162. Ruth Reeves, Fabric, *"Manhattan"* pattern, 1930. Block-printed cotton, 80 ¼ × 35 ⅛ in. Yale University Art Gallery, Gift of Jane Axelrod Hahn. **Page 184**

Fig. 163. Architects in costume for Beaux Arts Ball, ca. 1932. Avery Architectural and Fine Arts Library, Columbia University in the City of New York, Walter H. Kilham Collection. **Page 185**

Fig. 164. Fortunato Depero, *Broadway — Crowd — Roxi Theatre [sic]*, 1930. Ink and diluted ink on paper, 17 ⅝ × 23 ⅞ in. Museo di Arte Moderna e Contemporanea di Trento e Rovereto, Trento, Italy. © Estate of Fortunato Depero / Licensed by VAGA, New York, N.Y. **Page 186**

Fig. 165. Bernard Boutet de Monvel, *New York*, 1926. Oil on canvas, 33 × 21 in. Musée d'art et d'archéologie, Aurillac, France. **Page 187**

Fig. 166. Frans Masereel, *An Imaginary Portrait of New York*. From *Vanity Fair* (Feb. 1923), p. 37. **Page 187**

Fig. 167. Red Grooms, *The Builder*, ca. 1962. Ink on paper, 11 × 8 ⅛ in. Collection of Mimi Gross, New York. © 1998 Red Grooms / Artists Rights Society (ARS), New York. **Page 188**

Fig. 168. Joseph Stella, *American Landscape*, 1929. Oil on canvas, 79 ⅛ × 39 5/16 in. Collection Walker Art Center, Minneapolis, Gift of the T. B. Walker Foundation, 1957. **Page 189**

Fig. 169. Charles Demuth, *The Figure 5 in Gold*, 1928. Oil on composition board, 36 × 29 ¾ in. The Metropolitan Museum of Art, Alfred Stieglitz Collection, 1949 (49.59.1). Photograph © 1996 The Metropolitan Museum of Art. **Page 192**

Fig. 170. Photographer unknown. *Charles Demuth*, ca. 1920. From *Look Magazine*, Mar. 28, 1950, p. 52. **Page 195**

Fig. 171. Florine Stettheimer, *Portrait of Alfred Stieglitz*, 1928. Oil on canvas, 38 × 25 ½ in. The Alfred Stieglitz Collection, Fisk University, Nashville, Tenn. Gift of Georgia O'Keeffe. **Page 195**

Fig. 172. Charles Demuth, *Eggplant and Green Pepper*, 1925. Watercolor and graphite on paper, 18 × 11 ⅞ in.

The Saint Louis Art Museum, Eliza McMillan Fund. Page 196

Fig. 173. Alfred Stieglitz, *Charles Demuth's Hands*, 1923. Platinum or palladium print, 7⅝ × 9½ in. National Gallery of Art, Alfred Stieglitz Collection. © 1998 Board of Trustees, National Gallery of Art, Washington, D.C. Page 198

Fig. 174. Preston Dickinson, *Café Scene* (Portrait of Charles Demuth), ca. 1912–14. Charcoal and black chalk on tan wove paper, 18 × 13¾ in. Collection of Mr. and Mrs. Meyer P. Potamkin. Page 199

Fig. 175. Djuna Barnes, *Marsden Hartley*, center section from *Three American Literary Expatriates in Paris (Mina Loy, Marsden Hartley, and Gertrude Stein)*. Cartoon drawing from the *New York Tribune*, Nov. 4, 1923. Papers of Djuna Barnes, Special Collections, University of Maryland Libraries, College Park, Md. Page 199

Fig. 176. Man Ray, *Demuth's Hands*. Gelatin silver print, 9⅛ × 6¾ in. Courtesy George Eastman House. © 1999 Man Ray Trust / Artists Rights Society (ARS), New York / ADAGP, Paris. Page 200

Fig. 177. Florine Stettheimer, *Carl Van Vechten*, 1922. Oil on canvas, 30 × 22 in. Yale Collection of American Literature, Beinecke Rare Book and Manuscript Library, Yale University. Page 201

Fig. 178. Florine Stettheimer, *Portrait of Duchamp*, 1923. Oil on canvas, 30 × 26 in. Courtesy William Kelly Simpson. Page 201

Fig. 179. Charles Sheeler, *William Carlos Williams*, 1938. Photograph, 7 × 8½ in. Courtesy Museum of Fine Arts, Boston, William H. Lane Collection. Page 202

Fig. 180. Street lamp, New York, 1938. From Cecil Beaton, *Cecil Beaton's New York* (Philadelphia and New York, 1938), p. 11. Photograph by Hans Groenhoff. Page 204

Fig. 181. Stutz hose wagon, 1924. Photographer unknown, from George Klass, *Fire Apparatus: A Pictorial History of the Los Angeles Fire Department* (Los Angeles, 1974). Photograph courtesy Dale Magee. Page 205

Fig. 182. Berenice Abbott, *Zito's Bakery*, 1937. Gelatin silver print. Museum of the City of New York. Berenice Abbott / Commerce Graphics Ltd., Inc. Page 206

Fig. 183. Filling station, New York, 1923. Photographer unknown. Brown Brothers. Page 207

Fig. 184. Subway station, New York, 1925. Photographer unknown, from *A Pictorial Presentation of the Interborough Medium* (1925). Page 208

Fig. 185. Penn Square and North Queen Street, Lancaster, Pennsylvania. Parade in 1880 for the Garfield-

Arthur ticket. Lancaster County Historical Society, Lancaster, Penn. Page 209

Fig. 186. Alice Austen, *Ragpickers and Handcarts, West Twenty-third Street and Third Avenue*, ca. 1896. Courtesy of Staten Island Historical Society, Alice Austen Collection. Page 210

Fig. 187. Billboards on Market Street, San Francisco, 1924. Photographer unknown. Collection Patrick Media, Inc. Page 210

Fig. 188. Howard Thain, *The Great White Way — Times Square, New York*, ca. 1925. Oil on canvas, 30 × 36 in. © Collection of the New-York Historical Society. Page 211

Fig. 189. Leon Barritt, *The Progress of Art*, ca. 1900. Newspaper cartoon. Page 213

Fig. 190. Charles Demuth, *The Circus*, 1917. Watercolor and graphite on paper, 8 × 10⅝ in. Columbus Museum of Art, Columbus, Ohio; Gift of Ferdinand Howald. Page 216

Fig. 191. Charles Demuth, *At the Golden Swan*, 1919. Watercolor on paper, 8 × 10½ in. Collection Irwin Goldstein, M.D. Photograph by Bill Jacobson Studio. Page 217

Fig. 192. Charles Demuth, *My Egypt*, 1927. Oil on composition board, 35¾ × 30 in. Collection of Whitney Museum of American Art. Purchase, with funds from Gertrude Vanderbilt Whitney. Photograph copyright © 1996: Whitney Museum of American Art, New York. Photograph by Sheldan C. Collins, New York. Page 218

Fig. 193. John W. Eshelman and Sons grain elevators, ca. 1950. Photograph by and courtesy of S. Lane Faison, Jr. Page 218

Fig. 194. Charles Demuth, *End of the Parade, Coatesville, Pa.*, 1920. Tempera and pencil on composition board, 20 × 15 in. Curtis Galleries, Minneapolis, Minn. Page 220

Fig. 195. Charles Demuth, *Buildings, Lancaster*, 1930. Oil on composition board, 24 × 20 in. Collection of Whitney Museum of American Art. Gift of an anonymous donor. Photograph by Bill Jacobson, New York. Page 221

Fig. 196. Charles Demuth, *. . . And the Home of the Brave*, 1931. Oil on composition board, 29⁷⁄₁₆ × 23½ in. The Art Institute of Chicago, Gift of Georgia O'Keeffe, 1948.650. Photograph © 1998, The Art Institute of Chicago. All rights reserved. Page 222

Fig. 197. Charles Demuth, *Love, Love, Love (Homage to Gertrude Stein)*, 1928. Oil on board, 20 × 20⅞ in. © Museo Thyssen-Bornemisza, Madrid. Page 224

Fig. 198. Charles Demuth, *Longhi on Broadway*, 1928.

Oil on board, $33\frac{7}{8} \times 27$ in. Museum of Fine Arts, Boston. Gift of the William H. Lane Foundation. **Page 225**

Fig. 199. Berenice Abbott, *Janet Flanner, Paris*, 1927. Berenice Abbott / Commerce Graphics Ltd., Inc. **Page 226**

Fig. 200. Claude Cahun, *Autoportrait (Poupée japonaise debout)*, ca. 1928. Photograph, $4\frac{1}{8} \times 3\frac{1}{4}$ in. Courtesy Galerie Berggruen, Paris. **Page 226**

Fig. 201. Charles Demuth, *Poster Portrait: Duncan*, 1924–25. Oil on wood panel, $24\frac{3}{4} \times 28\frac{1}{2}$ in. Yale Collection of American Literature, Beinecke Rare Book and Manuscript Library, Yale University. **Page 227**

Fig. 202. Charles Demuth, *Study for Poster Portrait: Marsden Hartley*, 1923–24. Watercolor and graphite on paper, $10\frac{1}{8} \times 8\frac{1}{8}$ in. Yale University Art Gallery. Stephen Carlton Clark, B.A. 1903, Fund and Everett V. Meeks, B.A. 1901, Fund. **Page 228**

Fig. 203. Charles Demuth, *Calla Lilies (Bert Savoy)*, 1926. Oil on composition board, $41 \times 47\frac{1}{8}$ in. The Alfred Stieglitz Collection, Fisk University, Nashville, Tenn. Gift of Georgia O'Keeffe. **Page 229**

Fig. 204. Charles Demuth, *Poster Portrait: O'Keeffe*, 1923–24. Oil on wood panel, 23×19 in. Yale Collection of American Literature, Beinecke Rare Book and Manuscript Library, Yale University. **Page 230**

Fig. 205. Georgia O'Keeffe, *Alligator Pears*, ca. 1923. Oil on board, 9×12 in. Collection of the Williams Companies, Inc., Tulsa, Okla. © 1998 The Georgia O'Keeffe Foundation / Artists Rights Society (ARS), New York. **Page 230**

Fig. 206. Edward Weston, *Squash*, 1936. Photograph, $7\frac{9}{16} \times 9\frac{1}{2}$ in. Collection Frederick R. Weisman Art Museum at the University of Minnesota, Minneapolis. Gift of WPA Art Program, Washington, D.C. **Page 230**

Fig. 207. Charles Demuth, *Poster Portrait: Dove*, 1924. Oil on wood panel, $22\frac{1}{2} \times 26\frac{1}{2}$ in. Yale Collection of American Literature, Beinecke Rare Book and Manuscript Library, Yale University. **Page 231**

Fig. 208. Charles Demuth, *Poster Portrait: Marin*, 1926. Oil on wood panel, $33 \times 39\frac{1}{2}$ in. Yale Collection of American Literature, Beinecke Rare Book and Manuscript Library, Yale University. **Page 232**

Fig. 209. Charles Demuth, *Four Male Figures*, 1930. Watercolor and graphite on paper, 13×8 in. Collection of William Rush. Photograph courtesy the Fine Arts Museums of San Francisco. Photograph by Joseph McDonald. **Page 233**

Fig. 210. Charles Demuth, *Distinguished Air*, 1930. Watercolor, $16\frac{3}{16} \times 12\frac{1}{8}$ in. (irregular). Collection of Whitney Museum of American Art. Purchase, with funds from the Friends of the Whitney Museum and Charles Simon. Photograph copyright © 1998: Whit-

ney Museum of American Art, New York. Photograph by Sheldan C. Collins. **Page 233**

Fig. 211. Lucky Strike advertisement. From *Life*, Mar. 1, 1928. **Page 235**

Fig. 212. Allan D'Arcangelo, *U.S. Highway 1* [panel 2], 1963. Acrylic on canvas, 70×81 in. © Estate of Allan D'Arcangelo / Licensed by VAGA, New York, N.Y. **Page 236**

Fig. 213. Robert Indiana, *The Demuth American Dream No. 5*, 1963. Oil on canvas, 144×144 in. © Art Gallery of Ontario, Toronto. Gift from the Women's Committee Fund, 1964. Photograph by Carlo Catenazzi. **Page 237**

Fig. 214. Georgia O'Keeffe, *Cow's Skull—Red, White and Blue*, 1931. Oil on canvas, $39\frac{7}{8} \times 35\frac{7}{8}$ in. The Metropolitan Museum of Art, Alfred Stieglitz Collection, 1949 (49.59.1). Photograph © 1996, The Metropolitan Museum of Art. © 1998 The Georgia O'Keeffe Foundation / Artists Rights Society (ARS), New York. **Page 238**

Fig. 215. Alfred Stieglitz, *Georgia O'Keeffe: A Portrait—Painting and Sculpture*, 1919. Palladium print, $9\frac{3}{16} \times 7\frac{5}{8}$ in. National Gallery of Art, Alfred Stieglitz Collection. © 1998 Board of Trustees, National Gallery of Art, Washington, D.C. **Page 240**

Fig. 216. Georgia O'Keeffe, *Light Iris*, 1924. Oil on canvas, 40×30 in. Virginia Museum of Fine Arts, Richmond, Va. Gift of Mr. and Mrs. Bruce C. Gottwald. Photograph: Katherine Wetzel. © 2000 Virginia Museum of Fine Arts. © 1998 The Georgia O'Keeffe Foundation / Artists Rights Society (ARS), New York. **Page 242**

Fig. 217. Alfred Stieglitz, *Georgia O'Keeffe: A Portrait—Head*, 1918. Gelatin silver print, $9\frac{5}{16} \times 7\frac{5}{16}$ in. National Gallery of Art, Alfred Stieglitz Collection. © 1998 Board of Trustees, National Gallery of Art, Washington, D.C. **Page 243**

Fig. 218. Lee Marmon, Laguna Eagle Dancers, New Mexico, 1975. Photograph © Lee Marmon. **Page 246**

Fig. 219. Hudson Bay–style Navajo blanket, 1880–90, owned by Georgia O'Keeffe. $97\frac{1}{2} \times 60$ in. From Mary Hunt Kahlenberg and Anthony Berlant, *The Navajo Blanket* (New York, 1972), p. 59. **Page 247**

Fig. 220. Georgia O'Keeffe, *Pattern of Leaves*, ca. 1923. Oil on canvas, $22\frac{1}{8} \times 18\frac{1}{8}$ in. The Phillips Collection, Washington, D.C. © 1998 The Georgia O'Keeffe Foundation / Artists Rights Society (ARS), New York. **Page 248**

Fig. 221. Georgia O'Keeffe, *Cliffs Beyond Abiquiu, Dry Waterfall*, 1943. Oil on canvas, 30×16 in. © The Cleveland Museum of Art, 1998, Bequest of Georgia O'Keeffe, 1987.141. © 1998 The Georgia O'Keeffe

84¼ in. Statens Museum for Kunst, Copenhagen. Photograph: Hans Petersen. **Page 271**

Fig. 246. John Gast, *American Progress*, 1872. Oil on canvas, 12¾ × 16¾ in. The Autry Museum of Western Heritage, Los Angeles, Calif. Photograph courtesy Christie's Images, New York. **Page 272**

Fig. 247. Frederic Remington, *On the Southern Plains*, 1907. Oil on canvas, 30⅛ × 51⅛ in. The Metropolitan Museum of Art, Gift of Several Gentlemen, 1911 (11.192). Photograph © 1982 The Metropolitan Museum of Art. **Page 273**

Fig. 248. Buell (photographer), Buffalo bones ready for loading on Canadian Pacific Railroad boxcar, Moose Jaw, Sask., ca. late 1880s. Glenbow Archives, Calgary, Canada NA-448-3. **Page 273**

Fig. 249. Albert Bierstadt, *The Last of the Buffalo*, 1888. Oil on canvas, 71¼ × 119¼ in. The Corcoran Gallery of Art, Washington, D.C., Gift of Mrs. Albert Bierstadt, 1909. **Page 274**

Fig. 250. Henry Farny, *The Song of the Talking Wire*, 1904. Oil on canvas, 22⅛ × 40 in. Bequest of Charles Phelps and Anna Sinton Taft, The Taft Museum, Cincinnati, Ohio. **Page 275**

Fig. 251. Joseph Henry Sharp, *Prayer to the Buffalo*, n.d. Oil on canvas, 20 × 24 in. Buffalo Bill Historical Center, Cody, Wyo. Gift of Mr. and Mrs. Forrest Fenn. **Page 276**

Fig. 252. J. H. Sharp with Indian artifacts in his Taos studio, ca. 1946. Photograph courtesy Buffalo Bill Historical Center, Cody, Wyo. **Page 277**

Fig. 253. Will Connell, Walter Ufer in his Taos studio, 1932. Photograph courtesy Museum of New Mexico. **Page 278**

Fig. 254. Edward A. Kemp, *Entrance to San Gabriel Ranch, Alcalde, New Mexico*, ca. 1925. Courtesy Museum of New Mexico. **Page 278**

Fig. 255. Ansel Adams, *Ghost Ranch*, 1937. Copyright © 1998 by the Trustees of the Ansel Adams Publishing Rights Trust. All rights reserved. **Page 279**

Fig. 256. World War I armed forces badge, New Mexico division. **Page 279**

Fig. 257. Astley D. M. Cooper, *The Buffalo Head*, ca. 1890. Oil on canvas, 40 × 36 in. Buffalo Bill Historical Center, Cody, Wyo. Bequest in memory of Houx and Newell Families. **Page 281**

Fig. 258. Malcolm Varon, *Tool and storage shed, O'Keeffe's home, Abiquiu, New Mexico*, 1976. Photograph by Malcolm Varon, N.Y.C., © 1998. **Page 282**

Fig. 259. Todd Webb, *Untitled (Georgia O'Keeffe and Daniel Cotton Rich at Ghost Ranch)*, 1955. Gelatin silver print, 8 × 10 in. Collection of the Museum of Fine

Arts, Museum of New Mexico, Todd Webb Study Collection. Gift of Mr. and Mrs. Todd Webb. Photograph: Blair Clark. **Page 282**

Fig. 260. Laura Gilpin, *Georgia O'Keeffe Residence*, May–June 1960. © 1979, Amon Carter Museum, Fort Worth, Texas, Bequest of Laura Gilpin. **Page 283**

Fig. 261. Todd Webb, *On the Portal, Ghost Ranch, Abiquiu*, 1959. Gelatin silver print. © Todd Webb. **Page 283**

Fig. 262. Alfred Stieglitz, *Georgia O'Keeffe: A Portrait—Head*, 1924. Gelatin silver print, 9½ × 7½ in. National Gallery of Art, Alfred Stieglitz Collection. © 1998 Board of Trustees, National Gallery of Art, Washington, D.C. **Page 284**

Fig. 263. Alfred Stieglitz, *Georgia O'Keeffe: A Portrait—With Painting*, 1930. Gelatin silver print, 9⅜ × 7½ in. National Gallery of Art, Alfred Stieglitz Collection. © 1998 Board of Trustees, National Gallery of Art, Washington, D.C. **Page 284**

Fig. 264. Philippe Halsman, *Georgia O'Keeffe at Her Ranch*, 1948. Gelatin silver print. Philippe Halsman Studio. © Halsman Estate. **Page 285**

Fig. 265. Yousuf Karsh, *Georgia O'Keeffe*, 1956. © Yousuf Karsh. **Page 286**

Fig. 266. Arnold Newman, *Georgia O'Keeffe, Ghost Ranch, New Mexico*, 1968. Gelatin silver print. © Arnold Newman. **Page 287**

Fig. 267. Todd Webb, *Georgia O'Keeffe, Ghost Ranch, Abiquiu*, 1962. Gelatin silver print. © Todd Webb. **Page 287**

Fig. 268. David Bradley, *O'Keeffe at Work*, 1984. Acrylic on canvas, 30 × 24 in. Courtesy the artist. **Page 288**

Fig. 269. Jerome L. Milord, *Another Victim of Santa Fe Style*, 1989. Poster. © 1989 Jerome E. Milord. Courtesy Lewis E. Thompson, Thompson Productions. **Page 290**

Fig. 270. Charles Sheeler, *Home, Sweet Home*, 1931. Oil on canvas, 36 × 29 in. Detroit Institute of Arts, Gift of Robert H. Tannahill. Photograph © 1998 The Detroit Institute of Arts. Reprinted with permission of the Museum of Fine Arts, Boston, William H. Lane Collection. **Page 292**

Fig. 271. Edward Steichen, *Charles Sheeler, West Redding, Connecticut*, ca. 1932. Gelatin silver print, 17½ × 13⅞ in. The Museum of Modern Art, New York. Gift of Samuel M. Kootz. Reprinted with permission of Joanna T. Steichen. Copy print © 1999 The Museum of Modern Art, New York. **Page 294**

Fig. 272. Charles Sheeler, *Skyscrapers*, 1922. Oil on canvas, 20 × 13 in. The Phillips Collection, Washington, D.C. **Page 296**

Fig. 273. Charles Sheeler, *American Landscape*, 1930. Oil on canvas, 24 × 31 in. The Museum of Modern Art,

New York. Gift of Abby Aldrich Rockefeller. Photograph © 1999, The Museum of Modern Art, New York. **Page 297**

Fig. 274. Charles Sheeler, *Exterior of Sheeler's Ridgefield, Connecticut house*, ca. 1932. Gelatin silver print, 10¼ × 13⅞ in. Museum of Fine Arts, Boston, The Lane Collection. **Page 300**

Fig. 275. Charles Sheeler, *Photograph of "Bird's Nest," Sheeler's home in Irvington-on-Hudson, New York*, ca. 1943. Gelatin silver print, 5½ × 7⅞ in. Museum of Fine Arts, Boston, The Lane Collection. **Page 300**

Fig. 276. Charles Sheeler, *Doylestown House, Exterior View*, 1917. Gelatin silver print, 6⅝ × 9⁷⁄₁₆ in. Museum of Fine Arts, Boston, The Lane Collection. **Page 300**

Fig. 277. Aaron Siskind, *An Overhead Hood*, ca. 1935. Gelatin silver print, 10 × 8 in. Spruance Library, Bucks County Historical Society, Doylestown, Penn. **Page 301**

Fig. 278. Charles Sheeler, *Bucks County Barn (with Chickens)*, ca. 1916–17. Gelatin silver print, 8 × 10¹⁵⁄₁₆ in. Museum of Fine Arts, Boston. **Page 302**

Fig. 279. Charles Sheeler, *Bucks County Barn*, 1923. Tempera and crayon on paper, 19⅝ × 26 in. Collection of Whitney Museum of American Art. Gift of Gertrude Vanderbilt Whitney. Photograph copyright © 1998: Whitney Museum of American Art, New York. Photograph by Sandak/ Macmillan. **Page 302**

Fig. 280. Charles Sheeler, *Doylestown House: Interior with Stove*, ca. 1917. Gelatin silver print, 9⅛ × 6⅛ in. Museum of Fine Arts, Boston, The Lane Collection. **Page 303**

Fig. 281. Alfred Eisenstaedt, *"He focuses his camera on a still life."* From *Life* magazine, Aug. 8, 1938, p. 42. *Life* magazine © Time Inc. **Page 304**

Fig. 282. Sheeler's armchair, American, ca. 1800. Maple, 44 × 24¼ × 18¼ in. Mr. and Mrs. Andrew Dintenfass. Courtesy Yale University Art Gallery. Photograph by Joseph Szaszfai. **Page 305**

Fig. 283. Charles Sheeler, *South Salem, Living Room*, 1929. Gelatin silver print, 7³⁄₁₆ × 9⁹⁄₁₆ in. Museum of Fine Arts, Boston, The Lane Collection. **Page 306**

Fig. 284. Charles Sheeler, *American Interior*, 1934. Oil on canvas, 32½ × 30 in. Yale University Art Gallery. Gift of Mrs. Paul Moore. **Page 307**

Fig. 285. Hudson-Fulton Celebration exhibition at the Metropolitan Museum of Art, 1909. The Metropolitan Museum of Art. **Page 309**

Fig. 286. Bedroom from Hampton, New Hampshire (Shaw House), 1740–60, as installed and furnished in the American Wing at the Metropolitan Museum of Art in 1924. The Metropolitan Museum of Art, Pur-

chase, Gift of Mrs. Russell Sage, by exchange, 1911 (11.96). **Page 310**

Fig. 287. Parlor furnished in the style of ca. 1800 by George Francis Dow in 1907. Peabody Essex Museum, Salem, Mass. **Page 311**

Fig. 288. The Almodington Room, as originally installed in the American Wing at the Metropolitan Museum of Art in 1925. The Metropolitan Museum of Art, Rogers Fund, 1918 (18.99.1). Photograph courtesy Elizabeth Stillinger. **Page 312**

Fig. 289. Charles Sheeler, *South Salem Interior*, 1929. Gelatin silver print, 7⁵⁄₁₆ × 9½ in. Museum of Fine Arts, Boston, The Lane Collection. **Page 316**

Fig. 290. Charles Sheeler, *Portrait (Katharine)*, 1932. Charcoal on paper, 9½ × 8 in. Collection of Constance B. and Carroll L. Cartwright. **Page 317**

Fig. 291. Artist unknown, *Glass Bowl with Fruit*, ca. 1860. Watercolor and ink on paperboard, 18 × 14¹⁄₁₆ in. Abby Aldrich Rockefeller Folk Art Center, Williamsburg, Va. **Page 320**

Fig. 292. Entrance hall at Juliana Force's Barley Sheaf Farm, Holicong, Bucks County, Pennsylvania. Courtesy Avis Berman. **Page 323**

Fig. 293. Drawing room at Juliana Force's apartment, 10 West Eighth Street, New York, ca. 1932–36. Photograph courtesy Whitney Museum of American Art, New York. Photograph by Hans Van Ness, New York. **Page 323**

Fig. 294. Cover of brochure for Charles Sheeler exhibition at the Downtown Gallery, 1931. Downtown Gallery Records, Archives of American Art, Smithsonian Institution, Washington, D.C. **Page 324**

Fig. 295. The Nadelmans' Museum of Folk Arts, Alderbrook, New York, ca. 1932. © Estate of Elie Nadelman. **Page 326**

Fig. 296. Charles Sheeler, *Untitled* (Charles Sheeler's home, Ridgefield, Connecticut), 1939. Gelatin silver print, 9⁹⁄₁₆ × 7½ in. The Museum of Modern Art, New York. © 1999 The Museum of Modern Art, New York. **Page 327**

Fig. 297. Pieter Vanderlyn (attributed to), *Miss Van Alen*, ca. 1720. Oil on canvas, 31¼ × 26⅛ in. National Gallery of Art, Gift of Edgar William and Bernice Chrysler Garbisch. © 1998, Board of Trustees, National Gallery of Art, Washington, D.C. **Page 327**

Fig. 298. Charles Sheeler, *South Salem*, 1929. Gelatin silver print, 7⅛ × 9½ in. Museum of Fine Arts, Boston, The Lane Collection. **Page 328**

Fig. 299. Charles Sheeler, *Upper Deck*, 1929. Oil on canvas, 29⅛ × 22⅛ in. Courtesy the Fogg Art Museum,

Harvard University Art Museums, Louise E. Bettens Fund. **Page 329**

Fig. 300. Charles Sheeler, *Living Room of New York Apartment of Louise and Walter Arensberg (Southeast Corner)*, ca. 1918. Gelatin silver print, 7⁹⁄₁₆ × 9⅝ in. Collection of Whitney Museum of American Art. Gift of James Maroney and Suzanne Fredericks. Photograph copyright © 1996: Whitney Museum of American Art, New York. **Page 330**

Fig. 301. Charles Sheeler, *Vermont Landscape*, 1924. Oil on canvas, 18 × 24 in. Photograph courtesy James B. Hand, Boston. **Page 331**

Fig. 302. Yasuo Kuniyoshi, *Boy Stealing Fruit*, 1923. Oil on canvas, 20 × 30 in. Columbus Museum of Art, Ohio; Gift of Ferdinand Howald. **Page 332**

Fig. 303. Artist unknown, *Baby with Doll*, 1840–50. Oil on canvas, 15¾ × 12¼ in. Abby Aldrich Rockefeller Folk Art Center, Williamsburg, Va. **Page 333**

Fig. 304. Charles Sheeler, *Untitled* (Silver teaspoon, silver salt and pepper shakers; designed by Charles Sheeler, 1934–36), 1939. Gelatin silver print, 7¼ × 4⅝ in. The Museum of Modern Art, New York. © 1999 The Museum of Modern Art, New York. **Page 333**

Fig. 305. Edward Hicks (attributed to), *The Peaceable Kingdom*, 1832–34. Oil on canvas, 17¼ × 23¼ in. Abby Aldrich Rockefeller Folk Art Center, Williamsburg, Va. **Page 334**

Fig. 306. Stuart Davis, *The Paris Bit*, 1959. Oil on canvas, 46 × 60 in. Collection of Whitney Museum of American Art. Purchase, with funds from the Friends of the Whitney Museum of American Art. © Estate of Stuart Davis, Licensed by VAGA, New York, N.Y. Photography by Sheldan Collins, N.J., © 1990. **Page 338**

Fig. 307. Mark Tobey, *Broadway*, 1935–36. Tempera on composition board, 26 × 19³⁄₁₆ in. The Metropolitan Museum of Art, Arthur Hoppock Hearn Fund, 1942 (42.170). Photograph © 1996 The Metropolitan Museum of Art. **Page 343**

Fig. 308. Franz Kline, *The Bridge*, ca. 1955. Oil on canvas, 80 × 52¾ in. Munson-Williams-Proctor Institute, Museum of Art, Utica, N.Y., 56.40. **Page 344**

Fig. 309. Ellsworth Kelly, *Brooklyn Bridge, VII*, 1962. Oil on canvas, 92⅛ × 37⅝ in. The Museum of Modern Art, New York. Gift of Solomon Byron Smith. Photograph © 1999 The Museum of Modern Art, New York. **Page 345**

Fig. 310. Stuart Davis, *Lucky Strike*, 1924. Oil on paperboard, 18 × 24 in. Hirshhorn Museum and Sculpture Garden, Smithsonian Institution, Museum Purchase, 1974. © Estate of Stuart Davis / Licensed by VAGA, New York, N.Y. **Page 346**

Fig. 311. Stuart Davis, *New York–Paris No. 1*, 1931. Oil on canvas, 39 × 51¾ in. The University of Iowa Museum of Art, University purchase, 1955.5. © Estate of Stuart Davis / Licensed by VAGA, New York, N.Y. **Page 346**

Fig. 312. Stuart Davis, *Colonial Cubism*, 1954. Oil on canvas, 39⁵⁄₁₆ × 79⅛ in. Collection Walker Art Center, Minneapolis, Gift of the T. B. Walker Foundation, 1955. © Estate of Stuart Davis, Licensed by VAGA, New York, N.Y. **Page 347**

Fig. 313. Stuart Davis, *Rue Lippe*, 1928. Oil on canvas, 32 × 39 in. Scharf Collection. Photograph courtesy Sotheby's, Inc. © Estate of Stuart Davis, Licensed by VAGA, New York, N.Y. **Page 348**

Fig. 314. George L. K. Morris, *Indians Hunting No. 4*, 1935. Oil on canvas, 35 × 40 in. The University of New Mexico Art Museum, Albuquerque, N.M.; purchased with funds from the National Endowment for the Arts and the Friends of Art. Reprinted with permission of the George L. K. and Suzy Frelinghuysen Morris Foundation. **Page 349**

Fig. 315. George L. K. Morris, *Times Square, A.M.*, 1973. Oil on canvas, 91 × 120 in. George L. K. and Suzy Frelinghuysen Morris Foundation. **Page 350**

Fig. 316. Red Grooms with Ruckus Manhattan Construction Co., *Ruckus Manhattan: Rector Street*, 1975–76. Mixed media. © 1998 Red Grooms / Artists Rights Society (ARS), New York. Courtesy Marlborough Gallery, New York. **Page 351**

Fig. 317. New York, New York Hotel and Casino, Las Vegas, Nevada. Photograph courtesy New York–New York Hotel & Casino. **Page 352**

Fig. 318. Frida Kahlo, *My Dress Hangs There*, 1933. Oil and collage on masonite, 18 × 19½ in. Banco de México. Reproduction authorized by the Instituto Nacional de Bellas Artes y Literatura. Photograph courtesy the Centro Nacional de las Artes, Biblioteca de los Artes, Mexico. **Page 354**

Fig. 319. Piet Mondrian, *Broadway Boogie Woogie*, 1942–43. Oil on canvas, 50 × 50 in. The Museum of Modern Art, New York. Given anonymously. Photograph © 1999 The Museum of Modern Art, New York. **Page 355**

Fig. 320. Madelon Vriesendorp, *Freud Unlimited*, 1974. Watercolor/gouache, approximately 18 × 24 in. Photograph courtesy Madelon Vriesendorp. **Page 356**

Fig. 321. Marisol, *Baby Girl*, 1963. Wood and mixed media, 74 × 35 × 47 in. Albright-Knox Art Gallery, Buffalo, N.Y. Gift of Seymour H. Knox, 1964. **Page 358**

INDEX

Page numbers in italic indicate illustrations.

Americanophilia, xix, 61, 130. *See also* *américanisme*

American Painting of the Nineteenth Century: Realism, Idealism, and the American Experience (Novak), xiv

American Place, An (gallery; New York), 40, 194, 250, 269, *269*, 289, 290, 390n.97; announcement, *40*

American Progress (Gast), 272, *272*

American Scene, as a movement in American art, 245, 287, 336, 340. *See also* Regionalism

American Scene, The (James), 166

American Writers' Congress, 362n.27

"America's Coming-of-Age" (Brooks), 13

America the Menace: Scenes from the Life of the Future (Duhamel), 133

Amerikanismus, 54, 109, 111

Amerika series (Hartley), 112, *112*, 254

Amérique (Baudrillard), 353

Amérique moderne, L' (Huret), 57, 58, 59

Anasazi, 252. *See also* Indian, Pueblo

Anderson, Benedict, xx

Anderson, Sherwood, 5, 12, *34*; as a cultural nationalist, 13–14, 17, 20, 32, 215, 385n.69; on Europe, 32; as a member of Stieglitz's artistic circle, 15, 17, 20, 34, 36; *MSS* and, 18; on Stieglitz, 32. Works: "Hands," 199

Anderson, Tennessee, 5

Anderson Galleries, New York, 31, 39, 243, 383n.38, 391n.6

. . . And the Home of the Brave (Demuth), 222, *222*, 223, 286

Anointment of Our Well Dressed Critic (Crane), *10*

Another Victim of Santa Fe Style (Milord), 286, *290*

Antheil, George, 114, 121. Works: *The Airplane Sonata*, 114; *Ballet Mécanique*, 114, *115*; *A Jazz Symphony*, 114; *Transatlantic*, 114, *116*

antiquarianism: and the American aesthetic, 298, 311, 313, 314, 394n.51; folk art and, 324, 326; historicism and, 358

Antiques (magazine), 312

Apolinère Enameled (Duchamp), 51, *52*

Apollinaire, Guillaume, 61, 73; on advertising as art, 125, 209, 384n.49; *américanisme* of, 52, 60; and Duchamp, 48, 76; on modernization, 61, 106, 122

Aragon, Louis, 52

"Archie Pen Co." (Duchamp), 79, *79*, *122*

architects: in costume for Beaux Arts Ball, ca. 1932, 185, *185*; progressive European, and American factories, 375n.66, n.75

A Rebours (Huysmans), 59

Arensberg, Louise and Walter: and Duchamp, 45, 48, 50, 77–79, 81; collection of, 81, 92, 330; as patrons, 96, 136, 295, 299, 381n.88; and Sheeler, 295, 299, 330, 391n.5, 396n.88

Armory Show (1913), 16, 49, 50, 52, 136, 345

Armstrong, Louis, 30, 100

Art about Art (exhibition), 358, 398n.39

Art d'aujourd'hui, L' (exhibition), 121, *121*

art deco, 148, 305, 308, 390n.93

Arthur G. Dove (Stieglitz), 34, *35*

artists' colonies (fraternities), xx, 17–18, 31, 32, 253, 256, 257, 275, 299, 321; émigré, in New York, xvi, 49–51, 63, 85, 341. *See also* Stieglitz circle

Arts, The (periodical), 321, 391n.6

arts, decorative American, 297–98, 301, 315, 392–93n.26, 393n.32; and modernism, 294. *See also* period rooms

Art Students League, New York, 136

Art Vivant, L' (periodical), 98, 125; page from, *98*

Ashcan school, xv, 18, 161, 168, 172, 346

At the Golden Swan (Demuth), 217, *217*

At the Rodeo—New Mexico (O'Keeffe), 262, *263*

"Attic Which Is Desire, The" (Williams), 212, 229

Aucassin et Nicolette (Demuth), 220, *222*

Ault, George, 185

Auric, Georges, 107

Austen, Alice, *Ragpickers and Handcarts, West Twenty-third Street and Third Avenue*, 210, *211*

Austin, Mary, 259

Autoportrait (Poupée japonaise debout) (Cahun), 226, *226*

avant-garde: advertising and, 209–10, 212; American, xviii, 202, 368n.20; Coady's mockery of, 85; definition of, xvii; French, and America, xvi, xviii, 43, 52–54, 56, 58, 60, 66, 89; and the machine age, 15; rift in, 215; and the role of American history, 295, 297, 342

Babbitt, George F. (fictional character), 4, 214

Baby Girl (Marisol), 358, *358*

Baby with Doll (artist unknown), 332, *333*, 358

Bacon, Peggy, 321, *322*

Baker, Josephine, xxi, 116–17, *116*, 121

Balla, Giacomo, *Street Light*, 179–80, *180*

Ball Bearing (Léger), 118, *119*

Ball Bearing (Murphy), 375n.80

ball bearings, as artistic, 118, 120, 375n.80

ballet, 72, 96, 100–105, 114, 186–87, 373n.23, 376n.108

Ballet Mécanique (Antheil), 114, *115*

Ballets Russes, 186

Ballets Suédois, Paris, 100, 102, 373n.23, 376n.108

Bande à Picasso, la, 18

Bard, John and James, 321

Barley Sheaf Farm, 322, *323*

Barnes, Djuna, *Marsden Hartley*, 199, *199*

Barnum, P. T., 60

Barr, Alfred, Jr., 325, 395n.76, 397n.2

Barritt, Leon, *The Progress of Art*, 212, *213*

Barry, Ellen, 96, 118

Barry, Philip, 96, 100

Barzun, Henri-Martin, 49, 61

Bassett Hall (Sheeler), 395n.79

bathroom, as a repository of modern design, xvi, xxii, 123. *See also* plumbing

Battery, The (Stella), 143

Battle of Lights, Coney Island, Mardi Gras (Stella), 136, 176, *178–79*, 180

Baudelaire, Charles, 63, 74

Baudrillard, Jean, *Amérique*, 353

Bauhaus, xvii, 18, 33, 207

Baxandall, Michael, *Painting and Experience in Fifteenth-Century Italy*, xxii

Bayerisches Nationalmuseum, 327

Bazalgette, Léon, 369n.45

Beals, Jessie Tarbox, 171

Beardsley, Aubrey, 10, 195

bedroom from Hampton, New Hampshire (Shaw House, Metropolitan Museum of Art, New York), *310*

Behind the Laughing Mask (Farnham), 226

Behn, *Taos Indian Detour—3 days*, 251, *251*

Beinecke Rare Book and Manuscript Library, Yale University: Demuth's paintings at, 200, 235; Stieglitz's papers at, 40, 367n.124.

Bellows, George, 45, 168; *New York*, 173–74, *174*, 380n.66

Benchley, Robert, 95

Benton, Thomas Hart, 32, 39, 288–89, 382n.28

Bergman, Pär, 369n.54

Bergson, Henri-Louis, 16

Berlin, Irving, 28; "That Mysterious Rag," 102

Berlin: *Amerikanismus* in, 109, 111–12; as subject matter, 182, 185

Berlin: Symphony of a City (film) (Ruttmann), 182

"Between Four and Five" (Demuth), 382n.10

231; *Poster Portrait: Duncan*, 203, 226–27, 227; *Poster Portrait: Marin*, 38, 203, 232–33, 232, 286; *Poster Portrait: O'Keeffe*, 38, 203, 228–31, 230; *Rue du Singe Que Peche*, 384n.52; *Sensations of Times Square*, 384n.52; *Study for Poster Portrait: Marsden Hartley*, 203, 227, 228; *Tuberoses*, 383n.3n.37; *Views of the City*, 384n.52; "'You Must Come Over': A Painting, A Play,'" 391n.1. *See also* Stein, Gertrude

Demuth American Dream No. 5, The (Indiana), 235–36, 237, 357–58

Demuth's Hands (Man Ray), 199, 200

Denis, Maurice, 186

Depero, Fortunato, 91, 186, 360n.11; *Broadway—Crowd—Roxi Theatre* [*sic*], 186

depression, the, 96; collections of folk art and, 326; cultural nationalism and, xiv; the decline of *américanisme* and, 54, 132–33, 188; early modernism and, 339; and Stieglitz's circle, 33, 216, 289

Design for a Broadway Poster (Demuth), 385n.87

de Stijl, xvii, 18, 33

de Zayas, Marius, 365–66n.101; abstract caricatures by, 202, 223; cubism of, 16; exhibition organized by, 395–96n.84; and Picabia, 51; and Sheeler, 394n.63; and Stieglitz, 23, 364n.66, 381n.88

Diaghilev, Sergey, 96, 186–87, 373n.23

Dial (periodical), 10, 215, 317

Dickinson, Preston, 96, 98, 335, 372–73n.14, 373n.15; *Café Scene* (Portrait of Charles Demuth), 199, 199

"Difference between the Inhabitants of France and the Inhabitants of the United States of America, The" (Stein), 109

Dintenfass, Andrew, 393n.34

Dintenfass, Terry, 393n.34

Distinguished Air (Demuth), 233, 234

Divine Comedy (Dante), 140, 153

Dix, Otto, *Großstadt* (*Triptychon*) (*Big City* [*Triptych*]), 182, 182–83

Dodge, Mabel. *See* Luhan, Mabel Dodge

Dogtown series (Hartley), 289

"Dollar V4" (motorcycle) (Chaise), 359

Dos Passos, John, 108, 130, 212; and Murphy, 94, 96, 98–99, 126. Works: *Manhattan Transfer*, 185, 365–66n.101; *USA*, 384n.53

Douglas, Aaron, xxi, 360n.11

Douglas, Mary, xxii

Dove, Arthur, xx, 35, 241; Americanness of, xv, 286; assemblages by, 20, 25, 25, 30, 80, 122, 203; as a farmer, 32, 232,

289; as a modern, 5; and modern music, 30, 150; O'Keeffe on, 250; as part of Stieglitz's circle, 14, 16, 34, 196, 198, 239; poetry of, 19; portraits by, 5, 38, 203; poster portrait of, by Demuth, 38, 200, 203, 228, 231–32, 231, 237; recognition for, 386–87n.8; Stieglitz's portrait of, 34, 35; as un-American, 340. Works: *George Gershwin—Rhapsody in Blue, Part 1*, 30, 30; *Miss Woolworth*, 25, 30, 80; *Pen and Razor Blade*, 122

Dove (Murphy), 120

Dover Baby, 321

Dow, George Francis, 311–12, 392n.22

Downtown Gallery, New York, 198, 289, 323, 324, 324, 325, 393n.34

Doylestown House, Exterior View (Sheeler), 299, 300

Doylestown House: Interior with Stove (Sheeler), 302, 303

Dreams of the Rarebit Fiend (McCay), 167, 167

Dreier, Katherine, 45, 50, 72, 73, 135, 146, 208

Dreiser, Theodore, 12

dress: and aesthetics, xviii; Demuth's, xviii, 194–95, 195, 207, 382n.7, n.8, n.27, 383n.45; Murphy's, xviii, 117, 117, 127, 194–95; O'Keeffe's, 243, 283–84

Duchamp, Marcel, 50, 367n.9, n.10, 367–68n.12, n.13, 371n.87; advertising and, 209, 213; alter ego of, 46, 72–73; on America, 55, 55, 56; *américanisme* of, xv, 58, 60, 66, 80, 89, 137, 188; as an antibourgeois, 195; apartment/studio of, 44; attraction of America for, 53, 89, 140, 214, 219, 253, 299; and Brancusi's work, 78; and Cendrars, 61; and Coady, 85–87; conceptual art and, 357; on contemporary art, 64; cover of *Rongwrong* by, 24, 123; and Craven, 50, 60; as a dandy, xviii, xix, 80; and Demuth, 194, 196, 202, 203, 216, 222, 234; eroticism of, 74–76; exhibitions of, 370n.67; as an exile, 49–50, 72; as an expatriate, 92; irony of, 87, 222, 236; language of, 72; lessons for Americans from, xvi, 46–48, 49, 52, 76, 80, 86–87, 100, 215, 256; little magazines and, 51; machinery and, 68, 122; *Manhatta* and, 186; as member of the Puteaux group, 61; the Mona Lisa and, 76; neodadaism and, 357; portrait of, 199, 201; puns of, 208; readymades of, xix, 68–72, 74–77, 202, 337, 347, 357, 367n.1, 370n.67, n.74, 371n.82, n.99; and Sheeler, 295, 391n.5, 394n.63; and Stella, 136; and Stieglitz, 39, 43–44, 48, 76–77, 80,

368n.20; on Stieglitz's circle of artists, 19; titles for works by, 73–74, 152, 208; as a *transatlantique*, xix, 91, 92, 94, 140, 152, 186, 194. Works: *Air de Paris* (*50 cc of Paris Air*), 81, 84, 92; *Apolinère Enameled*, 51, 52; "*Archie Pen Co.*" [advertisement], 78, 79, 122; *Bicycle Wheel*, 69, 70, 78; *Bottlerack*, 69, 70, 75, 78; *Chocolate Grinder, No. 2*, 48, 48, 68, 69, 79; *Fountain*, 42, 43–46, 44, 48–49, 66, 68, 71, 73–78, 80, 100, 119, 137, 152, 367n.1, n.4; *Fountain* (photograph by Alfred Stieglitz, 1917), 42, 367n.3, n.4; *Fountain* (photograph by Alfred Stieglitz, from *The Blind Man No. 2*), 44; *In Advance of the Broken Arm*, 71, 71; *Large Glass*, 68, 75; *Moulin à café* (*Coffee Mill*), 68, 68; *Nude Descending a Staircase, No. 2*, 50, 50, 61; *Pharmacie*, 370n.67; *Pulled at Four Pins*, 79; *Sculpture for Traveling*, 72; *Traveler's Folding Item*, 72, 73, 75, 370n.67

Duchamp-Villon, Raymond, 61

dude ranch, in New Mexico, 245, 250, 254, 278–79, 390n.89

Duhamel, Georges, 57; *America the Menace: Scenes from the Life of the Future*, 133

Duncan, Carol, xxii

Duncan, Charles, 386n.93; photograph of, by Stieglitz, 15, 226; portrait poster of, by Charles Demuth, 203, 226–27, 227

Dunn, Dorothy, 259

du Pont, Henry F., 297, 396n.85

Eakins, Thomas: and Americanness, xiii, 319, 342, 391n.1; Greenberg on, 341; recognition for, 293, 294, 315, 325, 393–94n.44, 395n.76; as rooted, xv

Early American Art (exhibition), 321–22

Edison, Thomas, 56, 66, 89, 109

Edwards, Jonathan, 13

Effort Modern, L' (gallery; Paris), 381n.4, 384n.52

Eggplant and Green Pepper (Demuth), 196, 196

Eiffel Tower, Paris, 61, 158, 181, 209; Duchamp's *Bottlerack* as, 78

Eilshemius, Louis, 85, 322

Eisenstaedt, Alfred, "*He focuses his camera on a still life*," 303, 304

Electric Bulb, New Mexico (Davis), 253, 254

electricity: as quintessentially American, 66, 158–60; spectacles of, 158–59, 171–72, 180; Stella's "Hymn" to, 146, 150; as vulgar, 24–25. *See also* signs; advertising

19; changes in, 302, 339; continuity in, 340, 349, 397n.2; definition of, xvii; early, xiv–xvii, xxx–xxxiii; Euro-centricity and, xix, 340; European perceptions of, 47, 61, 63; folk art and, 319–27, 332–33, 394n.51, 398n.39; French artists in New York and, 46, 48–49, 50–53, 63; goal of, 341; interwar, xvii; legacy of, 339–40, 341, 345, 353, 397n.11; New York School and, 340–42, 345; and O'Keeffe, 286–91; politics of, 4, 14–15, 341–42; practitioners of, xx; and the Southwest, 253; Stieglitz's circle and, 18, 20, 25, 33, 34, 80, 254, 286–87, 288–90; subjects of, 20, 112, 209; transatlantic, xviii, 193; transcendent, 28–29, 31; at 291 gallery, 16; as un-American, 340, 397n.3

modernity: advertisements as signifiers of, 125–26; idealization of, 132; indications of, 104, 125; Léger as a student of, 126–30; New York's, as a magnet for artists, 52–56, 64

modernolatry, 61, 116, 188, 245, 369n.54

Moly-Sabata (collective), 370n.62

Mona Lisa, the, 358; Duchamp's, 76

Mondrian, Piet, 185–86, 187, 341, 355, 358; in America, 353, 354, 398n.31, n.32; and American abstract expressionism, xvi, 341. Works: *Broadway Boogie Woogie*, 355, 355; *Victory Boogie Woogie*, 355

Monet, Claude, 357

Monroe, Marilyn, 358

Morand, Paul, 185; *New York*, 133, 186

Moravian Pottery and Tile Works, 301, 392n.11

Morison, Samuel Eliot, 315

Morris, George L. K. 349; *Indians Hunting No. 4*, 349, 349; *Times Square, A.M.*, 350, 350

Morse, Samuel F. B., 146

Motherwell, Robert, xiii

motorcycles, exhibition of, and *américanisme*, 359

Mott, J. L., Iron Works, 72–73, 370n.76; showroom of, 71, 73

Moulin à café (Coffee Mill) (Duchamp), 68, 68

Moveable Feast, A (Hemingway), 98

Movement, Fifth Avenue (Marin), 175, 176, 233

MSS [Manuscripts], Number One, 19

Mumford, Lewis, 396n.94; on the American Wing, Metropolitan Museum of Art, 314, 315; as a cultural nationalist, xv, 4, 336; on O'Keeffe, 241, 318; as a revisionist, 298, 315, 317, 318–19, 335; on Stieglitz, 28, 365n.99; and

the Stieglitz circle, 17, 36, 318. Works: *The Brown Decades*, 318; *The Golden Day*, 318; *Herman Melville*, 318; *Sticks and Stones*, 318

Munson, Graham, 6

"Murder of Moonshine" (Marinetti), 179

Muro Lucano, Italy, 135, 138

Murphy, Baoth, 96, 96

Murphy, Gerald, 94, 95, 97, 117, 372n.4, 376n.82; aesthetic of, 96, 102–3, 117–19, 119, 121, 130, 132, 209, 211, 308; *américanisme* and, 89, 99–100, 102–5, 108, 187, 332, 334; Americanness of, xviii, 117–20, 127–28; children of, xx, 94–95, 94, 96; cubism of, 96, 104, 120–21, 130, 308; and Demuth, 193–95; as an expatriate, 89, 133; and Léger, 85, 126–30, 194, 376–77n.108; as a painter, 96–99, 120–21, 121–31, 194, 200, 348, 349; photographs of, 94, 95, 117; Picasso and, 96, 120, 194, 373n.17, n.24; as a product designer, 122; as proto-pop, 357; recognition for, 92, 96, 98–99, 119–20, 195, 235, 347, 357, 372–73n.14, 373n.15; social life of, 95–96, 95, 99–100, 119; subject matter for, 120–21, 123, 308; technique of, 121, 129, 130–31, 308; as a *transatlantique*, xix, 91, 92, 94–96, 193; *Within the Quota* (ballet) and, 100, 102–5, 102, 103. Works: *Ball Bearing*, 375n.80; *Boat Deck*, 120, 121, 121, 140; *Dove*, 120; *Library*, 120; *Portrait*, 120; *Razor*, 90, 96, 120, 121–25, 121, 129–30, 357; *Villa America*, 99, 99–100, 373n.19; *Wasp and Pear*, 120; *Watch*, 120, 120

Murphy, Patrick, 94, 96, 132

Murphy, Sara, 94, 94, 96, 100, 117, 117

Murrell, William, *Charles Demuth*, 382n.27

Museum of American Folk Art, New York, 326, 357, 395n.83

Museum of Early American Folk Art. *See* Museum of American Folk Art

Museum of Modern Art, New York, 375n.80, 376–77n.108, 380n.77; Demuth's work at, 198, 200; émigré artists at, 341; establishment of, and Stieglitz, 40, 289; exhibition of landscape painting at, 397n.14; folk art at, 325, 326, 395n.83; Léger's work at, 376–77n.108; Murphy's work at, 373n.15, n.17

Museum of Primitive Art, 326

music, modern, 10, 30, 71–72, 102, 114–17, 187; as American, 359; in France, 57, 100, 105, 106–7, 108, 374n.51. *See also* jazz

Musical Portraits (Rosenfeld), 34

musicians, expatriate American, 114–17

Music—Pink and Blue No. 1 (O'Keeffe), 240, 241

Mutt, Richard (pseudonym), 46, 74

My Dress Hangs There (Kahlo), 353–54, 354

My Egypt (Demuth), 203, 218, 218, 222, 223

"Mysticism of Money, The" (Loeb), 214

Nabis (group of artists), 17

Nadelman, Eli, 50, 327, 367–68n.12, 396n.85; Museum of Folk Arts, Alderbrook, New York, 326, 327

Nation (periodical), 10

nationalism, xiv, xxi–xxii, 3, 4; aesthetic of, 336; folk art and, 325; importance of, 92–93, 105; resurgence of, 31, 133, 298, 325, 336, 339, 340; synechdochic, xxii. *See also* cultural nationalism

National Theater, Munich, 187

Native Americans: associations with, 245; buffalo as metaphor of, 273–74; culture of, and modernism, 251, 253–56, 274–75, 293, 342, 350, 395n.74; foreigners' expectations of, 352; as subjects for Anglo artists, 260, 261, 262, 262, 274–75, 275, 280, 281. *See also* dancers, Indian; Indians, Pueblo; Taos Pueblo

Nature Morte: Quaker Oats (Severini), 107, 107

Naumburg, Margaret, 5, 362n.27

Negro Song (Picabia), 63, 65, 355

Newark Museum, 325, 371n.101, 378n.6, 394n.49, 395n.74

New Deal, Federal Art Program of, 395n.74

New Hope School, 299

Newman, Arnold, *Georgia O'Keeffe, Ghost Ranch, New Mexico*, 283, 287

Newman, Barnett, 341, 342, 346

New Mexico: artists in, 253–62, 275; attractions of, 250–56, 390n.90; Mabel Dodge Luhan in, 256–60; and the spirit of place, 250. *See also* O'Keeffe, Georgia, in New Mexico

"New Mexico" (Lawrence), 256

New Negro (Locke), 360n.11

New Negro movement (Harlem Renaissance), xxi, 360n.11

New New York, The (Van Dyke), 166

New Republic (periodical), 10, 361n.6

New School for Social Research, 395n.74

newspapers, tabloid, as a metaphor for Americanness, xvi, xxii, 103–5, 234, 346, 346

"new spirit," 4–5, 105, 119, 123, 130, 339

Sheeler, Katharine, 316, *317*, 322, 394n.49

Sheeler, Muysa, 393n.35

Sherwood Anderson (Stieglitz), 34, *34*

Shinn, Everett, 171

Signac, Paul, 121

signs, advertising, 209, 210–13; Duchamp's use of, 51, *51*; Demuth's use of, 206–9, 233; electrified, 57, 159, 171, 184, 211–12, *211*, 229; Wrigley's chewing gum, 148, *149*, 159

Simmel, Georg, 181

Singer Building (Singer Tower), New York, 156, 163, 168

Siphon, Le (Léger), *128*, 129

Siskind, Aaron, *An Overhead Hood*, 299, *301*

"six + X". *See* Stieglitz circle

S. K. F. industries, Sweden, 118

skulls, 276–80, *281*, 282, 390n.93. *See also* bones; O'Keeffe, Georgia, skull paintings by

Skyline View (Smith), *162*

Skyscraper Murder (Spewack), 185

skyscrapers: as advertising, 155–56; domination of, 155; as essentially American, 52, 57, 81, 85, 175, 320, 352; European perceptions of, xvi, 54, 89, 104, 105, 109, 213, 217; exoticism of, 163; iconography of, xv, 140; as landscape, 163; O'Keeffe's paintings of, 25–26, *27*, 244, 286; as personifications of America, 188, 353–54; Sheeler's depiction of, 295, *296*; Stella and, 140, 148, 155–58; Stieglitz's photographs of, as capitulation, 26, 266; as subjects for art, 15, 25, 81, *83*, 185, 244, 266, 295, 335, 345, 379–85n.46, n.51; as subjects for expatriate Americans, 116

Skyscrapers (Sheeler), 295, *296*

Skyscrapers: A Ballet of Modern American Life, 187. *See also* "Chant des Gratte-Ciels, Le"

Skyscrapers of Lower Manhattan (Rummel), 143, 145, *145*, 168

slang: American, 54, 72, 111, 345, 347; French, 72

Slinkard, Rex, 391n.1

Sloan, Dolly, 253

Sloan, John, 168, 171, 173, 253, 395n.74; *The City from Greenwich Village*, 172, *172*; *Fifth Avenue, New York*, 172, *173*; *Indian Detour*, 260, *261*

Smith, F. Hopkinson, *Skyline View*, *162*

Smith, Henry Nash, xiii, 315; *Virgin Land: The American West as Symbol and Myth*, xiii

Smith, Leon Polk, *N. Y. City*, 398n.32

Smoke and Steel (Sandburg), 34

snow shovel, 71–73, 75. *See also In Advance of the Broken Arm* (Duchamp)

Société Anonyme, 50, 72, 79, 136, 208, 378n.6

Société des Artistes Indépendants, Paris, 50

Society of Independent Artists, New York, 43, 45–46, 50, 66, 71, 78; First Exhibition of (photograph), *45*

Society of the Spectacle (Debord), 126

soil, as a Stieglitz circle metaphor, 32, 38, 198, 201

Soil, The (magazine), 85–86, *86*, 214, 322, 345, 394n.60

Soirées de Paris, Les (magazine), 60

Song of the Talking Wire, The (Farny), 274, *275*

Songs of the Sky series (Stieglitz), 20, *21*

Soupault, Philippe, 106–7, 122, 209

Sour Grapes (Williams), 203

South Salem (Sheeler), 328, *328*, 329

South Salem, Interior (Sheeler), 316, *316*

South Salem, Living Room (Sheeler), 298, 306, *306*

South Salem, N. Y., 295, 299, 322

Spanish Colonial Arts Society, 253

Spencer, Niles, 321, 373n.15

Spewack, Samuel, *Skyscraper Murder*, 185

spirit of place. *See* place, sense of

Spirit of St. Louis (airplane), 181

Spiritual America (Stieglitz), 2, 32, 43, 367n.2

spirituality: Indianism in the Southwest as, 254, 255, 256, 257, 260, 342; as a tenet of Stieglitz's circle, 14, 25, 32, 33, 215, 232, 288, 289

spirituals, Negro, 56, 100, 107

sports, American, Europeans' perceptions of, 57, 58, 209, 353, *353*

Spring and All (Williams), 202, 383n.37

Squash (Weston), 203, 229, *230*

"Star Spangled Banner, The," 223

"Steamboat Ragtime" (from *Parade*), 100

steam hammer, compared to monument, 86, *86*

Stearns, Harold, 214

Steichen, Edward, 39, 171, 185; *Charles Sheeler, West Redding, Connecticut*, 294; *The Flatiron—Evening*, 150, 163, *164*

Stein, Gertrude, 50; Demuth as an admirer of, 194, 203, 223, 234, 237; and Duchamp's *Fountain*, 76, 77; as an expatriate, 91, 108, 109; on love, 224–25; and Picasso, 373n.24; salon of, 256; and Stieglitz, 15, 16, 38; word-portraits of, 202, 203, 223. Works: "The Difference between the Inhabitants of France and the Inhabitants of the United States of America," 109; *Geography and Plays*, 109; *The Mak-*

ing of Americans, 109, 224; "The Psychology of Nations or What Are You Looking At," 109; *Three Lives*, 224. *See also Love, Love, Love (Homage to Gertrude Stein)* (Demuth)

Stein, Leo, 50, 257

Steinberg, Saul, 359

Stella, Joseph, 81, 135–61, *138*, 188, 190, 253, 381n.88; *americanismo* and, 135, 138, 188, 218, 219; associates of, 136; and Crane, 190, 381n.97; and Duchamp, 136; as an exile, 135, 136, 137–38, 150, 179, 378n.8; futurism and, 179–80; metaphors of, 150, 342; New York as subject for, 136, 137, *138*, 168, 174–75, 176, *178–79*, 181, 183–84, 188; palette of, 150, 153; rhetoric of, 137–38, 146, 168, 179, 378n.19; and Sheeler, 295; style of, 136–37, 179; subjects for, 242, 387n.25; titles used by, 143; as a *transatlantique*, xix, 91, 92, 136–38, 152, 179, 193; use of light by, 146, 150, 153, 211; visual cacophony in work of, 172, 176, 179–81. Works: *American Landscape*, 188, *189*; *The Battery*, 143; *Battle of Lights, Coney Island, Mardi Gras*, 136, 176, *178–79*, 180; *Broadway*, 143; *Brooklyn Bridge*, 138, *139*, 155, 358; *Brooklyn Bridge* [part of *The Voice of the City*], 143; *The Great White Way Leaving the Subway*, 143; *Portrait of Old Man*, 136, *136*, 179; *The Prow*, 143, 150, *158*; *Study for New York Interpreted*, 140, *141*, 143; *The Voice of the City of New York Interpreted*, 137, 138–54, *140–41*, 150, 152–53, 154, 160, 172, 180, 181, 183, 190, 203, 350, 378n.5, n.6, n.13, 381n.97; *The Voice of the City of New York Interpreted: The Bridge*, *142*, 143–46, 150, 153, 155, 358, 381n.97; *The Voice of the City of New York Interpreted: The Port*, 143–46, *144*, 146, 150; *The Voice of the City of New York Interpreted: The Skyscrapers*, *134*, 143, 148, 150, 155–58; *The Voice of the City of New York Interpreted: The White Way I*, 143, 146, *147*, 148, 150, 153, 159; *The Voice of the City of New York Interpreted: The White Way II*, 143, 146, 148, *149*, 150, 153, 154, 159. *See also Manhatta*

Sterne, Maurice, 257

Stettheimer, Carrie, 194

Stettheimer, Ettie, 194, 259

Stettheimer, Florine, xx, 386n.2; Americanness of, xv, 286; art of, 203, 223; Demuth and, 200; as an expatriate, 91; style of, xviii, xxi, 195; the *transatlantiques* and, 194. Works: *Carl Van*

Vechten, 199, 201; *Portrait of Alfred Stieglitz*, 195, *195*; *Portrait of Duchamp*, 199, *201*

Stettheimer sisters, 50, 96, 194

Stevens, Wallace, 203

Stewart, Donald Ogden, 96

Sticks and Stones (Mumford), 318

Stieglitz, Alfred: abhorrence of commercialism of, 20, 366n.112; aesthetic of, xviii, 64; antimodernism of, 20, 23, 23–24, 26, 33; archives of, 18, 40, 367n.124; as a cultural nationalist, xiv–xv, 4, 5, 16, 215, 287, 289, 340, 341, 362n.30; as a cultural voice, 13, 14, 31, 33, 34, 175, 201, 357, 363n.49; dada and, 367n.2; and Demuth, 16, 194, 195–201, 203, 216, 223, 235, 239, 382n.10, n.27, 383n.38; and Dove, 239; and Duchamp, 39, 43–44, 48, 76–77, 80, 368n.20; Europe and, 33; exhibitions of work by, 391n.6; exhibitions organized by, 16, 18–19, 31, 64, 196, 223, 269, 269, 363n.44, 387n.23; galleries of, 14, 31, 39, 234, 282; and Hartley, 239; idealism of, 23, 29; importance of rural life for, 24, 32–33, 249; and Lawrence, 255–56, 389n.57; on *Manhatta*, 381n.88; and Marin, 31, 196, 239; marriage of, to O'Keeffe, xx, 229, 266, 387n.25; modernism and, 20, 23–24; *MSS* and, 18; Mumford on, 28, 318, 365n.99; and New York, 24, 80, 166, 249, 289, 299; nocturnes by, 171, *171*, 172; and O'Keeffe, 198, 223, 259, 271, 283, 387n.25, 390n.97, 391n.104; and O'Keeffe's work, xxi, 31, 239–42, 244, 266, 269, 364n.80; parables told by, 32, 365n.96; paternalism of, 18, 31, 239, 365n.97; photography of, 17, 38, 163, 169, 198, *240*, 241, 223, 242–43, 283, 383n.39; and Picabia, 22, 23, 24, 31, 39, 66, 364n.66, 368n.20; portraits by, 5, 6, *34*, 35–38, 203, 223, 242–43, 265–66, 267, 383n.39; portraits of, 5, 22, 23, 24, *34*, *36*, 38, 66, 195, 203; reputation of, 20, 322; and Rosenfeld, xix, 14, 18, 31, 239; and Sheeler, 216, 295, 299, 322, 335, 391n.6; as spiritual leader, 14, 38; and Strand, 239; subjects of, 28, 185, 266; symbols and, 22, 23, 203; technique of, 28, 380n.72; tributes to, 38, 289, 366n.120; *291* (magazine) and, 50, 364n.66; urbanscapes by, 28, 29, 166; Van Wyck Brooks on, 20. Works: *Arthur G. Dove*, *34*, 35; *Charles Demuth's Hands*, 198, *198*; *The City of Ambition*, 28, *28*; *Equivalent, Mountains and Sky, Lake George*, 20, *21*; *Fountain*, 42, 43–45, *44*, 48, 76–77, 367n.3, n.4; *Fountain* (cropped ver-

sion), 76–77, *76*; *From the Shelton*, 28, *29*; *Georgia O'Keeffe: A Portrait*, 265, 266, 267; *Georgia O'Keeffe: A Portrait—Exhibition at An American Place*, 269, *269*; *Georgia O'Keeffe: A Portrait—Hands and Bones*, 266, 267, 283; *Georgia O'Keeffe: A Portrait—Head* (1918; gelatin silver print), *243*, 243; *Georgia O'Keeffe: A Portrait—Head* (1918; palladium print), *34*, 36; *Georgia O'Keeffe: A Portrait—Head* (1924), 243, 283, *284*; *Georgia O'Keeffe: A Portrait—Painting and Sculpture*, 240, 241; *Georgia O'Keeffe: A Portrait—With Cow Skull*, 266, 267, 283; *Georgia O'Keeffe: A Portrait—With Painting*, 243, 283, *284*; *Georgia O'Keeffe: A Portrait—with Paul Rosenfeld and Charles Duncan*, *14*, *15*, 226, 227; *Icy Night*, 171, *171*; *John Marin*, *34*, 35; *Marsden Hartley*, *34*, 35; *Old and New New York*, 161, *162*; *Paul Rosenfeld* (1920), *34*, 34; *Paul Rosenfeld* (1923), *9*, 34; *Paul Strand*, *34*, 36; *Picturesque Bits of New York and Other Studies*, 166; *Sherwood Anderson*, *34*, 34; *Songs of the Sky* series, 20, *21*; *Spiritual America*, 2, 32, 43, 367n.2; *Waldo Frank*, *34*, 37, 38; "Woman in Art," 240–41. *See also* An American Place (gallery); Intimate Gallery; *291* (gallery)

Stieglitz circle, 16–20, 266, 388n.30, n.34, 390n.102, 391n.1; antipathy evoked by, 215; art of, xix, 386n.2; billboards as vulgar for, 212; and Demuth, 194, 195–201, 222, 232; Greenberg on, 341, 397n.11; and Mumford, 318; nocturnes by, 172; origins of, 16; and popular culture, 80, 216; rhetoric of, xvi, 18–19, 30–32, 222, 228, 232, 249–50, 271, 289, 314, 342; and Sheeler, 299, 391n.6; as "six + X," 16, 196; and the Southwest, 254, 255–56, 289–90. *See also* Americanness

Stieglitz Memorial Portfolio, 1864–1946, 39, 366n.120

Still, Clyfford, 341, 347

still life, *119*, *271*; as advertisement, 130; as art, 130, 321; in Demuth's portraits, 225, 229–31; French café, 120, 129, 346, *346*; in Sheeler's work, 303, *304*; Southwestern-style, 262; trompe l'oeil, and pop art, 357; Wild West, 280, *281*. *See also* O'Keeffe, Georgia, still lifes by

Still Life on a Table: "Gillette" (Braque), 125, *125*

Still Life or Vanitas (Champaigne), 270, *271*

Stokowski, Leopold, 257

Storrs, John, 114, 185; *Forms in Space*, 114, *114*

Strand, Paul, 36, 244, 335, 388n.29; on Americanism, 31, 32; and Demuth, 197, 203; Europe and, 32; on futurism, 180; on Marin, 33, 232; the modernity of New York and, 25, 185; *MSS* and, 18; in New Mexico, 255, 257; on O'Keeffe, 241; as part of Stieglitz's artistic circle, 14, 16, 32, 34, 239, 289, 363n.44; photographic abstractions by, 25, 295; portrait by, 5, 36; and Sheeler, 295, 335, 391n.6; style of, 295; work of, 20, 375n.80. Works: *Alfred Stieglitz*, 34, 36; *Manhatta* (film), 137, 182, 183–84, 190, 295, 381n.88

Strand, Rebecca, 244, 257, 259, 289, 386n.2, 388n.29

Strange Interlude (O'Neill), 197

Strauss, Anselm, 161

Strauss, Richard, *Death and Transfiguration*, 269

Stravinsky, Igor, 102, 114; *Les Noces* (ballet), 96

Street Light (Balla), 179–80, *180*

Struss, Karl, 171

Studies in Classic American Literature (Lawrence), 80, 389n.57, 393n.38

Study for New York Interpreted (Stella), 140, *141*

Study for Poster Portrait: Marsden Hartley (Demuth), 203, 227, *228*

Stutz hose wagon, 205, *205*

Sullivan, Louis, 294

sun, as metaphor, 8, 10, 13, 25, 30

Surmâle, Le (Jarry), 59–60

surrealists, 33, 53, 106, 246, 345

Sweeney, John Johnson, 341

symbolism, xvii, xviii, 203, 204; *correspondances* (equivalencies) in, xv, 6, 65, 198, 239, 242, 243, 250, 280; O'Keeffe's, 239, 242, 243, 280, 282, 290–91; in referential portraiture, 202–203, 224–34. *See also* metaphor; symbolists

symbolists: French, 186; Picabia's use of language of, 64; Rosenberg's prose style deriving from, 6; Stieglitz's circle as latter-day, 17, 32, 76, 80, 212, 245, 250, 290, 363n.49. *See also* symbolism

Symons, Arthur, 6, 18

tabloids. *See* newspapers

"Tango du Boeuf sur le Toit," 107

Tanguy, Yves, xvi, 341

Taos Indian Detour—3 days (Behn), 251, *251*

Taos pueblo, 258, 262, *262*

Taos Pueblo (O'Keeffe), 258, 262, *262*

Wesselman, Tom, 235
West, Benjamin, xvi, 128, 358
Weston, Edward: *Excusado*, 87, 88; *Squash*, 203, 229, 230
Westport, Conn., as an artists' colony, 32
Wheelwright, Mary Cabot, 259
When Buildings Were White (Le Corbusier), 186
"When New York Became Central" (Rosenfeld), 361n.6
"*Which Is the Monument?*," 86, 86
Whistler, James Abbott McNeill, 10, 12, 13, 91, 150, 171–72, 284; *Nocturne in Blue and Green*, 150, *151*
White, Pearl, 100
White, Stanford, 169, 380n.64
White Barn (Sheeler), 325
White Buildings (Crane), 185
Whitehall Building, New York, 146
White Way I and *II*. See under *Voice of the City of New York Interpreted*
Whitman, Walt, 12, 60, 183; as a cultural icon, 13, 59, 186, 293, 342, 358, 369n.45, 393n.38; French adulation of, 52, 59, 87, 89, 109, 114, 131; Stella's admiration of, 137; transcendentalism of, 250. Works: "Crossing Brooklyn Ferry," 183; *Leaves of Grass*, 140; "Mannahatta," 183
Whitney, Gertrude Vanderbilt, 322
Whitney Museum of American Art, New York, 323, 358, 393–94n.44, 398n.39
Whitney Studio Club, 321, 322, 323, 394n.63, 398n.39
Whitney Studio Galleries, 323
Wiborg, Frank B., 94
Wiggens, Guy, 169
Wilde, Isabel Carleton, 394n.51
Wilde, Oscar, 203
Wilder, Thornton, 257
Wild West: bones as symbols of, 266, 272–74, 275–76; Europeans' fascination with, 56, 100, 106, 111; trompe l'oeil still lifes of, 280, *281*

William Carlos Williams (Sheeler), 201, *202*
Williams, Bert, 86
Williams, Raymond, xx, 23
Williams, Talcott, 10
Williams, William Carlos, 202; on American art, 219; and American history, 314; Americanness of, 5, 108, 109; and Demuth, 194, 202, 203, 220, 228, 235, 237, 383n.36; *MSS* and, 18; poetry of, 201, 202, 203, 212; sense of place and, 249, 250; and Stieglitz, 17, 365n.97. Works: "The Attic Which Is Desire," 212, 229; "Crimson Cyclamen (To the Memory of Charles Demuth)," 383n.37; "The Great Figure," 203–4, 206–7; *In the American Grain*, 314; "Perpetuum Mobile: The City," 185; "Pot of Flowers," 383n.37; *Sour Grapes*, 203; *Spring and All*, 202, 383n.37. See also *Figure 5 in Gold, The* (Demuth)
Williamsburg. *See* Colonial Williamsburg
Wilson, Edmund: ballet written by, 373n.23; on the decline of French culture, 108; in New Mexico, 253–54, 255, 256; on O'Keeffe, 241; prose style of, 6; on Rosenfeld, 6, 14, 20, 34, 385n.68; on the Stieglitz second circle, 196, 215–16, 386–87n.8. Works: "The Enchanted Forest," 253; "An Imaginary Conversation," 215–16; "Indian Corn Dance," 253
Wine of the Puritans, The (Brooks), 13
Wister, Owen, 272
Within the Quota (ballet), 100, 102–5, 114, 374n.35, 376n.108; backdrop and costumes for, by Murphy, 103–4, *103*; program for, by Murphy, *102*, 103
Woman (Man Ray), 81
"Woman in Art" (Stieglitz), 240–41
Woman with Plants (Wood), 228

women, American: as artists, xxi, 240–44, 386–87n.8, 387n.18, n.20; European perceptions of, xv, 55, 57–60, 66–67, 75, 89, 100, 102, 356; in New Mexico, 259–60
Wood, Beatrice, 43, 46, 48, 50, 75–76, 367n.3, n.10
Wood, Grant, 12, 288, 394–95n.66; *Woman with Plants*, 228
Wooden Virgin (O'Keeffe), 262, *263*, 264
Woollcott, Alexander, 96
Woolworth Building, 156, *156*, 184, 371n.103; and Duchamp, 80; Murphy's appropriation of, 104; Stella's use of, 155, 156
Woolworth Building, 156, *156*
wordplay, in modern art, 25, 66–67, 72, 73, 75, 222, 233, 367n.9
word-portraits, Gertrude Stein's, 202, 203
World War I, xvi, 8–9, 11; armed forces badge from, 279, *279*, 390n.93; effect of, on America, xvi, 8–9, 11
World War II, xvi, 340–42, 345
Worthington, Jonathan, 299, *300*, *301*
Wright, Wilbur, 56, 114
Wrigley's chewing gum, 148, *149*, 159

Yale Literary Magazine, 10
Yale University, studies in material culture at, 315, 393n.32. *See also* Beinecke Rare Book and Manuscript Library
"'You Must Come Over': A Painting, A Play" (Demuth), 391n.1
Young France and New America (Lanux), 87

Zelli's, Paris, 108
Zito's Bakery (Abbott), 206, 207
Zorach, William and Marguerite, 321, 330, 395–96n.84

The Great American Thing was edited by Stephanie Fay and
produced by Sam Rosenthal, both of the University of California
Press. It was designed by Christine Taylor and composed by
Wilsted & Taylor Publishing Services in Caledonia with
Metro display, typefaces designed by the great American
designer and puppeteer W. A. Dwiggins in 1938 and 1929.
The book was printed by Friesens Corporation in Canada.